GREAT PAINTERS

Patricia FRIDE-CARRASSAT

CHAMBERS

For the English-language edition:

Translated by
Rosetta Translations

Art consultant
Dr Patricia Campbell, University of Edinburgh

Series editor
Patrick White

Editor
Camilla Rockwood

Proofreaders
Stuart Fortey
Harry Campbell
Ingalo Thomson

Prepress
Vienna Leigh

Originally published by Larousse as *Les Maîtres de la Peinture* by Patricia Fride-Carrassat

© Larousse/HER, Paris, 2001

English-language edition
© Chambers Harrap Publishers Ltd 2004

ISBN 0550 10124 1

Cover image: Rembrandt, *Portrait of the Artist at his Easel*, 1660 (Paris, Musée du Louvre). Photo © RMN/C Jean.

Typeset by Chambers Harrap Publishers Ltd, Edinburgh
Printed in France by MAME

INTRODUCTION

Over the past few decades, the cultural scene has been brought to life by a series of large retrospective art exhibitions. Increasing numbers of visitors have turned these artistic displays into major events. Some of them offer us another chance to enjoy the work of great artists such as Botticelli, Matisse or Picasso. Others reintroduce us to lesser-known artists like Vermeer, La Tour or Lotto. Sometimes they also explore forgotten elements of an artist's work (Daumier's paintings and sculptures). But although Michelangelo believed architecture and sculpture were higher art forms, it is painting that really makes these exhibitions popular.

Masters or geniuses

The terms 'master' and 'genius' suggest an exceptional creature, on a higher plane than mere mortals. The word 'genius' covers a variety of concepts. The French Renaissance philosopher Diderot believed geniuses to be more concerned with 'the sublime' than with beauty, to display a natural facility for learning and invention and a sharp mind. Hume said they showed a 'kind of magical faculty of the soul'. For Kant, it was about a willing mind and the 'right moment'. Schopenhauer described the 'unnatural faculty' and 'other universe' of the genius, which comes from the primacy of intuitive consciousness over discursive consciousness. Freud saw genius as 'confused intelligence', accompanied by emotional and physical disturbances. Leonardo da Vinci, Michelangelo and Dürer were all geniuses, as were Caravaggio, Cézanne, Picasso and Ernst, whether they taught in their studios or in art schools, worked with well-known painters, or established themselves as 'masters' through their art alone. The work of a genius is clearly identifiable, and can revolutionize the way we see the world.

From craftsmen to artists

In the Middle Ages, painters were craftsmen who belonged to a structured, hierarchical association known as a guild. From the age of ten or eleven, an artist learned his trade in workshops (which also sold goods), under the direction of a master. Often, though not always, the craft was passed down from father to son. As an adult, following four years of study, an artist could call himself a master and begin to teach others.

The workshops of the Italian Renaissance (known as *botteghe*) followed in the tradition of the Ancient Greek *museion* and Roman *museums* (colleges for scholars or centres for philosophical debate), which drew together different skills to give an overall view of the arts. They were centres of artistic and intellectual exchange, but also provided training and displayed works of art. In the 15th century, artistic painters began to reject their craftsman status: Masaccio, for example, began signing his work. Artists also began to copy antique works. In the 16th century they began working with the humanists for aristocratic families and big commissioners, and then started attending the newly created 'academies'. A similar trend emerged in Flanders, although academies were not set up there until almost a century later.

In the 17th century, painters trained largely in these official academies. There were seventy in France alone, including the Royal Academy of Painting and Sculpture, which trained and housed artists. From 1663, when Colbert created the Prix de Rome, artists went to Italy to

study the work of the master painters of the Renaissance and antiquity. The Salon du Louvre was set up in 1667, and work had to be approved for exhibition there by a jury from the Academy. A handful of artists such as Caravaggio and Poussin rebelled and began working for themselves, independently of the patrons' demands.

By the 18th century, the Parisian Royal Academy model was beginning to spread throughout Europe. But the changes in the art market, the growing number of schools and exchanges and the development of the art trade were all altering the relationship between painters and official settings.

In the 19th century, painters gradually began to escape the confines of the academic world. Students at the Royal Academy were generally taught in private studios. If possible, they would exhibit their work at the Salon du Louvre, but they also used private salons or art galleries. Artists were demanding more freedom, and, in the latter part of the century, began to seek inspiration in places where they could indulge their love of fresh air and exoticism: Barbizon, Giverny, Provence, the Orient.

The 20th century saw the end of master-teachers, with the exception of the Bauhaus movement. Painters trained at art colleges, or in private schools. They enjoyed complete creative freedom – although when it came to making a living, they were still dependent on dealers.

Masters and their art

Cennini described how Giotto adapted to 'the modern' (Treaty of Painting, 1437). Poussin recognized the master's ability to capture 'the idea of things (...) resembling nature'. Delacroix identified a 'true artist' by his 'passion, drive and violence', contradicting David, who believed that an artist 'gives a perfect appearance, perfect form to his thoughts'. Manet wanted to 'seize the epic quality of real life', while according to Degas, 'an artist does not draw what he sees but what he makes others see'. Constable described Turner as painting 'with coloured vapour'. For Monet, the garden was 'the greatest masterpiece', and then came Van Gogh, who used 'red and green (to express) terrible human passions'. Finally, Matisse declared that 'the true meaning of a work of art is contained within it, and the viewer understands it before he has even identified the subject'.

In November 1852, Delacroix wrote in his journal: 'Opinions must change; no-one can ever know a master well enough to talk about him in absolute, definitive terms'. This comment shows how retrospectives, published works, the art market and changing trends have altered our perspective of artworks and masters.

About this book

This book introduces 73 masters of Western painting, from the Middle Ages to the 20th century, from Cimabue to Warhol, whether they spearheaded art movements (Carrache, Rubens, Delacroix, Monet, Picasso) or worked alone (notably Brueghel, Lotto, La Tour, Velázquez, Vermeer, Rembrandt, Chardin, Manet, Cezanne, Van Gogh and Bacon). Difficult decisions had to be made in order to select just 73 artists from a period of seven centuries. Although the choice of painters was based on certain criteria, some readers may feel a sense of injustice over those who have been left out. Our masters are those recognized today. Will some of the painters represented here be forgotten a few decades from now? Will others emerge from the shadows and be recognized in their historical context? In 1950, for example, La Tour, Vermeer, Caravaggio and Pontormo would not have featured in this book. Changing mentalities also have an effect on the list: 23 masters are included from the 13th to the 16th centuries, ten from the 17th century, six from the 18th, 17 from the 19th and 17 from the first 60 years of the 20th century.

Methodology

Strict criteria had to be applied in order to select the painters. These included: whether the artist broke away from the style of the period or maintained stylistic continuity (perhaps developing a particular style further); his contribution to the body of work; his living success and lasting quality; how his work was discovered or rediscovered; short-lived or lasting innovations with regard to themes and materials (format, medium, composition, light, technique, philosophy).

We eliminated artists we considered timid precursors, who never fulfilled their true potential, as well as students and followers (even those who are well-known but were not the original creators of a style); artists who may have produced equally good work but in smaller quantities, and hence were less influential; and 'hardliners' who focused too heavily on a single art form or technique.

The contemporary period, from 1960 onwards, seemed too recent to judge objectively – only Dubuffet, Pollock, Bacon and Warhol were felt to truly meet all the criteria.

A chronological approach

Starting with Cimabue, the book follows a chronological path up to the 20th century. Where artists' careers overlap, their dates of birth have been ignored; artists are ordered by the date of their first decisive contribution, or by pictorial relationships created by art history.

The book is divided into six major historical and stylistic periods: the 13th to 16th centuries (the Renaissance and its influence), the 17th century (Classicism and Baroque), the 18th century (Rococo and Neoclassicism), the first half of the 19th century (Romanticism), the second half of the 19th century (Realism, Impressionism, Postimpressionism, Symbolism) and the 20th century up until 1965 (Expressionism, Cubism, abstract art, Surrealism and the beginnings of contemporary art, from Abstract Expressionism to Pop Art).

Each section opens with an introductory text. These introductions place the artists and their work in their historical, political, economic, social and cultural context, as well as describing their working environment (the role of public and private commissioners, critical and public reception to their work). This makes it possible to compare what was happening stylistically during a particular period in different European countries.

Presentation of the painters

Every entry follows the same structure:
• A short introductory paragraph summarizes the painter's personality, focusing on his work and the stylistic features that have made him a master.
• 'Life and Career' shows the key points of the painter's life and the dates of his most important works.
• The 'Approach and Style' section shows the artist's favourite subjects, formats, media and techniques, his main commissioners, his travels and the artistic influences on his work, as well as the styles and materials he used and the way his work developed.
• 'A Great Painter' highlights the criteria which make the artist in question a master: success in his lifetime or the later rediscovery of his work, a new stylistic direction or the depth and originality of a particular style, invention or reworking of a subject, composition, material (colour, light, style), technique, main themes.
• The 'Key Works' section gives the quantity of paintings the artist produced (drawings and engravings are not included), major pieces of work and those works that particularly illustrate the development of the artist's style.
• One to three works by each artist are reproduced. These have been chosen to represent the development of the artist's mature style (Picasso's blue and pink periods, for example, are insignificant in comparison to Cubism). They may not be the most famous works, but are the best illustrations of the artist's strategy.
• A bibliography suggests some reference works for further study, such as exhibition catalogues, monographs and writings by painters.

Although we have made every effort to include a diverse and representative selection of artists, our choices are of course subjective. However, this should not prevent anyone with an interest in art from adding his or her own favourite painter to the list of masters.

Contents

List of abbreviations

Common abbreviations

S: San, Santo, Santa, Santi
B-A: musée des Beaux-Arts
coll: collection
coll part: collection particulière
RMN: Réunion des musées nationaux
G or gal: Gallery, Galerie, Galleria
AG: Art Gallery
NG: National Gallery
AI or IA: Art Institute or Institute of Art
AM or MA: Art Museum or Museum of Art ; Museo d'Arte ; Museu de Arte
GN: Galleria nazionale ; Germanisches Nationalmuseum
MC: Museo Civico
MFA: Museum of Fine Art
MN: National Museum, Museo National,
Km: Kunstmuseum
K: Kunsthalle

Abbreviations of museums

Amsterdam, Rm: Rijksmuseum
Amsterdam, SM: Stedelijk Museum
Antwerp, MMB: Museum Mayer Van der Bergh
Birmingham, BI: Barber Institute of Art
Boston, ISGM: Isabella Stewart Gardner Museum
Brunswick, SHAUM: Staatliches Herzog Anton Ulrich Museum
Brussels, B-A: musées royaux des Beaux-Arts
Budapest, SM: Szépemüvészti Múzeum
Cambridge FM: Fitzwilliam Museum
Cambridge [Mass], FAM: Massachusetts, Fogg Art Museum of Harvard University
Cardiff, NM of Wales: Cardiff, National Museum of Wales
Cincinnati [Ohio], TM: Taft Museum
Copenhagen, SMFK: Statens Museum for Kunst
Copenhagen, NCG: Ny Carlsberg Glyptotek
Copenhagen, OS: Ordrupgaard Sammlingen
Dresden, Gg: Staatliche Kunstsammlungen, Gemäldegalerie
Düsseldorf, KNW: Kunstsammlungen Nordrhein-Westfalen
Düsseldorf, Km: Staatlische Kunstmuseum
Edinburgh, NG: National Gallery of Scotland
Essen, FM: Folkwang Museum
Florence, Uffizi: Galleria dei Uffizi
Florence, Pitti: Palazzo Pitti
Frankfurt, SK: Städelsches Kunstinstitut
Glasgow, AG: City Art Gallery
Greenwich, NMM: National Maritime Museum
Hartford, WA: Wadsworth Atheneum
Karlsruhe, SK: Staatliche Kunsthalle
Kassel, SK, Gg: Staatliche Kunstsammlungen, Gemäldegalerie
Leipzig, M: Museum der bildenden Künste
London, BM: British Museum
London, BP: Buckingham Palace
London, CI: Courtauld Institute
London, DC: Dulwich College
London, KH: Kenwood House
London, RA: Royal Academy
London, SM: Soanes' Museum
London, TG: Tate Gallery
London, VAM: Victoria and Albert Museum

London, WM: Wellington Museum
London, Wall C: Wallace Collection
Lugano, TB: Thyssen-Bornemisza collection
Madrid, Ac S Fernando: Real Academía de Bellas Artes de San Fernando
Madrid, Escorial: Real Monasterio del Escorial
Madrid, Prado: Museo Nacional del Prado
Marlborough, IFA: International Fine Art
Melbourne, NGV: National Gallery of Victoria
Merion [Penn], BF: Pennsylvania, Barnes Foundation
Milan, Brera: Pinacoteca di Brera
Munich, AP: Alte Pinakothek
Munich, NP: Neue Pinakothek
Munich, SG: Städtische Galerie im Lenbachhaus
Munich, SMK: Staatsgalerie Moderner Kunst
Naples, Capodimonte: Museo nazionale Capodimonte
New Haven, YC: Yale Center of British Art
New York, Brooklyn: Brooklyn Museum of Art
New York , FC: Frick Collection
New York, HSA: The Hispanic Society of America
New York, MM: Metropolitan Museum of Art
New York, MOMA: Museum of Modern Art
New York, Guggenheim: The Solomon R Guggenheim Museum
Northampton, SC: Smith College
Otterlo, K-M: Kröller-Müller
Paris, Carnavalet: musée Carnavalet
Paris, C-J: musée Cognac-Jay
Paris, ENSB-A: École nationale supérieure des beaux-arts
Paris, J-A: musée Jacquemard-André
Paris, Louvre: musée du Louvre
Paris, MAD: musée des Arts décoratifs
Paris, MNAM: musée national d'Art moderne, Centre Georges-Pompidou
Paris, MAM: musée d'Art moderne de la Ville de Paris
Paris, Orsay: musée d'Orsay
Paris, PP: Petit Palais
Prague, NG: Národní Galerie
Rome, Colonna: Galleria Colonna
Rome, Farnese: Palazzo Farnese
Rome, Capitolina: Galleria Capitolina
Rome, Borghese: Galleria Borghese
Rome, Corsini: Galleria Corsini
Rome, Doria: Galleria Doria Pamphili
Rome, GAM: Galleria internazionale d'arte moderna
Rotterdam, BVB: Museum Boymans Van Beuningen
San Francisco, YMM: De Young Memorial Museum
Saint Louis, CAM: City Art Museum
Seville, M Provincial: Museo Provincial de Bellas Arte
Springfield, MA: Museum of Fine Art
Stockholm, Nm: Nationalmuseum
Stuttgart, Sg: Staatsgalerie
The Hague, M: Mauritshuis Museum
The Hague, Gm: Gemeentmuseum
Turin, GS: Galleria Sabauda
Venice, Ac: Galleria dell'Accademia
Venice, Doges: Doges' Palace
Venice, GAM: Galleria internazionale d'arte moderna di Ca' Pesaro
Versailles, m: musée national du château de Versailles
Vienna, Gg: Gemäldegalerie
Vienna, HM der S W: Historisches Museum der Stadt Wien
Vienna, KM: Kunsthistorisches Museum
Vienna, Ö G: Österreichische Galerie

FROM THE 13TH TO THE 16TH CENTURIES: THE PRE-RENAISSANCE, RENAISSANCE AND MANNERISM

In the course of the second half of the 13th century and the early 14th century, Europe, and in particular Italy, underwent a profound transformation marked by new ways of living and thinking. It also experienced an artistic revolution initiated by the naturalism of *Giotto, who, with *Masaccio nearly a century later, heralded the advent of the Renaissance. The Italian Renaissance in its strict sense (15th and 16th centuries) marked the passage from the Middle Ages to modern times. The artists – from Masaccio to *Veronese, from Giovanni *Bellini to *Leonardo da Vinci and *Dürer – were interested in all areas of knowledge connected with man and invented the artistic techniques which became the foundation stones of the Western aesthetic. The Classical order of the Renaissance was disrupted by Mannerism – the result of turbulent historical events – which was introduced by *Michelangelo and developed by *Pontormo.

The end of the Middle Ages and the beginnings of the Renaissance

Political, religious and social change – all signs of the pre-Renaissance – took place in medieval Italy. While the papacy managed to impose its supremacy on the Germanic Holy Roman Empire, the King of France, Philip the Fair, rejected the interference of Boniface VIII and had him arrested in 1302. After the death of Benedict XI in Rome, the Frenchman Clement V became Pope and was installed at Avignon.

The emergence of new powers. In Italy the merchant bourgeoisie won political power at the expense of the feudal aristocracy. After 1250 the city states grew rich and became rivals. Their merchants travelled through Burgundy in order to trade with Flanders. Venice had special links with Byzantium. The 'republican' awakening began, Roman law supplanted feudalism and local freedoms triumphed, leading to the cautious emergence of secular themes in art: realistic representations of daily life and profane love as sung about by the troubadours.

A world favourable to men and painters. This rapidly developing world saw a renewal of sentimental 'popular realism' concerned with narrative and nature. The development of individualism and the opening up of Christianity to nature found their expression in Dante's *Divine Comedy* (1306–21), the theological and philosophical works of St Thomas Aquinas and the teachings of St Francis of Assisi. The Pisani, sculptors of Tuscany, introduced a dignified naturalism, the forerunner of a new spirit, which was given greater depth by the paintings of *Cimabue and those of his pupils and followers: Duccio and in particular Giotto. As Aeneas Piccolomini, the future Pope Pius II, observed in 1455: 'With Petrarch, the art of letters revived; with Giotto, painting made its mark again; we have seen both arts reach perfection'.

The spiritual vigour of the Franciscans, whose order was created in the 13th century, offered a new concept of the world: the heroic Christ, triumphant over death, was succeeded by a suffering Christ in the image of man. Assisi was the cradle of the new Italian spirituality; the work of Giotto 'spoke from God to man' (S Fumet, 1953).

Commissions for paintings increased; not only from churches and religious institutions (at this time painting was less costly than mosaic) but also increasingly from secular sources: commissions from municipalities, such as that carried out by Ambrogio Lorenzetti for the city of Siena, and the decoration of items such as marriage chests and birthing beds.

At the end of the Middle Ages, some craftsmen-painters – finding themselves valued by those commissioning works of art from them – began to display their artistic personalities.

International Gothic. The development of International Gothic, or the aristocratic, precious, 'courtly' style, was helped along by the upheaval which led to the installation of the Pope at Avignon. The Sienese painter Simone Martini worked there in 1339, while French and Italian painters decorated the Palace of the Popes and the Carthusian monastery at Villeneuve-lès-Avignon. In Italy the main practitioners of International Gothic were Gentile da Fabriano, Pisanello and Sassetta. After flourishing in the European courts between 1390 and 1425, and in France with the art of Enguerrand Quarton among others, the style ran out of steam in Italy in about 1425, at the same time as the painter Masaccio in Florence was initiating the Renaissance.

The 15th century, the advent of the Renaissance

The Great Schism ended in 1414 with the Council of Constance, which elected a single Pope, Martin V. Rome became the seat of the papacy, thus guaranteeing the unification of Christianity in the West. Martin V was interested in archaeology and encouraged the production of works of art. In Italy the medieval world was in decline and the city states, run by powerful families, were regrouping and expanding. In 1453, the fall of Constantinople sounded the death knell of the Christian Empire in the East and the Hundred Years War between France and England came to an end. Spain was unified by the marriage of Ferdinand of Aragon and Isabella of Castile; they completed the Reconquest in 1492. Modern monarchies were born.

A new economic era. The European economy of the 'merchants' developed; trading in spices and fabrics was particularly strong. Powerful Italian bankers and nobles established themselves: the Medici in Florence, the Sforzas in Milan, the Montefeltros in Urbino, the Scrovegni in Padua, Isabella d'Este in Ferrara, Federico II of the Gonzagas in Mantua and the doges in Venice. Commerce dominated the life of the city state and encouraged patronage, which was further motivated by bitter rivalries.

Technological and scientific renewal. Navigational techniques were modernized in order to stimulate an increase in trade. Improvements in weaving technology enabled larger fabric sizes to be produced and metallurgy was developed. In Germany, printing with movable metal type encouraged the spread of learning. The increase in scientific knowledge, particularly in the fields of anatomy, geometry and astronomy, led to occasional tension with the Church, which stuck to its dogmas.

Humanism, a revolution in thought. 'The Renaissance was above all a cultural phenomenon, a concept of life and reality – which examined the heart of things beyond appearances – which influenced the arts, literature, science and morals' (E Garin). This cultural revolution, which led to a decompartmentalization of knowledge, was the only period in the history of art which had such an awareness of itself, its possibilities and its affirmation of man's existence. This anthropomorphic, humanist view of man, seen as 'free', tended towards universality. Christian humanism was the result of a mode of thought founded on rebirth and the revival of the ancient worlds of Greece and Rome.

The humanist philosophers Marsilio Ficino and Pico Della Mirandola declared that the Christian religion was in the tradition of the Platonism of antiquity. This belief was in contrast to the scholasticism of the Middle Ages, which had never managed to reconcile theology and philosophy or to achieve the perfect harmony of man and the terrestrial and celestial spheres. The dignity of man and Neoplatonism were given a special place in Florence under the aegis of these philosophers, who in 1462 founded the first organized academy, the Platonic Academy.

Scientific knowledge and literary, historical and political learning were revolutionized by this new concept, which gave priority to reason, method and intellectual rigour. The centralizing state looked for 'modernity' in political ideology. Intellectuals (Machiavelli, Thomas More, Rabelais, Erasmus, Copernicus, Petrarch), architects (Alberti, Brunelleschi) and sculptors (Ghiberti, Donatello) saw themselves as examples of man in his natural surroundings, at the centre of the world.

Humanism and the art of the quattrocento. The first stage of the Renaissance began in Florence with Masaccio in about 1425. Art took its inspiration from all fields of learning, from the repertoire of antiquity and the anatomical lessons of statuary, as well as from nature, out of which the three-dimensional, spatial view of the modern world emerged. This was a period of research, analysis, conquest and artistic freedom. The theories of architects and sculptors had an impact on painting. Form and volume, often presented on a human scale, were rationalized through perspective. The representation of anatomy became accurate as a result of the development of the system of proportions and the science of foreshortening. Masaccio placed his figures within a real space, which was created in accordance with the perspective of the architect Brunelleschi and bathed in a natural light. Uccello developed the art of perspective. *Piero della Francesca, the master who worked in Arezzo and Urbino, Mantegna, the painter of the d'Este family at Mantua, and Melozzo da Forli, named as the 'papal painter' of Sixtus IV in 1478, excelled in the art of perspective and foreshortening.

A secular art derived from antiquity developed. Allegorical and mythological subjects, nudes and portraits (a reflection of the cult of the human being) were used to glorify princes and cities. Religious art changed: the face of God became more human and the Virgin displayed tenderness towards the Child in the work of Filippo Lippi and Fra Angelico.

The enthusiasm of private and public patrons led to the formation of flourishing studios and numerous workshops in which the master supervised his pupils. Collections were built up in art-collectors' exhibition rooms, in cabinets of curiosities or in larger establishments such as the gallery of the Medici in Florence. Guided by Ficino, artists steeped themselves in Platonic humanist thought, which glorified formal beauty, seen as the fruit of intellectual, rational, sensual and divine knowledge. *Botticelli cultivated a scholarly, secular poetic ideal which concentrated on the beauty of line.

In Rome, the papacy expressed its desire for monumentality and solemnity, reminiscent of the Roman Empire and the Roman Republic. Venice shone with colour and light in the Byzantine tradition.

The first independent artists. Masaccio, one of the first 'free' painters, signed his works. Recognized as creative individuals, artists were respected and praised. A contract between Piero della Francesca

and the brotherhood of S Maria della Misericordia stipulated 'that no painter other than Piero della Francesca could hold the brush' – evidence of the esteem in which the artist was held. Jan *van Eyck signed his *Arnolfini Marriage Group*, just as Mantegna and Giovanni Bellini signed their paintings. The relationships between artists and their patrons – the Church and the great families of the city states, who tried to outdo each other in magnificence and were jealous of each other's artists – were sometimes tense: disagreements could crop up over the subject matter and its symbolism, the style of execution or the amount of the fee. Artists moved from place to place at the request of their patrons: Leonardo da Vinci went to the court of the Sforzas in Milan, and *van Eyck moved to Portugal to paint the portrait of Isabella, the future wife of Philip the Good.

Northern Europe and the spread of oil painting

While Italy mastered perspective, Flanders perfected oil painting. It replaced tempera and fresco painting, which required rapid execution because of the short drying time. Oil painting provided new artistic possibilities with its delicacy, bright colours, infinitely graded tones, unequalled visual realism and its suitability for depicting landscapes bathed in light. Glazes (transparent layers of oil paint applied over opaque ones) created the illusion of depth. The brothers Hubert and Jan van Eyck explored oil painting in all its richness. In a strict sense they did not belong to the Renaissance since they examined the appearance of reality rather than its principles, and their style still belonged to late medieval Gothic. They analysed the effects of light on colour but not on form. Antiquity did not concern them. The real took precedence over the creation of an ideal world based on drawing. It was the same for *Van der Weyden, even though his realism was new. He painted beings of flesh and blood, humble, moving and tender, who took their place in a world filled with humanity.

However, these painters have a special place in the history of the Renaissance by virtue of their new vision of the sensory world, which they expressed through the technique of oil painting and their mastery of perspective. It is thought that oil painting was brought to Venice in about 1475 by the painter Antonella da Messina. This new technique enabled the Venetian Giovanni Bellini to invent tonal painting in 1482 and to produce, before Leonardo da Vinci, the first examples of aerial perspective.

Attempts at moral and religious reform. In Florence, the reformer Savonarola and the moral crisis at the end of the 15th century threw the city into turmoil. The papal court was shaken to its core and Savonarola was executed in 1498. This followed the earlier crisis of the 14th century led by the English anticlerical and antipapal reformer Wycliffe (d.1384), who after the Great Schism (1378) came down in favour of the separation of Church and State. He was the precursor of the Reformation and was influenced by the Bohemian reformer John Huss, who was burnt at the stake in 1415 after being declared a heretic by the Council of Constance.

The 16th century: the High Renaissance and Mannerism

The period 1503–34 in Rome saw powerful popes from the Medici family – Julius II, Leo X and Clement VII – consolidate their religious authority. Monarchies were also strong with Francis I ruling in France, Charles V in Spain and Henry VIII in England.

Times of genius. The first third of the century marked the high point of the Renaissance as regards architecture, sculpture and painting. The architect Bramante and the artists Leonardo, Michelangelo and *Raphael were working in Florence and Rome. In Venice, *Titian, the decorative painter Veronese and *Tintoretto were well established, as was *Lotto, a creative artist outside the norm.

Painting became universal, expressing the ideal of harmony and equilibrium between the ancient pagan spirit and the religious spirit, between humanism and dogma, between the 'heroic' world and the sensory world. The search for absolute formal beauty and harmony went beyond the observation of nature and tended towards the ideal of perfection informed by the aesthetics of the Graeco-Roman ideal: perfect geometry of the body, a measured expression and a balanced, dynamic pose.

Skilled in several fields, artists enjoyed great fame. Learning was no longer restricted to scholars, and artists acquired the encyclopedic humanist knowledge of the well-read: Michelangelo read Dante and Dürer read Erasmus, while Titian and Aretino were friends. Leonardo da Vinci and *El Greco built up their libraries. When Raphael portrayed the Platonic Academy in *The School of Athens*, he painted Michelangelo as Heraclitus and Leonardo as a philosopher, probably Plato. Although protected and respected by their powerful patrons, they had some hard struggles. Michelangelo came up against the Popes, who were appalled by the boldness of his nudes in *The Last Judgement*; these were later 'corrected' by Daniele da Volterra, nicknamed the 'breeches maker'. Similarly, Veronese got into trouble with the Inquisition: judged too secular in its treatment, *The Last Supper* became *The Feast in the House of Levi*. Artists worked for the city states and then for the European courts: Leonardo ended his days at the court of Francis I, Charles V bowed down before Titian and Leo X visited Raphael.

Geniuses outside Italy. The Flemish humanist painter *Brueghel the Elder, surpassing Matsys or Lucas Van Leyden, accurately depicted the daily life of peasants. He showed a universal understanding of the human condition and the landscape. The Dutch painter Hieronymus *Bosch with his wide-ranging imagination saw the 'decline of the Middle Ages'; his vision of the sensory and spiritual worlds

combined the didactic and the moral. The German artist Dürer, together with his contemporaries Cranach and Altdorfer, dominated painting and engraving at the time. Dürer's awareness of his talent, his self-questioning through the examination of his own face and the interest he had in nature bear witness to the close relationship he saw between art and life, just as Leonardo did.

Creation of the official academies. Vasari inaugurated the history of art and aesthetic judgement with his *Lives of the Artists* (1550). Then in 1563 he founded the Academy of Drawing in Florence, which broke with the guilds just before the decree of 1571 made the new independent status of painters official. From 1577, painters could go to the Academy of St Luke in Rome, the prototype of future official academies.

Northern Europe, the crisis in religion and its repercussions on art. As a result of attempts at reform, Protestantism came into existence in 1517 with the *95 Theses* against 'the virtues of indulgences' by the German Martin Luther. In the 1530s Luther became influential and won over the French humanist Calvin. Exiled, Calvin drafted the statute of the Reformed Church in Geneva in 1541 and then, back in Strasbourg, he led the French Protestant Church. At the same time, the Dutch humanist Erasmus took a position against Luther's doctrine of predestination. Thomas More – an English political figure, Catholic humanist and friend of Erasmus – recommended the reform of the Church.

These considerations had artistic consequences. While Luther had no views on art, Calvin was an iconoclast and Erasmus disapproved of the cult of statues. The German *Grünewald, a bold expressionist inspired by the mysticism of the late Gothic Middle Ages and opposed to the concepts of the Renaissance, was first won over by Luther, who had been forced into exile, and then stopped painting. On the other hand, the German *Holbein the Younger, an artist associated with the Renaissance through the accuracy of his observation and his re-emergent Classical style, left Protestant Germany for England and entered the service of Henry VIII in 1536.

In the Low Countries, where prosperity depended on trade and industry, this religious crisis led to a schism. In 1584-5 Flanders, with its links to Catholic Spain, remained loyal to the Roman Catholic Church, while Holland became Calvinist and Protestant. Flemish painting, dominated by *Rubens in the 17th century, was Baroque, while the Dutch paintings of *Rembrandt and *Vermeer continued the tradition of depicting subjects from everyday life.

Political instability in Italy, the crisis in religion and Mannerism. After 1520, the Renaissance was put to the test by political instability, the death of Leo X in 1521, the Sack of Rome by Charles V in 1527, economic decline and the weakening of the bourgeoisie. The powerful Protestant Reformation threatening the papacy was a destabilizing influence, as a result of which the Council of Trent (1545-63) began a complete review of internal discipline and the reaffirmation of the dogmas of the Catholic Reformation. These historical problems had repercussions in art. Artists moved away from the Classical ideal. In Rome, Giulio Romano intensified the *maniera* (Mannerism) introduced at the beginning of the century by Michelangelo and Raphael. The forcefulness of the situations and the dramatic expressions, the flexing of musculature, the complexity of twisted bodies (*forma serpentina*) and experimentation with form were supported by an acid range of colours.

The political and religious conflicts which had taken place in Florence were reflected in the intense line of Botticelli (d.1510) and the art of Andrea del Sarto. Composition without regard for perspective, unbalanced poses (*contrapposto*), bold foreshortening and elongation, jagged planes, strident colouring, iridescence and an icy light marked the high point of Mannerism in the work of Pontormo, Rosso and Parmigianino. *Correggio in Parma and Titian in Venice had a Mannerist period, while Veronese and especially Tintoretto demonstrated a Mannerist luminosity specific to the Venetians.

Mannerism then spread throughout Europe up until 1620. While the French painter Fouquet established himself in the 15th century as the talented but short-lived forerunner of the Renaissance, Italian Mannerists from Florence founded the first French School of Fontainebleau under Francis I, which was followed by a French school subject to Flemish influence. The portrait painter Clouet was influenced by Primaticcio. In Spain El Greco worked under the patronage of Philip II, the son of Charles V. The extreme spirituality, the dramatization and the elongation of figures in El Greco's paintings connects him to Mannerism. The cold, detached art of the German Holbein, similar to that of the Florentine painter Bronzino, and the tormented art of his compatriot Grünewald, who was strongly affected by the religious crisis and the Peasants' Revolt (1524), perhaps connects them too to Mannerism. The excesses of this style led in about 1580 to an 'anti-Mannerism' embodied by Annibale *Carracci and *Caravaggio.

Cimabue

Cimabue marked the transition between Byzantine and Gothic art, making changes in the areas of subject, technique and form. His figurative language represented a new way of painting. The sensitivity of the modelling, the transparency of the colours, the elegance of the lines and the realistic expressions – all these lent a sense of humanity and naturalness to the sacred figures, which until then had been depicted in the formal style characteristic of Byzantine art.

LIFE AND CAREER

• Cimabue, real name Cenni di Peppo (Florence c.1240–Florence after 1302), 'was, so to speak, the first cause of the renewal of painting', as Giorgio Vasari wrote in 1550. Dante praised him as the greatest painter before *Giotto, but his biography is not well known and remains conjectural.
• In c.1265–8 he painted a large *Crucifix* in Arezzo (church of S Domenico). In 1272 he spent time in Rome but no trace remains of his stay there. A little later he painted a *Crucifix* in tempera (Florence), the innovative significance of which was rediscovered during its restoration after the Florence floods of 1966. In 1277–9 he led a team of artists from Rome (Jacopo Torriti), Siena (Duccio) and Florence (Giotto) in painting frescoes (*Evangelists, Christ, Life of Mary and the Saints*) in the Upper Church of the Basilica di S Francesco in Assisi; these frescoes were badly damaged in the earthquake of 1997. As a result Cimabue came to be seen as the greatest Florentine painter.
• Towards the end of the 13th century, Cimabue painted several *Maestàs* (representations of Madonna or Christ Enthroned or 'in Majesty') (Bologna, church of S Maria dei Servi; Florence; Turin, GS; Paris, Louvre); the *Maestà* of the Louvre, close to Duccio in style, was painted in Pisa for the church of the convent of S Francesco. Cimabue probably also contributed to the mosaics in the dome of Pisa Cathedral (*St John the Evangelist* and *Christ in Majesty*) in 1301–2.

Cimabue initiated the great age of Tuscan painting: Giotto, Duccio and Simone Martini were all influenced by him. His intuitive understanding of a new, fundamentally 'modern' way of painting pictures prefigured post-medieval art.

APPROACH AND STYLE

Cimabue produced crucifixes, cycles of the lives of the saints and the Virgin, the Apocalypse (inspired by Byzantine themes) and the symbolic *Virgin in Majesty*, paintings on wood, frescoes and mosaics. He received commissions from the Dominican and Franciscan orders and from the Guelf cities, in particular Arezzo and Assisi.

• At first his crucifixes were stylistically still close to Byzantine art, as shown by the stiffness of his poses and faces and by the dark drapery enhanced with gold. Then under Tuscan influence the artist began to display a new sensitivity, seen in the modelling of the bodies using curves and volumes, in the lightness and transparent quality of the loincloths which became gauzes with loose, flowing folds, and in a colour range that included blues, pinks, mauves and light yellow, achieving an effect of great delicacy through the technique of tempera painting (*Crucifix*, Florence).
• The mosaics which he created combined grace with monumentality. The voluminous garments gave the figures a firm base, while the delicate face and hair gave them a natural appearance.
• The composition of Cimabue's frescoes was inspired by Byzantine churches (S Francesco in Assisi: *Evangelists, Life of Mary, Life of Christ* and *Lives of the Saints*). His sense of space is apparent in the oblique perspective of his structures; in the *Virgin in Majesty* of this cycle he relates the symbolic and perspective spaces to each other. While the outline of some figures is rendered by hatched lines, still in the style of Byzantine art, many of them show firm modelling that emphasizes volume.
• In this *Maestà* painted in fresco, and even more so in those painted on wood, he decorated the Virgin's throne with inlays of imitation enamel and gilt filigree, in a manner reminiscent of the religious goldsmith's art, thus creating an illusion of reality. The solemn humanity of the Virgin and in particular her monumentality were inspired by the sculptures of Nicola Pisano (c.1220–83).
• His style later took on a Gothic quality, visible in the unity of the forms, the serenity of the faces, the elegance of the lines and the expensive pigments – all used in order to create an impression of reality.

**Maestà di Santa Trinità
(Virgin in Majesty)**
c.1280. Tempera on wood,
3.85 x 2.23m, Florence,
Uffizi

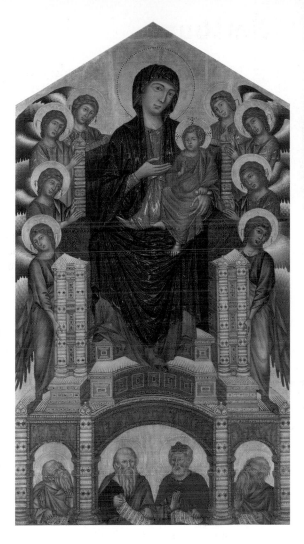

*At the centre of the composition, the Virgin
surrounded by angels presents her son to
the faithful. At the bottom, four prophets
(from left to right: Jeremiah, Abraham,
David and Isaiah) are painted half-length,
debating and showing their amazement at
the apparition of the Virgin in Majesty
with her son. This exemplary work was
painted during Cimabue's mature period.
Although the gold background and the
somewhat formal figures have been
borrowed from Byzantine art, the picture
diverges noticeably from it by virtue of its
symmetrical composition arranged round a
vertical axis, the impression of depth
created by the arrangement of the angels in
tiers on each side of the throne, and the
volume suggested in the folds of the Virgin's
robes. The arrangement of the space is
highly symbolic: at the bottom, level with
the viewer, the prophets reveal their human
nature; while the heavenward gazes of
Jeremiah and Isaiah and the majesty and
monumentality of the Virgin and Child
express the divine. The 'realistic' expression
of the faces of the four prophets contrasts
with the solemn gentleness of the Virgin,
the Infant Jesus and the angels. The delicate
shades of colour in the setting and the
drapery contribute to the harmony and
beauty of this work.*

A GREAT PAINTER

◆ A famous master in his own time, Cimabue sank into oblivion until the 20th century.
◆ An innovative artist, he distanced himself from orthodox Byzantine art by incorporating
into it aspects of Gothic art and the art of late antiquity.
◆ He invented a new figurative language, introducing 'realistic' elements such as the motifs
used by goldsmiths.
◆ He displayed a new sensitivity towards the reproduction of space.
◆ He is thought to have been the first to use a wooden panel coated in gesso, then painted
in tempera.

KEY WORKS

Apart from the frescoes, only seven works by Cimabue are preserved in museums
today, while eight others have been listed at auction (no works are dated).
Crucifix, Arezzo, S Domenico
Crucifix, Florence, S Croce
Life of Mary, Evangelists, Christ and the Saints, Assisi, Basilica di S Francesco
Virgin in Majesty, Florence, Uffizi
Virgin in Majesty, Paris, Louvre
St John the Evangelist and *Christ in Majesty*, Pisa, dome of the cathedral

BIBLIOGRAPHY

Baldini, U and Casazza, O, *The Cimabue Crucifix*, Olivetti, Milan, 1989; Battisti, E, *Cimabue*, translated by Robert and
Catherine Enggass, Pennsylvania State University Press, University Park, PA, 1967; Bellosi, L, *Cimabue*, translated by
Alexandra Bonfante-Warren, Frank Dabell and Jay Hyams, Abbeville Press, New York and London, 1998; White, J,
Studies in Late Medieval Italian Art, The Pindar Press, London, 1984

Giotto

Giotto was the first 'modern' Mediterranean artist in Western painting. He freed himself from the conventional pictorial language of the Byzantine (Greek) figurative and Western (Latin) Gothic styles in order to introduce a 'natural' approach and breathe life into painting. His conception of space, his command of composition, his lively three-dimensional quality, his appreciation of shaded colours, and the importance he gave to natural light were also modern characteristics.

LIFE AND CAREER

• According to legend, Giotto di Bondone (Vespignano, near Florence, c.1266–Florence 1337), the 'reformer' of Western painting, was 'discovered' by *Cimabue while drawing his sheep. Indeed, the Tuscan master who trained Giotto at about ten years old is likely to have been the already famous Cimabue, but no documentary evidence for this exists.
• In c.1280, Giotto lived in Assisi, then moved to Rome where he discovered the figurative language of antiquity. In Assisi he painted the *Scenes from the Old and New Testaments*. He married in around 1287 and one of his sons and one of his grandsons also became painters. Painted in Florence, his *Crucifix* (c.1290) reveals a humanity that had not been seen before. On his return to Assisi, together with his many assistants he completed the frescoes in the cycle of the *Life of St Francis of Assisi* (1295-8), begun by Cimabue in around 1277, and the *Doctors of the Church* on the vault. At the same time Giotto was also working in Florence, where he painted the altarpiece of the *Ognissanti Madonna* (c.1300-10, Florence), an example of a painting on a wooden panel, and the *Badia Polyptych* (c.1300-10, Florence, Uffizi). He then went to Rome, summoned by Pope Boniface VIII to help with the jubilee of 1300.
• He was the first Tuscan painter to paint in northern Italy, in Rimini and Padua: a *Crucifix* (c.1300-3, Rimini, Temple of Malatesta), and scenes from the *Lives of the Virgin and Christ*, *Allegories of Vices and Virtues* and *The Last Judgement* (1304-6, Padua), an exemplary work of fundamental importance in European painting. In Assisi he painted the *Life of Mary Magdalene* and *Allegories of St Francis* (1314, Lower Church). In Rome he designed the *Stefaneschi Polyptych* for the main altar of St Peter's. In the church of S Croce in Florence, he painted the *Scenes from the Lives of St John the Baptist and St John the Evangelist* (c.1317, Peruzzi Chapel), the polyptychs of the *Coronation of the Virgin* (after 1320) and the *Virgin with Two Saints and Archangels* (after 1320, Bologna), and the *Life of St Francis* (1325-8, Bardi Chapel). He joined the guild of *medici e speziali* (doctors and pharmacists) in 1327.
• Robert of Anjou, King of Naples, invited him to that city, where he stayed from 1329 to 1333. Back in Florence in 1334, he was appointed foreman of the work carried out on the cathedral dome and worked on the *Last Judgement* (Bargello Chapel).

Giotto's successful career took him all over Italy. As a result of his success (at its peak c.1330) some of his works were executed under his supervision by his many pupils and assistants, including Taddeo Gaddi and Maso di Banco.

APPROACH AND STYLE

Giotto decorated chapels and naves with fresco cycles illustrating subjects from the Old and New Testament (eg the lives of the Virgin, Christ and Mary Magdalene) and the life of St Francis of Assisi. He also created works painted on wood, altarpieces and polyptychs (including crucifixes, crucifixions, Madonnas and versions of the Virgin and Child)

and mosaics of all sizes. These were for private and public patrons including Robert of Anjou in Naples, the clergy in Rome and Assisi and the great banking families in Padua (Scrovegni) and Florence (Bardi, Peruzzi).

● Even in his earliest works Giotto gave Christ a new majesty, as well as modernity, humanity and physical reality.

● In fresco, he reinvented the concept of space, giving it a coherence and rationality based on a sense of perspective represented by a cube-shaped box open at the front in which the narrative elements were presented in a set manner. He placed profoundly human characters within a structured landscape. Their various postures, resulting from Giotto's direct observation, were enhanced by the first use of foreshortening in Italian painting. Objects were rendered with decorative precision.

● Giotto brought back 'eloquent', sober, dignified gestures and poses as a means of expressing feelings. In his religious works, the solid, earthly figures have nothing mystical about them. The way the stories of St Francis are told is livelier, more spontaneous and more down-to-earth than the narrative style used for the stories inspired by the Bible. The perspective is more refined, the pictorial style less rigid, the colours more nuanced and the garments more flowing and soft. He also introduced an innovative approach to the landscape in his paintings, using backgrounds that were less stony, less angular, planted with trees, and enhanced with natural light and shade.

● For perhaps the first time in Western art, the frescoes of Giotto's mature period combined the subject matter of the cycles of the Virgin Mary and Christ, resulting in an even greater eloquence as regards spatial unity and illusion. These frescoes contain foreshortening, figures enhanced by the depiction of volume and mass, trompe-l'œil architecture with complex vanishing points, and atmospheric skies. He devised new sources of illumination which bathed his scenes in bright natural light. The profiles of some of his figures are perfectly 'naturalistic'. His portraits are full of life.

● His art sometimes displays Gothic characteristics of great refinement: slenderness of architectural structures, elongated figures, graceful and well-balanced body language, penetrating expressions and glances, gentleness and pathos in the sacred figures, almost life-sized majestic characters, an abundance of decorative elements, a sumptuous depiction of objects and details, splendour in the colouring, use of expensive pigments, refined, intense shadows and denser, softer masses. He made his pictures more concrete.

A GREAT PAINTER

◆ Giotto's artistic merit was recognized during his own lifetime.
◆ As the 'reformer' of Western painting, Giotto completed the break with Byzantine art.
◆ He renewed the figurative language of painting by endowing his figures with 'naturalistic' characteristics, such as a smile on a child's face, an individual profile, and contemporary or exotic costumes.
◆ His depiction of landscapes was also innovative in that Giotto added 'realistic' and 'human' dimensions, showing for example the façade of a Gothic cathedral, contemporary houses, and multicoloured marble effects in trompe l'œil.
◆ Giotto was one of the first to combine the cycle of the Life of Christ with that of the Life of the Virgin.
◆ He dealt with spatial representation by exploring the potential of both linear and aerial perspective. He was the first to introduce off-centre composition, figures arranged in a line and in depth, and effects of volume for drapery. He introduced natural sources of light.
◆ Giotto reformed the concept and technique of fresco painting: he used architecture as a natural setting and prepared smaller surfaces for painting.
◆ Giotto was the first to undertake several ambitious fresco painting projects simultaneously.

Giotto

- Composition and perspective became more complex. Giotto imagined a single viewpoint, oblique or central, following the principles of rational perspective. He extended spaces beyond the composition, and put empty spaces next to filled spaces.
- His figures move freely, and no longer as a group. In this he anticipated the first portraits painted as separate works. He introduced exoticism into painting by adding black, Muslim and Oriental figures. His final frescoes are less lively and less timeless; the scenes are more unified and symmetrical.

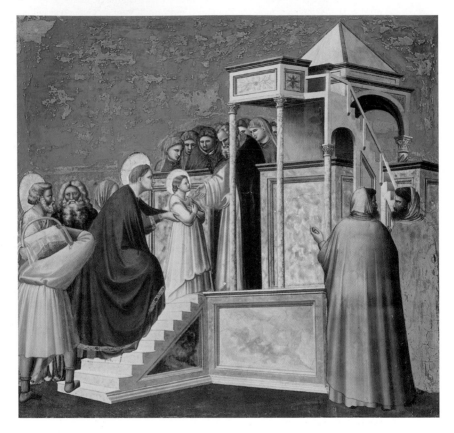

KEY WORKS

About 180 works by Giotto have been catalogued.

Scenes from the Old and New Testament, c.1280, Assisi, Upper Church

Crucifix, c.1290, Florence, S Maria Novella

Life of St Francis of Assisi, 1295–8, Assisi, Upper Church

Ognissanti Madonna, c.1300–10, Florence, Uffizi

Lives of the Virgin and Christ, 1304–6, Padua, Scrovegni (or Arena) Chapel

Life of St Mary Magdalene, 1314, Assisi, Lower Church

Stefaneschi Polyptych, Rome, Vatican, Pinacoteca

Polyptych of the Coronation of the Virgin, after 1320, Florence, S Croce, Baroncelli Chapel

Polyptych of the Virgin with Saints and Archangels, after 1320, Bologna, Pinacoteca

BIBLIOGRAPHY

Baxandall, M, *Giotto and the orators: humanist observers of painting in Italy and the discovery of pictorial composition, 1350-1450*, Clarendon Press, Oxford, 1986; Maginnis, H B J, *Painting in the Age of Giotto: A Historical Re-evaluation*, Pennsylvania State University Press, University Park, PA, 1997

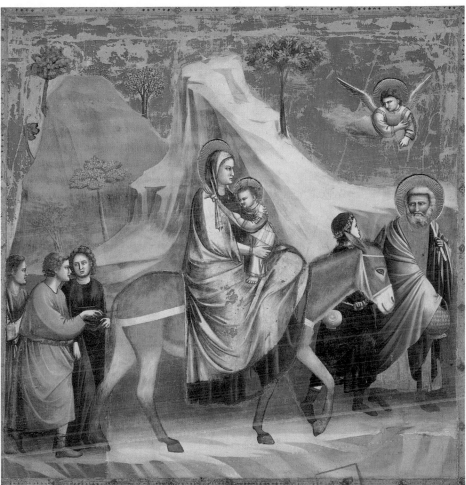

The Presentation at the Temple and **The Flight into Egypt**
1304–6. Frescoes, Padua, Scrovegni Chapel

*Recognized as Giotto's masterpiece, the cycle of frescoes in the
Scrovegni chapel displays the artist's maturity. These two scenes
show how well he understood space and perspective with regard to
architecture, landscape and figures. Giotto has introduced
contemporary buildings with an oblique vanishing point, a less
angular, more realistic landscape and an example of his command
of foreshortening (the angel).*
*His characters are seen in profile or rear view instead of the usual
front-on position. The powerful three-dimensionality of the
characters is conveyed by the simplification of the flowing drapery
and the soberness of their very human gestures. The profound and
sometimes moving expressions and glances are always dignified.
His sense of detail and his sophisticated execution almost approach
trompe l'œil, as can be seen in the imitation marble, the basket and
the wicker-covered jug. The sophisticated colour range of the light-
toned marble, the sandy rocks and the subtle light and shade –
dense, flowing and soft in execution – confirm his desire to
represent nature and life. In this he has moved far away from the
rigid, formal style of Byzantine art.*

Masaccio

The majestic nature of the paintings by Masaccio, one of the first artists of the Renaissance, contrasts starkly with the gentleness of late Gothic art. He advocated a return to basics, to nature and to the observation of the real world. As a result of this observation he was able to convey the reality of space through perspective, as well as the three-dimensionality of forms and the expression of emotion – all enhanced by natural light.

LIFE AND CAREER

• Masaccio, 'Sloppy Tom', real name Tommaso de Giovanni di Simone Guidi (San Giovanni Valdarno, near Florence, 1401–Rome 1428), is considered one of the great innovators of the Renaissance with regard to temperament, training and art. Little is known of his life. It is known that at the age of 16 he went to Florence, where he trained as a painter; *Giotto's work made a deep and lasting impression on him. At the age of 23 he enrolled at the Academy of St Luke. Aiming for a new status as an artist who would be more independent of society, he did not train in a studio with other artists, but worked alone. He did, however, accept joint commissions.
• In around 1423–4 he collaborated with Masolino on *The Madonna and Child with St Anne* (Florence), in which he was able to use his new, forceful pictorial language. This was seen again in the frescoes of the Brancacci Chapel, which was dedicated to St Peter (1424–7) – a model work for painters and sculptors. Earlier, in 1422, he had been commissioned to paint the *Consecration* in the church of the Carmine, known as *Sagra del Carmine* (lost), and the picture of *St Yves* (lost), which was admired by the Mannerist painter Giorgio Vasari almost a century and a half later. Masaccio was one of the painters whom Vasari immortalized in his *Lives of the Artists*, the first biographical work in the history of painting.
• In Rome in 1425, Masaccio and Masolino collaborated on a triptych for the church of S Maria Maggiore; its panel *St Jerome and St John the Baptist* (London, NG) is entirely by Masaccio. They also painted the frescoes in the Branda Chapel, completed after Masaccio's death (1425–31, Rome, church of S Clemente).
• The architect Brunelleschi and the sculptor Donatello, Masaccio's 'masters' and protectors, encouraged the young artist in his painting. He painted *The Crucifixion* (Naples, Capodimonte) single-handed, as well as the *Madonna and Child* (London, NG) from the polyptych of the church of the Carmine in Pisa (1426). Back in Florence, he achieved a perfect rendering of perspective in the fresco of *The Holy Trinity* (1426–7). Soon after his return to Rome in 1428, Masaccio died.

The painters of the Renaissance who succeeded him bore witness to his artistic contribution. *Leonardo da Vinci wrote: 'After Giotto, art went into decline again ... until ... Masaccio showed through the perfection of his art that those who are inspired by models other than nature, the mistress of all masters, struggle in vain.'

APPROACH AND STYLE

In Florence and Rome, Masaccio painted mainly frescoes for the private chapels of his patrons, and triptychs for public churches on themes such as the Madonna, the saints, the Crucifixion and the Holy Trinity.
Masacccio admired the 'pure' unornamented art of Giotto, the treament of space based on the architect Brunelleschi's rational perspective, and the sculptural vigour and new consciousness of the human being as expressed by the sculptor Donatello.

• Through a new language – laconic, dry, powerful and sometimes violent – Masaccio lent his figures a physical and moral presence, very different from the characteristic gentleness of Masolino. The solid shapes stand out in their sculptural simplicity against a background

KEY WORKS
A maximum of 30 paintings by Masaccio are known about.
The Madonna and Child with St Anne, 1423–4, Florence, Uffizi
Brancacci Chapel, 1424–7, Florence, church of S Maria del Carmine
Crucifixion, 1426, Pisa, church of the Carmine
The Holy Trinity, 1426–7, Florence, church of S Maria Novella

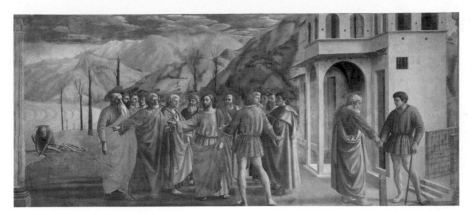

The Tribute Money (detail)
Brancacci Chapel, 1424–7, fresco, Florence, church of Santa Maria del Carmine

This fresco juxtaposes three scenes from St Matthew's Gospel, showing successive stages of the story. St Peter is asked to pay tribute money by the tax collector. He takes a coin from the mouth of a fish in Lake Tiberias which had swallowed it and pays the tax collector with it. Part of the action takes place in a structured space which has been constructed according to the precise and logical mathematical rules of perspective. More innovative is the landscape with its lake and hills stretching far into the background, which is represented by soft colours that contrast with the colourful figures of Christ and the apostles in the foreground. Their solid sculptural forms, soberly portrayed, stand out with an expressiveness that is enhanced by the luminosity of the reds and the green. This realism of colour and light enhances the monumentality of the work.

illuminated by natural light and chiaroscuro. The austere dignity of the expressions allows the reality of the emotions and a new sense of reality to come through.
• Masaccio reached the height of his art when, in order to enhance what was simple and real in his pictures, he incorporated the innovations of Brunelleschi and Donatello into painting. He mastered the technique of central perspective in trompe l'œil, which he applied in a logical, quantifiable manner, following the rules of mathematical perspective as laid down by Brunelleschi not long before. He used linear perspective to construct simple but monumental architectural settings, like huge shapes in a landscape, while also paying attention to aerial perspective. Even the halos were shown in perspective. Dressed in garments with many loose folds and clearly outlined, the figures are strongly three-dimensional. Some of the foreshortening is very bold. By including portraits of the donors (those who commissioned religious works of art) – a custom which Masaccio was the first to introduce – his paintings became historical chronicles and accounts of individual lives. The faces convey a sense of reality suffused with humanity – a sense of reality that is dramatic, moving, intense and powerful. The strong colours express the essence of the action with great economy of means. The chiaroscuro highlights the truthful representation of light and shade. The shadows create relief, while the imposing figures emerge from the half-light.

A GREAT PAINTER

◆ Masaccio's artistic importance was recognized by the artists of the Renaissance during his own lifetime. His pictorial language, not fully understood at first, achieved recognition only later.
◆ He completely changed pictorial art. He marked a decisive break with Byzantine art and was one of the great innovators of the Renaissance.
◆ Masaccio was the first to introduce portraits of donors into his paintings, and to deal with the subject of the consecration of a church.
◆ He was the first to apply linear, centralized perspective and rational perspective, and he heralded the beginnings of aerial perspective. He excelled in the technique of trompe l'œil.
◆ His figures have the appearance of sculptures and lively, believable facial expressions – this was something completely new at the time. They move in a natural light which had rarely been depicted until then.

BIBLIOGRAPHY
Berti, L, *Masaccio*, Pennsylvania State University Press, University Park, PA, 1967; Cole, B, *Masaccio and the art of early Renaissance Florence*, Indiana University Press, Bloomington, IN and London, 1900, Procacci, U, *All the Paintings of Masaccio*, Oldbourne, London, 1962

Van Eyck

Renaissance Flanders inspired Jan van Eyck's vision of the world. He expressed a new awareness of reality through the use of oil paint (which he popularized) and his technical command of linear perspective. His art is striking in its attention to detail, close observation of nature and light, and creation of interior spaces and landscapes inhabited by realistic characters. The brightness, variety of colours and quality of his painting provoke a sense of wonder.

LIFE AND CAREER

• The Flemish painters Jan van Eyck (c.1390/1400–Bruges 1441) and his brother Hubert (?–1426) painted together. Jan was a talented illuminator who before 1417, then again from 1422 to 1424, worked for the Dukes of Bavaria, who were also Counts of Holland. In 1425, on the death of Duke John, he entered the service of Philip the Good, Duke of Burgundy, as painter and 'valet'. In that year he produced *The Virgin and Child in a Church* (Berlin) as an illumination. It appears that between 1426 and 1429 he lived in Lille; he then spent some time making preparations for the portraits, meetings and marriage of Philip the Good and Isabella of Portugal (the portraits are now lost). In 1429 he was probably back in Bruges, but there is uncertainty about his activities until 1432.

• In 1432 he completed his enormous religious masterpiece, the polyptych *The Adoration of the Lamb* (Ghent), which was innovative in its structure and attention to detail. His mature works include three portraits that are in London (NG): *Thymotheos* (1432), *The Man in the Red Turban* (1433) and his secular masterpiece, *The Arnolfini Marriage Group* (1434). In that same year he married and had a son. Subsequent portraits are particularly striking because of the intensity of the sitter's gaze: *Baudouin de Lannoy* (c.1435, Berlin museums) and *Jean De Leeuw* (1436, Vienna, KM). He painted numerous Madonnas, sometimes using a canopy as a background, such as *The Virgin and Child* (1433, Melbourne, NGV), or with a landscape in the distance. The figure of the person who commissioned the painting may be present, as in *The Madonna of Chancellor Rolin* (c.1435, Paris). *The Madonna of Canon van der Paele* (1437, Bruges) combines spirituality and realism. *The Madonna of the Fountain* (c.1439, Antwerp) symbolizes gentleness, while the *Triptych of St Catherine* (1437, Dresden, Gg) is very small and takes painting into a world in miniature. Female characters are rare in his work; he painted his wife, Marguerite van Eyck (1439, Bruges, B-A), a *Woman at her Toilet* and a *Women Bathing* (both lost). His final painting, never completed, was *The Madonna of Nicolas van Maelbecke*, dating from 1440–1 (Great Britain, private collection).

After his death, he was succeeded by his pupil Petrus Christus. In Bruges, Hans Memlinc, Quentin Matsys and Joos van Cleve were inspired by van Eyck's *Holy Families* and his *Virgins with Donor*, as well as by his secular scenes set in the interiors of houses. His works also became well known among Italian painters and art collectors.

APPROACH AND STYLE

Van Eyck revealed his talent in his portraits, his paintings of the Madonna (sometimes including the donor), several religious scenes, some rare nudes and various other themes. He painted on wooden panels, which – the Ghent polyptych apart – were often small. His patrons

included all the great figures of his time: William IV, John of Bavaria and especially Philip the Good.

After living in the valley of the Meuse within the diocese of Liège, then possibly in Lille, van Eyck is thought to have settled in Bruges in 1429. He was influenced by Franco-Flemish miniature painting and French International Gothic.

● At first his illuminations were inspired by the style of International Gothic: elegant, refined and complex use of line; a multiplicity of characters and anecdotal details; subtle colours. However, the realism of the compositions and the delicate nature of the light effects were new. His first paintings were reminiscent of illuminations but with gentle, ethereal natural light suffusing the interiors.

● From 1432 onwards his talent established itself. Innovations included the mastery of the technique of linear perspective with a single vanishing point – a technique which gave his work a rigorous structure and allowed for the careful positioning of buildings and people. Aerial perspective generated spaces inhabited by substantial figures with sweeping, powerful forms, sometimes with the sculptural and decorative character of monumental nudes. His paintings became golden and warm, the details portrayed were carefully chosen and the light, whose effect on objects van Eyck had studied, became more refined. Although his compositions were still influenced by medieval art, his technical and stylistic development as well as his analysis of the world and its people definitely tended towards realism. His perfect command of the technique of oil painting enabled him to depict the world, whose appearance he so carefully examined, and render the beauty of its component parts. His technical virtuosity endowed the elements in his paintings with an almost tangible precision.

● His portraits were usually head-and-shoulder images with the face shown in three-quarter view, turned towards the left and gazing at the viewer. Sometimes the hands were also shown. The depiction of the characters' inner life is respectful, human and precise, and rendered with very few colours; a patch of red, such as a garment or a turban, highlights the figure, who is often painted against a black background. A sense of restraint led the artist to abandon coloured contrasts in favour of brown tones, only the face emerging from the shadow with its stern or gentle gaze (J-P Cuzin, 1999). The double portrait of the Arnolfini group is enhanced by the virtuoso depiction of the play of light and reflections and the rendering of fabrics and furs.

A GREAT PAINTER

◆ Famous throughout Europe in the 15th century as a young illuminator and subsequently as a painter, van Eyck sank into oblivion until the 1930s.

◆ A Flemish artist par excellence, van Eyck reformed the art of his country. He was one of the first artists in Flanders to abandon International Gothic in favour of the 'realism' of the tangible world.

◆ Van Eyck painted the first monumental nudes in northern European painting (Adam and Eve in *The Adoration of the Lamb*). The founder of Western portrait painting, he was the first to depict his subjects gazing back at the viewer. He was also the first to paint a non-religious interior scene (*The Arnolfini Marriage Group*), which inspired the painters of northern Europe.

◆ His command of linear perspective with a single vanishing point and of aerial perspective made him a seminal figure in 15th-century Flemish painting.

◆ His interiors are bathed in a golden light which filters in through the window.

◆ Although he did not invent the technique of oil painting, he perfected and popularized it. He applied successive transparent layers of paint (glazes) to a carefully prepared wooden panel, thus achieving a remarkable rendering of the materials.

VAN EYCK

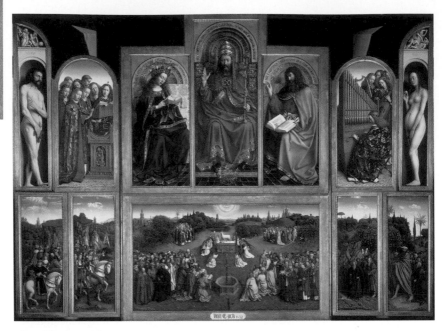

The Adoration of the Lamb
Whole altarpiece and details: the central panel, the Virgin (upper part). 1432. Oil on wood, 3.50 x
4.61m (open), Ghent, cathedral of St Bavon

*The central panel dictates the entire composition. At the centre of this panel there
shines the mystic Lamb on the sacrificial altar; converging on it in calm rejoicing
are the prophets, patriarchs, martyrs and virgins. It is surrounded by the angels and
apostles in attitudes of adoration. Van Eyck disregards realism in the arrangement
and respective size of the figures; as in primitive art, their size reflects their symbolic
importance. Yet in this very complex work of art, a mastery of the rules of perspective
enables the artist to lead the viewer's eye smoothly towards the background of the
composition, where imaginary cities can be seen with belfries rising against a sky of
wonderfully shaded blue. There are several middle-distance and background planes
with alternating exotic palms and luxuriant trees, creating an enchanting floral
representation of the tangible world. The infinite variation of tonalities – the green of
the fields and the blue and red of the garments – harmonize with each other in the*
light radiating from the Lamb at the centre of the composition. The meticulous rendering of detail endows
even the tiniest elements such as precious stones or small flowers with a reality as powerful as that of the
monumental figures flanking the central scene. The figure of Adam represents the distress of man after the
Fall. His pale body and the tousled hair framing his anxious face emerge from the half-light as he moves
towards the redeeming Lamb – a movement indicated by his right foot, which is protruding from the
frame.
The Virgin emanates light, gentleness and dignity in spite of the sumptuousness of her attire and the
magnificence of her crown with its sparkling details (a speciality of the van Eyck brothers).

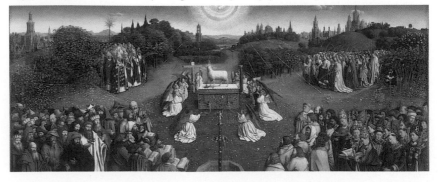

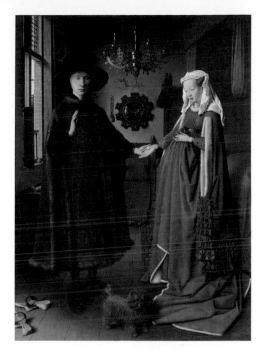

The Arnolfini Marriage Group,
also known as **Giovanni Arnolfini and His Wife**,
1434. Oil on wood, 82 x 59.5cm, London, NG

This full-length double portrait takes the viewer into the home of a wealthy Flemish couple belonging to the merchant bourgeoisie. It is certainly a realistic picture, but 'to Van Eyck all reality was mysterious … he studied [the object] as if trying, through a sort of poetic patience, to divine the answer to its riddle, to "charm" it and to endow its image with a second, silent life' (Henri Focillon).

The perspective composition leads to the wall at the back of the room, forming a plane which is exactly parallel with the surface of the canvas. Thus the viewer, along with the couple, is drawn into a box where the light sets off every detail. Here, every detail means more than is apparent at first sight: the dog represents faithfulness and the last candle still alight in the chandelier symbolizes marriage. Within the mirror there is an even more important world than the one that it reflects. Three people can be seen there: the married couple and an observer – either the viewer or the artist, who transports the viewer to another world that is silent, concentrated and eternal. 'Johannes de Eyck fuit hic' ('Jan van Eyck was here'): around this signature on the wall and the convex mirror the whole composition is discreetly centred, its soft colours and subdued light making the satin, the velvet, the fur, the rug, the brass even more real than in reality.

KEY WORKS

There are some 40 known works by van Eyck, not including those which are lost, doubtful or merely attributed.
The Virgin and Child in a Church, 1425, Berlin museums
The Adoration of the Lamb, 1432, Ghent, cathedral of St Bavon
The Man in the Red Turban, 1433, London, NG
The Arnolfini Marriage Group, 1434, London, NG
The Madonna of Chancellor Rolin, c.1435, Paris, Louvre
Baudouin de Lannoy, c.1435, Berlin museums
The Madonna of Canon van der Paele, 1437, Bruges, B-A
The Madonna of the Fountain, c.1439, Antwerp, B-A

BIBLIOGRAPHY
Bochert, T H, *The Age of Van Eyck: The Mediterranean World and Early Netherlandish Painting 1430-1530*, Thames and Hudson, London, 2002; Dhanens, E, *Hubert and Jan van Eyck*, Alpine Fine Arts, New York, 1980; Harbison, C, *Jan van Eyck: The Play of Realism*, Reaktion, London, 1991; Pächt, O, *Van Eyck and the founders of early Netherlandish painting*, Harvey Miller, London, 1994

Van der Weyden

Rogier van der Weyden was, with van Eyck, one of the greatest painters from the Low Countries in the 15th century. He preserved some Gothic elements in his works but also introduced a new realism. He based his art on the harmony between rhythmic construction of lines and expressive, sacred emotion. His realism led him to create characters of flesh and blood who are humble, moving and tender.

LIFE AND CAREER

• Rogier van der Weyden (Tournai c.1400–Brussels 1464) started his career in 1427 as an apprentice to Jan *van Eyck and Robert Campin, becoming a master painter in Tournai in 1432. None of his existing works is signed or dated. His early works, painted between 1432 and 1434, reflect the influence of his masters: *St Luke Drawing the Virgin* (Boston, MFA), the small *Standing Madonna* (Vienna, KM) and the *Annunciation* (Paris, Louvre).

• In 1435 he settled in Brussels, becoming the city's official painter in 1436 and setting up a studio. The following year he had a son, Pierre, who also became a painter. Van der Weyden produced numerous masterpieces: the *Deposition* (1436, Madrid); the *Altarpiece of the Virgin* known as 'de Miraflores' (c.1437, Granada, Chapel Royal; New York, MM); the *Calvary Triptych* (c.1440, Vienna); *Man Reading a Letter* or *St Yves* (1440, London, NG). Nicolas Rolin, chancellor to Philip the Good, commissioned the famous *Polyptych of the Last Judgement* for the Hospices de Beaune (c.1445–9, in situ). Van der Weyden produced diptychs such as that of *Laurent Froimont*, in which a Virgin and Child (Caen) is combined with the portrait of the donor, Froimont (Brussels).

• Working in Italy in 1450, probably in Rome and certainly in Ferrara, he painted the *Virgin of the Medici* (Frankfurt, SK) and the *Entombment* (Florence). An Italian influence can also be seen in the deliberate simplicity of the *Braque Triptych* (c.1450–2, Paris, Louvre), in contrast with the *Bladelin Altarpiece* (c.1452, Berlin museums) which is more in keeping with the northern tradition.

• Subsequent works reveal considerable complexity in their composition. Examples include the *Triptych of the Seven Sacraments* (1452–4, Antwerp Museum); the *St John Altarpiece* (c.1455, Berlin museums); the *St Columba Altarpiece*, commissioned for a church in Cologne (1450–60, Munich), and the *Triptych of the Nativity* (1450–60, Berlin museums). The artist painted portraits of *Jean le Gros* (?, Chicago, AI) and *Isabella of Portugal* (?, Malibu, California).

• Van der Weyden allowed himself some bold innovations in his final works: the *Crucifixion* known as the 'Great Crucifixion' (after 1456, Madrid, Escorial), the *Diptych of the Crucifixion* (Philadelphia, MA), the *Diptych of Philippa of Croy* (San Marino, Huntington Library and AG and Antwerp Museum), the portrait of *Francesco d'Este* (New York, MM) and the *Man with an Arrow* (Brussels, B-A).

• At the very end of his life, he returned to a graphic, Gothic style.

Van der Weyden's art inspired many European artists: Italian painters, who were sensitive to the 'naturalistic' details, and those in the Low Countries such as Hugo van der Goes, Hans Memlinc, Petrus Christus, Dierick Bouts and Gérard David. He was often imitated and copied up until the 16th century.

APPROACH AND STYLE

Rogier van der Weyden produced religious scenes and portraits, painted with oils on wood, as single panels, diptychs or polyptychs, and large or small. His commissions came from religious brotherhoods (such as Louvain), religious patrons (the Bishop of Tournai) or private patrons (Chancellor Rolin, J de Braque, P Bladelin, Ferry de Clugny).

In Tournai he learned about Gothic art. His masters – Robert Campin, Jan van Eyck and possibly the Master of Flémalle – trained him in their techniques. He then settled in Brussels and subsequently travelled to Italy, where he visited Rome and Ferrara, cities whose art had no impact on his style.

- At first, van der Weyden borrowed several elements from Gothic art including its formal aspect, sacred motifs, gold background and the oblique or symmetrical construction found in some Tournai sculptural reliefs of the time. He echoed the art of his masters: from Campin he learned the representation of space, the sequence of forms and the power of three-dimensional expression; from van Eyck he learned to paint in a refined, elegant style, enhanced by the use of precious materials. He also learned from these two masters about the importance of naturalistic attention to detail.
- He then broke with his training. Whether simple or elaborate, his subject was never hidden as with van Eyck; he presented it in a balanced, complex composition which might be monumental or everyday, with harmoniously arranged masses in warm or cold colours. The undulating, flowing lines of the body and drapery were rendered in arabesques that would have been unknown to Campin and practitioners of the Gothic style. Van der Weyden introduced into his paintings a non-illusionistic 'realism' and moving solemnity. The expressive suffering of flesh-and-blood characters, united by close bonds, affects the viewer deeply (*Deposition*).
- In his mature works, the spiritual intensity of the characters became more pronounced, in two very different stylistic directions: his elaborate, rhythmic constructions emphasized the outlines and the harmony of flowing lines, both of the characters and of the vast, undulating landscapes in the background (*Calvary Triptych*); but also, he would

A GREAT PAINTER

◆ A 15th-century artist famous throughout Europe until the mid-16th century, van der Weyden was rediscovered in the 20th century.

◆ He modernized the Gothic style and introduced emotion and expressiveness into his figures.

◆ He developed the theme of the secular portrait painted half-length against a landscape and introduced the Pietà into the southern Low Countries. He invented the subject of the *Man Reading a Letter*, depicted half-length.

◆ He produced new interpretations of the scenes of the Passion, charging them with emotion and creating images such as Mary Magdalene wringing her hands in sorrow and the Virgin expressing tenderness towards her Child. He broke with existing conventions of colour (the Virgin and St John are dressed in white in the Escorial Crucifixion, instead of the customary blue and red) and subject matter (*St Luke Painting the Virgin*).

◆ Van der Weyden invented or developed a new form: the diptych with the Virgin and Child on one side and the portrait of the donor on the other, both depicted half-length.

◆ He revived and established his formal concept of 'style': tense figures with dynamic outlines, inseparable from the drama expressed in the scene. The landscape was in harmony with the characters' emotions.

◆ Van der Weyden developed an original technique: he painted portraits on parchment which was then applied to wooden panels (*Triptych of the Seven Sacraments*).

sometimes eliminate background space, preferring the restraint of a more archaic stylistic approach (*Polyptych of the Last Judgement*).
• His classical Italianate style – the composition centred round an axis of symmetry – was reinforced, even if the heads were out of line. He developed a monumentality and an intimate, gentle, rhythmic relationship between figures whose faces expressed sadness. At the same time he painted slender figures without volume or movement, set against linear landscapes of great formal complexity but without depth.
• He sometimes returned to the Gothic style or produced lucid works reminiscent of icons (*Braque Triptych*).
• His later works, as with those of his mature period, reveal a duality of inspiration. Sometimes his was a graceful, 'modern' art setting supple, active figures within a restricted space and using complex decoration and a subtle colour palette; but at other times his art was ascetic and archaic, with Gothic figures set against highly detailed backgrounds towards which the eye is drawn by elaborate perspective (John L Ward, 1968). In the end, his composition became severe, with tense, nervous shapes and sculptural, graphic, abstract lines; the linear figures were defined by dynamic outlines emphasizing the dramatic quality of the rendering.
• The diptych portraits show the same stylistic evolution as his other works. In them the subjects are represented half-length in three-quarter view, with a sidelong gaze and hands held together in prayer. They are painted with great precision against a sombre, neutral background, having a sober, dignified appearance and harmonious shapes and colours.

Deposition
c.1436. Oil on wood, 2.20 x 2.62m,
Madrid, Prado

Painted for the religious brotherhood of the Archers of Louvain, this work dominated 15th-century Flemish painting. Its composition – concentrated on the horizontal and vertical axes, rigorously structured and perfectly balanced – is contained within an oval. The verticality is offset by a diagonal extending from the head of the young man standing at the top of the ladder, who has removed the nails and freed Christ from the cross, down to the Virgin and the right foot of St John, passing through the old man with a white beard (Nicodemus) and the head of Christ. The horizontal alignment of the faces is softened by the S-shaped undulating line of some of the postures. Mary's suffering can be seen on her face and more particularly in the curve of her body which is the same as that of her son (Von Simson, 1935). The balanced suppleness of the masses and the fluidity of the arabesques add rhythm to the movement of the bodies and the flowing drapery. The pathos of the faces unites the characters and arouses emotion in the viewer. According to Erwin Panofsky (1953), van der Weyden did not paint action or drama but concentrated on the expression of human passions. Against a Gothic background of gold, cool colours are used for the most moving characters – the women and the young man – while warm colours are reserved for the others.

KEY WORKS

Van der Weyden produced about 100 paintings. Of these, 85 are in museums and about 15 have been listed at auction.

Deposition, c.1436, Madrid, Prado
Calvary Triptych, c.1440, Vienna, KM
Polyptych of the Last Judgement, c.1445–9, Beaune, Hospices
Entombment, c.1449 or 1450, Florence, Uffizi
St Columba Altarpiece, between 1450 and 1460, Munich, AP
Crucifixion, known as the 'Great Crucifixion', after 1456, Madrid, Escorial
Laurent Froimont, ?, Caen and Brussels, B-A
Isabella of Portugal, ?, Malibu, California, J P Getty Museum

BIBLIOGRAPHY

Châtelet, A, *Rogier van der Weyden*, Gallimard, Paris, 1999; Thürlemann, F, *Robert Campin: a monographic study with critical catalogue*, Prestel, Munich and London, 2002

Piero della Francesca

The powerful, contemplative, poetic art of Piero della Francesca stands out because of the monumental simplicity of its composition, the geometry and mathematical perspective of its pared-down forms and the relationship between colour and light. It gives an impression of contemplative silence. Sophistication and eloquence are the distinctive features of his art.

LIFE AND CAREER

• Piero della Francesca, real name Piero di Benedetto or P dal San Sepolcro (Borgo San Sepolcro, a hamlet near Arezzo, c.1416–Arezzo 1492), was the greatest Italian Renaissance painter of geometric perspective.

• In 1439, he worked in Florence as assistant to the painter Domenico Veneziano. Known and respected as an artist in his native village, he painted there the *Polyptych of the Misericordia* (1445–c.1454/60, Sansepolcro) and the *Virgin of Hope* (*Madonna del Parto*, c.1450?, Monterchi, cemetery chapel).

• In 1445 he worked in Urbino for Federico II da Montefeltro whose *Portrait* (c.1451, Paris, Louvre) he painted. *The Flagellation of Christ* (c.1447–9, Urbino, GN) is set in a mainly architectural setting, while *St Jerome Penitent* (1450, Berlin museums) and *The Baptism of Christ* (c.1452–3, London) are set in vast landscapes.

• Piero next went to Venice, then to Rimini where the Malatesta family commissioned him to paint *St Sigismond and Sigismond Pandolfo Malatesta* (1451, Rimini, Temple of Malatesta).

• In Ferrara, he painted a fresco in the Estense Palace (1447–52, lost) for Leonello d'Este.

• Back in Arezzo, he painted for the Bacci family the masterpiece *The Legend of the True Cross* (c.1454–8, Arezzo), recently restored, and in Borgo he painted the *Polyptych of St Augustine* (c.1460–9, main altar in the church of S Agostino), whose panels have been separated and are now in London, New York, Washington, Milan and Lisbon.

• In Rome, he decorated Pius II's room in the Vatican (1458–9, lost). The plague of 1468 drove him from Borgo to Bastia in Corsica, after he had completed *The Resurrection of Christ* (1463–5, Sansepolcro, MC).

• Having returned to Urbino in 1469, he worked on the *Polyptych of St Antony* (c.1469, Perugia, GN); the *Annunciation* in its upper section is truly astonishing for its architectural perspective. He painted Federico II da Montefeltro and his wife Battista Sforza in the *Diptych of the Duke of Urbino* (c.1472–3, Florence, Uffizi) and the altarpiece of *The Virgin and Child in Majesty Surrounded by Angels and Saints* (*Brera Altarpiece*) (c.1475, Milan). In 1478 he became a significant administrative and religious figure in his village. His *Madonna of Senigallia* (c.1478–80, Urbino) is influenced by the art of the Flemish painter Justus of Ghent, who lived in Urbino between 1473 and 1475. Piero painted the *Nativity* (c.1483–4, London, NG). He died, blind, in 1492.

He was passionate about mathematics and wrote a geometrical treatise on how to use perspective in painting as well as other studies on the subject. Piero knew many fellow artists and had one follower, Fra Luca Pacioli, but no successor. His influence was considerable in Ferrara, Florence, Rome and Venice, and on Luca Signorelli, Perugino, *Raphael, Antonello da Messina, Giovanni *Bellini and, ultimately, *Leonardo da Vinci.

APPROACH AND STYLE

Piero painted mural frescoes, polyptychs and paintings on wood, of all sizes. He was commissioned to paint scenes of courtly life, portraits and religious subjects for the great families Montefeltro of Urbino, Este of Ferrara, Bacci of Arezzo and Malatesta of Rimini, and religious subjects for the clergy of Borgo San Sepolcro, Arezzo and Rome (Pope Pius II). His works are full of physical similarities with those of *Masaccio. His spatial luminosity, inspired by Sassetta, gave prominence to people and objects by means of light and colour, as in the work of Masolino, Fra Angelico and Domenico Veneziano. He achieved the same optical refinement as Justus of Ghent and the Flemish painters.

• In his early works he was already using geometry to simplify forms, stripping and reducing them to their essentials: the face became oval and the neck cylindrical, while the garments were regular in volume and had deep, often vertical, folds. Through geometry the whole composition was arranged in a monumental and simple fashion, with the main figure in the centre and the others in symmetrical, parallel positions (*Polyptych of the Misericordia*).

• A mastery of 'Albertian perspective', the classic perspective known to Brunelleschi and further developed by Piero some 30 years later, together with the use of bifocal construction (two lateral points) linked to a very low horizon line, enabled him to portray elements of classical architecture next to vast, luminous landscapes.

• He used few colours and contrasted their shades in a cool, uniform tonality. White was much used to define shapes and volumes, becoming slightly tinted when in contact with adjoining colours. It forms a luminous aura which transfigures the geometry, shapes the faces, defines the folds in the clothes and brings out the details of the architecture. This clear, cold light – often abstract and arbitrary, of an even intensity and without shadows or chiaroscuro – freezes the figures into impassive, silent attitudes (*The Flagellation of Christ*).

• In his mature period, from 1455 onwards, Piero produced extraordinarily complex compositions and perspectives using precise mathematical logic, moving the vanishing point to the side. He raised the horizon line, linking open sky and structured interior, landscape and buildings. His 'geometrized' figures – silent, dignified, devoid of emotion – are in harmony with the architecture (*The Legend of the True Cross*).

A GREAT PAINTER

◆ Recognized in his own lifetime, his artistic importance was later completely overlooked until the 20th century. He was rediscovered by R Longhi (1927) and K Clark (1951).

◆ Piero is recognized as a true 'developer' of a new vision (R Longhi): that of the early Renaissance outside Florence.

◆ He secularized religious themes and painted a subject that was uncommon in Italian art: the 'Madonna of the Birth' (*Madonna del Parto*). According to P Rotondi of the Vatican Museum, Piero was the first to paint a picture out of doors (*The Baptism of Christ*), in which 'the agility of the brushstrokes and the absence of retouching prove that the painting was produced in one session.'

◆ He developed an absolute geometrical representation of forms, completely reducing them to their essentials, from which silence seemed to emanate. The artist was the first systematically to apply geometric, classic perspective to painting.

◆ Colour became light for the first time and he had an intuitive understanding of shadows. He anticipated the art of Leonardo in the use of complementary colours.

Piero della Francesca

• Later, the silence in his paintings became less pronounced and the light less radical. Piero painted a night scene in which a visible light source created shadows, reflections and contrasts (*Dream of Constantine*, an episode from *The Legend of the True Cross*). The atmosphere of his interiors became warmer, with the light filtering through the windows in reference to the Flemish tradition (*Madonna of Senigallia*). The subtle, meticulous care paid to details reconciled the visions of Italy and northern Europe (*Portrait of Battista Sforza* in the *Diptych of the Duke of Urbino*).

The Flagellation of Christ
c.1447–9. Tempera on poplar wood,
58.4 x 81.5cm, Urbino, Galleria Nazionale
delle Marche

This small panel shows two scenes taking place in Jerusalem. On the left, the flagellation is set in the praetorium of Pontius Pilate, the Roman governor of Judaea, who is portrayed seated. On the right, the scene set in the open shows a Byzantine dignitary and a sumptuously dressed nobleman in conversation. According to Lightbown's interpretation (1992), a Byzantine envoy is asking the Christian nobleman Francesco Sforza to help him in a crusade against the Turks. Behind them stands a guardian angel, soberly dressed and barefoot, a guide for men in their divine mission.

The scene featuring Christ is shown in the middle distance with a large paved area in front. The paving continues behind the envoy and nobleman in the foreground, who are twice the size of the figures in the background. Also visible are Herod's white house and a horizon with trees.

This work shows the painter's perfect understanding of the perspective of ancient, classical and Renaissance architecture (that of Brunelleschi and Alberti). It uses a restrained palette of colours with subtle shades of reds and whites, and is illuminated by a cold light that comes from several sources, the shadows indicating the complexity of the composition. Devoid of emotion, the colossal characters are frozen within an imposing architectural setting, 'a luminous cage without cracks in which humanity cannot stray' (A Chastel, 1982). This magnificent, silent composition pays close attention to details, and in this it shows a Flemish influence.

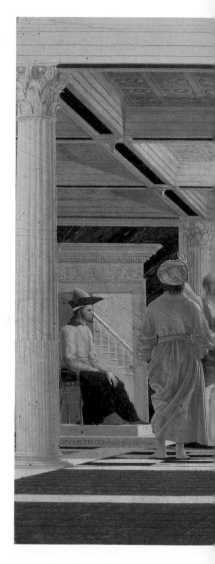

KEY WORKS

Piero della Francesca is known to have painted 40 works, of which 16 are
lost. They range in size from very small to very large.

Polyptych of the Misericordia, 1445–c.1454/60, Sansepolcro, Pinacoteca
The Flagellation of Christ, c.1447–9, Urbino, GN
The Baptism of Christ, c.1452–3, London, NG
The Legend of the True Cross, c.1454–8, Arezzo, church of St Francis
Diptych of the Duke of Urbino, c.1472–3, Florence, Uffizi
The Virgin and Child in Majesty Surrounded by Angels and Saints (*Brera
Altarpiece*), c.1475, Milan, Brera
The Madonna of Senigallia, c.1478–80, Urbino, GN

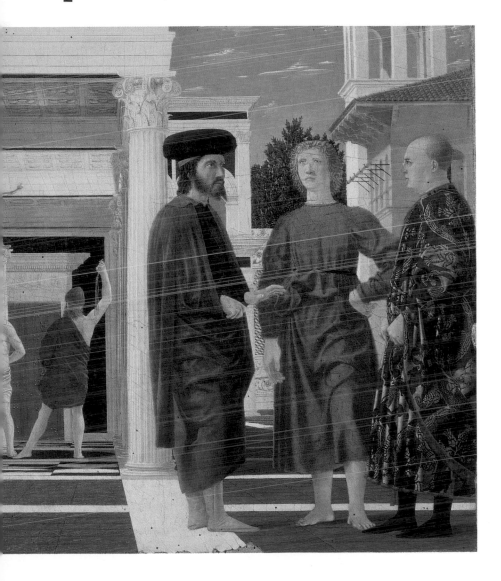

BIBLIOGRAPHY

Lightbown, R W, *Piero della Francesca*, New York and London, Abbeville Press, 1992; Michael, M, *Piero della Francesca*, Assouline, Paris, 1995

Bellini

Giovanni Bellini, the 'creator' of Venetian painting, sought to represent in his works the harmony between man and nature. He was the first of the great classic Venetian masters: remarkable on the one hand for the gentleness, musicality and poetry of his art and on the other for his sense of balance, of composition and of harmony with regard to blended, tonal colours.

LIFE AND CAREER

- Giovanni Bellini (Venice c.1425/33–Venice 1516) belonged to a family of Italian painters (including his father Jacopo, his half-brother Gentile and his brother-in-law Mantegna) and moved among the great masters of his time: Paolo Uccello, Filippo Lippi, Andrea del Castagno and Donatello). He started painting in around 1449 and set up his own studio in around 1460. He travelled very little, and then only in Italy.
- Originally he felt close to the Paduan master Mantegna, whose influence can be seen in *The Transfiguration and The Crucifixion* (1455, Venice). After 1460 he gradually freed himself from this influence: *Christ on the Mount of Olives* (London, NG), the *Pietà* (Milan), *Madonna and Child* (Houston, MFA), *Christ Blessing* (Paris, Louvre) and his masterpiece of 1464, the *Polyptych of San Vicenzo Ferreri* (Venice).
- During a journey to Urbino, Bellini discovered the art of *Piero della Francesca, which inspired him when painting *The Altarpiece of the Coronation of the Virgin* (1473, Pesaro).
- In 1475 Antonello da Messina, who had imported the Flemish technique of oil painting to Italy, was staying in Venice. According to legend, it was then that Bellini discovered the importance of this technique and used it in one of his first portraits, *Portrait of a Humanist* (1475–80, Milan), and in *The Madonna and Child Blessing* (1475–80, Venice, Ac).
- From around 1480 onwards, Bellini's work displayed real artistic maturity. It was distinguished by a kind of symbiosis between the emotions he portrayed and the landscapes he painted. This can be sensed in *The Resurrection of Christ* (c.1480, Berlin museums), *St Jerome* (c.1480, Florence, Pitti), *St Francis in Ecstasy* (c.1480, New York) and *The Crucifixion* (Florence, Corsini). His masterly use of space combined with his invention of tonal painting (or tonalism: the harmonious blending of shades while taking into consideration their exposure to the light) produced new masterpieces: *The Transfiguration* (c.1485, Naples), the *St Job Altarpiece* (c.1485, Venice, Ac), the *Triptych of the Frari* (1488, Venice), the *Portrait of J Marcello* (?) (1485–90, Washington, NG) and the *Madonna and Child* (1480–90, Bergamo, Ac Carrara).
- From 1490 onwards, his paintings heralded the love of nature, lyricism of colours and free movement of figures that were to develop in the 16th century. This influenced his paintings of the Madonna and Child, including the *Madonna in the Field* (1505, London NG), as well as other works: the *Sacred Allegory* (1490–1500, Florence), the *Pietà* (1505, Florence), the *Baptism of Christ* (1500–2, Vicenza), the *Portrait of the Doge Leonardo Loredano* (1501, Washington) and the *San Zaccaria Altarpiece* (1505, Venice).
- His later masterpieces, of which there were many, are the culmination of his Venetian style: *The Madonna and Child Blessing in a Landscape* (1510, Milan), *The Assumption* (1513, Murano), *The Feast of the Gods* (1514, Washington), *Lady at her Toilet* (1515, Vienna) and *The Drunkenness of Noah* (1515, Besançon, B-A), one of his last paintings.

His school produced talented artists such as Catena, Cariani and Cima da Conegliano. Bellini heralded the art of Giorgione, *Titian, Sebastiano del Piombo and others.

APPROACH AND STYLE

Bellini painted pictures, altarpieces and religious triptychs on all kinds of subjects, including numerous Madonnas, several portraits and a few subjects from antiquity. His oil paintings, on wood or canvas and in all sizes, were painted for the religious communities of Venice, the doge of Venice and a number of private patrons.

Bellini borrowed from several of his contemporaries. He admired Mantegna for his humanist, archaeological and spatial concerns. Andrea del Castagno taught him about light. In Urbino, Rimini and Ferrara he discovered the art of *Piero della Francesca and the architecture of medieval towns. The stylistic and technical contributions of Antonello da Messina, in Venice, played a fundamental part in the creation of a style that is Bellini's own but that also has elements of the art of Giorgione and Titian.

- At first, Bellini's style was similar to the 'violent' art of Mantegna. He admired this artist's rigorous construction of space and his natural and architectural landscapes with their three-dimensional vigour, matching that of the characters. Bellini's figures were distinguished by heavy strokes, bold foreshortening, dramatic expressions and strong musculature, which he set in a softer landscape. He adopted the architecture of his time, very much that of terra firma: towns and their ramparts, fortified castles, bridges and churches. In his archaeological and geological landscape the bowels of the earth were opened up, and twisting paths with sharp bends were shown.
- Bellini used several compositional models in his versions of the Madonna. Most often the Virgin was set directly in the landscape, against a background of sky, a wall or a canopy which separate her from it. Or she might be set inside the apse of a church, sometimes in the heart of the countryside.
- Bellini's art developed from 'archaeological décor to natural space' (H Peretz, 1999). He sought to achieve a harmonious balance between the figure and nature, combining a greater suppleness of posture with 'rounder' landscapes. Real and natural space, inspired by Piero della Francesca in particular, dominated the composition. The golden, celestial light – borrowed from Castagno – flooded the idyllic landscapes in the background, making the forms stand out. The foreground was still archaeological and lit by a cold light. The volumes remained geometric and the drapery a little rigid, but the faces had become calmer.
- From 1475 onwards, the play of light, the wide stretches of landscape and the technique of oil painting – all dear to Antonello da Messina – led Bellini to use precise strokes, less bright colours and a sensitive, refined, more vibrant light. He created his own style within a new space, in which light became a fundamental element. He introduced historical, standardized Roman architectural elements and, later, contemporary buildings into the natural, real landscape. The light created and brought together spaces, shapes and colours. He used a great wealth of colours, taking into consideration their exposure to the light. This tonal painting made possible subtle hues of colour, progressively shaded tones, the 'destructurization' of volumes into supple shapes and the unification of elements in a blend of colours. In the dawn light, hazy landscapes in deep greens and rich browns would be bathed in a soft radiance.
- Architecture later became less important in Bellini's paintings, the artist concentrating his attention instead on the unity of man and nature, and the complete harmony between human emotions and the poetic, serene landscape. His portraits and nature breathe in unison, vibrating in a natural light that is soothing and calming.
- Some works were more narrative, giving the characters a new rhythm. Bellini moved away from tradition by treating both secular and religious subjects in an identical way.

A GREAT PAINTER

◆ Known and recognized throughout history, Bellini left his mark on Venetian, Italian and European painting.
◆ The artist broke definitively with Gothic art and became recognized as the promoter of a style the balanced but free composition of which heralded the great age of 16th-century Venetian painting.
◆ His imagination was inexhaustible; he was equally at home producing well-ordered landscapes and tender Madonnas. Bellini ignored all differences between the sacred and the profane.
◆ His compositions were organized around figures set in new spatial arrangements. He used several compositional schemes for his Madonnas: most notably, in the *Madonna Enthroned* the Virgin is raised up at the centre of the composition while the saints surrounding her are at floor level. The geometric discipline of the chequerboard floors links them with the natural landscape.
◆ Bellini tried out all the possibilities that oil painting had to offer.
◆ He invented tonal painting in 1482, enabling him to blend together shapes, colours and light.

The Baptism of Christ
1500–2. Oil on canvas,
400 x 263cm, Vicenza, church of Santa Corona

This vast canvas is representative of Bellini's development as a mature painter. Although the influence of his contemporaries is still perceptible, the painter's own style is emerging. The rock in the foreground reveals an interest in archaeology typical of Mantegna, while figures and buildings are placed in the landscape according to perspective. But the way the characters are arranged in space – placed at various heights and depths – is new. The use of oil paint brings together the characters and the various elements of the landscape, lending an infinite tenderness to the painting in a tonality that is characteristic of Bellini. The shaded tones, enhanced by a warm red, blend into a heavenly twilight.

BIBLIOGRAPHY

Brown, P F, *The Renaissance in Venice: A World Apart*, Weidenfeld and Nicolson, London, 1997; Fry, R, *Giovanni Bellini*, Ursus Press, New York, 1995; Humfrey, P, *The Altarpiece in Renaissance Venice*, Yale University Press, New Haven, CT and London, 1993; Humfrey, P, *The Bellini, the Vivarini and the Beginnings of the Renaissance Altarpiece in Venice*, I Tatti, Florence, 1988; Robertson, G, *Giovanni Bellini*, Clarendon Press, Oxford, 1968

KEY WORKS

Bellini produced about 220 paintings.
The Transfiguration, 1455, Venice, M Correr
Pietà, 1460, Milan, Brera
Polyptych of San Vicenzo Ferreri, 1464, Venice, church of S Giovanni e Paolo
The Coronation of the Virgin (Pesaro Altarpiece), 1473, Pesaro, M Civici
The Resurrection of Christ, 1475-9, Berlin museums
St Francis in Ecstasy, c.1480, New York, FC
The Transfiguration, c.1485, Naples, Capodimonte
Portrait of a Humanist, 1475–80, Milan, Civiche Raccolte d'Arte
Triptych of the Frari, 1488, Venice, church of the Frari
Sacred Allegory, 1490–1500, Florence, Uffizi
The Doge Leonardo Loredano, 1501, Washington, NG
The Baptism of Christ, 1500–02, Vicenza, church of S Corona
San Zaccaria Altarpiece, 1505, Venice, in situ
The Madonna and Child Blessing in a Landscape, 1510, Milan, Brera
The Assumption, 1513, Murano, church of S Pietro Martire
The Feast of the Gods, 1514, Washington, NG
Lady at Her Toilet, 1515, Vienna, KM

The Feast of the Gods
1514. Oil on canvas, 1.70 x 1.88m, Washington, National Gallery of Art

This canvas, one of the last works in the painter's long life, is inspired by antiquity. It shows the culmination of his art, defined by the harmonious balance between landscape and figures. The luxuriant trees echo the sumptuous feast of the gods, enjoying earthly pleasures. Living beings and inanimate objects, set within a perfect space, are bathed in a soft, delicate light that gently brushes over the warm hues. Forms and colours seem to merge as a result of the tonal effect. In this painting with its sensual, poetic mastery, the artist heralds more than the beginnings of the great age of Venetian painting. It already contains elements of the burgeoning art of Titian.

Botticelli

Botticelli – Florentine humanist, nonconformist painter, anxious and intuitive – strove for a poetic ideal, which was at the same time erudite and profane. He used beautiful, elongated, supple and sinewy lines. After hearing Savonarola's sermons, he lapsed into a form of intellectual and aesthetic asceticism.

LIFE AND CAREER

• The Italian painter Sandro Botticelli, properly Alessandro Filipepi (Florence 1445–Florence 1510), worked in his native city, which at the time was thriving both commercially and artistically under the aegis of the Medici family.

• On his father's advice, Botticelli was first apprenticed to a goldsmith. This experience had a decisive impact on his work. He then joined Filippo Lippi's studio. The influence of the Hellenist and Neoplatonic philosopher Marsilio Ficino was dominant at the court of the Medicis and among artists, particularly Botticelli. Ficino's philosophy responded to questions about man's place in the universe and the meaning of religion; it strove to regenerate Christianity and the Church in the light of the Platonism of antiquity, in order to achieve an ideal of purity. It declared that beauty was the almost mystical path that made possible the transition from creature to creator and the harmony between terrestrial and celestial spheres.

• Botticelli produced paintings of the Madonna and Child (sometimes on the model of those by the master Filippo Lippi) such as *The Madonna of the Guidi of Faenza* (c.1465–70, Paris, Louvre) or those of London, New York, Washington, Florence, Naples and elsewhere. He admired the sculptors Verrocchio and Pollaiuolo, as well as the work of *Leonardo da Vinci. Becoming a master artist in 1470, he demonstrated the fluidity of his brushstrokes in *The Return of Judith*, an episode from *Scenes of the Life of Judith* (1470, Florence, Uffizi) and in the *Self-Portrait (?) with a Medal* (1470, Florence, Uffizi).

• In around 1478 his art reached maturity. *Primavera* (c.1478, Florence, Uffizi) and *The Birth of Venus* (c.1481–2, Florence, Uffizi), which he painted for the villa of the Medici, confirm the special bond he had with this family, whom he portrays in the two versions of the *Adoration of the Magi* (1475–80 and 1500, Florence, Uffizi). The face of *St Augustine* (1480, Florence, Uffizi) shows the concentration of a quiet intellectual, rather than piety, while *Guilio de' Medici* (c.1480, Bergamo, Ac Carrara) appears concerned.

• After spending time in Milan, in 1481–2, Botticelli painted another *Adoration of the Magi* (Washington) at the request of Ludovico the Moor, Duke of Milan. But more importantly he was summoned to Rome to paint frescoes in the Sistine Chapel (notably *The Trials of Moses* and *The Chastisement of the Levites*). The large expanse required by the story did not suit him; some details and portraits, very successfully painted, dominate the overall composition.

• Back in Florence, he painted the allegorical frescoes in the Villa Memmi, including *Venus and the Graces Offering Gifts to a Young Girl* (Paris, Louvre). From 1483 to 1490 he produced about 20 large Madonna *tondi*, including *The Madonna of the Magnificat* (c.1483–5, Florence, Uffizi) and *The Madonna of the Pomegranate* (c.1487, Florence, Uffizi). The scholarly Medicean allegory of *Minerva and the Centaur* (c.1488), the *Holy Conversation* known as the *St Barnabas Altarpiece* (c.1490) and especially *The Annunciation* (1489–90), all in the Uffizi, Florence, show an agitated linear rhythm that foreshadows a crisis.

• In 1492 Botticelli was badly affected by the death of his patron Lorenzo de' Medici and the expulsion of his son. The apocalyptic sermons delivered by Savonarola, castigating 'vanities', led the artist seriously to doubt the moral validity of his work. In 1498 Savonarola, condemned as a heretic, was executed. But Botticelli was very shaken by this end-of-century moral crisis. The political and spiritual agitation of the Florentine world is reflected in *The Calumny* (c.1495, Florence, Uffizi), the two *Pietàs* (c.1495, Munich; Milan, Poldi Pezzoli), the virtuous stories of Lucretia and Virginia (c.1499, Boston, Gardner M; Bergamo, Ac Carrara), the scenes from the *Life of St Zenobius* (1495–1500, London, NG; New York and Dresden), the *Mystic Nativity* (1501, London, NG) and the *Crucifixion* (1500–5, Cambridge, Mass.). All these paintings contain a moralizing message.

At the end of his career as a draughtsman and painter, only his pupil Filippino Lippi (the son of his old master) understood the style of Botticelli, the greatest Florentine painter of the late 15th century. His art, very different from the new Mannerism developing in Florence, fell out of favour until the 19th century. It then re-emerged as a model for the Pre-Raphaelites and the Art Nouveau painters.

APPROACH AND STYLE

Botticelli painted portraits, large secular, mythological, symbolic and decorative compositions inspired by the *Stanzas for the Tournament* by Politian and, for the Medici villas, Neoplatonic subjects taken from Ficino or from historical or literary works. He produced devotional works (saints, Madonnas) for the Lama, Vecchietti and Segni families and for the goldsmiths' guild, altarpieces commissioned by the Church and frescoes for Pope Sixtus IV. He painted on canvas and wood, and in fresco. He devoted some of his time to the minor arts.

In Florence, he was influenced by the art of Filippo Lippi, Leonardo da Vinci and the sculptors Verrocchio and Pollaiuolo. He spent some time in Rome.

• His training as a goldsmith gave Botticelli a taste for engraved motifs and an incisive line drawn with perfect precision. From Filippo Lippi he learned to paint with bold, vigorous strokes (a typically Florentine line that was also typical of Pollaiuolo, who is said to have inspired him) and well-defined outlines, using radiant flesh tones and warm, bright colours. The biblical subjects with their sometimes cruel faces became poetic and melancholy under his brush, while light subtle colours mixed with richer tones added a lyrical intensity. The flowing drapery emphasized the mannered poses of the figures while underlining the almost dancing rhythm of the characters, in the manner of Verrocchio. The fastidiousness of Botticelli's drawing, his elegant, expressive and very individual line were a natural development of the traditional linearity of Florentine art. For him, poetic invention prevailed over reality, and drawing over painting.

• From 1478 onwards, in his mature period at the height of the Florentine Renaissance, Botticelli painted compositions with a musical rhythm, carefully defining the outline of each element and working on relief and modelling. Tangled masses of flowing blond hair, clothes billowing in the wind, the instability of apparently fragile characters, the transition to a peaceful landscape – all were characteristic of his art. However, melancholy and anxiety were never far beneath the surface (décor of the Villa Medici).

• The mastery of some Leonardesque elements (the arrangement of the composition and the convergence of gestures and looks) was complemented by a nostalgic, fragile dream world symbolized by ancient monuments. His observational precision reflected his concern for realism, which led to the individualization of some figures (*Adoration of the Magi*). Linearity became more marked in the circular compositions which followed the 'law of the frame' (*The Madonna of the Pomegranate*) and had an elegiac feeling about them. The extreme refinement of detail that characterizes his work is also present in his expressive portraits of worried-looking laymen and clerics (*St Augustine*).

• After 1490 the lines became sharper and the body language more exaggerated. The accumulation of linear, almost angry, convulsive rhythms pointed to a more tormented spiritual and artistic inspiration. The figures became elongated and their gazes empty (*The Calumny*).

• After 1500, the spiritual upheaval that Botticelli experienced led to broken lines, violent

A GREAT PAINTER

◆ Botticelli was famous in certain intellectual circles during his own lifetime but he soon sank into oblivion. He was rediscovered in the 19th century.

◆ Florentine in his love of line, Botticelli introduced elongation, fluidity and a graceful sinewiness into his art – a style that broke with the humanist and artistic quest of the Renaissance.

◆ He transposed biblical subjects, turning them into secular and mythological themes inspired by the Neoplatonic ideal. He created large *tondi* of Madonnas with graceful, languid, curving lines in a harmony of circular shapes. His draughtsmanship acquired great elegance; his line was pure and unique.

colours, turmoil and confusion. His inspiration became heightened, his characters tortured and stylized, and the rules of perspectives were disregarded. Botticelli then refined his line to achieve the purest style of drawing, presenting moral and virtuous messages in a frenetic narrative (*Mystic Nativity*). He created allegorical compositions with an apocalyptic tone. u His last works convey a sense of peace and the possibility of rediscovered hope (*Mystic Nativity*).

The Birth of Venus
c.1481–2. Tempera on canvas, 1.72 x 2.78m,
Florence, Uffizi

Together with Primavera, this canvas adorned the walls of the Villa di Castello, which belonged to the Medici family. The mythological subject shows Venus, goddess of beauty, coming to life after Zephyr has breathed upon her. She is relinquishing her statuesque immobility with a certain melancholy, or she is simply being propelled towards the coast by allegorical figures of the wind. A nymph hastens towards her to wrap her in a cloak. From a symbolic or allegorical point of view, the painting is an affirmation of beauty born of the fusion of spirit and matter, imagination and nature. The painting could also illustrate the ancient theme of Aphrodite Anadyomene, the goddess who emerged from the foam of the waves, a subject portrayed in a work by Apelles that was described by Pliny and Politian.
The choice of this subject, which reflects the humanist ideal of the Renaissance, is combined with an extreme sophistication of form. Botticelli here reached the limit of the expressive linear possibilities acceptable to the Renaissance. The delicately drawn blond hair blowing in the wind, the garments filled with air, the abstract foam with flowers whirling in the air above the waves and the unbalanced pose of Venus give life to this painting, filling it with uncertainty and fragility. Everything seems unreal and elegiac: the jagged coastline, the gold of the tree trunks, the skilful tangle of the allegorical figures representing the wind, the naked elegance of Venus, the sumptuousness of the drapery and the dancing rhythm. The lines are dominant, musical and ethereal, the modulations of colour light and transparent.

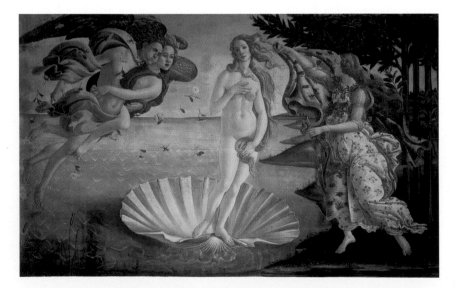

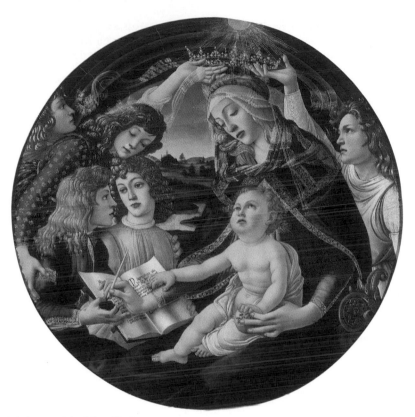

The Madonna of the Magnificat
c.1483–5.
Tempera on wood, 1.18m in diameter, Florence, Uffizi

The title of this painting refers to the first word of the canticle that the Virgin is writing in the book before her. The composition sits perfectly within the format of the tondo because of the rhythm of the line, which describes volutes and arabesques, curves and counter-curves. Everything is circular: the arrangement of the arms, the hands, the bull's-eye window, the divine light, the wavy, curly hair, the winding stream, the volute of the Virgin's throne and the roundness of the pomegranate. The colours of this composition are warm, strong, luminous and transparent, creating an atmosphere of ideal, lyrical sprituality.

KEY WORKS
Botticelli painted between 150 and 180 works.
Self-Portrait with a Medal, 1470, Florence, Uffizi
Primavera, c.1478, Florence, Uffizi
The Birth of Venus, c.1481–2, Florence, Uffizi
Adoration of the Magi, 1481–2, Washington, NG
The Madonna of the Magnificat, c.1483–5, Florence, Uffizi
The Calumny, c.1495, Florence, Uffizi
Pietà, c.1495, Munich, AP
Mystic Nativity, 1501, London, NG
Crucifixion, 1500–5, Cambridge, Mass., FAM

BIBLIOGRAPHY
Lightbown, R W, *Sandro Botticelli: life and work*, London, 1989

Leonardo da Vinci

Leonardo da Vinci, humanist genius of the Renaissance, experimented in every area of knowledge and art. The painter developed a theory of art and science based on observation and rigour. His methodical, complex, continuous search for the pictorial ideal introduced important innovations in the fields of composition and perspective. Also new were the technique of *sfumato* and the enigmatic smile of his characters.

LIFE AND CAREER

• Leonardo da Vinci (Vinci, near Florence, 1452–Amboise 1519) was the illegitimate son of a notary and a peasant woman.

• During his training in Florence, from 1469 to 1479, Leonardo worked in Verrocchio's studio together with *Botticelli, Domenico Ghirlandaio, Filippino Lippi, Perugino and others. Leonardo then became acquainted with the great culture of Florence through Lorenzo the Magnificent and the Neoplatonist Marsilio Ficino. In *The Baptism of Christ* by Verrocchio (c.1472, Florence, Uffizi) he helped to paint the angel with the sweet expression seen in profile on the left. In spite of some uncertainty, *The Annunciation* (c.1472, Florence, Uffizi) is attributed to Leonardo by art historians. *The Portrait of Ginevra de' Benci* (1474, Washington NG), *The Annunciation* (c.1478, Paris, Louvre), the *Madonna with a Carnation* (c.1478, Munich, AP) and the *Benois Madonna* (c.1480, St Petersburg, Hermitage) are also attributed to the artist. At the same time as he was painting, his *Codices* reveal that he was interested in literature, philosophy, technology, science, geology and anatomy.

• His scientific and technical curiosity made him the model for the *ingeniere*, or engineer, at the service of princes and monarchs. Very soon he was dividing his time between Florence and Milan, and in 1482 Ludovico Sforza, Duke of Milan, took him into his service. Because of his departure from Florence his mature work *The Adoration of the Magi* (1481–2, Florence) remained unfinished. Leonardo blossomed in a favourable artistic atmosphere and his pictorial techniques developed as a result. His theoretical reflections on painting as an instrument of knowledge were accompanied by practical experiments, in particular with painting materials and pigments. These experimental techniques proved fatal to the conservation of works such as *The Last Supper* (c.1495–7, Milan), a fresco which is now in very bad condition. *The Virgin of the Rocks* (c.1488, Paris) is a perfect illustration of his research into chiaroscuro. His ambitious sculpture, the *Equestrian Monument to Francesco Sforza*, the Duke's father, was never made and is known only through drawings (c.1490, Windsor Castle). Louis XII conquered the Duchy of Milan in 1499 and the life-size model for the statue was destroyed.

• Between 1500 and 1506 Leonardo was based mainly in Florence. In Mantua he painted the *Portrait of Isabella d'Este* (1500, Paris, Louvre), then he travelled to Venice, where he failed to find any commissions, and on to Ferrara. He worked there for a year (1502) as military architect to Cesare Borgia, the governor of the Duchy of Milan. He then produced the cartoon for *The Battle of Anghiari* (1503–5, destroyed), a pendant to *The Battle of Cascina* by *Michelangelo (1504), as the two painters pitted themselves against each other. *Leda* (1503–5, lost) and the famous *Mona Lisa* (1503–5, Paris) were painted during his time in Florence.

• During his second period in Milan (1506–13), he was in the service of the governor of the duchy, appointed by Louis XII, and probably worked on the second version of *The Virgin of the Rocks* (1495–1508, London,

NG). He produced drawings for the *Equestrian Monument to Gian Giacomo Trivulzio* (1508–13, London, Wall C) and painted the *Virgin and Child with St Anne*, which was never completed (c.1510, Paris).

● Between 1513 and 1516 he lived in Florence for only six months. He spent three years in Rome as a guest of Giuliano de' Medici, brother of Pope Leo X. He devoted his time to the study of science and technology.

● On his patron's death in 1516, he went to France at the invitation of Francis I. Leonardo arrived there with three canvases: the *Mona Lisa*, the *Virgin and Child with St Anne* and his last masterpiece *St John the Baptist* (c.1515, Paris). He spent the rest of his life near Amboise.

Leonardo's legacy consists of paintings which have been admired throughout the world since the day they were painted, treatises on several subjects and reflections on his theories. He trained a few pupils, including Andrea Salaino and his loyal friend Francesco Melzi. His followers included Andrea Solario, Giovanni Antonio Boltraffio, Ambrogio de Predis, Sodoma and, the most famous, Bernardino Luini; they turned out to be better at imitating his art than carrying on its tradition. His influence on Andrea del Sarto, Fra Bartolommeo, *Raphael and others was considerable.

APPROACH AND STYLE

Leonardo only painted a few canvases, often unfinished. These included altarpieces, devotional paintings, monumental compositions, religious or mythological subjects and portraits. He painted mainly with oil paint, on wood and in fresco. An impressive number of drawings and cartoons confirm the precision of his work and the rigour of his compositions.

His paintings and drawings were mainly commissioned by the clergy (*The Adoration of the Magi* and *The Last Supper*), Isabella d'Este, Louis XII and his last patron, Francis I.

He worked mainly in Florence, Milan and Rome.

● In Florence, Leonardo was trained in the Florentine style of the quattrocento with its clearly defined outlines. But he soon moved ahead of his Florentine contemporaries with their particular graphic, three-dimensional tradition.

● During his first visit to Milan, Leonardo began to develop his art in the pictorial atmosphere of Lombardy, faithful to the concept of a 'natural' poetic universe and particularly sensitive to colour and light. He introduced important innovations in painting: his choice of subjects, the composition, the atmosphere, the colours, the medium (glazes) and the smiling gentleness of the faces were all the result of ceaseless research.

● He developed a science of the 'visible', giving priority to painting. With his expert eye he carried out a scientific exploration of living beings and nature, establishing a methodical way of working before moving on to the actual representation.

A GREAT PAINTER

◆ Leonardo is 'the' legendary genius, universally admired throughout the centuries.

◆ A humanist of the Renaissance, heir to the Florentine tradition, artist-engineer, Leonardo strove to achieve that perfection which was to change the concept of painting in the 16th century and thereafter. He marked the transition between the quattrocento, represented by Botticelli, Pollaiuolo, etc, and the cinquecento, represented by Raphael, Fra Bartolommeo, etc.

◆ Leonardo was innovative in his choice of subject matter for *The Madonna and Child* and *The Last Supper*.

◆ His research into painting materials led to the creation of new glazes.

◆ His study of composition resulted in the creation of the pyramidal group.

◆ Leonardo radically changed aesthetics with his *sfumato*, his chiaroscuro, his use of aerial perspective, the quality of his light and the enigmatic smile of his portraits.

LEONARDO DA VINCI

- He broke down the divisions between disciplines: his study of space based on optics led him to the study of perspective and the theory of light. He worked out a particular technique which he then applied to his painting, thus creating *sfumato* – the gradual transition from light to dark shades – which was the softening effect of the hazy atmosphere on outlines.
- In 1500 he transformed the art of painting, which in the hands of others would appear dry and hard compared with the softness and subtlety of his art. He arranged his characters in geometric, classic, elegant, 'pyramidal' compositions. He integrated the figures into a natural landscape which was hilly, mountainous, or rocky with caves. The distant landscapes were suffused with a bluish, lunar haze which was one of Leonardo's innovations. Using the new technique of chiaroscuro, he was able to modulate the light against a background of shadows, softening the colours and shading off the values and contrasts, thus creating an impression of relief and depth.
- His invention of aerial perspective enabled him to tone down contrasts and blur the shape of distant objects in a hazy atmosphere.
- Leonardo also introduced innovations in his religious paintings by subtly changing the meaning traditionally given to the subject. He replaced the image of devotion in *The Madonna and Child* with a dramatic feeling latent with tenderness and dread; *The Adoration of the Magi* became a scene of wonder; and the symbolic representation of *The Last Supper* became a living portrayal of Christ's word. *The Battle of Anghiari* is remarkable for its compositional cohesion in spite of its separate scenes and numerous characters.
- The figure at the centre of every composition emanates beauty and a perfect, inexpressible grace; and the 'movements that convey the emotion of the soul' (Leonardo) are suggested in all their variety and with a concern for the 'real'. Leonardo achieved this result by creating new glazes and by making preparatory anatomical drawings, in 'mathematical' detail, of the facial muscles – the source of both expressions of horror and the famous Leonardo smile.

Virgin and Child with St Anne
c.1510. Oil on wood,
1.68 x 1.30m, Paris, Louvre

Behind the group huddled closely together in the foreground, a distant landscape can be seen: mountain peaks seem to evaporate in a bluish atmosphere in which all tones blend together. Yet this gracefulness, both ethereal and balanced, depends on the precise positioning of all the planes through a technique of successive glazes which create an evanescent effect. The prism-shaped elements of the hills are balanced by the triangular group of the three divine figures surmounted by Mary's loving face. The gentle curve of the posture of St Anne, the Child and the lamb is balanced by the verticality of the Virgin, who is the axis of the composition. The pyramidal construction of the figures sets the principal subject in a landscape whose pleasantness is echoed by the smiles of the Virgin and St Anne.
Leonardo replaced the three-dimensional forms and linear modelling of Florentine art with harmonious grace, mystery and emotion. These smiling faces convey an impression of life in a landscape bathed in a soft light, with distant, bluish, blended, ethereal vistas created by chiaroscuro, sfumato and aerial perspective combined with soft, hazy colours.
This painting is a high point in the history of art: compositional technique and the science of painting materials simply vanish behind the poetry of the finished work.

KEY WORKS

Leonardo produced about 15 authenticated works and five whose attribution is contested. Six works have disappeared.

The Adoration of the Magi, 1481–2, Florence, Uffizi
The Last Supper, c.1495–7, Milan, S Maria delle Grazie
The Battle of Anghiari, 1503–5, destroyed
Mona Lisa, 1503–5, Paris, Louvre
The Virgin of the Rocks, c.1488, Paris, Louvre
The Virgin of the Rocks, 1495–1508, London, NG
Virgin and Child with St Anne, c.1510, Paris, Louvre
St John the Baptist, c.1515, Paris, Louvre

BIBLIOGRAPHY

Kemp, M, *Leonardo da Vinci: the marvellous works of nature and man*, Dent, London, 1981

Bosch

Bosch, an artist untypical of the late 15th century and a contemporary of Leonardo, wove together the tangible and spiritual worlds. He portrayed the follies of human beings in the grip of sin. Enigmatic symbols and diabolical creatures mingle with realistic figures among cities and landscapes, as in some sort of didactic, moralistic entertainment. He used pure, soft colours in a lively, meticulous style.

LIFE AND CAREER

• The Dutch artist Hieronymus Bosch, real name Jerome van Aken ('s Hertogenbosch 1453–'s Hertogenbosch 1516), probably learnt his craft from his father and grandfather, who were both painters, and by studying the Flemish primitives, *van Eyck, Dutch painters such as Geertgen tot Sint Jans, the Rhineland painters, and so on. In 1481 Bosch married the daughter of a bourgeois family and became a person of importance. Hostile to the corruption of the Church and the monastic orders and to the heresy of sects, in 1486 he joined the religious confraternity of Notre Dame where Erasmus had studied when he was young. There he found a spiritual climate and sense of simple virtue close to the approach advocated by St Bonaventure (13th century) and the mysticism of Ruysbroeck (14th century). Bosch lived in an atmosphere influenced by the *devotio moderna* (modern devotion) movement. Between the extremes of earthly voluptuousness and spiritual disembodiment, he introduced scorn for human vices and a feeling of anguish and intense compassion for men sometimes shown as naked and weak in a hostile universe.

• The *Conjuror* (Saint-Germain-en-Laye, Mm), in which Bosch tackled a genre scene combined with religious faith, marked the beginning of his career as a painter. None of his works has been dated. His early work was produced before 1503. *The Seven Deadly Sins* (Madrid) are represented in an original manner, on a circular support, with harsh realism. *The Extraction of the Stone of Madness* (Madrid) exposes human folly and credulity. By contrast, *The Crucifixion* (Brussels, B-A) is conventional. *Christ Carrying the Cross* (Madrid, Palacio Real, and Vienna, KM) reveals the brutality of the mob. *The Ship of Fools* (Paris) illustrates the folly of sinful humanity that leads to death.

• In his mature period (1503-12), Bosch painted large triptychs. *The Haywain* (Madrid) shows the hell of vices and denounces the love of ephemeral earthly riches; this prefigured the Vanitas pictures of the following centuries. He was inspired by the *Golden Legend* to paint *The Temptation of St Antony* (Lisbon), which develops the theme of good and evil. *The Garden of Earthly Delights* (Madrid) swarms with naked figures, strange beasts, and sexual and plant motifs, set in a fantastic landscape. *The Last Judgement* in Vienna is traditional, but that in Munich (AP) – the culmination of his demonic vision – is populated by deformed demons or 'insectiforms'. Only saints and hermits resist the temptation of earthly vices: *St Jerome* (Ghent, B-A); *St Christopher* (Rotterdam, BVB); *The Altarpiece of the Hermits* (Venice).

• The last great masterpieces (from between 1510 and 1516) – such as *Christ Carrying the Cross* (Ghent) and *Christ Crowned with Thorns* (Madrid, Escorial) – depict crowds and executioners who are ever more cruel when confronted with Christ's humanity. In *The Adoration of the Magi* and *The Epiphany* (Madrid), Bosch combined the divine with the fantastic in a more peaceful manner. His landscapes became more gentle.

Bosch's work invites many questions and interpretations. His paintings were frequently copied and imitated over the next century and heralded the works of *Brueghel and Teniers. Later, his 'devilish' paintings became objects of revulsion.

APPROACH AND STYLE

Bosch was tireless in his representation of everyday life and the diabolical nature of human vices: madness, evil, jealousy, violence, slander, envy, aggression and lust. He later introduced religious and humanist themes into his work. He produced paintings and triptychs, possibly for the altars of the clergy and certainly for the libraries and oratories of the doges of Venice and Philip II of Spain, who was a great lover of his work.

Bosch spent the whole of his career in 's Hertogenbosch, where he may have worked with

Memlinc. He was familiar with the work of the Flemish painters Dierick Bouts, van Eyck and *van der Weyden, whose technique of oil painting and close attention to detail he mastered. He also knew the work of Dutch painters such as Geertgen tot Sint Jans and the Master of the Life of the Virgin, which may have inspired him to paint genre scenes and to adopt a different approach to religious subjects. From the Rhineland painters and Schongauer he borrowed the Germanic style of drawing. In an era that was already historically inclined towards the representation of the demonic, he found inspiration in the *ars moriendi* (engravings on the subject of death), the *Vision of Tungdal* (a 13th-century Irish poem on the subject of hell), the tarot and treatises on alchemy.

- Although no exact chronology exists, his work nonetheless reveals a spiritual and artistic development.
- He illustrated his approach by depicting the three stages that had to be overcome to achieve a state of grace: ridding the soul of temptations and vices, achieving enlightenment by meditating on the humanity of Christ and his Passion, and attaining an inner, spiritual life by assimilating the thoughts and feelings of Jesus. In this way, according to St Bonaventure (d.1274), the soul could be united with God.
- At the beginning of his career, the artist painted genre scenes of popular subjects with a poignant if heavy sense of scorn and a new, caustic sense of the grotesque, tackling the theme of mankind's stupidity, savagery and lack of belief. But his vision of the world was never exclusively secular and into it he introduced religious meditation and mysticism. His moralizing, ironic language created a new range of subject matter that encompassed subjects such as jealousy or greed. His composition and technique were still hesitant (*The Conjuror*).
- Once he was in total command of his art, Bosch developed new religious and secular models to express his humanist vision of the sacred and the blasphemous, of everyday life and the folly of people who have fallen into temptation, vice and sin. He placed realistic, human figures among little demonic, hybrid, symbolic and allegorical creatures, which recurred in an enigmatic, colourful manner (eggs, hollow trees, etc). 'There is in Bosch – in the guise of religious painting – a philosophical body of work which readers of Thomas More, Erasmus or Machiavelli could respond to' (C-H Roquet, 1968).
- Towards the end of his life he painted large triptychs portraying the life of Christ and the saints and expressing opposition to human folly. These often unfolded in three stages: the Creation or Eden, the world of sinners, and Hell or Purgatory. As a man of faith he focused his attention on the history of the world, the life of Christ and his Passion. The meditating saints see themselves as the only ones that can be saved from sin. Bosch thus looked at the 'inner human space', tested by temptation and then saved by deliverance.
- His paintings are all executed in oil on wood panels. Only a few drawings have been preserved. A dazzling technique allows his incisive drawing to show through thin layers of paint. The visible brushstrokes and the slight impasto indicate a lively, meticulous rendering. The purest colours, oranges and reds, burn brightly in the landscapes, next to softer, shaded tones, in a range going from pink to violet and blue.
- Bosch invented his own rules of composition and created original settings. In a Gothic arrangement, he put in the foreground figures in bas-relief, over-large heads and a swarming mass of characters and demons (*Christ Crowned with Thorns*); he never used perspective

A GREAT PAINTER

◆ Although famous throughout Europe in his own lifetime, Bosch sank into oblivion until the 20th century.
◆ The painter of human vices and troubled spirituality, Bosch broke with traditional philosophy and religious feeling by combining the reality of everyday life, the imaginary and the sacred, and by replacing devotion with moral, didactic concerns. In his paintings intelligence prevailed over the picturesque.
◆ Bosch painted subjects of everyday life, or genre scenes. He developed new subject matter based on the spiritual life and everyday human concerns.
◆ His compositions were sometimes bold, as were his sense of colour and virtuoso rendering. He was the master of infernal fires and fantastic landscapes but he could also portray the world of the emotions. In his imaginary bestiary and his extraordinary scenes depicting the Passion, he displayed the vast range of human expressiveness, from hatred through pathos to gentleness.

in the Italian manner. The backgrounds, reminiscent of Memlinc's, show landscapes with people going about their business, indifferent to what is happening around them, both in the foreground and in the background. The solidness of the composition made it possible to organize and present clearly the large number of episodes taking place.

• His late works display a formal, harmonious balance and reflect inner peace. The cities and undulating or circular landscapes are serene, silent and verdant, bathed in a soft, golden light. By contrast, the demonic symbols have multiplied and the human brutality is even more realistic than before, culminating in the exaggerated expressions of the figures with pointed, emaciated faces, their eyes full of hatred.

BIBLIOGRAPHY
Cinotti, M , *The Complete Paintings of Bosch*, Weidenfeld and Nicolson, London, 1967; Marijnissen, R H and Ruyffelaere, P, *Bosch*, Tabard Press, Antwerp, 1987

Christ Carrying the Cross
Between 1510 and 1516. Painting on wood, 76.7 x 73.5cm, Ghent, Musée des Beaux-Arts

In this scene from the Passion of Christ, 'the characters are projected onto a single foreground, more or less without any concern for perspective [...] it is the heads alone which, seen 'in close-up', create a rhythmical composition of masses and volumes' (G Dorflès, 1953). This compositional technique emphasizes the cruelty, rage and hatred of the figures. These feelings are expressed in their gestures but even more so in their facial expressions. Their complexions are ashen or bright red, while aggression gnaws away at their faces. Evil intentions drive men to acts of madness. Bosch shows viewers what they are or what they may become, physically and morally, if they deny the human and divine qualities present in each of them.

The Haywain
Between 1503 and 1512. Central panel of the triptych, 135 x 100cm, Madrid, Prado

This panel is flanked by two side panels. The first represents the creation of Eve, the garden of Eden and original sin. It is calm and serene, contrasting with the panel depicting Hell, which is full of flames and small devils torturing sinners. The central panel links the two scenes and reveals what has happened between these two moments. It shows an enormous cart laden with hay being dragged towards hell by demons and surrounded by a crowd intent on plundering it in order to acquire its illusory earthly riches. According to a Flemish proverb, 'the world is a pile of hay, every one takes what he can', while according to the Bible, 'the grass withers, and its flowers fall away'. Wealth and pleasure are objects of greed and human folly. Characters who have fallen into temptation and swarming devils symbolizing vice are bathed in a golden light broken by blood-red patches of garments. In the sky, Christ shows his stigmata, symbols of the sacrifice he made in order to save sinners.

KEY WORKS

There are 146 works by Bosch, all undated.
The Seven Deadly Sins, Madrid, Prado
Christ Carrying the Cross, Madrid, Palacio Real, and Vienna, KM
The Haywain, Madrid, Prado
The Ship of Fools, Paris, Louvre
The Temptation of St Antony, Lisbon, MN
The Last Judgement, Vienna, KM
The Altarpiece of the Hermits, Venice, Doges
The Garden of Earthly Delights, Madrid, Prado
Christ Carrying the Cross, Ghent, B-A
The Adoration of the Magi, Madrid, Prado
The Temptation of St Antony, Madrid, Prado

Dürer

Receptive to the humanist ideas of the Renaissance, Dürer was particularly aware of his artistic talents. His painted work, 'complex and contradictory' (P Vaisse, 1999), was a synthesis of Germanic and Dutch Gothic influences with contemporary ideas from Italy. Advocating an exact representation of the world, he combined an erudite, objective style with a masterful, meticulous rendering of objects. His work expressed the absolute link between art and life, in the same way as Leonardo's did.

LIFE AND CAREER

• Albrecht Dürer (Nuremberg 1471–Nuremberg 1528), a German artist who was a precocious genius, began his training at the age of 13 with his father, a goldsmith. Between 1486 and 1490 he studied in the workshop of the painter-engraver Michael Wolgemut. Having completed his apprenticeship, Dürer went on the customary tour, which took him to the Low Countries and Colmar (1490–4). In Basel in 1492 he met various humanists including Henri VIII's astronomer, the mathematician Nicholas Kratzer. At that time Dürer's work was essentially graphic, except for a few early paintings: a portrait of his father (1490, Florence, Uffizi) and a Self-Portrait (1493, Paris).

• In 1494 he married and travelled to Venice, where he discovered the great masters. He was also interested in nature; the spontaneous style of his watercolour landscapes was in sharp contrast to the meticulous precision of his scientific studies of animals.

• He was back in Nuremberg in 1495, by which time his art had matured. Frederick the Wise of Saxony became his patron. Dürer produced several series of engravings, including the masterpiece of the Apocalypse (1498, Paris, Louvre, Fonds Rothschild; London, BM), whose gnarled, seething style – although still medieval in spirit – already revealed something of his personality. In some paintings, including the Wittenberg Altarpiece (1496–7, Dresden, Gg) and the Virgin and Child (1496–7, Dresden, Gg), he was still influenced by Italian and Flemish art. These were followed by more personal paintings: the Portrait of Frederick the Wise (1496, Berlin museums), a 'psychological', restrained work; the Haller Madonna (1498, Washington, NG), inspired by *Bellini; and the Portrait of Oswolt Krell (1499, Munich, AP), notable for its formal richness and depth. He painted his second Self-Portrait (1498, Madrid), then a third (1500, Munich), in which he gives himself a Christ-like appearance. The Lamentation of Christ (c.1500, Munich) was his last painting of this period. He moved in humanist circles in Nuremberg. His copper engravings show his interest in portraying nudes in the Italian style.

• From 1500 onwards Dürer found inspiration for his art through travel. He painted the celebrated Paumgartner Altarpiece (1502–4, Munich) and The Adoration of the Magi (1504, Florence); he also produced watercolours of plants and animals, as detailed and accurate as natural history plates.

• In 1505 he fled from the plague and returned to Venice, the city of colourists, where his talent was already recognized and envied – except by Giovanni Bellini, who admired him. His compatriots commissioned him to paint The Feast of the Rose Garlands (1506, Prague); he also painted The Madonna with the Siskin (1506, Berlin), Christ among the Doctors (1506, Lugano, TB), with musculature in the style of *Leonardo, and the Portrait of a Young Venetian Woman (1505, Vienna). His Venetian experience culminated in the synthesis of the ideal classical beauty which had been the aim of his quest, with Adam and Eve (1507, Madrid), painted in Nuremberg.

• In Nuremberg, Dürer also painted The Martyrdom of the Ten Thousand (1508, Vienna, KM) and The Adoration of the Holy Trinity (1511, Vienna, KM). Away from Venice, Dürer became more of a graphic artist than a colourist and, from 1510, concentrated on engraving. His masterpieces included Knight, Death and the Devil and Melancholia (1513–14, Strasbourg, Cabinet des Estampes et des Dessins; Colmar, Musée d'Unterlinden), in which his mastery of technique and modelling is used to express thoughts in the form of allegories.

• In 1512 Maximilian I of Augsburg took him into his service in the city which was to become the capital of German Renaissance art. There Dürer painted works including the portrait of his patron (1519, Vienna) and The Virgin and Child with St Anne (1519, New York), a pre-Mannerist masterpiece.

- After the death of his patron, Dürer turned to Charles V in 1520 and spent a year in the Low Countries, mainly in Antwerp, where he met the painters Joachim Patinir, Lucas van Leyden and Quentin Matsys; there he also saw the paintings of the Flemish masters *van Eyck, Hugo van der Goes and *van der Weyden. But after Maximilian's death the political and religious situation had become difficult with the growth of the Reformation and the Peasants' War. Worn out, Dürer painted little and feverishly: *The Flood* (watercolour, 1525, Vienna, Albertina); *The Four Apostles* (1526, Munich), and the portraits of Hieronymus Holzschuher and Jakob Muffel (1526, Berlin). During his last years in Nuremberg, Dürer devoted most of his time to theoretical works, including his *Treatise on Human Proportions*, which was published in 1528, six months after his death.

Dürer was a painter, engraver, graphic artist and theoretician, as much in the fields of mathematics and fortifications as in art; he was a humanist artist and the most famous of German painters. His art influenced his German contemporaries – especially Hans Baldung, Lucas Cranach and Albrecht Altdorfer – as well as the European Mannerists of the 16th century and the German Romantics of the 19th century.

APPROACH AND STYLE

Dürer painted mainly biblical scenes and portraits in oil on wood that were commissioned by religious and private patrons, but he also painted landscapes and animals in watercolour and gouache and produced engravings and drawings. His paintings, polyptychs, devotional works and altarpieces were usually small to medium-sized.

In Nuremberg Dürer became acquainted with the work of Michael Wolgemut, who was inspired by Rhenish art and van Eyck. In the Low Countries he studied the works of Jan van Eyck and van der Weyden in particular; also those of Lucas van Leyden, Patinir, Quentin Matsys, and Dutch artists, especially Van der Goes. In Colmar he got to know the work of Martin Schongauer. In Basel he mingled with the humanists, while in Venice he admired the art of Mantegna and Giovanni Bellini. He was also acquainted with the work of Leonardo da Vinci.

- At the start of his career, Dürer produced engravings and assimilated aspects of European painting: from Wolgemut he took decorative elements and a monumental, austere Gothic style; van Eyck's work taught him the importance of detail, while that of van der Weyden exposed him to a new, sensitive realism; from Schongauer, the last medieval Rhenish mystic, he learnt linear and decorative Gothic mannerism. The great Venetian masters taught him the foundations of the theory of art and the study of realism. He painted landscapes and animals from life. In his early portraits the sharpness of the sitter's gaze was directly inspired by van Eyck. Dürer applied his pictorial and humanist discoveries to his introspective self-portraits, images of a free-thinking man. This period of his career was marked by Gothic mannerism and a multiplicity of styles.
- He achieved mastery of his art by assimilating the Italian approach, the German Gothic tradition and Dutch art. His paintings of the Madonna and Child (*Nativities, Madonnas,*

A GREAT PAINTER

◆ Dürer experienced fame and recognition in Europe in his own lifetime, especially for his graphic work. His success has lasted throughout the centuries.
◆ He broke with the German Gothic tradition to assert his modernism – a modernism with regard to subject matter as much as to composition and modelling. He was the first modern artist north of the Alps, and he belongs to the stylistic continuity of Italian Classicism.
◆ He was remarkable as the only German artist to have developed from being a craftsman of the Middle Ages to being a humanist, classical painter of the Renaissance.
◆ Dürer showed amazing aptitude at assimilating European art and a remarkable ability to reinterpret it. He created new compositions by combining Dutch and Italian models.
◆ He dealt with 'Germanic' themes in pre-Baroque compositions (*The Martyrdom of the Ten Thousand*). He created what is probably the first introspective and 'stand-alone' self-portrait in Western painting. He changed the way traditional subjects were treated.
◆ His technical mastery and innovations were mainly in the field of engraving.
◆ He strove to portray the formal classical ideal of the human body (*Adam and Eve*).
◆ He aimed to achieve perfect realism in his pictures of animals.
◆ The painter discovered 'absolute' colour, as opposed to Venetian tonal colour.

Adoration of the Magi) used pyramidal composition of Flemish or Italian inspiration. Dürer precisely applied the laws of proportion and perspective, which he made more complex by placing his vanishing point on a diagonal. His natural or idealized architectural or landscaped backgrounds seem to 'breathe'. His drawing became freer and the drapery of his figures fuller, although sometimes still archaic. The Madonnas emanate a Bellini-like sweetness. He strove to give an exact, rational representation of the world through an objective concept of painting, while working in a profession that was concerned with luxury. The portraits of his mature period reveal his realism, his sense of psychology and his skill at capturing the essence of the individual (*Self-Portrait* of 1500).

• Dürer's career reached its peak in Venice. He abandoned the tonal expression of colour and light in favour of golden colours and developed a pure, non-tonal palette. Following in the footsteps of the Italian Renaissance masters, he created an ideal classic nude (*Adam and Eve*). His drawing and modelling became supple, the attitudes of his figures more relaxed, their expressions peaceful and their movements subtle.

• In Nuremberg, the increased number of characters in his paintings and the meticulous care he took to depict the details of bodily violence recall northern European art of the late Middle Ages. For the first time crowds were organized in spiralling masses, heralding

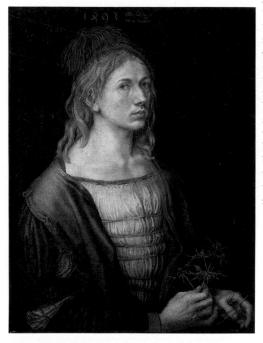

Altdorfer, *Brueghel, *Tintoretto and the Baroque. His final portraits display an increased objectivity and seriousness.

• At the end of his life Dürer produced only a few paintings, at first in a pre-Mannerist style and later inspired by the austere spirit of the Reformation. He summarized his artistic development thus: 'When I was young I made engravings of all kinds of new works; now [...] I am beginning to see nature in its original purity and to understand that the supreme form of artistic expression is simplicity.'

Self-Portrait
1493. Oil on parchment transferred to canvas,
56.5 x 44.5cm, Paris, Musée du Louvre

Dürer signed his self-portrait and inscribed it with a note which can be translated as follows: 'Things are with me as they are decreed in Heaven' or 'My fate will progress according to the Supreme Order'. He holds a thistle in his hands, symbolizing the suffering of Christ (L Grote) or marital fidelity. This work is the first 'stand-alone' self-portrait easel painting in German art. As in his two self-portraits of 1498 and 1500, here the artist shines a light on himself, portraying himself as a free-thinking man with a capacity for introspection that is entirely in keeping with the humanist spirit. It is clearly the portrait of a northern European artist: the restrained expression is reminiscent of German Gothic and the precision of the painting is inspired by van Eyck. But his desire to show himself as an independent man, with a certain aristocratic elegance, is closer to the Italian spirit than to Flemish art.

BIBLIOGRAPHY

Anzelewsky, F, *Dürer: His Art and Life*, translated by Heide Grieve, Gordon Fraser, London, 1980; Landau, D and Parshall, P, *The Renaissance Print*, 1470-1550, Yale University Press, New Haven, CT and London, 1994; Panofsky, E, *The Life and Art of Albrecht Dürer*, 4th edn, Princeton University Press, Princeton, NJ 1971

KEY WORKS

Dürer produced about 190 works, not including his engravings (a very important part of his output).

Self-Portrait, 1493, Paris, Louvre
Haller Madonna, 1498, Washington, NG
Self-Portrait, 1498, Madrid, Prado
'Christ-like' Self-Portrait, 1500, Munich, AP
Paumgartner Altarpiece, 1502–4, Munich, AP
The Adoration of the Magi, 1504, Florence, Uffizi
Portrait of a Young Venetian Woman, 1505, Vienna, KM
The Feast of the Rose Garlands, 1506, Prague, Národní Gallery
The Madonna with the Siskin, 1506, Berlin museums
Adam and Eve, 1507, Madrid, Prado
The Adoration of the Holy Trinity, 1511, Vienna, KM
Maximilian I, 1519, Vienna, KM
The Virgin and Child with St Anne, 1519, New York, MM
The Four Apostles, 1526, Munich, AP
Portrait of Hieronymus Holzschuher, 1526, Berlin museums

The Adoration of the Magi
1504. Oil on wood, 100 x 114cm, Florence, Uffizi

This painting (originally the central panel of an altarpiece) was produced during Dürer's mature period and is entirely original. Painted after his first journey to Venice, it reveals strong Italian influences. Dürer structured his composition using a complex, bold perspective, with a diagonally slanting vanishing point. He has placed the figures, monumental but with unaffected expressions, in a setting in which nature is interspersed with constructions built by man. The main group is dominant although it appears to have been relegated to the left-hand side of the picture. There are Flemish references in the landscape and in the meticulous rendering of details and materials. The eye is drawn to every part of the painting: the insects in the foreground, the precious stones decorating the sumptuous attire of the magus (whose face is Dürer's), the silhouettes of castles in the background. These details are interesting in themselves without diminishing the main theme, that of the Adoration of the Christ Child. While the bright colour range is Dürer's alone, the light is very Venetian.

Grünewald

Grünewald combined a harrowing quality with a very modern pictorial boldness and a formal language based on late Gothic thought and mysticism. He developed a painting style rich in hallucinatory visions.

LIFE AND CAREER

- The identity of Matthias Grünewald remains conjectural. He is thought to be the same person as Mathis Nithardt, or Gothardt (Würzburg, Bavaria, c.1475/80–Halle, Saxony-Anhalt, 1528), also known by the name Mathis Gothard or Nithard or Neithardtreste. His work is of uncertain attribution except for his masterpiece, the *Isenheim Altarpiece*, which is signed with the monogram MG.
- Born in humble circumstances, he is believed to have received his training in Würzburg and was perhaps inspired by the art of Hans Holbein the Elder in Augsburg. He completed his training as a painter in around 1500. He may have been a pupil of *Dürer (J von Sandrart, 1675). He is thought to have discovered Italian art in Italy or through the painter Jacopo de' Barbari, who was staying in Nuremberg.
- His earliest work is probably a panel portraying *The Last Supper, St Dorothy and St Agnes* (c.1500, Germany). He then painted the panels of an altarpiece for the parish church of Lindenhart, near Bayreuth, which included *The Derision of Christ* (completed in 1504, Munich).
- The archives of Aschaffenburg mention the presence of Grünewald, master Mathis, as a painter in the town in 1505. A *Crucifixion* of his (c.1507, Basel) would have belonged to an altarpiece. In 1509, the *Heller Altarpiece*, commissioned by the merchant Jakob Heller and with interior panels painted by Dürer, was delivered to the Dominicans of Frankfurt am Main. Only the two outer panels in monochrome, painted by Grünewald in around 1510, have survived: *St Elizabeth of Thuringia and St Lucia* (Karlsruhe) and *St Laurence and St Cyriakus* (Frankfurt). After 1509 he painted the *Small Crucifixion* (Washington). In 1510 he worked as a hydraulic engineer, directing the extension and restoration work at Aschaffenburg Castle, the residence of Uriel von Gemmingen, Archbishop of Mainz. In 1511 he was appointed Uriel von Gemmingen's artistic adviser and court painter.
- His masterpiece, the *Isenheim Altarpiece*, was commissioned in around 1512–16 by Guido Guersi, the preceptor (head) of the Antonite monastery at Isenheim (Upper Rhine). Among the themes dealt with on the nine painted panels are *The Crucifixion*, *The Resurrection* and *The Temptation of St Antony* (Colmar). Guersi died in 1516 and Grünewald returned to Aschaffenburg, entering the service of Archbishop Albrecht von Brandenburg. He was in Frankfurt am Main between 1514 and 1516, but he was mentioned in the will of Canon Reitzmann as having been commissioned to paint a triptych for the collegiate church of Aschaffenburg. Two panels of this have survived: *The Virgin and Child* (1517 and 1519, Stuppach) and *The Miracle of the Snow* (1517 and 1519, Freiburg im Breisgau). Grünewald was once again appointed court painter in Mainz until around 1526.
- From 1520 onwards he painted several altarpieces, of which only a few panels have survived: three for Mainz Cathedral; one for the collegiate church of Halle in Saxony, of which the only surviving panel, *St Erasmus and St Maurice* (c.1520–5, Munich), portrays St Erasmus with the features of the Archbishop of Mainz, who commissioned the work; the *Tauberbischofsheim Altarpiece* (c.1525, Karlsruhe) with a panel representing *Christ Carrying the Cross* and, on the reverse side, *The Crucifixion*; and a lost altarpiece bearing the coat of arms of the Brandenburgs, the predella of which, *The Lamentation of Christ*, is still in the church of Aschaffenburg.
- Grünewald settled in Mainz after 1526, then in Frankfurt and finally in Halle, where he resumed his activities as a hydraulic engineer and was also involved in the manufacture of soap. He died in Halle in 1528.

The art of Grünewald, painter and graphic artist, died with him. It seems he had no workshop or pupils, except possibly in Aschaffenburg. He is not known to have had any followers, successors or even imitators, but much later his painting influenced the development of Expressionism and modern art in general.

APPROACH AND STYLE

Unlike Dürer, who also painted secular subjects, Grünewald painted only sacred themes, in which he revealed the passionate nature of his faith. He borrowed many elements from the *Revelations of St Bridget* (a visionary mystic canonized in 1391), which were published in 1492, and his most frequent subject was that of Christ's redemptive suffering. He painted mainly triptychs but also a few canvases, which were probably all commissioned.

Grünewald travelled throughout Germany, spending time in Bavaria and Saxony in particular, and he knew his German contemporaries well: Dürer, Holbein the Elder, Cranach the Elder and Baldung. He was also acquainted with the work of the Flemish artists *van Eyck, the Master of Flémalle, *Bosch and Memlinc, and Italian ones such as Mantegna, *Leonardo da Vinci, *Pontormo and Rosso Fiorentino.

• So few works have survived that an analysis of Grünewald's development over his 25 years as an artist is not possible. However, from 1504 onwards the artist displayed a violent mysticism, imbued with a dramatic tension that would remain characteristic of his work until the end. Three panels on the theme of the Crucifixion, produced successively in around 1507, 1512-16 and 1523-5, make a comparison possible: the dramatization of the agony of Christ and the suffering of his mother becomes more intense with each version. In the first panel the Virgin, praying next to St John the Evangelist, presents an image of resignation. In the next work she presents an image of suffering, on the point of losing consciousness, and in the last of the three she is unable to bear the sight of her suffering son. The agony of Christ reaches a paroxysm; his fingers are contorted towards heaven and his body is twisted. In all three works the black background and deathly pale light are part of the tragedy. This is very different from contemporary representations in which the ideal beauty of Christ was proof of his divinity. Grünewald's *Crucifixions* do not relate the historical event 'but rather are tragic contemplations beyond history' (P Bianconi).

• Although Grünewald was an artist who always followed his own path, there are some elements – composition, colours, formal references and even inspiration – which link him to other painters. For example, his fantastical vision of *The Temptation of St Antony*, filled with gesticulating, devilish figures, is reminiscent of Bosch; his transparent colours, shaded off and changing, and his elongated, tormented forms place him in the tradition of Holbein the Elder. The powerful forms of the Burgundian sculptor Claus Sluter are echoed in the movement of the drapery of his figures. Grünewald and Dürer may have influenced each other from 1508 onwards, since they both worked on the *Heller Altarpiece*, and the *Isenheim Altarpiece* has sometimes been attributed to Dürer.

• Although he had nothing to do with the humanist investigations of the Italian Renaissance, the freedom and scale of Grünewald's *Crucifixions* place him within its sphere of influence. The rigour of his pyramidal composition is reminiscent of Leonardo, but his realistic perspective is less structured than that of van Eyck and less rational than that of the Italians. His figures, sometimes very sculptural, do not have the volume and density of Mantegna's; rather they seem to float in space like those of *Pontormo.

A GREAT PAINTER

◆ Grünewald's name was mentioned for the first time in 1675 by Sandrart (*Teutsche Akademie*). There are still many unknown areas of his life and work.
◆ Although Germanic and Gothic in essence, his work does not belong to the mainstream of any pictorial tradition.
◆ Grünewald treated religious themes in a personal manner, both from a compositional and a formal point of view. He represented atrocity as well as peace and gentleness, moving from an overabundant use of symbols to a restrained style, from incandescent landscaped backgrounds to black ones, from sinewy lines to gentle modelling.
◆ His *Crucifixions* express in their own way the violence of his times. 'No other master has delved so deeply into horror, none has ever introduced such passion and vehemence into the depiction of the decomposing corpse of a torture victim' (P Vaisse).
◆ His sometimes dense, sometimes translucent technique enabled him to achieve a realism which draws the viewer in.

GRÜNEWALD

- Like the figures, the landscapes belong to the realm of phantasmagoria and mysticism rather than being the result of the observation of nature, yet they are imbued with empirical realism. 'Each element is individualized in the elaboration of one of its visible qualities, whether of a radiant nature (such as the luminous gradation of colours in *The Resurrection*) or of a mechanical nature (such as the frenetic, sinewy pleating of Mary Magdalene's dress in the Isenheim Crucifixion)' (P Bianconi). By contrast, the backgrounds are dark and inert. The unreal, deathly pale or incandescent light freezes the colours; in scenes full of anguish it heightens the violence of the emotions in the same way that it brings out the tenderness and gentleness of the Madonna whose face it caresses.

KEY WORKS

Grünewald left behind only one altarpiece (18 panels), 7 paintings and about 40 drawings.

The Last Supper, St Dorothy and St Agnes, c.1500, Germany, private collection

The Derision of Christ, 1504, Munich, AP

The Crucifixion, c.1507, Basel, Km

Heller Altarpiece, 1509 and 1510, Karlsruhe, SK and Frankfurt, SK

Small Crucifixion, after 1509, Washington, NG

Isenheim Altarpiece, c.1512–16, Colmar, Musée d'Unterlinden

Aschaffenburg Triptych, 1517–19, Stuppach, parish church and Freiburg im Breisgau, Augustiner Museum

St Erasmus and St Maurice, c.1520–5, Munich, AP

Tauberbischofsheim Altarpiece, c.1525, Karlsruhe, SK

The Lamentation of Christ, c.1525, church of Aschaffenburg

Isenheim Altarpiece
The Crucifixion, The Concert of the Angels and The Virgin and Child
c.1512-16. Tempera and oil on limewood panel, polyptych when open: around 7.70 x 5.90m, Colmar, Musée d'Unterlinden

This altarpiece was commissioned by the Sicilian Guido Guersi, the preceptor (head) of the Antonite monastery in Isenheim. The altarpiece consists of nine painted and two carved panels that are visible or concealed depending on the three ways in which the altarpiece can be presented: closed, partially open or fully open. The open altarpiece shows the central panel carved by Nicolas de Haguenau, while the side panels depict The Visit of St Antony to St Paul *and* The Temptation of St Antony. *When partially open, the altarpiece shows* The Concert of the Angels, The Virgin and Child *and, on the sides,* The Annunciation *and* The Resurrection, *with* The Entombment *painted on the predella. When the panels are opened fully, carvings of Christ and the apostles form the plinth of the central carved panel.*

The altarpiece illustrates Grünewald's artistic tendencies. There is the expressionism and realism of the battered flesh, and the anguish of the Virgin in the Crucifixion *on discovering the body of Christ on the cross, slightly off-centre, covered in purulent wounds: both she and Mary Magdalene gesture imploringly towards Christ, while John the Baptist points at the lifeless, pallid corpse. There is the tenderness of the* Virgin and Child, *the incandescent, warm illumination of* The Annunciation *and the apocalyptic, demonic vision associated with temptation, reminiscent of *Bosch. In this one polyptych the artist has combined the soberness of the composition and the black background with the complexity and over-embellishment of the setting, which blends into a golden landscape and a light that is sometimes sunny, sometimes pallid, and colours that are dense or translucent.*

BIBLIOGRAPHY

Hayum, A, *The Isenheim Altarpiece: God's Medicine and the Painter's Vision*, Princeton University Press, Princeton, NJ, 1989; Ruhmer, E, *Grünewald: The Drawings, Complete Edition*, Phaidon Press, London, 1970; Ruhmer, E, *Grünewald: The Paintings, Complete Edition*, Phaidon Press, London, 1958

Michelangelo

Together with Leonardo da Vinci, Michelangelo is the supreme Renaissance genius. He stood out from his contemporaries through his rebellious spirit and artistic determination. His work expresses an extraordinary sculptural force and tumultuous energy which was to become a characteristic of the Baroque. His great inventiveness as a painter, from the point of view of both form and colour, led him towards a new conception of space.

LIFE AND CAREER

• Michelangelo, in full Michelangelo di Lodovico Buonarroti (Caprese, near Arezzo, 1475–Rome 1564), was an Italian artist born into a family of intellectuals. He enjoyed a long career (75 years) as a painter, sculptor, architect and graphic artist. In 1488 he went to work in the workshop of Domenico Ghirlandaio in Florence, where he became acquainted with the art of Filippo Lippi and *Botticelli. Very soon he moved away from the art of the *quattrocento* (15th century). He studied the antique statues in the collection of Lorenzo de' Medici (known as the Magnificent), whose guest he was between 1489 and 1492. He preferred sculpture and anatomical studies to painting. He was interested in the writings of Politian, an Italian poet and humanist who advocated a bold, spirited, innovative art. However, he did copy the older masters, *Masaccio, *Giotto and, of course, *Leonardo da Vinci.
• After the death of Lorenzo the Magnificent in 1492 and the subsequent unrest in Florence, he left for Bologna, passing through Venice, before returning to the Florentine Republic, which by then was under the theocratic rule of the preacher Savonarola, who disapproved of art and culture. In 1496 Michelangelo travelled to Rome, where he stayed for five years and painted *St Francis Receiving the Stigmata* (now lost).
• In 1501 Michelangelo returned to Florence, where Leonardo da Vinci was becoming established as the city's leading painter. In 1504 he was commissioned to produce *The Battle of Cascina*, a project for the Palazzo Vecchio, the cartoon of which has been destroyed. This work is known only through unfinished drawings. It related an episode of the war against Pisa (1364); its patriotic message – conceived by Machiavelli, who was then Secretary of the Republic – was intended to encourage the citizens of Florence to look after their own security rather than call upon a *condottiere*, or leader of a mercenary army. This complex work, considered exemplary at the time, also aimed to compete with Leonardo's *Battle of Anghiari* (1503–5). *The Holy Family*, also known as the *Doni Tondo* (1504–5, Florence), is the only painting on wood by the artist.
• At the beginning of 1505, Pope Julius II (Medici) summoned Michelangelo to Rome to build his tomb. After several draft designs and because of disagreements with the Pope and his family, the artist fled to Florence without having honoured his contract; he was therefore obliged to accept a replacement commission. In 1508, at the request of Julius II, he started on the vast project of decorating the ceiling of the Sistine Chapel in Rome with frescoes depicting scenes from Genesis. The project was completed in 1512. In 1513 he entered into another contract with Julius II to build his tomb.
• However, the new Pope Leo X, a Medici, summoned him to Florence for a number of architectural and sculptural projects and to build fortifications; there are few mentions of drawings and paintings by Michelangelo during this period. In Rome, after a tense relationship with Clement VII, who was another Medici, he was asked by the new Pope, Paul III (Farnese), to paint the wall above the altar of the Sistine Chapel

with the subject of the Last Judgement. This work (1536–41) with its pre-Mannerist fervour undermined the idea of balanced structures that was typical of the Renaissance. Still in the Vatican, he decorated the Pauline Chapel (of Paul III) with *The Conversion of St Paul and The Martyrdom of St Peter* (1542–50).

• After 1546, Michelangelo devoted himself mainly to architecture (the dome of St Peter's, Rome) and drawing.

His solitary, tenacious work aroused the admiration of painters, connoisseurs and the Florentine Academy. He developed close relationships with some of his contemporaries, such as Sebastiano del Piombo and Daniele da Volterra.

APPROACH AND STYLE

In Florence Michelangelo painted a few religious paintings commissioned by rich merchants (Agnolo Doni and Taddeo Taddei), while in Rome he was commissioned by the popes to paint three monumental fresco projects on religious subjects. He admired the art of Masaccio in Rome and Giotto in Assisi and Padua; he was also familiar with Leonardo's work in Florence.

• From the old masters Michelangelo borrowed the handling of volume, the sculptural solidity of bodies and garments (Giotto), the mastery of space and a powerful, sobriety (Masaccio). In spite of his taste for the sculptural, he was inspired by Leonardo's intertwined figures: he expressed the beauty of the male body by representing 'nude figures' in movement, in 'extraordinary attitudes' and with 'marvellous foreshortenings' (Vasari, 1550). He built complex links between his characters through the interaction of bodies and the direction of their gazes (*The Holy Family*). He rejected strong contrasts between shadows and light but not chiaroscuro in the strict sense, since this enabled him to create modelling. He used bright, pure, acid, clear, metallic colours, prefiguring Mannerist developments.
• In Rome, his three-dimensional stylistic innovations undermined the art of the Renaissance, foreshadowing Mannerism and the Baroque. His Sistine Chapel frescoes were revolutionary as regards composition: highly articulated with a complex division into rectangles. In handling the innovative theme of Genesis, he gave the illusion of two distinct yet united symbolic spaces, earthly and celestial. The curved surface of the vault made it difficult to set the figures in perspective; he solved this problem by juxtaposing different scales. The colossal, athletic nudes, with their powerful three-dimensional strength, were conceived like painted sculptures, constructed in masses and filling the vault. Michelangelo achieved the brilliant feat of integrating pictorial décor with existing architecture, while adding his own trompe-l'œil

A GREAT PAINTER

◆ Michelangelo was recognized as a painter by the élite and by art patrons during his own lifetime.
◆ Ever since, his monumental works have been admired down the ages.
◆ A humanist, he laid the revolutionary foundations of Mannerism and the Baroque.
◆ Michelangelo brought innovations to traditional Christian subject matter (*The Holy Family, The Last Judgement*).
◆ He created a new chromatic range and brought together bold colours, using numerous *cangianti* (shimmering transitions from one colour to another). He made use of *quadratura* (trompe-l'oeil architecture with illusory perspective), juxtaposed figures in different scales and invented the *figura serpentina* (serpentine figure).
◆ Through his virtuosity and command of space, he created swirling compositions in which empty spaces alternated with spaces teeming with figures.

architecture. The bodies are striking in their beauty, in the virtuosity of their poses – including the *figura serpentina* (born of *contrapposto*, a shifting of weight combined with a spiral twisting movement) – and in the accuracy of their modelling. Respect for the canons of beauty, elongated bodies, delicate or powerful musculature and figures in motion are combined with piercing, clear colours, ranging from pink to violet and from yellow to orange.

• His tempestuous *Last Judgement* in the Sistine Chapel, painted 30 years after the ceiling, broke with the traditional representation of the subject and the organization of space. In fact, it was unlike any other painting produced before or since. Michelangelo portrayed a vengeful God who judged men instead of a God enthroned in the heaven of the righteous. The figures are not arranged from the bottom upwards, from the damned to the chosen, according to the clear spatial structure of the quattrocento; instead they are shown in vigorous whirling, swirling movements. Groups of massive, thick-set nudes alternate with the empty spaces in the composition. The form, attitudes and expressions are dramatic. The colours of the wall, softer than those of the ceiling, lend unity to the whole work.

• In his last frescoes, Michelangelo's style became even more bold, unrestrained and pared down: dramatic nudes were expressed in simplified volumes and the colours were lighter and softer.

Scenes from Genesis
1508–12.
Detail: the Prophet Daniel, 1511.
Fresco, 3.95 x 3.80m, Rome, Vatican, ceiling of the Sistine Chapel

In this colossal, unique ceiling, Michelangelo revealed his fundamental conception of humanism; for him the organization of material space gave meaning to the world and raised men to the level of God.
While the walls of the Sistine Chapel narrate episodes of the Old and New Testaments, the ceiling dominates them physically and symbolically, drawing the attention of the viewer back to the creation of the world itself. This monumental fresco is structured in compartments, coffers, lunettes, triangles and strips which separate the various scenes of the creation and the figures of the sibyls and prophets. The latter announce the Holy Word of God, the complex culmination of a spatial and moral ascension, progressing from the everyday to the divine. The symbolism is accentuated by the trompe-l'œil architecture in which it is set.
The figure of Daniel illustrates Michelangelo's style and innovations: the personal interpretation of the subject, the sculptural painting demonstrating his anatomical knowledge, the young, athletic nude holding the book in a bold, foreshortened pose, and the harmony between real and imitation architecture and between painting and trompe-l'œil sculpture. His new concept of space balances filled and empty areas, and light and metallic colours, rich in cangianti (transitions from yellow to green, and from violet to mauve), which prefigure Mannerism.

BIBLIOGRAPHY
Hartt, F, *Michelangelo*, Thames and Hudson, London, 1998; Hibbard, H, *Michelangelo*, 2nd edition, Penguin, Harmondsworth, 1985; Mancinelli, F, 'Michelangelo at Work' in *The Sistine Chapel: Michelangelo Rediscovered*, ed A. Chastel, Muller Blond and White, London, 1986; Roskill, M W, *Dolce's 'Aretino' and Venetian Art Theory of the Cinquecento*, University of Toronto Press, Toronto, 2000; Seymour, C J, *Michelangelo: The Sistine Chapel Ceiling*, Thames and Hudson, London, 1972; Steinberg, L, *Michelangelo's Last Paintings*, Phaidon, London, 1975; Wilde, J, *Michelangelo: Six Lectures*, Clarendon Press, Oxford, 1978; Wyss, B, 'The Last Judgment as Artistic Process: The Flaying of Marsyas in the Sistine Chapel', Res, 28 (1995), pp 62–77

KEY WORKS

Michelangelo only painted a few works but these were exceptionally ambitious and influential.

The Battle of Cascina, 1504, cartoon, destroyed

The Holy Family, also known as the *Doni Tondo*, 1504–5, Florence, Uffizi

Genesis, 1508–12, Rome, Vatican, Sistine Chapel

The Last Judgement, 1537–41 Rome, Vatican, Sistine Chapel

The Conversion of St Paul and the The Martyrdom of St Peter, 1542–50, Rome, Vatican, Pauline Chapel

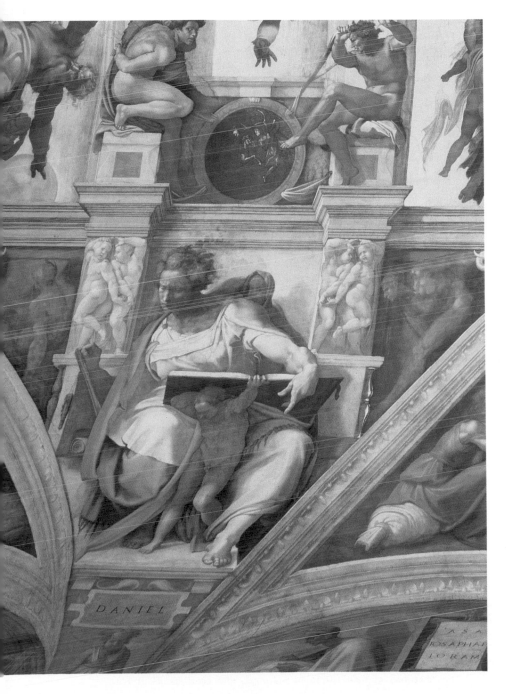

DANIEL

Raphael

Raphael's ability to absorb the art of his predecessors and especially that of his Renaissance contemporaries together with his pictorial innovations made him the master of a revived Classicism. His sense of moderation, the harmonious balance of his compositions and the sensual grace of his figures' poses give his work an elegant reserve which is unique to him.

LIFE AND CAREER

• Raphael, born Raffaello Santi or Sanzio (Urbino 1483–Rome 1520), Italian Renaissance humanist, probably trained with his father, Giovanni Santi, in the workshop of Perugino (c.1499–1500), with whom he collaborated. He started by painting altarpieces for the churches of Città di Castello (1500–4), *The Coronation of the Virgin* (1502–3, Rome) and the *Ansidei Altarpiece* (c.1505, London, NG), which were inspired by his master Perugino.

• Between 1504 and 1508, Raphael lived in Florence and became famous with *The Marriage of the Virgin* (1504, Milan). Already he had a perfectly Classical style. He altered the aesthetics of the Virgin. In the eyes of his contemporaries his ability to convey female beauty equalled that of *Leonardo da Vinci: *The Madonna of the Grand Duke* (1504, Florence); *The Connestabile Madonna* (1504, St Petersburg, Hermitage); *The Canigiani Madonna* (1507, Munich, AP); *The Madonna of the Goldfinch* (c.1506, Florence, Uffizi) and *The Virgin and Child with the Infant John the Baptist in a Landscape* (*La Belle Jardinière*) (1508, Paris). In Perugia he painted the fresco *The Trinity with Saints* (1505–8, church of S Severo) and altarpieces including *The Entombment of Christ* (1507, Rome), inspired by *Michelangelo. His portraits are reminiscent of Leonardo: *Agnolo Doni and Maddalena Doni* (c.1505, Florence), *Portrait of a Lady with a Unicorn* (1505–6, Rome, Borghese) and *The Mute Woman* (1507, Urbino, GN).

• Between 1508 and 1520 Raphael worked in the Vatican for Pope Julius II and then for Leo X. The first stage of his work was the decoration of the Pope's private rooms, or Stanze. The frescoes, painted with the assistance of Giulio Romano and Giovanni Francesco Penni, show the evolution of his style, moving from equilibrium towards a certain tension, starting with the cycle in the Signature Room with *The Dispute over the Sacrament, The School of Athens* and *Mount Parnassus* (1508–11), and continuing with the cycle of the Room of Heliodorus with *The Expulsion of Heliodorus* (1511–14) and that of the Room of the Fire in the Borgo with *The Burning of the Borgo* (1514–17). At the same time, Raphael was painting other frescoes in Rome: *The Triumph of Galatea* (1511, Villa Farnesina); the ceiling of the *Loggia of Psyche* (1517, Villa Farnesina) and the ceiling of the funerary chapel of S Maria del Popolo. He also painted altarpieces with a perfect circular composition, as seen in *The Madonna of Foligno* (1511–12, Rome), *The Sistine Madonna* (1513–14, Dresden, Gg) and *The Madonna of the Fish* (c.1514, Madrid, Prado).

• He created cartoons for tapestries in the Sistine Chapel, including the *Acts of the Apostles* (1515, London, VAM); he also painted devotional works with complex lines, including *The Madonna with the Blue Diadem* (1510–11, Paris, Louvre), the famous *tondo* of *The Madonna of the Chair* (1514, Florence) and *St Cecilia* (1514, Bologna, Pinacoteca). He excelled in the art of the single or double portrait: *A Cardinal* (c.1510, Madrid, Prado), *Baldassare Castiglione* (c.1515, Paris), *Raphael and His Fencing Master* (c.1518, Paris) and *La Donna Velata* (c.1516, Florence, Pitti).

• From 1515 onwards, Raphael's remarkable success forced him to leave the execution of many works to his pupils and collaborators. It is

thought that the decoration of the loggias of the Vatican should be attributed entirely to Raphael's workshop. He himself was appointed architect in charge of works in St Peter's, Rome, as successor to Bramante.

• His last works, such as *Christ Carrying the Cross* (1517, Madrid, Prado), *The Holy Family* (1518, Paris) and the portraits including Pope Leo X with *Two Cardinals* (1518–19, Florence), are more complex. At the age of 37, Raphael painted his last work, the famous *Transfiguration* (1519–20, Rome).

A painter, graphic artist, architect, sculptor and archaeologist, Raphael died prematurely at the height of his fame. Giovanni da Udine, Giulio Romano, Penni, Perino del Vaga and Marcantonio Raimondi, who succeeded him, all worked in his studio. The great Florentine painters Fra Bartolommeo and Andrea del Sarto continued his work. His style of drawing established itself as a model and inspired the French ideal practised by *Poussin, *David, *Ingres and the Academicians. The English Pre-Raphaelites, the Nabis and even *Picasso acknowledged his influence.

APPROACH AND STYLE

A famous painter of Madonnas, Raphael produced altarpieces, frescoes (both secular and religious), devotional paintings and portraits. His works were of various sizes, on wood or canvas, for private patrons (Agnolo Doni, Agostino Chigi) or religious ones (the Pope).

In Urbino, he discovered the art of *Piero della Francesca. In Florence he became well acquainted with the art of his contemporaries Perugino (his master for one year), Leonardo da Vinci, Michelangelo and Fra Bartolommeo, and he is thought to have been familiar with the works of Venetian painters.

• Raphael responded to the size and freedom of *Piero della Francesca's compositions. From Perugino he took the pure lines of his drawing, the limpid light, the sweetness of the faces, a particular grace and gentleness and the stylized scattered trees with delicate leaves. He often divided his altarpieces into two parts, one celestial and the other earthly.

• In Florence, his study of Michelangelo inspired him to develop a complex compositional technique; he adopted Michelangelo's ability to breathe life and strength into figures with tense faces. From Leonardo he borrowed the bluish shade of his hazy landscapes (conveyed by a discreet *sfumato*), the mysterious expressions of his characters, and the pyramidal composition which reinforces the unity of the groups of figures and lends them dignity and tranquility (*The Madonna of the Grand Duke*). Fra Bartolommeo was the inspiration for his symmetrical arrangement of celestial figures in a semicircle with the important figures at the sides, and for the solemn nature of his religious subjects.

• The works he produced in Rome illustrate his development towards the purest Classical equilibrium. This is expressed in the rigorous, perfect geometry, the Classical architecture and the pastoral grace of his compositions. Movement is introduced through a tense, animated

A GREAT PAINTER

◆ A genius of the Renaissance, Raphael enjoyed universal acclaim, especially among those painters interested in drawing and sometimes even among colourists.
◆ Raphael absorbed, extended and revitalized the Classical art of his contemporaries.
◆ He was an innovator, showing great imagination and creativity, particularly with regard to his favourite subject, the Madonna, and double portraits – a form which he developed.
◆ He achieved perfection in the harmonious, measured balance of his compositions.
◆ Like Leonardo da Vinci, Raphael created an ideal of beauty for the faces of his female characters.
◆ Some 20th-century critics have emphasized the large number of elements he borrowed from his contemporaries, to whom he was indebted for many aspects of his art.

RAPHAEL

Michelangelesque style, reflecting his studies of form and expressed in increasing numbers of sculptural academic nudes in complex poses, enhanced by a special use of colour. All these aspects combine to create scenes of great drama.

• His colours are reminiscent of those of the Venetian artists Sebastiano del Piombo and *Lotto. Later he abandoned a warm, vibrant atmosphere in favour of light colours, and Classical precepts in favour of pre-Baroque illusionism and trompe l'œil. His portraits achieved a new power. In his last religious works he created more complex, turbulent, lively compositions.

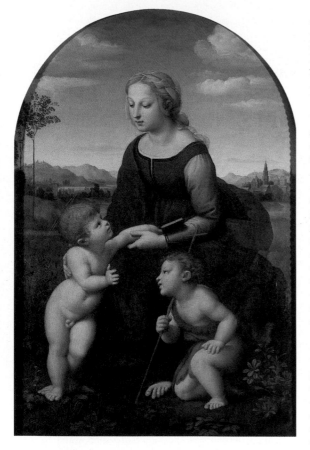

The Virgin and Child with the Infant John the Baptist in a Landscape, known as **La Belle Jardinière**
1507. Oil on wood, 122 x 80cm, Paris, Musée du Louvre

This Madonna combines Raphael's main sources of inspiration: the pyramidal composition, the Leonardesque landscape with softened sfumato, the Michelangelesque contrapposto of the Infant Jesus and the delicate shrub in the style of Perugino. Raphael has achieved a perfect expression of female beauty (the pure oval of the face and the sophisticated simplicity of the hairstyle) and the characters' gazes wonderfully convey their silent emotion. The figures are perfectly integrated into the landscape. His genius succeeded in combining intensity and grace; he was admired by the humanists of his time (including Ariosto) and, because of the long duration of his success, he enjoyed a unique position in the history of art: 'The painter most admired by teachers for his erudite composition (his sense of drawing and line) and his beautiful harmony, and also the most popular because simple souls see in his Madonnas the enhanced expression of their own feelings' (A M Brizio, 1966).

KEY WORKS
Raphael produced about 185 paintings, both canvases and frescoes.
The Coronation of the Virgin, 1502-3, Rome, Vatican
The Marriage of the Virgin, 1504, Milan, Brera
The Madonna of the Grand Duke, 1504, Florence, Pitti
La Belle Jardinière, 1507, Paris, Louvre
The Entombment of Christ, 1507, Rome, Borghese
Agnolo Doni, c.1505, Florence, Pitti
Cycle of the Signature Room, 1508-11, Rome, Vatican
The Madonna of Foligno, 1511-12, Rome, Vatican
Cycle of the Room of the Fire in the Borgo, 1514-17, Rome, Vatican
The Madonna of the Chair, 1514, Florence, Pitti
Baldassare Castiglione, c.1515, Paris, Louvre
The Holy Family, known as *The Great Holy Family of Francis I*, 1518, Paris, Louvre
Pope Leo X with Two Cardinals, 1518-19, Florence, Uffizi
The Transfiguration, 1519-20, Rome, Vatican

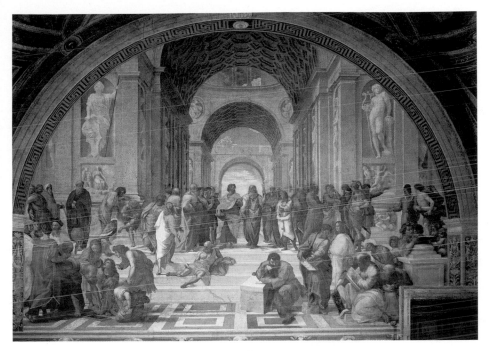

The School of Athens
1509–10. Fresco, base 7.70m, Rome, Vatican Palace, Signature Room

The scene is set in Athens – the centre of philosophy and a key reference for humanist culture – in an interior whose majestic Classical architecture is reminiscent of Bramante's design for St Peter's: perfect arcades beneath a coffered vault, walls punctuated with niches to accommodate antique sculptures and a central cupola pierced by windows. The allegorical figures of Philosophy and the Liberal Arts (Grammar, Rhetoric, Dialectic, Music, Arithmetic, Geometry and Astronomy) grouped together in this Platonic Academy, where there is much lively but friendly debate, are personified by Raphael's contemporaries. The painter has brought them to life and given them likenesses. Standing at the centre are Plato (left) and Aristotle (right). Holding their respective works, Timaeus and Ethics, they are turned towards the viewer, stressing their philosophical points with gestures. Ptolemy and Zoroaster are also present. One of the philosophers, who may have Leonardo's features, is sitting on the steps. In the foreground, on the left, Heraclitus has been given the imposing features of Michelangelo, drawing a figure on a slate with a compass. Perugino and Raphael are shown wearing round hats: white for Perugino and blue for Raphael. This assembly of artist-philosophers symbolizes humanist emulation and the spirit of the time.
So far as three-dimensionality is concerned, Raphael displays here a supreme confidence and freedom. The perfection of the scenic composition, the distribution of the groups in space and the balance of the picture with its alternation of immobile characters and characters in motion create an atmosphere of peaceful harmony, friendship and fulfilment. It illustrates the most Classical phase in Raphael's development, which is here close to the art of Leonardo da Vinci.

BIBLIOGRAPHY
Beck, J H, *Raphael*, Thames and Hudson, London, 1994; Joannides, P, *The Drawings of Raphael with a Complete Catalogue*, Phaidon, Oxford, 1983; Jones, R and Penny, N, *Raphael: 1483-1520*. Yale University Press, New Haven, CT and London, 1983; Trustees of the National Galleries of Scotland, *Raphael: The Pursuit of Perfection*, exhibition catalogue, National Galleries of Scotland Publications, Edinburgh, 1994; Vasari, G, *Lives of the Artists*, translated by G Bull, (2 vols), Penguin, Harmondsworth, 1996

Titian

Titian, a prolific artist with a fiery temperament, dominated Venetian painting in the 16th century. He moved from 'naturalist' representation to inner exaltation, through Classicism and then Mannerism. He is a painter of beauty, joy and drama who developed the use of brilliant colours enhanced by a confident, smooth technique.

LIFE AND CAREER

• The unusually long-lived Italian painter Titian, properly Tiziano Vecellio (Pieve di Cadore c.1488–Venice 1576), was the son of a notary. He started his artistic career in the workshop of Sebastiano Zuccato, then he joined Gentile Bellini's workshop before becoming the pupil of Giovanni *Bellini.

• In 1508 he and Giorgione, whom he admired, painted frescoes in the Fondaco dei Tedeschi in Venice. It is difficult to know whether to attribute some works to Giorgione (d.1510) or to Titian. This is particularly true of *Pastoral Symphony* (c.1508–10, Paris, Louvre) and the *Sleeping Venus* (c.1508–10, Dresden, Gg).

• Between 1508 and 1511, he distanced himself from his 'master' and the quattrocento to develop a naturalism, sense of space and use of colour which became the characteristic features of 16th-century Venetian art: *Pope Alexander VI Presenting Jacopo Pesaro to St Peter* (c.1508, Antwerp, B-A), *St Mark Surrounded by St Cosmas and St Damian, St Sebastian and St Rocco* (1510, Venice), the *Portrait of a Man*, known as *Ariosto* (1510, London, NG), and the fresco of the *Miracle of the Newborn Child* (1510–11, Padua) illustrate this development.

• After 1512, Titian's work expressed the Classical ideal of Renaissance beauty: *The Baptism of Christ* (c.1512, Rome, Doria), *Sacred and Profane Love* (c.1515, Rome) and *The Young Woman at Her Toilet* (1516, Paris, Louvre). Then his Classicism disappeared, giving way to the gusto of his masterpiece *The Assumption of the Virgin* (1518, Venice). At the same time, Titian painted mythological subjects for Alfonso I d'Este: *The Worship of Venus* and *The Bacchanal* (1518–19, Madrid, Prado). He also produced religious works: the *Gozzi Altarpiece* (1520–2, Ancona, MC), the *Averoldi Polyptych* (1520–2, Brescia, church of S Nazaro e Celso) and *The Entombment* (c.1523, Paris, Louvre). He married in 1525 and had two sons who both became painters.

• The *Pesaro Altarpiece* (1526, Venice) marked a new stage in compositional complexity with the scene being skilfully set off-centre. In about 1530, his art became calmer: *Madonna with the Rabbit* (1530, Paris, Louvre), *The Madonna and Child with the Young St John the Baptist and St Catherine* (c.1530, London) and *Woman in a Fur Coat* (c.1535–7, Vienna, KM).

• At the same time he was also painting pared-down portraits whose aim was to convey the psychological truth of the sitter: *Man with a Glove* (1523, Paris), *Portrait of Federigo Gonzaga* (c.1528, Madrid, Prado) and *Portrait of Pietro Aretino* (after 1527, Florence, Pitti). Aretino, the celebrated Italian poet, writer, pamphleteer and epicurean, respected and feared by the great, was Titian's friend and 'impresario' and observed the painter's developing Mannerism.

• From 1533 onwards, Titian's art spread throughout the courts of Europe. He painted sumptuous portraits of the ruling class in Ferrara, Rome (1545–6), Bologna (1530 and 1533), Spain, Augsburg (1548), etc: *Portrait of Charles V* (c.1532, Madrid, Prado), *Eleonora Gonzaga and Francesco Maria della Rovere* (1536, Florence, Uffizi) and *Francis I* (1538, Paris, Louvre). He stressed the concrete nature of reality in the *Presentation of the Virgin at the Temple* (1534–8, Venice, Ac) and the *Venus of Urbino* (1538, Florence).

• After 1540, he was attracted to the prevailing Mannerist style: *Christ Crowned with Thorns* (c.1543, Paris, Louvre) and the ceilings painted in the church of S Spirito (1542, Venice, Salute); *Portrait of Doge Andrea Gritti* (1540, Washington, NG) and *Ranuccio Farnese* (1541–2, Washington, NG); *Paul III and His Nephews* (1546, Naples) and the portraits of *Charles V* (one of them 1548, Madrid).

• In 1551, Titian settled in Venice. He painted self-portraits (after 1560, Berlin museums and 1570, Madrid, Prado), he decorated churches (S Spirito and the Church of the Jesuits) and he worked for Philip II of Spain. Bright colours bring life to *Venus Bandaging the Eyes of Cupid* (1560–2, Rome, Borghese) and *The Annunciation* (1566, Venice). Thick paint applied

with bold strokes can be seen in *The Martyrdom of St Laurence* (after 1557, Venice), *Christ Carrying the Cross* (c.1568, Madrid, Prado), *Judith* (c.1570, Detroit, IA) and *Tarquin and Lucretia* (after 1570, Vienna, Gg). A cold light emphasizes the suffering of the central figure of *St Sebastian* (1570, St Petersburg, Hermitage) and Marsyas in *The Flaying of Marsyas* (c.1575, Archbishop's Palace, Kromeriz, Czech Republic). Titian ended his artistic career with the *Pietà* (1576, Venice), a canvas he left unfinished when he died from the plague. It was completed by his disciple, Palma Giovane.

Although Palma Vecchio was influenced by Titian, and his collaborators Palma Giovane and the northern European painter Lambert Sustris continued the tradition of his art, the master had no real successor of enduring fame. Nevertheless his use of colours was strongly echoed by *Veronese, and by painters from *Rubens and *Velázquez in the 17th century to *Delacroix in the 19th century. He was also the inspiration for some of *Rembrandt's luminous effects.

APPROACH AND STYLE

Titian painted frescoes, canvases and panels of all sizes. The religious works were commissioned in particular by the clergy in Venice, Padua, Parma, Mantua and Ancona, while the mythological works and portraits were commissioned by the Italian princes in Mantua, Ferrara, Urbino and Rome. His patrons included the doges of Venice, the great rulers of Europe (Charles V, Philip II of Spain, Francis I of France) and the Roman popes and cardinals (Paul III, Cardinal Farnese).

He admired Giovanni Bellini and Giorgione in Venice and *Giotto in Padua. He was inspired by *Michelangelo in Rome, by the Venetian Mannerism of Vasari and by that of Giulio Romano in Mantua. He went on to develop new and personal forms of expression.

● His early works reveal fervour and an inclination to drama, expressed with a naturalism which still belonged to the 15th century. The formal elements were strongly rhythmic, in harmony with living nature. Titian broke new ground with his conception of space and colour. He painted his figures confidently with bold foreshortening and gave structure to his forms by a strictly controlled use of intense, contrasting colours. His psychological portraits are set on a single pictorial plane.
● At first inspired by Giorgione, Titian later developed his own majestic Classicism, moving towards a greater compositional equilibrium with a formal, sweeping, solemn rhythm. Humans (ideal female and mythological beauty, or happy, serene characters) are in close, lyrical harmony with the surrounding peaceful landscape. The tender, luminous colours of Giorgione were enriched by the purity of Giovanni Bellini.
● His art then developed towards an illusionistic naturalism that was lively and spirited. The new chromatic Classicism of bright colours applied with free, bold strokes was mainly inspired by Michelangelo. When dealing with themes from antiquity, Titian tended towards

A GREAT PAINTER

◆ Titian's success spread during his own lifetime from the Italian duchies to all the courts of Europe.
◆ Renaissance artist and 'promoter' of Venetian Classicism, Titian established the reign of colour and the great colourists.
◆ He transformed the concept of ideal beauty when he created the *Venus of Urbino*, which remained the model of the perfect nude throughout the history of painting. He created one of the first expressive nudes (*St Sebastian*). Female beauty, which had been idealized, became familiar and human. Titian revitalized mythological subjects, traditional subject matter (his last *Annunciation*) and the portrayal of subjects from antiquity.
◆ His models adopted new poses, non-traditional and sometimes casual (*Portrait of Pietro Aretino*).
◆ He introduced a hitherto unknown complexity to the technique of colour, which later became more restrained as his mastery of texture, materials and especially pigments grew.
◆ His disintegration of form through colour generates an almost palpable physical sensation of warmth

TITIAN

Dionysiac joy at the expense of the controlled Apollonian approach. He made his religious compositions richer, more imposing and more animated, intensifying the dramatic and mortal character of the human condition. He glorified female beauty, which he rendered in an intimate and 'familiar' way; his ideal of beauty became human reality. Yet his portraits could also stress elements of pomp and majesty.

• Between 1515 and 1542 he concentrated especially on colour technique: he superimposed many layers, thick or thin, then covered these with a final coat of varnish tinted with green, blue or red. By finely grinding pigments he obtained a new chromatic range whose transparency he made use of; the colour of the deeper layers was different from that perceived by the eye on the surface of the canvas. After 1542 Titian took a more sober approach to his art; he used fewer pigments but increased the number of layers (up to 15 for rare pink hues). He often applied the last layer with his finger rather than a brush.

• After his stay in Rome, the artist was attracted by the restlessness of Mannerism and developed a taste for strong colours and elongated forms. He abandoned the pleasing subjects of mythology and female sensuality of his mature works in favour of dramatic, morbid themes, the deeper values of humanity and the passions. The formal tension and the contrast of the colours were reflected in a violent, turbulent style. Colour deconstructed his paintings in a wavelike movement. The flow of radiant, golden, reddish or whitish paint conveyed movement to the figures. He reserved warm colours for passion and cold colours for suffering. His portraits captured the truth of the sitter's character in all its rawness.

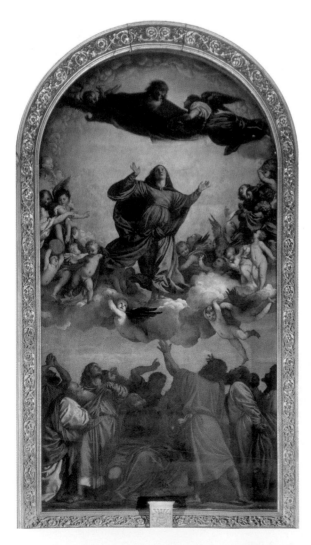

The Assumption of the Virgin
1518. Oil on wood, 6.90 x 3.60m,
Venice, Santa Maria dei Frari

*This monumental altarpiece illustrates the new art developed by Titian. As a result it was received by his patrons, the Frari, and by writers and painters as a revolutionary work which aroused both reservations and admiration. It shows Titian's break with Giorgione's gentleness and colour schemes. It also reveals his understanding of the Classicism of Michelangelo, from whom Titian has borrowed the figure of God the Father, and of the Classicism of *Raphael, who was the inspiration for the pyramidal composition. Titian has abandoned the Classical perfection of unity of perspective, instead linking the three superimposed planes through an unusual effect of light. Dressed in blue and red, the Virgin is an active figure, rising towards God. The apostles, portrayed naturalistically, are counterbalanced by the angels and cupids, who are bathed in luminous colours and radiating a remarkable dramatic power. The forms of the characters – seen face on, from behind or in three-quarter view – are lively, animated and spirited, showing a new ease and suppleness and perfect foreshortening. They are endowed with a chromatic harmony which is present in both earthly and celestial worlds.*

Man with a Glove
c.1523. Oil on canvas, 100 x 89cm, Paris, Musée du Louvre

This early work gives a foretaste of the characteristics which would make Titian's 'informal' portraits famous. The artist has painted the subject half-length and in three-quarter profile, with his arm resting casually on a marble support. With his elegant but noble appearance, he fills the picture space, close to the viewer and yet detached. The dark background and black garments allow Titian to emphasize the young man's physical characteristics: the translucency of the skin of his face, the beginnings of a moustache and beard, and the hands 'with the skin raised by the tendons and marked by blue veins' (L Hourticq, 1919). The luminosity of the ruff illuminates his face in the same way that his cuffs illuminate his hands. This technique had been developed by the artist to highlight the psychology and bearing of the sitters. A few coloured details such as the sapphire and pearl medallion, the gold ring with the coat of arms and the turned-back glove made of fine leather (all signs of a typically humanist elegance) soften the ostentatious austerity of this young aristocrat. Although the face still appears dreamy in the manner of Giorgione, the hands placed in the foreground in the Florentine manner of Leonardo are expressive; one hand is probably pointing towards the portrait which would be the pendant to this one, that of a fiancée or a wife, while the other hand hangs down casually. The pre-Romantic portraits of the late 18th century were influenced by this painting.

KEY WORKS

Titian painted several hundred canvases and panels and numerous frescoes.
St Mark Surrounded by St Cosmas and St Damian, St Sebastian and St Rocco, 1510, Venice, Salute
Miracle of the Newborn Child, 1510–11, Padua, frescoes of the Scuola del Santo
Portrait of a Man, 1511, London, NG
Sacred and Profane Love, c.1515, Rome, Borghese
The Assumption of the Virgin, 1518, Venice, S Maria dei Frari
Man with a Glove, c.1523, Paris, Louvre
Pesaro Altarpiece, 1526, Venice, S Maria dei Frari
The Madonna and Child with the Young St John the Baptist and St Catherine, c.1530, London, NG
Venus of Urbino, 1538, Florence, Uffizi
Paul III and His Nephews, 1546, Naples, Capodimonte
Portrait of Charles V, 1548, Madrid, Prado
The Martyrdom of St Laurence, after 1557, Venice, Church of the Jesuits
The Annunciation, 1566, Venice, church of S Salvatore
St Sebastian, 1570, St Petersburg, Hermitage
Self-Portrait, 1570, Madrid, Prado
Pietà, 1576, Venice, Ac

BIBLIOGRAPHY

Crowe, J A and Cavalcaselle, G B, *Life and Times of Titian*, 2nd edn, John Murray, London, 1881; Gronau, G, *Titian*, translated by Alice M Todd, Charles Scribner's Sons, New York, 1904; Hope, C, *Titian*, Jupiter Books, London, 1980; Panofsky, E, *Problems in Titian: Mostly Iconographic*, Phaidon, London, 1969; Rosand, D (ed), *Titian: His World and His Legacy*, Columbia University Press, New York, 1982; Wethey, H E, *The Paintings of Titian*, 3 vols, Phaidon, London, 1969-75

Lotto

Lotto, a mystic Venetian painter, was an anxious, solitary man. A 'provincial nomad', poor and independent, this individual, inventive narrative painter conceived of each painting as an original work. He moved away from the prevailing sensual, serene style of Venetian Classicism. Lotto introduced 'temperamental painting' (G Bazin) to Venice – a style which distanced itself from the art of Titian.

LIFE AND CAREER

- Lorenzo Lotto (Venice c.1480–Loreto 1556/7) was a contemporary of *Titian and suffered from his dominance of Venetian art. As a result Lotto lived and painted mainly in the Veneto, the Marches and Bergamo. Nothing is known of his training but he may have been taught by Giovanni *Bellini or Alvise Vivarini. He found his artistic inspiration in numerous sources: northern European, Venetian, Florentine and Roman.
- Between 1498 and 1508 he lived in Treviso, where he painted realistic works: *The Virgin and Child with St John the Baptist and St Peter Martyr* (1503, Naples, Capodimonte), *Portrait of Bishop Bernardo de' Rossi* (1505, Naples, Capodimonte), *A Young Man with a Lamp* (1506–8, Vienna, KM) and the *Allegory of Virtue and Vice* (1505, London, NG). He also produced his first monumental altar paintings, which were original in concept: *The Virgin and Child with Saints* (1505, Treviso, church of S Cristina al Tiverone), *The Assumption* (1506, Treviso, Asolo Cathedral) and his first *St Jerome* (1506, Paris).
- After living in the Marches, then in Rome in 1508 (the Vatican frescoes are lost), he developed a very personal language, as expressed in *The Virgin and Child with Saints* (1508, Rome, Borghese).
- His talent came to fruition in Bergamo between 1513 and 1526 in a series of paintings with very varied treatments: *The Transfiguration* (1510–2, Recanati, Pinacoteca), *The Deposition* (1512, Jesi, Pinacoteca) and *The Entombment* (1516, Bergamo, Ac Carrara), marked by a northern pathos which contrasts with the Raphaelesque gentleness of his *Madonna* (1518, Dresden, Gg). Lotto then went through a serene, poetic period which inspired him to paint *Susanna and the Elders* (1517, Florence, Uffizi); his most beautiful altar paintings, which include *The Virgin and Child with Saints* (1521, church of S Bernardino in Pignolo) and *The Virgin and Child with St Jerome and St Nicholas of Tolentino* (1523–4, Boston, MFA); *St Catherine of Alexandria* (1522, Washington, NG); and *The Mystic Marriage of St Catherine* (1523, Bergamo). His portraits of that period were realistic and sensitive: *Giovanni Agostino della Torre and His Son, Niccolo* (1515, London, NG) and *Portrait of Messer Marsilio and His Wife* (1523, Madrid). This period came to a close with the frescoes he painted in the Suardi Chapel (1523–5, Trescore).
- Back in Venice in around 1526, he produced works for the churches in the Marches: the designs for the marquetry in the church of S Maria Maggiore (1524–32, Bergamo), paintings for the churches of Ponteranica and Celana, and *Christ Carrying the Cross* (1526, Paris, Louvre). He revealed his great originality in *St Nicholas of Bari in Glory* (1529, Venice).
- In around 1530, Lotto was based in the Marches. He introduced further innovations in the *Crucifixion* (1531, Ferno, church of Monte S Giusto), *St Lucy Before the Judge* (1532, Jesi, Pinacoteca), *The Adoration of the Shepherds* (1534, Recanati, Pinacoteca), *The Annunciation* (1534–5, Recanati) and *The Holy Family* (1536–7, Paris). As a portrait painter he demonstrated his psychological acuteness, aesthetic sense and knowledge of symbolism and allegories by including in the pictures objects which personalized or defined his models: *Portrait of Andrea Odoni* (1527, London), *Portrait of a Young Man* (1530, Venice, Ac), *Portrait of Lucrezia Valier* (1533, London) and *Portrait of a Gentleman* (1535, Rome, Borghese).
- In the last 20 years of his life, the tension present in his art reflected financial worries, the unreliability of commissions and his restless wanderings: *The Madonna of the Rosary* (Venice, church of S Domenico), and *The Distribution of the Alms of St Francis* (1542, Venice, church of S Giovanni e Paolo). In Treviso from 1542 to 1545, then in Venice from 1545 to 1549, he finally found inspiration in Titian, a source which his youth had led him to reject in the past: *Gentleman with Gloves* (1542–3, Milan, Brera); portraits of Febo da Brescia (1543–4, Milan, Brera) and Laura da Pola (1543–4, Milan, Brera); *Portrait of Fra Gregorio Belo* (1547, New York); and *Madonna and Saints* (?, Venice, S Maria della Piazza).
- Worn out, Lotto settled in Loreto in 1549 and became an oblate: that is, he joined the religious community of the Sacra Casa, following the rules without taking his vows and

making over to them his goods and pictures. He produced many more paintings, including *The Presentation at the Temple* (1552–6, Loreto), his last work.

Lotto died completely forgotten. He had no successors and no obvious influence on other artists.

APPROACH AND STYLE

A painter of religious works, altarpieces, devotional paintings, frescoes and portraits, Lotto painted few mythological subjects. He preferred themes such as the Madonna and saints, the mystic marriage of St Catherine, and St Jerome. He painted with oils on wood and canvas, or in fresco, producing works of various sizes. He received commissions from both churches and private patrons.

Lotto was influenced by many artists. He borrowed the expressive, spirited, sharp style of *Dürer, *Bosch and the portrait painter *Holbein the Younger; the colours, light and Venetian Classicism of Giovanni Bellini, Antonello da Messina and Palma Vecchio; the Florentine line of *Botticelli; the Classical serenity of *Raphael and Fra Bartolommeo; the Roman, Classical, Mannerist, formal style of *Michelangelo and Raphael during his Stanze phase; and the Emilian gentleness and Baroque of *Correggio.

● His early works reveal influences from various sources: Germanic and Dutch art, reflected in his deliberate, formal and stylistic archaism, and the art of the great Venetians of the 15th century, seen in his choice of colours very different from the mellow, tonal art of Giorgione or Titian. But Lotto's paintings also reveal a forceful personal idiom (*The Virgin and Child with Saints*, 1505). His first portraits established a link between the physical appearance and personality of his models; they reflect a natural and sincere psychological realism, pre-Caravaggesque in style and with a delicacy typical of Bellini (*Portrait of Bishop Bernardo de' Rossi*).

● His art developed after he became acquainted with the work of Raphael in Rome and, when he was in Bergamo, with the work of the Lombard artists, Vincenzo Foppa, Borgognone and *Leonardo da Vinci as well as the followers of Giorgione, Palma Vecchio and Cariani. Symbolic (sometimes to the point of impenetrability), seductive and inventive,

A GREAT PAINTER

◆ Misunderstood during his lifetime, Lotto was nevertheless a success among a select circle of enlightened enthusiasts. He sank into oblivion until 1895, when he was rediscovered by the art historian Bernard Berenson. He obtained real recognition in 1998 with an exhibition of his work at the Grand Palais in Paris.

◆ A man of the Renaissance, complex, unclassifiable, a Venetian painter on the margins of Classicism, he was neither a true Mannerist nor a real Baroque artist; his art was unlike any other. Although Italian, he had deep affinities with German art.

◆ Lotto's talent as an inventive narrator is apparent in every painting. He interpreted religious subject matter with boldness and even 'irreverence' (G Bazin): for example, the heavily symbolic presence of the wrathful cat in *The Annunciation*; a modern narrative in *The Holy Family with Three Angels*; and a moving reticence and bitterness in the *Portrait of Fra Gregorio Belo* with the Crucifixion in the background.

◆ He refined his portrait painting by concentrating on both the physical and psychological aspects of the sitter. He developed a humorous approach with hidden allusions: in the *Double Portrait*, faithfulness after death is represented by a squirrel, a symbol of oblivion, opposite a little dog, a symbol of fidelity. The name of sitters was only revealed to people in the know; this is the case with Lucina Brembate – the family coat of arms is shown on the ring and 'Lucina' is indicated by the syllable 'ci' on the crescent of the moon (*luna*).

◆ He also introduced the undomesticated, 'romantic' Venetian landscape.

◆ His techniques were varied: refined, polished oil painting, but also gouache and fresco paint laid down quickly with a 'pre-Impressionist' sensitivity. Lotto mixed pure colours with a Mannerist and Venetian palette.

◆ Often unusual and unconventional in size (square or wider than their height), his paintings use complex, innovative compositions – incorporating features such as an unstable diagonal, a canopy raised above the Virgin or a cupola open to the sky – which combine Mannerist aesthetics, Baroque dynamism and renascent Classicism.

his work emanated a very personal serenity and poetry, uninfluenced by antiquity. His altar paintings were now larger, with lively, connected arabesques; they now told a narrative, employing a sense of humour and a 'naturalism' which anticipated *Caravaggio (*A Woman Taken in Adultery*). Lotto sometimes even achieved a pre-Baroque dynamism in the gestures and expressions of his figures (*The Transfiguration*). His colours were resonant, luminous and sumptuous, his technique elegant and his settings intimate and soft, like those of Correggio (*Virgin and Child with Saints*, 1521).

• Having settled in Venice, he established a style that was all his own: great expressiveness, unusual compositions, a bold choice of subject matter and a use of colours which were sometimes Mannerist, acid and atonal, and sometimes soft and refined (rugs, jewellery, drapery), with a delicate light illuminating wild landscapes.

• His portraits display unparalleled psychological subtlety and a perfectly balanced style. They are reminiscent of those of Holbein the Younger and the Venetian Giovanni Battista Moroni (*Portrait of a Young Man*). In his later portraits his sitters are more animated, displaying emblematic objects (such as compass and plans, globe, book or engraving) or presented in an unbalanced composition in an unusual format (*Portrait of Lucrezia Valier*) which prefigures 17th-century painting. Lotto developed a personal style which was neither truly Titianesque nor Mannerist.

• Back in the Marches, he produced paintings in a rich range of colours with striking lighting effects (*The Annunciation*). The works painted during his last, very pious, period reflect his anguished state of mind: melancholy altarpieces and portraits with subtle blended colours, sumptuously painted (*Portrait of Febo da Brescia*). His last religious painting – classic composition, restricted range of dull colours and 'tachist', blurred strokes – revealed a new style, modern and unconventional as always (*The Presentation at the Temple*).

The Mystic Marriage of St Catherine
1523. Oil on canvas, 1.89 x 1.34m, Bergamo, Accademia Carrara

Lotto painted the theme of St Catherine several times. This particular canvas was commissioned for Niccolo Bonghi in Bergamo. It shows Lotto's unusual, albeit Venetian, style and his taste for combining the religious and the everyday. The scene is set against a dark, neutral background. Behind the Virgin, seated in an unusual pose on a Gothic chair, is Niccolo Bonghi. His realistic, stern features in the style of Holbein the Younger contrast with the beauty of the other faces, mystic and pleasant, reminiscent of Raphael and Umbrian art. The subtlety of the shades, the sophisticated realism of the details and the sumptuousness of the fabrics and jewellery run counter to the Mannerist style. The archaic rigidity of the patron contrasts with the Baroque gestures, the lively expressions and the flowing drapery.

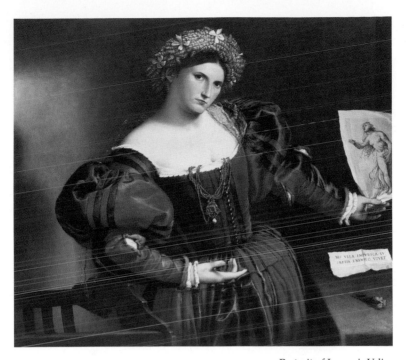

Portrait of Lucrezia Valier
1533. Oil on canvas, 9.59 x 1.10m, London, National Gallery

This portrait is thought to be that of Lucrezia Valier on the occasion of her marriage. She is shown in a diagonal, unbalanced posture on a canvas which is wider than it is long – a format unknown in Venice at the time. The painting includes three symbolic elements: a drawing of the Roman heroine Lucretia committing suicide (an episode narrated by Livy), a sheet of paper on which is written 'That, by following Lucretia's example, no woman may survive her dishonour' and a wallflower, a symbol of fidelity. Although out of place in a marriage scene, these moralizing historical elements show the young wife off to her best advantage. Lucrezia appeals to the viewer with a shy gesture, and her lively, sincere and melancholic eyes seem to ask for the viewer's judgement on the matter in question. The magnificence of her moiré dress with its sumptuous colours contrasts with the dark, sober colours used for men, while her sparkling jewellery and her exquisite, sensual, transparent veil reflect the influence of the Venetian art of colour. The gravity of the subject, the simplicity of the face and her realistic expression contrast with the sensuality and elegance of this virtuous, faithful woman.

KEY WORKS
Lotto painted about one hundred works.
Portrait of Bishop Bernardo de' Rossi, 1505, Naples, Capodimonte
St Jerome, 1506, Paris, Louvre
Giovanni Agostino della Torre and His Son, Niccolo, 1515, London, NG
The Virgin and Child with Saints, 1521, Bergamo, church of S Bernardino in Pignolo
The Mystic Marriage of St Catherine, 1523, Bergamo, Ac Carrara
Portrait of Messer Marsilio and His Wife, 1523, Madrid, Prado
Portrait of Andrea Odoni, 1527, London, Hampton Court
St Nicholas of Bari in Glory, 1529, Venice, church of the Carmini
The Annunciation, 1534–5, Recanati, Pinacoteca
The Holy Family, 1536–7, Paris, Louvre
Portrait of Lucrezia Valier, 1533, London, NG
Portrait of Fra Gregorio Belo, 1547, New York, MM
The Presentation at the Temple, 1552–6, Loreto, Palazzo Apostolico

BIBLIOGRAPHY
Berenson, B, *Lorenzo Lotto*, 3rd edn, Phaidon, London, 1956; Brown, D A, Humfrey, P, and Lucco, M, *Lorenzo Lotto, Rediscovered Master of the Renaissance*, Yale University Press, New Haven, CT and London, 1997; Humfrey, P, *Lorenzo Lotto*, Yale University Press, New Haven, CT and London, 1997

Correggio

A forerunner of the Baroque a century before its birth, Correggio was a 'provincial', solitary painter who evolved from a revived Classicism to a pre-Baroque style which he made his own through his mastery of space, his grasp of asymmetric composition seen from below, and his motifs, forms, colours and light.

LIFE AND CAREER

• Very little is known of Correggio, properly Antonio Allegri da Correggio (Correggio, near Parma, 1489?–Correggio 1534), an Italian artist from Emilia. He started painting in his native town and in Mantua, where he was subject to many influences. Through him Parma became a Renaissance and then a pre-Baroque city. His first subjects were the *Evangelists* (1507, Mantua, church of S Andrea) and the *Mystic Marriage of St Catherine* (1509, Washington, NG), works inspired by Mantegna.

• His paintings soon became more gentle, as for example *The Madonna and Child in Glory with Angels* (1508–10, Florence, Uffizi). He painted nocturnal, Mannerist scenes, including the *Nativity* (1512, Milan, Brera), then larger, more tender paintings – inspired by Dosso Dossi who was in Mantua in 1512, and by Lorenzo Costa and Ercole de' Roberti – such as *The Madonna with St Francis* (1514, Dresden). Correggio revealed himself as a 'Classical' painter with *The Campori Madonna* (1517–18, Modena) and *The Rest on the Flight into Egypt* (?, Florence, Uffizi). His *Madonna and Child with the Young St John* (c.1517, Milan) has a Leonardo-like sensitivity, but he was also a Mannerist, as can be seen in his more animated, brightly coloured paintings reminiscent of the Sienese artist Beccafumi: *The Adoration of the Magi* (1516–18, Milan), *Noli me tangere* ('Do not touch me', the words uttered by the risen Christ to Mary Magdalene; 1518, Madrid, Prado), and the *Holy Families*, such as the one in Orléans (1517, B-A).

• Influenced by his stay in Rome in 1517–19, he adopted the style of *Raphael and *Michelangelo for the paintings commissioned by the Abbess Giovanna da Piacenza in Parma, the allegorical frescoes in the refectory of the Benedictine convent of S Paolo (1519, Parma). These are set in oval compartments, where they are embellished with cherubs, in lunettes (figures painted in grisaille) and on the cupola (*Diana in a Chariot*). In the church of S Giovanni Evangelista, the fresco (1520–3) of the cupola depicts the vision of St John the Evangelist in Patmos. This octagonal cupola and its pendentives anticipate the Baroque style, which is also found in some paintings such as *The Deposition* and *The Martyrdom of Two Saints* (1524–6, Parma). Correggio went on to produce further masterpieces, some of them with a Classical approach: *The Virgin Adoring the Child* (1524–6, Florence, Uffizi), *The Madonna of the Basket* (1525–6, London, NG), *The Education of Cupid* (1528, London, NG), *The Madonna and St Sebastian* (1525–6, Dresden, Gg), *The Mystic Marriage of St Catherine* (1526–7, Paris) and *Jupiter and Antiope* (1528, Paris).

• His third cupola decoration reflects the ferment of the Catholic Reformation and the Baroque, which he introduced pictorially in *The Assumption of the Virgin* and *The Four Saints* (1526–9, Parma Cathedral). Employing a similar aesthetic approach, he painted *The Madonna of the Bowl* (1530, Parma), *The Day* (1527–8, Parma), *The Adoration of the Shepherds*, known as *The Holy Night* (1529–30, Dresden, Gg), and *The Madonna with St George* (1531–2, Dresden, Gg).

• In around 1530, Correggio was in the service of Frederick II Gonzaga; his works from this period are mythological and allegorical: *The Allegory of Vice* and *The Allegory of Virtue* (c.1529–30, Paris, Louvre). Some

paintings seem to reflect a desire to annihilate matter itself: *Danae* (c.1530, Rome, Borghese) and, even more so, *Jupiter and Io* (c.1531, Vienna), in which Jupiter, a cloud in the shape of an evanescent human figure, without outlines, embraces Io who is real, voluptuous and sensual.

Correggio was admired for his Classicism and personal style by the Mannerists, his pupil Parmigianino and Primaticcio, and for his Baroque flights of fancy by the later great Baroque artists, Giovanni Lanfranco, Andrea Pozzo, *Pietro da Cortona, Baciccia, Luca Giordano and others. Inspired by the Florentine artists of the early 16th century, Fra Bartolommeo and Andrea del Sarto, he influenced them in turn. He also became a source of inspiration for the great colourists of the following centuries.

APPROACH AND STYLE

Correggio produced oil paintings on wood and canvas, frescoes (for cupolas) and tempera paintings. He painted religious, allegorical and mythological subjects and portraits. His patrons were the clergy and the ruling class, including Charles V and the d'Este and Gonzaga families of Mantua.

• His early works were influenced by the art of Mantegna, the Lombard painter from Mantua, in their perspective, lightness of drawing and balanced rhythm. Correggio was acquainted with the Italian Mannerists: the fantastic, sweeping landscapes of the Ferrara artist Dosso Dossi; the imaginativeness of the firm, subtle style and sophisticated, almost Flemish execution of Ercole de' Roberti, also from Ferrara; the refined, vibrant luminarism of the Sienese painter Beccafumi; and the Classical, original, troubled gentleness of Lorenzo Costa and Amico Aspertini, who were based in Bologna.

• He produced dynamic compositions in vibrant colours with numerous Virgins or Madonnas inspired by Raphael, Andrea del Sarto and Fra Bartolommeo. He copied *Leonardo's technique of *sfumato*, which, used more diffusely, blurred the outlines and gave his figures a gentle sweetness which was all his own. He adopted the tonal colours of the Venetians, in particular the pictorial texture developed by *Titian.

• In his mature period, he acquired the noble, naturalistic style, balanced composition, transparent shadows and fluidity of drawing of Raphael and *Leonardo. From Michelangelo he took his sculptural approach and strength of drawing as well as the use of trompe l'œil, grisaille and virtuosic perspectives. He was very familiar with antiquity and mythology. His first cupola had a Classical subject and a very structured,

A GREAT PAINTER

◆ Greatly admired in Italy in his own lifetime and throughout Europe during the following centuries, Correggio nevertheless remained little known.
◆ He was a master of Renaissance Classicism before turning to Mannerism. But, being a great innovator, he changed its rules and heralded the arrival of Baroque a century in advance.
◆ He developed a scholarly range of subjects with antique and mythological themes.
◆ When painting frescoes, he abandoned the pouncing method in favour of squaring up the drawing, applying tempera hatching on the fresco layer, then working on the dried paint to harmonize the colours.
◆ Correggio's compositions were based on asymmetry. He created the first ever composition seen from below (known as *da sotto in sù*) in 1521.
◆ He developed a very personal *sfumato* and an original colour range, in which warm and cool colours were contrasted. In addition, he scattered patches of cold light over his figures.

symmetrical composition expressed in tonal colours and monochrome shades.

• In his next cupola he abandoned this rigorous architectural organization in favour of spatial freedom. Correggio created a pre-Baroque type of composition seen from below (*da sotto in sù*), which revealed his profound knowledge of the human body and perspective.

• His third cupola represents the culmination of his artistic research and the beginning of Baroque aesthetics, reflected in the skilful concentration of immaterial bodies, foreshortened and projected into an infinite, circular, vertiginous, destructured space, as if caught by an upward, concentric movement.

• Some of his paintings echo the Baroque spirit of his frescoes. Their composition is off-centre, oblique or circular, animated by figures in motion portrayed by undulating lines, bright contrasting colours and patches of bright light. The feelings expressed sometimes appear intense and moving.

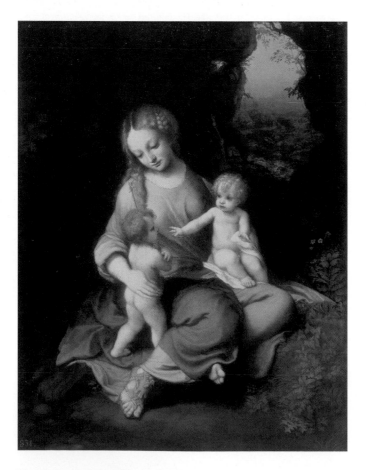

The Madonna and Child with the Young St John
c.1516. Oil on wood transferred to canvas, 48 x 37cm, Madrid, Prado

The painting is Classical in its subject matter, pyramidal composition and integration of the figures into the landscape, fitting into the tradition of the Madonnas portrayed by Leonardo, Raphael and his pupils. The fluid forms, hazy outlines and refined choice of tonal colours harmonize with the light, ethereal, bluish landscape inspired by Dosso Dossi and Leonardo. The Virgin displays a tender sweetness, conveyed by her half-smile and her face, which is delicately surrounded by a Leonardo-like sfumato as modified by Correggio.

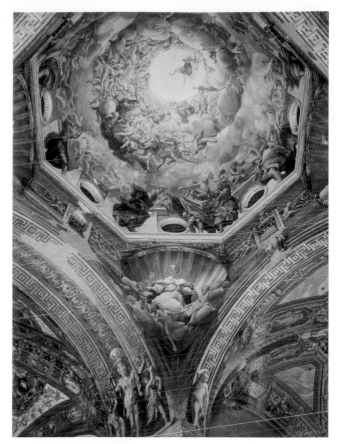

The Assumption of the Virgin
1526–9. Frescoes, diameter 11m approx, cupola of Parma Cathedral

This masterpiece reveals the pre-Baroque genius of Correggio, who developed his own style after 1520. He created an illusionistic work, completely open to the sky, with a vertiginous, limitless spatiality and simulating an empty space of infinite height. With its perspective 'seen from below' and its off-centred, 'destructured' composition (in contrast to the central axis taken for granted by Classicism) this is a Baroque flight of fancy. The colourful, almost abstract swirl of post-Michelangelesque angels, moving with a joyous, ethereal lightness, surrounds the Virgin in several concentric, rhythmically ascending circles. The figures shrouded in clouds and colour are caught in an idealized, symbolic light. They give the impression of 'breaking through' the material space and of being 'sucked up' into the divine one.

KEY WORKS
Correggio painted about a hundred known works.
The Madonna with St Francis, 1514, Dresden, Gg
The Campori Madonna, 1517–18, Modena, G Estense
The Madonna with the Young St John, c.1517, Milan, Castello Sforzesco
The Adoration of the Magi, 1516–8, Milan, Brera
Vision of St John the Evangelist, 1520–3, Parma, church of S Giovanni Evangelista
The Deposition, 1524–6, Parma, GN
The Mystic Marriage of St Catherine, 1526–7, Paris, Louvre
The Assumption of the Virgin, 1526–9, Parma Cathedral
The Madonna of the Bowl, 1530, Parma, GN
The Adoration of the Shepherds, known as *The Holy Night*, 1529–30, Dresden, Gg
Jupiter and Io, c.1531, Vienna, KM

BIBLIOGRAPHY
Brown, D A, *The Young Correggio and His Leonardesque Sources*, Taylor and Francis, New York and London, 1981; DeGrazia, D (ed), *Correggio and his Legacy*, exhibition catalogue, National Gallery of Art, Washington, DC, 1984; Gould, C, *The Paintings of Correggio*, Faber, London, 1970; Quintavalle, A C, *Correggio: Opera completa*, Rizzoli, Milan, 1970; *The Age of Correggio and the Carracci*, exhibition catalogue, National Gallery of Art, Washington, DC, 1986

Pontormo

Pontormo, the greatest of the Florentine Mannerist painters, developed a tense, strange anti-Classical style, which portrayed images of an anxious humanity confronted with dramatic situations. His innovations included drawing with greater freedom and setting his compositions in an unreal, non-existent space. He endowed his figures with great sculptural strength, which contrasted with the mannered, stylized details. Dramatic tension can be seen in the poses of the characters and the wild expressions on their faces, the tension being reinforced by cold, acid colours and an arbitrary, icy light.

LIFE AND CAREER

• Jacopo Carruci, known as Jacopo da Pontormo (Pontormo 1495–Florence 1556), was an Italian painter, who worked in Florence throughout his life. He spent time in the workshops of *Leonardo da Vinci, Piero di Cosimo, Albertinelli and most importantly Andrea del Sarto, between 1512 and 1514. While still very young he took part in collective projects for Pope Leo X and became the Medici family's painter in Florence.

• His first Florentine frescoes and paintings were reminiscent of the art of his master Andrea del Sarto, the Classicism of Fra Bartolommeo and the *tondo* of *Michelangelo: this can be seen in The Visitation, also known as the Holy Conversation (1514–16, church of S Annunziata), and St Veronica (1515, church of S Maria Novella). He began to find his personal style with Joseph in Egypt (1515, London) and the frescoes Vertumnus and Pomona (1519–20, Poggio a Caiano), the only Mannerist work he produced that displayed fantasy and happiness. The solemn portrait of Cosimo the Elder, father of Lorenzo the Magnificent (1519, Florence, Uffizi), conveys a feeling of anxiety through the look in his eyes.

• In about 1520, after the death of *Raphael and Michelangelo's departure for Rome, Pontormo became one of the most important artists in Florence. In 1521 Leo X died, the Catholic Reformation began and the artist's paintings lost their serenity, as is evident in the frescoes of the Passion of Christ (1523, Galluzzo), inspired by *Dürer, and The Supper at Emmaus (1525, Florence). Figures, rhythm, colours and composition were completely transformed. Classicism was replaced by an original, tense Mannerism which reached its culmination in the altar painting The Deposition (1526, church of S Felicità) and The Visitation (1528–9, church of Carmignano).

• As a portrait painter, he also adopted the Florentine Mannerist style in Portrait of a Young Man, possibly Alexander de' Medici (c.1525–7, Lucca), Portrait of a Halberdier (c.1527–8, Los Angeles, Getty Museum) and The Lady with a Lap-Dog (?, Frankfurt, SK).

• Pontormo was already acquainted with Michelangelo's drawings before leaving for Rome in about 1539. There he discovered the Sistine Chapel, whose dramatic force would influence his works during the last 15 years of his life: his paintings, his cartoons for tapestries (1545–9, Rome, Quirinale) and the frescoes of San Lorenzo – now lost but known through drawings – on which he worked from 1546 for the last ten years of his life. His diary, which he wrote between 1555 and 1556, describes the life and career of this solitary painter away from the mainstream, his moving spiritual agitation and his intuitive hypersensitivity.

Pontormo was a very productive painter and draughtsman. As well as producing sketches for his paintings, Pontormo also made drawings for

their own sake, a completely new phenomenon which reflected his freedom and the pleasure he derived from drawing. Some imitators and in particular his pupil, the portrait painter Bronzino, continued the 'Florentine style'.

APPROACH AND STYLE

Pontormo produced mainly commissions for religious patrons, large-scale works and portraits; only one mythological subject by him is known. He painted decorative frescoes for the villas of Ottavio de' Medici, Pope Leo X, Alexander de' Medici, Duke Cosimo de' Medici and others. Canvases and altar paintings on wood were commissioned by the Carthusian monks of Galluzzo and the clergy. His portraits were mainly of the Medici family.

Based in Florence, Pontormo was originally inspired by the 'elder statesmen' of the Renaissance but then grew away from them. He retained the sense of beauty and expressiveness of Florentine drawing, the engravings of Dürer, the legacy of Leonardo da Vinci and Raphael, and the Roman Mannerism of Michelangelo.

• At first he imitated the narrative style of Andrea del Sarto with his well-structured rhythms and colour, but without his muted shades. He was influenced by Fra Bartolommeo and the triangular harmony of Classicism, but he shifted the axis of symmetry, thus undermining the ideal of equilibrium while at the same time preserving the circular unity of the figures and the light.

• A few years later he abandoned traditional Classical composition and adopted the taut, dramatic facial expressions of Michelangelo's figures. At the same time he painted serene, idyllic scenes with realistic, monumental figures, displaying the beauty and decorative drawing of Florentine art, without depth or space, in light, unusual colours (*Vertumnus and Pomona*). The portraits of this period reflect the angular style and psychological sensitivity of northern artists, particularly Dürer (*Cosimo the Elder*).

• The year 1523 marked a decisive change in his style when Pontormo broke free from Classicism. His compositions (Passion frescoes at the Charterhouse of Galluzzo) became dense and sophisticated, filled with numerous, tense figures drawn in an elongated, exaggerated, serpentine line and hanging motionless in a non-existent space. The harsh colouring, clear and light, is full of contrasts: pink is emphasized by a green shadow, and red by violet or white reflections. His work became increasingly Mannerist, traditional religious themes being reinvented so as to deepen their meaning; for instance, he rejected the traditional composition used for the Holy Conversation. Edifying subjects were replaced by dramatic evocations (*The Deposition* no longer showed the cross) which moved and disturbed the viewer. In an unreal space, the sculptural, three-dimensional power of the unstable, troubled, sorrowful figures stands out against the contradictory rhythms of the spiralling

A GREAT PAINTER

◆ Pontormo's talent was not recognized during his lifetime. The 17th and 18th centuries did not understand his art and rejected its originality. He sank into oblivion until the beginning of the 20th century.

◆ The greatest Florentine Mannerist, Pontormo broke completely with Renaissance Classicism. His highly graphic technique, however, belonged to the Florentine tradition.

◆ He reinterpreted some religious themes, such as the Deposition, in a very original manner.

◆ He developed a new three-dimensional interpretation of religious subject matter: dramatization of gesture; *cangianti*; light, clashing colours; and icy, arbitrary lighting.

composition. The somewhat inexpressive faces convey a dramatic tension with their sombre, wild, melancholic look. The flesh and fabrics are treated subtly by means of colour transitions – *cangianti* – between iridescent, pale, acid and lurid colours (mauve is next to orange and sea green), washed out by a cold light which gives harsh outlines to the forms. The careful stylization of the details, such as the blond curls and carefully trimmed beards, reflect the artist's illusionistic, smooth, almost 'enamelled' style.

• This psychological portrayal of religious figures was repeated in his solemn portraits, which are dominated by elegance of form, haughty poses and the power of the Florentine line (*The Lady with a Lap-Dog*).

• His increasingly unreal religious art achieved its ultimate, desperate expression in his strange, feverish drawings, filled with clusters of contorted, entwined bodies.

The Deposition
1526. Oil on wood, 3.13 x 1.92m, Florence, church of Santa Felicità

This altar painting combines the influences of northern European, Florentine and Roman art: expressiveness is achieved by the intensification of Dürer's graphic style, the sculptural quality of Michelangelo's bodies and even a reference to the latter's Bacchus in the angel on the left. The scene is not identifiable, either by its location on Golgotha, by the Cross or by any other indication of its context. Only the language of the bodies and the pathos of the expressions point unambiguously to Christ's Deposition from the Cross. The extended arm of the Virgin replaces the arm of the Cross in order to balance the composition. The artist has chosen to fill the whole pictorial space with a grouped, compact composition in which the characters float in an apparent state of weightlessness, rising in a spiral round a vertical axis. The gestures of their hands and contorted bodies are even more eloquent than the expressions on their wild faces filled with dramatic tension. The elegance of the languid figure of Christ and the young man who supports him in the foreground, the refinement of the carefully executed details such as the blond curls and beard of Christ merge with the subtle, brutal collisions of clashing colours, pink and yellow, orange and sea green. Pontormo used his palette of colours with the greatest subtlety when painting flesh and fabrics, whether tight-fitting or loose with broken folds. The scene is frozen, the figures dazzled and the colours washed out in the cold, neon-like light from an unknown source.

KEY WORKS
Only about 45 works by Pontormo are known: some 35 in museums and 10 listed at auction.
Holy Conversation (or *The Visitation*), 1514–16, church of S Annunziata
Joseph in Egypt, 1515, London, NG
Vertumnus and Pomona, 1519–20, Poggio a Caiano, Villa Medici
The Supper at Emmaus, 1525, Florence, Uffizi
Ecce Homo, 1522–5, Galluzzo near Florence, frescoes of the Charterhouse
The Deposition, 1526, church of S Felicità
Portrait of a Young Man, c.1525–7, Lucca, Pinacoteca
Frescoes of S Lorenzo, 1546–56, destroyed

BIBLIOGRAPHY

Clapp, F M, *Jacopo Carucci da Pontormo: His Life and Work*, Yale University Press, New Haven, CT, 1916; Costamagna, P, *Pontormo: catalogue raisonné de l'œuvre peinture*, Gallimard/Electa, Paris, 1994; Cox-Rearick, J, *The Drawings of Pontormo*, revised edn, 2 vols, Hacker Art Books, New York, 1981; Freedberg, S I, Painting in Italy, 1500–1600, 3rd edn, Yale University Press, New Haven, CT and London, 1993

Holbein

The art of Holbein the Younger was based on rigorous, precise observation. Measured and cold, more secular than religious, his painting employs a pitiless realism in which form often prevails over human content. At times a humanist painter with a Classical style, at other times a Mannerist, Holbein was a brilliant portrait painter and also very skilled at ornamental designs and architectural decoration.

LIFE AND CAREER

• The German artist Hans Holbein the Younger (Augsburg 1497/8–London 1543) was born into a large family of painters. He trained with his father Hans Holbein the Elder in Augsburg. At the age of 17 he went to work in the workshop of Hans Herbst in Basel. Extremely precocious and talented, he soon became independent. Well-known to the prosperous merchant bourgeoisie, he painted the *Diptych of Jakob Meyer and His Wife* (1516, Basel, Km). In 1519 he was admitted to the Painters' Guild of Basel, where he took over his deceased brother's workshop and married.

• In the course of ten years he produced mural paintings which are now lost and almost all his religious works: the impressive *Dead Christ* of the *Oberried Altarpiece* (1521, Basel), whose style combined archaic and modern elements; the *Solothurn Madonna* (1522, Solothurn, MS), influenced by Italian and Germanic art; the *Passion Altarpiece* (1524, Basel), remarkable for its luminosity; and *The Madonna of Burgomaster Meyer Altarpiece* (1526, Darmstadt, Hesse Collection). The figures of the Virgin in the *Meyer Altarpiece*, Venus in *Venus and Amor* and *Lais of Corinth* (1526, Basel, Km), the *Madonna and the Saints* depicted in grisaille on the organ shutters in Basel Cathedral (c.1526, Basel, Km) are all reminiscent of the art of *Leonardo da Vinci. Holbein's Madonnas in the style of Mantegna and Leonardo seem to imply that he travelled to Italy or that he saw Leonardo's work during his stay in France between 1523 and 1526 when he was possibly seeking the patronage of Francis I. There he painted a portrait of his friend Erasmus (1523, Paris, Louvre). Although he belonged to the German pictorial tradition, he was nevertheless receptive to Renaissance concepts.

• In 1526, Holbein fled the Reformation and settled in London. Erasmus recommended him to the politician and humanist Thomas More, author of *Utopia* (1516). Holbein acquired fame as a portrait painter: *Sir Henry Guildford* (1527, London), *Sir Thomas More* (1527, New York, FC), *William Warham, Archbishop of Canterbury* (1527, Paris, Louvre), *Nicholas Kratzer* (1528, Paris, Louvre) and *Sir Thomas Godsalve and His Son John* (1528, Dresden, Gg).

• Back in Basel between 1528 and 1531, he executed painted decorations on façades, including that (now lost) of the council chamber of the town hall. He also painted portraits such as *The Artist's Family* (1528-9, Basel, Km) which have a touching humanity and realism about them.

• Having settled permanently in London in 1532, he painted countless portraits of merchants: *Georg Gisze* (1532, Berlin) and *Derich Born* (1533, London, Wallace Collection). His decorative work was widely known through his drawings and engravings. At that time he worked mainly for Henry VIII, whose service he entered in 1536. Thenceforth he concentrated on decorative projects, miniatures, designs for jewellery and numerous portraits of the aristocracy and the court, most of them half-length: *The Ambassadors* (1533, London), portrayed life-size; *Robert Cheseman* (1533, The Hague, M); *Charles de Solier* (1534-5, Dresden); and *Richard Southwell* (1536, Florence, Uffizi). In 1538 he was sent on a diplomatic mission to Burgundy and passed through Lyons.

- He returned to London, probably in 1541, where he concentrated on portrait painting: *Anne of Cleves* (1539, Paris), *Thomas Howard* (1539–40, London Wallace Collection), *Margaret Wyatt* (1540, New York, MM), *Henry VIII* (1540, Rome) and *John Chambers* (1541–3, London). He died from the plague in London at the height of his fame.

His painted façades made his reputation, as did his skill as a portraitist. Holbein the Younger established himself as a very great painter as well as a brilliant draughtsman and illustrator, but after his death Flemish artists supplanted him with regard to artistic influence. In the 19th century, his naturalism influenced Romantic painters such as *Géricault.

APPROACH AND STYLE

Holbein created monumental façade decorations in fresco for the city of Basel and its aristocrats. His religious scenes (individual paintings and polyptychs on wood) were commissioned by the clergy and merchant bourgeoisie. His countless portraits on wood – half-, three-quarter- or full-length – depicted his family and friends as well as aristocrats, courtiers and wealthy merchants.

Holbein worked mainly in Basel and London. He enriched his Germanic Augsburg-based style by absorbing stylistic elements of his compatriots Hans Baldung and Albrecht Altdorfer, as well as influences from the northern Italian Renaissance – especially that of Leonardo da Vinci, whom he is thought to have met in France. He was inspired by the Mannerism of the Florentine painter Bronzino and the Lombard artist Moretto, by the German painter Lucas Cranach, and by the School of Fontainebleau and the French artist François Clouet. He was also influenced by the Flemish art of *van Eyck and Memlinc.

- His first religious works were imbued with a nocturnal, fantastical atmosphere. They were located in a theatrical, ornamental, non-Classical but Italianate setting or in a landscape painted in graphic, Germanic style. The compositions were bathed in a cold, theatrical light reminiscent of Baldung. With his oblique perspectives he created tension and a sense of unrest that recalled Altdorfer.
- Unlike his contemporaries he preferred a cold, sometimes glacial realism and a reticence of feeling, similar to German Late Gothic. He found secular subjects to be a greater source of inspiration than religious mysticism.
- His large decorative works with illusionistic effects were inspired by the frescoes of ancient Rome. The compositions, sometimes overloaded, are filled with slightly elongated or stooping figures in exaggerated poses. Their supple, dancing poses reflect the influence of Mannerism.

A GREAT PAINTER

◆ Holbein is one of the greatest portrait painters of all time and during his lifetime he was as famous in Germany, Switzerland and England as *Raphael and *Titian.

◆ Modern and original in his ability to synthesize European art of various periods, he continued to paint in the style of Renaissance Classicism while also being influenced by the beginnings of Mannerism and developing his own personal style.

◆ Holbein reinterpreted well-known subjects by introducing innovations in his choice of format, in his composition and in the poses and expressions of his figures. He 'secularized' certain religious subjects. He was a master of the art of portrait painting.

◆ Holbein absorbed Italian artistic principles, which he sometimes combined with German aesthetics. He interpreted Classical and Mannerist forms with ease while introducing a modern touch. He was the only painter capable of painting 'in the style of Leonardo' without producing a pastiche. He established himself as the master of detail and realism.

◆ The objective coldness of his paintings keeps the viewer at a distance, and this particular quality tends to make him less highly regarded today than he once was.

HOLBEIN

- In contrast, his Classical, light, symmetrical, pyramidal, balanced compositions, his sense of space, his knowledge of anatomy reflected in twisting movements and foreshortenings, the sweetness of his faces, the chiaroscuro, the Leonardesque smile (although without *sfumato*) – all these reflected the Italian Renaissance of the 16th century.
- In his portraits he moved from a humanist Classicism to Mannerism. He preferred to paint not ideal beauty but individualized features, rendered with a detached, objective realism based on rigorous observation. He looked for a face's profound meaning beyond its outward appearance. The Flemish materiality of his still lifes and the precise, trompel'œil rendering of objects made his paintings seem more real than reality itself.
- At the end of his life, Holbein concentrated mainly on portrait painting. He favoured lines, surfaces and flatness over modelling, depth and the play of colours in light. He portrayed the sitter full-face (or nearly so) in a neutral or white light which emphasized the aristocratic appearance of the sitter by creating coldness and distance between the work and the viewer. His portraits were inspired by Italian, French and German Mannerism, reinterpreted in a personal manner.

Nicholas Kratzer
1528. Oil on wood, 83 x 67cm, Paris, Louvre

Holbein here portrays Nicholas Kratzer, astronomer and friend of the humanist Thomas More, with his astronomical instruments. This portrait is close to the Classical ideal through its atmosphere rather than through any Italian formal approach. There is great restraint in Kratzer's bearing and the simplicity of his clothing, a quality enhanced by the limited colour range. The typically Flemish still life consisting of his astronomical instruments stresses Kratzer's profession more than his social status or his feelings.

Anne of Cleves
1539. Parchment on canvas, 65 x 48cm, Paris, Louvre

Anne of Cleves, Henry VIII's wife, is portrayed full-face. Holbein favoured lines and surface over modelling. The 'appearance' of the aloof princess prevails over the depth of her 'being'. Her crossed hands represent resignation. The neutral light from the front flattens her against a wall which is also neutral in colour, while emphasizing the gold on the red velvet, a mark of her rank. In this portrait Holbein has achieved a perfect balance between face, dress and setting. Here the artist has achieved a reconstructed synthesis of European Mannerism.

KEY WORKS

Holbein the Younger produced about 170 known works.
Oberried Altarpiece, containing the *Dead Christ*, 1521, Basel, Km
Passion Altarpiece, 1524, Basel, Km
Venus and Amor, 1526, Basel, Km
Sir Henry Guildford, 1527, London, Wallace Collection
Nicholas Kratzer, 1528, Paris, Louvre
Georg Gisze, 1532, Berlin museums
The Ambassadors, 1533, London, NG
Charles de Solier, 1534–5, Dresden, Gg
Anne of Cleves, 1539, Paris, Louvre
Henry VIII, 1540, Rome, Borghese
John Chambers, 1541–3, London, NG

BIBLIOGRAPHY
Chamberlain, A B, *Hans Holbein the Younger*, 2 vols, G Allen and Unwin, London, 1913; Ganz, P, *The Paintings of Hans Holbein*, translated by R H Boothroyd and Marguerlte Kay, Phaidon Press, London, 1950; Hervey, M F S, *Holbein's 'Ambassadors', the Picture and the Men: An Historical Study*, G Bell and Sons, London, 1900; Wornum, R N, *Some Aspects of the Life and Works of Hans Holbein, Painter, of Augsburg*, London, 1867

Tintoretto

The 15th-century Venetian Tintoretto was a restless, nonconformist painter, a colourist who developed a pictorial language of great formal power and intense dramatic expression, conveyed by a play of forms, personal colours, luminous effects and a lively, quick execution using generous brushstrokes. The stylistic devices of Mannerism were used by the artist for their expressiveness. His work was marked by great suggestive power and an individual use of colour.

LIFE AND CAREER

• Tintoretto, properly Jacopo Robusti (Venice 1518–Venice 1594), Italian painter of the Renaissance, was the son of a dyer (*tintore*). He worked in *Titian's workshop, where their rivalry began. In 1539 he qualified as an 'independent painter'. He lived in Venice and travelled little but became acquainted with new stylistic trends through the humanist Aretino in 1527, the artists Francesco Sansovino and Salviati, and through engravings which were in circulation.

• Receptive to the prevailing Mannerism, he is said to have painted mythological scenes to decorate the coffered ceilings in the Venetian palace of the Pisani family (1541, Modena; Vienna, KM). From 1545 onwards, he painted portraits for the Venetian bourgeoisie and aristocracy: *Portrait of a Gentleman* (c.1545, Paris, Louvre).

• Tintoretto knew the work of *Michelangelo, as is apparent in *St Mark Freeing the Slave* (1548, Venice), an innovative masterpiece which confirmed his style. *St Rocco among the Plague Victims* (1549, Venice, church of S Rocco) shows his evolution towards a luminous style. *The Story of Genesis* (painted for the Scuola della Trinità, 1550–2, Venice, Ac) displayed a new concept of landscape and Titian's influence, which became even more obvious in the following years: *Susanna and the Elders* (c.1555–6, Vienna). Later he was inspired by *Veronese in the *Six Scenes from the Old Testament* (1555, Madrid, Prado) and *The Healing of the Paralytic* (1559, Venice, S Rocco). He married in 1550 and three of his eight children became painters.

• His art blossomed and he painted with passion. The rate of his production and the speed at which he worked were prodigious. Between 1562 and 1566 he painted the 'Miracles of St Mark' for the Scuola Grande di S Marco: *The Stealing of the Dead Body of St Mark* (Milan, Brera), *The Discovery of St Mark's Body* and *St Mark Saving a Saracen from a Shipwreck* (Venice), distinguished by a highly elaborate, luminous and theatrical architectural setting. He painted *The Adoration of the Golden Calf* and *The Last Judgement* (1562–4, Venice, church of the Madonna dell'Orto).

• In 1564 he began work on the vast project of decorating the Scuola di San Rocco: on the ceiling of the Sala dell'Albergo, *St Rocco in Glory*; on the walls, the *Scenes from the Life of Christ* (1564–7); on the ceiling of the Sala Grande, the *Scenes from the Old Testament*, and on the walls the *Scenes from the Life of Christ* (1576–88).

• He also painted numerous portraits, especially of old men, marked by a merciless realism: *Alvise Cornaro* (c.1564, Florence, Pitti), *Old Man with a Child* (1565?, Vienna, KM).

• Towards the end of his career he became solemn and very pious. Single-handedly he painted the four *Allegories* for the Doges' Palace in Venice (1577, in situ). From 1580 onwards, because of the large number of commissions and the work in progress at the Scuola di San Rocco, his workshop collaborated with him on great projects such as: *The Splendour of the Gonzaga* in Mantua (1580, Munich, AP); the 'Scenes from the Life of Hercules', painted between 1581 and 1584 in the Ducal Palace, including *The Origin of the Milky Way* (1582, London, NG); *Paradise* (1588–7) and *The Last Supper* (1592–4, Venice), the artist's final spectacular, poetic vision.

His portraits reveal great psychological perception, unwavering in their rendering of the truth: *The Prosecutor M Grimani* (c.1580, Madrid, Prado) and *Vincenzo Morosini* (c.1581–2, London).

Tintoretto's art aroused the admiration of men of letters and the reproaches of the conservative clergy who saw him as an agitator. His pictorial vocabulary was reduced to figurative diagrams by the generations of artists who succeeded him.

APPROACH AND STYLE

Tintoretto painted works of various sizes and enormous religious compositions, frescoes and canvases, commissioned by religious brotherhoods. Scenes of chivalry and mythology, portraits of gentlemen, ladies, doges and prelates were privately commissioned. He also painted a few presumed self-portraits.

His painting displayed a multicultural taste, ranging from Classicism to Tuscan, Roman and Emilian Mannerism and Venetian art. In Rome in about 1547, he admired the sculptural qualities of the bodies painted by Michelangelo and the Mannerism of Salviati. In 1580 in Mantua he discovered the Mannerist frescoes of Giulio Romano with their violent narrative style and formal richness. He also borrowed from the Venetians, the troubling Mannerism of Pordenone, the unrealistic, vigorous Mannerism of Schiavone, the luminous, colourist Classicism of Titian and the decorative, poetic, refined Classicism of Veronese.

• Until 1542, Tintoretto painted in the classical Venetian tradition. Then he developed great formal strictness and an original 'luminism' (powerful light effects). He borrowed Roman and Emilian Mannerist elements: the oblique, off-centre composition of Giuliano Romano, the plasticity of form, firmness of line and bulging musculature of Michelangelo, the foreshortening of moving figures captured 'in flight' and the effects of perspective, set in a Titian-like coloured, luminous space enhanced by colour contrasts. In this period, Tintoretto's art was marked by a powerful plasticity, animated by lively figures and steeped in a harsh light.

• He then began to develop his own style. He portrayed common people with restrained gestures, depicting them realistically in various attitudes like actors on a stage. He developed a dramatic sense, further enhanced by a 'divine' light and a spectacular whirling effect, set in a multiple, fantastic concept of space. He created unity in his compositions by means of a powerful light which enveloped contrasting colours in a violent alternation of shadows and light.

• In about 1550 he was inspired by the Venetians again. He admired Titian for his brilliant use of colour, his lush, deep landscapes in light-intense colours, the balance between colour, line and light, and his warm impasto. He was inspired by Veronese with his sensual, poetic nudes, his use of decorative elements, his way of linking together characters, the richness of his foreshortenings and his vast crowd scenes.

• His late period revealed his mysticism and his dramatic, vigorous stylistic approach which appealed directly to the viewer's emotions. In his dynamic compositions, set in an architectural or landscape setting, the characters swirl around beneath pale or golden 'spotlights' which fade and multiply the colours vigorously applied by the artist. 'The artist shatters space and its formal structure and uses mainly light to convey his dramatic visions' (A Pallucchini, 1968).

• In effect, it was the speed of his pictorial technique which created the movement. Some of his late creations, produced with the help of his pupils, show a clear systemization of his art.

• His portraits followed the same development with regard to modelling. A series of old men were portrayed first in brown monochrome against light backgrounds, then against dark backgrounds, and then in various shades of purple. Tintoretto depicted what was essential without making any concessions: the psychological strength of his models, their lucidity and their physical frailty merge into the coloured impasto.

A GREAT PAINTER

◆ Admired and criticized during his own lifetime, badly copied during the centuries that followed, Tintoretto was only rediscovered as a great master in the early 20th century.

◆ He embodied the 'Mannerist crisis' of an independent artist.

◆ He developed an unusual range of subject matter: The Death of Abel, The Probatic Pool, the cycle of St Mark, The Origin of the Milky Way, etc.

◆ Before starting to paint, the artist built scale models with small wax figurines which he arranged as on a stage. He painted the largest painting in the world (Paradise: 7 x 22m). He was as happy painting on canvas as in fresco. His speed of working exceeded that of all other painters.

◆ His work was always bathed in a particular light. Tintoretto suggested form, rejected the traditional pose for portraits and loved impasto which engulfed figures and the halos which illuminated faces often portrayed against the light.

TINTORETTO

St Mark Freeing the Slave
1548. Oil on canvas, 4.15 x 5.41m, Venice, Galleria dell'Accademia

This episode, taken from the Golden Legend by Jacques de Voragine, was painted for the Scuola Grande di San Marco. It tells the story of a servant who worshipped the relics of St Mark against the wishes of his master and was consequently tortured, but then miraculously freed by the saint. The scene takes place in an architectural setting in which the characters are placed as if on the stage of a theatre. Tintoretto has painted the sudden appearance of St Mark at the crucial moment when the executioner – surrounded by his instruments of torture, pieces of wood and hammers – is about to put the slave to death. The astonishing foreshortening of St Mark echoes that of the slave on the ground, but in reverse. The unity of time, place and space is maintained. The carefully chosen moment puts the emphasis on the crowd while the main characters of the composition are linked together in the oval of a closed space.

This painting with its innovative, accomplished style confirmed the artist's status as a master. Tintoretto demonstrated his ability to produce a magnificent new work based on borrowed artistic elements: foreshortening from Michelangelo, narrative and formal elements from the Mannerists and light from the Venetians. His talent was based on his mastery of colours, his effects of light, the warmth of his Titianesque impasto and his burning desire to paint.

BIBLIOGRAPHY
Fontanari, Roberto, *Jacopo Tintoretto: ritratti*, exhibition catalogue, Electa, Milan, 1994; Lepschy, A L, *Tintoretto Observed: A Documentary Survey of Critical Reactions from the 16th to the 20th Century*, Ravenna, Longo, 1983; Newton, E, *Tintoretto*, Longmans, Green & Co, London, 1952; Nichols, T, *Tintoretto: Tradition and Identity*, Reaktion, London, 1999

The Last Supper
1592–4. Fresco, 3.65 x 5.68m, Venice, church of San Giorgio Maggiore

This final work by Tintoretto on one of the artist's favourite subjects displays its originality in its oblique perspective and its forms bathed in colours which have become sources of light; the rapid brushstrokes are breathtakingly skilful and the impasto warm. His use of light was revolutionary: the figures of the saints, placed against the light, emerge from the shadows thanks to their luminous halos. 'Two sources of light cut through the vast, empty room in which Christ is giving communion to the apostles: real light is projected by the lamp illuminating the figures from behind while an unreal light shines brightly round the head of Christ, and the angels who are descending from heaven seem to be made from the same luminous substance. The reality of everyday life, marked by an almost popular flavour, is transfigured by this double light in a way which could be described as Expressionist' (P de Vecchi, 1971).

KEY WORKS

During his long life Tintoretto painted over 300 works.
Mythological scenes, 1541, Modena, G Estense, coffered ceiling
St Mark Freeing the Slave, 1548, Venice, Ac
Susanna and the Elders, c.1555–6, Vienna, Km
The Discovery of St Mark's Body, Venice, Ac
Frescoes, 1564–87, Venice, Scuola di San Rocco
Allegories, 1577, Venice, Doges' Palace
Portrait of Vincenzo Morosini, c.1581–2, London, NG
Paradise, 1588–92, Venice, Doges' Palace ('cartoon' in the Louvre)
The Last Supper, 1592–4, Venice, S Giorgio Maggiore

Veronese

Veronese – great Italian artist and painter of decorative schemes, colourist of Venetian fêtes and pageants – painted poetic representations of happiness and beauty. He revelled in the sumptuousness of clothes and food. His pictorial language is bold with vertiginous perspectives and light, luminous colours.

LIFE AND CAREER

• Veronese, properly Paolo Caliari (Verona 1528–Venice 1588), Italian artist, was as brilliant a colourist as his contemporaries *Titian and *Tintoretto. He began his training as a painter at the age of ten with Antonio Badile and his father, a sculptor, in Verona, a thriving artistic centre close to Parma and Mantua. He was inspired by the Brescian painters and the Mannerists in the tradition of Parmigianino and Titian. Under their influence he painted allegorical frescoes (1551, Villa Soranzo of Treville).

• In 1553 Veronese arrived in Venice to decorate the Doges' Palace, in collaboration with the Mannerist painters Ponchino and Zelotti: *Juno Scattering her Gifts over Venice* (1553–4, in situ). This work reveals his great talent as a muralist. He then worked on the formal aspect of his art in *The Coronation of the Virgin* (1555, church of S Sebastiano) and his use of colours in *Scenes from the Life of Esther* (1556, church of S Sebastiano), *The Madonna in Glory with St Sebastian* (1559–61, church of S Sebastiano) and *The Pilgrims of Emmaus* (1559–60, Paris, Louvre). His sense of light exploded in masterpieces such as *The Feast in the House of Simon the Pharisee* (1560, Turin). He also excelled in the art of portraiture; his portraits had a precious, luminous quality: *Portrait of Countess Nani* (c.1556, Paris).

• The frescoes in the Villa Barbaro at Maser in Venetia, built by Palladio, are impressive and wonderfully fresh, radiating happiness. At the same time Veronese developed his sense of the poetic in paintings such as *The Rest on the Flight into Egypt* (1560–70, Ottawa, NG).

• His style developed towards the luminism (powerful light effects) of Bassano: *The Martyrdom of St Sebastian* (1565, church of S Sebastiano) and *The Family of Darius before Alexander* (1565–7, London). He produced gigantic works whose 'indirect' handling of subjects – Catholic beneath a secular appearance – were sometimes condemned by the Inquisition: *The Marriage at Cana* (1562–3, Paris) and *The Presentation of the Cuccina Family to the Virgin* (1571, Dresden, Gg). He was censured in particular for the German attire of the soldiers and the apostle picking his teeth. The Inquisition was sometimes placated by a simple change of title: *The Last Supper* became *The Feast in the House of Levi* (1573, Venice, Ac).

• Veronese's art as an official painter now became plainer, more intimate and lyrical, enhanced with landscapes: *The Allegory of Venice* (1575–7, Venice, Doge's Palace), *The Rape of Europa* (1580, Venice, Doges' Palace), *Moses Saved from the Water* and *Venus and Adonis* (1580, Madrid). His last works were devoted to the representation of expressions of glory such as the ceiling in the Doges' Palace, *The Triumph of Venice*, or pathos: *Lucretia* (c.1583, Vienna, KM) and *St Pantaleon Healing a Sick Boy* (1587, Venice). He painted numerous portraits including the *Portrait of a Sculptor* (c.1587, New York, MM).

The unskilled assistants in Veronese's workshop were unable to take over his role. His art was a universal source of inspiration from the Italian Baroque to the neo-Impressionism of *Seurat, including in particular *Rubens, *Velázquez, *Tiepolo, *Delacroix and *Monet.

APPROACH AND STYLE

Veronese produced huge room decorations and paintings, dealing with religious and secular subjects (allegorical, mythological and contemporary), for the Doges' Palace and the private villas of great families (Barbaro, Cuccina, etc) as well as for churches. He also painted a number of life-size portraits.

In Verona, he created decorative schemes that were in harmony with the architecture of the villas built by Sanmicheli and Palladio. In Venice he discovered the work of Titian, Tintoretto and Bassano but he did not abandon the Mannerism of the Florentines, Salviati and Giorgio Vasari. In Parma he discovered the work of Parmigianino and *Correggio, and in Brescia that of Savoldo and Moretto. In Mantua he admired the art of Primaticcio, the frescoes of Giulio Romano, and in Rome those of *Michelangelo and *Raphael. Veronese combined his interest in architecture with his vast knowledge of painting.

In the course of his stylistic development, the painter assimilated, interpreted and went beyond the Mannerist, Classical and luminist principles of his Italian predecessors: the rhythmic values of Parmigianino; the formal flights of fancy, the elegance and nuances of Correggio; the cold, silvery effects of Savoldo; the architectural motifs and shimmering colours of the noble, serene figures of Moretto; the busy décor of the tumultuous compositions, unusual perspectives and saturated colours of Giulio Romano; the cold, clashing colours of Primaticcio; the monumental sculptural quality of Michelangelo and the Classicism of Raphael; the construction through tonal colours, the drama or the idealized reality of Titian; and the crepuscular, cold luminism of Bassano and Tintoretto.

• At the beginning of his career, Veronese's art was Mannerist, peaceful and pure, against a background of Classical Palladian or Mannerist architecture, in which the colours were still tonal.

• In Venice from 1560 onwards, this tonal approach disappeared and his colour range became lighter. Veronese developed a melodious, poetic decorative style, emanating joy and happiness. His put his subjects at the service of colour. His low-relief compositions with lowered viewpoints extolled beauty and happiness. The light, luminous colours with notes of pearly grey harmonized with transparent, coloured shadows in a rejection of chiaroscuro. The colours contained in the clearly outlined shapes, sometimes close to each other and sometimes complementary, were handled in an intuitive manner. This approach was later followed by Seurat, working on a scientific basis. In this respect Veronese went beyond Titian's tonal painting and the Venetian luminism of Bassano; he discovered the maximum effect of luminosity and intensity which characterizes the amazing purity of his art.

• His decorative schemes are illusionistic, bathed in a diffuse light, always favouring architectural representations and simple perspectives, filled with monumental figures, skilful foreshortenings and flights of fancy in the style of Michelangelo. Crowds fill the foreground, full of

A GREAT PAINTER

◆ Veronese was admired during his lifetime, then studied in the following centuries by painters throughout Europe.

◆ A great painter of decorative schemes, Veronese worked in the Venetian colourist tradition.

◆ He particularly favoured the subject of biblical meals, which he revolutionized by making them secular. He painted architectural motifs, sometimes borrowed from the actual building he was decorating. He developed multiple low-angle perspectives.

◆ Veronese was as skilled at fresco painting as at oil painting. He was a pioneer in the use of complementary colours, and his colour palette was designed to provide as much luminosity as possible.

rich, bright colours, while the grandiose trompe-l'œil architecture creates a background dominated by cool colours; the academic accuracy of the poses and details of construction are apparently not a priority.

In the 1570s Veronese extolled the magnificence of Venice in joyful, happy monumental works in which form and light were represented in an ideal manner. His free use of colour secularized subjects and under-played sacred elements; Veronese included buffoons among Jesus's ret-inue and introduced his painter friends into a group of musicians in *The Marriage at Cana*. He told the Inquisition tribunal that he demanded 'the same freedom for painters as for poets and lunatics'.

• His last works were less complex, melancholic and intimate, with sub-dued colours illuminated by a crepuscular, diffuse light, and displaying a preference for landscape over architecture, bringing them closer to the naturalist art of Bassano. Nevertheless, 'his figurative language main-tained its formal characteristics in the sharpness of the play of colours, which is the approach of a free and pioneering artist' (T Pignatti, 1999).

The Marriage at Cana
1562–3. Oil on canvas, 6.66 x 9.90 m, Paris, Louvre

Painted for the refectory of the convent of San Giorgio Maggiore, this canvas uses a scene of Venetian pageantry to give a secular interpretation of the biblical story – an interpretation which was condemned by the Inquisition. It is a masterpiece both in size and composition, crowded in the foreground, airy in the background and closed in by ancient columns at each side. In accordance with the principles of Mannerism, Veronese has increased the number of points of perspective.
Many of the 132 characters are identifiable. In the group of musicians in the foreground, Titian is represented as a bass player while Tintoretto, Bassano and the artist himself play the smaller viols. Assisted by some of his collaborators and in particular by Fra Benedetto for the architectural elements and some of the figures, Veronese here revealed his talent as a colourist and decorative painter as well as his prodigious imagination. The figures, many in striking poses, are clothed in shimmering, pearly fabrics while the tables are covered with sophisticated food. The bright, warm colours of the figures, in contrast to the light, cold, white colours of the Palladian architecture, show his rejection of chiaroscuro and tonal colouring in favour of a luminous colour range with coloured shadows – a triumphant indication of his joyful individual style.

KEY WORKS

Veronese produced about 300 paintings and frescoes.
Allegorical frescoes, 1553–4, Venice, Doges' Palace
The Coronation of the Virgin, 1555, Venice, church of S Sebastiano
The Feast in the House of Simon the Pharisee, 1560, Turin, GS
Portrait of Countess Nani, c.1556, Paris, Louvre
Frescoes at the Villa Barbaro, 1562, Maser, in situ
The Martyrdom of St Sebastian, 1565, Venice, church of S Sebastiano
The Family of Darius before Alexander, 1565–7, London, NG
The Marriage at Cana, 1562–3, Paris, Louvre
Venus and Adonis, 1580, Madrid, Prado
St Pantaleon Healing a Sick Boy, 1587, Venice, church of S Pantaleon

Venus and Adonis
1580. Oil on canvas, 2.12 x 1.91m, Madrid, Prado

*Adonis is dozing on Venus's lap, tired out after hunting wild boar. They are
watched by Cupid, who is stroking a greyhound. This mythological subject
allowed Veronese to give free rein to his decorative talent. The composition is
straightforward and contains few characters. Architecture has been abandoned
in favour of a lively, ethereal landscape. The colour scheme consists mainly of
blue, green and yellow. The colour of the threatening sky which heralds the
death of Adonis is in harmony with the fabric worn by the goddess of love, who
is looking somewhat melancholy. The colours and their complementary shades
balance each other.*

BIBLIOGRAPHY
Beguin, S and Marini, R, *All the Paintings of Veronese*, Flammarion, Paris, 1970; *Paolo Veronese Restored*,
exhibition catalogue, Verona, Venice and Washington, 1988; *The Marriage at Cana*, exhibition catalogue, Louvre,
Paris, 1992

Brueghel the Elder

Brueghel was a meticulous observer. A humanist and an epicurean narrator of everyday life in the countryside, he developed a universal concept of the human condition. His art sometimes combined opposites in the same work: influences of different periods, religious and secular subjects, classical 'Baroque' composition and Italianate or Dutch style, as well as various techniques. He clothed his characters in pure colours while using mainly a blend of browns, greens and blues for his landscapes.

LIFE AND CAREER

• Pieter Brueghel the Elder, also spelt Breughel (Bruegel, Brabant, c.1525/30–Brussels 1569), was born into a family of Flemish painters. He was apprenticed to Pieter Coecke van Aelst, then in 1551 became a master of the Guild of Painters of Antwerp. As a graphic artist and engraver of landscapes for the publisher and print-seller Hieronymus Cock between 1552 and 1555, he travelled in the Italian Alps.

• His first paintings were landscapes: *Landscape with Christ Appearing to the Apostles* (1553, Belgium, private collection) and *The Fall of Icarus* (1558, Brussels, B-A). Following a form traditional in Flanders, he entertained viewers with scenes of country people working or feasting, often illustrating popular proverbs: *Village Wedding Feast* (1556, Philadelphia), *Twelve Flemish Proverbs* (1558, Antwerp, MMB) and *The Proverbs* (1559, Berlin). His work often contained a certain morbidity and a sense of the tragic: *The Combat between Carnival and Lent* (1559, Vienna), *The Triumph of Death* (1562–3, Madrid) and *The Fall of the Rebel Angels* (1562, Brussels, B-A). He was inspired by Hieronymus *Bosch in *The Suicide of Saul* (1562, Vienna) and *Dulle Griet* (*Mad Margot*, 1563, Antwerp, MMB). His powers of observation came to the fore in *Children's Games* (1559–60, Vienna). Brueghel excelled in the representation of interiors and landscapes as well as architecture, as seen in *The Tower of Babel* (1563, Vienna and Rotterdam).

• In 1563, he married his master's daughter and settled in Brussels. His son Pieter Brueghel the Younger was born the following year, and he also became a painter. Brueghel the Elder painted religious works: *The Adoration of the Magi* (1564, London), which met the criteria of Italian classical composition but contained Dutch details; *Carrying the Cross* (1564, Vienna), where Christ is lost in the crowd and the landscape; *The Census at Bethlehem* (1566, Brussels); and *The Massacre of the Innocents* (1565–6, Vienna, KM). In the 'Months' series (1565) he portrayed the everyday life of peasants, set in an infinitely vast natural landscape: *Hunters in the Snow* (Vienna), *The Tempest* (Vienna), *Haymaking* (Prague), *The Corn Harvest* (New York) and *The Return of the Herd* (Vienna). The painter incorporated the cycle of the seasons even in religious subjects such as *The Conversion of St Paul* (1567, Vienna) or *The Adoration of the Magi in a Winter Landscape* (1567, Winterthur, private collection).

• In his final years, he returned to the theme of popular celebrations: *The Dance of the Wedding* (1566, Detroit, IA), *The Peasant Dance* and *Peasant Wedding* (c.1568, Vienna). He counterbalanced these scenes of joy with depictions of physical human misery: the crippled *Beggars* (1568, Paris, Louvre), the blind in body or spirit in *The Parable of the Blind* (1568, Naples) and *The Misanthrope* (1568, Naples). In all subjects the treatment of the landscape remained unaffected by the human condition, as is clear in *The Proverb of the Bird's Nest* (1568, Vienna) and *The Magpie on the Gallows* (1568, Darmstadt, Landesmuseum).

A year before his death he had a second son, Jan I, known as Velvet Brueghel, who also became a famous painter. Pieter Brueghel the Younger made copies of his father's works, but the younger son was the more talented. Their descendants also became painters.

APPROACH AND STYLE

Brueghel the Elder painted his works in oils on wood or in tempera on canvas. They were medium-sized and included single pieces and series. His subjects belonged to the 'minor' genre of everyday life. He painted highly structured panoramic landscapes, organized around biblical scenes, as well as astrological illustrations, satanic scenes, proverbs and popular

scenes of country life. The cycle of the seasons was always present in his art. He produced no devotional paintings or heroic scenes which might have been pretexts for large nudes. Brueghel was influenced by the colourful art of the late Middle Ages and the artists of northern Europe such as Joachim Patinir, Bosch and Van Eyck. He travelled in Italy, to Rome, Naples and Sicily, and adopted the great principles of re-emergent Italian art.

• At first Brueghel was interested in panoramic views of the Alps and Naples with blue horizons inspired by Patinir. His precision of detail and the depth of his panoramas were constant throughout his life.

• In 1556, in his first scenes of everyday life, the landscape played an important part and the composition was similar to that in medieval illustrations: an abundance of often decorative motifs and carefully constructed lines, contrasting with the spontaneity of the bustling figures. In his country scenes, he strove to represent reality while introducing further levels of interpretation by adding small details (the four berets in *Children's Games* form a face). His paintings were inhabited by a mass of small figures, creating numerous vignettes of everyday life. Brueghel preferred his human beings to be made of flesh and blood, working, living, eating and feasting.

• From about 1562, the artist began to integrate his characters more into the landscape and the powerful, domineering forces of nature – symbolizing an alliance between man and the soil. In the 'Months' cycle, the landscape consists of parallel planes and coloured masses, brought to life by the presence of living elements, both vegetable and human, which blend into the space. Besides the descriptive narrative (common to Flemish painters since van Eyck) and picturesque, decorative features, the paintings tend to convey a poetic view of the seasons and even more of the 'idea' of a cosmic, universal season; this new vision of Brueghel was that of an 'eternal cycle' (C de Tolnay) encapsulating human beings and nature, thus connecting Brueghel with the concepts of the Baroque.

• His mythological and biblical scenes were highly original interpretations compared with traditional humanist representations; sacred episodes are steeped in a secular world but the eternal always wins over the immediacy of everyday life. Sometimes one detail may be the key to the understanding of a large composition. In *The Fall of Icarus* the main subject appears to have become an episode of secondary importance because he is set within the permanence of nature, with the peasant in the foreground tirelessly working the land. In *Carrying the Cross* the drama is part of life and takes place before the curious, the frightened and above all the indifferent. *The Fall of the Rebel Angels* and *The Triumph of Death* were inspired by the demonic, supernatural subject matter of Bosch, imaginatively reinterpreted. A sense of the tragic nature of life is seen in *The Tower of Babel*, a building destined to be destroyed although it was dedicated to the eternity of mankind.

• Brueghel's compositions were clear, rhythmic and unified in spite of their numerous details, being defined by long structural lines drawn with black stone, in contrast to the Flemish primitives, who composed their works first and foremost around the details.

• The painstaking execution reveals small brushstrokes and a sometimes fluid, diluted

A GREAT PAINTER

◆ Known mainly for his paintings of peasant life, Brueghel first became famous in Flanders, then in the rest of Europe. His success has lasted down the centuries.

◆ An artist of the Renaissance because of his Classicism and humanism, Brueghel combined the principles of Italian art with a resolutely and characteristically Flemish inspiration. In some respects he heralded the arrival of Baroque.

◆ Brueghel was the first artist in northern Europe to include human beings and nature in a humanist vision which respected Flemish descriptive realism. He saw Italy as a vast landscape and did not copy the great masters. He preferred a vision of characters anchored in reality to the Italian idealization of man. He was in search of a 'new conscience which was not yet the historical conscience' (C-H Rocquet, 1968).

◆ Long known as 'the Droll' or 'the Peasant', Brueghel raised the minor genre of painting everyday life to the level of great art.

◆ Some canvases were painted in tempera on a rough, unprepared background which in time absorbed part of the paint, thus producing a matt finish. On the other hand, when oils were used, a brown or beige ground helped fix the colours while unifying the overall tone.

texture. Conversely, sometimes the brush is used freely with a thick, oily, unctuous impasto which conveys movement; in the latter case the forms are only faintly modelled and the outlines remain blurred. The patches of colour created by the silhouettes, the diffuse light and the harmonious colours all contribute to the unity of the picture; there is an opposition between the luminous upper universe and the pathos of the earthly world (*The Blind*).

• Towards the end of his career, Brueghel simplified his pictorial vocabulary. He painted landscapes with fewer but more important characters. The concentrated, balanced composition, the monumentality of the figures, the idea of space, even where the viewpoint is not high, and the invariable association of mankind with nature are all elements which connect him with the art of the Renaissance.

• Brueghel thus showed himself to be skilled at combining opposites: he found inspiration in the art of the late Middle Ages and the Renaissance, as well as heralding the beginning of Baroque in a style which was both linear and sculptural. He brought together the colossal and the miniature, the festive and the tragic, eternity and immediacy, myth and reality, immobility and movement, life and death, laughter and drama, humour and seriousness.

The Combat between Carnival and Lent
1559. Oil on wood, 1.18 x 1.64m, Vienna, Kunsthistorisches Museum

This scene of everyday peasant life symbolizes the transition from Carnival, the days before Lent, to Lent itself. It is a parody of a fight, presenting those who are celebrating Carnival and those who are fasting. The former, on the left, are led by the embodiment of Carnival: a round, fat man straddling a barrel with a pie on his head and brandishing a spit. His followers, also wearing items of food, follow him and play music. On the right, a skinny, sickly woman represents Lent. Seated on a prayer stool and pulled along by a monk and a nun, she wears a beehive on her head evoking the honey of Lent and holds out two herrings on the end of a wooden paddle. The container of mussels, the craquelin (a festival bread) and the pretzels which are the food of Lent will soon be consumed by the cortège following her.

The painter selected his subject from the traditions of the Low Countries. The quality of the observation of popular life, typical of Brueghel, reveals an understanding of flesh-and-blood humanity, with all its imperfections. The fête is here a means of representing the human comedy. Each figure – with precise colouring reminiscent of the art of the miniature – takes its carefully determined place in a composition that extends beyond the boundary of the canvas, beyond the visible and into Brueghel's imaginary world.

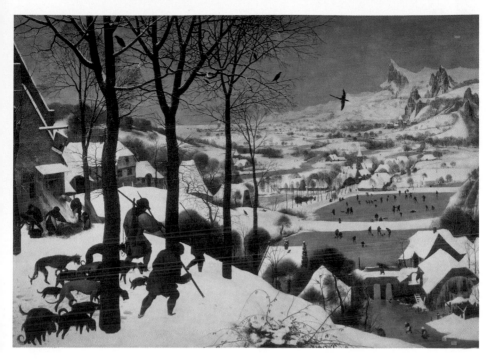

The Hunters in the Snow (Winter, from the 'Months' series)
1565. Oil on wood, 1.17 x 1.62m, Vienna, Kunsthistorisches Museum

Brueghel invites us to go with the hunters into the winter landscape: our gaze follows the diagonal of the trees towards the frozen ponds and on to the distant background, where we discover winter or, more precisely, the essence of winter. A second diagonal marks the boundary between the foreground (the village and its inhabitants) and the landscape below it and in the distance.
The figures and those parts of nature that are still alive – the trees and the birds – appear like Chinese shadow puppets against the background of the brilliant white of the snow, modified by the steely grey of the ice and the sky. Even the hunters in the foreground are seen from behind, so that they look more like silhouettes than human beings. Yet these shadows moving in the vastness of the frozen landscape make their presence felt through the wide range of their activities: scenes of everyday village life and winter sports on the ice.

KEY WORKS
A total of 45 paintings and 135 drawings have been identified as definitely by Brueghel. Most of these paintings were signed and dated during the period 1553–68.
Village Wedding Feast, 1556, Philadelphia, John G Johnson Collection
The Proverbs, 1559, Berlin museums
The Combat between Carnival and Lent, 1559, Vienna, KM
Children's Games, 1559–60, Vienna, KM
The Triumph of Death, 1562–3, Madrid, Prado
The Fall of the Rebel Angels, 1562, Brussels, B-A
The Suicide of Saul, 1562, Vienna, KM
The Tower of Babel, 1563, Vienna, KM and Rotterdam, BVB
The Adoration of the Magi, 1564, London, NG
Carrying the Cross, 1564, Vienna, KM
The Census at Bethlehem, 1566, Brussels, B-A
Series of 'Months', 1565, Vienna, KM; Prague, Národni Gallery, New York, MM
The Peasant Dance and Peasant Wedding, c.1568, Vienna, KM
The Parable of the Blind, 1568, Naples, Capodimonte
The Proverb of the Bird's Nest, 1568, Vienna, Km

BIBLIOGRAPHY
Barker, V, *Pieter Bruegel the Elder: A Study of his Paintings*, 2nd edn, G Allen and Unwin, London, 1927; Grossmann, F, *Brueghel: complete edition of the paintings*, 3rd edition, Phaidon, London, 1973; Klein, H A and Klein, M C, *Peter Bruegel the Elder: Artist of Abundance*, Macmillan, New York, 1968; Stechow, W: *Peter Bruegel the Elder*, Thames and Hudson, London, 1970

El Greco

El Greco was a great colourist, a solitary and original artist, an ardent religious painter and a 'humanist' portraitist. He drew his inspiration from his Greek roots and from Italian and Spanish art. His paintings emanate spirituality and drama; he took Mannerism to extremes, with a vertiginous elongation of the bodies and a cold, acid tonality.

LIFE AND CAREER

• The Spanish painter El Greco, properly Domenikos Theotokopoulos (Candia, Crete, a Venetian possession, 1541–Toledo 1614), was born into a lower-middle-class Catholic family. Little is known of his early life; it is possible that he was taught the art of icon painting and that of the Venetian Renaissance by the master Gripiotis. These influences can be seen in *Death of the Virgin* (Syros, Church of the Dormition), in the *Portable Altar* (Modena, G Estense) and in *St Francis Receiving the Stigmata* (Geneva, private collection). El Greco became a master painter at the age of 25.

• He decided to go to Italy and settled in Venice (c.1568–70), where he was influenced by the masters of colour and light: *Christ Healing the Blind Man* (c.1570-2, Parma, GN), in which the positioning of the figures was inherited from *Tintoretto, and *Christ Driving the Traders from the Temple* (c.1570-2, Washington). He is said to have visited *Titian's workshop regularly.

• In Rome between 1570 and 1577, he fulfilled his desire to learn about the art of antiquity, the Renaissance and Mannerism. He painted many portraits, very Venetian in style, including the *Governor of Malta Vincenzo Anastagi* (c.1575, New York, FC) and the Croatian miniaturist *Giulio Clovio* (1570-5, Naples), who introduced him to Cardinal Farnese. The Cardinal in turn introduced him to the circle of scholars in his entourage, dominated by his librarian Fulvio Orsini. El Greco's name appeared in the registers of the Academy of St Luke in 1572. Some of his work was inspired by *Michelangelo, for example the *Pietà* (1570-2, New York, Hispanic Society) and later *St Sebastian* (c.1577, Palencia Cathedral). Yet he remained faithful to the Venetian masters: *Boy Lighting a Candle* (c.1570-5, Naples, Capodimonte) and *The Annunciation* (c.1575, Madrid, Prado).

• Receiving few commissions in Rome, he turned to the royal patronage of Philip II of Spain and to his friend Louis de Castilla, whose father was Dean of Toledo Cathedral. In 1577 he arrived in Toledo in Spain, where he was nicknamed El Greco ('the Greek'). He lived there until his death in the style of a cultured aristocrat. He married and had one son. He painted three altarpieces for the church of S Domingo el Antiguo in Toledo, representing *The Assumption, The Adoration of the Shepherds* and *The Trinity* (1577-9, Chicago, AI and Madrid, Prado), which reflected Michelangelo's sculptural approach to painting. *The Despoiling of Christ*, showing Christ having his tunic removed (1577-9, Toledo), was criticized by his patrons, as was *The Martyrdom of St Maurice* (1580-2, Madrid). The *Allegory of the Holy League*, also known as the *Dream of Philip II* (1580-2, Madrid), was also badly received because it strayed too far from the rules of the Catholic Reformation.

• Thereafter, royal and religious commissions from Madrid were replaced by private commissions for devotional paintings in Toledo: *St Francis Receiving the Stigmata* (1585-90, Madrid, private collection), *The Crucifixion with Two Patrons* (c.1590, Paris, Louvre) and *The Lamentation of Christ* (1580-95?, Paris, Stavros Niarchos Collection) – all distinguished by their great dramatic power. He immortalized the Castilian nobility in paintings such as *The Gentleman with His Hand on His Chest* (c.1577-83, Madrid, Prado) and the persons present at *The Burial of Count Orgaz* (1586, Toledo), a masterpiece depicting a sumptuous funeral and a 'gallery' of naturalistic portraits.

• Between 1580 and 1585, El Greco painted the subjects recommended by the Council of Trent – saints, the Passion of Christ and the Holy Family: *St Jerome* (early 17th century, Madrid), *St John the Evangelist and St Francis* (c.1590-5, Madrid), *The Tears of St Peter* and *The Holy Family* (1603-7, Toledo, Tavera Hospital).

• In around 1595, the bodies of his figures became elongated and unreal, as seen in the paintings decorating the College of S Maria de Aragon in Madrid (*The Baptism of Christ*, 1596–1600, Madrid, Prado). This stylization reached its peak in the paintings of the Chapel of St Joseph in Toledo (*The Coronation of the Virgin*, 1599, in situ) and the five paintings in

the Hospital of Charity in Illescas near Toledo (*The Virgin of Charity*, 1603–5). The world of saints and apostles is filled with tormented, emaciated beings. *The Crucifixion* (1605–10, Madrid, Prado), *The Adoration of the Shepherds* (1612–14, Madrid, Prado), *The Vision of the Apocalypse* (c.1608–14, New York, MM) and the *Laocoon* (1610–14, Washington, NG) are characteristic of his 'visionary' style, which contrasts with the psychological realism of his portraits: the Hellenist humanist and friend of the painter, *Antonio de Covarrubias y Leiva* (before 1600, Paris, Louvre), *The Cardinal Fernando Niño de Guevara* (c.1610, New York) and *Fray Hortensio Felix Paravicino* (1609, Boston, MFA). The two versions of the *View of Toledo* (1605, New York, MM; 1610–14, Toledo, Greco Museum) reveal different approaches: more 'romantic' in the first, more 'topographical' in the second.

Although admired by his best 'disciple', Luis Tristan, and later by his compatriot *Velázquez, who like him excelled in the truthful intensity of his portraits, his art remained isolated, without any real successor.

APPROACH AND STYLE

El Greco painted altarpieces and large devotional paintings for the court, the clergy and the secular aristocracy. He painted portraits, two landscapes of Toledo and only one mythological subject. His pictures were painted mainly on canvas but sometimes also on wood or copper.

El Greco probably learnt Byzantine art and contemporary Italian art from his master Gripiotis. In Venice he was inspired by Titian, Tintoretto and Bassano. In Rome he learnt about antiquity, the art of Michelangelo and Roman Mannerism. In Spain, in Madrid and Toledo, he was particularly sensitive to religious mysticism.

• From Crete he borrowed the bright colours and the frontal compositions characteristic of religious icons, while from his training he retained the naturalism and perspective inherited from the Italian Renaissance.

• In Venice he painted religious subjects set in an architectural décor – sometimes presented as ruins in which the space is created by light which enhances the shimmering colours applied in small strokes.

The Venetian richness of colours, shimmering and luminous, and his rapid brushstrokes were inspired by Titian, in his opinion 'the best connoisseur and imitator of nature'. The nocturnal, violent light was reminiscent of Bassano, while his preoccupation with form, movement and composition were reminiscent of Tintoretto. El Greco imitated the composition and atmosphere of these great masters both in his religious scenes (*Christ Driving the Traders from the Temple*) and in his portraits. In Rome he was inspired by the powerful, sculptural art of Michelangelo and Mannerism with its formal boldness and cold, acid colours (*Pietà*).

• In Spain he developed his own art. He produced dramatic religious paintings in which colour created shapes, highlighted in an unusual whirl of light. The brushstrokes were broad and thick. The composition was richer and the subtle treatment of the subject and Mannerist colours no longer reflected the stereotypes used for religious subjects (*The Martyrdom of St Maurice*). His mysticism was reminiscent of that of St Theresa of Avila or St John of the Cross. The folds of the clothes, twisted round the body of the saints, were full of expression. Crowds of figures animated by supernatural rhythms moved in unreal, fantastic, distant landscapes. The bodies were foreshortened and represented in warm colours which sometimes changed into cold, acid tones.

A GREAT PAINTER

◆ Both criticized and admired, El Greco was successful during his own lifetime. But his art, often misunderstood, sank into oblivion. He was rediscovered in France at the beginning of the 20th century.

◆ El Greco was a great Italianate colourist, unique in his sculptural originality, which had a visionary dimension.

◆ In accordance with the religious subject matter recommended by the Council of Trent, he produced many versions of the same subjects; he painted St Francis more than 20 times. He developed his ability to express spiritual life and enriched the art of portraiture.

◆ His individual Mannerism, which he used to convey his mystic vision, achieved a dramatization hitherto unknown in painting, using an original harmony of cold shades and masterful brushstrokes. It was Expressionism before its time.

EL GRECO

- In his secular paintings, he presents a more realistic portrayal of his humanist contemporaries: they display a distinct personality, elegance of pose and clothes, and sumptuous colours or magnificent black and white (*The Burial of Count Orgaz*).
His saints, often penitent, and his scenes depicting the Passion of Christ express violence or meditation, painted in a harmony of reds and ochres.
- In around 1595 his Mannerism, his exalted spirituality and his sense of dramatization reached their peak. The elongation of the emaciated bodies – immaterial and sinuous to the point of appearing unreal – came close to fantasy, with swarming bodies becoming entangled and beams of light and unusual colours, acid and glacial, moving in a pyramidal or spiral rhythm.
- His psychological portrayal of his models, set in a sober composition, achieved an intense truthfulness. The free and easy brushstrokes enhanced the colours. His style became more expressive and violent. The troubled atmosphere in his religious works no longer followed the usual formal schemes. There was a certain expressionism in his art. His use of the same religious subjects throughout his career is explained by his theoretical reflections, such as those found in the margins of his copy of Giorgio Vasari's *Lives*; his main objective was to translate an ideal of beauty, based on the model of nature. Like all Mannerist painters, he concentrated on colour and light, then achieved an abstraction of form and space by increasing the intensity of the gestures; and yet he always remained faithful to the art of the Venetians.

KEY WORKS

El Greco produced about 170 paintings.
Christ Driving the Traders from the Temple, c.1570–2, Washington, NG
Giulio Clovio, 1570–5, Naples, Capodimonte
Pietà, 1570–2, New York, Hispanic Society
The Despoiling of Christ, 1577–9, cathedral of Toledo
The Martyrdom of St Maurice, 1580–2, Madrid, Escorial
The Burial of Count Orgaz, 1586, Toledo, church of S Tomé
St Jerome, early 17th century, Madrid, Prado
The Cardinal Fernando Niño de Guevara, c.1610, New York, MM
The Vision of the Apocalypse, c.1608–14, New York, MM
The Adoration of the Shepherds, 1612–4, Madrid, Prado

BIBLIOGRAPHY

Brown, J, *El Greco of Toledo, exhibition catalogue*, Toledo Museum of Art, Little, Brown, Boston, 1982; Cossio, M B, *El Greco*, 2nd edn of English translation, Elliot's Books, 1989; Davies, D, *El Greco*, Phaidon, Oxford, 1976; Kelemen, P, *El Greco Revisited: Candia, Venice, Toledo*, Macmillan, New York, 1961; Mertzios, K D, *Dominikos Theotokopoulos: O bios kai ta erga tou [Dominikos Theotokopoulos: his life and works]*, Athens, 1966; Wethey, H E, *El Greco and his School*, 2 vols, Princeton University Press, Princeton, NJ, 1962

The Adoration of the Shepherds
1612–4. Oil on canvas, 3.19 x 1.8m, Madrid, Prado

El Greco painted this altarpiece for a crypt in the convent of the Dominican sisters in Toledo, Santo Domingo el Antigua. The arrangement was that in exchange they would allow the painter and his son to have tombs there. But on the painter's death in 1614, his body was buried in a common grave because his son could not afford to pay the costs.

The vertical format of the canvas is emphasized by the unreal elongation of the figures, which form two circular groups, bathed in a cold light with surprising luminescent effects. The dominant bluish colour is made warmer by the shimmering patches of red-orange, yellows and jade green. In the background, a gallery defined by arches, in the form of an altarpiece, creates depth. According to El Greco's pupil Luis Tristan, the shepherd on his knees in the foreground is an image of the artist. In the centre of the composition the Infant Jesus illuminates the scene with his divine light. The distorted anatomies, the extreme elongation of the bodies and the whirling drapery go well beyond Mannerism: these are the unmistakable signature of El Greco's final works. The expressive gestures and troubled faces exalt religious emotion. The brushstrokes are broad, fast but meticulous.

THE 17TH CENTURY:
'REALITY', CLASSICISM AND THE BAROQUE

The 18th century saw the development of new relationships between art, the academies, the public and patrons. At the end of the 16th century in Italy, Annibale *Carracci and *Caravaggio, wanting to be true to nature, demonstrated their 'anti-Mannerism'. The former, after his naturalist beginnings, adopted an 'eclectic Classicism', while the latter embraced a revolutionary 'realism'. In Rome the work of the Carracci brothers influenced the Classicism of *Poussin, which was admired by Le Brun in Paris. In about 1630, the Baroque aesthetic of *Piero da Cortona became established in Rome, as did that of *Rubens in Flanders. A self-sufficient art flourished in Holland with *Hals, *Rembrandt and *Vermeer, in Spain with *Velázquez and in France with *La Tour.

Europe in the 17th century

The Counter-Reformation. At the end of the Council of Trent (1563), the Catholic Church sought to revive public religious fervour under the authority of the Popes Sixtus V, Clement VIII and Paul V. The order of the Jesuits, founded in 1540 by Ignatius Loyola, took an active role in religious reconstruction (*Spiritual Exercises*, 1548). Philip Neri – representing the lower clergy, who were recognized by the Church in 1575 – turned towards the poor. The Archbishop of Milan, Charles Borromeo, applied new religious guidelines (*Roman Catechism*, 1566) and Francis de Sales founded the order of the Congregation of the Visitation (*Introduction to the Devout Life*, 1608).

The political landscape outside Italy. In 1579, by the Union of Utrecht, the seven Calvinist provinces of the northern Low Countries (including Holland and Utrecht) rebelled against Spanish rule, proclaiming their independence and founding the republic of the United Provinces. Its trade in textiles and precious metals prospered, while banking flourished in Amsterdam. With a powerful navy, the country was in touch with its colonies and the world.

The Evangelical Union between the German cities and the Protestant princes was formed in 1608. The Catholics responded in 1609 with the creation of the German Catholic coalition, the Holy League. The Thirty Years War (1618–48) was triggered by this conflict: with Protestants fighting Catholics, it set in motion the destruction of the Germanic Holy Roman Empire. In France, during the reigns of Louis XIII and Louis XIV, the frontiers of the country were enlarged and consolidated by wars. The striking feature of the 'Great Century' was its cultural brilliance.

The development of the sciences. Galileo was tried by the Holy Office of the Inquisition (1633) for his investigations which confirmed Copernicus's hypotheses concerning the movement of the Earth. Cassini, founder of the Paris Observatory (1672), discovered the laws governing the rotation of the moon. Newton, Kepler and Huygens discovered the laws of gravity, while Torricelli invented the barometer. Progress was made in the fields of mechanics, engineering, physics, optics, astronomy, chemistry, biology, botany and neurology. Pascal, Descartes (*Discourse on Method*), Leibniz and others combined scientific and philosophical research.

Man, the painter and the patron. Patrons no longer played an essential role in the choice of subjects. Caravaggio painted insignificant people: in his canvases, fortune tellers, peasants and women of the streets appeared alongside saints or the Virgin Mary. After he had painted many uncommissioned pictures, his style – poetic and violent like his own dissolute life – won him the admiration (or rejection) of his patrons. He was pursued for a murder and Poussin said that he was born 'to destroy painting'. Like him, his most loyal follower and the last Caravaggesque painter, Valentin de Boulogne, frequented low dives and taverns; he lost his life there.

The 'modern awareness of the artist' was born. Carracci dared to refuse to decorate the palace of Cardinal Odoardo Farnese for a sum he thought too small, and Rembrandt expressed his complete artistry even as his life was darkened by family dramas and financial difficulties. The rigorous style of Poussin was encouraged and appreciated by his Roman patron, whom the artist preferred to Louis XIII with his royal restraints.

On the other hand, the Baroque style of Pietro da Cortona perfectly suited the requirements of Urban VIII, who thus established his fame, his power and his wealth. La Tour was not the humble, sensitive person suggested by his paintings, but a man greedy for money and recognition. Velázquez, court artist and portrait painter of eminent people, had his ambition satisfied by Philip IV. Vermeer's discreet art was a reflection of the hushed world of the women he painted. Like other painters he made effective use of the scientific knowledge of his time, particularly the camera obscura, in constructing his perspectives.

The pictorial aesthetic

The 'reality' of Carracci and Caravaggio. Northern Italy was opposed to Mannerism. Annibale Carracci, c.1580–90, and Caravaggio, c.1590–1600, from Bologna and Lombardy respectively, practised an art 'dominated by a return to a sensual view of nature ... a completely new desire to communicate with the public' (L Salerno, 1991). Carracci executed his first few naturalistic 'genre portraits' while Caravaggio turned his attention to the common people; his saints were neither rich nor beautiful but human, the Virgin a simple woman of the people. He made the everyday sacred, he freed it from triviality, and he put religion within the reach of ordinary people.

Caravaggio had many followers in Italy, such as Gentileschi, Manfredi and Giordano, as well as the Spanish Catholic tenebrist painter Ribera. Velázquez was initially a follower, as were the Flemish painter Rubens and, in France, La Tour, Vouet and, the most faithful, Valentin de Boulogne. The Dutch masters, including Terbrugghen, employed a clear Caravaggism in the expressive faces of their figures.

The Classicism of the Carracci brothers and Poussin in Rome. Carracci opted for an 'eclectic' Classicism which added the serene expression of human torment and the observation of nature to the Renaissance model. Co-founder of the Accademia degli Incamminati (those who 'have moved forward' on the road of painting), he trained Reni, Albani, Domenichino and others. The French artist Poussin respected the proportions of antiquity and the measured expression of the passions. The landscape painter Claude Lorrain worked small historical figures into his pictures.

French Classicism. Poussin had admirers in Paris: the Jansenist Champaigne, the Raphaelesque Le Sueur, Le Brun, the first painter of the king, and his successor Mignard – all of whom embodied the Classical 'great taste' of the Sun King. This style glorified knowledge, order and reason. The 'man of culture' had to control his passions, as prescribed by the Royal Academy of Painting and Sculpture (founded in 1648 and run by Le Brun). The Academy established a hierarchy of the genres: history painting, the 'grand genre', glorified history, religion, mythology and allegory; then came landscape painting and portraiture; and at the bottom of the scale came genre scenes and still life. The Academy gave the artist 'dignity' and legitimacy once more; its motto was *Libertas Artibus Restituta* (freedom returned to the arts). This official Classicism contributed to France's artistic renown in Europe, at the same time as the Baroque was becoming established. Painters exhibited a variety of styles, from the Mannerism mixed with Caravaggism of Leclerc to the Baroque temptation of Vouet, which was rejected by official art. Under Louis XIII, Rubens painted the Medici Gallery in the Palais du Luxembourg, but, under Louis XIV, the plan for the colonnade of the Louvre designed by Bernini was abandoned. Supported by the theorist Félibien, Poussin advocated the virtues of drawing, which he pitted against the Baroque, colourist painting of Rubens, which was defended by another theorist, Roger de Piles. This aesthetic argument was resolved in the early 18th century with the victory of colour.

Baroque art in Italy, the response of the Counter-Reformation. By about 1630 Caravaggism had died away, the Classicism of Poussin was blossoming and the Baroque was at its peak. The term Baroque (from the Portuguese *barroco*: irregular pearl), described an exuberant style. It was applied to the architecture of Bernini and Borromini and then to painting. The Roman Catholic Jesuits encouraged triumphal Catholic art, the multiplication and enhancement of religious images. Painting had to teach, persuade, attract and move the faithful. The Popes Urban VIII, Innocent X and Alexander VII, as well as other patrons, incorporated their personal justification into the pictures. Painters created scenes of magnificence on frescoed ceilings to proclaim the new subjects of the Counter-Reformation: martyrdom, vision, ecstasy, and their patrons' glory. The Baroque was defined by abundance, swirling dynamics, illusionistic effects and infinite, dazzling space. Dominated by Pietro de Cortona, the Genoese Baciccia and the Jesuit Father Pozzo, this style was initiated in Parma by *Correggio and Lanfranco.

Baroque art in the rest of Europe. In Spain the Counter-Reformation took place during the reigns of Philip IV and Charles II. The Spanish Golden Age began with the final mystical works of *El Greco. In Seville, the 'sentimental Baroque' of Murillo interpreted the teaching of the Jesuits, and Zurbarán became the 'painter of the monks'. In England, it was expressed in the work of Van Dyck, Rubens and the decorative painter Thornhill; in Austria with Rottmayr; and in Bohemia (Prague) with Skreta. In the southern Low Countries (Flanders), which were Spanish and Catholic, the Catholic revival triumphed, giving encouragement to the painting of Rubens, Jordaens, Snyders and others.

In the United Provinces. Here, painting preserved a traditional character. Because of Calvinism there were no religious patrons. The merchant bourgeoisie had a taste for painting based on observation, a reflection of their image, and encouraged portraits, scenes of biblical and family life, still life and landscape. In Haarlem, Hals invented the group portrait, while in Amsterdam the bourgeois class remained loyal to the objective portrait tradition. Rembrandt enjoyed considerable success and had many followers, including Hinck and Dou. A Catholic trend asserted itself in Holland with Lastman, Elsheimer, and the Utrecht school with its Caravaggist painters. In Delft could be found intimist painters of everyday life such as Vermeer and Fabritius, loyal to Rembrandt. Landscape painters, painters of architecture or church interiors, marine painters, painters of animals and still lifes all excelled in their art.

These trends, particularly Baroque and the intimism of the north, found an echo in the art of the 18th century with the Rococo artists *Tiepolo and *Watteau, and the poetic painter *Chardin.

Carracci

Annibale Carracci reconciled the language of painting with reality. Then, together with his brother Agostino and his cousin Ludovico, he founded a very active academy of painting in Bologna. Using his superior knowledge of decorative schemes, Carracci reinterpreted Classicism and blended it with early Baroque, thus creating a new, vibrant art, eclectic yet personal.

LIFE AND CAREER

• Annibale Carracci (Bologna 1560–Rome 1609), the most brilliant of the three Carracci brothers, was trained in the workshop of the Mannerist artist Prospero Fontana. After painting *Dead Christ* (1582, Stuttgart, Sg) he began painting realistic works: *Portrait of an Old Woman* (1582, Bologna, private collection), *The Butcher's Shop* (c.1582–3, Oxford), *Man Eating Beans* (c.1583–4, Rome, Colonna) and *Self-Portrait with Other Figures* (1585, Milan, Brera). Meanwhile he painted his first altarpiece, the *Crucifixion with Saints* (1583, Bologna).

• Between 1582 and 1585, the three Carracci founded the painting academy of the Desiderosi (those 'desirous' of learning and succeeding) in Bologna; in 1590 this was renamed the Incamminati (those who 'have moved forward' on the road of painting). They defined their ideal pictorial principles, based on the imitation of nature and the Classicism of the Renaissance and antiquity. In collaboration with Ludovico and Agostino, Annibale Carracci painted a cycle of frescoes on the *Stories of Jason*, the fresco *Europa* and that of the *Wanderings of Aeneas* (c.1583, Bologna).

• Carracci then became interested in the art of northern Italy. In 1585 he went to Parma where he discovered *Correggio, then in 1588 he discovered the Venetian painter *Veronese. The impact of these aesthetic influences can be seen in his altarpieces of the *Baptism of Christ* (1585, Bologna), the *Pietà* (1585, Parma), the *Assumption of the Virgin* (1592, Bologna), the *Madonna with Saints* (1592, Paris, Louvre) and the *Resurrection of Christ* (1593, Paris, Louvre). His frescoes reveal the influence of Veronese's luminous colours and Correggio's spatial movement: *Story of Romulus* (1588–92, Bologna). His paintings from this period include the *Portrait of Claudio Merulo* [?] (1587, Naples, Capodimonte) and mythological scenes: *Venus with Satyr and Cupids* (1588, Florence) and *Venus and Adonis* (1588–9, Madrid, Prado). His landscapes depicted the reality of nature: *Fête Champêtre* (1584, Marseilles, B-A), *Fishing and The Hunt* (1587–8, Paris), *Landscape* (1589–90, Washington, NG) and another *Landscape* (1593, Berlin museums).

• In 1595 Carracci was summoned to Rome by Cardinal Farnese. There he painted *The Charity of St Rocco* (1594–6, Dresden) and the frescoes of the *Story of Hercules and Ulysses* (1595, Rome, Palazzo Farnese, Camerino). Between 1597 and 1604 he painted his most important work, a fresco decorating the ceiling of the gallery in the Palazzo Farnese, on the mythological theme of the 'loves of the gods': the *Triumph of Bacchus and Ariadne*, flanked by *Pan and Diana* and *Mercury and Paris*. This colossal work required the help of his brother and his pupils Domenichino and Albani.

• Carracci received other commissions: *Christ in Glory with Saints* (1597–8, Florence, Pitti), *Birth of the Virgin* (1598–9, Paris, Louvre), the *Pietà* (1599–1600, Naples, Capodimonte), the *Assumption* (1600–1, Rome, church of S Maria del Popolo) and the *Toilet of Venus* (1594–5, Washington, NG). He decorated the Herrera Chapel and then the chapel of the palace of Cardinal Aldobrandini: six 'lunettes' narrating the Life of the Virgin set in a landscape, of which only the *Flight into Egypt* and

the Entombment are exclusively by him (1602–3, Rome, Doria Pamphili). He created several versions of the *Pietà with St Francis and Mary Magdalene* (1602–7, Paris, Louvre; 1603, Vienna, KM; 1606, London, NG), as well as *Christ Appearing to St Peter* (1602, London, NG) and *The Stoning of St Stephen* (1603–4, Paris, Louvre).

From 1605 onwards Carracci was unable to paint because of ill health, but he continued to supervise his workshop. His many pupils continued his work, each according to their own style and feelings. Guido Reni freely interpreted and idealized his master's teachings. Carracci inspired the Classical painters of the 17th century, Claude Lorrain and *Poussin, especially in their rendering of landscapes.

APPROACH AND STYLE

Carracci painted a wide range of subjects: religious and mythological themes, genre scenes, portraits and landscapes. He tackled every kind of picture, from altarpieces, easel paintings and oils on canvas to gigantic frescoes on the walls, ceilings and vaults of palaces and chapels. His paintings were commissioned privately by the Herrera and Fava families and Cardinals Farnese and Aldobrandini.

Trained in Bologna by the Mannerist painter Prospero Fontana, Carracci completed his education in painting by studying the art of northern Italy. Later, he found inspiration in the work of Correggio in Parma, Veronese in Venice and *Michelangelo and *Raphael in Rome, as well as in the Classical art of antiquity.

• His first two religious paintings were innovative in the simplicity of their composition, in their bold foreshortening reminiscent of Mantegna, and in their massive forms and emergent naturalism reflected in broad brushstrokes and thick impasto; they were criticized and rejected. He then painted portraits and everyday genre scenes. From Federico Barocci, Bartolomeo Passerotti and Antonio Campi he took a sense of naturalism and a simple reality, also found in the work of the Flemish artists Pieter Aertsen and Joachim Beuckelaer. But Carracci broke with the caricature and burlesque of the northern European artists and treated naturalistic themes more seriously. To give them a sense of objective reality, he represented figures full-length and life-size, paying great attention to colour and technique.

• After his break with Mannerism, Carracci found inspiration in

A GREAT PAINTER

◆ Carracci was greatly admired during his lifetime and up until the Neoclassicists accused him of eclecticism. He was rehabilitated by the 1956 exhibition in Bologna.

◆ Carracci's naturalistic, realistic, modern art was in marked contrast to Mannerism. Revolutionary in its approach, it heralded 17th-century Classicism but also included Baroque elements.

◆ He revived the concept of *natura* (nature and naturalness) and breathed new life into his subjects, whether religious or landscapes.

◆ He introduced into his art a new vision, which was modern in spirit. He produced the first realistic paintings in Italian art: direct, lively interpretations of the landscape, which became more intellectual in his later style.

◆ He created the naturalistic genre scene, full-length and life-size.

◆ He introduced a dialogue between the spectator and the painting through the illusionism of his art (*Resurrection of Christ* and *Christ Appearing to St Peter*).

◆ His compositions were based on Classical principles or followed a circular, Baroque rhythm.

◆ For his naturalistic paintings, Carracci used large brushstrokes and is said to have 'applied the paint dry', while his Classical paintings have a more fluid touch. He was a master of the technique of fresco.

CARRACCI

Correggio's work, which suggested another approach: he invited the viewer to enter the pictorial space in order to engage with the message more directly. Thereafter 'the fundamental aspect lay in the understanding of spatial movement, the dynamism of the form extending in space, the expansion of the form without heaviness, and the fluid rhythm of narrative composition'; moreover, 'his paintings were remarkable for ... the search for grace, the animated illusion of life, ... the blurred yet expressive outlines and the understanding of what was natural ...' (A Brejon de Lavergnée, 1979). Carracci was strongly influenced by the art of Veronese: his clear, balanced compositions, the vast scale of his forms and his luminous colours. The Academy of the Incamminati taught Classical principles in conjunction with the rendering of reality. Carracci preferred lively, animated compositions and anatomical correctness: the refined, porcelain-like quality of the female mythological characters and the sculptural forms of the male nudes and the drapery, skilfully fore-shortened, fill out the space of the canvas. The painted texture was smooth or displayed a slight impasto.

• In Rome he could give free rein to his penchant for monumental, structured space. Assisted by scholars, he put together programmes of artistic work, assimilated the Classical art of antiquity and made references to Renaissance art (Michelangelo's Sistine Chapel and Raphael's Stanze) that were 'allusive' rather than 'retrospective' (R Longhi). The decoration of the Farnese Gallery was the result of this rich, varied aesthetic development. Probably encouraged by Fulvio Orsini, the librarian at the Palazzo Farnese and *El Greco's protector, he developed a sophisticated range of subject matter and compositions, consisting of tableaux, illusionistic elements and colossal sculptural figures embracing every inspiration from Classicism to pre-Baroque. By contrast, his religious paintings, especially the *Pietàs*, were Classical, realistic and moving.

• 'His landscape paintings first of all included paintings which were both realistic and imaginary in the Venetian tradition (*The Hunt*), followed by a series of idealized landscapes in which natural forms and architecture combined to create the composition (*Landscape*, Berlin). The first type of landscape in which detail predominates [is] realistic and human [...], while the later type is more intellectual (*Landscape with the Flight to Egypt*)' (A Schnapper, 1966).

KEY WORKS

The work of Annibale Carracci includes 145 listed titles, ranging from very small (30 x 22.5cm) to the monumental (décor in the Farnese gallery, 20 x 6.59 x 9.80m).
Crucifixion with Saints, 1583, Bologna, church of S Maria della Carità
The Butcher's Shop, c.1582–3, Oxford, Christ Church
Stories of Jason, Europa and Aeneas, 1583–4, Bologna, Palazzo Fava
Baptism of Christ, 1585, Bologna, church of S Gregorio
Pietà, 1585, Parma, GN
Fishing and The Hunt, 1587–8, Paris, Louvre
Venus with Satyr and Cupids, 1588, Florence, Uffizi
Story of Romulus, 1588–92, Bologna, Palazzo Magnani
Assumption of the Virgin, 1592, Bologna, Pinacoteca
Resurrection of Christ, 1593, Paris, Louvre
The Charity of St Rocco, 1594–6, Dresden, Gg
Ceiling of the Farnese Gallery, 1597–1604, Rome, Palazzo Farnese
Flight into Egypt, 1602–3, Rome, Doria Pamphili
Pietà with St Francis and Mary Magdalene, 1602–7, Paris, Louvre

BIBLIOGRAPHY

Bohn, B, *Italian Masters of the 16th century – Annibale Carracci*, catalogue raisonné, Abaris Books, New York, 1996; Goldstein, C, *Visual fact over verbal fiction: a study of the Carracci and the criticism, theory, and practice of art in Renaissance and Baroque Italy*, Cambridge University Press, Cambridge, 1988 Holland, R (ed), The Carracci: Drawings and Paintings, exhibition catalogue, The Hatton Gallery, Newcastle Upon Tyne, 1961; *The Age of Correggio and the Carracci*, exhibition catalogue, National Gallery of Art, Washington, DC, 1986

Pietà
1585. Oil on canvas, 3.74 x 2.38m, Parma, Galleria Nazionale

Just like his frescoes in the Farnese gallery, painted ten years later, this painting illustrates Annibale Carracci's artistic approach. The technique of illusionism has been used to reinforce the subject, making it more sincere, expressive and convincing and no longer merely decorative, as was the case with Mannerism. It makes tangible – and defines – the pictorial space. The viewer is invited to enter into the picture and participate symbolically in the scene and its emotions, welcomed in by the gestures and the expressions on the faces of the characters. Carracci reveals himself as modern by his 'obstinacy at remaining in the terrestrial world and endowing the beings affected by religious mystery with the fullness of everyday human forms and appearances, by his combination of the everyday and the fabulous, heralded by Correggio, by this naturalism which brings back liveliness to "soft skin", dismissing the abstract ideal and suggesting an attainable ideal, as well as the Baroque penchant for the artificial and the theatrical' (A Brejon de Lavergnée, 1979)

Caravaggio

Caravaggio was a revolutionary, adventurous, violent artist, but also a 'Christian humanist' who revealed a new awareness: he introduced everyday life into the domain of the sacred. He promoted a new form of religious perception by painting the truth about living beings and objects; his characters make their presence felt by their flesh and blood. His work is characterized by the revolutionary way he used chiaroscuro.

LIFE AND CAREER

- The Italian painter Caravaggio, properly Michelangelo Merisi da Caravaggio (Caravaggio, Lombardy, c.1573–Porto Ercole 1610), began his training in 1584 in the workshop of Simone Peterzano in Milan. But nature was his only real 'master'.
- From 1591–2 to 1606 he worked in Rome. He spent some time in prison as a result of his turbulent lifestyle. At the age of 20 he had already developed a sophisticated style and was inspired by the people with whom he mingled. He rejected Roman Mannerism and his innovative talent attracted famous patrons, including Cardinal Del Monte, who also gave him a home when he left the workshop of the Mannerist painter Giuseppe Cesare, known as Cavalier d'Arpino.
- His first known works date from around 1591 and incorporate new subject matter and naturalism: *The Young Sick Bacchus* (Rome, Borghese) and *The Concert* (New York, MM). These were the prelude to a masterpiece, *Bacchus* (c.1592–3, Florence): a transfigured self-portrait, a thematic revolution, and a pretext to portray a scene filled with everyday objects such as fruit and wine, depicted as such. At the same time he painted *Boy with a Basket of Fruit* (c.1592–3, Rome) and *Boy Bitten by a Lizard* (Florence, Longhi Collection).
- The characters shown in his secular, religious or mythological scenes are all elevated to the same rank, portrayed in the present time and with the same truthfulness, whether in *The Fortune Teller* (1594, Paris), *The Lute Player* (1594, Moscow, Hermitage), *The Rest on the Flight to Egypt*, the only landscape painted by the artist (1594–6, Rome), *The Sacrifice of Isaac* (1594–6, Florence, Uffizi) or *Judith Beheading Holofernes* (1595–6, Rome, Coppi Collection). The poetic *Narcissus* (1594–6, Rome, GN), *St Catherine of Alexandria* (1595–6, Lugano, TB), the moving *Magdalene* (1595–6, Doria Pamphili), *St John the Baptist* (1597–8, Doria Pamphili) and the sumptuous *Basket of Fruit* (1596, Milan) are all in the same vein. His knowledge of Classicism is clearly evident in the *Supper at Emmaus* (1596–8, London, NG). He painted the *Head of the Medusa* (1596–8, Florence, Uffizi) and *Love Victorious* (1598–9, Berlin museums).
- The cycle of three paintings on the *Life of St Matthew* marked a turning point in Caravaggio's work. *The Calling of St Matthew*, the *Martyrdom* and *St Matthew and the Angel* (1598–1602, Rome) revolutionized the role of light in painting, capturing events at key moments while lending the characters a new sculptural quality. *The Crucifixion of St Peter* and *The Conversion of St Paul* (1600–1, Rome) also conveyed the immediacy of the action portrayed. Caravaggio was sometimes more Classical (*The Entombment*, 1602–4, Rome) and sometimes more naturalistic (*The Madonna with Pilgrims*, 1603–5, Rome; *The Madonna with the Serpent*, also known as *The Madonna Palafrenieri*, 1605, Rome, Borghese). While *St Jerome and David* (1605–6, Rome, Borghese) were well received, *The Death of the Virgin* shocked its viewers with the realism of a corpse devoid of dignity.
- In 1606, after a murder, Caravaggio fled to Naples. There he painted the monumental *Madonna of the Rosary* (1607, Vienna, KM) and *The Seven Acts of Mercy* (1607, Naples, church of Pio Monte della Misericordia).

- In 1607, he was in Malta, where he painted *Alof de Wignacourt* (Paris, Louvre), Grand Master of the Order of Malta. *The Flagellation of Christ* (c.1607, Naples, S Domenico Maggiore) and *The Beheading of St John the Baptist* (1607, Naples, La Valette) are austere and tragic works, foreshadowing the sombre qualities of his final paintings. In 1608 Caravaggio was in Sicily (Syracuse, Messina and Palermo), still on the run from the law, and painting as a matter of urgency. The sombreness of his compositions and colours increased further, as can be seen in *The Burial of St Lucy* (1608, Syracuse, church of S Lucia), *The Raising of Lazarus* and *The Adoration of the Shepherds* (1609, Messina, Museo Nazionale) and *The Nativity* (1609, Palermo, church of S Lorenzo). In 1610 he died of malaria. His body was found on a beach at Porto Ercole.

The artistic revolution brought about by Caravaggio, a contemporary of *Carracci, appealed to many painters throughout Europe in the years after his death. Unfortunately, they often misinterpreted the master's lessons, adopting only his chiaroscuro technique at the expense of the modern quality of his art. Caravaggism, Classicism and Baroque all developed simultaneously.

APPROACH AND STYLE

At first Caravaggio painted mainly small easel paintings depicting everyday life: musicians, tavern scenes, children with fruit and flowers, and fortune tellers. These were commissioned by private patrons, in particular Cardinal del Monte and the Marchese Giustiniani.

Later he executed large paintings for churches, depicting pious old men, soldiers, vagabonds, courtiers and young scoundrels, represented life-size and half-length or full-length.

Caravaggio had probably seen works by the Brescia painter Giovanni Girolamo Savoldo, who contrasted areas of shadow with areas of light; by Antonio Campi (Cremona), who advocated realism and naturalism; by *Correggio with his nocturnal light; by the Genoese artist Luca Cambiaso; and by the Sienese Beccafumi, known for his original treatment of light. He was also familiar with the work of the Venetian *Lotto with its cold, clear colours; with Giorgone and his famous *Tempest*; with *Tintoretto, the painter of deep shadows; and with Jacopo Bassano and

A GREAT PAINTER

◆ Well-known by his contemporaries as much for his dissolute life as for his work, Caravaggio was little appreciated except by a few connoisseurs. He created a new aesthetic which became very successful: his art was copied and interpreted by dozens of European artists for over 30 years. Caravaggism ended with its French exponent Valentin de Boulogne (d.1632). However, later artists were also influenced by Caravaggio's art for a time (Luca Giordano). Having sunk into oblivion, his work was rediscovered in the 1930s by R Longhi, who published a book about him in 1952.

◆ Caravaggio broke decisively with Mannerism. He created a revolutionary art, dominated by popular realism and a personal interpretation of chiaroscuro.

◆ He created a new repertoire of subjects and forms. At the beginning of his career he freely interpreted traditional subjects (*Bacchus*), he painted the first still life in the history of painting as a subject in itself (*The Basket of Fruit*) and portrayed saints as ordinary people. In his more mature period he treated religious subjects like genre scenes (*The Vocation of St Matthew*) without worrying about the conventions of the time: there was no God, no sky and no movement. He was bold enough to show the Virgin lifeless, her body swollen and her legs uncovered (*The Death of the Virgin*).

◆ He did not make preliminary drawings but applied the paint directly to the canvas. At the end of his life he used the preparatory coat as an artistic element in itself.

◆ Caravaggio revolutionized chiaroscuro, using it as a means of expression with emotional impact. In this way he freed himself from the dichotomy of line and colour.

CARAVAGGIO

his 'nocturnes'. His realism was inspired by the market scenes of the Dutch artist Pieter Aertsen, who also lived in Italy, and by Bassano's rustic realism. In Rome, the art of Carracci and the monumentality of *Masaccio's figures were echoed in Caravaggio's large paintings.

• Caravaggio's early works reveal his love of poetic naturalism inspired by everyday life: Bacchus is portrayed as a young Roman boy and not as a mythological god. The artist painted half-length pictures in which the figures are seen in close-up so as to bring the subject closer to the viewer. The light comes from the side, thus making the individuals stand out. Subtle lighting effects outline dark surfaces against a light background (*The Rest on the Flight to Egypt*). His early technique used a smooth surface finish, contrasting chiaroscuro, an innovative reality and naturalism, and clear, tonal colours, as seen in his *Basket of Fruit*, a masterpiece of painting in its own right which glorifies the extreme ripeness of the fruit and the leaves that are beginning to dry.

• The paintings produced in Rome (the cycle of the *Life of St Matthew*) abandoned the then traditional approach to painting, replacing it with a realistic representation of holy subjects enhanced by a chiaroscuro technique which convincingly revealed the natural forms. The light, an essential element, freezes the gestures and the dramatic action in a beam that pierces the darkness. It emphasizes every detail with an implacable pictorial truth, restoring intensity to the simple, tonal colours applied with smooth brushwork. The figures are captured both physically and spiritually in a timeless silence, internalizing the historic moment. *The Conversion of St Paul* reveals Caravaggio as 'the great creator of simple forms' (R Longhi, 1952), of solid, clear compositions in which he 'captured the truth of the moment and immobilized it' (G C Argan, 1974).

• He combined realism with a stylized art, as reflected in the grace and beauty of the Virgin in *The Madonna with Pilgrims*, in contrast to the poverty and simple manners of the peasants with their worn, wrinkled faces, the simplification of the peasants' hands and feet, and the symbolism of the rod transformed into a 'rod of light'. In *The Death of the Virgin* he was bold enough to depict the Virgin Mary as a simple woman of the people, portrayed in death, without her spiritual dimension being altered at all in the process.

• His final monumental paintings, tragic, sober and austere, contain bare spaces without decoration and without red drapery. They are steeped in a monochrome range of browns or shades of muted brown-red earth colours, 'as if cast in bronze' (R Longhi). Caravaggio used a brown preparation, alternating light and dark areas as elements of light and darkness; the light became dull and muted. His technique became freer and more rapid, showing a great economy of means.

KEY WORKS
Caravaggio is known to have painted about 90 paintings.
Bacchus, c.1592–3, Florence, Uffizi
Boy with a Basket of Fruit, c.1592–3, Rome, Borghese
The Fortune Teller, 1594, Paris, Louvre
The Rest on the Flight to Egypt, 1594–6, Rome, Doria Pamphili
The Basket of Fruit, 1596, Milan, Pinacoteca Ambrosiana
Cycle of the Life of St Matthew, 1598–1602, Rome, church of S Luigi dei Francesi
The Crucifixion of St Peter and *The Conversion of St Paul*, 1600–1, Rome, church of S Maria del Popolo
The Entombment, 1602–4, Rome, Vatican, Pinacoteca
The Madonna with Pilgrims or *The Madonna of Loreto*, 1603–5, Rome, church of S Agostino
The Death of the Virgin, 1605–6, Paris, Louvre
The Beheading of St John the Baptist, 1608, La Vallette, St John's Cathedral
The Raising of Lazarus, 1609, Messina, National Museum

The Calling of St Matthew (from the cycle of the Life of St Matthew)
1599–1600. Oil on canvas, 3.22 x 3.40m, Rome, Contarelli Chapel,
church of S Luigi dei Francesi

*This is not a traditional religious scene or an anecdotal representation but a
'human' story, frozen in time. Full of meaningful looks, the silent scene unfolds in
Caravaggio's own time, in a gambling joint frequented by ordinary people. As the
tax collector Levi (who would become St Matthew) is counting the money he has
collected, Jesus – portrayed as a man of the people with his halo the only sign of
divinity – enters the room, accompanied by Peter, and points at him. Jesus's hand
gesture, reminiscent of Mantegna and *Michelangelo, is highlighted by a divine
light and hesitantly imitated by Peter.*

*As an ordinary man who has been suddenly chosen, Levi wonders at his selection.
Time seems to have been frozen by Jesus's unexpected arrival, and it is evidently a
fleeting visit, since his feet show that he is already leaving. The importance of the
event and its immediacy is reinforced, captured and frozen by the intensity of the
chiaroscuro which throws it into relief. Far from the cold, clear, iridescent shades of
Mannerism, the colours have become intense once more.*

BIBLIOGRAPHY

Friedlaender, W, *Caravaggio Studies*, 2nd edn, Princeton University Press, Princeton, NJ, 1974; Gash, J,
Caravaggio, revised edn, Chaucer Press, London, 2004; Kitson, M, *The Complete Paintings of Caravaggio*,
Weidenfeld and Nicolson, London, 1969; Langdon, H, *Caravaggio: a life*, Chatto and Windus, London, 1998; Moir,
A, *Caravaggio*, concise edn, Thames and Hudson, London, 1989; Spear, R, *Caravaggio and his Followers*, exhibition
catalogue, Cleveland Museum of Art, Cleveland, OH, 1971; *The Age of Caravaggio*, exhibition catalogue,
Metropolitan Museum of Art, Electa, New York and Milan, 1985; Whitfield, C and Martineau, J (eds), *Painting in
Naples, 1606–1705: From Caravaggio to Giordano*, exhibition catalogue, Royal Academy, London, 1982

Rubens

Rubens, a diplomat and collector, was above all a genius of Baroque painting. He achieved the synthesis of Flemish culture and the ideals of the Renaissance. The richness of his lively, innovative work is marked by dynamic form and the glorification of colour. His pictorial language was narrative and decorative, perfectly comprehensible and with a new strength, suppleness and spirit.

LIFE AND CAREER

- The Flemish painter Peter Paul Rubens (Siegen, Westphalia, 1577–Antwerp 1640), the son of a lawyer, was orphaned at the age of ten. In 1589 he settled in Antwerp. He learned his craft from the landscape painter Tobias Verhaecht and from Antwerp history painters such as the Francken brothers, the Pourbus brothers, Adam van Noort and especially Otto van Veen with his 'classicized' Romanism. He became a free master of the Guild of St Luke in 1598.

- Rubens travelled to Italy. While there, between 1600 and 1608, he became interested in the art of the Italian masters, antiquity, the Renaissance and *Caravaggio. In 1603, he was in Valladolid, Spain, on a diplomatic mission to the Duca di Lerna, whose portrait he painted several times. He is known to have spent time in Genoa in 1607. He produced religious paintings, including *The Baptism of Christ* (Antwerp, B-A), *The Virgin Venerated by the Saints* (Grenoble, B-A), the *Circumcision* (c.1607, Genoa) and *The Adoration of the Shepherds* (Fermo, Pinacoteca), which is reminiscent of Caravaggio.

- He then left Italy to join his mother, who was ill in Antwerp. During the period 1609–15 he developed the 'Rubensian' style, combining Italian art with an eloquence of his own. In 1609 he married Isabella Brant, an event he captured in *The Artist and His Wife Isabella Brant* (Munich, AP); they were to have three children. In the same year he was appointed court painter by the Archduke Albert. He carried out three major commissions: *The Adoration of the Magi* (Madrid, Prado) and the two triptychs of *The Erection of the Cross* (1610) and *The Descent from the Cross* (1610 and c.1612, Antwerp). At the same time, Rubens increased the number of secular, humanist and allegorical subjects that he painted: *The Coronation of the Virtuous Hero* (Munich, AP), *Jupiter and Callisto* (1613, Kassel, SK) and *Samson and Delilah* (c.1609, London NG) – paintings marked by pictorial boldness.

- A pioneer of the Antwerp school of painters who was swamped with commissions, he founded his own studio. Well-established specialist painters – including notably Anthony Van Dyck, Jacob Jordaens and Frans Snyders – painted flowers, animals, still lifes and landscapes for him. He reserved the 'noble' figures for himself. He painted the following large compositions with his own hand: *The Lamentation of Christ* (1614, Vienna), *The Entombment of Christ* (1615, Cambrai, church of St Géry), *The Hippopotamus and Crocodile Hunt* (c.1616, Munich), *The Rape of the Daughters of Leucippus* (c.1616, Munich) and *The Lance* (1618, Antwerp, B-A).

- In his mature period between 1620 and 1628, he painted several large decorative series including the cartoons for the tapestry of *The Story of Decius Mus* (c.1617, Vaduz, Liechtenstein Collection) and *The Life of St Charles Borromeo* (1620, Antwerp, Jesuit church, burnt down in 1718). In Paris, Marie de Médicis asked him to decorate a gallery of the Palais du Luxembourg, for which he produced the cycle of *The Life of Marie de Médicis* (1621-5, Paris). He also produced other cartoons, particularly for Louis XIII. He painted several colourful masterpieces: *The Adoration of the Magi* (Antwerp, B-A), *Tomyris and Cyrius* and *The Flight of Lot* (1625, Paris, Louvre), *The Mystic Marriage of St Catherine* (c.1625, Antwerp, church of the Augustines) and *The Adoration of the Magi* (1626-9, Paris).

- In addition, he painted portraits: *Portrait of Marie de Médicis* (c.1623, Madrid) and *The Duke of Buckingham* (1625, Osterley Park). He painted his own family: *Isabella Brant* (1620, Florence, Uffizi) and his future sister-in-law in the *Portrait of Susanna Lunden* (?) (*The Straw Hat*) (1625, London). Isabella Brant died in 1626. Devastated, Rubens agreed in 1628 to carry out diplomatic missions at the request of the Infanta Isabella. During this period he painted numerous portraits of Philip IV, King of Spain, he copied the *Titians in the Royal Collections and he became acquainted with *Velázquez. He left Madrid for London in 1629, where he painted *The Apotheosis of James I* (1629-34, London, ceiling of the Banqueting House in Whitehall).

In 1630 he married the young Hélène Fourment in Antwerp (*The Artist and Hélène in the Garden in Antwerp*, c.1631, Munich, AP); they were to have five children. His style developed and became lyrical, as can be seen in the Whitehall ceiling painting, in the *Story of Achilles* (1630–2, Rotterdam, BVB), in his religious paintings *The Martyrdom of St Idelfonso* (c.1631, Vienna), *The Martyrdom of St Liévin* (1635, Brussels, B-A), *The Road to Calvary* (1636, Brussels, B-A) and *Christ on the Cross* (1635, Toulouse, Augustines), and in mythological compositions in which his young wife figures: *The Judgement of Paris* (1632, London, NG).

In 1633, the Infanta entrusted him with a new diplomatic mission. In 1635, he fell ill and bought the manor house of Het Steen which he painted between 1635 and 1638 (London, NG). He painted many lyrical landscapes: *Landscape with Shepherds and Shepherdesses* (1635, Paris, Louvre), *Landscape with Rainbow* (c.1636, Munich) and *Kermesse* (c.1637, Paris), a swirling, *Brueghel-like composition. *The Garden of Love* (Prado and Dresden) anticipated *Watteau.

• In 1635, he designed the decorations in Antwerp to welcome the Cardinal Infant of Spain, who then appointed him court painter. He painted more family portraits with a happy mood: *Hélène Fourment and her Son Frans* (c.1635, Munich, AP), *Hélène Fourment and her Children* (c.1636, Paris, Louvre) and *The Little Pelisse* (c.1639, Vienna). *The Fall of the Titans* (1637, Brussels, B-A) and *The Consequences of War* (1638, Florence) retained all the vivacity of his art. *The Three Graces* (1639, Madrid) was still a celebration of Flemish nudes. In about 1640 Rubens painted his last work, *The Madonna with Saints* (Antwerp).

The undisputed master of pictorial art, Rubens trained dozens of pupils. His great skill at engraving allowed his work to be widely circulated. Admired and copied, his work inspired French painters such as Charles de La Fosse, Watteau, *Delacroix, *Cézanne and Renoir, as well as the British artists *Constable and Gainsborough.

APPROACH AND STYLE

Rubens painted in every genre: historical, religious, mythological, official and family portraits, self-portraits and landscapes. His paintings, both on canvas and wood, were of varying sizes. His genius was apparent in his paintings but even more so in his large-scale decorative cycles.

After his 'Romanist' training in Antwerp with its Classical tendencies, his interest in the Antwerp history painters and the work of Brueghel the Elder, he discovered the works of Titian and *Tintoretto in Venice. In Rome he became familiar with the art of antiquity and of the *Carracci, Bassano, Caravaggio and Adam Elsheimer, whom he probably met there. He also discovered the work of the great artists of the Renaissance, including *Michelangelo and *Raphael. He travelled to Mantua, Florence, London, Paris and Madrid.

As official court painter and portrait painter, Rubens worked for the Duke of Mantua, the Archduke Albert, the Genoese nobility, Ferdinand II of Tuscany, Marie de Médicis, Isabella of Spain, Charles I of England, Philip IV of Spain and the clergy.

• Rubens started out as a history painter. His compositions were well balanced, with sculptural effects; nevertheless, he did not reject Mannerist effects. But his early paintings were always marked by northern European naturalism. His drawing already conveyed the movement of forms.

A GREAT PAINTER

◆ A renowned artist during his lifetime, Rubens has remained famous in Europe ever since.

◆ The art of this first modern Baroque painter was the impetus for a long pictorial debate between draughtsmen and colourists.

◆ Rubens developed an idealized kind of history painting with realistic 'accessories'. His ability to revitalize themes and to present the same subject in various ways in all the different genres demonstrated his inexhaustible thirst for innovation.

◆ His formal language and rhythmic dynamism ensured that both the subject as a whole and each separate element were perfectly comprehensible, even in the profuse detail of the decorative cycles.

◆ Rubens was a skilful colourist who mastered every aspect of Baroque illusionism and displayed a rare artistic subtlety.

◆ In his paintings on wood, his white preparation enhanced the effects of glaze and transparency (*The Descent from the Cross*).

RUBENS

- His journey to Italy inspired him to use chiaroscuro effects of great sculptural and dramatic force, in which he incorporated the naturalism and luminous monumentality of Caravaggio's figures (*The Adoration of the Shepherds*).
- Having assimilated the art of the Renaissance, Rubens now revealed his own genius. His early style 'moved from contrasting violence to Classical appeasement' (J Foucart, 1999), from sculptural, dramatic force to a balanced composition based on the movement of lines and harmony of masses, and on precise, sweeping, eloquent drawing. The colours, at first bright and clear, became rich and simple, developing harmonies between red and blue, the white and silvery grey of the fabrics, and the light ochre and pink of the flesh steeped in a golden light (*The Descent from the Cross*). Here he finally brought together the Renaissance and Flemish traditions. His power and formal dynamism developed and blossomed. He revived the decorative academicism of the Carracci with a luminous, rich flow of colours typical of Venetian painting.
- Later his painting became more narrative and passionate. His decorative, monumental compositions were organized around ascending diagonals or swirling spirals. His vigour and freedom of imagination resulted in bravura pieces of painting whose colours were richer and warmer with a more spontaneous, animated movement. The flowing colours with their 'pre-Romantic' heightening do not diminish the overall understanding of the subject or the rhythmical unity of the whole (*The Life of Marie de Médicis*). Titian's warm colours become lyrical on Rubens's palette. The choice of tones, colour harmonies and the use of violet showed the artist's increasing boldness. His flowing colours, increasingly free, triumphed over formal organization (*The Adoration of the Magi*, Antwerp).
- Towards the end of his life, Rubens painted dramatic, lyrical landscapes with a cosmic, universal significance. His religious paintings pushed Baroque to extremes with a labyrinth of lines and shapes and the frenzied movement of colourful crowds of people (*The Massacre of the Innocents*). At the same time he painted his family with tenderness and freshness; and his sensual, languid nudes are bathed in a delicate, unifying light, on a par with those of Titian.

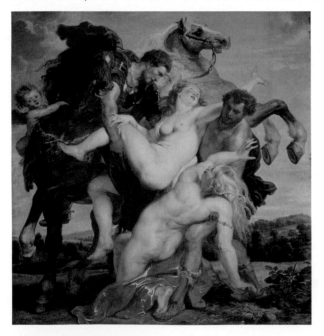

The Rape of the Daughters of Leucippus
c.1616. Oil on canvas, 2.22 x 2.09m, Munich, Alte Pinakothek

This painting – showing Castor and Pollux abducting two of the three daughters of Leucippus – illustrates Rubens's passage from Classicism to Baroque. The composition is balanced and calculated but with a vigorous ascending, diagonal movement, produced by coloured masses which create a new effect of dynamism. This vigour is accompanied by a feeling of pathos suggested by the opulent nudes (influenced by Venetian painting) who are being subjected to human brutality. The formal three-dimensional quality and realism of the detail are sumptuous. The immobility of the little Cupid and the peaceful landscape with its low horizon counterbalance and emphasize the impetus and lyricism of this event, which is painted in warm, dazzling, subtle colours.

The Arrival of Marie de Médicis in the Harbour of Marseille (from the cycle of **The Life of Marie de Médicis** in 21 scenes) 1622–5. Oil on canvas, 3.94 x 2.95m, Paris, Musée du Louvre

Marie de Médicis commissioned this cycle from Rubens. Although the preliminary sketches in Paris were his own work, he required the assistance of his collaborators in Antwerp to fulfil the commission. This picture combines the official character of the scene, historical reality and faithful portraits of the characters with a mythological world. His Baroque enthusiasm is seen in his poetic, allegorical eloquence, the dynamism of the off-centred composition, the powerful vitality of the sea monsters and opulent, physical mermaids and nymphs, and the rich, resonant colours. He used a light touch to portray the lace, fabrics, armour and water.

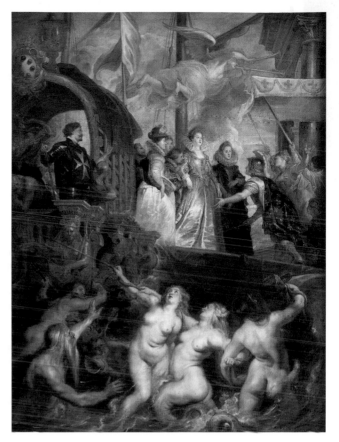

KEY WORKS

Rubens painted hundreds of paintings, ranging from huge cycles to paintings of everyday life.
The Circumcision, c.1607, Genoa, Sant'Ambrogio
The Erection of the Cross, 1610, Antwerp Cathedral
The Descent from the Cross, c.1612, Antwerp Cathedral
Jupiter and Callisto, 1613, Kassel, SK
The Lamentation of Christ, 1614, Vienna, KM
The Rape of the Daughters of Leucippus, c.1616, Munich, AP
Cycle of *The Life of Marie de Médicis*, c.1621–5, Paris, Louvre
Portrait of Marie de Médicis, c.1623, Madrid, Prado
Portrait of Susanna Lunden (?) (The Straw Hat), 1625, London, NG
The Adoration of the Magi, 1626–9, Paris, Louvre and Antwerp, B-A
The Martyrdom of St Idelfonso, c.1631, Vienna, KM
The Artist and Hélène in the Garden at Antwerp, c.1631, Munich, AP
The Road to Calvary, 1636, Brussels, B-A
Landscape with Rainbow, c.1636, Munich, AP
Kermesse, c.1637, Paris, Louvre
The Consequences of War, 1638, Florence, Pitti
The Three Graces, 1639, Madrid, Prado
The Little Pelisse, c.1639, Vienna, KM
The Madonna with Saints, 1640, Antwerp, Sint Jacobskerk

BIBLIOGRAPHY

Alpers, S, *The making of Rubens*, Yale University Press, New Haven, CT and London, 1995; Burchard, L, *Corpus Rubenianum Ludwig Burchard: an illustrated catalogue raisonné of the work of Peter Paul Rubens*, Phaidon, London and New York, 1968-86; Burckhardt, J, *Erinnerungen aus Rubens [Recollections of Rubens]*, translated by Mary Hottinger, Phaidon Press, London, 1950; Downes, K, *Rubens*, Jupiter Books, London, 1980; White, C, *Peter Paul Rubens: Man and Artist*, Yale University Press, New Haven, CT and London, 1987

poses and appearances reflected the psychology of his subjects, whom he captured with his rapid, brilliant technique (*Portrait of Isaac Abrahamsz Massa*).

• Between 1625 and 1630, Hals developed a style influenced by the clear Caravaggism of Utrecht. He lightened his palette, exploited the mobility of light and paint, and increased the realism of subjects which were often full of liveliness. He also increased the speed of his brush-strokes; the paint became fluid, light or thick, opaque or transparent, echoing the lively, free nature of the subject (*The Merry Drinker*).

• Hals then returned to subjects more austere both in their monumen-tality and in the colour range chosen for them. Although still influenced by the Dutch portrait tradition of Van Dyck, Hals sometimes emulated Rembrandt: the large figure of a sombre, sober dignitary would be placed against a neutral background of monochrome browns. The atmo-sphere was heavy, the sitter's presence intense and reverential, and the gestures elegant. His models are clothed in blacks enhanced by pure or silvery whites, always applied with broad brushstrokes (*Portrait of a Woman*).

• Between 1640 and 1650 he painted the professors and theologians of his generation. The aged, 'destructured' subject was reconstructed with blurred outlines. The brushstrokes became more disjointed and hesitant. The blacks and whites now included coloured reflections. A tense expres-sionism appeared in the eyes and hands.

• As regards group portraits, his first picture of 1616 had distanced itself from the Mannerism of Cornelis van Haarlem in its animation, its spatial expansiveness, the movement of the characters, the spontaneity of the poses and the true-to-life, fleeting expressions. The richness of the colours and the vigorous brushstrokes enhanced the dynamic effect of the painting (*The Banquet of the Officers of the St George Civic Guard*).

• 'Disorder' sometimes threatened his compositions (*The Banquet of the Officers of the Archers of St Adrian*). Hals then quickly restructured and clarified them at the risk of making his models look like statues. He maintained the angles of the heads and the complex interaction of the gazes but remodelled the outlines. The backgrounds became darker, including more blacks enhanced with silvery whites and orangey browns. On the other hand, the clothes became brighter with the use of orange, green, red and yellow colours (*The Officers of the Archers of St George*).

• The final group portraits, austere and dark, enhanced with touches of white, display a certain tension in the faces and eyes and even in the paint itself (*The Regentesses of the Old Men's Almshouse in Haarlem*).

KEY WORKS

209 paintings are known for certain to be by Frans Hals, of which 195 are portraits; 21 further paintings are attributed to him.

Portrait of a Man Holding a Skull, c.1611, Birmingham, BI

The Banquet of the Officers of the St George Civic Guard, 1616, Haarlem, Frans Hals Museum

Double Portrait of a Couple, 1622, Amsterdam, Rm

Portrait of Isaac Abrahamsz Massa, 1626, Toronto AG

The Banquet of the Officers of the Archers of St Adrian in Haarlem, 1627, Haarlem, Frans Hals Museum

Portrait of Verdonck, 1627, Edinburgh, NG

The Gypsy Girl, c.1628–30, Paris, Louvre

Portrait of Cornelia C Vooght, 1631, Haarlem, Frans Hals Museum

The Meagre Company, 1633–7, Amsterdam, Rm

The Regents of the St Elizabeth Hospital of Haarlem, 1641, Haarlem, Frans Hals Museum

Portrait of a Woman, 1648–50, Paris, Louvre

Portrait of a Man, 1660–6, Kassel, SK

The Regentesses of the Old Men's Almshouse in Haarlem, 1664, Haarlem, Frans Hals Museum

The Company of Captain Reynier Reael and Lieutenant C
M Blauew in Amsterdam, known as The Meagre Company
1633–7. Oil on canvas, 2.09 x 4.29m,
Amsterdam, Rijksmuseum

*This group of men, painted full-length and life-size, is one of a series
of eight paintings. Unfinished because of a disagreement with the
person who commissioned it, the painting was finally completed by
Pieter Codde (the part on the right).*

*Hals here demonstrates his absolute mastery of space, his skill at
characterization and his craftsmanship as a painter. He solved the
compositional problems which he had encountered before by
breaking up the scene with the oblique lines of the weapons, with the
varied, lifelike poses of the men and with movements of elbows,
hands and heads, and by establishing a natural rapport between the
individuals forming the group and the viewer, who is drawn into
their world. The men are dressed in black with brown, golden or
silvery reflections, lightened by refined shades of blue, yellow and
orange on a monochrome background. The brilliance of Hals's
brushstrokes breathes life into the characters and brings them alive.*

The Meagre Company
Detail: the Flag Bearer

*This detail is typical of the art of Frans Hals, who was then at the
peak of his success. The pose of the flag bearer, the sumptuousness of
the pale grey colours and the subtle reflections, together with the
rapid, lively painting technique, oscillate between realism and
Baroque. This figure caused *Van Gogh to exclaim in 1885: 'I have
rarely seen a more divinely beautiful figure. He is unique. Delacroix
would have been really taken by him ...'*

BIBLIOGRAPHY
Slive, S, *Frans Hals*, 3 vols, Phaidon, London, 1970–74; Slive, S, *Frans Hals*, exhibition catalogue, Prestel, Munich,
1989

Pietro da Cortona

A painter and architect at the service of the Catholic Church during the triumphant period of the Catholic Reformation (the Counter-Reformation), Pietro da Cortona played a vital role in Roman Baroque from a pictorial, decorative and theatrical point of view and – with his ability to make his decorative works fit in with their surroundings – from an architectural point of view. His means of expression were in keeping with the new grandeur of the clergy. His frescoes were the work of a genius: he created unreality and sumptuousness by means of a profusion of colours and forms set freely in space.

LIFE AND CAREER

• Pietro Berrettini da Cortona (Cortona, Tuscany, 1596–Rome 1669) was born into a family of craftsmen and artists. He was trained in Florentine Classicism by Andrea Commodi, and followed his master to Rome in 1612. With Baccio Ciarpi, he discovered the art of the Classical Renaissance and drew on the style of the artists of antiquity. He then turned to the Baroque style of Giovanni Lanfranco.

• He first painted Classical frescoes, tinged with a new expressiveness, such as those of the Villa Arrigoni (c.1616, Frascati).

• His Baroque language evolved in about 1624: *The Sacrifice of Polyxena* (Rome, Capitoline), *The Triumph of Bacchus* (Rome, Capitoline), *The Oath of Semiramis* (London, Mahon Collection) and *The Life of Solomon* on the ceiling of the Palazzo Mattei (Rome), inspired by *Titian and *Rubens. His decoration of the church of S Bibiana (1624–6), encouraged by his patrons Barberini and Sacchetti, brought him great success. Pietro then began to produce numerous frescoes and altarpieces: frescoes in the Villa Sacchetti (1626–9, Castelfusanno), *The Rape of the Sabines* (1629, Rome), which combines Baroque splendour and Classical elements, *The Madonna and Child with Four Saints* (1628, Cortona, church of S Agostino) and *Venus as Huntress Appears to Aeneas* (1630–5, Paris).

• At the height of his career he was appointed director of the Academy of St Luke (1634–8). He painted *The Triumph of Divine Providence* on the ceiling of the Palazzo Barberini (1633–9, Rome), a prime example of illusionistic, theatrical Baroque. He was also asked to decorate the church of S Lorenzo, the Chiesa Nuova and the Vatican.

• In 1637 Pietro went to Florence where he worked for Ferdinand II, Grand Duke of Tuscany, decorating the Pitti Palace: *The Four Ages of Man* (1637 and 1640, Sala della Stufa), fresh, well-balanced frescoes, and *Venus, Jupiter, Mars, Apollo* (1641–7, Rooms of the Planets), which are perfectly integrated into a décor dominated by gilt and white stucco.

• During his final period he was in Rome again, from 1647 until his death. He painted the cupola of the Chiesa Nuova (1648–51) and the *Story of Aeneas* (1651–4, Palazzo Doria Pamphili), which he adapted to the Baroque architecture of Borromini. He then began to concentrate more on architecture. He prepared cartoons for mosaics for St Peter's (1651), oversaw the decoration of the Palazzo Montecavallo, decorated the cupola and apse of the Chiesa Nuova (1655–60) with an *Assumption of the Virgin*, and painted the vault of the nave on the subject of *The Vision of St Philip Neri during the Construction of the Church* (1664–5), his last fresco painting.

• His altarpieces also contained Baroque innovations: *The Nativity of the Virgin* (1643, Perugia, GN), *Romulus and Remus Brought Back by Faustulus* (1643, Paris), *St Charles Borromeo Carries the Holy Nail among the Plague Victims* (1667, Rome) and a last altarpiece for the church of S Ignacio (1669, Pistoia).

• He painted a small number of Classical landscapes including *Landscape with Bridge* (1625, Rome, Capitoline) and *Landscape with Boats* (1625, Rome, Capitoline).

The art of Pietro da Cortona was not taken up by his pupils Giovanni Francesco Romanelli or Ciro Ferri. During this same period, *Poussin in Rome favoured a purely Classical style, while Charles Le Brun in Paris made a few Baroque attempts combined with a Poussinesque style. Pietro inspired the masterpieces of the Roman artists Giovanni Battista Gaulli, also known as Baciccia, and Andrea Pozzo and, outside Rome, Luca Giordano and Gregorio de Ferrari. In the following century his influence is seen in the works of Giovanni *Tiepolo. These artists absorbed his aesthetic approach, keeping it alive and spreading it for over a century.

APPROACH AND STYLE

Pietro da Cortona painted the themes of the Catholic Reformation (martyrdom, visions, the glorification of the Popes) with a rhetoric rich in allegories, emblems, metaphors and symbols. He also painted mythological and secular subjects. As well as his frescoes on ceilings and on the vaults of churches, he also produced easel paintings and altarpieces.

His patrons included the Barberini family, several Popes (Urban VIII, Innocent X, Clement IX) and also private sponsors (Cassiano dal Pozzo, the Marchesi di Sacchetti), the Frenchman La Vrillière and Ferdinand II, Grand Duke of Tuscany.

Trained in Rome by the Classical Florentine painters, Pietro in addition copied the art of antiquity, *Raphael and Polidoro da Caravaggio, the famous decorative artist of the first half of the 16th century whose work influenced Baroque artists. Pietro was also inspired by the Baroque style of Giovanni Lanfranco and Rubens, as well as the renascent art of *Veronese and Titian, before he turned to Annibale *Carracci, the master of the Farnese Gallery, for inspiration.

• Between 1616 and 1624 he took as a model the frescoes painted on façades by Polidoro da Caravaggio. The latter's enthusiastic, amazingly free style, his 'expressionism' and realism inspired Pietro after 1624. His frescoes remained Classical in their choice of subject, balanced composition and technique (*The Dawn*).

• From 1624, Pietro showed interest in the Baroque art of Lanfranco, which incorporated the complicated perspectives and bold foreshortenings of *Correggio. He appreciated Rubens's Baroque dynamism, the Venetian colouring of Veronese and that of the Bacchanals of Titian, who was a dominating presence in Rome. Pietro painted pictures endowed with dignified heroism, still Classical but treated with energy and a great freedom in the use of colours (*The Triumph of Bacchus*, 1624). He also concentrated on portraying 'pure' landscapes depicting serene nature.

• Pietro continued to oscillate between Raphael's Classicism and the unrestrained nature of the Baroque (*The Rape of the Sabines*). As a result of his training and in his quest for ideal beauty and Classical equilibrium, he combined the solidity of Roman drawing, the elegance of the Florentine line and the clarity of Venetian colours (*The Four Ages of Man*). Light was a constant element in his art and he continued in this direction at the same time as his style became more Baroque.

• In the 1630s, his Baroque paintings were marked by grandiloquence, unbounded imagination, movement and a profusion of decorative elements. In *The Triumph of Divine Providence* he reached the peak of his art. By means of bustling, lively representations of heroic subjects, Pietro wanted to dazzle, surprise, persuade and charm the viewer. He preferred the eternal and universal to small details, which he translated into an allegorical, symbolic language. He rejected realism because it ran counter to the imaginary and the unreal, to which he aspired.

• In his Baroque compositions, Pietro was clearly inspired by the illusionism of Annibale Carracci, which was based on the tangible rendering of pictorial space. He abandoned

A GREAT PAINTER

◆ Pietro da Cortona was a famous painter at the service of the Popes of the time. His art had its followers until the 18th century. He was little known by the general public.

◆ He became the most representative and most eminent figure of Baroque art. But his quest for ideal beauty was inspired by his desire to achieve Classical equilibrium.

◆ He raised the heroic themes of the Catholic Reformation to epic status. He depicted the new subject matter of divine providence.

◆ The decorative, monumental, illusionistic composition of his frescoes was based on a swirling spiral or an ascending diagonal, adapted to the architecture of the setting.

◆ Pietro used rich colours to make fantasy and the imaginary believable, in an unrivalled dynamism in which the overall vision was more important than the detail.

◆ He was a genius at combining painting, sculpture, both real or imitation (*quadratura* – foreshortening and perspective effects – and stucco), and architecture. His use of light was the unifying element of Baroque art.

◆ He also excelled in the art of fresco painting. The wide, fluent brushstrokes in his frescoes and the impasto in his paintings on canvas added dynamism to his creations.

PIETRO DA CORTONA

painting within added frames in order to create a total illusion across the entire painted space; although he did sometimes compartmentalize the architectural space and fit his painting into it. Gilt or white stucco, illusionistic or painted, blend in with the composition, whose scale is always larger than life. Motifs and figures, caught up in the general movement, stand out against the light background. The decoration extends over large surfaces and the drapery swirls about in apparent disorder. However, the exchange of looks and gestures between the figures adds unity to these Baroque compositions.

• The unstable space deepened while the illusionistic perspective opened up architectural vistas. Optical illusion and trompe l'œil blurred the boundaries between painting, sculpture and architecture. Sensual, brilliant drawing incorporated numerous foreshortened, twisted figures within the décor. Forms became entangled, describing curves and counter-curves. The changing light, sometimes dramatic and sometimes heavenly, was dazzling, revealing warm, lyrical colours; the juxtaposed areas of colours acquired solidity through broad, thick brushstrokes.

• In his final decorative paintings, Pietro separated the coffered architecture and decorative stucco from the purely pictorial part (*The Vision of St Philip Neri*). The light, clear shades of his ceilings heralded the new Baroque illusionism, in which the viewer seems to gaze into an azure infinity. His easel paintings showed the same aesthetic reinvention.

KEY WORKS

Pietro da Cortona painted numerous canvases and vast ceilings.
The Triumph of Bacchus, 1624, Rome, Capitoline
Landscape with Bridge, 1625, Rome, Capitoline
The Rape of the Sabines, 1629, Rome, Capitoline
The Triumph of Divine Providence, 1633–9, Rome, Barberini Palace
Venus as Huntress Appears to Aeneas, 1630–5, Paris, Louvre
The Four Ages of Man, 1637–41, Florence, Pitti Palace
Romulus and Remus Brought Back by Faustulus, 1643, Paris, Louvre
Cupola of the Chiesa Nuova, 1648–51, Rome
The Story of Aeneas, 1651–4, Palazzo Doria Pamphili
The Assumption of the Virgin, 1655–60, Rome, Chiesa Nuova (also called S Maria in Vallicella)
The Vision of St Philip Neri during the Construction of the Church, 1664–5, Rome, Chiesa Nuova
St Charles Borromeo Carries the Holy Nail among the Plague Victims, 1667, Rome, church of S Carlo ai Catinari

BIBLIOGRAPHY

Briganti, G, *Pietro da Cortona o della pittura barocca*, 2nd edn, Sansoni, Florence, 1982; Campbell, M, *Pietro da Cortona in the Pitti Palace: a study of the Planetary Rooms and related projects*, Princeton University Press, Princeton, NJ, 1977; Scott, J B, *Images of Nepotism: the Painted Ceilings of Palazzo Barberini*, Princeton University Press, Princeton, NJ, 1991

The Triumph of Divine Providence

1633–9. Frescoes, Rome, Barberini Palace, ceiling of a drawing-room

At the request of the Barberini family, Pietro here glorified the pontificate of Urban VIII. The scholar Francesco Bracciolini devised the subject matter to be depicted: 'The triumph of divine providence and the achievement of its aims through the spiritual power of the Pope.' The treatment mixed the symbols of triumphant Catholicism (large bees crowned with laurel, symbolizing the temporal and spiritual power of the Barberini family) and those of Classical mythology (Chronos). Divine providence is enthroned in the centre, above the clouds. The use of a monumental style combined with references to the authority of the Barberinis and mythology lends a feeling of verisimilitude to this visually surprising work of imagination and fantasy. The forms swirl freely and move beyond the architectural frame, which is represented in trompe l'œil.

The apparent opening through to the sky, the breeze blowing the drapery, the crowds of symbolic figures and the circles of cherubs, seen from below, give the illusion that the imaginary, ideal world is bursting into the real world through the power of the Pope. In this scene of jubilation, the lively, golden light with its unifying effect enhances the colours and arranges the masses in a harmonious pattern of general movement. The overall effect is sumptuous and swirling

Poussin

Poussin was the personification of French Classicism. Solitary, demanding and respected, he developed a scholarly, poetic, sensitive style. He combined a Christianity tinged with stoicism and a poetic pantheism. He advocated careful drawing, balanced composition, restrained emotions and an emphasis on figures moving in an 'ideal' landscape. He used pure, but never exuberant, colours with a smooth texture.

LIFE AND CAREER

• The French painter Nicolas Poussin (Les Andelys 1594–Rome 1665) worked briefly in the workshops of Quentin Varin, Noel Jouvenet, Ferdinand Elle and Georges Lallemand. In 1622 he was commissioned to paint his first religious paintings in Paris. He worked with Philippe de Champaigne on the decorations of the Palais du Luxembourg. He became acquainted with the Italian poet Gian Battista Marino, who recommended that he visit Rome.

• During his first stay in Rome (1624–40), Poussin met Cardinal Francesco Barberini, the nephew of Pope Urban VIII, for whom he painted *The Death of Germanicus* (1628, Minneapolis). He also became friendly with Cassiano dal Pozzo, who was passionate about antiquity. Poussin sought, received and carried out large official commissions, which were unsuccessful: *The Martyrdom of St Erasmus* (1627, Rome).

• Between 1627 and 1633, he decided to execute easel paintings for private collectors. These included religious subjects such as *The Massacre of the Innocents* (c.1628–9, Chantilly) and *Lamentation over the Body of Christ* (c.1629, Munich, AP), melancholic themes such as *Echo and Narcissus* (c.1627, Paris, Louvre), poetic subjects (*Inspiration of the Poet*, c.1630, Paris, Louvre) and tragic subjects (*Tancred and Erminia*, c.1631, St Petersburg, Hermitage). He painted numerous scholarly allegories such as *The Death of Adonis* (c.1627, Caen, B-A), *The Triumph of Flora* (c.1627, Paris) and *The Empire of Flora* (c.1631, Dresden, Gg). His theatrical style was based on his observations of human passions. After a serious illness, he married Anne-Marie Dughet in 1630; she was the sister of his pupil, the landscape painter Gaspard.

• In around 1634–6 his reputation crossed the Alps. Cardinal Richelieu commissioned him to paint mythological paintings: *The Triumph of Pan* (London, NG), *The Triumph of Bacchus* (Kansas City Museum) and *The Triumph of Neptune* (c.1636, Philadelphia). He created large historical compositions including *The Adoration of the Golden Calf* (c.1633–6, Paris, Louvre), *The Rape of the Sabines* (c.1637, Paris, Louvre) and *The Israelites Gathering Manna in the Desert* (1637–9, Paris, Louvre). *The Shepherds of Arcadia* (c.1638–40, Paris, Louvre) symbolized his ideal, poetic aspirations. He began working on the series *The Seven Sacraments* (1636–40, Washington), inspired by antiquity.

• At the request of Richelieu, he was appointed first painter to the king in 1640 and went to Paris, but the works he was commissioned to carry out were too imposing and did not suit him: *The Institution of the Eucharist, Time Revealing Truth* (Paris, Louvre) and the decoration of the Great Gallery of the Louvre (unfinished). He was a victim of Parisian rivalries, particularly on the part of Simon Vouet, and left Paris. However, he remained in contact with many collectors, including Paul Fréart de Chantelou.

• In Rome from 1643, he confirmed his reputation with *The Seven Sacraments*, second series (1644–8, Edinburgh, NG), produced for Chantelou, and *The Judgement of Solomon* (1649, Paris). The painter's demanding, austere character is revealed in his *Self-Portrait* (1650, Paris).

• Attracted to the philosophy of stoicism, more especially that of Seneca, he painted the *Lives of Plutarch* and *The Story of Phocion*, which consisted of two paintings, one of which is the *Landscape with the Funeral of Phocion* (1648, Plymouth Collection, Oakley Park). After the 1640s the 'ideal' landscape became a subject in its own right for Poussin. *Landscape with St John on Patmos* (c.1644–5, Chicago, AI), *Landscape with Man Running from a Serpent* (1648, London, NG), *Landscape with Pyramus and Thisbe* (1651, Frankfurt, SK), *Landscape with Diana and Orion* (1658, New York) and the complex *Four Seasons* (1660–4, New York) all reveal the artist's dedication to pantheism. Poussin painted his last painting, *Apollo and Daphne*, in 1665 (Paris, Louvre).

A 'painter-draughtsman' on the margins of contemporary taste, Poussin worked on his own. He trained no pupils and he was not directly copied. However, he did influence contempo-

rary French artists in their Classicism: Sébastien Bourdon, Laurent de la Hyre and later Charles Le Brun. His art played an important part in the development of Neoclassicism at the end of the 18th century. It influenced *Ingres, *Delacroix, *Cézanne and *Picasso.

APPROACH AND STYLE

Poussin painted religious and historical subjects and themes from antiquity, at first in large and later in medium formats. He produced landscapes and bucolic scenes inspired by Latin odes or contemporary literature. He was more comfortable with the private patronage of Cassiano dal Pozzo, Vincenzo Giustiniani and Paul Fréart de Chantelou than with the official commissions of Cardinal Barberini and Louis XIII.

Poussin preferred Rome to Paris. In Rome he drew models from antiquity, copied *Titian's *Bacchanals* and studied *Raphael. As a 'painter-philosopher-scholar', he leaned towards reason and the 'ideal' and was therefore opposed to the approach of *Caravaggio. He was inspired by the decorative schemes of the second school of Fontainebleau, represented by Toussaint Dubreuil, Ambroise Dubois and Martin Fréminet. He despised the small-scale Flemish and Dutch painters.

• Poussin's art was based on deep reflection: 'Subject matter must be used only if it is noble. One must start with the arrangement, then follow it by adding ornamentation, decoration, grace, vivacity and costume, using accuracy and judgement in everything. These last two come from the painter himself and cannot be learnt. It is Virgil's golden rod [inspiration from antiquity], which no one can find or take up unless guided by fate.'

• His method was very personal: he first looked for the 'conception of the idea', which he studied and pondered; then he combined it with a particular three-dimensional arrangement, considering the number of characters, composition, poses, rhythm and colours. He produced shaded sketches or wash drawings, and positioned little wax or earthenware figures in a kind of theatre to establish his design. Finally, Poussin would begin painting on a red or sometimes light-coloured preparation, going through four stages. He outlined the architecture of the composition with a ruler and compass, incising them into the preparation. Then he positioned his characters according to identical vanishing points and painted each element individually. He applied his thinly-textured colours in light coats, without glaze.

• During his early period, from 1627 to 1633, Poussin's inspiration was poetic, allegorical and scholarly, freely interpreted in flowing lines with warm, bold colours (*The Triumph of Flora*). He personalized each composition according to his feelings, but his arrangement was always Classical, pyramidal or in bas-relief. He rejected illusionism. Very soon he came to glorify human emotion (*The Massacre of the Innocents*). After 1630 he produced some quickly executed paintings.

• His great historical paintings of 1635 were solemn, well-balanced compositions with

A GREAT PAINTER

◆ Appreciated during his lifetime by a small number of enlightened admirers, Poussin was a firm supporter of drawing in painting, exemplified by *Raphael; he was opposed to the Venetian colourists and the Flemish painter *Rubens. He thus initiated a stylistic argument leading to a fundamental debate which was to preoccupy artists until the 19th century. His works were sometimes admired and sometimes rejected depending on the times, but they still form a point of reference today.

◆ A model of French Classicism (and 18th-century Neoclassicism), Poussin was only distantly connected with the Baroque aesthetics fashionable in Rome at the time. His art reflected his sensitivity and his philosophy.

◆ Poussin created original series of works while remaining respectful of the Christian doctrine and liturgy. He established himself as one of the creators of the 'ideal' landscape, following on from the Italians *Carracci and Domenichino. His complex treatment of his subjects had to be read on several levels: religious, mythological, allegorical and Classical.

◆ His compositions were always based on equilibrium and stability, even when the animated poses of the figures were presented in a theatrical manner.

◆ Poussin's technique was extremely rigorous: he developed his subject intellectually, then defined it and constructed it with the help of drawings and models before he started painting.

POUSSIN

intense but controlled feelings (*affetti*) and figures with animated faces and gestures (*The Rape of the Sabines*). Other paintings inspired by antiquity showed characters whose three-dimensional qualities were conveyed by the drapery of their clothes, with idealized bodies and faces, painted in cold colours (*The Seven Sacraments*).

• *The Treatise on Passions*, published after the artist's death, was the result of his lectures and thinking: in it he stressed the link between painting and poetry and discussed the expression of the passions – his most important contribution to Classical theory and a reflection of a Latin poem by the French painter and theoretician Charles Alphonse Dufresnoy (*De' Arte grafica*, translated by Roger de Piles in 1668). Quoting the saying 'Ut pictura poesis', Dufresnoy declared that 'painting and poetry are sisters'. Poussin also saw himself in the tradition of Descartes, who had published *The Passions of the Soul* in 1649.

• In his mature period, from 1642 onwards, his interest in morality and stoicism were reflected in themes from the New Testament and Roman history. His images were monumental and austere, with a perfect symmetry, pure lines and firm modelling. The faces were serious and the gestures expressive; the scenes were enlivened by the use of bright colours (*The Judgement of Solomon*).

• Nature played an important part in Poussin's work. Omnipotent and omnipresent, it came to symbolize the artist's aspiration to a particular ideal. Poussin used sketches made on the spot, notes and drawings to recreate an intellectual landscape constructed according to the laws of perspective. He included small figures (*Landscape with Man Running from a Serpent*). The landscape became more monumental and lively while the figures became simple forms frozen in the face of the eternal force of nature (*Landscape with Diana and Orion*).

• In 1655 the artist's hand began to shake. To compensate for his inability to draw a continuous line, he changed to a technique consisting of commas and dashes, using a broad brush with which he could handle sensitive vibrations (*The Four Seasons*).

KEY WORKS

Poussin painted about 200 paintings and produced 450 drawings.
The Martyrdom of St Erasmus, 1627, Rome, Vatican
The Triumph of Flora, c.1627, Paris, Louvre
The Death of Germanicus, 1628, Minneapolis, IA
The Massacre of the Innocents, c.1628-9, Chantilly, Condé Museum
The Triumph of Neptune, c.1636, Philadelphia, MA
The Adoration of the Golden Calf, c.1633-6, Paris, Louvre
The Rape of the Sabines, c.1637, Paris, Louvre
The Shepherds of Arcadia, c.1638-40, Paris, Louvre
The Seven Sacraments, 1644-8, Edinburgh, NG
The Judgement of Solomon, 1649, Paris, Louvre
Self-Portrait, 1650, Paris, Louvre
Landscape with the Funeral of Phocion, 1648, Plymouth Collection, Oakley Park
Landscape with Pyramus and Thisbe, 1651, Frankfurt, SK
The Death of Sapphire, c.1654-6, Paris, Louvre
Landscape with Diana and Orion, 1658, New York, MM
The Four Seasons, 1660-4, Paris, Louvre
Apollo and Daphne, 1665, Paris, Louvre

The Shepherds of Arcadia
c.1638–40. Oil on canvas, 85 x 121cm, Paris, Musée du Louvre

*Several characters are reading an inscription engraved on an ancient
tomb set in a landscape: 'Et in Arcadia ego', which could be translated
as: 'I, Death, exist even in Arcadia'. This painting symbolizes the
aesthetic and philosophical aspirations of the painter: 'My natural
disposition compels me to look for and love well-ordered things, fleeing
from confusion which is my complete opposite and as hostile to me as
light is to darkness.'*
*In this painting Poussin declared his Classicism and his love of
antiquity. The perfectly balanced composition, centred around a tomb
set in an idyllic landscape, shows four characters: three shepherds and
the Allegory of 'Felicity subject to death' (G. Bellori, 1672). This figure
of a woman is standing in the foreground, beautiful, imposing and
austere, pushing the three masculine characters, who are more
accessible with their relaxed poses, into the background. Her face, like a
bas-relief from antiquity, is shown in profile, and its timelessness
contrasts with the astonished expressions and questioning hand
gestures of the other figures.*
*The enchanting landscape is shown as a place of happiness and
perfection; nevertheless, it exudes an atmosphere of measured
melancholy that envelops the figures. The light gracefully emphasizes
the gestures rather than the bodies, causing the gestures to stand out
against the dark background of the tomb. As we contemplate this
improbable group set in this imaginary natural landscape, a first
impression of poetic grace is soon replaced by one of silent meditation.*

BIBLIOGRAPHY

Blunt, A, *Nicolas Poussin*, revised edn, 2 vols, Pallas Athene, London, 1995; Blunt, A, *The Paintings of Nicolas Poussin: A Critical Catalogue*, Phaidon, London, 1966; Friedlaender, *Nicolas Poussin: a new approach*, Thames and Hudson, London, 1966; Friedlaender, W and Blunt, A, *The Drawings of Nicolas Poussin: Catalogue Raisonné*, 5 vols, London and Leipzig, 1939–74; Pace, C, *Félibien's Life of Poussin*, Zwemmer, London, 1981

La Tour

The humane, spiritual work of Georges de La Tour contrasts with his material greed and violent temperament. His daytime scenes with their light colours and realism, reminiscent of Caravaggio, show respect for human dignity and underline the physical and psychological frailty of his characters. The very individual chiaroscuro of his 'nocturnal' scenes simplifies the picture planes and immobilizes the pale or sometimes reddish figures. Candle light conveys soberness, silence, drama and Christian hope.

LIFE AND CAREER

• There is little accurate information about the life of Georges de La Tour, a French painter from Lorraine (Vic-sur-Seille, near Metz, 1593–1652), and even less about the dates of his paintings. The son of a prosperous baker, he is believed to have trained as a painter in Nancy in Lorraine. Between 1610 and 1615 he is thought to have travelled to Rome and between 1615 and 1620 to Utrecht. Both cities were centres of luminist art and Caravaggism, whose main practitioners were the Italian Carlo Saraceni and the Dutchman Gerrit van Honthorst. He may also have become acquainted with these trends through artists moving around and their works being circulated.

• By his marriage in 1617 to the aristocratic Diane Le Nerf, the daughter of a treasurer of Henri II, Duke of Lorraine, he became a bourgeois of Lunéville, where he then settled. Prosperous and enjoying many privileges, he became famous, and in 1623 Henri II, Duke of Lorraine, commissioned several paintings from him (now lost).

• Between 1631 and 1635 he was in the midst of and affected by such events as the Thirty Years' War, riots, epidemics, rural famine and the rebellion of the peasants in Lorraine.

• In his first period, before 1638, he painted daytime scenes reminiscent of Annibale *Carracci's naturalistic pictures – The Pea-Eaters (Berlin museums) – and other works marked by a Caravaggesque realism which also included Italian and Flemish elements; in these works he recorded physical decline: The Old Man and The Old Woman (both before July 1624, San Francisco), The Hurdy-Gurdy Player with a Dog (Bergues), St James the Less (Albi, Toulouse-Lautrec Museum), the famous Musicians' Brawl (c.1625–30?, Malibu), St Jerome Penitent (Stockholm and Grenoble, B-A), in which St Jerome is shown naked, decrepit and hurt by the ropes, The Tears of St Peter (lost), St Thomas (Albi, Toulouse-Lautrec Museum) and The Hurdy-Gurdy Player (c.1631–6?, Nantes). The Fortune Teller (New York), The Cheat with the Ace of Clubs (Geneva, private collection) and The Cheat with the Ace of Diamonds (c.1625, Paris) portray old age and cunning.

• He probably moved to Paris in about 1638–42? to escape the fire of Lunéville (1638), which destroyed part of his work. Concerned about his artistic career, he swore loyalty to the French and Louis XIII when Charles IV, Duke of Lorraine, abdicated. La Tour is mentioned in 1639 as 'painter in ordinary to the King'. He is believed to have painted a St Sebastian for Louis XIII and a St Jerome for Cardinal Richelieu.

• Back in Lunéville in 1643, he began painting his nocturnal scenes: Boy Blowing at Lamp (Dijon, B-A), St Joseph the Carpenter (early 1640s, Paris), the enigmatic The Dream of St Joseph (early 1640s, Nantes) and The New-Born (1645–8, Rennes). He painted several repentant Magdalenes: The Repentant Magdalene, also known as Magdalene Fabius (Washington), The Magdalene with Two Flames, also known as Magdalene Wrightsman (New York, MM) and The Magdalene with the Smoking Flame, also known as Magdalene Terff (Paris). The subject and composition of Job and His Wife are surprising: the bulk of an enormous female form clad in red dominates a meek, curled-up man. He painted further nocturnal scenes: The Adoration of the Shepherds (1644?, Paris), St Sebastian Tended by St Irene (c.1649, Paris), The Tears of St Peter (1645, Cleveland), The Denial of St Peter (1650, Nantes, B-A) and St Alexis (1648, lost). The enigmatic subject of The Woman Catching a Flea (Nancy) is shown engrossed in an intimate occupation, thus turning the viewer into a voyeur.

• Georges de La Tour died of the plague at the height of his fame.

An artist famous in Lorraine and Paris, La Tour was also financially and socially successful. After his death, his son Étienne and his workshop continued to receive commissions but produced work of only average quality.

APPROACH AND STYLE

La Tour painted daytime and nocturnal scenes in oil on canvas. He painted many versions of works on a deliberately restricted range of subjects – religious scenes, genre and devotional scenes – often in a horizontal format and life-size. He did not set his characters in landscapes or interiors; nor did he draw any architecture or halos and wings for his angels. There are no known portraits or drawings by him.

He painted for Henri II, Duke of Lorraine, and for King Louis XIII.

In Lorraine, La Tour became acquainted with the complex poetic Mannerism of Jacques Bellange's daytime and nocturnal pictures and the work of Jean Leclerc, a pupil of the Caravaggist Italian painter Carlo Saraceni (who had returned to Nancy from Italy in 1620). During the journeys he is believed to have made to Rome and Utrecht, La Tour may have discovered *Caravaggio and the Caravaggism of the Dutch painters Gerrit van Honthorst, Daniel Seghers, Hendrick Terbrugghen, Matthias Stomer and Dirck van Baburen, as well as the naturalism of Annibale Carracci. In Lunéville, where he was ennobled, and then in Paris in about 1630, he became acquainted with the trend towards realism and the final examples of Mannerism in the 'nocturnal' style.

• Before 1638, La Tour's daytime scenes revealed Caravaggio's influence in the choice of subject, the composition, the realistic, luminist treatment and the work's poetic and spiritual dimensions. These works are also reminiscent of the clear, naturalistic style of Dutch Caravaggism. He painted the 'vile and horrifying truth' (P Mérimée) in clear, refined colours. Without derision, complacency or picturesqueness, La Tour portrayed his vision of an ugly, miserable world with a moving, merciless realism. The formal expression of the faces and the formal poses are contradicted by the activity of the hands and the power of the gazes exchanged between the characters.

• In his final daytime scenes, including *The Fortune Teller*, he denounced the farcical ideas of illusion, beauty, wealth and love with seriousness and irony; yet his brilliant craftsmanship highlighted the elegance of the jewellery and fabrics. The meditating saints and the penitents remind the viewer of the existence of moral laws, the vanity of material things and the stoicism which emerged at the time of the misfortunes which affected Lorraine. This realistic approach – set in a cold, clear light – was inspired by the Dutch painters but also 'by Mannerist art as reflected in the brilliant finish, the exquisiteness of the shades, the refined brushstrokes and a certain descriptive eloquence' (R Fohr, 1968). La Tour's style developed in the direction of a simplification of planes and a monumental stylization of the figures, reaching a peak in his nocturnal scenes.

• 'The inner tension of the nocturnal scenes ...' (J Thuillier, 1973), the reddish and brown atmosphere caused by the artificial light of a poor candle – symbolic of the passage of time – whose flame might be visible or concealed, immobilized the bodies and gazes of the

A GREAT PAINTER

◆ A famous painter in his own time, La Tour fell into oblivion after his death. In 1915, H Voss 'rediscovered' him. Ever since the exhibition at the Orangerie 'Peintres de la réalité en France au XVIIe siècle' (Painters of Reality in 17th-Century France) (1934) and one entirely devoted to the painter (1972), his art has enjoyed worldwide success.

◆ La Tour was influenced by the Mannerism of Lorraine and Paris, by realism and by Italian, Flemish and Caravaggesque luminism; out of these he developed a very personal sculptural style.

◆ The painter portrayed homely scenes, which he endowed with an ambiguity and poetic mystery that has endured to this day.

◆ When dealing with more Classical subjects, he added innovations in the poses used (the crossed hands of St Peter) and introduced an unusual range of subject matter, either local to Lorraine (*St Alexis, The Hurdy-Gurdy Player*) or of topical interest, set against a background of war and drama.

◆ His summary preparation of the canvas had no effect on the smooth texture of his painting or the quality of the finish.

◆ The originality of his work was due to his simplification of planes, the effect produced by candlelight, and the soberness of his palette and monochrome backgrounds; even in the violence of their interaction, the characters seem frozen in silence and immobility, imprisoned in deep contemplation. His paintings portray a moving, stoical tension, a moral and spiritual quest.

characters. The light turned forms which had become timeless into stylized 'Cubist' shapes, paring down and provoking emotion. The coloured impasto disappeared in favour of a smooth surface which invited the viewer to follow the track of light laid down by the painter. This aura endowed the often anonymous figures with a real presence. The juxtaposition of a child and an old man was enough to add a poetic, metaphysical dimension to a scene. La Tour's final religious paintings revealed a pessimistic solemnity. The artist also reduced his range of colours: a few touches of blue, yellow and green around the often bold reds emphasized the contrast.

● 'La Tour thus moved from a brilliantly descriptive art, not without archaism and clumsiness, towards a more synthetic language, full of restraint and mastery, characterized by a soberness and monumentality of form, a reverence in gesture and expression, a concentration of luminous effects and a unity of the whole achieved by a quality of "silence" which is very much his own' (R Fohr).

The Hurdy-Gurdy Player
c.1631–6? Oil on canvas,
162 x 105cm, Nantes, Musée des
Beaux-Arts

Also known as The Hurdy-Gurdy Player with the Hat *or* The Hurdy-Gurdy Player with the Fly – *a reference to the life-sized insect near the pink ribbon on the instrument – this painting was much admired by Mérimée and Stendhal. Far from being a picturesque representation, this daytime scene displays a pitiless realism which highlights the vulnerability and the affecting physical decline of this poverty-stricken old man with his misshapen mouth, deep wrinkles and unkempt beard and hair. The natural light freezes the character in a sober range of beige and orange shades, against a neutral but detailed background. Only the red patch of the hat breaks the harmony of the shades. La Tour gave the same extreme expression to* The Fortune Teller, *whose colour range is based on browns and reds, enriched by the brilliant polychromy of the details. The intentionally exaggerated realism and brilliant brushstrokes of this painting are typical of La Tour's early works.*

BIBLIOGRAPHY
Nicolson, B and Wright, C, *Georges de La Tour*, Phaidon, London, 1974; Thuillier, J, *Georges de La Tour*, Flammarion, Paris, 1992

The New-Born
Between 1645 and 1648. Oil on canvas, 76 x 91cm, Rennes, Musée des Beaux-Arts

*In this intimate, silent 'nocturnal' scene bathed in a reddish light, the new-born child,
illuminated by an ethereal white light, seems to have been touched by God's grace, while the
mother watches solemnly over it. 'Tightly wrapped in its swaddling clothes […] the child is
merely a promise of life, protected by the women. There is no joy in its presence, not even a
smile: only gravity in the presence of a destiny begun in this world of illusion and suffering.
But beyond any thought, and more effectively than any words, La Tour here speaks of maternity
and the link – part possession, part solicitude and part hope – between life which has been
fulfilled and life which is beginning' (J Thuillier, 1973). Perhaps La Tour is expressing his own
suffering as a father devastated by the many deaths among his children; or perhaps it is a
Nativity in which the Infant Jesus is tended by the Virgin and St Anne. La Tour does not use
any traditional sacred references, yet there is an air of holiness about the image. Whatever the
interpretation, the extreme sparseness of the details and the characters barely emerging from a
black background are worth noting. The figure of the mother appears like a sculptural
pyramidal block, almost 'Cubist', set off by the sinuous outline of the woman holding the
candle.*

KEY WORKS

Art historians have listed 80 paintings by La Tour, of which about 43 originals have been discovered;
only two are dated and signed: *The Tears of St Peter* (1645) and *The Denial of St Peter* (1650). There
are about 30 studio paintings and copies, but no drawings.

The Old Woman, before July 1624, San Francisco, YMM
The Hurdy-Gurdy Player with a Dog, Bergues, Mm
Musicians' Brawl, c.1625–30, Malibu, J P Getty Museum
St Jerome Penitent (with a Cardinal's Hat), Stockholm, Nm
The Hurdy-Gurdy Player, c.1631–6?, Nantes, B-A
The Fortune Teller, New York, MM
The Cheat with the Ace of Diamonds, c.1625, Paris, Louvre
St Joseph the Carpenter, early 1640s, Paris, Louvre
The Dream of St Joseph, early 1640s, Nantes, B-A
The Repentant Magdalene, also known as *Magdalene Fabius*, Washington, NG
The Magdalene with the Smoking Flame, also known as *Magdalene Terff*, Paris, Louvre
The New-Born, between 1645 and 1648, Rennes, B-A
Job and His Wife, Épinal, Musée Départemental des Vosges
The Adoration of the Shepherds, 1644?, Paris, Louvre
St Sebastian Tended by St Irene, c.1649, Paris, Louvre
The Tears of St Peter, 1645, Cleveland, MA
The Woman Catching a Flea, Nancy, Musée Historique Lorrain

Velázquez

Portrait painter to King Philip IV of Spain, 'Velázquez personified balance, mastery, modesty and reserve' (Y Bottineau, 1998). He had a brilliant career at court. Inspired by Flemish and Italian painters, he displayed an exceptional sense of reality, naturalness and human psychology. Although his pictorial technique was perfect from the beginning, his style developed considerably, from a sculptural, Caravaggesque style to a 'pre-Impressionist' one.

LIFE AND CAREER

The Spanish painter Diego Rodriguez de Silva y Velázquez (Seville 1599–Madrid 1660) belonged to the gentry. He began his training in Seville in 1611 with Francisco Pacheco, a scholarly painter who was a good theoretician and teacher. Velázquez became his son-in-law in 1618, having become a member of the painters' guild in 1617. He painted devotional paintings until 1623: *St John on the Island of Patmos* (1618, London, NG); *The Adoration of the Magi* (1619, Madrid); and portraits, but in particular *bodegones* (still lives and genre scenes), inspired by Flemish and Italian painters: *Old Woman Frying Eggs* (1618, Edinburgh, NG), *The Water Seller* (1620, London, WM) and *Christ in the House of Martha and Mary* (1619–20, London), whose subject was an episode from the life of Jesus.

● In Madrid and Toledo between 1622 and 1629, Velázquez was influenced by tenebrism (the art of night effects and shadows), and in particular by the work of José de Ribera. He broadened his artistic knowledge when he became acquainted with the work of *El Greco. He painted the portrait of the poet *Don Luis de Góngora* (1622, Boston) and *St Ildefonso Receiving the Chasuble from the Virgin* (1623, Seville, M Provincial).

● Philip IV appointed him court painter in 1623: the portrait of *Philip IV in Armour* (1625–6, Madrid, Prado) and the full-length portrait of *Philip IV* (1628, Madrid, Prado). He painted court portraits: *The Count-Duke of Olivares* (1624, Sao Paolo, MA). *The Triumph of Bacchus*, also called *The Drinkers* (1628, Madrid, Prado), was inspired by paintings by *Titian and *Rubens in King Philip's collection.

● Between 1629 and 1630, probably encouraged by Rubens, Velázquez travelled to Italy. He visited Genoa, Venice, Ferrara and Naples. In Rome it is likely that he painted *Joseph's Bloody Coat Brought to Jacob* (Escurial) and *The Forge of Vulcan* (Madrid), reminiscent of the Carracci, as well as a portrait of the King's sister, *Portrait of the Infanta Maria* (1630, Madrid); she became Queen of Hungary by her marriage to Ferdinand III in 1631.

● An excellent painter of the King and an ambitious courtier, he immortalized the royal family between 1630 and 1644: *Prince Balthasar Carlos with a Dwarf* (1631, Boston, MFA), the equestrian portrait of *Philip IV* (1635, Madrid), *Prince Balthasar Carlos on a Pony* (1635, Madrid), *Philip IV in Hunting Costume* (1635, Madrid), *The Infante Don Ferdinando in Hunting Costume* (1635, Madrid), *Balthasar Carlos in Hunting Costume* (1635, Madrid), *Philip IV in Brown and Silver* (1635, London) and *Philip IV at Fraga* (1644, New York, FC). Dignified and full of life, these characters are portrayed against a landscape or interior background. The artist displays gentleness in *The Lady with Fan* (1646, London) and humanity in the portraits of the dwarfs *Francisco Leczano* (1637), '*El Primo*' and *Don Sebastian de Morra* (1644), and those of the jesters *Castaneda* (1635), *The Buffoon Calabazas* (1639) and *Jester Called Don Juan de Austria*, all in the Prado in Madrid. He produced a few rare religious paintings: *Christ at the Column* (1632, London, NG), *The Crucifixion* (1630, Madrid, Prado) and *The Coronation of the Virgin* (1641–2, Madrid, Prado).

● As supervisor in charge of the decoration and paintings for the Alcazar and Buen Retiro palaces in Madrid, he executed *The Surrender of Breda* (1635, Madrid, Prado), a moving painting full of humanity. He produced 'picaresque' paintings of the philosophers *Menippus* and *Aesop* (1639, Madrid, Prado), while the *View of Saragossa* (1647, Madrid, Prado) was commissioned by Prince Balthasar Carlos.

● During his second journey to Italy between 1649 and 1651 (the King had asked Velázquez to go there to purchase works of art), he painted several masterpieces in Rome: the portrait of his servant *Don Juan de Pareja* (1650, New York, MM) as well as *Pope Innocent X* (1650, Rome), of which the Pope is said to have exclaimed 'Too truthful!'. Admired as much as deplored, this painting remained in the family. He also painted the two views of *The Garden of the Villa Medici* (1650?, Madrid) and the sensual, Titian-like *Venus at Her Mirror* (c.1650, London), seen from the back. In 1652 he was commissioned to arrange and decorate the court apartments.

• Awarded the title of Knight of St James, honoured and fulfilled, he organized the marriage of the Infanta and Louis XIV in 1660. He painted the portraits of the royal family: *Portrait of the Infanta Maria Teresa at the Age of 14* (1652, Vienna), *The Infanta Margarita at the Age of Three* (1654, Vienna), *at the Age of Five* (1656, Vienna) and *at the Age of Eight* (1659, Vienna), and *The Infante Philip Prosper* (1659, Vienna) – all of them looking frail and expressionless, dressed in sumptuous clothes, painted in delicate colours with a vibrant touch. The head-and-shoulders portrait of *Philip IV* (1655, Madrid, Prado) was one of the last portraits of the King.

• Velázquez's final two masterpieces were *Las Meninas* (1656), an evocation of the daily life of members of the royal family, in which he had the audacity to include himself at their side, and *The Spinners* (1657?), a realistic interpretation of a mythological theme; both dealt with the interaction of a complicated reality and symbolism.

Developing from brutal realism to a mysterious, seductive poetic style, Velázquez was a forerunner of the Impressionists *Monet and Whistler. *Manet described him as the 'painters' painter'. In the 20th century *Picasso with his series of paintings derived from *Las Meninas* and *Bacon with his *Screaming Pope* and *Pope Innocent X* paid tribute to this precursor of modern art.

APPROACH AND STYLE

Velázquez was a master of every genre: portraiture, historical, religious and mythological subjects, the female nude, landscape and still life. He was almost the only artist to paint the royal family and several courtiers, on canvases of every size.

Velázquez was influenced by the style of the Flemish painters Pieter Aertsen and Joachim Beuckelaer, which had been taken up by the northern Italians Passerotti, Campi and *Carracci. He knew Zurbarán and some of the Spanish colourists, as well as Herrera and Juan Martinez Montanes, the polychrome sculptor. He broadened his pictorial knowledge in Toledo with El Greco and in Madrid, where he discovered the works of Titian and Rubens. In Venice he copied *Tintoretto's *Last Supper*, while in Rome he copied *Michelangelo's *Last Judgement* and some of *Raphael's work. He was inspired by the paintings of Annibale Carracci and Domenichino.

• At first, in his devotional paintings, Velázquez was inspired by his contemporaries, including Zurbarán. He then broke with the religious and stylistic traditions of Seville. He began painting genre scenes inspired by Flemish and Italian painters, notable for the solidity of their composition, the power of their sculptural forms, the brutal realism and hardness of the faces, the violence of the contrasting light and the range of their Spanish polychromy. As well as including working-class characters, who were thus raised in status, he 'had the audacity to give his sacred history scenes a secondary role in his *bodegones*' (Y Bottineau, 1969). In his first portraits, distinguished by their sculptural quality and striking truthfulness, he paid homage to El Greco. He then turned towards Titian-like court portraits.

• The influence of Rubens could be seen in Velázquez's flexible brushstrokes, modelling

A GREAT PAINTER

◆ Velázquez, the most talented Spanish portrait painter of the 17th century, was admired and praised throughout Europe during his lifetime. He is still admired and enjoyed today.

◆ Stylistically unclassifiable, sometimes close to Classicism, he first of all took inspiration from the art of the Flemish and Italian masters, then moved away from a traditional approach. He had an exceptional sense of reality, which prevailed in all his work.

◆ In terms of subject matter, Velázquez was innovative, painting 'religious' *bodegones*, dwarfs and jesters. He painted the first nude in Spanish painting (*Venus at Her Mirror*), well before *Goya's *Naked Maja*.

◆ His portraits used a new way of placing figures in space in more natural poses.

◆ For the first time, a painter made a drawing in the open as the preparation for an oil painting.

◆ In the portraits, the rapidity of the brushstrokes does not affect the evocation of reality, which became pre-Impressionist in his landscapes. Velázquez achieved more and more effects, using a smooth, fluid technique with impasto, and coming close to 'tachism' in his optical mixing of colours.

and brighter colours. He continued to study the Renaissance masters and the Venetian colourists, developing a vision imbued with humanism, reminiscent of Carracci and Domenichino. He then abandoned the *bodegones*. Having mastered space, he continued to soften the modelling of the body, driven more by realistic than aesthetic concerns, lightening and moderating his palette and making his brushstrokes less heavy (*Portrait of the Infanta Maria* and *The Forge of Vulcan*).

• The maturity of his art was reflected in the simplicity of his compositions, the sumptuousness of his colours and his powerful sculptural approach. Velázquez depicted the royal family, dwarfs and jesters with astonishing psychological acuteness. He treated them all with the same dignity and humanity, respectful of their social and physical differences. He excelled in conveying his subjects' natural expressions, the setting and the light. Figures were portrayed either indoors against a sober background with warm colours or in the open against a light, luminous background. His technique was brisk.

• In his equestrian or hunting portraits, Velázquez intensified the sense of vitality and realism. His technique of impasto, applied with rapid strokes, suggested the materials, silks, velvets and embroideries (*Philip IV in Brown and Silver*).

• Inspired by the colours of the Venetian school, he developed a harmony of colours between face, clothes and background which emphasized the expression (*Innocent X*) or the sensuality of the painting. Thus *Venus at Her Mirror* reveals her mysterious expression in the mirror while her nudity is sumptuously portrayed. His landscapes, transposed to oils from drawings made in the open, concentrated on the light in a pre-Impressionist manner. At the same time his religious paintings remained Classical in style.

• His final royal portraits reveal an innovative approach to the traditional court portrait. The composition was simple but the association of a simple bunch of flowers and a royal character was bold (*Portrait of the Infanta Margarita*, 1654, Vienna, KM). This period was marked by the expressionless look on the faces of the royal children, frozen in their human frailty, the colours and the scintillating, vibrant silver greys, subtle composition and a magnificently flexible technique. *Las Meninas* and *The Spinners*, with their subtle composition and complex subject matter, concluded his permanent quest for reality associated with mystery, using a 'tachist' technique (dabs of colour).

KEY WORKS

Velázquez produced about 100 paintings. This relatively small number is explained by his position as a courtier and a cultured painter, worthy of the King of Spain's friendship.

The Adoration of the Magi, 1619, Madrid, Prado
Christ in the House of Martha and Mary, 1619–20, London, NG
Portrait of the Poet Don Luis de Góngora, 1622, Boston, MFA
Full-length Portrait of Philip IV, 1628, Madrid, Prado
The Forge of Vulcan, 1630, Madrid, Prado
Portrait of the Infanta Dona Maria (the King's sister), 1630, Madrid, Prado
Equestrian Portrait of Philip IV, 1635, Madrid, Prado
Philip IV in Brown and Silver, 1635, London, NG
The Dwarf Francisco Lezcano, 1637, Madrid, Prado
The Surrender of Breda, 1635, Madrid, Prado
Lady with Fan, 1646, London, WC
Pope Innocent X, 1650, Rome, Galeria Doria-Pamphili
The Garden of the Villa Medici, 1650?, Madrid, Prado
Venus at Her Mirror, c.1650, London, NG
The Infanta Maria Teresa at the Age of 14, 1652, Vienna, KM
Head-and-shoulders Portrait of Philip IV, 1655, Madrid, Prado
Las Meninas, 1656, Madrid, Prado
The Spinners, 1657?, Madrid, Prado
The Infante Philip Prosper, 1659, Vienna, KM

BIBLIOGRAPHY

Brown, J, *Velázquez: painter and courtier*, Yale University Press, New Haven, CT and London, 1986; Curtis, C B, *Velázquez and Murillo*, J W Bouton, New York, 1883; Domínguez Ortiz, A, Pérez Sánchez, A E and Gállego, J, Velázquez, exhibition catalogue, Metropolitan Museum of Art, New York, 1989; Orso, S N, *Velázquez, los Borrachos, and painting at the court of Philip IV*, Cambridge University Press, Cambridge, 1993; Stirling Maxwell, W, *Velázquez and his Works*, London, 1855

Philip IV in Brown and Silver
1635. Oil on canvas, 1.99 x 1.13m,
London, National Gallery

Philip IV in Armour
c.1625–8. Oil on canvas,
57 x 44cm, Madrid, Prado

*These three portraits of the King of Spain clearly show
Velázquez's stylistic evolution during his career, as he
deals with the same subject.*

*In the first of these royal portraits, dating from the
artist's early years in Seville, Velázquez portrays the
King's hard, realistic face in a sculptural manner. The
contrasts between light and colours are still abrupt,
while the technique is smooth and fluid. After his first
journey to Italy in 1628, Velázquez softened his
modelling; he used the Venetian approach to colour and
chose to develop chromatic harmonies at the expense of
the traditional black.*

*In the 1635 portrait, the silver embroidery is rendered
with small patches of impasto, applied with rapid
brushstrokes.*

*The 1655 portrait, on the other hand, reveals a very
simple composition and sober colours, particularly in the
dress, which emphasizes the psychology of the character,
the moving, lucid expression of a king in decline,
rendered with supreme skill and with absolute realism.
Velázquez also knew how to portray the magnificence of
the Infanta's dresses, the shimmering and sparkling
satin fabrics with silvery reflections which stand out
against a background of finely-worked curtains,
achieved with a pre-Impressionist 'tachist' technique.*

Head-and-shoulders Portrait of Philip IV
1655. Oil on canvas, 69 x 56cm,
Madrid, Prado

Rembrandt

A history painter and nonconformist portrait painter, Rembrandt convinces and moves the viewer with his use of chiaroscuro, his earthy and flamboyant colours, his impasto, his 'expressionist' technique in his introspective self-portraits, and his paintings in which realistic representation is transformed into inner reality. Rembrandt was also undoubtedly the greatest etcher in the history of art.

LIFE AND CAREER

- The Dutch painter and engraver Rembrandt, properly Rembrandt Harmensz van Rijn (Leyden 1606–Amsterdam 1669), was the eighth child of a miller who lived near the Rhine. He trained as a painter in the workshop of Jacob van Swanenburgh in Leyden, then in Amsterdam with the history painter Pieter Lastman, a great admirer of *Caravaggio. He did not make the journey to Italy which was traditional for artists.
- Back in Leyden, he painted *Balaam and His Ass* (1626, Paris, CJ), which clearly reveals Lastman's influence, the *Flight into Egypt* (1627, Tours, B-A), painted in browner shades, *Two Philosophers Disputing* (1628, Melbourne, NGA), *Peter Denying Christ* (1628, Tokyo, Bridgestone M) and *Pilgrims at Emmaus* (1629, Paris), where reality and fiction are merged in a personal language of chiaroscuro.
- Rembrandt was also passionately interested in realistic, psychological portrait painting: *Laughing Man in a Gorget* (c.1628, The Hague, Mauritshuis) and *The Prophetess Hannah*, whose model was the artist's mother (1631, Amsterdam). He painted scenes of everyday life, both religious and secular: *Jeremiah Lamenting the Destruction of Jerusalem* (1630, Amsterdam) and *Scholar in a Lofty Room* (c.1628, London, NG).
- He settled in Amsterdam in 1631. *The Anatomy Lesson of Professor Nicolaes Tulp* (1632, The Hague) confirmed his fame as an artist. He had lodgings in the house of a rich art dealer, Hendrick van Uylenburgh, whose cousin Saskia he married in 1634. Saskia's elegance and beauty inspired many of Rembrandt's paintings: *Saskia as Flora* (1635, London, NG) and *Portrait of Saskia Laughing* (1633, Dresden, SK). He also produced more intimate scenes such as *Esther Preparing to Intercede with Assuerus* (1633, Ottawa, NG) or contemplative ones such as *The Philosopher Meditating* (1632, Paris). He painted over 40 portraits of the bourgeoisie between 1631 and 1633, including *The Amsterdam Merchant Nicolaes Ruts* (1631, New York, FC) and *Portrait of a Noble (Oriental) Man* (1632, New York, MM).
- *The Life of Christ* (1633–9, Munich, AP), a dynamic, luminist painting, was one of his few religious commissions. *The Feast of Belshazzar*, also known as *Belshazzar's Feast: the Writing on the Wall* (1635, London), and *The Blinding of Samson* (1636, Frankfurt, SK) were painted in the same style.
- From 1636 onwards, he reached a peak in his art: *Danae* (1636, St Petersburg, Hermitage), *Man in a Historical Costume* (1636, Washington, NG) and *Tobias and the Angel* (1637, Paris, Louvre). He painted a small number of landscapes: *Landscape with a Long Arched Bridge* (c.1638, Berlin museums) and *Landscape with a Castle* (c.1640, Paris, Louvre). At this time Rembrandt was earning a great deal of money and his house was full of paintings (*Raphael, *van Eyck, Giorgione), etchings (*Dürer, Callot, *Rubens, Mantegna), drawings by *Brueghel, objets d'art, silks and porcelain. He had numerous pupils in his studio.
- His mature period in the 1640s – in spite of Saskia's death in 1642, leaving behind her one-year-old son Titus – was marked by a serene, balanced, profound and rich art: *The Holy Family* (1640, Paris), *Saskia with a Red Flower* (1641, Dresden), *The Adoration of the Shepherds* (1646, London, NG) and *The Pilgrims at Emmaus* (1648, Paris). *The Night Watch* (1642, Amsterdam) was badly received by those who had commissioned it and it damaged the painter's reputation; Rembrandt had presented this group portrait as a living scene and not as a row of characters talking. Sales of his paintings decreased and risky speculation brought about his bankruptcy.
- The great masterpieces of the 1650s were steeped in gold and red: *The Man with the Golden Helmet* (1650, Berlin), *Girl at the Window* (1651, Stockholm, Nm), *Aristotle* (1653, New York), *Jacob Blessing the Sons of Joseph* (1656, Kassel, SK) and his son *Titus Reading* (1656–7, Vienna, KM). *Bathsheba at her Bath* (1654, Paris, Louvre) – the model for this was

Rembrandt's servant Hendrickje Stoffels, who had become his mistress – was condemned for immorality. In 1657, he became bankrupt and lost everything when he was put into liquidation.

• The death of his companion Hendrickje in 1663 and his bankruptcy did not seem to affect his artistic production, which revelled in a complete freedom of technique: *Moses with the Tablets of the Law* (1659, Berlin museums), *Peter Denying Christ* (1660, Amsterdam, Rm), *The Syndics* (1662, Amsterdam, Rm), *The Jewish Bride* (1665, Amsterdam, Rm), *St Matthew and the Angel* (1661, Paris, Louvre), *The Conspiracy of Claudius Civilis* (1661, Stockholm), *The Portrait of Titus* (1663, London, DC) and *A Family Portrait* (1668–9, Brunswick, SHAUM)

• Rembrandt constantly scrutinized his own face. A gallery of over 50 self-portraits provides a private diary spanning over 40 years of the artist's life (between the ages of 20 and 63): *Self-Portrait* of 1626 (Kassel), 1629 (The Hague, Mauritshuis), 1632 (Glasgow) and 1640 (London), and *Portrait of the Artist at His Easel* of 1660 (Paris) and 1669 (London, NG).

A prolific painter, etcher and drawer, Rembrandt trained many pupils including Carel Fabritius, Gerard Dou, Govert Flinck and Ferdinand Bol. His art led to copies, pastiches, studio replicas and fakes. The painters of the Romantic movement, including *Goya, who saw him as a master, admired his vision of the individual.

APPROACH AND STYLE

Rembrandt favoured history painting and portrait painting, including single, double and group portraits, and in particular self-portraits. He painted themes from antiquity, mythological and biblical subjects, scenes from everyday life, realistic female nudes and a few landscapes. He produced small paintings on wood as well as canvases of all sizes.

His clients were mainly important figures (merchants, doctors, preachers) as well as rabbis and artists. He executed religious paintings, commissioned by the Church, and historical, heroic paintings for the Italian Count Antonio Ruffo.

Trained in Leyden, then in Amsterdam, Rembrandt admired the work of *Leonardo da Vinci. He was also inspired by the dynamic, Baroque art of Rubens and by the chiaroscuro of the German artist Adam Elsheimer, whose barely lit characters merge into the shadows. The tonal painting of his female portraits is reminiscent of *Titian.

• Rembrandt rejected the Classical theory of art: hierarchy of genres, perfect drawing, ideal beauty and smooth finish. In the early years of his career, he was influenced by Pieter Lastman's approach to history painting, which emphasized the realistic and psychological elements. Rembrandt also adopted the expressive richness of his master's staccato style of drawing and hatching. He wanted to present history painting in a new light, far removed from the narrative detail and the precision of Classical art.

A GREAT PAINTER

◆ Admired and famous during his own lifetime, Rembrandt enjoyed enormous success. His renown is just as great in the 21st century.
◆ An anti-academic, he broke with all the traditional precepts of paintings and introduced a new sculptural approach which brought his innovatively portrayed characters to life.
◆ He painted the largest series of self-portraits in the history of Western painting. He broke with the rules of the official portrait and introduced a new narrative approach by imposing his own historical, literary, poetic, remote vision of Calvinism, favouring universal history and a style of painting imbued with human authenticity.
◆ Rembrandt developed a pictorial method which was very much his own: he started painting from a monochrome sketch drawn with a brush and divided into areas for the various colours that were to be applied. The smooth, transparent backgrounds were the first to be painted. The numerous reworkings reflect his desire to create relief through chiaroscuro.
◆ Subject and finish, colour and light are in perfect sympathy. The painter was the first to propose the break-up of Classical pictorial language through expressionist impasto. His was 'a militant observation of reality' (J Foucart, 1971), using a varied technique, 'the first seed of the disintegration of the pictorial language' *(idem)*

- Having achieved maturity in his art, Rembrandt reduced his use of spatial effects, preferring sombre, almost monochrome shades of browns and greys, applied in adjacent patches. He used large brushstrokes to achieve a rough surface with impasto, creating approximate outlines and planes set in a vivid half-light, a poetic chiaroscuro from which a radiant light emerged, thus illustrating in a spectacular manner his naturalistic realism and imaginative vision.
- In his final years he was inspired by Leonardo's *Last Supper*. In *The Pilgrims at Emmaus* (1648) he portrayed 'the sudden revelation that sealed men's fate' (J Foucart). His love of drawing led him to abandon all spatial effects in favour of monumental characters who stood out from the surface of the canvas. The compositions were highly structured and dynamic. The thick paint and his brilliant technique, using warm, earthy colours and flamboyant reds and golds, brought the canvas to life.
- Rembrandt's main interest was portraits. His individual portraits reveal the range of human diversity: wrinkled old men, portraits of his womenfolk as figures from antiquity and mythology, and portraits of his son Titus (*Titus in a Monk's Habit*). The look in the sitter's eyes is direct and the women are painted with a rich, luminous, golden impasto reminiscent of Titian.
- Rembrandt's artistic development, from the 'physical' representation of reality to the expression of inner life, was reflected in his self-portraits, which reveal the multiple facets of his personality: Rembrandt as a patriot, a bourgeois, a gentleman of the Renaissance, an apostle and so on, but also as the object of a narcissistic, anxious introspection. In his youth as in his more mature period, his lucidity was sometimes ironic, with tousled blond streaks in his hair, scratched with the handle of his brush, and too prominent a nose. His group portraits (*The Anatomy Lesson*, *The Night Watch*) give the impression of life at its most intense. Each character, brought to life by his movements, is both an individual in his own right and a member of the group.

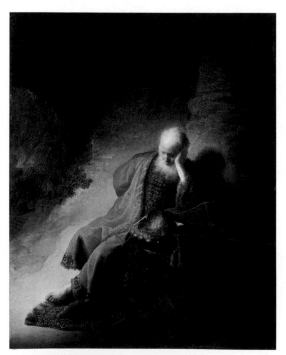

Jeremiah Lamenting the
Destruction of Jerusalem
1630. Oil on wood,
58 x 46cm, Amsterdam,
Rijksmuseum

*This painting, which dates from
Rembrandt's early years, shows the
prophet Jeremiah distraught at the sight
of Jerusalem on fire, set in a vast, infinite
exterior space. The dramatic nature of his
feelings can be read on his worn, wrinkled
face – as genuine as* The Prophetess
Hannah *and reminiscent of* The
Philosopher Meditating *in his resigned,
pensive attitude. While the background is
simply painted in brown, red and gold,
the clothes, carpet and copperware reveal
great technical precision, magnificent
craftsmanship and an excellent sense of
colour.*

BIBLIOGRAPHY
Alpers, S, *Rembrandt's Enterprise: The Studio and the Market*, University of Chicago Press, Chicago, 1988; Bomford, D, Brown, C, Roy, A et al, *Art in the Making: Rembrandt*, National Gallery Publications, London, 1988; Bredius, A, *Rembrandt: The Complete Edition of the Paintings*, 4th edition, revised by H Gerson, Phaidon, London, 1971; Bruyn, J, Haak, B, Levie, S H et al, *A Corpus of Rembrandt Paintings*, Stichting Foundation Rembrandt Research Project, Martinus Nijhoff, The Hague, Boston and London, 1982-9; Schwartz, G, *Rembrandt: His Life, His Paintings*, Penguin Books, Harmondsworth, 1984; White, C, *Rembrandt: by himself*, National Gallery Publications, London, 1999

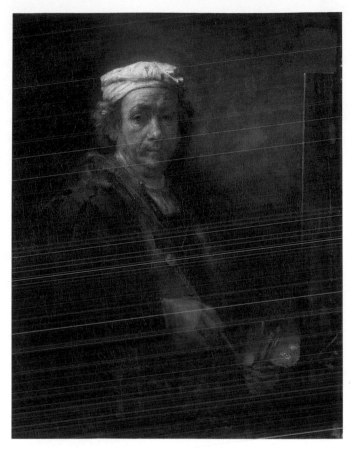

Portrait of the Artist at His Easel
1660. Oil on canvas, 111 x 85cm, Paris, Musée du Louvre

This self-portrait, one of his last, shows Rembrandt tightly framed. The emphasis is on the psychological and physical authenticity of his person, honestly portrayed with wrinkled skin, heavy eyelids, large nose and tousled hair. Only his face, his painter's palette and the part of the canvas he is painting emerge from the earthy shades. The brushed paint, gold and red, suffused with light, prevail over details and drawing. His presence and his gaze stand out from the canvas, directly addressing the viewer.

KEY WORKS

Today, some 400 works have been identified as being by Rembrandt; about 55 of these are self-portraits. Because (unlike most other artists) he had so many pupils and imitators, there are problems of attribution, and the number of works now thought to be by him is decreasing.

The Pilgrims at Emmaus, 1629, Paris, J-A
Jeremiah Lamenting the Destruction of Jerusalem, 1630, Amsterdam, Rm
The Prophetess Hannah (the artist's mother), 1631, Amsterdam, Rm
The Anatomy Lesson of Professor Nicolaes Tulp, 1632, The Hague, M
The Philosopher Meditating, 1632, Paris, Louvre
Belshazzar's Feast, 1635, London, NG
Man in a Historical Costume, 1636, Washington, NG
The Holy Family, 1640, Paris, Louvre
Self-Portrait, 1640, London, NG
Saskia with a Red Flower, 1641, Dresden Gg
The Night Watch, 1642, Amsterdam, Rm
The Pilgrims at Emmaus, 1648, Paris, Louvre
The Man with the Golden Helmet, 1650, Berlin museums
Aristotle, 1653, New York, MM
Portrait of the Artist at His Easel, 1660, Paris, Louvre
The Conspiracy of Claudius Civilis, 1661, Stockholm, Nm
The Jewish Betrothed, 1665, Amsterdam, Rm

Vermeer

An untypical master of Dutch art, Vermeer painted the intimate, everyday life of silent, timeless women. His genre scenes with their complex compositions, including sumptuous still lifes, are illuminated by drops of luminous colours, often yellows and blues. The purity of the light, the unusual, scintillating, 'pointillist' reflections, the physical sensations and the perfection of his art create an impression of naturalness which is very moving.

LIFE AND CAREER

• Jan Vermeer, known as Vermeer of Delft (Delft 1632–Delft 1675), a Dutch painter who sank into oblivion for a long period, grew up with a father who was a weaver of silk fabrics, an innkeeper and an art dealer. After probably being apprenticed to Leonaert Bramer, who was famous in Delft in the 1650s, Vermeer became a master of the painters' guild in 1653 and married. It appears that he led a retiring life and found it hard to earn a living as a painter and seller of engravings.

• A printer saw him as the heir to Carel Fabritius (d.1654), whose pupil Vermeer is thought to have been and who had himself been *Rembrandt's pupil. Vermeer's interest in light and his admiration for Fabritius played a positive role in the development of his work. Only three of his paintings are dated: *The Procuress* (1656, Dresden), *The Astronomer* (1668, Paris, Louvre) and *The Geographer* (1669, Frankfurt). Characteristic of his work was the bourgeois genre scene, built entirely around female characters.

• His early paintings were influenced by the Utrecht School, whose members were inspired by *Caravaggio: *Christ in the House of Martha and Mary* (Edinburgh), *Diana and Her Companions* (The Hague, Mauritshuis), as well as *The Procuress*, also known as *The Courtesan*, which heralds his mature period.

• Vermeer's first more personal work was *Girl Asleep at a Table* (New York). Between 1655 and 1660, he painted further masterpieces which revealed his stylistic characteristics, such as the organization of the interior, the choice of poses and fabrics and his love of reflections: *Woman Reading a Letter* (Dresden). *The Milkmaid* (Amsterdam) is above all a magnificent still life (much admired by the British painter Joshua Reynolds), while *The Little Street* (Amsterdam) captures, as if in a snapshot, women working outdoors, a subject rarely explored by the artist.

• The *View of Delft* (The Hague), the only landscape Vermeer ever painted, with 'sun shining on the town after a thunderstorm', is 'Impressionist' in its use of light and its technique. It is one of the most famous of Vermeer's paintings, 'the most beautiful painting in the world' (Marcel Proust, 1921). The series of musicians that he painted shows his particular interest in the rendering of space: *The Music Lesson* (New York, FC), *The Concert* (Boston, ISGM), *A Lady at the Virginals with a Gentleman* (London) and *A Lady Drinking and a Gentleman* (Berlin museums). From 1660 until his death, Vermeer continued painting musical themes such as a lute player, flute player, guitar player and spinet player.

• Between 1660 and 1665, he painted *A Young Woman with a Water Jug* (New York), *Woman Weighing Pearls* (Washington, NG), *Woman in Blue Reading a Letter* (Amsterdam, Rm) and the *Girl with Turban* (The Hague), sometimes referred to as 'The Mona Lisa of the North'.

• The *Lacemaker* (Paris, Louvre) and *An Artist in His Studio*, sometimes called *The Art of Painting* (Vienna), are thought to have been painted during his final period, between 1665 and 1670. He also painted paintings on the theme of the letter, such as *The Love Letter* (Amsterdam), characterized by its complex composition, and *The Lady with her Maidservant* (New York, FC). Among his final works, *The Allegory of Faith* (New York, MM) appears 'laborious', while the *Lady Standing at the Virginals* (London, NG) is more schematic in its composition. In 1672 he was experiencing financial problems and decided to sell his paintings.

His art was devoid of narrative, unlike the art of his contemporaries Jan Steen or Gerard Terborch, minor Dutch masters of the genre scene, and did not have any followers apart from Van Meegeren, a talented forger of the 20th century. Vermeer fascinates in the same way as *Piero della Francesca and *La Tour, also painters of silence. The British painters

Joshua Reynolds and Thomas Gainsborough, the Frenchman *Watteau and later the Impressionists saw him as a forerunner inspired by genius.

APPROACH AND STYLE

Vermeer was particularly interested in interior genre scenes. He favoured such themes as the letter and music, set within the intimacy of a woman's life, sometimes in the presence of a man who played a secondary role. He painted portraits, two urban landscapes and a few rare religious and mythological scenes, on wood or on canvas. At first he painted rather large pictures, gradually reducing them in size as he painted more intimate subjects.

His paintings were bought by the Frenchman Balthasar de Monconys and Jacob Dissius, a Delft printer.

Vermeer's art resembled the town of Delft itself, a city of 'cold, delicately enamelled ceramics, thick, soft, silent carpets, a city of luxury goods but also of mathematical and scientific instruments' (R Huyghe, 1985).

• At first the painter was influenced by the Caravaggist Utrecht School, Rembrandt's chiaroscuro and the Dutch genre scene painters, including Erasmus Quellinus. He adopted the Caravaggesque themes and style fashionable at the time in Holland and interpreted them with an honest realism. He was inspired by the clear Caravaggesque style of Dirck van Baburen. He did not paint many religious subjects, preferring as his subjects sensual women being wooed, amber-coloured wine and reflective crystal glasses. His paintings are bathed in an enchanting chiaroscuro and deep tones, all distinguished by great craftsmanship. He had not yet developed an interest in space and depth.

• Very soon he became influenced by the art of Gerrit Dou and Carel Fabritius (brilliant pupils of Rembrandt) and his Dutch contemporaries Pieter de Hooch and *Hals. He returned to the realistic tradition of the north and its poetry. In his subjects 'without story and without words', he concentrated on rendering reflections, conveying visual and tactile sensations through materials and emphasizing the genuineness of the figures set in a clear space in broad daylight. This was the beginning of the pictorial style which made Vermeer so famous, unmarked by any dominant trend or particular chronology. Vermeer combined Dou's skilful imitation of the real, Hals's exaltation of the material at the expense of the real, the natural accuracy of trompe l'œil and of Fabritius's still lifes, and De Hooch's art of domestic scenes set in a realistic, illuminated interior space. In his quest to create spatial volumes, he combined solid forms and the vibration of luminous colours.

• He displayed originality in his choice of colours: sapphire blue, faded blue, lemon yellow, bright red and ochre red. At times he applied the paint in impasto, sometimes with small strokes and sometimes as a glaze, or occasionally simultaneously as in *The Milkmaid*. He

A GREAT PAINTER

◆ Recognized during his own lifetime, Vermeer sank into oblivion in the 18th century. He was rediscovered in 1866 by Théophile Thoré. The writer Marcel Proust was enthusiastic about Vermeer's paintings. Since then, he has aroused passionate interest as one of the greatest of all painters.

◆ Vermeer, painter of light, has remained an unclassifiable artist because of his choice of subjects and his original vision, made possible by his technique and perfect representation of form. His art originated in the Dutch artistic tradition of his time.

◆ He created mute genre scenes 'without a story'.

◆ His complex compositions reflect his interest in the rendering of pictorial space.

◆ His technique was very individual. He painted from life with the help of a camera obscura. He applied a touch of very light-coloured paint to the still slightly wet coloured layer. His scintillating 'pointillism' perfectly rendered the brilliance of sunlight falling onto the scene. Using a brush, he applied layers of sticky, creamy, fairly fluid paint which flowed slightly beyond the outlines of the drawing. In the darker parts of the painting, he coloured the darkness and increased the intensity of the colour in order to achieve the 'highest pitch of the colour', which he dissolved in light and not in the shadow like his predecessors.

◆ Vermeer was a master of pure, white light and a brilliant painter of visual, tactile and even auditory sensations, achieved by the silence intrinsic to his art. He portrayed precise, clear reality impeccably rendered.

adapted the material of the objects to his manner of painting them, which 'never moves away from the absolute truth of the colour value which connects it to its model and merges with it' (R Huyghe).

• In his mature period, Vermeer's art developed: the spatial quality became perfect, the light clear and limpid and the brushstrokes thick. The 'pointilliste' or 'pearly' paint – now visible because of the solidity of the impasto and the roughness of the texture – for the first time revealed the brilliance of sunlight striking a surface.

• The light which emanated from the paintings of Vermeer, painter of light, remained faithful to reality, but became tinged with melancholy; it went slightly beyond the drawing in order to reduce the dryness of the outline and suggest a slight fuzziness. He coloured and lit up the darkness, reducing contrasts, and placed the source of light parallel to the plane of the scene, thus creating fictitious 'luminous volumes' and timeless works.

• A painter of immobile, fragile, mute figures and of the illusion of depth, Vermeer achieved his optical effects through the use of light colours which dazzled, giving the various elements in the scene a scintillating sparkle: for instance, the copperware, milk or pearls. The windows which are the source of light do not reveal an outside view. Vermeer's world is clear, simple, enclosed, calming and silent.

• His final paintings show an even greater technical assurance, combining immobility and movement. His art is laden with objects. Heavy curtains define the foreground, while the greys and browns merge with the lighter colours. Absolute objectivity found its limits and finally returned to stylization and sobriety.

It is 'always, whatever the genius with which [the paintings] have been created, the same table, the same carpet, the same woman, the same unique beauty, an enigma [...], the particular impression produced by the colour' (Marcel Proust, 1921).

KEY WORKS

Some 30 works by Vermeer are known; only three of them are dated.
Christ in the House of Martha and Mary, Edinburgh, NG
The Procuress or *The Courtesan*, 1656, Dresden, Gg
Girl Asleep at a Table, New York, MM
Woman Reading a Letter, Dresden, Gg
The Milkmaid, Amsterdam, Rm
View of Delft, The Hague, Mauritshuis
A Lady at the Virginals with a Gentleman, London, BP
A Young Woman with a Water Jug, New York, MM
Girl with Turban (or *with the Pearl*), The Hague, Mauritshuis
The Lacemaker, Paris, Louvre
The Love Letter, Amsterdam, Rm
An Artist in His Studio or *The Art of Painting*, Vienna, KM
The Astronomer, 1668, Paris, Louvre
The Geographer, 1669, Frankfurt, SK

BIBLIOGRAPHY

Blankert, A, Montias, J M and Aillaud, G, *Vermeer*, Rizzoli, New York, 1988; Gowing, L, *Vermeer*, 3rd edn, Giles de la Mare, London, 1997; *Johannes Vermeer*, exhibition catalogue, The Hague and National Gallery of Art, Washington, Yale University Press, New Haven, CT, 1995; Montias, J M, *Vermeer and his Milieu: A Web of Social History*, Princeton University Press, Princeton, NJ 1989; Slatkes, L J, *Vermeer and his Contemporaries*, Abbeville Press, New York, 1981; Wheelock, A K, *Jan Vermeer*, Thames and Hudson, London, 1981; Wheelock, A K, *Perspective, optics and Delft artists around 1650*, Garland, New York and London, 1977

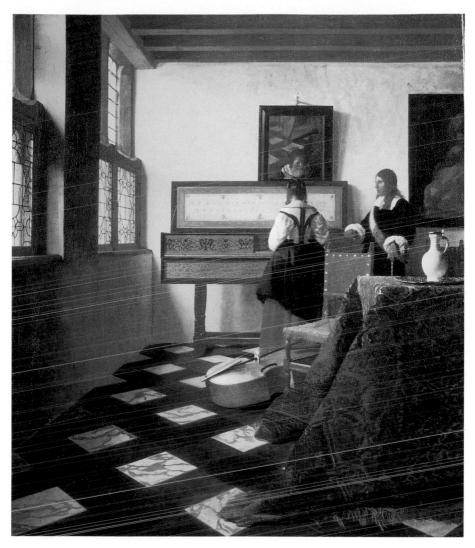

Gentleman and Lady Playing the Spinet or **The Music Lesson**
c.1660. Oil on canvas, 73.5 x 64.1cm, London, Buckingham Palace

*A gentleman appears to be listening to a lady playing the spinet; she is seen from the
back. On the lid of the spinet, there is a Latin inscription meaning: 'Music is the
companion of joy and a remedy for pain.' This interior scene sums up Vermeer's art as a
painter of light and the female figure, in a universe dominated by the optical illusion of
depth. The sculptural sensuality of the picture is steeped in silence and timelessness.
The artist shows his perfect command of space: the table, chair and viola da gamba,
seen in perspective, guide the spectator's eye towards the back of the picture. The
construction is based on interlocked rectangles of different sizes. The crystalline light
further emphasizes the structure of the scene. Vermeer's excellent 'pointillist' technique
and craftsmanship reflect his mature artistic development. The soft, coloured paint is
enriched by luminous dots. These convey the brilliance of the incident light which adds
a sparkle to the silk of the carpet, the nails and velvet of the chair and the copper whose
reflection can be seen on the pure white porcelain jug. The tactile feeling of the materials
– marble, metals, wood and fabrics – attracts the eye and almost the hand. The tinted
mirror reflects the face of the girl playing and part of the floor.
This painting with its complex composition and wealth of detail exudes a sense of
tranquillity not only for the eye but also for the ear and the sense of touch. The
timelessness of the characters in this closed scene and the strangely silent music in the
painting convey an atmosphere of universality and meditation.*

THE 18TH CENTURY:
ROCOCO AND NEOCLASSICISM

In the 18th century, science, philosophy and artistic concerns became closely linked. A new freedom began to make itself felt and some European courts were captivated by the new ideas that were around. The French painters *Watteau, Boucher and *Fragonard and the Italian *Tiepolo portrayed the carefree happiness and libertine behaviour of worldly society, which *Hogarth in England also painted with gusto. *Chardin had no stylistic connection with Rococo: the agitated style associated with Louis XV's reign and which ended with that of Louis XVI. In the third quarter of the century, the reaction to Rococo and a new return to antiquity sparked off Neoclassicism, a movement led by *David.

The Enlightenment in Europe

With the death of Louis XIV in 1715, a certain concept of absolutism disappeared, and Louis XV eventually became 'the Well-Beloved'. At his side, Madame de Pompadour advocated a policy of reform inspired by the thinking of the Enlightenment: freedom of religion, equitable justice, abolition of torture, economic development and the development of teaching, arts and science. The regime became weaker with the War of the Austrian Succession (1740–8) and the Seven Years' War (1756–63); the coffers were empty and the first signs of unrest appeared. Louis XVI, king since 1774, called on the bourgeoisie to reform the State; from this arose a conflict with the nobility and clergy. The general discontent culminated in the French Revolution in 1789.

In Europe, the second half of the 18th century was marked by the 'enlightened despotism' of its rulers, inspired by the values of the Enlightenment. Borrowing ideas from philosophers (French ones in particular), Frederick the Great of Prussia, Catherine the Great of Russia, Charles III of Spain, Maria Theresa and Joseph II of Austria, and Gustav III of Sweden more or less adapted absolute monarchy to the new rational spirit.

The evolution of ideas. The philosophy of the Enlightenment gave rise to a new perception of the world (involving method, measurement and observation), advocating secular thought which promoted the individual (natural man, man as a social animal) and that which was useful. Empiricism, factual certainty and 'shared' knowledge, together with scientific and technical progress, gave rise to criticism of the social hierarchy and religious power, and a desire for radical reform. The encyclopedic, rationalist spirit of Diderot, the scientific spirit of d'Alembert and the sense of law and justice of Montesquieu fuelled the discussions of the literary salons. There too the sensualism of Condillac, who saw in sensation a way of accessing knowledge, Rousseau's feeling for nature, Voltaire's sense of freedom, justice and tolerance, and Buffon's natural history stirred up passionate debate. Locke, Hume, Newton and others were the incarnation of the Enlightenment in Great Britain; Leibnitz, Wolff, Kant and Lessing represented the German thought of the Aufklärung. But already, for Rousseau, the technical progress resulting from the English Industrial Revolution had become a threat to 'happiness'.

Cosmopolitanism, academies and the art market. The royal courts were in close contact with the writers and artists who travelled all over Europe. The Italian Ricci worked in London and his compatriot Tiepolo in Germany and Spain; the French painters Boucher and Charles André Van Loo painted respectively for the kings of Sweden, Denmark and Poland, and for the house of Savoy in Italy. Diderot, in Russia, advised Catherine the Great on her purchases of works of art; Voltaire went to the Prussia of Frederick the Great.

The creation of national academies spread throughout Europe. In Russia, the Imperial Academy of St Petersburg (1724) and the Academy of Arts in Moscow (1757) were set up. In London, Hogarth supported the foundation of the private academy of St Martin's Lane (1734), a forerunner of the Royal Academy (1768). Spain created the Royal Academy of Fine Arts of San Fernando (1752) and Belgium created a Royal Academy of Fine Arts (1769). These institutions contained excellent collections of art. While the Académie Royale in Paris exercised a near-monopoly on 'grand' painting, the so-called 'minor' genres also began to make their mark, although not in the Salon. Trade in art began with the shop opened by Gersaint, a friend of Watteau. Landscapes, genre scenes, still lifes and portraits were much in demand. The great collectors (the Abbé de Saint-Non, Count Tessin and the rich bourgeois Pierre Crozat) played a large part in the expansion of this market.

The renewal of the pictorial aesthetic

The birth of Rococo in Paris. In 1699, Louis XIV had asked for 'less serious' paintings. Later, Madame de Pompadour, a friend of writers and philosophers, also made friends with artists whom she encouraged in painting with a lighter touch.

The aesthetic debate which started in the 17th century between the supporters of colour, favoured by *Rubens, and drawing, promoted by *Poussin, saw the triumph of the former in 1717 on the occasion of the acceptance of a painting by Watteau by the Académie: the *Embarkation for Cythera*.

Panelling, overmantels and overdoors were filled with grotesques, exotic fantasies and 'rocaille': a reference to the artificial rocks encrusted with shells placed in gardens. Painting became the mirror of worldly society, carefree and then decadent. It was decorative, full of tricks, swirling, delicate in manner and illuminated with a crystalline light in the paintings of Boucher and Natoire, or more serious in the case of Coypel and Van Loo. The subjects and overall tone favoured elegance, sophistication and lightness, directed towards the senses rather than the mind. Easel paintings predominated. This 'French style' moved away from religious and history painting and towards sparkling, luxurious decoration, picturesqueness, eroticism and a dream-like quality, such as were to be found in the *fêtes galantes* of Watteau. The exoticism of chinoiserie, Turkey and an imaginary Orient enlivened the 'pastoral' works of Boucher, while Fragonard excelled at *figures de fantaisie*. Society portraits with a mythological theme, pictures of wildlife, landscapes with ruins and seascapes were also very successful.

Writers and art critics such as Mariette, Cochin the Younger and Diderot (*Salons*, 1759–81) attended the Salon of the Académie Royale, which relaxed its rules: neither Watteau nor Chardin trained at the Académie; painters moved away from theoretical debate and towards spontaneity and novelty, and freed themselves from royal patronage. Thus Chardin could express the realism which Diderot admired, just as he appreciated the moralizing works of Greuze.

Rococo in Italy and Central Europe. After a period of eclipse in the 17th century, Venice recovered its brilliance by harking back to *Veronese: Ricci launched the new Rococo style, which Tiepolo pushed to its limit. At the same time, the *vedute* (city views) of Canaletto, Bellotto and Guardi gave credibility to these mementoes of Venice. Italian Rococo was not seen as a development of Baroque but as 'a self-sufficient style category' (G Brunel). Giaquinto was successful in Naples and Turin, while Crespi flourished in Bologna.

In Prussia and Austria, the brilliance of French (Van Loo) and Italian (Tiepolo, Carlone) Rococo painting overshadowed the art of the German decorative painters. The youngest, including Rottmayr and Troger, were trained in Italy, unlike Holzer and Maulbertsch, the 'Viennese Tiepolo'. Portraits became fashionable.

England on its own. Rococo found no echo on the English side of the Channel; only Thornhill was attracted by the style of the Venetian decorative painters. Landscape painting, on the other hand, attracted collectors: studies of nature distinguished the works of Richard Wilson, the first great English landscape painter. Hogarth, although trained in the Rococo style, produced series of narrative paintings for the urban merchant class. His junior, Reynolds, who became the first President of the Royal Academy in 1768, favoured the art of the portrait (as did Gainsborough) and, being opposed to the prevailing mood of cosmopolitanism, laid claim to the creation of an English school of painting.

Neoclassicism

The reaction to Rococo. Neoclassical art appeared in Rome between 1760 and 1770 under the aegis of two Germans, the theorist Winckelmann and the aesthetic painter Mengs, following the discovery of the ancient sites of Herculaneum in 1738, Paestum between 1740 and 1744, and Pompeii in 1748. The reaction to Rococo gave rise to a fresh look at Classicism based on intellectual rigour, a taste for nature, the Graeco-Roman virtues of heroism and civic responsibility, the *beau idéal* of antiquity, and 'noble simplicity and peaceful grandeur' (Winckelmann). In Rome, the French painter Vien, still influenced by the Rococo style, and the Scot Hamilton launched Neoclassicism. The theory of Neoclassicism was later formulated in the writings of the archaeologist the Comte de Caylus, the engraver and critic Cochin the Younger and the aesthetician Quatremère de Quincy, all French. Paradoxically, the Italians were not the driving force behind the movement: accustomed to Classicism, they felt no thrill when Roman remains were uncovered, and being familiar with Baroque they did not reject Rococo.

An international movement. In France, some aspects of Neoclassicism tied in with the ideas of Rousseau and the rationalism of Diderot (the simplicity and perfection of nature, didactic art, morality). A moralizing approach enlivened the works of Vien, David and Greuze. David, the leader of Neoclassicism, put his art at the service of the French Revolution by illustrating contemporary events such as the deaths of Marat and Bara and the Tennis Court Oath. He was preceded by Peyron and followed by Regnault and Guérin. Precise, analytical drawing conveyed immobility; colour had no shimmer to it and the paint was applied smoothly. David's meeting with Bonaparte in 1797 was decisive in the artist's career and development.

England leaned towards a Gothic revival, even though its portrait painters, such as Romney with his more severe style, were inspired by antiquity. However, the Milanese Appiani, the Swiss Angelica Kauffmann and Russian and Danish artists were in the tradition of Mengs and David. The French Revolution, brought on by the teachings of the Enlightenment, saw the end of 18th-century monarchical society. Neoclassicism became coloured by the Romanticism of the early 19th century: David again and Gros.

Watteau

Watteau, an enigmatic artist and painter of *fêtes galantes* and theatrical scenes, was the incarnation of French painting at the time of the Regency. His paintings of beautiful women and charming gentlemen in satin clothes have a dream-like quality, but his world was often serious. His art, born of his perception of the feminine world, shows signs of Flemish and Venetian influences which he made his own, incorporating a sophistication and lyricism touched with joy or melancholy depending on the work.

LIFE AND CAREER

Jean-Antoine Watteau (Valenciennes 1684–Nogent-sur-Marne 1721), French painter, was enrolled by his father, a carpenter-roofer, in the studio of Guérin where he worked from 1699 till 1702. He then moved to Paris where he was first employed as a copyist for Gerard Dou. There he discovered the religious scenes painted by *Titian and *Rubens and immersed himself in pictures of chivalrous behaviour, fashions and customs which inspired him to paint *The True Gaiety* (1702–3, Valenciennes, B-A).

• Between 1704 and 1708 he worked with Claude Gillot (a painter but more significantly a decorator and theatre wardrobe master) and became passionately interested in the *commedia dell' arte*: *Harlequin, Emperor in the Moon* (1707, Nantes, B-A), *What have I done, damned assassins?* (1704–7, Moscow, Pushkin) and *Comedians* (1706–8, Paris, Carnavalet).

• Gillot sent his brilliant pupil to Paris, to Claude III Audran, the famous decorator of the royal chateaux, based in the Palais du Luxembourg where Watteau admired the paintings of Rubens in the Medici gallery. Between 1708 and 1709 he learned the art of decorating and worked in Marly, Meudon, the chateau of La Muette and the Parisian hotel of Poulpry-Nointel. In April 1709 the artist entered the Académie Royale's competition for the Prix de Rome: he won only the second prize and returned to Valenciennes where he painted *The Bird Nester* (1710, Edinburgh) and military subjects such as *The Flying Camp* (1709–10, Moscow, Pushkin).

• He returned to Paris in 1710 and worked with Sirois (father-in-law of the art dealer Gersaint) whom he represented as an actor: *In the Costume of Mezzetin* (c.1717, London); 'Mezzetin' was the stage name of the Italian actor A Constantini, a contemporary of the painter, who was famous for his interpretation of Harlequin. Watteau joined the Académie in 1712 when he presented *Jealousy* (lost) and *A Party for Four* (San Francisco, MFA). He was accredited as a history painter and a painter of 'gallant scenes' in 1717 with the *Embarkation for Cythera*. Between 1712 and 1717 he lived successively at the house of Sirbois, the painter Nicolas Vleughels and then the painter and collector Crozat, who invited him to his parties in Montmorency where Watteau admired the paintings by Van Dyck and Titian. He painted *The Enchanter* and *The Adventuress* (1712, Troyes, B-A).

• Between 1715 and 1721 Watteau painted and drew prolifically. His style was a synthesis of Flemish and Venetian art as can be seen in his landscapes: *La Bièvre at Gentilly* (c.1715, Paris, pr coll) and *The Seasons*, of which only *Summer* has survived (c.1715, Washington, NG); in his realistic subjects: *The Savoyard with a Marmot* (1716, St Petersburg, Hermitage); in his mythological and religious subjects: *Nymph and Satyr*, also known as *Jupiter and Antiope* (1715, Paris, Louvre), *The Judgement of Paris* (1720, Paris, Louvre); in his nudes: *The Toilette* (1717, London, Wall C) and in his rare portraits, *Antoine Pater* (1716?, Valenciennes) and *Portrait of a Gentleman* (1716, Paris, Louvre). But the paintings which were to make him famous were his *fêtes galantes* showing courtly figures in rural surroundings: *The Serenader* (1715, Chantilly, Condé mus), *The Perspective* (1715, Boston), *The Champs Élysées* (1717, London, Wall C), *The Pleasures of Love* (1717, Dresden, Gg), *The Pleasures of the Ball* (1717, London), *Assembly in a Park* and *The Faux Pas* (1717, Paris, Louvre), *Venetian Pleasures* (1717, Edinburgh), *The Shepherds* (1717, Berlin), *Fête in a Park* (1718, London), *The Music Party* (1718?, London) and *A Halt during the Chase* (1720, London). His passion for the theatre continued, as is seen in *Love in the Italian Theatre* and *Love in the French Theatre* (1717 and 1718, Berlin museums), *The Indifferent Man* and *The Delicate Musician* (1717, Paris, Louvre), then *Gilles* (1717–9, Paris, Louvre).

- In 1719, suffering from consumption, he went to London to consult a doctor. Returning to Paris in 1720, he moved into Gersaint's house and painted *The Shop Sign*, also known as *Gersaint's Shop Sign* (1720, Berlin) and *French Comedians* (1720, New York). Watteau died prematurely at the age of 37 at the house of Pierre Crozat.

The paintings by Watteau, a successful draughtsman and decorator, were sought-after throughout Europe. He had no pupils but worked with J-B Prater and Nicolas Lancret who continued his art but without his eloquence. The whole of Europe plagiarized his work: his nephew Louis-Joseph in Paris, Mercier in London and Pesne in Berlin. Other painters, such as François Boucher, Jean-Baptiste Oudry and François Lemoyne, adopted and modified his manner of painting. The theme of the *fête galante* became one of the components of Rococo.

APPROACH AND STYLE

Watteau saw the *fête galante* as a gathering of people in a garden planted with trees and embellished with rocks or on the terrace of a palace; the figures are conversing, declaring their love, dancing, playing music or acting. These scenes of manners should not cause Watteau's landscapes, portraits, paintings of military, popular, religious and mythological subjects, allegories and female nudes to be overlooked.

Watteau painted all these subjects on wood panels or canvas, in various sizes but with a preference for smaller ones. He also created theatre scenery, overdoor paintings, screens, and wood panelling as well as harpsichord decorations and shop signs. J de Julienne, E-F Gersaint, P Crozat, A de La Roque and Frederic II of Prussia were among his greatest admirers. He was inspired by French artists such as L de Boulogne, Jean Bérain, Charles de La Fosse, Italian artists including Titian and Flemish artists such as Van Dyck and in particular Rubens.

- In Valenciennes, in order to improve his skill, Watteau copied the colourist artists of the north and reproduced the sometimes rustic realism of Teniers' genre scenes.
- Watteau's encounter with Gillot who passed on his passion for the theatre and actors to the artist, marked a turning point in his career. He borrowed the more relaxed style of French painting, developed by the painter L de Boulogne. While working with Audran he learnt the art of decoration in the tradition of the ornamentalist Bérain and conceived new exotic and Chinese fantasy motifs. In the Palais du Luxembourg he discovered the warm colours and striking vivacity of Rubens's art and was fascinated by it. His technique became

A GREAT PAINTER

◆ Worshipped during his lifetime and after his death, Watteau fell into oblivion with the birth of Neoclassicism. He became famous again during the Second Empire: the Goncourt brothers, C Baudelaire and P Verlaine praised him highly.
◆ Although he was a painter of *fêtes galantes*, he was accepted by the Académie as a history painter; this says as much about Watteau's importance at the time as the decline of the hierarchy of genres. The artist embodied the French painting of his time.
◆ 'Watteau revitalized gracefulness ... that subtle thing which is like the smile of the line, the soul of a form, the spiritual appearance of the paint' (E and J de Goncourt, 1860).
◆ He was the great, poetic, inspired interpreter of *fêtes galantes* which became fashionable at the end of the 17th century. Inspired by the theme of escape to an enchanted, unreal world, he painted female figures, turning away from the viewer and moving away towards the background of the painting. He made chinoiserie and exoticism popular.
◆ This sophisticated draughtsman and colourist set out to convey the texture of satin fabrics. He applied highlights of bright colour to the garments in matching tones, sometimes white, golden or silvery. His paintings, subtly coloured, were painted with rapid brushstrokes.
◆ The apparent superficiality of the paintings conveys an atmosphere of magic, tinged with a feeling of personal melancholy.

smooth and creamy but later he adopted a more fluid medium. But his methods condemned his canvases to a state of precarious preservation. In the house of his patron Crozat he discovered and admired Van Dyck's drawings, and learnt the art of landscape painting which he developed and perfected.

• The painter then synthesized the *bellifontaine* style of Audran, J Callot's heir, the warm colours of Rubens and the delicate, luminist Venetian shades of Titian, which he endowed with a poetry tinged with sadness and melancholy (*Nymph and Satyr*).

• His final artistic period was very productive and more accomplished technically. He portrayed realist subjects in the spirit of northern Europe, intimist, sensual nudes in the Venetian style, a few portraits and scenes from the world of the theatre. When composing his paintings, Watteau painted or sketched the landscapes and then placed in them characters from his sketchbooks, namely his friends, dressed in theatrical costumes for the occasion. The elegant characters, male and female, were dressed in satin fabrics of sophisticated colours, in Spanish-style or theatrical clothes (*Love in the Italian Theatre*). But above all, Watteau painted *fêtes galantes*. The female figures, seen from behind, in a relaxed attitude, emphasize the dream-like impression. They are enigmatic, and sometimes melancholic, in a powdery, hazy atmosphere in monochromes of greens, browns and orange shades (*Embarkation for Cythera*).

In 1718 Watteau returned to realism, inspired by Dutch painting. He painted contemporary subjects in a modern light (*Gersaint's Shop Sign*). The figures are arranged in groups, as a mass, and their physical presence is stronger as a result. The Venetian shades are soft and deep.

Embarkation for Cythera
1717. Oil on canvas, 1.30 x 1.92m, Paris, Musée du Louvre

This departure for the island of love is Watteau's most famous painting of fêtes galantes, captured in their elusiveness between 'the yearning for the future and nostalgia of the past' (R Huyghe, 1972). 'Note the full impasto of the little figures with their swimming eyes and blurred look … The beautiful, flowing fluidity of the brush on the décolletés and naked flesh, punctuating the shady wood with their voluptuous pink colours! … and the rays of the sun setting on the dresses' (Goncourts, 1860).
The undulating composition guides the viewer's eye from the statue to the stern of the boat, taking in all the couples, their intimacy exposed (as is the case with the artists of the north). The clothes shimmer in a palette of sophisticated Venetian shades. The intoxication does not conceal the melancholy, perceptible in the attitude of the characters seen from behind. The scene is steeped in a hazy, twilight atmosphere of a world of lost illusions and impossible dreams.

KEY WORKS

About 200 works by Watteau are known. They were produced in the course of just 15 years. His work also includes numerous drawings, some of them drawn with three colours of chalk (red, black and white).

The Bird Nester, 1710, Edinburgh, NG
The Perspective, 1715, Boston, MFA
Antoine Pater, 1716?, Valenciennes, B-A
Mezzetino, c. 1717, London, Wall C
Embarkation for Cythera, 1717, Paris, Louvre
Assembly in a Park, 1717, Paris, Louvre
Venetian Pleasures, 1717, Edinburgh, NG
The Shepherds, 1717, Berlin, Charlottenberg
Pleasures of the Ball, 1717, London, DC
Fête in a Park, 1718, London, Wall C
The Music Party, 1718?, London, Wall C
Gilles, 1717–9, Paris, Louvre
A Halt during the Chase, 1720, London, Wall C
The Shop Sign, also known as *Gersaint's Shop Sign*, 1720, Berlin, Charlottenberg
The French Comedians, 1720, New York, MM

BIBLIOGRAPHY

Antoine Watteau, exhibition catalogue, RMN, Paris, 1984; Posner, D, *Antoine Watteau*, Weidenfeld and Nicolson, London, 1984; Sunderland, J, *The Complete Paintings of Watteau*, Weidenfeld and Nicolson, London, 1971; *Watteau*, exhibition catalogue, RMN, Lille, 1998

Tiepolo

Tiepolo, the distinguished and prolific 18th-century Venetian painter, adapted himself to every requirement with inexhaustible enthusiasm, astonishing speed and great spirit. His paintings portrayed the life of the aristocracy. He set his sumptuous, elegant forms in a vertiginously aerial space, distinguished by dazzling colours and unparalleled luminosity.

LIFE AND CAREER

• Giovanni Battista or Giambattista Tiepolo (Venice 1696–Madrid 1770), son of a merchant, was trained in G Lazzarini's workshop and also studied with F Bencovich and G Piazzetta. After completing *The Sacrifice of Isaac* (1716, Venice, church of the Ospedaletto), he joined the guild of Venetian painters in 1717. In 1719 he married C Guardi, sister of the famous painter F Guardi.

• He painted pictures with brown as the dominant colour: *The Repudiation of Hagar* (1719, Milan, Rasini coll), *The Madonna of Mount Carmel* (c.1720, Milan, Brera), *The Rape of Europa* (1720–2, Venice, Ac) and *Alexander and Campaspe* (c.1725–6, Montreal).

• His first important fresco decoration, *The Force of Eloquence* (c. 1724–5, Venice), displayed the impetuous tone of his light-coloured palette. He then painted *The Apotheosis of St Theresa* (1725, Venice, church of the Scalzi). Between 1726 and 1728 he painted frescoes for the archbishopric of Udine: *Rachel Hiding the Idols*, *The Judgement of Solomon*, *Sarah and the Angel* and others (1727–8), and ten Roman historical paintings for the Palazzo Dolfin in Venice including the *Triumph of Scipio* (1725–30, St Petersburg, Hermitage), works notable for their great luminosity.

• In his mature period he received commissions for frescoes from all over Italy. In Milan, he produced *The Triumph of the Arts* (1731, destroyed, Palazzo Archinto), *The History of Scipio* (1731, Palazzo Casati Dugnati), *The Course of the Chariot of the Sun* (1740, ceiling of the Palazzo Clerici); in Bergamo he painted the scenes of *The Life of St John the Baptist* (1732–3, Colleoni Chapel); in Vicenza he painted *Force, Temperance, Justice and Truth* (1734, ceiling of the Villa Loschi-Zileri); in Venice he painted *St Dominic in Glory* and *The Apparition of the Virgin Mary to St Dominic* (1737–9, ceiling of the church of S Maria dei Gesuati). At the same time he painted large dramatic canvases: *Abraham Visited by the Angels* (1732, church of S Rocco) and *Hagar and Ishmael* (church of S Rocco); also the *Gathering of Manna* and *The Sacrifice of Melchizedech* (1738–40, church of Verolanuova near Brescia); the triptych of *The Passion of Christ* (1739, Venice, church of S Alvise) and the small painting of *Jupiter and Danae* (c.1736, Stockholm).

• In 1740 he settled in Venice again. He decorated the ceiling of the Scuola del Carmine, (*The Apparition of the Madonna of Mount Carmel to the Blessed Simeon Stock*, 1740–4). The quadratura artist G Mengozzi Colonna created the architectural settings for him, framing the *Antony and Cleopatra* series (c.1747–50, Palazzo Labia, paintings in Edinburgh and Melbourne). Tiepolo produced other masterpieces: *Venice Receiving the Homage of Neptune* (1745–50, Venice), *Consilium in Arena* (1749–50, Udine, MC), *The Arrival of Henry III at the Villa Contarini* (1750, Paris), *The Renowned Announcing the Arrival of their Host to the Inhabitants* (c.1750, Venice, Villa Contarini). Tiepolo was also celebrated as a portrait painter: *Antonio Riccobono* (c.1745, Rovigo, Ac), the *Portrait of a Prosecutor* (c.1750, Venice).

• Painter to the European courts, Tiepolo arrived in Germany in 1750, accompanied by his two sons, Giandomenico and Lorenzo, to create extravagant frescoes depicting the *Life of Frederic Barbarossa* (1751–3, Würzburg).

• Back in Venice in 1753, he was commissioned to paint the frescoes to celebrate the magnificence of the Republic, the great families and the clergy: *The Triumph of Faith* (1754–5, Venice, church of the Pietà), *The Sacrifice of Ifigenia, Orlando furioso* (1757, Vicenza, Villa Valmarana), *Nuptial Allegory* (1758, Venice, Palazzo Ca' Rezzonico), *The Triumph of Hercules* (1761, Verona, Palazzo Canossa), the *Apotheosis of the Pisani family* (1761–2, Stra; sketch at the Musée d'Angers). He continued painting portraits, including a series of oriental studies, *Head of an Oriental* (1755, San Diego, MA); *Woman with a Parrot* (1758–60, Oxford).

• In 1761 Tiepolo travelled to Madrid in Spain at the request of Charles III to paint the ceilings of the royal palace: *The Apotheosis of Spain*, *The Apotheosis of the Spanish Monarchy* and *The Apotheosis of Aeneas* (1761–4, in situ). The dawn of Neoclassicism heralded the end of Tiepolo's art of fantasy and light. He had a second wind in his seven altarpieces for the church of Aranjuez including *The Immaculate Conception* (1767–9, Madrid), his last painting before he died suddenly in Madrid.

He was succeeded by his sons. His art inspired F Boucher, *Fragonard and *Delacroix, and the French draughtsmen of the 18th century.

APPROACH AND ARTISTIC STYLE

Tiepolo painted religious, mythological, historical and often allegorical paintings (in homage to his patrons) as well as portraits. The altar and easel paintings, of medium to large size, were largely commissioned by the clergy. Tiepolo worked mainly in and around Venice (notably Bergamo and Vicenza), in Udine, Milan, then in Germany and Spain. His gigantic frescoes decorated churches, the villas and palaces of the Dugnati, Labia and Pisani families and the European courts of K P von Greiffenklau, Prince-Bishop of Würzburg, and Charles III in Madrid.

In Venice, Tiepolo became familiar with Piazzetta's chiaroscuro technique. He was inspired by the art of *Veronese and the Baroque and by S Ricci, the originator of Venetian Rococo painting in the early 18th century. He was also influenced by *Rembrandt, as can be seen in the density of his painting. In Würzburg he discovered themes of chivalry and in Madrid he encountered emergent Neoclassicism.

• At first Tiepolo painted mainly pictures with linear outlines, abrupt brushstrokes and warm colours concentrating on a range of browns with a strong chiaroscuro. His style was jerky. In his subsequent larger canvases his composition became bolder, the dramatic tension more relaxed, while a faint, diffuse light enveloped the bright colours which now came in a wider palette. The style of his first fresco (1724–5), marked by hard modelling and sometimes exaggerated perspective effects, still reflected his debt to the art of S Ricci and Veronese. From Ricci he borrowed his decorative sense, joyfulness, clarity and vibrant touch while from Veronese he acquired an interest in decorative schemes, space and the aristocratic beauty of the figures. In Udine (1726–30) his art became less academic, evolving towards the Rococo, and Tiepolo developed the flowing arabesques, impetuous dynamism, violence and audacity which marked his compositions. His palette became lighter and a natural luminosity invaded his celestial spheres. The limpid blue sky and trails of pinkish, white clouds brought out the light, pearly colours of the clothes and ornaments. The details of the faces and objects were naturalistic and his figures' expressions emanated humanity.

• In his mature period, his genius for decoration and theatricality became even stronger. The bold grandiloquence of his compositions reinforced the moving quality of his inspiration. Formal exuberance was steeped in an atmospheric light which emphasized the bold colours. If the inspiration was happy the composition became elegiac, the atmosphere aerial and the colours warm and sunny (*The Course of the Chariot of the Sun*). The magnificent decoration and painted architecture (sumptuous columns and false perspectives of palaces and gardens) conveyed an imposing dignity to the festivities in which the secular heroes participated in 18th-century dress (Palazzo Labia). In the Baroque tradition, the figures in the allegories were based on members of rich contemporary families and the symbolic characters, whether secular or biblical, were endowed with lively effects and poses, in

A GREAT PAINTER

◆ Tiepolo's fame had already spread throughout during his lifetime. His creativity has been acknowledged since the end of the 19th century.
◆ Following in the tradition of Veronese's decorative schemes and Baroque pomp, Tiepolo developed a highly individual decorative genius.
◆ He revitalized the allegorical vocabulary of the great families, and introduced chivalrous subjects which advocated courtesy and generosity.
◆ The artist displayed boldness in his impetuous composition and emphasized the 'grandiose' and 'heroic' aspect of his characters.
◆ Tiepolo developed a clear, silky harmony of colours and a new, sunny light.

the spirit of the time. The sensual paint and silvery harmony of the colours were steeped in a brilliant luminosity. Tiepolo showed his satirical, humorous vision of the mores of his time by using naturalist details (*Consilium in Arena*).

• In Würzburg Tiepolo reinterpreted his concept of décor and iconography: he combined the golds and whites of the stucco with the allegorical compositions which he enriched with a dimension which was both pagan and sacred. Thus, the four *Continents* were symbolized by the presence of a multicoloured crowd while the scenes in the *Wedding* and *Investiture* were transfigured by an atmosphere of holiness. Tiepolo recounted stories of poems of chivalry in a moving and melancholy manner. The paintings were dominated by soft colours and evoked an idyllic, dreamy atmosphere.

• In Madrid, his compositions and décors became more subdued although the foreshortening was still bold. The opaque, purplish colours and the fainter, more muted light expressed his anxiety faced with the emergence of Neoclassicism.

• In his final paintings he abandoned Rococo splendour, replacing it with an ascetic tension. A hachured finish and light-coloured, milky shades expressed the contemplative atmosphere and the sombre, threatening character of the landscape.

• His expressive official and allegorical portraits – with a sketched or polished finish – reflected the diversity of his talent and his sense of reality.

The Apotheosis of the Pisani Family
1761–2. Fresco, 23.5 x 13.5m, Stra, Villa Pisani

On the gigantic, oval ceiling of the main drawing room of the Villa Pisani, Tiepolo expressed his love of heroic fantasy, bold perspective, the decorative illusionism of grisaille and painted architecture. The members of the Pisani family are sitting enthroned, especially the children to whom this Apotheosis is dedicated. The allegorical figures of the continents and of trade explain their prosperity. The artist has depicted a bustling world, weightless but anchored in reality, the theatre of life. He has distributed the figures irregularly in the blue sky whose infinity is conveyed through the luminous opening. Sumptuously dressed in light colours, the foreshortened figures are caught in a maelstrom of intense light.

The Arrival of Henry III at the Villa Contarini
c.1750. Fresco transposed onto canvas, 3.30 x 7.40m, Paris, Musée Jacquemart-André

*In this work Tiepolo celebrated the visit of King Henry III to the noble Italian Contarini family in 1574, the same year that this son of Henry II and Catherine de' Medici was crowned King of France. In this historical scene, the painter has depicted the world of the aristocracy, theatrically glorifying the dreams and ambitions of the nobility. This grandiose fresco is in the tradition of *Veronese's style. Assisted by his son Domenico, Tiepolo developed a powerful formal, pictorial, even declamatory language. The painting is bathed in a sunny light, and is framed by sculpted architectural columns and painted perspectives, executed by the* quadratura *painter Colonna.*

KEY WORKS

The catalogue of Tiepolo's work includes about 300 paintings (ranging from canvases of one square metre to decorative schemes of 540 square metres): frescoes in about 27 palaces, villas and other residences and 15 churches as well as over 250 canvases.

The Force of Eloquence, c.1724–5, Venice, ceiling of the Palazzo Sandi
Alexander and Campaspe, c.1725–6, Montreal, MA
Rachel Hiding the Idols, The Judgement of Solomon, Sarah and the Angel, 1727–8, Udine, Archbishop's Palace
Scipio and his Slave, 1731, Milan, Palazzo Dugnati
Hagar and Ishmael, 1732, Venice, church of S Rocco
Jupiter and Danae, c.1736, Stockholm, university
St Dominic in Glory, 1737–9, Venice, church of S Maria dei Gesuati
The Apparition of the Madonna of Mount Carmel to the Blessed Simeon Stock, 1740–4, Venice, Scuola dei Carmini
Venice Receiving the Homage from Neptune, 1745–50, Venice, Doges' Palace
The Meeting of Anthony and Cleopatra, 1747–50, Edinburgh, NG
Cleopatra's Banquet, 1747–50, Melbourne, NG
The Arrival of Henry III at the Villa Contarini, c.1750, Paris, J-A
Portrait of a Prosecutor, c.1750, Venice, GQ Stampalia
Apollo Introduces Beatrice of Burgundy to Frederic Barbarossa, the Wedding ..., 1751–3, Würzburg, Kaisersaal
The Sacrifice of Ifigenia, 1757, Vicenza, Villa Valmarana
Woman with a Parrot, 1758–60, Oxford, Ashmolean Museum
The Apotheosis of the Pisani family, 1761–2, Stra, Villa Pisani
The Apotheosis of the Glory of Spain, The Apotheosis of the Spanish Monarchy, 1761–4, Madrid, Royal Palace
The Immaculate Conception, 1767–9, Madrid, Prado

BIBLIOGRAPHY

Christiansen, K, *Giambattista Tiepolo, 1696-1770*, exhibition catalogue, Metropolitan Museum of Art, New York, 1996; Levey, M, *Giambattista Tiepolo*, Yale University Press, New Haven, CT and London, 1986; Morassi, A, *A Complete Catalogue of the Paintings of G. B. Tiepolo, including pictures by his pupils and followers wrongly attributed to him*, translated by Peter J Murray and Linda Murray, Phaidon Press, London, 1962; Rizzi, A, *Mostra del Tiepolo*, 2 vols, Udine, Villa Manin Passariano, 1971

Hogarth

As a committed artist in Georgian England, Hogarth's work was testimony to the culture in which he lived. He brought to life satire and edifying conversation, humour and convention, the real and the imaginary. He tried to raise society's moral standards and to express his own philosophy. A renowned portraitist and painter of scenes of London's fashionable society as well as its common people, he invited the viewer to 'read' his pictorial narrative and descriptions, whether simply sketched or beautifully finished.

LIFE AND CAREER

William Hogarth (London 1697–London 1764), British artist, engraver, illustrator and painter, was the son of a schoolmaster. He began work with J Thornhill, his future father-in-law, creating his first realistic representations of everyday life: *The Street* (1725, Upperville, United States, Mellon coll), *The Recognition of Paternity* (c.1726, Dublin, NG), *The Sleeping Congregation* (1728, Minneapolis, IA), *The Beggar's Opera* (1728, London, TG; New Haven, YC).

• In 1729, he married his master's daughter and became a portrait painter to the aristocracy with 'conversation pieces', the group portraits that were then fashionable: *The Wedding of Stephen Beckingham and Mary Cox* (c.1729, New York, MM), *The Wollaston Family* (1730, Leicester AG), *The Fountaine Family* and *The Reception at Sir Richard and Lady Child* (1730, Philadelphia, MA), *Children Acting in a Play* (1731), *Portrait of Henry VIII and Anne Boleyn* (lost). He painted several satirical series: *The Career of a Prostitute* (1732, destroyed), *The Rake's Progress* (1735, London), as well as portraits of ordinary people: *Sarah Malcolm in Prison* (1733, Edinburgh) and *The Distressed Poet* (1729–36, Birmingham, MA). He also painted religious subjects – *The Good Samaritan and The Pool of Bethesda* (1735–6, London, Saint Bartholomew's Hospital) – in works of classical composition executed in a Rococo style: *Moses Brought to Pharoah's Daughter* (1746, London), *Paul before Felix* (1748, London, Lincoln's Inn Society).

• He was commissioned to paint portraits by the prosperous middle class: *George Arnold* (c.1738, Cambridge, FM), *Captain Thomas Coram* (1740, London), *The Graham Children* (1742, London), *Mary Edwards* (1742, New York, EC) and *Benjamin Hoadly, Bishop of Winchester* (1743, London, TG). He also probably visited Paris where he became familiar with the French Rococo. Works dating from this time include the portrait of *Mrs Elizabeth Salter* (1744, London), *Portrait of the Painter and his Pug* (1745, London), *Captain Lord George Graham in his Cabin* (1745?, Greenwich), *Hogarth's Servants* (1750–5?, TG) and *Garrick and his Wife* (1757, London, Windsor Castle).

• Hogarth painted a series of works satirizing fashionable society, the best known being *Marriage à la Mode* (1745, London) which describes the unhappy union between an impoverished aristocrat and a rich middle-class heiress. Hogarth also turned his attention to other realistic subjects from contemporary life: *The Shrimp Girl* (1740?, London), *At the Tailors* (1744, London), *The Ball* (1745, Camberwell, South London, AG), *The Roast Beef of Old England* (1748, London).

• In 1753, Hogarth printed and published a humorous treatise on aesthetics, *The Analysis of Beauty*. After expanding the moralizing and satirical series in *The Election* (1754, London), he attempted for the last time, unsuccessfully, to establish himself as a history painter with the triptych for the church of St Mary Redcliffe in Bristol depicting *The Three Marys*

at the Tomb, The Ascension, The Closing of the Tomb (1756, Bristol, City AG) and *Sigismond* (1760, London, TG).

Renowned for his portraits and engravings, Hogarth gave a particular character to British art, but after his death the success of J Reynolds, T Gainsborough and B West eclipsed his work for some time. During the 19th century, only *Ingres produced portraits of middle-class subjects in the same spirit as Hogarth, capturing them in natural poses showing off their improved social status.

APPROACH AND STYLE

The main body of Hogarth's work consisted of portraits of the aristocracy and in particular the middle classes, the genre scenes of his conversation pieces and his series of moral tales. He also painted historical scenes and, later in life, political and polemical subjects. His paintings ranged from large to small but were mainly of average size. He painted commissioned portraits and his genre paintings were popular with his friends and patrons, who included M Edwards.

Hogarth spent his entire career in London, working mainly alone, or in the 'grand style' with the historical painter J Thornhill. The world he moved in was a community of artists, writers, politicians and patrons. He was familiar with the work of *Watteau, who inspired his conversation pieces, as well as the French portraitists H Rigaud, M Quentin de La Tour and the Italian J Amigoni.

• Hogarth tackled political, religious and social subjects. They were intended for everyone, apart from the critics whom the artist despised. He wanted to establish English painting in its own right by liberating it from its traditional situation and from the French and Italian styles. He wanted to make it a part of everyday life so as to give it meaning as a living truth. To do this he had to draw upon London's motley social mix, English culture and history (the novels of Fielding and Defoe), the burgeoning industrial revolution and the power and commercial affairs of the middle classes.

• In love with liberty, he also glorified the dignity and happiness of man, denouncing the debauched nobility dispossessed of its power, the triumph of religion that relied on ignorance and credulity, corrupt magistrates, the perversity of politics, the violence of the masses, and fashion with all its artifice. To all these things, Hogarth 'responded (pictorially) with insolence or with vulgar provocation' (P Georgel, 1978). The artist wanted to create a morally improving style of painting, which he achieved through comedy since it 'improves morals through laughter' (according to Hogarth, returning to the Latin definition).

• Hogarth wrote that his vision of beauty was based on the balance between 'ordered diversity' and the 'serpentine line'. This appeared

A GREAT PAINTER

◆ Famous in his lifetime, Hogarth's reputation has been recognized throughout the centuries.

◆ Hogarth founded a school of British painting which was anti-French and Italian and he was its leading exponent. His morally improving art, whose aim was to enlighten ordinary people, contrasted with the formal, aristocratic art of the time.

◆ A highly inventive artist, he introduced a new genre which he called 'modern moral subjects', presented in his various picture series. This 'comic history painter' (Fielding, 1742) introduced the conversation piece to England. He was the first artist of distinction to portray the middle classes.

◆ As a portraitist he devised original compositions when he painted his friends, his domestic circle or himself.

◆ Hogarth created an independent English school of painting, was involved in events leading to the founding of the Royal Academy, and established the Saint Martin's Lane Academy.

throughout his work with its dynamic unity, the excitement of reality and the awakening of the mind where laughter and horror met.

• Hogarth broke with the tradition of the English portrait as painted by P Lely or G Kneller and painted his subjects more naturally, going about their business. Sometimes naively, he revealed their character, personality and social standing, conveying the newly discovered power and grandeur of a merchant, a doctor, a bishop or a captain. He had a completely individual interpretation of the morality of his time. Consequently, his judgement of worth, whether positive or negative, became a substitute for description. He produced simple half-length portraits of his subjects, painting more elaborate scenes for his self-portraits and those of his friends. After his journey to Paris in 1744, Watteau and the French Rococo style influenced his sumptuous treatment of the shimmering colours of taffeta and the striking harmony of complementary colours.

• The theatre and the comedies of Molière influenced his first series of conversation pieces with their arrangement of images in cycles (*Before and After*), the division into scenes, the composition, the gestures and the expressions. The artist also introduced a brutal or moving element. The later series had a more narrative, dramatic feel (*The Rake's Progress*). The moral message clearly conveyed by the parable was reinforced with biblical quotations.

• Hogarth excelled at crowd scenes where he depicted society as seen in popular prints, with all its excesses.

• Hogarth's technique was Rococo with a delicate, spontaneous, free, fresh touch and skilful drawing full of vitality and vigour. His style recalls that of his Italian contemporary, J Amigoni.

BIBLIOGRAPHY

Antal, F, *Hogarth*, Routledge and Kegan Paul, London, 1962; Bindman, D, *Hogarth*, Thames and Hudson, London, 1981; Einberg, E and Egerton, J, *The Age of Hogarth: British Painters Born 1675–1709*, Tate Gallery with the assistance of the J Paul Getty Trust, London, 1988; *Manners and Morals: Hogarth and British Painting 1700–1760*, exhibition catalogue, Tate Gallery, London, 1987; McWilliam, N, *Hogarth*, Studio Editions, London, 1993; Paulson, R, *Hogarth*, 3 vols, Lutterworth Press, Cambridge, 1991–3

The Orgy (from **The Rake's Progress** series)
1735. Oil on canvas, 62.5 x 75cm,
London, Soane Museum

In this series Hogarth presented contemporary, morally improving subjects in a new genre which enjoyed enormous success. The Rake's Progress consists of eight parts, and may have been inspired by Italian engravings or Fielding's comedy. In it, Hogarth captured the nature and the lives of the colourful Londoners who display their position in society as well as their inmost character through their dress, bearing and expressions.

The painter imposed his own point of view, in this case critical, combining the comic (the theft of the rake's watch), with violence (the woman angrily destroying a planisphere, mutilated portraits on the wall), or drama, suggested by details such as a girl spitting out her drink or a young singer watching as a prostitute undresses. The 'ordered diversity' and 'the serpentine line', guarantees of beauty, the brown, green and red colours, and the subtle, fresh, delightful Rococo style contribute to the dynamism and excitement of this comic yet moving denunciation of immorality.

KEY WORKS

Hogarth painted about 200 canvases and produced over 250 engravings.

The Reception at Sir Richard and Lady Child, 1730, Philadelphia, MA
Children Acting in a Play, 1731, pr coll
The Rake's Progress, 1735, London, SM
Sarah Malcolm in Prison, 1733, Edinburgh, NG
Captain Thomas Coram, 1740, London, Foundling Hospital
The Shrimp Girl, 1740?, London, NG
The Graham Children, 1742, London, TG
Mrs Elizabeth Salter, 1744, London, TG
At the Tailors, 1744, London, TG
Portrait of the Painter and his Pug, 1745, London, TG
Captain Lord George Graham in his Cabin, 1745?, Greenwich, NMM
Marriage à la Mode, 1745, London, TG
Moses Brought before Pharaoh's Daughter, 1746, London, Foundling Hospital
The Roast Beef of Old England, 1748, London, TG
The Election, 1754, London, SM
Hogarth's Servants, 1750–5?, London, TG

Chardin

Chardin was a modest, meticulous still life painter. He was unusual in that he presented the simple, eternal, essential truth of objects and people at a time when taste favoured softness, elegance and pictorial refinement. His works are deeply satisfying, filled with poetry and feeling. His work is notable for the exquisite composition, the complex use of space, the steady light and the apparent simplicity of his paintings, in which the dominant colour is often a warm shade of brown.

LIFE AND CAREER

• The career of the French painter, Jean Simeon Chardin (Paris 1699–Paris 1779), the unassuming and modest son of a carpenter, was pursued almost entirely in Paris under Louis XV. Typical of the era, he was largely self-taught, although he studied briefly under P-J Cazes and N Coypel, and in 1724 was admitted to the Academy of Saint Luc. Most importantly, through his paintings of *The Skate and The Buffet* (Paris) he was admitted to the Royal Academy of Painting as a painter 'of animals and fruit' in 1728. Founded by Ch Le Brun in 1648, the powerful Academy had until then been dismissive of still life, a category considered inferior in the hierarchy of genres. After his exceptional admission to the Academy, he was taught there and regularly showed his work with other artists at the Salon du Louvre, which had been held annually since 1667. *A Mallard Drake Hanging on a Wall and a Seville Orange* (1728–30, Paris, Musée de la Chasse et de la Nature), *The Running Dog* (1724, Los Angeles), *Cat Watching a Partridge and Dead Hare* (1727–8, New York) date from this period.
• In 1730 he received his first commissions from C-A de Rothenbourg: *The Attributes of Science and The Attributes of Art* (1731, Paris) and *Music Instruments and Parrot* (1731, pr coll). He extended his body of work with *Still Life with Cutlets ...* (1732, Paris, J-A), *Still Life with Carafe, Silver Goblet, Peeled Lemon ...* (1733, Karlsruhe), *Mortar and Pestle, Red Copper Cauldron ...* (c.1734, Paris) and *Pipes and Drinking Pitcher* (1737?, Paris).
• In 1733 he painted the human figure in the Dutch style: *Lady Sealing a Letter* (1733, Berlin). The principal figure is often shown completely absorbed in work or play, as in *The Fountain* (1733, pr coll) and *Young Girl with Battledore* (1737, pr coll) and the paintings in Stockholm (Nm) – *The Washerwoman* (c.1734), *The Drawer* (1738) and *The Tapestry Maker* (1743). The same characteristic is seen in the numerous works at the Louvre including *The Blower* (1734), *Young Man with Violin* (1738), *The Return from the Market* and *The Governess* (1739), *The Industrious Mother* and *The Blessing* (1740) and *Boy with Teetotum* (1741). The French King acquired *The Lady with a Bird-Organ* in 1751 (Paris, Louvre). Chardin's work also became increasingly popular in foreign courts. He painted the renowned *Soap Bubbles* (1739, Washington, NG), *The Schoolmistress* (1740, London, NG) and *The House of Cards* (1741, London, NG). Widowed in 1735, he remarried in 1744.
• With the support of the Academy's director, N de Largillière (who died in 1746), Chardin was made an adviser there in 1743. He held the office of treasurer from 1755 to 1774 and oversaw the hanging of the Salon from 1755. He received a pension from the King in 1752, and lodgings in the Louvre in 1757. From 1748 Chardin devoted himself to still life painting: *Dead Partridge, Pear ...* (1748, Frankfurt), *Kitchen Table* (1756, Carcassonne), the celebrated *Wild Strawberries* (1761, pr coll) and, in the Louvre: *The Olive Jar* (1760), *Grapes and Pomegranates* (1763), *Brioche* (1763), *Water Glass and Jug* (c.1760) and *The Silver Goblet* (c.1768). There is also the oval canvas of *Dead Drake hanging from its Leg* (1764, Springfield, MA).
• In 1765 he produced a series of overdoor paintings for the Marquis de Marigny: *Attributes of Civilian Music and Attributes of War Music* (Paris, pr coll). His work was held in high regard by the Academy until 1770. When J B M Pierre became its director, Chardin resigned his responsibilities.
• Towards the end of his life, his eyesight failing, he experimented with pastel and produced several intimate, sensitive works: *Self-Portrait* (1771 and 1775, Paris) and *Portrait of Madame Chardin* (1775, Paris).

Numerous contemporaries made attempts to work in the genre of the 'modest poet of governesses and dead rabbits' (Pierre Rosenberg, 1979), except for *Fragonard, master of the Rococo and erotic subjects. Chardin died in obscurity in 1775, but there are echoes of his work in that of *Manet, *Cezanne, *Matisse, *Braque and G Morandi.

APPROACH AND STYLE

Chardin painted still life: animals, fruit, artists' equipment, cooking utensils and scenes depicting everyday domestic life, in a setting populated by honest, hardworking non-aristocratic people, mainly women, adolescents and children. He made portraits and self-portraits in pastel on canvas and occasionally wood. He produced some large overdoor paintings, but preferred to paint on a more modest scale.

European monarchs, courtier collectors and other artists bought his works, of which Chardin often painted several versions.

Chardin did not travel. P-J Lacaze and N Coypel respectively introduced him to drawing from antiquity and to light as a means of defining the solidity of objects. Chardin was familiar with the still lifes of his contemporaries N de Largillière and A-F Desportes. He saw the work of the Dutch artists P Claesz and W Heda, and the Flemish-inspired portraits of the French artist J Aved, which led him towards genre painting. He was familiar with the work of the Dutch painters *Rembrandt, G Dou, Van Mieris, possibly *Vermeer, and the French artist Le Nain. 'I must forget everything that I have seen, even the way in which these objects have been treated by others', he said.

- Nonetheless Chardin's early still lifes (1724–8) do reveal the influence of his contemporaries, in the accuracy and opulence of the representation. His studies (1730–3) led him to rearrange objects according to his own vision; he put platonic truth, eternity, nobility and perfection first. His early paintings depicted dead animals, fruit, bottles and silver goblets. From 1730 he added ordinary, humble objects from the kitchen: a leather pot, cauldrons or jugs, together with meat, vegetables or fish.
- He introduced figures into his genre scenes (1733–40), drawing them from those around him; he yielded to the pleasure of the eye and poetic sentiment, but avoided trivia and the picturesque detail of the 'little masters' of the North. He chose the most commonplace scenes, unfussy and timeless. He captured his anonymous, expressionless characters going about their business in their own private world: a child playing or an adult at work. He reduced their presence to its essence in his rendering of a gesture or the turning of a neck. A sense of solemnity and restraint emanates from his canvases, as well as modesty, compassion, understanding and a fondness for children. He set his characters clearly against a dark background, achieving a skilful juxtaposition of background and foreground.
- From 1748 to 1768 he returned to still life painting. He varied the themes and the pieces in the composition, painting ordinary or exotic fruit, bottles, glasses, a coffee pot and the

A GREAT PAINTER

- ◆ Recognized by the French Royal Academy and admired by the art critic Diderot (*Salons*, from 1751 to 1781) and by many contemporaries, Chardin enjoyed great success in his day but was forgotten after his death. In 1845 a sale of his work caused a sensation and in 1846 P Hédouin, his first biographer, returned him to prominence.
- ◆ Chardin caused a definitive rearrangement of the hierarchy of genres and revived the 'lesser' genre of still life, giving new life to the style. He broke with the tradition of the 'little masters' of northern Europe.
- ◆ Chardin offered a deliberately limited repertoire of objects and figures, constantly reworked and renewed and therefore never dull. He was the greatest poet of childhood (P Rosenberg).
- ◆ He used separate touches of colour, barely 'readable' close-to, which at a distance blend perfectly into a sublime whole.
- ◆ He was a master of the science of composition, often pyramidal.
- ◆ His perfect and eternal representation of reality extended beyond that reality: 'an' object becomes 'the' object, its very essence. The true simplicity of the objects and human beings that he depicted made the art of still life worthy again. The modest, anonymous ces of the figures, captured in immobility and with a sense of the eternal, are iniscent of the art of Vermeer or *La Tour.

ke. Whether simple or complex, these works display unparalleled skill and magnificence. The early, slightly unbalanced compositions were succeeded by stronger, more complex arrangements. Chardin was interested in volume and mass; he multiplied and miniaturized objects, enlarging the space around them. He reduced the individuality of the elements in his canvases, presenting an immediate and harmonious overall vision.

• His first canvas grounds were treated with a thin, graduated wash of different shades of brown, amalgamated and blended into a gamut of red and orange. Light played an increasing role, illuminating the composition and creating myriad reflections. The precise rendering of his early works became 'raw' and 'rough', at once smooth and gritty. At the height of his skills and after 1748, 'Chardin's painting technique [in oils] is unusual. He sets down colours one after the other with almost no mixing so that the effect is a little like a mosaic' (M Chaumont, 18th century). The broad, juxtaposed, almost 'pointillist' strokes became smoother and porcelain-like. Reflections and transparency grew into a mysterious, shadowy, completely harmonious blend.

• In 1765 Chardin was busy with large-scale decorations and in 1769 he threw himself into the art of grisaille, before completing his life's work with subdued, sensitive portraits in pastel (1771-9).

• To arrive at the essence of his art, Chardin sought 'truth' over appearance and detailed description. He did not paint an object so much as its very essence, whether it was a goblet, a piece of bread or a jug. His self-portraits revealed a synthesis of the medium, physical and mental likeness, and stylization.

BIBLIOGRAPHY

Chardin, exhibition catalogue, RMN, Paris, 1999; Conisbee, P, *Chardin*, Phaidon, Oxford, 1985; de Goncourt, E, *French eighteenth-century painters: Watteau, Boucher, Chardin, La Tour, Greuze, Fragonard*, Phaidon, Oxford, 1981; Naughton, G, *Chardin*, Phaidon, London, 1996; Rosenberg, P, *Chardin, 1699–1779*, exhibition catalogue, RMN, Paris, 1979; Rosenberg, P, *Chardin: New Thoughts*, University of Kansas, Lawrence, KS, 1983; Wildenstein, G, *Chardin: catalogue raisonné*, revised by Daniel Wildenstein, translated by Stuart Gilbert, Cassirer, Oxford, 1969

The Blessing
1740. Oil on canvas,
49.5 x 38.5cm, Paris, Musée du Louvre

The Blessing (benedictus in Latin) is the prayer (or grace) spoken together before a meal. Since it first appeared at the Salon this well-known work has given pleasure with its simplicity, truth, accessibility, tenderness and modesty. In a decent middle-class household, a silent complicity has been established between the three figures, captured in a timeless everyday pose. The skilful composition manages the large empty spaces, the colouring is gentle and subtly shaded while the execution is smooth and silky. This everyday scene shows how 'Chardin mixed secular and sacred happiness' (P Rosenberg, 1979). Meticulous and hesitant, he drew many sketches and rough drafts for this picture and painted several versions of it.

The Olive Jar
1760. Oil on canvas, 71 x 98cm, Paris, Musée du Louvre

In this painting Chardin achieved perfection in his art. He has mastered the composition and the space, controlling the warm and harmonious colouring against the bistre background glowing in the blend of colours. A soft tonal light surrounds the work in a veiled, peaceful, silent atmosphere.
'It is as though the porcelain vase is really made of porcelain; it is as though these olives are really separated from the eye by the water in which they are immersed … Here is someone who truly understands the harmony of colours and reflections. Oh Chardin! It is not the white, red or black that you mix on your palette: it is the very substance of the objects, it is the air and the light that you take on the tip of your brush and apply to the canvas … We understand nothing of this magic. There are thick layers of colour applied one on top of the other whose effect seeps through from the lowest layer to the topmost one. Another glance and it appears as if a haze has been blown onto the canvas … Come close and everything changes, becomes flat and disappears; move away and everything is recreated and reproduced'. (Diderot, Salon of 1763).

KEY WORKS

Chardin painted about 400 works, 36 of which are owned by the Louvre.
The Running Dog, 1724, Los Angeles, Pasadena MA
Cat Watching a Partridge and Dead Hare, 1727–8, New York, MM
The Ray, 1728, Paris, Louvre
The Buffet, 1728, Paris, Louvre
The Attributes of Science, 1731, Paris, Musée J-A
Still Life with Carafe, Silver Goblet, Peeled Lemon ..., 1733, Karlsruhe, SK
Lady Sealing a Letter, 1733, Berlin, Charlottenberg
Mortar and Pestle, Red Copper Cauldron ..., c.1734, Paris, CJ
Pipes and Drinking Pitcher, 1737?, Paris, Louvre
The Return from the Market, 1739, Paris, Louvre
The Blessing, 1740, Paris, Louvre
Boy with Teetotum, 1741, Paris, Louvre
Dead Partridge, Pear ..., 1748, Frankfurt, SK
The Lady with a Bird-Organ, 1751, Paris, Louvre
Kitchen Table, 1756, Carcassonne, B-A
The Olive Jar, 1760, Paris, Louvre
Wild Strawberries, 1761, pr coll
Attributes of Civilian Music, 1765, Paris, pr coll
The Silver Goblet, c.1768, Paris, Louvre
Self-portrait, 1771 and 1775, Paris, Louvre

Fragonard

A Rococo painter and draughtsman, Fragonard was a light-hearted, lively artist, sensitive and impulsive, daring and free. His work embodied the aspirations, contrasts and contradictions of the 18th century. It displays a lively imagination, dazzling gifts and great facility of execution. His feeling for movement and his virtuosity, his light, sensual palette and the role played by love in his 'playlets' were characteristic of his era.

LIFE AND CAREER

• Jean Honoré Fragonard, French master of the Rococo style (Grasse 1732–Paris 1806), was from a modest background and arrived in Paris at the age of six. He trained briefly under Jean Siméon *Chardin, then François Boucher. In 1752 he was awarded the Prix de Rome. From 1753 to 1756 he trained at the Royal School under the direction of Carle Van Loo.

• During his youth, he produced history paintings: *Jeroboam Sacrificing to Idols* (1752, ENSB-A), *Prix de Rome*, *Psyche Shows her Sisters the Presents She has Received from Cupid* (1753–4, London, NG), *The Washing of the Feet* (1745–55, Grasse Cathedral), and painted courtly subjects, *Blind Man's Buff* (1755, Toledo) or *The Scale* (1755, Lugano, TB).

• Between 1756 and 1761 Fragonard lived in Rome and travelled in Italy, supported by his friends the painter Hubert Robert and the Abbé de Saint-Non, a rich young art lover. He learnt from the Italian masters, from Annibale *Carracci to *Tiepolo, who inspired him to paint *The Stolen Kiss* (1759, New York), *The Washerwomen* (c.1760, Saint Louis, Missouri, MA), The Storm (c.1759, Paris, Louvre), *Grand Cascade at Tivoli* (c.1761, Paris, Louvre), *White Bull in the Stable* (before 1765, Paris, Louvre) and *The Stable* (c.1760, Paris, pr coll).

• On his return to Paris in 1761, by now fully skilled, Fragonard painted *The Bathers* (c.1763, Paris), *Coresus and Callirhoë* (1765, Paris), his admission piece for the Academy which was particularly admired by Diderot and bought by the King. However, Fragonard gave up history painting soon after. His interest turned towards miniature cabinet paintings, landscapes and erotic subjects: *Gardens of the Villa d'Este*, also known as *Le Petit Parc* (before 1765?, London), *The Swing* (1767, London), *The Powder Magazine* (1770, Paris, Louvre), *The Shift Withdrawn* (c.1770, Paris, Louvre) and *The Kiss* (c.1770, Paris, Louvre) and *The Happy Lovers* (1717, Switzerland). Fragonard moved into the Louvre and married in 1768.

• He painted the famous *Figures de fantaisie*, bold portraits painted with great spirit: *Mademoiselle Guimard*, *The Portrait of Abbé de Saint-Non*, *Diderot*, *The Writer* (1769, Paris, Louvre) as well as *The Reader* (Washington, NG). In 1771, at the peak of his art and his fame, Fragonard rejected official recognition and turned down the post of painter to the King. He continued with the erotic theme in the four panels commissioned by Madame du Barry, which included *The Pursuit* (1770–3, New York, FC). These were dismissed as unfashionable by younger painters who were followers of the emerging Neoclassicism. Disheartened, he left Paris for a few months in 1773 and 1774, accompanied by the rich art lover Bergeret who took him to Rome where the posthumous influence of Tiepolo was growing.

• Little is known of his Parisian period, between 1774 and 1806. His work remained unchanged at first: *Young Girl Playing with her Dog* (c.1775, Munich), *The Melted Horse*, a game played at the time (c.1775–80, Washington, NG). He then tried to adapt himself to new artistic ideas: *Fair at Saint-Cloud* (1775–80, Paris), *The Adoration of the Shepherds* (1776, Paris). *The Bolt* (1784, Paris), *The Sacrifice of the Rose* (1785–8, Los Angeles, pr coll), *A Lady Carving her Name on a Tree* (c.1780, London, Wall C) and *The Fountain of Love* (c.1785, London, Wall C) all reveal a definite sense of melancholy. There is also a Romantic feeling to *The Vow to Love* (1780–5, Paris).

• Overwhelmed with grief at the death of his daughter in 1788, then ruined by the French Revolution, Fragonard gave up painting. His old pupil *David came to his assistance: he was nominated a member of the arts jury and then a member of the Conservatoire of the Louvre.

He was a solitary painter and had pupils, including his son Evariste and his sister-in-law Margaret Gerard, rather than direct followers or imitators. Renoir and Bonnard looked to his

work in painting female flesh tones. His spirited style has been emulated by artists f
*Daumier to *Dubuffet. With the freedom of his application of paint, he could perhaps
seen as the 'father of pure painting' (Pierre Rosenberg), the Impressionists and the Actior
Painting of *Pollock.

APPROACH AND STYLE

Fragonard painted every genre: portraits, domestic scenes, landscapes, pastiches of the great
masters, miniatures and so on. He undertook religious, historical, mythological and alle-
gorical subjects. He preferred painting oval pictures of average size, using oils on canvas.
His customers were mainly private patrons such as the Marquis de Véri, the Comtesse du
Barry and Mademoiselle Guimard, as well as his friends the Abbé de Saint-Non, Bergeret
and others.
The artist was taught by successively Chardin, Boucher and Carle Van Loo before visiting
Rome, Tivoli, Naples, Bologna, Venice and Genoa and immersing himself in the art of the
great Italian masters, from Carracci to *Veronese, from Barocci and Solimeno to Tiepolo,
and the Baroque of *Correggio and *Pietro da Cortona. He painted with the landscape artist
Hubert Robert. In Rome or during a journey he may have made to the Netherlands, he also
contemplated the art of the masters of northern Europe, the landscape painter Jacob van
Ruïsdael and the works of *Rembrandt, Van Dyck and Jordaens. At the Palais du
Luxembourg he made copies of paintings by *Rubens, La Fosse and others.
Distanced from the official and academic circuit, Fragonard learnt the reality of objects from
*Chardin. 'Fragonard is reminiscent of Rubens seen through the brilliance of Boucher'
(Goncourt, 1860). He learnt warmth of colour in particular from the Italian and European
masters. 'His world is that of joie de vivre, gaiety, freedom of style, happiness and above all,
vivacity. He is the observer who never over-emphasizes or caricatures. He describes accu-
rately, with a smile, with rapture, with a wonderfully steady eye ... He develops and yet
remains the same' (Pierre Rosenberg). His style changed according to his subjects, but he
excelled at always capturing the moment. His art reached its peak in about 1771.

● His first history paintings were great religious or allegorical spectacles, painted with
restraint and moderation, very 'French' in style and colouring. They were admired by his
contemporaries for 'the warmth of their composition and their harmonious impact'.
● In Rome in 1759, his landscapes of stormy and cloudy skies reflected the influence of
the Dutch painter Van Ruïsdael. Hubert Robert taught him the power and the 'vigour' of

e, the guarantor of beauty, but Fragonard did not share his taste for ruins. Lush, abun-
t vegetation and aquatic elements crept into Fragonard's paintings.

The artist was more a painter of love than of debauchery and ribaldry. His first courtly
scenes were close to those of Boucher: imaginative, contrived, elegant, languorous, delicate
and light, in true Rococo spirit, they already had a very definite style. The figures merged
with or stand out against an ever more luxuriant natural world. The more intimate indoor
scenes glorify desire and love. The extravagance of his later canvases and the liveliness of
his sketches depended on the freedom of his technique. The sensuality, gaiety and vivacity
of the subjects was reflected in a bright palette and the freedom of his touch which was
impetuous and lyrical to the point of being capricious and almost unfinished.

- The portraits showed the priority of execution over likeness and spontaneity of attitude
over pose. Fragonard developed the Rococo style to the extreme: his bold work became more
modern and his rapid, energetic brushwork led him towards an almost abstract style.

- After 1774 he painted more allegories of Love; less immediate, the subjects echoed the
style of Correggio. Some works were reminiscent of the painters of northern Europe. The art
of Fragonard's art absorbed the lesson of emerging Neoclassicism; his work became
smoother, as vibrant colours gave way to ochres and browns and chiaroscuro brought its
magic. Romantic melancholy and concern tinge in his final work.

Portrait of Abbé Saint-Non
1769. Oil on canvas, 80 x 65cm,
Paris, Musée du Louvre

*This kind of picture 'painted in an
hour', with broad brushstrokes
applied with a rapid, impasto
technique using vivid colours,
ignores the realistic detail and
psychological analysis fashionable
in portraits of the time. Nor does it
correspond to any official category.
This figure de fantaisie, like the
portraits of the writer, the singer
and the soldier, all of the same size,
would have been painted by
Fragonard to hang in his apartment
in the Louvre. These quickly painted
portraits, spontaneous and lifelike,
framed a half-length view of the
subject, richly dressed and usually
standing behind a stone pedestal.
They are in the spirit of the
'character portraits' originally
developed by Frans Hals.*

BIBLIOGRAPHY

de Goncourt, E, *French eighteenth-century painters: Watteau, Boucher, Chardin, La Tour, Greuze,
Fragonard*, Phaidon, Oxford, 1981; de Nolhac, P, *J-H Fragonard, 1732–1806*, Paris, 1905; Rosenberg, P,
Fragonard, exhibition catalogue, Metropolitan Museum of Art, New York, 1988; Wildenstein, G, *The
Paintings of Fragonard: Complete Edition*, translated by C W Chilton, Phaidon, London, 1960

The Kiss
1770. Oil on Canvas, oval 54 x 65cm, Paris, Musée du Louvre

'Fragonard is the poet of erotic painting: he avoids the indecency of the genre through the liveliness of his execution. Art must dance on hot coals; only a slight intoxication can excuse the licentiousness and orgies of the brush. The sketch is their modesty and their ideal: the indecency begins when it is finished. One can excuse the witty suggestion of a libertine fantasy, but the explicit portrayal of smut would be unforgivable. I also much prefer Fragonard's Romantic washes to his well-known painting The Swing' (Paul de Saint-Victor, 1860). This analysis applies to The Kiss. *If amorous advances are often made through surreptitious play, this delightful 'playlet' reveals a sincere, passionate relationship, carnal and sensual, direct and unequivocal.*

KEY WORKS

Fragonard painted 420 paintings (Jean-Pierre Cuzin, 1987).
Blind Man's Buff, 1755, Toledo, USA, MA
The Stolen Kiss, 1759, New York, MM
The Storm, 1759, Paris, Louvre
The Bathers, 1763, Paris, Louvre
Gardens of the Villa d'Este, known as *Le Petit Parc*, before 1765?, London, Wall C
Coresus and Callirhoë, 1765, Paris, Louvre
The Swing, 1767, London, Wall C
Mademoiselle Guimard, c.1769, Paris, Louvre
The Portrait of Abbé de Saint-Non, 1769, Paris, Louvre
The Happy Lovers, c.1770, Switzerland, pr coll
The Kiss, c.1770, Paris, Louvre
Young Girl Playing with her Dog, c.1775, Munich, AP
Fair at Saint-Cloud, 1775–80, Paris, Banque de France
The Adoration of the Shepherds, 1776, Paris, Louvre
The Bolt, 1784, Paris, Louvre
The Vow to Love, 1780–5, Paris, Louvre

David

A history painter and Neoclassical portraitist in the tradition of the great French exponents, David had a fiery temperament. He became involved in the history of France, illustrating the Revolution, the Consulate and the Empire, a real survivor in the world of painting. Morality, idealism and reality fed his art, which was powerful, direct and varied, evolving from 'Neoclassical Rococo' into 'pre-Romantic Neoclassicism' and presenting itself at its perfection as 'pure' Neoclassicism, faithful to the bas-reliefs and friezes of the ancient world.

LIFE AND CAREER

- Jacques Louis David (Paris 1748–Brussels 1825), the French painter, was born into a middle-class family and lost his father at an early age. Following his admission to the Académie de Saint-Luc, David was taught by Joseph Vien from 1766. He painted historical subjects and portraits: *Marie-Josèphe Buron* (1769, Chicago, AI), *The Death of Seneca* (1773, Paris) and *Erasistratus Discovering the Cause of Antiochus' Disease* (1774, Paris, ENSB-A), which was awarded the Prix de Rome.
- Living in Rome from 1775 to 1780, he was attracted by the classical world; he made drawings of the ancient monuments and became familiar with the ideas of the Neoclassical theorist A R Mengs and the archaeologist J J Winckelmann which were developed by younger men such as Quatremère de Quincy. After a trip to Naples he painted *The Burial of Patroclus* (1779, Dublin, NG) and *St Roch Interceding with the Virgin for the Plague-Stricken* (1780, Marseilles).
- After his return to France in 1780 David presented *Andromache Mourning Hector* (1783, Paris), his admission piece to the Academy, and *Belisarius Begging Alms* (1784, Paris). Now well-known, he opened a studio which was visited in particular by Jean-Germain Drouais, Anne Louis Girodet-Trioson and Antoine Jean Gros. He made his mark with *The Oath of the Horatii* (1784, Paris), a picture specially painted in the 'classical atmosphere' of Rome, which was the epitome of Neoclassical painting. This was followed by *The Death of Socrates* (1787, New York, MM), *The Love of Paris and Helena* (1788, Paris, Louvre) and *The Lictors Bring to Brutus the Bodies of his Sons* (1789, Paris, Louvre). He also immortalized *Count Potocki* (1780, Poland, Warsaw mus), *Alphonse Leroy* (1783, Montpellier, Favre), *Charles-Pierre Pécou* (1784, Paris, Louvre) and his father-in-law, *Lavoisier and his Wife* (1788, New York).
- In 1789 the French Revolution erupted. David's political activity turned his life upside down. He became a deputy to the Convention, was elected to the Committee of National Safety, organized Revolutionary gatherings, and put his art to the service of the nation by recording contemporary events: *The Death of Marat* (1793, Brussels), *The Death of Bara* (1794, Avignon, Calvet), the heroic occasion of *The Tennis Court Oath* (sketches of 1791, Versailles). He painted *The Comtesse de Sorcy-Thélusson* (1790, Munich), *The Marchioness of Orivilliers* (1790, Paris, Louvre), *Louise Trudaine* (1791, Paris, Louvre), *The Sérizat Family* (1795, Paris, Louvre) and a *Self-Portrait* (1794, Paris, Louvre). After the death of Robespierre in 1794, David was imprisoned. He painted *View of the Garden of the Palace of Luxembourg* (Paris, Louvre) and began work on *The Sabines* (finished in 1799, Paris).
- David met Napoleon Bonaparte in 1797. He continued his painting of contemporary history: *Equestrian Portrait of Bonaparte Crossing the Great Saint Bernard Pass* (1800–1, Versailles). As chief painter to the Emperor from 1804, he commemorated the coronation celebrations: *The Consecration of the Emperor Napoleon and Coronation of the Empress Josephine* (1805–7, Paris; replica made in 1821, Versailles, mus), *The Distribution of the Eagles* (1808–10, Versailles). He painted brilliant portraits of: *Henriette de Verninac* (1799, Paris, Louvre), *Madame Récamier* (1800, Paris, Louvre), *Pope Pius VII* (1805, Paris, Louvre), *Napoleon* (1812, Washington, NG) and *Madame David* (1813, Washington, NG). He was not appointed to the post of Director of the Beaux-Arts, which he coveted, and gave up his official duties in 1813. He completed *Leonidas* (1814, Washington, NG).
- In 1814, during the Restoration under Louis XVIII, David went into exile in Belgium. Having achieved artistic freedom, he moved slightly away from antiquity: *Cupid and Psyche* (1817, Cleveland, MA), *The Anger of Achilles* (1819, Fort Worth, Kimbell AM), *Mars Disarmed by Venus and the Three Graces* (1824, Brussels). He produced a number of simple, powerful portraits in the French tradition: *General Gérard* (1816, New York), *Emmanuel Joseph Sieyès* (1817, Cambridge [Mass.], FAM) and *Countess Daru* (1820, New York, FC). He died in Brussels in 1825.

David marked a revival in French painting. The pupils he influenced were many, inc
Drouais, Gerard, Girodet-Trioson, Gros, Wicar and Fabre. Other important painters ackr.
edged his role as 'the father of modern painting': Classical artists, particularly *Ingres,
well as the Romantics (Gros and *Delacroix), who owed their dramatic inspiration to him.

APPROACH AND STYLE

David chose noble subjects: classical antiquity, allegory, mythology, religion, contemporary
history, and portraiture. He painted only one landscape. He was inspired by the works of
Homer, Ovid, Virgil, Livy and Petrarch. He painted with oils on canvas or sometimes wood,
in all sizes; some of his paintings were huge with life-size figures. He worked for his own
circle and political allies (the Comte d'Angiviller, Lavoisier, Trudaine, Madame Récamier).
David drew inspiration from his Roman experience: Classicism, Graeco-Roman art and the
Renaissance. He was also inspired by the French and Italian 17th century, the Neoclassicism
emerging at the end of the 18th century, and the colours of Venice and Flanders. He trained
in Rome, worked in Paris and ended his days in Brussels.

• David trained with Joseph Vien. His work carried the mark of the 18th century and also
contained the seeds of Neoclassicism. David's early canvases show a slightly hesitant style
but a powerful sense of colour; the painter tried to respect the Academy's requirements, in
the hope that he would be accepted as a history painter.
• He left for Bologna in Italy, where the works of *Carracci and his school introduced him
to eclectic Classicism. Later he settled in Rome, the city of Graeco-Roman antiquity, the
Renaissance and the Classicism of *Raphael and *Poussin. He was attracted by the sur-
rounding Neoclassicism, and 'the vigour of tone and of shade' (David) of the Italian
painters. He distanced himself from the inferior, unrestrained imitators of the Rococo style
and the art of Vien, preferring a calmer yet spirited composition that called to mind the
Mannerism of Giulio Romano and the dramatic Classicism of Charles Le Brun. His male fig-
ures and warriors were expressive, with their stylized form and strong colouring. David
painted epic compositions with many characters, spread over several scenes (The Burial of
Patroclus). One of the foundations of his style was his reuse of his very precise sketches and
then 'painting just and true first time' (David).
• On his return to Paris, David reached a thematic and formal maturity in classical scenes
in which fewer figures were arranged in a regular manner, like bas-reliefs. Tragic drama, ele-
gantly restrained gestures and steady expressions, touched with grandeur, emanated from
classical statuary. The scenery was simple, formal, without trivial detail, with a cold con-
trasting light. The 'ideal of beauty' inspired by the Classical masters Raphael and Poussin,
the perfect sculptural contours of the nude figures, conformed to the model examples of
Graeco-Roman statuary, asserting themselves through the pre-eminence of the line, in a
severe and sombre style (The Oath of the Horatii). David wanted to 'rekindle virtue and patri-
otic feeling' (Angiviller).

A GREAT PAINTER

◆ David dominated the painting of his time. He enjoyed adulation and suffered
disparagement. His work has been valued to this day, apart from a short period
during his life when Romanticism was dominant.
◆ A Neoclassical painter, he broke away from the Rococo style; his classical
inspiration coloured his work, placing him at the meeting point of Classicism and
Romanticism. 'The father of modern painting' (*Delacroix), he also created a
sterile academicism.
◆ David stood out with his thematic diversity, but he preferred heroic subjects
(Brutus) and interpreted classical, historical and courtly themes. He established a
vision of the head of state and the nation as hard-working citizens.
◆ In order to work out his compositions, David squared up each figure before
transferring it to the canvas. He studied gestures from a nude model, which he
then transferred and clothed. An architect helped him work out perspectives.
◆ His friezes and frontal composition were related to the models of classical
bas-reliefs and frescoes; he counteracted the age-old pyramidal order. He gave
a strong contemporary feeling to his geometric compositions.
◆ His skills progressed from a smooth technique to broader strokes. In particular
ᴉe established as the background of his canvas the modern use of neutral tones.

fluence of Van Dyck and *Rubens, whom he admired during his travels in Flanders,
cted in his portraits, which have more colour, more harmony and greater perfection
tail.

n 1789, David became the painter of Revolutionary events, and heroic allegories (*The
eath of Socrates*). He freed himself from the aesthetic constraints of classical antiquity,
maintaining that painting is 'an art which will become more interesting than ever, because
your wise [parliamentary] laws, your virtues and your actions will increase the number of
subjects worthy of recording for posterity before our very eyes'.

• His simple portraits with their neutral backgrounds and sweeping technique were a tri-
umph. David used his stay in prison to immerse himself in antiquity and the Classicism of
Poussin, favouring aesthetic impact over morality.

• As painter to Napoleon Bonaparte, the artist applied the Emperor's strict iconographic
instructions to his paintings of current events (lavish ceremonies, battlefields and the like).
The meaning of the event was transformed into historical accuracy (*The Consecration*). On
the other hand, his style became freer; influenced by his pupil Gros, he challenged the bal-
ance of Neoclassicism and embraced the colouring of the Venetians and Rubens (*The
Distribution of the Eagles*).

• In Brussels, his courtly, idealized subjects, inspired by classical mythology, displayed a
more leisurely, graceful style, with fresh colours and a smooth technique. The simplicity and
openness of his last portraits of French Revolutionaries and deposed dignitaries, in brilliant
colours and exquisite settings, reveal his interest in Van Dyck and Rubens, as well as the
British portrait painter Sir Thomas Lawrence.

The Oath of the Horatii
1784. Oil on canvas, 3.30 x 4.25m, Paris, Musée du Louvre

*This work, commissioned by the Comte d'Angiviller, Director of Royal Buildings under Louis XVI and an
ardent devotee of history painting, glorifies morality and heroism. It illustrates the event described by the
Latin author Livy when three brothers, the Horatii, make an oath to their father before going to fight the
Curiatii in the conflict between Alba and Rome. This painting proved a great triumph and became the
epitome of Neoclassicism. The atmosphere is virile, heroic and virtuous; the linear geometry of the
vertical and horizontal lines overrides the feminine element, which is full of curves and in the Rococo
style. All the elements of the painting make reference to classical archaeology: the focused composition in
bas-relief, the architecture, the garments and the powerful sculptured bodies of the men. The setting is
Spartan, without detail, the moment is dramatic and the heroes are austere and brave; the colour is bold,
with a cold light and a smooth finish. The purity of the lines and the harmony of the group of sisters is
reminiscent of the Classicism of Poussin.*

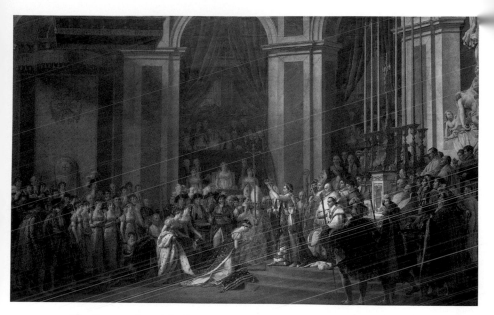

The Consecration of the Emperor Napoleon and Coronation of the Empress Josephine
1805–7. Oil on canvas, 6.1 x 9.3m, Paris, Musée du Louvre

*This commission from the Emperor conferred exceptional status on David, similar to that enjoyed by
*Titian under Charles V, *Velázquez under Philip IV and Le Brun under Louis XIV. An immense compo-
sition of perfect unity, it includes 200 portraits, all completely different in attitude and expression. Faced
with this gallery of portraits, Napoleon exclaimed: 'What truth! This is not a painting, it is alive!' Silk,
velvet, gold and precious stones of striking realism clothe the participants in this scene of contemporary
society, painted with great vigour.*

KEY WORKS

David produced over 200 works: paintings, sketches and drawings in pencil and pen and ink.
The Death of Seneca, 1773, Paris, PP
St Roch Interceding with the Virgin for the Plague-Stricken, 1780, Marseilles, B-A
Andromache Mourning Hector, 1783, Paris, ENSB-A
Belisarius Begging Alms, 1784, Paris, Louvre
The Oath of the Horatii, 1784, Paris, Louvre
Lavoisier and his Wife, 1788, New York, MM
The Comtesse de Sorcy-Thélusson, 1790, Munich, AP
The Tennis Court Oath, (sketches from 1791), National Museum of the Palace of Versailles
The Death of Marat, 1793, Brussels, B-A
The Sabines, 1799, Paris, Louvre
Madame Récamier, 1800, Paris, Louvre
Equestrian Portrait of Bonaparte Crossing the Great Saint Bernard Pass, 1800–1, National
Museum of the Palace of Versailles
The Consecration of the Emperor Napoleon and Coronation of the Empress Josephine,
1805–7, Paris, Louvre
General Gérard, 1816, New York, MM
Mars Disarmed by Venus and the Three Graces, 1824, Brussels, B-A

BIBLIOGRAPHY

Brookner, A, *Jacques-Louis David*, Chatto & Windus, London, 1980; Crow, T, *Painters and Public Life in
Eighteenth-century Paris*, Yale University Press, New Haven, CT and London, 1985; Dowd, D J, *Pageant-
Master of the Republic: Jacques-Louis David and the French Revolution*, University of Nebraska Press,
Lincoln, NE, 1948; Herbert, R, *David, Voltaire, 'Brutus', and the French Revolution: an essay in art and
politics*, Allen Lane, London, 1972

THE TRIUMPH OF ROMANTICISM (1789–1848)

Between 1789 and 1848, political developments and economic, social and cultural conditions combined with scientific and technical discoveries to spark off a renewal of modes of thought and art.

The historical situation in Europe

France. The Revolution (1789–94), the Directory (1795–9), the Consulate (1799–1804) and the Empire (1805–15) caused great upheaval, while in Europe the war and new political structures shook the old monarchies, which had to oppose the expansionism of Napoleon and face up to the rise of nationalism. With the fall of the Empire, the restoration of the monarchy was the source of further unrest: Louis XVIII (1815–24) attacked the remains of the Revolution and reduced France to the frontiers of 1789; then the intransigence of Charles X (1824–30) resulted in the Three Glorious Days of the revolution overthrowing him in 1830; as for Louis-Philippe (1830–48), brought to power by the liberal bourgeoisie, he abdicated after the workers revolted. The Second Republic was established and inspired uprisings throughout Europe. It ended with the coup d'état of Louis Napoleon Bonaparte on 2 December 1851. The French embarked on the colonial conquest of the African continent. In 1830 Charles X occupied Algeria. Abd el-Kadar surrendered in 1847.

Great Britain. Great Britain (the United Kingdom since 1800), with a strong colonial empire and the world's premier industrial and commercial power, led the coalitions which ended in the defeat of the French at Waterloo (1815) and the fall of Napoleon I. When Queen Victoria came to the throne in 1837, she had to face a strong current of republicanism. The parliamentary monarchy and the establishment of a cabinet of ministers came into being in 1841. Greece, supported by Great Britain, France and Russia, entered into a war against the Turks, and in 1822 proclaimed its independence, which became effective in 1830.

The German states hostile to France. In 1789, the states of the German Holy Roman Empire watched the French Revolution sympathetically but after 1792 they opposed it. The French attacks (1796 and 1797) contributed to the end of the Empire (1804). The Rhine Confederation was created by Napoleon in 1806; in reaction, the idea of unity was strengthened and this was achieved in 1871. While the revolution of 1848 against Austria was suppressed, a modern political system nevertheless emerged. The glorification of nationalism, resulting from wars, gave birth to the concept of 'German-ness'.

Spain. The Napoleonic armies occupied Portugal and Spain; the enthronement of Joseph Bonaparte precipitated an uprising of the Spanish people (1808). The Central and South American countries ruled by Spain chose this moment to revolt and obtained their independence in 1825.

The industrialization of Europe and its social consequences

Scientific and technical progress. Relying on experimental science, the industrial society developed. The Industrial Revolution began in Great Britain with the use of the steam engine. The discoveries were then put to the service of the material conquest of the world (the electric telegraph, gas lighting in the streets of London, the first railway in 1825, and so on). Coal was the fuel for all metallurgical operations (first steel works, 1811). The mechanization of mines and factories intensified. The first steam ship crossed the Atlantic.

Germany began its industrialization later (coal from the Ruhr, steel industry, chemicals, the first railway in 1835); the union of its railways and the creation of two great shipping companies, in 1847 and 1857, gave it a new momentum. In France, in *De l'industrie française*, published in 1819, Chaptal recognized the birth of the industrial civilization: the first silk weaving industry appeared in 1805 and the first railway route was opened in 1831. But France then suffered a delay which it would try overcome after 1870.

Scientific discoveries came thick and fast. In 1800, Volta invented the electric battery. The British doctor and physicist Young studied the interference of light (1804). Dalton conceived the atomic theory and applied it to chemical phenomena. Davy and Faraday developed medical and industrial chemical applications. In Germany in about 1820, Gauss established laws concerning the reliability and wear of materials. With Wilhelm Weber he worked on electricity and magnetism (1833), studying coefficients of torsion and the influence of friction on vibratory movements. Liebig perfected chemical fertilizers (1839). In France, Joseph Fourier studied the circulation of heat (1807). In parallel with Young, Fresnel discovered the wave theory of light (1814). The mathematician Poisson wrote a treatise on mechanics demonstrating the application of mathematics to physics and engineering; he also discovered the laws

of electrostatics and excelled in the study of probability (1837). Ampère founded electrodynamics (1821). The Frenchman Champollion decoded hieroglyphs (1822). Niepce invented photography (1829). The Central School of Arts and Manufacture was created in Paris in 1830. Lithography appeared and posters became widespread. Strengthened by these discoveries, capitalism developed rapidly.

Utopian socialism and workers' movements. The events of 1848 provoked the abolition of seigniorial rights in central and eastern Europe. The forming of new national entities accelerated and political and social ideas were bubbling everywhere.

Babeuf, the first to defend a political, statist view of communism (the organization of production and the control of commerce and competition), was guillotined in 1797. He became the prime inspiration of French socialism from the Directory to the end of the Empire. The industrial era opened the way to utopian socialism. The British textile industrialist Owen created a workers' colony (New Harmony, USA) in 1825. This was the same year as the death of Saint-Simon, who had proposed a theory of payment of wages and advocated the struggle against industrial anarchy and wild liberalism. Charles Fourier imagined phalangists responding to the era of the 'society industry, faithful and attractive' (1829).

Poverty, the work carried out by women and children, and the movement of work from craftsmen to the factory caused the first revolts: Luddism in Great Britain (Nedd Ludd) and the revolt of the silk workers in Lyon (1831). The revolution of 1848 brought into prominence Blanqui and Blanc, the first advocates of nationalization and the distribution of production by the state, which Proudhon opposed. However, they were all opposed to liberal capitalism. In 1847 Marx and Engels founded the Communist League and drafted the *Communist Manifesto*. In Great Britain, the First International Association (1856) was followed by the Trades Union Congress (1868). The ideas of Marx spread throughout Europe and the First International was founded in London in 1864.

The development of ideas

German and Anglo-Saxon Romantic literature turned away from the culture of antiquity and the century of the Enlightenment: 'Today, German muses are the ones which prevail. O Germany! Our great days are finished, theirs are beginning', wrote C Dorat in 1768.

Sturm und Drang in Germany. This movement, literally meaning 'Storm and Stress', was born at the end of the 18th century. It took its name from a theatrical work written in 1776 by Klinger. This pre-Romantic melodrama was opposed to the rationalism of the Enlightenment: a strong feeling for nature, the primacy of the individual and the natural good taken from Rousseauism, the 'attack' on free thought and the glorification of human emotions were associated with retreat to the ancient national history of a country, in reaction to revolutionary and Napoleonic violence. Novalis introduced the glorification of mystical Romanticism after 1800. Sturm und Drang, led by Herder, brought together a whole generation of writers: Schiller, Goethe and Heine.

Shakespeare, who had already been glorified by Lessing in the previous century, was the prime inspiration for Sturm und Drang and the European theatre. The return to sources, drawn into the song and popular poetry which exalted national feelings and then nationalism, moved these writers, who had read the Gaelic poems of Ossian (published by Macpherson in 1760). Goethe scoffed at French literature, 'powdered and outmoded'; Schiller reviled this 'paragraph-making century'. These pre-Romantics admired discovery, originality, genius and nature; new, strong, sincere emotions; that which was real. Sensitivity, daydreaming and emotional violence were mixed in their personalities. The Pan-German and dualist philosophy of Fichte, which succeeded that of Kant, the idealism of Schelling, which identified the spirit and nature in a work of art, and the philosophy of Hegel for whom beauty – Classical in its balance of form and ideas, but Romantic in the pre-eminence of ideas over form – had to be the expression of sensitivity, illustrated the power of the German pre-Romantic movement. Beethoven, father of Romantic music, was a forerunner of Carl Maria von Weber, Mendelssohn, Schubert, Schumann and Wagner, the nationalist Romantic.

English Romanticism. This found its source in literature in the rediscovery of Shakespeare in the 18th century, in the poetry of Edward Young, Blake and Macpherson, the 'Gothic' novels of Horace Walpole and the dark writings of Ann Ward-Radcliffe, a trend followed by Mary Shelley (*Frankenstein*), the American Edgar Allan Poe, and even to some extent by Dickens. Wordsworth, Milton, the Scotsman Walter Scott, Shelley and Byron and Thomas Macaulay expressed themselves in poetry and in the imaginary or historical novel of the golden age of Romanticism. The beautiful disorder of English landscape gardens celebrated freedom in nature.

The opposition to the rationalism of the 18th century in France. Nostalgia for the medieval period, its spirituality and its imagination, stimulated the imagination. The *Song of Roland* became popular again. Chateaubriand travelled among the Gauls, druids and ancient Celts and went to the heart of the Middle Ages in his *Génie du christianisme* (1802). Vivant Denon, author of the *Travels in Upper and Lower Egypt* (1802), who became director general of museums in the same year, founded Orientalism, followed by Chateaubriand (*Itinéraire de Paris à Jérusalem*, 1811) and Hugo (*The Orientals*, 1829). Madame de Staël, author of De l'Allemagne, 1810), opposed Napoleon and imperial despotism, while Constant introduced his readers to German thought. The philosophy of Maine de Biran posed the three fundamentals of Romanticism: 'individualism', 'subjective life' and 'living intensity'.

European Romanticism. The second generation of romantics (Stendhal, Balzac, Vigny, Musset, Nerval, Lamartine, Dumas and Hugo) was contemporary with Romanticism in Spain (Larra, Martínez de la Rosa) and Italy (Manzoni in literature, Bellini, Donizetti and Rossini in music). Daydreaming and exultation distinguished the scores of Chopin, violent and dramatic effects orchestrated the work of Halévy, while romantic passion inspired Berlioz.

Russian Romanticism was expressed by Pushkin and Lermontov. The idea of a typically Russian music came into being with Glinka, 'the father of Russian music'.

Art as the image of thought

The spirit of nationalism. The ideas of people and nations were reinforced by the nationalist movements. German authors appropriated the Gothic in reaction to the 'good taste' of France. Goethe brought together *Dürer and the Gothic, while Novalis glorified the Middle Ages; Friedrich von Schlegel discovered the German Primitives and defended the Pan-Germanism, illustrated by the Nazarene painters (Overbeck, Pforr).

The peak of Neoclassicism and the birth of Romanticism. In the 1780s, Neoclassicism achieved its peak with *David. While this art spread throughout Europe, the French Revolution and then the First Empire projected current events into history painting. Like the Romantic Gros, David glorified this historic, glorious modernity with a relaxed, enthusiastic style. Gros gave a dramatic dimension to the events of the Consulate and the Empire. The paintings of Girodet-Trioson and Prud'hon combined Neoclassicism and Romanticism; the subjects were Romantic but the style remained forced. *Géricault and the young *Delacroix glorified the dramas of human destiny. Géricault was the incarnation of Romantic genius but remained classical in his technique and the style of his figures. At the same time, *Ingres, influenced by the formal purity inspired by Greek vases and the painting of the quattrocento, freed himself from the antique ideal severity of David in favour of a 'mannerist' sophistication. Georges Michel transformed landscapes and nature with his lively pictorial technique.

The central museum of the Louvre, created in 1793, was enriched by the Napoleonic conquests; the paintings of previous centuries informed and inspired artists.

The Spanish painter *Goya also made use of current events in his hatred of the French invader. Like *Friedrich, the leading figure of German Romanticism, his sensibility led towards the fantastic, the morbid and the demonic. Meanwhile in Great Britain several painters opened the way to pictorial Romanticism: Copley took an interest in modern epics while Fuseli took his inspiration from the texts of Shakespeare and Blake from those of the Bible and Dante as well as his own poems.

Official restraints and individual revolt. While Napoleon regulated art and put it to the service of his glory, other countries gave painters more freedom. Friedrich gave free rein to his imagination, at the risk of being censured by the academies. *Goya translated his emotions and fantasies without restriction.

In Great Britain the Royal Academy provided a theoretical training but left artists free to develop as they pleased. In France on the other hand, under Charles X and then Louis-Philippe, the tendency was to a restricting academicism. Winning the Prix de Rome was essential to an artist's recognition. Canvases turned down for the Salon du Louvre by the jury, which was itself controlled by the Academy, were marked with an 'R' on the back and became unsaleable.

Some artists dared to rebel: Géricault lambasted the mediocrity of the training given by the Academy. The sculptor Carpeaux followed the way of Rude, an artist detested by the Académie. Baudelaire, as an art critic, saw a 'nimble, frequent masturbation' in the paintings of Vernet.

The triumph of Romanticism

Romanticism reached its apogee with *Turner and Delacroix, between about 1824 and 1840.

The Romantic movement in France. During this period, the conflict between the aesthetics of Romanticism and Classicism, triggered by *The Massacre of Chios*, which was exhibited at the Salon in 1824, set the supporters of Delacroix against those of Ingres. The advocates of tradition saw it as a 'massacre of painting' and compared it to the *Vow of Louis XIII* by Ingres. The opposition was crystallized still more by the *Death of Sardanapalus*, shown in 1827 at the same time as the *Apotheosis of Homer* by Ingres. Delécluze was outraged: 'The first rules of art', he said, 'seem to have been violated by bias'. Sensitive to the scandal provoked by the work, Charles X put an end to all commissions from Delacroix. Baudelaire, who supported the plastic approach of painting, declared of the Salon of 1846: 'Romanticism lies neither exactly in the choice of subjects nor in precise truth but in the manner of feeling it ... As for me, Romanticism is the most recent, the most current expression of beauty ... Whoever speaks of Romanticism speaks of modern art – that is to say, intimacy, spirituality, colour, aspiration towards the infinite, expressed by all the means which the arts embrace.'

In the same years, at the Salons of 1824 and 1827, the new treatment of landscapes by the British painter *Constable made a triumphant entrance; he captivated the romantics.

The East, imaginary in the case of Ingres, became real for Delacroix (1832); the artist renewed his range of subjects and stimulated the freedom of his technique with the sumptuous brilliance of his colour,

freeing himself from the last traces of the classical ideal. As Delacroix triumphed over Ingres, so Romanticism triumphed over Classicism.

The English landscape school. The years of the 1820s saw the blossoming of topographical landscape painting, dominated by Bonington. He was succeeded by two currents of the Romantic inspiration led by Constable and Turner. Constable's paintings emanated a freshness and a naturalness, achieved by a brilliant technique, while Turner composed spectacular scenes, both historical and modern, set in the natural landscape in which he sought to recreate the effects of light, using a dissolved palette.

The contemporary pictorial currents of Romanticism

Troubadour art. Appearing in the second half of the 18th century and continuing until 1830, troubadour art was inspired by the non-classical past, the period from the Middle Ages to the 17th century. In about 1780, the Comte d'Angivillier commissioned some canvases on the history of France for Louis XVI. The Musée des Monuments français, created by Alexandre Lenoir in 1795, then put forward a picturesque representation of the Middle Ages which appealed to the artists who adopted this 'troubadour' style. The romantic, the sentimental and the anecdotal were evident in the works of Fleury-Richard and Revoil. Even Ingres, the genius of the movement which was inspired by the Greek ideal, allowed himself to be attracted by the Gothic; his nostalgia for the past was Romantic but his execution was Classical.

The Orientalists. Orientalism was stimulated at the end of the Egyptian campaign (1798–9) and made its appearance in the work of numerous painters who were inspired by revolutions and wars of independence (Greece), and attracted by the new regions opened up by acquisitive colonial policies (Maghreb). The 'Egyptian fashion' spread to furniture and architecture; an Egyptian department opened in the Louvre (1826) and obelisks were erected in Paris (1836), London and New York.

The imaginary Orient of Gros (*The Battle of Aboukir*, 1806), Ingres (*La Grande Odalisque*, 1814; *The Turkish Bath*, 1863), and Delacroix (*The Massacre of Chios*, 1824; *Greece on the Ruins of Missolonghi*, 1826) was succeeded by the real Orient of Delacroix himself (*Women of Algiers in their Apartment*, 1834), Fromentin, writer, art historian and painter, and Chassériau, a painter whose work was a synthesis of the ideal form of Ingres and the sensuality of the colours and style of Delacroix. The British artist Wilkie, the Italian Hayez and the German Rottmann also participated in this movement.

The Nazarenes. Between 1809 and 1840, German and Viennese painters, with Overbeck and Pforr at their head, formed a group together in Rome. They rejected antiquity and Neoclassicism, affirming their national and religious identity with frescoes and canvases embodying pure sentiments, inherited from the Middle Ages. As a model they took the aesthetic of the Italian primitives and the painters of the Renaissance, before Raphael: Dürer, Fra Angelico and Perugino. This movement influenced the German painting of the second half of the 19th century.

A bourgeois art. An eclectic commissioned art was developed in France under the July Monarchy (1830–48). It allied the style and the subjects of the past with a colouring of Romanticism: Vernet, Delaroche and Couture, masters of this art, charmed the British painters of Victorian academicism (throughout the second half of the 19th century – the style against which the Pre-Raphaelites (including Holman Hunt, Millais and Burne-Jones) protested after 1848.

The Barbizon School. Inspired by Constable, between 1830 and 1860 the Barbizon School (near Fontainebleau) marked an important step in the art of French landscape painting, with the appearance of painting of the actual subject outdoors, instead of in the studio. Daubigny, Théodore Rousseau, Diaz de la Peña and Millet, head of the group, broke with the historical, classical landscape tradition and moved away from landscape as Corot had perceived it; however, they preserved the imprint of Romanticism with the emotional charge of their subjects, and the luminosity and poetry of the clearings in the forest of Fontainebleau. The little sketches of pure colour by Daubigny heralded the Impressionists. For *Courbet, Barbizon was a springboard towards realism.

The first half of the 19th century seemed like a transitional period, affected by political events (Revolution, the Napoleonic Wars and claims of nationalism) and the formation of the great colonial empires, the development of industrialization and the social movements which sparked off a transformation in society, accompanied by art. This was to give birth to a modern view of art and then the avant-garde, represented in the 19th century by realism, the art of *Manet and Impressionism.

Goya

Goya was a man of the Enlightenment, a modern, humane, impulsive 'visionary' who rebelled against convention. His paintings underwent an unexpected change from the Rococo to 'dark' works. His art was linked to the history of his country and his personal life. A master of portraiture, decoration and cartoons for tapestries, he was also an engraver equal to Dürer and Rembrandt. His subjects moved from reality to fantasy, from the good-humoured to the tragic, from bright, colourful painting to monochrome work and dark tones. His brushwork, always stylized, showed a smooth or brushed technique.

LIFE AND CAREER

• The Spanish painter Francisco de Goya y Lucientes (Fuendetodos, Aragon, 1746–Bordeaux 1828), son of a master gilder, joined the studio of J Luzan in Saragossa at the age of 13. In 1763 and 1766 he failed the entrance examination for the San Fernando Academy in Madrid, following which he left for Rome. On his return to Saragossa in 1771, he painted his first frescoes (*The Adoration of the Name of God*, 1771, Basilica del Pilar) and decorated the church of the Carthusian monastery of Aula Dei with paintings depicting the life of the Virgin (1772–4, in situ).

• In Madrid in 1773 he married the sister of Francisco Bayeu, a renowned painter, who introduced him to the royal workshop. There he produced cartoons for Charles III: crowd scenes and hunting scenes, and figures set in country scenes such as *The Dance of the 'Majos'* and *The Sunshade* (1775, Madrid).

• In 1780 the artist was finally accepted into the San Fernando Academy, but he returned to Saragossa and painted *The Virgin in Glory with Holy Martyrs* (for the dome of the Pilar Basilica). In Madrid, he produced altarpieces and made his name with the portraits of *Count of Floridablanca*, his friend and patron (1783, Madrid), *The Architect Ventura Rodríguez* (1784, Stockholm) and *The Duchess of Osuna* (1785, Majorca, March coll).

• Employed as court painter from 1786, Goya painted Madrid's high society: *The Marchioness of Pontejos* (1786, Washington, NG), the child *Osorio* (1787, New York), *The Family of the Duke of Osuna* (1788, Madrid). He continued to create cartoons: *Seven Rural Scenes* (1787, Madrid, pr coll), *The Crockery Vendor* (1788, Madrid), *The Orchard of San Isidorio* (1788, Madrid) and *The Puppet* (1791–2, Madrid). He also continued with religious themes: in *The Life of San Francisco de Borja* (1788, Valencia Cathedral), the eeriness stands out.

• He was appointed personal painter to Charles IV in 1789. The official images of the King, Queen Marie-Louise and the court were painted in swift succession: *The Marchioness of La Solana* (1789, Paris, Louvre).

• Goya became deaf while in Cadiz in 1792 and his work reflects his anxiety: *Rain of Bulls/Bull-Racing* (1792 –4, Madrid, pr coll), *Travelling Actors* (1792–4, Prado). He was still painting portraits such as *La Tirana* (1794, Majorca, March coll) and those of the Duchess of Alba, who played a dominant role in his life: *The Duchess of Alba* (1794, Madrid) and *The Duchess of Alba Wearing a Mantilla* (1797, New York). Becoming director of the Academy in 1795, he painted his ministerial friends, the *French Ambassador Guillemardet* (1798, Paris, Louvre), made a *Self-Portrait* (1798, Castres, Goya mus), and undertook religious commissions including the fresco of *Miracle of Saint Anthony of Padua* (1798, Madrid) and the painting of *The Arrest of Christ* (1798, Toledo Cathedral). The *Caprices* series, satirical etchings, were made at some time between 1793 and 1799.

• In 1799, his position as first painter and portraitist to the King earned him numerous commissions: he painted *Queen Marie-Louise* (1799, Madrid, Prado), *Equestrian Portrait of the King* (1799, Madrid, Prado), *The Countess of Chinchón* (1799, Madrid, Sueca coll), *The Family of Charles IV* (1799, Madrid, Prado) and, in 1800, *The Naked Maja* followed by *The Clothed Maja* (Madrid, Prado).

• In the years 1800–8, as well as some savage images (*Cannibals Preparing Their Victims*, Besançon, B-A), Goya painted his most beautiful portraits: *The Duke and Duchess of Fernán Nuñez* (1803, Fernán Nuñez coll), *Doña Isabel de Cobos de Porcel* (1805, London), *Ferdinand VII on Horse-Back* (1808, Madrid, Ac S Fernando).

The Puppet (El Pelele)
1791–2. Cartoon, 267 x 160cm, Madrid, Prado

This work is from the final period of the artist's cartoons for tapestries, such as
Blind Man's Buff. *This sample of rural life had its source in literature inspired*
by Rousseau in the 18th century, which had spread throughout Europe: in
Spain, for example, Valdes, a friend of Goya, published In Praise of Country
Life *in 1799.*
In this cartoon, women are making fun of a dancing jack, an allegory of the
male sex, who is being thrown in the air using a sheet. Possibly Goya is
depicting his unhappy love affair with the Duchess of Alba. In any event he is
illustrating the evil character of the female sex. The rapid execution is casual but
controlled using brilliant colours, painted in a light 18th-century style, which
well express the grace of the common people and the ironic theme.

GOYA

- In 1808, the Spanish monarchy collapsed; following the Napoleonic occupation, the country revolted. Goya depicted human savagery in his series of engravings of the *Disasters of War* (1810-15) and in his major canvases of *Dos de Mayo* and *Tres de Mayo de 1808* (1814, Madrid). He painted portraits of *Canon Llorente* (1810-11, São Paulo mus) and his friend *Silvela* (1809-12, Madrid, Prado). He was also merciless in his depiction of both imaginary figures and human beings in *The Colossus* (1808-10, Madrid, Prado), *Lazarillo de Tormes* (1808-10, Madrid, Maranon coll), *Majas on a Balcony* (1806-10, New York, MM), *Young Majas and Old Majas* (c.1808-10, Lille), *The Madhouse* (1808-12, Madrid) and *Inquisition Scene* (1812-14, Madrid), in which the Church was not spared.
- In 1814, King Ferdinand VII returned to Madrid and Goya resumed his position as official painter. He immortalized the great and the good of Spain, his friends: *The Duke of San Carlos* (1815, Saragossa mus) and *The Duke of Osuna* (1816, Bayonne, B-A). When he was unwell, he painted himself in his *Self-Portrait* (1815, Madrid, Ac S Fernando) and also represented himself in *Self-Portrait with Doctor Arrieta* (1819, Minneapolis, IA). He painted the moving *Last Communion of Saint Jose de Calasanz* (1819, Madrid), before retiring to his house, Carabanchel, known as the Quinta del Sordo ('house of the deaf one'). He took up etching again (*Disparate and Proverbs*), and decorated the walls of his home with 'dark' works, nightmarish and haunting: *Witches' Sabbath*, *Duel with Clubs*, *Two Old Men Eating*, *Man Mocked by Two Women*, *Saturn* and so on (1820-1, Madrid).
- In 1823 Ferdinand VII restored the absolute monarchy. As a liberal, Goya exiled himself to Paris and then Bordeaux. He painted *Portrait of Juan of Muguiro* (1827, Madrid, Prado) and the well-known *Milkmaid of Bordeaux* (c.1827, Madrid). He died in voluntary exile in 1828.

Goya stands at the close of the 18th century, as well as that of the 'golden age' of Spanish art. His works foreshadowed the modern plastic art of *Delacroix, Corot, *Manet and *Cézanne, as well as Expressionism and the imagination of surrealism.

APPROACH AND STYLE

Goya was fond of genre painting (hunting, romantic and popular themes, social vices, disappointments in love, human violence, witches and devils), historical and religious subjects, portraits and still life.

His cartoons for tapestries, his paintings on canvas and sometimes wood, his murals, painted in oils or in fresco, in all sizes, were commissioned from him by the Spanish kings Charles III, Charles IV and Ferdinand VII, his patrons and his friends (the ministers Floridablanca, Jovellanos, the Duchess of Alba and the Osuna family), as well as by the clergy.

After starting painting in Spain, Goya travelled to Rome where he discovered the art of Corrado Giaquinto. He was aware of the talent of his 17th-century compatriot *Velázquez, and the ageing *Tiepolo (who died in 1770), whom he met in Madrid. 'I have had three masters', he said, '*Rembrandt, Velázquez and Nature.'

- Goya's early religious canvases reveal a style of presentation inherited from the Italian Baroque-Rococo of Corrado Giaquinto, where simplicity and energy were born of the Iberian heritage of Zurbarán, Murillo and Velázquez. His frescoes and cartoons, tinged with Spanish rusticity, show the decorative influence of Giambattista Tiepolo in the subjects, the generous and powerful forms, the clarity of the trompe-l'œil ceilings, and the effects of sunlight. The artist produced some sketches of the countryside that were realistic, fresh and spontaneous, influenced by nature's direct lesson in which various colours in the soft light brought light and shade together (*The Sunshade*).
- A society portraitist, he adorned or revealed his subjects in the tradition of Velázquez, or caused his figures to emerge from a warm, colourful half-light borrowed from Rembrandt; he painted light impasto with broad strokes. This period placed Goya in the aesthetic lineage of Spain through the candour and boldness of his use of colour, and the variety of touch.
- Social and political crises, the painter's own personal disappointments and his deafness transformed his amiable perception of life into a pessimistic criticism that included contempt for women (*El Pelele* or *The Puppet*). Faithful to the spirit of the century of Enlightenment, he condemned vice and perversion. He expressed his torment in tragic or haunted works in which animal and human forms merged with one another (*Caprices*).

The Family of Charles IV
1800. Oil on canvas, 2.80 x 3.36m, Madrid, Prado

Drawing its inspiration from the composition of Las Meninas *by Velázquez, this royal painting combines psychological and physical trueness to life: pretension, incompetence, the puppet presence of a disturbingly degenerate King, the absurd dress which emphasizes the ugliness of the Queen and of the King's sister, the prettiness and innocent freshness of the children, and the beauty of the young princess holding her baby. The lightness of the rendering of the clothing, transparent and standing out in a clear space, ethereal, shows Goya's closeness to Velázquez. This work reveals the painter's talent as a portraitist. From a face represented in the cruellest fashion to the purest beauty* (Doña Isabel de Cobos de Porcel, *1805), Goya's 'revolutionary humanism' is always evident.*

A GREAT PAINTER

◆ Goya enjoyed great popularity during his lifetime both at home and abroad.
◆ He embraced the Rococo before breaking with all artistic convention to develop a free, individual style which foreshadowed all modern art.
◆ He introduced anonymous crowds into his scenes and gave a new perspective to war, substituting horror for glory. He explored a satirical connection between animals and man.
◆ Goya established himself as a master of portraits, cruel and lucid, but with a particular fondness for childhood.
◆ His highly individual style alternated between a spirited touch and a smoother technique, between bright, cheerful colours and darker shades. His superimposition of colours is reminiscent of *Rembrandt, and the mingling of small strokes heralded the technique of Impressionism. His 'dark' murals were created using lamp black, white, ochres, some red and a little blue, applied with a paintbrush and spatula.
◆ He outlined his frescoes straight onto fresh mortar and modified the initial design in the course of laying down the colours. In his monochrome pieces, Goya built up the thick paste with a knife and treated the shadows of the face by blending black and transparent paint.

Goya

- While some delicate portraits in silvery tones appear as a final tribute to the 18th century, other more bitter ones were the fruit of his clear-headed view of humanity.
- He was shattered by the war and the fall of the Spanish monarchy (1808): his historical paintings demystified the heroism of battles and revealed their savagery. He broke with the traditional aesthetic, using dynamic composition with a powerful, spirited technique to convey a tragic realism, with shadows full of pathos worthy of Rembrandt (*Tres de Mayo*).
- The genre paintings from the period 1808–14 were executed in monochrome shades, using brilliant, deep blacks, warm ochres, garish blues, muted greens and occasionally strident reds (*The Madhouse*).
- Once more unwell (1819), Goya expressed his malaise in his religious canvases, freely and swiftly executed, and in his 'dark paintings' which were an expression of Spain's chronic despair. The sombre colours and expressionist technique conjure up a world of nightmares, scenes of witchcraft inhabited by monsters, deranged figures, and a mockery of love (*Witches' Sabbath*).
- In Bordeaux he found some inner peace, returning to lyricism, to softness and colour (*The Milkmaid*).

Witches' Sabbath
1820–1. Mural in oils transposed onto canvas, 1.40 x 4.38m, Madrid, Prado

This work is part of a series of 14 'dark paintings' conceived by Goya for his house, Quinta del Sordo. This cycle is undoubtedly the most fantastic of the series. In a range of sombre greys, the painter presents his hallucinations and his memories, some of them relating to the collapse of the monarchy, the Napoleonic occupation and absolute power, while others relate to his own suffering, both physical and mental.

Witches' Sabbath *is constructed around the great goat (a devil in a monk's habit, on the left-hand side), surrounded by a group of witches and sorcerers. A wild, fierce pessimism consumes the witches' sabbath, which is being watched by two outsiders. The half-buried woman may be an allegory of the Spanish monarchy; as for the young woman in black seated in the far right, outside the diabolic circle, this is possibly the impassive witness of his own nightmare. Here Goya has developed a creative liberty hitherto unknown: brilliant technique is used to express the artist's own world and his fantasies.*

KEY WORKS

Goya's works include around 700 paintings, 280 etchings and thousands of drawings.

The Dance of the 'Majos', 1775, Madrid, Prado

The Virgin in Glory with Holy Martyrs, 1780, Saragossa, Pilar Basilica

Count of Floridablanca, 1783, Madrid, Banco Urquijo

The Architect Ventura Rodríguez, 1784, Stockholm, NM

Osorio, 1787, New York, MM

The Family of the Duke of Osuna, 1788, Madrid, Prado

The Crockery Vendor, 1788, Madrid, Prado

The Puppet, 1791–2, Madrid, Prado

The Duchess of Alba, 1794, Madrid, Duke of Alba coll

The Duchess of Alba Wearing a Mantilla, 1797, New York, Hispanic Society

Miracle of Saint Anthony of Padua, 1798, Madrid, hermitage of S Antonio de la Florida

The Naked Maja and *The Clothed Maja*, 1800, Madrid, Prado

The Clothed Maja, 1800, Madrid, Prado

The Family of Charles IV, 1805, London, NG

Old Majas, 1808–10, Lille, B-A

The Madhouse, 1808–12, Madrid, Ac S Fernando

Dos de Mayo and *Tres de Mayo*, 1814, Madrid, Prado

Last Communion of Saint Jose de Calasanz, 1819, Madrid, church of S Anton

Man Mocked by Two Women, 1820–1, Madrid, Prado

Witches' Sabbath, 1820–1, Madrid, Prado

Milkmaid of Bordeaux, c.1827, Madrid, Prado

BIBLIOGRAPHY

Desparmet Fitz-Gerald, X, *L'oeuvre peint de Goya*, 4 vols, Paris, 1928–50; Gassier, P and Wilson, J, *Goya: his life and work*, Thames and Hudson, London, 1971; Glendinning, N, *Goya and his Critics*, Yale University Press, New Haven, CT and London, 1977; *Goya*, exhibition catalogue, Patrimonio Nacional, Madrid, 1996; *Goya: un regard libre*, exhibition catalogue, RMN, Lille, 1998; Licht, F, *Goya in Perspective*, Prentice-Hall, Englewood Cliffs, NJ, 1973; Symmons, S, *Goya*, Phaidon, London, 1998

Friedrich

Friedrich, a remarkable, solitary and melancholic painter, lived in a bare studio, ideal for the development of an imagination fertile in symbols and visual metaphors. His gloomy landscapes, high mountains, sprawling seascapes and frozen landscapes, bathed in an unreal, often misty, sometimes morbid atmosphere, expressed an intense spirituality. Cold nature in white, blue, green and brown colours and the vast, vertiginous world were made real with the precision of the tiny brushstrokes.

LIFE AND CAREER

The German painter Caspar David Friedrich (Greifswald 1774–Dresden 1840) came from a large family, and his father made soap and candles. From 1781 he was faced with the deaths of his mother, a younger sister, a brother who drowned while trying to save him from the ice that gave way under his skates, and finally another sister. Haunted by these tragedies which all took place within the space of ten years, he studied art and entered the Academy of Fine Art in Copenhagen in 1794. In 1798, he settled in Dresden, an important centre of Romantic thinking; there his friends included the painter Philipp Otto Runge and the writers and poets Ludwig Tieck and Novalis. Following the success of his large sepia drawings and watercolours, which attracted Goethe's admiration, he began painting: *Mist* (1806, Vienna, KM) and *Summer* (1807, Munich, NP).

● His first great oil painting, *The Cross on the Mountain*, or *The Tetschen Altarpiece* (1807–8, Dresden), a masterpiece, was also the subject of scandal and criticism. This was also the case with subsequent paintings, *Monk on the Seashore* (c.1809, Berlin) and *The Abbey in the Oak Wood* (1809, Berlin).
● His travels throughout Germany and the Baltic coast in 1809 inspired him to paint *Mountain Landscape with Rainbow* (1808, Essen, Folkwang mus) and *Riesengebirge* (1810, Moscow, Pushkin). In 1810, his fame reached its peak when the royal house of Prussia acquired some of his works. He painted *Morning in the Riesengebirge* (c.1810, Berlin), *Winter Landscape with Church* (1811, Dortmund mus), *Rocky Landscape in Elbsandsteingebirge* (1811, Dresden, Gg), *Port by Moonlight* (1811, Winterthur, O Reinhart mus), *Tombs of Ancient Heroes* (1812, Hamburg) and *The Cross on the Mountain* (1812, Düsseldorf). He was elected a member of both the Berlin and Dresden Academies in 1816.
● He travelled the Baltic again in 1815 and 1818 as these paintings show: *Ships in the Harbour* (1815–17, Potsdam, Sans-Souci) and *Townscape in the Moonlight* (c.1817, Winterthur). The paintings completed during the year of his honeymoon to Rügen and Winterthur stimulated contemplation and questioning: *Chalk Cliffs of Rügen* (c.1818, Winterthur), *Wanderer above the Sea of Fog* (1818, Hamburg), *On a Sailing Boat* (1818, St Petersburg, Hermitage). He also painted *Two Men Looking at the Moon* (1819, Dresden, Gg), *The Convent Cemetery in the Snow* (1817–19, destroyed) and *Mist* (1818–20, Hamburg, K).
● From 1820, he immortalized the rural landscapes he found so appealing: *Meadows in Greifswald* (1821, Hamburg, K), *The Tree of Crows* (1822, Paris), *Rural Landscape* (1822, Berlin), *Landscape near Dresden* (1824, Hamburg, K), *Ruin of Eldena* (1825, Berlin, National Gallery). The sea continued to fascinate him, as did mountains: *Shipwreck on the Coast of Greenland* (1822, disappeared), *Reefs by the Seashore* (1824, Karlsruhe), *Mount Watzmann* (c.1824, Berlin), *The High Mountain* (destroyed during World War II). He met Friedrich Overbeck, leader of the Nazarenes but he was not sympathetic to their art, preferring that of J C C Dahl, an influential landscapist from Dresden. He sank into depression in 1826 and painted *The Shipwreck* (c.1827, Hamburg).
● The peak of his later period was between 1832 and 1835: *The Great Precinct at Dresden* (1832, Dresden), *The Three Ages of Life* (1835, Leipzig), *Easter Morning* (c.1835, London, NG). *Seascape in the Moonlight* (c.1836, Dortmund) was his last painting. An apoplectic fit in 1836 led to his eventual death.

Friedrich's contemporaries were not particularly influenced by his works, apart from C G Carus, K Blechen and his pupils, the most talented of whom was A Heinrich who died in 1822. His contemporary Philipp Otto Runge encouraged the emergence of a new style of landscape painting of which Friedrich, and 25 years later Jean-Baptiste Corot and Théodore Rousseau, would be the originators.

APPROACH AND STYLE

Friedrich painted every element of nature (the Baltic Sea, the Harz Mountains), a country-side brought to life with islands, rocks and trees seen in the varying lights of different days and different seasons. The landscape would be punctuated by traces of human presence (such as a cross, a cemetery, a church or a fishing boat). He painted on canvases, panels and cardboard of all sizes.

His work was admired by numerous private patrons including Count F A von Thun-Hohenstein, J-G von Quandt and D d'Angers; friends who bought his work included C G Carus and the Berlin bookseller G A Reimer. He also numbered some of the crowned heads of Europe among his supporters: Frederick-William III of Prussia, Karl August, Grand Duke of Saxe-Weimar, Frederick VI of Denmark, and the Tsar and court of Russia.

Friedrich settled in Dresden and travelled all over Germany: Neubrandenberg, Rügen, Greifswald (his childhood home), Bohemia, and the Harz and Reisengebirge regions. He was influenced by his contemporaries, the German J C C Dahl and the Norwegian J C Seydelmann.

- Friedrich's work displays deep reflection, born of scrupulous observation of nature, made real through small, light brushstrokes. Through his association with Philipp Otto Runge, he produced formal landscapes (*Mist*). He invented his own language using signs: the *Tetschen Altarpiece*, conceived as an altar painting, was not a crucifixion in a landscape 'but a simple landscape with a cross, a statue' (H Zerner, 1982); as for *Monk on the Seashore*, it revealed a hitherto unknown asceticism and a rejection of the picturesque: his monk is not praying, nor does he blend into the landscape. Beyond a sense of mystery, his creations arouse feelings with a religious or contemplative dimension.

- The symbolic power of his art grew gradually until its fruition in 1810, while his work wavered between realism and poetry throughout his career. His poetry blossomed in his imaginary views in which an originality of subject and expression can be seen, more transcendental than realistic (*Abbey in the Oak Wood*). Fed by his observations, he offered a vision of nature that was universal and sometimes idyllic (*Mountain Landscape with Rainbow*). His colouring, more intense, developed in paintings often conceived in pairs representing a formal and thematic antithesis: the rising and setting of the sun, the ages of man (youth and hope versus old age and death), or wide open space contrasted with the enclosed, gloomy space of the forests.

- Between 1812 and 1814, Friedrich replaced Christian symbolism with patriotic anti-Napoleonic symbolism. Sombre, leaden landscapes predominated. The technique is fluid and yet seems striated.

A GREAT PAINTER

◆ Known only in Germany during his lifetime, Friedrich was forgotten before his death; the originality of his work, and his own individuality, was too pronounced. He was rediscovered around 1890 as a result of his symbolism. He is recognized today as the greatest German landscape painter of the 19th century, but he is still relatively unknown by the general public.

◆ As a landscape artist, Friedrich broke away from the previously established conventions of the genre; he reinvented landscape by loading it with symbols drawn from naturalistic motifs such as broken rocks, ruins, drifting ice, fog and shadows.

◆ Friedrich painted in oils, meticulously placing tiny, fluid touches of colour in cold tones, in careful work with a 'calligraphic' quality. His touch gave a sense of materiality and extended into his mature works. The light of the aurora borealis, twilight and back-lighting suggest the idea of transcendence.

◆ He simplified his compositions to the extreme, thereby achieving a powerful expression with true pictorial asceticism. The symmetry, so perfect as to be glacial, is occasionally broken by a fracture of the space (such as a rift or a precipice) that plunges the eye into the abyss and gives a feeling of vertigo.

◆ Friedrich's art corresponds in part to the demands and unattainable dreams of the Romantics: he was 'personal and objective at the same time, with immediacy of expression, unconventional, universally intelligible, ... not discursive and wholly evocative' (H Zerner, 1982).

- Between 1815 and 1818, Friedrich became less unconventional in his choice of subjects and their treatment; marine landscapes in small format had a straightforward composition (*Wanderer above the Sea of Fog*). The heavy symbolism subsided while space played an essential role (*Cloister Cemetery in the Snow*). His happiness in his marriage and friendships seemed to give him a new freedom: the female form appears more often (*The Two Sisters on the Balcony Overlooking the Harbour*, c.1820, St Petersburg, Hermitage) and the denser colours take on their own symbolism.
- From 1820 Friedrich depicted landscapes that were always extraordinary, although they were the result of his study of nature. He expressed his quest for the divine through his polar landscapes, in contrast to the tradition of Italian biblical scenes. His range of subjects became wider; he painted his first interiors and some patriotic themes. Following Dahl he used more liquid paint, as well as fresher colours. His 'tachist' touch, inspired by Seydelmann, used longer strokes, and he painted pictures in a wider variety of sizes.
- In about 1826 his melancholy came to the fore and his morbid thoughts can be seen in his many daytime and nocturnal landscapes with luminous or wintry effects.
- At the peak of his later activity his sensitivity was heightened and he revealed a talent for colour (*The Great Precinct at Dresden*). A clear symbolism emerged with motifs seen in close-up and associated with death: Hunnish tombs, ruins, tombs and owls.

The Wanderer above the Sea of Fog
1818. Oil on canvas, 74.8 x 94.8cm, Hamburg, Kunsthalle

'Friedrich! The only landscape painter who until now has had the power to move every part of my soul, he who created a new genre: the tragedy of landscape', declared the Romantic sculptor D d'Angers. With a view of Saxon Switzerland in the mist, the painter has sought to represent the vastness of the world. The painting is striking; the man stands between nature and God, like a witness to the 'spectacle'. The simple composition, conceived with no middle ground, creates an impression of vertiginous space, almost physical, as in Chalk Cliffs of Rügen. Like the figure in the painting, the viewer experiences the landscape, that icy ocean of cold tones.

In 1976 the critic H Zerner suggested a symbolic interpretation of the elements with the mist representing restlessness and hidden reality, the barrier between earth and heaven, and the rocks, which link the two, representing faith. The man standing, seen from behind, seems to be collecting his thoughts, perhaps remembering someone who has passed away.

Tree with Crows
1822. Oil on canvas, 54 x 71cm, Paris, Musée du Louvre

Friedrich replaced the traditional allegories of religious painting with a symbolism drawn from nature and free from convention. On the horizon, to the left of the painting, the island of Rügen can be seen; behind the parched oak surrounded by crows a burial mound looms, probably a Hunnish tomb. The natural elements metaphorically recall anguish, sin and death; the twisted oak, torment; the crows, ill omens and unhappiness; and the setting sun the last breath of life. The graphic expressionism of the tree can be seen throughout Friedrich's work.

KEY WORKS
It is estimated that Friedrich produced 310 paintings.
The Cross on the Mountain or *The Tetschen Altarpiece*, 1807–8, Dresden, Gg
Monk on the Seashore, c.1809, Berlin, Charlottenberg
The Abbey in the Oak Wood, 1809, Berlin, Charlottenberg
Morning in the Riesengebirge, c.1810, Berlin, Charlottenberg
Tombs of Ancient Heroes, 1812, Hamburg, K
The Cross on the Mountain, 1812, Düsseldorf, Km
Townscape in the Moonlight, c.1817, Winterthur, O Reinhart museum
Chalk Cliffs of Rügen, c.1818, Winterthur, O Reinhart museum
Wanderer above the Sea of Fog, 1818, Hamburg, K
Rural Landscape, 1822, Berlin, National Gallery
The Tree of Crows, 1822, Paris, Louvre
Moon Rise over the Sea, 1822, Berlin, National Gallery
Landscape near Dresden, 1824, Hamburg, K
Reefs by the Seashore, 1824, Karlsruhe, SK
Cemetery in the Snow, 1826, Leipzig Museum
Mount Watzmann, c.1824, Berlin, National Gallery
The Shipwreck, c.1827, Hamburg, K
The Great Precinct at Dresden, 1832, Dresden, Gg
The Three Ages of Life, 1835, Leipzig Museum
Seascape in the Moonlight, c.1836, Dortmund Museum

BIBLIOGRAPHY
Betthausen, P, Riemann, G and Robinson, W W (eds), *The Romantic Spirit: German Drawings 1780–1850, from the Nationalgalerie, Berlin, and the Kupferstich-Kabinett, Dresden*, Pierpont Morgan Library, New York and London, 1988; Rosenblum, R, *Caspar David Friedrich and Modern Painting*, A.&t Lit 10: Autumn 1966, pp 134–46; Sala, C, *Caspar David Friedrich and romantic painting*, Editions Pierre Terrail, Paris, 1989; Sumowski, W, *Caspar David Friedrich – Studien*, F Steiner, Wiesbaden, 1970

Turner

An ambitious but misanthropic painter and watercolourist, Turner had two major preoccupations: to rival the masters of the past as well as his contemporaries, and to convey his feeling for nature through topical subjects. He preferred to paint landscapes and gave a supreme role to light, which endowed his work with a dream-like dimension by making drawing and the contrast of light and shadow irrelevant. His painting developed from a classic, illusionistic technique to one of tonal shades and intense colour in a built-up impasto, and then to a swirl of colour and light which was sometimes 'formless'.

LIFE AND CAREER

• The British painter Joseph Mallord William Turner (London 1775–London 1851) was the son of a barber. He took lessons at the Royal Academy from 1789 to 1793 under Thomas Malton, who specialized in architectural drawing and topographical landscapes. He exhibited his watercolours at the Academy every year, working at the same time with architects and topographers.

• The period between 1792 and 1796 was pivotal: with Thomas Girtin, Turner studied the watercolours of J R Cozens. He embarked on his first study trips to Wales and Kent. He began painting in oils in 1793 and showed *Fishermen at Sea* (1796, London) at the Academy. He also painted *Morning Amongst the Coniston Fells* (1798, London).

• Highly regarded by his peers, the academicians, and respecting the traditional hierarchy of genres and classical composition, Turner chose the landscape genre to which he added a historical dimension. He exhibited his paintings, accompanied by the epic quotations of J Thomson: *Aeneas and the Sibyl* (1798, London, TG), *Lake Buttermere* (1798, London, TG) and *The Fifth Plague of Egypt* (1800, Indianapolis), the first of his historical landscapes. After 1813, he turned to quotations from his own poem, *The Fallacies of Hope*, for the captions of his paintings.

• In 1803, Turner arrived in France by way of *Calais Pier* (1803, London, NG). There he immortalized the Seine and discovered the art of *Watteau, *Géricault, *David and others in Paris, then went to Switzerland. On his return to Britain in 1804 he opened his own gallery and presented contemporary subjects such as *The Shipwreck* (1805, London). In 1807, seeing the success of his fellow countryman Sir David Wilkie, he produced a number of genre paintings: *The Forge* (1807, London, TG), *Sunrise in the Mist* and *Fishermen Cleaning and Selling Fish* (1807, London, TG), as well as paintings of the English countryside: *The Thames near Walton Bridge* (c.1810, London, TG). His taste for historical subjects became clear with *The Battle of Trafalgar* (1808, London, TG) and *Snow Storm: Hannibal and his Army Crossing the Alps* (1812, London, TG) in which the dematerialization of the landscape can first be seen. He wanted to rival the luminous virtuosity of the painter Claude (Lorrain): *Thompson's Aeolian Harp* (1809, Manchester, City AG) and *Dido Building Carthage* (1815, London).

• He travelled again in Europe from 1817. He pitted himself against the Dutch landscapists by painting *The Dordrecht Packet-Boat from Rotterdam* (1818, New Haven, YC). He captured the light in Venice. He drew inspiration from Watteau for his painting *Richmond Hill on the Prince Regent's Birthday* (1819, London, TG).

• Between 1820 and 1830 he established his style: *Whatever will Please You* (1822, pr coll), a tribute to Shakespeare and Watteau, *The Bay of Baiae with Apollo and the Sibyl* (c.1823, London, TG), followed by *The Fort at Dieppe* (1825, New York, FC), *Cologne: The Arrival of a Packet-Boat* (1826, New York, FC) and *Ulysses Deriding Polyphemus* (1829, London). He painted remarkable compositions with a personal use of colour that moved away from tonal structure, such as *Death on a Pale Horse* (c.1825–30, London, TG), *Regulus* (1828–9, London, TG) and *Calais Sands at Low Water* (1830, Bury). From 1829 to 1837, Lord Egremont invited him to his country estate at Petworth; there he created *Music Party at Petworth* (c.1830, London, TG).

• From 1835 his work became more abstract: *Venice, the Piazzetta* (1835, London, TG), *Burning of the Houses of Parliament* (1834–5, Philadelphia), *Keelmen Heaving in Coals by Moonlight* (1835, Washington, NG), *Juliet and her Nurse* (1836, pr coll), *The Fighting Temeraire* (1839, London, NG) and *A Mountain Scene, Val d'Aosta* (c.1838, Melbourne).

- Around 1840 he moved even further towards the abstract by allowing objects actually to merge with their surroundings: *Slavers Throwing Overboard the Dead and Dying* (1840, Boston); *Snow Storm – Steam-Boat off a Harbour's Mouth* (1842, London); *Light and Colour ...* (1843, London); *Rain, Steam and Speed* (1844, London); *Venice, Evening ...* (1845, London); *Landscape with a River and a Bay in the Distance* (c.1845, Paris), a whirlwind of colour; and *Angel Standing in the Sun* (1846, London, TG), an almost formless canvas. He died a recluse at his home in Chelsea.

Turner's work seems close in style to *Monet; it differs however from the analytical work of the Impressionists; Turner rather opened the way to 'pure' abstract painting. For posterity, the painter bequeathed some of his work to museums in London.

APPROACH AND STYLE

Turner was a painter of landscapes: historical (mythological, biblical, classical or contemporary) or heroic (warriors and naval subjects), scenes embodying the fury of the elements (avalanches, storms and conflagrations) and picturesque rural scenes (gypsies, fishermen and fishmongers). He produced some interior scenes and 'pictures of nothing', 'pure' images of ephemeral subjects. His historical landscapes were oils on large canvases, apart from a couple of rare exceptions (one square and one octagonal canvas). The other less ambitious landscapes were of various sizes.

The painter profited from a clientele of patrons and collectors (including Dr Monro, R Colt Hoare, W Fawkes, Lord Egremont) and the unconditional support of the critic John Ruskin. He studied Italian Renaissance painting and works of the pupils of *Carracci (Guercino, Albani); he admired the work of his British contemporaries, the watercolourist Girtin, the genre painter Wilkie and, from the 18th century, the classic landscapes of R Wilson. He wanted to match the French painting of the 17th and 18th centuries, represented by Claude, *Poussin and Watteau. He was also familiar with the Dutch landscapists of the Golden Age such as S van Ruïsdael and the van de Velde family. Turner travelled throughout Europe but his career was based mainly in England.

- His training in watercolours enabled him to develop a feeling for atmospheric perspective, a freer technique, and to distance himself from the monochrome background, brightening his palette. His early canvases were either picturesque or they displayed a realism that was inseparable from his feeling for nature. Turner depended on his observation of landscapes, recorded in his sketches, drawings and watercolours, as the basis for the work he then carried out in his studio. From this point, he only used watercolour during his travels.
- His main interest turned to landscape whose context was historical (*Aeneas and the Sibyl*) or classical (*The Tenth Plague of Egypt*, 1802, London, TG); he learnt about the outlines of composition, the skilfully shaded tonal colours and the still light of *Poussin and Claude. He was also drawn to the moving light of the Venetian colourists (*Titian, *Tintoretto and

A GREAT PAINTER

◆ Celebrated in Britain and Europe during his lifetime, Turner remains an artist of great renown to this day, as a result of retrospectives of his work and the opening of the Turner Gallery in London in 1987.
◆ A landscapist of Classical and Romantic structure, Turner tended towards non-thematic stylistic abstraction.
◆ Turner broke new ground in his celebration of the railways before the Impressionists (*Rain, Steam and Speed*) and he remained an innovator particularly in the details he incorporated: black sails (*Peace – Burial at Sea*, 1842, London, TG), falling stones (*The Fall of an Avalanche in the Grisons*, 1810, TG) or the pathetic sight of a howling dog. He was the first to represent a subject that needed a title for it to be recognized.
◆ His white paint, laid down in tiny strokes, shone out. Turner painted in dazzling colours and was successful in seeking to achieve 'pure' light-colour.
◆ He worked with a knife and brought watercolour techniques to oil painting. The artist had a large palette, a lump of flake white and two or three brushes 'with which he drove the white ... into every part of the surface' (Sir J Gilbert) In order to create *Rain, Steam and Speed*, he used 'fairly short paintbrushes, a dirty palette, and was standing nearly pressed against the canvas', one of his friends reported.

*Veronese) and the classic Bolognese painters of Rome (Guercino, Guido Reni etc). He painted in the Dutch style with the smooth sea polished like a mirror, an infinite sky and an air of calm (*Dordrecht*).

• Between 1820 and 1830, Turner assimilated all his influences and established his own style: the composition became subject to more complex lines, the intense light became radiant, the colour more vivid (blue, red, yellow), with warm browns and the omnipresent white (*Calais Sands at Low Water*). In order to give the painting a strong feel and to avoid mixing the intense colours, Turner worked with a knife.

• His style changed in 1835, working around the theme of fire; his canvases became enflamed with atonal colour and light (*Burning of the Houses of Parliament*).

• From 1842, he created a rhythmical composition, swirling and centrifugal (*Light and Colour*) based on Goethe's *Treatise on Colour*. Eventually he was painting canvases where the subject lost its readability (*Angel Standing in the Sun*), in which red and gold elements floated: trees, figures and thick clouds. His landscapes were 'pictures of nothing' (William Hazlitt, 1816, quoted by A J Finberg, 1967).

• His final, calmer, unfinished works show the disintegration of shapes that have become almost abstract, and the elimination of any detail in the golden light, full of emotion.

Ulysses Deriding Polyphemus. Homer's Odyssey
1829. Oil on canvas, 132 x 2.03m, London, National Gallery

Polyphemus, the formidable Cyclops, had taken Ulysses and his companions captive. In order to escape, Ulysses managed to blind him in his one eye. In this historic landscape, with a dramatic, mythical subject, Turner demonstrated his ability to construct a work with French, Italian and Dutch influences. He asserted his magic touch with colour and light, based on the alternation of warm and cold tones, blues and golds. The sun sets everything alight, like molten gold. Nature is everywhere; 'with a wild majesty around the struggle between the monster and the hero, she swamps them both with her awesome magnificence' (H Focillon, 1938). 'Polyphemus asserts his perfect power and is, therefore, to be considered as the central picture of Turner's career' (John Ruskin, 1863 lecture).

Rain, Steam and Speed
1844. Oil on canvas, 91 x 122cm, London, National Gallery

The colourful, burning light serves to convey emotion rather than transcribe reality as it is observed and lived. To produce this work, Turner stood on the footplate of a locomotive, travelling at full speed. The artist worked on the painting in his studio using his notes and sketches. The impalpable smoke and currents of air from the train are made real on the canvas using impasto. The solid elements, the bridge and the train, evaporate into an unreal, romantic atmosphere: 'It was no doubt a quick piece done in a wild fury, blurring the sky and the earth with a stroke of the brush, a work of true extravagance, but done by a genius', declared the rapturous Theophile Gautier (Histoire du Romantisme, *1872).*

KEY WORKS

Turner produced 282 canvases, about 100 of which were unfinished, and several thousand watercolours, gouaches, drawings and prints.
Fishermen at Sea, 1796, London, TG
The Fifth Plague of Egypt, 1800, Indianapolis, MA
The Shipwreck, 1805, London, TG
Sunrise in the Mist and *Fishermen Cleaning and Selling Fish*, 1807, London, NG
The Fall of an Avalanche in the Grisons, 1810, London, TG
The Battle of Trafalgar, 1808, London, TG
Snow Storm: Hannibal and his Army Crossing the Alps, 1812, London, TG
Dido Building Carthage, 1815, London, NG
Regulus, 1828–9, London, TG
Ulysses Deriding Polyphemus, 1829, London, NG
Calais Sands at Low Water, 1830, Bury, Bury AG and M
Burning of the Houses of Parliament, 1834–5, Philadelphia, MA
Val d'Aosta, c.1838, Melbourne, NGV
Slavers Throwing Overboard the Dead and Dying, 1840, Boston, MFA
Snow Storm – Steam-Boat off a Harbour's Mouth, 1842, London, TG
Light and Colour (Goethe's Theory), 1843, London, TG
Rain, Steam and Speed, 1844, London, NG
Venice, Evening, Departure for the Ball, 1845, London, TG
Landscape with a River and a Bay in the Distance, c.1845, Paris, Louvre

BIBLIOGRAPHY

Butlin, M and Joll, E, *The Paintings of J M W Turner*, revised edn, 2 vols, Yale University Press, New Haven, CT and London, 1984; Cormack, M, *J M W Turner, RA, 1775–1851: A Catalogue of Drawings and Watercolours in the Fitzwilliam Museum*, Cambridge, Cambridge, 1975; Gage, J, *J M W Turner: 'A Wonderful Range of Mind'*, Yale University Press, New Haven, CT, 1987; Herrmann, L, *Ruskin and Turner*, Faber and Faber, London, 1968

Constable

Modest and discreet, sensitive and persevering in his work, Constable cherished the English countryside and its cloudy skies. A naturalistic, Romantic landscape painter, he concentrated on direct and scrupulous observation of nature. Every painting had a subject linked to his personal life and was nurtured over time. His work embraced the transparency of reflections on water and every aspect of the rolling clouds, painted with a very free technique.

LIFE AND CAREER

• The British painter John Constable (East Bergholt, Suffolk, 1776–London 1837), the son of a rich miller, was forced to work from the age of 16. He had the good fortune to meet the art lover Sir George Beaumont and the painter Joseph Farington who in 1799 persuaded him to study at the Royal Academy, where he first exhibited in 1802.

• At the same time, on his own he studied English landscape painting of the 18th century and classical landscape painting of the 17th century. He preferred the sensations evoked by his wanderings in his native countryside, around the River Stour, which he depicted in watercolours and painted sketches, although this did not prevent him from painting other subjects to earn a living. His views of London, for example, were in the tradition of more formal landscapes: *View of Epsom* (1809, London); *Malvern Hall* (1809, London); *Flatford Mill from a Lock on the Stour* (c.1811, London); *Landscape with a Double Rainbow* (1812, London); *Dedham from Langham* (c.1813, London, TG).

• His first success in the field of 'great' formal landscapes was entitled *Boatyard near Flatford Mill* (1814, London). In 1816 he married, settled in London and established his talent: *Wivenhoe Park, Essex* (1816, Washington, NG); *Weymouth Bay* (*Weymouth Bay Before the Storm*, 1816, London and 1819, Paris). He became an associate member of the Royal Academy and his success was confirmed: *The White Horse* (1819, New York), *Stratford Mill* (1820, London), *Salisbury Cathedral from Lower Marsh Close* (1820, Washington, NG).

• At the 1824 Salon in Paris, the famous *Hay Wain* (1820, London) filled the Romantics (particularly *Géricault and *Delacroix) with enthusiasm for its chromatic freshness and freedom of style; Constable was awarded the gold medal. In the same year he stayed in Brighton where his wife was being nursed. Inspired by the work of the meteorologist L Howard, he observed the passing clouds, variations in light and atmospheric changes. He devised new pictorial processes which were better adapted to his scientific knowledge of natural phenomena.

• *Salisbury Cathedral* (1823, London), his first important commission, was more an architectural than an atmospheric landscape, unlike the radiant *The Lock* (1824, Lugano, TB) which enjoyed great success, as did *Leaping Horse* (1825, London). After *Hadleigh Castle* (c.1828–9, London), Constable was in 1829 elected an associate member of the Royal Academy, but he was very badly affected by the death of his wife in the same year, and his last major work, *Salisbury Cathedral, from the Meadows* (1831, London), seems to show that. He oversaw the execution of his engraved work between 1829 and 1834. From 1833 to 1836, he gave lectures on the history of landscape painting.

Constable was only equalled by his contemporary *Turner in the art of landscape painting, and was finally eclipsed by him altogether, although they were inspired in different ways.

Apart from his painted works, watercolours and drawings, Constable also left *Lectures on the History of Landscape Painting*, a collection of engrav-

ings entitled *English Landscape Scenery* and his *Correspondence.* The success of his art in Great Britain was not prolonged. In France, the Romantics revelled in his great freedom of execution, while the Barbizon School of painters and the Impressionists discovered his ability to paint from life at any moment of the day.

APPROACH AND STYLE

Constable tirelessly painted the landscapes of his native countryside on the banks of the River Stour, the cloudy skies of the Kent coast in all their atmospheric variations (storm, rainbow, setting sun), and Salisbury Cathedral. He left a few rare portraits and religious scenes. His paintings of all sizes were executed on canvas, paper, paper mounted on canvas, cardboard or panels. He accepted commissions from his patrons and friends including Sir George Beaumont and the Fisher family.
He was inspired by Claude and the British watercolourist Thomas Girtin. He also admired the old masters, including *Rubens.
Constable only ventured from his own village and London on a few occasions, sometimes to the north of England, but mainly in the south. He never went abroad.

• Trained at the Royal Academy in the study of landscape painting, Constable's development was only from drawing to painting. He sought to simplify composition, introducing contrasts in light and to show his attachment to the classic landscape painting of Claude (*Dedham Vale*, 1809, London, VAM): 'For the last two years, I have been running after pictures and seeking truth at second hand. ... I shall shortly return to Bergholt where I shall make some laborious studies from nature – and I shall endeavour to get a pure and unaffected manner of representing the scenes that may employ me. ... There is room enough for a natural painter.' This is demonstrated in *Malvern Hall*, one of his first works painted in the open air, which was innovative in its freedom of colour, luminosity and freshness, the dazzling pure white and the light strokes.
• After some watercolours in the style of Girtin, he expressed himself directly through sketches in oil. Nevertheless, the landscapes he painted were still reminiscent of traditional compositions (*View of Epsom*). In order to distance himself from this, he observed natural atmospheric phenomena with extreme acuteness.
• In order to capture these nuances of subject matter and luminosity, he found subtle methods including 'that of covering his canvas with white spots to render the glistening of wet leaves and dew, and the use

A GREAT PAINTER

◆ In Great Britain Constable was eclipsed by *Turner, but he enjoyed great success in France compared with other 19th-century artists. During his lifetime his large paintings brought him fame but today his small watercolours and oil sketches are more appreciated.
◆ Constable's work, painted from nature and in nature, introduced a freshness, a sincerity and an emotion which differed from the paintings produced in the studio by his contemporaries.
◆ Nature, seen directly, and painted for its own sake, was his only subject.
◆ Constable painted his sketches directly in oils, on a red ground in order to preserve the unity of the painting. To express atmospheric changes he used different methods, one being the famous 'Constable's snow'.
◆ Constable varied his technique: fluid, transparent paint for reflections on water and thick impasto for fluffy clouds or the heavy clouds signalling the approaching storm.
◆ The liveliness of his brushstrokes was often softened in the finished work.
◆ The spontaneity of accurate depiction, a great freedom of execution of cloudy, living skies, a freshness and a dazzling colour distinguished his style.

of a broader brush or a palette knife to achieve a more varied consistency' (W Vaughan, 1979).

- At the peak of his art, from 1816, he chose huge formats to express his direct perception of the countryside (*The Hay Wain*) and, in a new development, he painted the seaside (*Weymouth Bay*). In his own words, he sought to symbolize 'the natural phenomenon in its purest meaning'. His sensitivity created an art that was faithful to the humble reality of his native country to which he was emotionally attached and which he painted with great emotion.

- Still unsatisfied, he studied the phenomena of nature scientifically: the clouds and their changes according to the seasons, the weather and the time of day. In this way, Constable mastered light much better: 'The sky is the source of light in nature and governs everything', he declared. He pursued his investigation of the changes in tone of natural light, of the passage from fine weather to a storm, followed by a rainbow (*Hadleigh Castle*; *Salisbury Cathedral, from the Meadows*). The light becomes livid and dramatic.

- He painted nature for its own sake, in all its diversity. For him, the question was not 'what' to paint, but 'how' to paint. Consequently he chose his technique to ensure diversity: 'The agitation of the storm is echoed by the agitation of the canvas worked with a knife' (P Wat, 1995).

KEY WORKS

Constable painted about 1,465 works in his early years and 1,087 mature works (oil paintings and watercolours).

View of Epsom, 1809, London, TG
Malvern Hall, 1809, London, TG
Flatford Mill from a Lock on the Stour, c.1811, London, VAM
Landscape with a Double Rainbow, 1812, London, VAM
Boatbuilding near Flatford Mill, 1814, London, VAM
Weymouth Bay, 1816, London, VAM and 1819, Paris, Louvre
The White Horse, 1819, New York, FC
Stratford Mill, 1820, London, NG
The Hay Wain, 1821, London, NG
Salisbury Cathedral, 1823, London, VAM
Leaping Horse, 1825, London, RA
Hadleigh Castle, c.1828–9, London, TG
Salisbury Cathedral, from the Meadows, 1831, London, pr coll, on loan to the NG

BIBLIOGRAPHY

Beckett, R B (ed), *John Constable's Discourses*, Suffolk Records Society, Ipswich, 1970; Leslie, C R, *Memoirs of the Life of John Constable*, revised edn with an introduction and notes by Jonathan Mayne, Phaidon, London, 1995; Parris, L and Shields, C, *John Constable 1776-1837*, Tate Gallery, London, 1973; Parris, L, and Fleming-Williams, I, *Constable*, Tate Gallery, London, 1991; Parris, L, Fleming-Williams, I and Shields, C, *Constable: Paintings, Watercolours and Drawings*, The Tate Gallery, London, 1976; Reynolds, G, *Catalogue of the Constable Collection in the Victoria and Albert Museum*, V & A Publications, London, 1973; Rosenthal, M, *Constable: The Painter and his Landscape*, Yale University Press, New Haven, CT, 1983

Weymouth Bay
(Weymouth Bay Before the Storm)
1819. Oil on canvas, 88 x 112cm, Paris, Musée du Louvre

Constable described himself as 'a painter of the natural history of the skies', emphasizing less the pompous dimension of the subject matter than his sentimental and sincere artistic approach. He immersed himself in his subject, here at Weymouth Bay, a place near where he spent his honeymoon.

With its light contrasting with the landscape, the sky evokes a poetic feeling that Constable has created through his appropriate treatment of the subject. 'It will be difficult', he said, 'to name a class of landscape in which the sky is not the keynote, the standard of scale, and the chief organ of sentiment.'

Light, in 'conflict, unity, shadow, nuance, reflection and refraction' (P Wat, 1999), overwhelms the painting: the sandy beach, the dune, the rocks, the sea, the gloomy sky, low and heavy, underlined by shadow, and the little figures providing the sense of scale. The sensitive, realistic touch recreates the agitation of the elements; the violence of the coming storm can be felt in the leaden tones, enhanced by touches of white, the last slivers of light before the storm. A smooth, vivid technique emphasizes the resonant dimension of the landscape.

Ingres

A determined, susceptible and tempestuous painter, Ingres was also a talented draughtsman and colourist. Although his work was seen as a triumph of Classicism, he was also influenced by the aesthetics of Romanticism, reflected in his desire to express the essence of being and in his use of abstract arabesques and coloured flat tints. Beyond the Graeco-Roman and Gothic subjects and ornamentation of his troubadour period or the garments of an imaginary Orientalism, he also excelled in conveying a tactile quality to materials and developed a sensuality of the nude through his curved, almost abstract line.

LIFE AND CAREER

• Jean Auguste Dominique Ingres (Montauban 1780–Paris 1867), French painter, studied drawing and painting with his father, a decorative artist. At the age of eleven, he enrolled at the Royal Academy in Toulouse. His master was the painter J Roques, a former pupil of Joseph Marie Vien. Music was his hobby and he was a second violinist in the Orchestre du Capitole.

• He lived in Paris between 1797 and 1806 where he associated with artists and joined *David's studio. He left the year he received the Prix de Rome for *The Ambassadors of Agamemnon* (1801, Paris, ENSB-A). He painted his *Self-Portrait at the Age of 24* (1804, Chantilly, Condé) and also received commissions including the three portraits of *Monsieur, Madame and Mademoiselle Rivière* (1805, Paris), *La Belle Zélie* (1806, Rouen, B-A) and *Napoleon on his Imperial Throne* (1806, Paris). Exhibited at the 1806 Salon, these portraits were judged 'archaic'.

• From 1806 to 1820 Ingres lived in Rome where he fell in love with *Raphael's frescoes, the Roman ruins and collections of antiquities. His work was admired by Paris art critics, in particular *François-Marius Granet* (1807, Aix-en-Provence, Granet), which displayed a pre-Romantic sensitivity, *Madame Devauçay* (1807, Chantilly) and *The Bather of Valpinçon* (1808, Paris). On the other hand, the anatomical deformities of *Œdipus and the Sphinx* (1808, Paris, Louvre) and especially of *Jupiter and Thetis* (1811, Aix-en-Provence) were strongly deplored by the critics. Hurt, Ingres decided to stay in Rome. He painted numerous portraits – *Charles Marcotte of Argenteuil* (1810, Washington, NG); *Joseph-Antoine Moltedo* (1810, New York) – and created some large compositions: *Romulus's Victory over Acron* (1812, Paris, ENSB-A) and *The Dream of Ossian* (1813, Montauban). After his marriage in 1813 and a trip to Naples, he painted *Madame de Senonnes* (1814–16, Nantes), *La Grande Odalisque* (1814, Paris) which shocked the purists at the 1819 Salon, and *Paolo and Francesca* (1814, Chantilly, Condé).

• In 1815, the Empire collapsed and Ingres lost his French clientele. As a result he turned to the English colony: *The Montagu Sisters* (1815, London, pr coll) and *The Stamaty Family* (1818, Paris, Louvre). He became interested in historical subjects, known as 'troubadours', closer to his own time than his classical subjects: *Henri IV Receiving the Spanish Ambassador* (1817, Paris), *The Death of Francis I* (1817, Paris) and *The Death of Leonardo da Vinci* (1818, Paris).

• Invited to Florence by the sculptor Bartolini between 1820 and 1824, Ingres continued to excel in the art of portrait painting: *Lorenzo Bartolini* (1820, Paris, Louvre), *Count Gouriev* (1821, St Petersburg, Hermitage) and *Madame Leblanc* (1823, New York, MM). He was commissioned by the government to paint *The Vow of Louis XIII* (1820–4, Montauban). The success of *The Wish* confirmed him as the defender of Classicism in reaction to the Romanticism of *The Massacre of Chios* (1824) by *Delacroix; the two artists were pitted against each other by their respective partisans until their death.

• This marked the beginning of a brilliant official career. In the following year he was elected to the Académie des Beaux-Arts and opened a studio. He continued painting portraits: *Madame Marcotte de Sainte-Marie* (1826, Paris) and *Monsieur Bertin* (1832, Paris). The style of his *Apotheosis of Homer* was in strong contrast with Delacroix's *Death of Sardanapalus* (1827). He was badly affected by the failure of *The Martyrdom of St Symphorian* (1834, Autun Cathedral). He stopped exhibiting at the Salon and moved to Rome as director of the Villa Medici.

- Between 1835 and 1842, Ingres taught and reorganized the Institution but drew and painted only a little: *Odalisque and Slave* (1839, Cambridge [Mass.]) and *The Sickness of Antiochus* (1840, Chantilly, Condé).
- Back in Paris he left behind a priceless record of personalities such as *Ferdinand Philippe, Duc d'Orléans* (1842, pr coll), *The Comtesse d'Haussonville* (1845, New York, FC), *The Baronne de Rothschild* (1848, pr coll) and *Madame Moitessier* (1851, Washington, NG; 1852–6, London). He was married for a second time, to Delphine Ramel (portrait in 1859, Winterthur, O Reinhart mus).
- His fame led to the commissioning of some monumental decorative projects: *The Golden Age* and *The Iron Age* (1842–9, Château de Dampierre, unfinished), *Apotheosis of Napoleon* (1853, destroyed) and cartoons for stained glass windows. He also painted religious paintings: *The Virgin of the Host* (1854, Paris) and *Joan of Ark at the Coronation of Charles VII* (1854, Paris, Louvre). His last paintings were *Venus Anadyomene* (1848, Chantilly), *The Source* (1856, Paris, Orsay) and *The Turkish Bath* (1862, Paris). His last sketched canvas was *Jesus in the Midst of the Doctors* (1862, Montauban, Ingres).

Ingres had an impressive career which was crowned with success (*Self-Portrait at the Age of 79*, 1858, Cambridge [Mass.], FAM). He was responsible for the revival of classical French painting in the 19th century. He trained and inspired over 200 French and foreign pupils and followers, including H Lehmann, E Amaury-Duval, H and P Flandrin, the Swiss B Menn and the Italian C del Bravo. Ingres had an effect on Symbolism and Art Nouveau and influenced the art of *Degas, *Gauguin, Renoir and, in the 20th century, *Matisse, the Nabis, *Picasso and pop art artists. There is a museum in Montauban devoted to him.

APPROACH AND STYLE

Ingres found his subjects in ancient, medieval and national history, ancient literature (such as Homer, Ossian and Dante), the Bible and mythology. In particular he painted portraits, nudes and large decorative pieces, on canvases of all sizes.

His main patrons included the middle-class Rivière and Bertin, socialites and the French nobility (Madame de Senonnes and the Duc d'Orléans) and English aristocrats, as well as Napoleon I, the French government and the Governor of Rome.

In Paris, he trained with David, who made him aware of Classicism and the French and Flemish Primitives; he became interested in the art of Jan *van Eyck, the French illuminators of the Middle Ages, the School of Fontainebleau and classical painters such as Philippe de Champaigne. In Italy and particularly in Rome, he discovered the Florentine art of *Masaccio, the monuments and objects of Graeco-Roman antiquity, the Madonnas and frescoes of Raphael and the Tuscan Mannerism of *Pontormo. He also admired Byzantine buildings and the frescoes of *Giotto. The painter preferred to work from nature with live models.

A GREAT PAINTER

◆ Ingres was very famous during his own lifetime; this was unfailing whether his art aroused criticism or admiration.

◆ Neither Neoclassical nor an academician but a passionate defender of drawing, Ingres was a Classical, Romantic and Realist painter all at the same time.

◆ Ingres was an innovator with his Orientalist imagination and his troubadour themes dealing with the Middle Ages and the Renaissance (*The Death of Leonardo da Vinci*).

◆ His art was based on the line; he elongated the bodies of his female nudes, endowing them with an intense expressive strength which conveyed the individual character of each model. He based his art on the truth of the drawing and combined the real and the ideal.

◆ To prepare his paintings, Ingres sketched an idea on paper, then chose his subject: 'Draw for a long time before you think of painting', he told his pupils. After a long period of documentation and maturing of the composition and details, he painted quickly. Sometimes he reworked a painting much later.

◆ For his paintings of subjects from antiquity, he drew a living model, nude, fore clothing or draping the model in real fabrics.

- His first portraits and nudes were judged 'archaic', 'dry and episodic' and 'Gothic' in style, but critics were impressed with his precise classical drawing, the sophistication of the modelling, the incisive line, the sweetness of the light and the subtlety of the reflections inspired by van Eyck and the art of the illuminator. His female portraits had the faces of Raphael Madonnas. On the other hand, the 'expressionist mannerism' of his line interpreted the lesson of David in an unusual manner. The painter elongated the bodies of women to the limits of reality and anatomical coherence (*Jupiter and Thetis*); it was said that he had added a vertebra to the female body. With his passion for the violin, the taut line of music could perhaps have found an echo in this sculptural originality.

- Ingres evolved towards an official Classicism, not based on the pursuit of 'ideal beauty' but on style: 'Style is nature', he declared. His history painting which aimed to convey grandeur was inspired by the art of the old masters, his literary notes (on Homer and Pliny) and his biographical notes (on Raphael, Henri IV and so on); they embodied a perfection of composition and drawing and the search for local colour. His work was also distinguished by a pre-Romantic approach (*The Dream of Ossian*) and a natural, elegant realism which was clearly reflected in his portraits.

- Ingres reinforced his Classicism in compositions inspired by Raphael and reminiscent of Champaigne (*The Vow of Louis XIII*). His religious scenes and monumental decorations, marked by a breathless 'Raphaelism', do not diminish his creative vigour in any way.

- The expressionism of his line remained characteristic of his style, reflecting the strong character of his models whose individuality he captured through their pose, dress and facial expression. His love of curves and arabesques, the smooth modelling without strong shadows or light, were enhanced by the muted colours he used (*The Turkish Bath*). Although the colour, mainly that of the fabrics, set off the models, drawing remained fundamental: 'One must model roundly', the artist declared, 'without visible internal details.'

La Grande Odalisque
1814. Oil on canvas, 91 x 162cm, Paris, Louvre

*This odalisque, a figure which originated in the Orientalist imagination of the painter, was subjected to the sarcasm of the critics from the moment it was exhibited: weakness, anatomical aberration and chromatic monotony were the main criticisms made about this picture. Only those close to the painter defended the boldness of the expressive curve of the elongated back, the penetrating look, the Raphaelesque sweetness of the face, the sensual, round modelling of the languid body, caressed and smoothed down by a diaphanous light, heralding the japonisme and muted colours of *Manet.*
This classical rendering, interpreted from life, combined the formal synthesis of Madame de Récamier's portrait (1800) by David and the serpentine style and elongated proportions of the Tuscan Mannerists. Ingres merged all these borrowed elements into a powerful style of his own which he developed further in the bold play of curves and counter-curves, from the Odalisque and Slave *to* The Turkish Bath.

Monsieur Bertin
1832. Oil on canvas, 116 x 96cm, Paris, Musée du Louvre

L-F Bertin was the founder of the Journal des Débats, *a happy, prosperous middle-class writer on law and politics who lived during the reign of Louis Philippe. Ingres portrayed him in an unusual pose for the time, with his powerful hands resting on his knees. The attitude of the character reveals the human truth of the model more than does the expression of the face. Critics thought the pose vulgar: 'a great man looking like a rich farmer.' 'Is not Ingres actually showing us a "rich farmer who became a great man"?'*
(D Ternois, 1984)

▌KEY WORKS

Ingres painted about 177 paintings and thousands of preparatory drawings.
Monsieur, Madame and Mademoiselle Rivière, three portraits, 1805, Paris, Louvre
Napoleon on his Imperial Throne, 1806, Paris, Musée de l'Armée
Madame Duvauçay, 1807, Chantilly, Condé
The Bather of Valpinçon, 1808, Paris, Louvre
Joseph-Antoine Moltedo, 1810, New York, MM
Jupiter and Thetis, 1811, Aix-en-Provence, Granet
The Dream of Ossian, 1813, Montauban, Ingres
La Grande Odalisque, 1814, Paris, Louvre
Madame de Senonnes, 1814–16, Nantes, B-A
Henri IV Receiving the Spanish Ambassador, 1817, Paris, Petit Palais
The Vow of Louis XIII, 1820–4, Montauban Cathedral
Madame Marcotte de Sainte-Marie, 1826, Paris, Louvre
The Apotheosis of Homer, 1827, Paris, Louvre
Monsieur Bertin, 1832, Paris, Louvre
Odalisque and Slave, 1839, Cambridge [Mass.], FAM
Ferdinand-Philippe, Duc d'Orléans, 1842, pr coll
Venus Anadyomene, 1848, Chantilly, Condé
Madame Moitessier, 1852–6, London, NG
The Virgin of the Host, 1854, Paris, Orsay
The Turkish Bath, 1862, Paris, Louvre

Brainse Fhionnglaise Finglas Library
T: (01) 834 4906 E: finglaslibrary@dublincity.ie

BIBLIOGRAPHY

Ingres, exhibition catalogue, Paris Museums, Paris, 1968; Rosenblum, R, *Jean-Auguste-Dominique Ingres*, Thames and Hudson, London, 1967; Tinterow, G and Conisbee, P, *Portraits by Ingres: Image of an Epoch*, exhibition catalogue, Metropolitan Museum of Art, New York, 1999; Whiteley, J, *Ingres*, Oresko Books, London, 1977

Géricault

In only twelve years as a painter Géricault, a passionate, charming and sensitive artist, succeeded in acquiring recognition for his art. His work displayed the fieriness of the horse, his favourite subject. His topical subjects, carefully thought-out and endowed with scientific realism, illustrated the violence of contemporary life. He glorified the body and emphasized the importance of form and composition, with a smooth finish in brown and red ochre. While representing Romantic genius through his subjects and the dramatic expression of his paintings, his technique and style remained Classical.

LIFE AND CAREER

• Theodore Géricault (Rouen 1791–Paris 1824), French painter, was born into a wealthy family which moved to Paris. In 1808 his inheritance enabled him to satisfy his two passions, painting and horses. Between 1808 and 1812, he trained in the workshop of Carle Vernet and with Pierre Narcisse Guérin. He studied antiquity, nature and the ancient masters.
• His first paintings were on the theme of horses and military subjects: *Portrait of an Officer of the Chasseurs of the Imperial Guard Commanding a Charge* (1812, Paris) for which he received the gold medal at the 1812 Salon; *Portrait of a Carabinier* (c.1812–4, Paris; Rouen, B-A); *The Wounded Cuirassier* (1814, Paris, Louvre; New York, Brooklyn mus); *The Honorable Artillery Company* (c.1814, Munich, NP).
• From 1816 to 1817 after his failure in the Prix de Rome competition, Géricault travelled at his own expense to Italy where he stayed mainly in Rome. He became passionately interested in the Renaissance masters and in 17th-century Classicism. His early paintings were lively with numerous horses: *Race of Free Horses* (1817, Lille; Paris, Louvre), *Run of Free Horses in Rome* (1817, Baltimore, Walters AG), *Horse Held by Slaves* (1817–8, Rouen).
• Back in Paris, he became interested in landscapes and animals as subjects: *Landscape with an Aqueduct* (1817–20, New York), *Landscape with a Roman Tomb* (c.1818, Paris, PP); Heroic landscape with Fishermen (1818, Munich, NP), *Taming of the Bulls* (1818, Cambridge [Mass.], FAM). *The Cattle Market* (1817, Cambridge [Mass.], FAM). He studied the protagonists of boxing matches, and concentrated on facial expressions in the painting of *Alfred Dedreux as a Child* (1817, Paris, R. Lebel coll; New York, MM) and the *Portrait of an Oriental* (1819–21, Besançon).
• He was inspired by contemporary, historical and political events: *Cart with Wounded Soldiers* (1818, Cambridge [GB]) showed a scene from the retreat from Russia. He was inspired by various events such as the murder of the magistrate A Fualdès in Rodez and the sinking of ship *The Medusa*, which he transformed into tragic sagas. To create the latter work, he drew and painted numerous sketches that finally resulted in the huge, important painting of *The Raft of the Medusa* (1819, Paris), recognized as the manifesto of pictorial Romanticism. Exhausted by making this painting which was both criticized and admired, and suffering from depression, he did not honour a commission he had received from the government which he passed on to *Delacroix. He retired to Fontainebleau.
• He was in London in 1820–1 where he exhibited *The Raft of the Medusa* with great success. There he also discovered *Constable, Henry Fuseli and *Turner's watercolours. He took up lithography, depicting scenes of everyday life and sporting subjects. He painted *Derby at Epsom* (1821, Paris).
• It was in Paris that he ended his career with *The Lime Kiln* (c.1821–2); the sketches for *The Opening of the Doors of the Inquisition*, *The Slave Trade*; *Portrait of Lousie Vernet as a Child* (c.1818–19, Paris, Louvre), *Portrait of an Inhabitant of the Vendée* (c.1822–3, Paris, Louvre) and storm scenes. The series of ten portraits of the insane, five of which are lost, were perfect clinical models, respectful of the illness; they were produced on the initiative of the psychiatrist Georget: *Monomaniac of Gambling* (1822–3, Paris, Louvre); *Monomaniac of Thieving* (1822–3, Ghent, S-K); *Monomaniac of Envy* (1822–3, Lyon). Géricault treated these portraits with absolute scientific realism. He endowed these people alienated from life with true dignity, without voyeurism or sentimentality.

A painter, engraver and at times a sculptor, Géricault died prematurely. His art opened up new paths in the 19th and 20th centuries for the young Delacroix, *Daumier, *Courbet, *Manet, *Degas, *Cézanne and the painters of French modern art.

196

APPROACH AND STYLE

Géricault was fascinated by horses and made them his favourite subject in the themes he treated: officers, battle scenes, slavery, then work in the fields, horse racing and farriery. He also painted sporting scenes (boxing, trapeze), portraits (children, adults and the insane), landscapes and various important, famous events (murder, shipwreck). His paintings were of various sizes, sometimes vast.

While the French State bought few of his works, his friends (Marceau, Dedreux, the lithographer Charlet, psychiatrist Georget and painter Horace Vernet) collected them.

In Paris, in Vernet's studio, Géricault concentrated on the representation of horses. In the studio of Pierre Narcisse Guérin, academic history painter, at the École des Beaux-Arts, he learnt about the Neoclassical works of *David. Baron Gros inspired him to create new compositions. He copied the old masters at the Louvre in a very personal manner: equestrian portraits by Van Dyck and *Titian, lions by *Rubens, canvases by *Rembrandt and The Flood by *Poussin.

In Italy, in Florence, Rome and Naples, he became familiar with the sculpture of antiquity, the art of the Renaissance and the frescoes of *Michaelangelo and the *Carracci family. He was also fascinated by nature.

In Britain, Géricault was entranced by the English landscape and animal painters, by Constable, Fuseli and others. In Brussels a visit to David revived his admiration for the master's technique and skill at plasticity. Lunatic asylums and morgues fed his taste for scientific realism.

• His passion for horses and contemporary military events inspired Géricault to paint soldiers and battlefields with great expressiveness. The imperial officer displaying the fervour of a victorious hero was conveyed by an enthusiastic, spirited composition and lively brushstrokes, while the anxiety of the wounded officer on the ground, leading his horse down a slope, was emphasized by wide flat tints without relief or drive. There followed a quieter period with Classical landscapes, reminiscent of those by Poussin.

• Géricault maintained his interest in the balance of masses, the accuracy of movement and the linear plastic purity of the academic nude. He transformed topical subjects into large historical compositions (The Raft of the Medusa). The off-centre, diagonal compositions enhanced the effect of the cadaverous nudes, distinguished by a funereal realism. He reduced his palette to earth colours, steeped in the contrast of shadows and light. His preliminary sketches of silhouettes and faces, sometimes unfinished, were striking portraits.

• The new objectivity of the English landscape painters fascinated him; he was particularly interested in the quality of light in Constable's painting. His horse-racing paintings demonstrated that associating speed with Neoclassicism was impossible: the spontaneity of the galloping horse, emphasized by a spirited technique, was incompatible with the 'pure',

A GREAT PAINTER

◆ Famous but controversial during his lifetime, Géricault was also well-known for his lithographs. After his death, his reputation acquired legendary dimensions.

◆ Géricault is either seen as a Neoclassical artist on the basis of his paintings, although far removed from the cold Neoclassicism of David's followers, or as a Romantic because of the modernity of his subjects and their treatment. Accents of realism and outbursts of lyricism completed his syncretic palette.

◆ It is impossible to classify Géricault artistically because he was constantly trying to reconcile his contradictions and deal with his dissatisfaction. The 'acceleration of death' (J Michelet) did not allow him to achieve this. Nevertheless, he was innovative in his choice of subjects. He was the first to paint a boxing match. He was the only painter of his time to depict the breaking-in of horses. He gave news items a historical dimension.

◆ Like the painter Antoine-Jean Gros, he was one of the first French artists to practice lithography.

◆ He often favoured Classical sculptural plasticity and composition at the expense of the subject. The language of chiaroscuro and an elliptical style sought to freeze movement at a particular instant. His canvases, with their treatment and wide brushstrokes, had a sketch-like quality which opened the way to a freer, more 'modern' rendering.

ideal Neoclassical form which froze the gesture, reinforcing this freezing of movement with a composed, calm, smooth, illusionistic finish. Romantic feelings and emotions conflicted with Neoclassical reasoning and heroism.

• The realism of his final monochrome paintings was the result of keen, unprejudiced observation of rural, agricultural, mining or working humanity in distress. The mutilated human fragments and heads of unparalleled cruelty were examples of authentic Romanticism. The studies of the insane, with their apparently cold scientific realism, force the viewer to take notice of these dignified mad figures and recognize their existence.

• Throughout his artistic career, Géricault searched for new plastic expressions to represent his subjects as forcefully as possible. It was, he said, 'this feverish exaltation which upsets and dominates everything, and produces masterpieces'.

Officer of the Chasseurs of the Imperial Guard Commanding a Charge
1812. Oil on canvas, 2.92 x 1.94m, Paris, Musée du Louvre

Still an unknown painter at the time, Géricault astonished everyone when he presented this painting. The accuracy of observation, the fieriness of the rider and the horse and the jerky brushstrokes, more reminiscent of a sketch than of a finished painting, were very innovative at the time. The composition is reminiscent of Gros, the fieriness of Rubens and the light of Rembrandt. The Romantic modernism lay in the choice of the moment that imperial grandeur was wavering in Russia – sublimated in this hero who 'turns round towards us and reflects' (J Michelet). Géricault expressed in paint the doubts of his time, the ruins of the Empire and the awareness of death. The thick brushwork broke with the Classicism of David.

The Raft of the Medusa
1819. Oil on canvas, 4.91 x 7.16m, Paris, Musée du Louvre

The frigate Medusa *sank in 1816. A raft carrying some of the sailors drifted on the high seas for 13 days. Géricault made use of this tragic, contemporary event. He chose to freeze the scene at the moment when hope was rising at the sight of a possible salvation. The deceptively realistic construction of this collection of bodies (the living and the dead in a tangled mass), frozen in this moving moment, symbolizes Romanticism.*

In contrast, the pyramidal composition, academic modelling of the bodies, the relationship between light and shade and the earthy colours are all classical elements (ancient, Renaissance, 17th-century and Davidian). As in the Officer, the historian J Michelet saw in this painting committed to art a symbol of the political shipwreck of France.

KEY WORKS

Géricault produced over 300 painted sketches and paintings, as well as numerous drawings, watercolours, lithographs and a few sculptures.

Officer of the Chasseurs of the Imperial Guard Commanding a Charge, 1812, Paris, Louvre
The Wounded Cuirassier, 1814, Paris, Louvre
The Honourable Artillery Company, c.1814, Munich, NP
Race of Free Horses, 1817, Lille, B-A
The Cattle Market, 1817, Cambridge [Mass.], FAM
Horse Held by Slaves, 1817-8, Rouen, B-A
Landscape with an Aqueduct, between 1817 and 1820, New York, MM
Cart with Wounded Soldiers, 1818, Cambridge [GB], Fitzwilliam Museum
The Raft of the Medusa, 1819, Paris, Louvre
Portrait of an Oriental, 1819-21, Besançon B-A
Derby at Epsom, 1821, Paris, Louvre
The Lime Kiln, 1821-2, Paris, Louvre
Monomaniac of Envy, c.1821-3, Lyon, B-A
Portrait of an Inhabitant of the Vendée, c.1822-3, Paris, Louvre

BIBLIOGRAPHY

Bazin, G, *Théodore Géricault: Etude critique, documents et catalogue raisonné*, 6 vols, La Bibliothèque des Arts, Paris, 1987-94; Eitner, L and Nash, S A, *Géricault, 1791-1824*, exhibition catalogue, Fine Art Museums, San Francisco, CA, 1989; Eitner, L, *Géricault: His Life and Work*, Orbis, London, 1983; Laveissière, S, Chenique, B and Michel, R, *Géricault, exhibition catalogue*, RMN, Paris, 1991

lacroix

Delacroix was a man of his century, charming and cultivated, passionate and rigorous, an art historian and theoretician of colour. He was the acknowledged master of Romanticism and one of the last great decorative painters. The influence of the Classical masters and the Orient is clearly evident in his work. The impetus of his first sketches remained intact in his canvases. His dynamic, lively subjects, compositions and forms reflected his fiery talent as a colourist.

LIFE AND CAREER

● Eugène Delacroix, a French painter (Saint-Maurice, near Charentons 1798–Paris 1863), was the son of V Oeben, a relative of the famous cabinetmakers Riesener, and of C Delacroix, a politician. He joined Pierre Narcisse Guérin's workshop in Paris, then enrolled at the Beaux-Arts whose academicism, far removed from the pictorial innovations introduced by Baron Gros and *Géricault, did not suit his artistic temperament. At first he painted classical and religious compositions such as *The Virgin of the Harvest* (1819, church of Orcemont) and *The Virgin of the Sacred Heart* (1821, Ajaccio Cathedral). *Dante and Virgil in the Inferno*, known as *Dante's Boat* (Paris), the first painting he exhibited at the Salon in 1822, reflected his enthusiasm for *The Raft of the Medusa* (1819) by Géricault. Delacroix began writing his *Journal*, which he continued until 1863. From then on he exhibited regularly at the Salon. Baudelaire was his most ardent defender. The study of *The Orphan Girl at the Cemetery* (1823, Paris) and *The Massacre of Chios* (Salon of 1824, Paris) made him the pioneer of the Romantic movement, in opposition to the artists of Classicism, led by *Ingres.
● Even before his journey to London in 1825, Delacroix admired contemporary English painters including *Constable, whose *Hay Wain* he had seen at the 1824 Salon. He looked for subjects in English literature: to Lord Byron for *The Execution of the Doge Marino Faliero* (1826, London, Wall C), Walter Scott for *The Murder of the Bishop of Liège* (1829, Paris, Louvre) and later William Shakespeare. He painted a few 'real' portraits such as *Baron Schwiter* (1826, London, NG) and a number of imaginary or allegorical oriental portraits including *Mulatto Woman* (1824–6, Montpellier), *Greece on the Ruins of Missolonghi* (1826, Bordeaux) and *Turk Seated on a Sofa Smoking* (1817?, Paris, Louvre).
● At the 1827 Salon he exhibited *The Death of Sardanapalus* (Paris), which marked the peak of Romanticism. The painting was much admired by Charles X who commissioned him to paint *The Death of Charles the Bold* (*The Battle of Nancy*, 1831, Nancy, B-A). He painted *Christ in the Garden of Gethsemane* (1827, Paris, church of St-Paul-St-Louis), *Still Life with Lobster* (1827, Paris, Louvre), and nude works such as *Woman with a Parrot* (1817, Lyon, B-A) and *Study of a Female Nude Reclining on a Divan* (1825–32, Paris, Louvre). The government of the July Monarchy shared in the success of *Liberty Leading the People* (1830, Paris). Delacroix struck up friendships with Stendhal, Mérimée, Dumas, George Sand and Chopin.
● In 1832 Delacroix accompanied Count de Mornay to Morocco. The latter had been sent on a diplomatic mission to Sultan Moulay Abd er-Rahman. During this brief journey Delacroix discovered the beauty of North Africa, which made a lasting impression on him: *Moroccan Military Exercises or Fantasia* (1832, Montpellier), *Women of Algiers in their Apartment* (1834, Paris), *Jewish Wedding in Morocco* (1841, Paris), *The Sultan of Morocco* (1845, Toulouse, B-A), *Arab Buffoons* (1848, Tours), *Turkish Women Bathing* (1854, Hartford, Wadsworth Atheneum), *Moroccan Horseman Crossing a Ford* (1858, Paris, Louvre) and *Arab Camp* (1863, Budapest, SM).
● He was back in Paris in 1833 and was commissioned by Louis-Philippe to decorate the Palais-Bourbon (1833–47, in situ) and the Palais du Luxembourg with decorative and allegorical paintings (1842–6, in situ). In the Galerie des Batailles in the historical museum of the chateau of Versailles he painted *The Battle of Taillebourg* (1837) and *The Entry of the Crusaders into Constantinople* (1841, Paris).
● During the same period he painted *Christ on the Cross* (1835, Vannes mus) and *St Sebastian* (1836, church in Nantua). He painted the portrait of *George Sand* (1838, Copenhagen, OS), *Chopin* (1838, Paris, Louvre) and his *Self-Portrait* (c.1839, Paris, Louvre). He was inspired by literature: *The Death of Ophelia* (1838, Munich, NP), *Hamlet and the Two Gravediggers* (1839, Paris, Louvre), *The Shipwreck of Don Juan* (1840, Paris, Louvre), *The Bride of Abydos* (1843, Paris, Louvre) and *Rebecca* (1846, New York, MM).

- In 1848, the French Republic commissioned him to paint *Apollo Overcoming the Serpent Python* (1848–51, Paris). He decorated a room in Paris's Hôtel de Ville (destroyed, sketches in Paris, Carnavalet). The subjects of Delacroix's paintings were quite varied: *The Puma* (1852?, Paris, Louvre), *Sea from the Heights at Dieppe* (1852, Paris, pr coll), *Portrait of A Bruyas*, a collector of Manet's paintings (1853, Montpellier, Fabre) and *The Pilgrims of Emmaus* (1853, New York, Brooklyn mus).
- Under the Second Empire, at the Universal Exhibition of 1855 the artist was triumphant with 42 paintings. He was made a Commander of the Légion d'honneur and was elected to the Institut de France. He decorated the church of St Sulpice: *Heliodorus Driven from the Temple* and *Jacob Wrestling with the Angel* (1855–61, Paris). He painted *The Lion Hunt* (1855, Bordeaux), *The Rape of Rebecca* (1858, Paris, Louvre), *Arab Horses Fighting in a Stable* (1860, Paris, Louvre), and *Furious Medea* (1862, Paris, Louvre). He painted his last paintings: *The Arab Tax* (or *Arabs Skirmishing in the Mountains*, 1863, Washington), scenes of animals fighting and *Tobias and the Angel* (1863, Winterthur, O Reinhart museums).

Delacroix died of tuberculosis. His *Journal*, his *Correspondence*, articles and his project for a *Dictionary of Fine Arts* were published after his death. His work, which was extensive and varied, foreshadowed the Impressionists and the Fauves, but also *Courbet, *Cézanne, Signac and modern painting.

APPROACH AND STYLE

A painter of religious, mythological, literary and historical subjects, Delacroix remained faithful to the genre scene, landscape painting, seascape, still life, fighting animal and portrait painting. The Orient, at first merely imagined, then observed in 1832, was an important source of inspiration.

The public commissions carried out for Charles X, Louis-Philippe, Thiers, Napoleon II and others developed into gigantic frescoes. His easel paintings in oil, watercolours and gouache pictures of all sizes, were bought by collectors and dealers.

Delacroix learnt his art in the studio of the Neoclassical painter Pierre Narcisse Guérin. Although he admired the Classical artists (*Raphael, *Poussin), his masters remained the Colourists, *Titian, *Veronese and *Rubens. He was influenced by the early Romantics, Géricault and Gros, and the British watercolourist and painter Richard Parkes Bonington. In London he discovered Constable, *Turner and Reynolds, and English Romantic literature, which he preferred to the epic Romanticism of Lamartine and Hugo.

- A Classical artist in training and conviction, Delacroix at first painted nude figures and copied ancient masters.
- Those of his paintings which were not specially commissioned were particularly striking, with their dramatic choice of subject, political meaning (*The Massacre of Chios* coincided

A GREAT PAINTER

◆ Delacroix became famous when he exhibited at the Salon in 1822. All the movements of modern art claim some connection with him. His canvases, rather than his vast decorative schemes, won the admiration of the public.
◆ Breaking with academism and Neoclassicism, Delacroix advocated a 'Classicism of reality', Romanticism of the subject and the free translation of his personal impressions.
◆ 'Everything is the subject; the subject is yourself: your impressions, your emotions when faced with nature', Delacroix declared; contemporary history and spirited animals become Romantic subjects. The eclectic nature of his literary, visual and imaginary sources complicates the understanding of his work (*Liberty Leading the People*).
◆ The rigour of his classical composition and drawing balances the vehemence of the colours. With perfect mastery, Delacroix avoided, as he put it, 'this infernal commodity which is the brush' and its lapses. The thick impasto whose colours were nevertheless well-mixed, gave his painting the appearance of a sketch. The hachured or tachist strokes created a pre-Impressionist visual blend.
◆ After important preparatory work (drawings and sketches), Delacroix painted without stopping. His rational, analytical use of colour, which he divided into pure shades, was innovative. His earthy shades incorporated bitumen (which has been detrimental to the preservation of colours). Their brilliance of his paintings was enhanced by the use of rich varnishes (after 1825).

ith the mood of philhellenism) and sincere execution within a classical composition. Even when Delacroix painted morbid scenes, he was strongly averse to pathos.

• Between 1825 and 1830, Delacroix moved away from the systematic rigour of classical composition and interpreted his subjects with emotion in a free, sometimes sketchy style. He was influenced by the English aesthetic of Bonington and Constable with its delicate atmospheric unity and finely shimmering colour. From the great Venetian colourists Titian and Veronese and the Flemish artist Rubens he absorbed his enthusiasm for colour and movement while always being respectful of the drawing (*The Death of Sardanapalus*).

• The turning point in his career came in 1832 when he travelled to Morocco: '[The] living sublime runs here through the streets and ... assassinates you with its reality. ... At each step there are ready-made paintings.... You would think yourself in Rome or Athens', he wrote. He was fascinated by the Orient with its multicoloured patterns and its sunlight.

• The great decorative paintings of his mature period diverged from the epic ideal of French Romanticism, being composed with a clear arrangement in the Classical tradition. The way he adapted to architecture, grandiose subjects and style, the extraordinary power of his colours which compensated for the dim light, his idealistic overall view and the realistic accuracy of his details revealed his brilliant pictorial talent and rigorous aesthetic approach.

• Towards the end of his career he returned to classical compositions in his easel paintings while his treatment, still free and spontaneous, was adapted to the subject and the feelings of the painter.

The Death of Sardanapalus
1827. Oil on canvas, 3.95 x 4.95m, Paris, Musée du Louvre

This tragic composition, inspired by a dramatic story by Byron, was explained in the 1827 Salon's catalogue: 'The insurrectionists are besieging him in his palace ... Lying on a magnificent bed on top of an enormous stake, Sardanapalus orders his eunuchs and the officers of the palace to cut the throat of his women, his pages and even his horses and favourite dogs. None of the things which ever gave him pleasure should survive him ... Baleah, Sardanapalus' cupbearer, finally sets light to the stake and then falls on it himself.'

*This painting breaks all the academic rules of perspective and the readability of the forms and colours. 'The first rules of art seem to have been deliberately violated', said Delécluze, a follower of *David. Indeed, Delacroix has depicted the dramatic commotion and bloody panic. The highly charged emotional content is translated pictorially by using the edges of the canvas to cut off the scene, the display and piling up of the bodies and the riches, arranged in the shape of pyramid of colours which topples towards the spectator. The warmth of the colours sets the composition ablaze while the bodies and objects are defined by controlled brushstrokes.*

Arab Horses Fighting in a Stable
1860. Oil on canvas, 64.4 x 81cm, Paris, Musée du Louvre

Delacroix has expressed the excitement of the action, the shouting of the men and the sound of the hooves. Previously quiet, the stable has suddenly becomes a hive of bustling activity. Delacroix delved into the memories of his Moroccan voyage: 'I saw there all the most fantastic things that Gros and Rubens could have imagined', he wrote. The frantic agitation and intense emotion have been conveyed through a lively, rhythmic plasticity and a dynamic, sketch-like treatment which reinforce the power of the participants' postures and gestures.

KEY WORKS

Delacroix's works included frescoes, canvases, painted sketches, watercolours, sketches, engravings and lithographs. He produced about 853 paintings as well as thousands of drawings, pastels and wash drawings.

Dante and Virgil in the Inferno, 1822, Paris, Louvre
The Massacre of Chios, 1824, Paris, Louvre
The Orphan in the Cemetery, 1823, Paris, Louvre
Mulatto Woman, 1824–6, Montpellier, Fabre
Greece on the Ruins of Missolonghi, 1826, Bordeaux, B-A
The Death of Sardanapalus, 1827, Paris, Louvre
Liberty Leading the People, 1830, Paris, Louvre
Military Exercises of Moroccans or Fantasia, 1832, Montpellier, Fabre
Women of Algiers in their Apartment, 1834, Paris, Louvre
Chopin, 1838, Paris, Louvre
Self-Portrait, c.1839, Paris, Louvre
The Capture of Constantinople by the Crusaders, 1841, Paris, Louvre
Arab Buffoons, 1848, Tours, B-A
Apollo Overcoming the Serpent Python, 1848–51, Galerie d'Apollon, Paris, Louvre
The Lion Hunt, 1855, Bordeaux, B-A
Jacob Wrestling with the Angel, 1855–61, Paris, church of Saint-Sulpice
Arab Horses Fighting in a Stable, 1860, Paris, Louvre
The Arab Tax or *Arabs Skirmishing in the Mountains*, 1863, Washington, NG

BIBLIOGRAPHY

Johnson, L, *Delacroix*, Weidenfeld and Nicolson, London, 1963 [best short account]; Johnson, L, *The Paintings of Eugene Delacroix: A Critical Catalogue*, 6 vols, Oxford University Press, Oxford, 1981-9; Joubin, A (ed), *Journal d'Eugene Delacroix*, 3 vols, Paris 1932, revised 1981, translated and edited by W Pach, London, 1938; Trapp, F A, *The Attainment of Delacroix*, Johns Hopkins Press, Baltimore, MD and London, 1971; Wilson-Smith, T, *Delacroix: A Life*, Constable, London, 1992

Daumier

Daumier was a fervent republican and a keen observer of the mores and society of his time. He is mainly known for his caricatures, although his passion was painting. Sensitive, spontaneous, intuitive and empiric, he painted the lower classes with compassion and tenderness but lambasted the bourgeoisie with fairness and realism. His variations on a single theme reveal a strong, unusual plasticity, varied, dark, rich in impasto, sometimes heightened with coloured touches. This treatment, often perceived as unfinished, is very expressive and surprisingly modern.

LIFE AND CAREER

• Honoré Daumier (Marseilles 1808–Valmondois 1879), French artist, was the son of a picture framer and decorative painter who was tempted to follow a writing career in Paris. In order to help his father with his financial problems, Daumier started working for lithographers when still quite young and showed great talent for drawing at an early age. In 1821 he studied with A Lenoir, a former pupil of *David and founder of the Musée des Monuments français, then taught himself at the Louvre and the Académie Suisse which he attended between 1823 and 1828.

• Daumier had a tumultuous career as a noted political caricaturist, under the guidance of the polemicist Philipon, founder of the satirical journals *Caricature* in 1830, *Charivari* in 1832 and the *Association mensuelle* in 1834. The artist produced drawings, lithographs (*La Rue Transmonain*, 1834; *The Legislative Belly* in 1834) and modelled busts in clay. He captured the politicians and mores of his time with unparalleled acuteness. His painting (whose chronology is uncertain) was already very personal: *Aquafortist* (c.1836, Paris, pr coll); *Workmen in the Street* (c.1839, Cardiff); *Somnambulists* (c.1847, Cardiff); *The Singing Couple* (c.1847, Amsterdam, Rm); *Bathers* (c.1847, Glasgow, AG); and *Two Lawyers* (c.1848, Lyon). The sidelining of his work at the Salon exhibitions reinforced his anti-establishment attitude towards the academic jury.

• The 1848 Revolution, the Third Republic and his friends coming into power contributed to the development and acknowledgement of his painting. The project of his sketch-painting, *The Republic* (1848, Paris), short-listed by judges favourable to the provisional government, failed to win but Daumier now began to exhibit at the Salon: *The Miller, his Son and the Donkey* (1849, Glasgow); *Don Quixote Going to the Wedding of Gamache* (c.1850, Boston, Pine coll). His painting activity increased: *The Fugitives* (c.1849, Minneapolis); *We Want Barabbas* (*Ecce Homo*, c.1850, Essen, Folkwang mus); *The Burden* (c.1850, Prague, NG); *The Waiting Room* (c.1851, Buffalo [NY]); and *The Fugitives* (1852–5, Winterthur, O Reinhart mus).

• In 1853 he made friends with the painters of the Barbizon school (Millet, T Rousseau) and Corot who, besides landscapes, were also interested in everyday life like him. Daumier produced *The Print Collectors* (1853–5, Algiers) and *The Print Collector* (c.1860, Philadelphia and Paris), *Three Lawyers Conversing* (c.1856, Washington), the colourful atmosphere of *The Return from Market* (c.1856, Winterthur, O Reinhart mus).

• Literature and the theatre were also a source of inspiration, such as the fables of La Fontaine *The Thieves and the Ass* (c.1858, Paris, Louvre), *The Drama* (c.1859, Munich), *Crispin and Scapin* (c.1858–60, Paris), *Don Quixote* alone or with *Sancho Panza* (from 1849 to 1873, Munich, AP; Melbourne, NGV; New York, MM; Paris, Orsay, etc). *The Hypochondriac* (1862–3, Merion [Penn.], BF) was also inspired by literature. The following works, *Third-Class Carriage* (c.1862–4, New York; Cardiff, NM of Wales), *The Wait at the Station* (c.1863, Lyon, B-A), *The Laundress* (1863, Paris) and *Chess Players* (c.1863, Paris, PP) exude a feeling of intense suffering. His final works, *Pierrot Playing the Mandolin* (c.1873, Winterthur, O Reinhart mus) and *Woman Carrying a Child* (1873, Zurich), reflected the modernity of his pictorial treatment. Struck with blindness, Daumier found it hard to make a living, in spite of Corot's help, and eventually died from an apoplectic fit.

An all-round artist, draughtsman, lithographer and model-maker, he did not succeed in shaking off his image as a caricaturist and becoming recognized as a painter, except by the poets and critics Charles Baudelaire and T de Banville. His work was greatly admired by the

Romantics such as *Delacroix and Préault and the Barbizon painters. Daumier influenced the generation of *Manet, *Degas, *Monet, *Toulouse-Lautrec, *Van Gogh, the Fauves, German Expressionists, Soutine, *Picasso and others.

APPROACH AND STYLE

Daumier developed a limited number of themes. His desire to portray daily life drove him to paint numerous street and railway scenes, the hard work of the 'noble' professions (lawyers in particular), performing artists (street acrobats, painters and musicians), print collectors, theatre scenes (*Don Quixote, The Hypochondriac*, the fables of La Fontaine), and also some religious and mythological subjects.

He painted on wood or canvas and his pictures were small or medium-sized. He received few public commissions. His main customers were his friends who sometimes commissioned work from him.

Introduced to painting by the Neoclassicist A Lenoir, Daumier later turned to the sculpture of antiquity and the art of *Titian. He admired *Rembrandt's luminous contrasts and the dynamic movement in *Rubens's art. He was inspired by Spanish tenebrism and the balanced composition and *figures de fantaisie* of *Fragonard.

• Daumier's artistic career did not develop according to a definite plan. He started as a political caricaturist, revealing himself as an expressive, moving, imaginative artist before he turned to painting and engraving.

• His modest situation, his intuitive perception of Paris society, his sense of realism, supported by a 'wonderful, almost divine, memory which served him as a model' (Baudelaire) and a fertile imagination, led him to portray many facets of human life, sometimes inspired by literature. The universal dimension of hard work and the poverty of the lower classes impinged on Daumier's works. He treated these subjects simply, without sentimentality or declamatory effect. The composition was sober and the expression sincere.

• According to P Georgel, there was 'nothing more deceptive than his realism. In his case, observation goes hand in hand with dreams; in the depths of his memory, myth and reality are one' (1972). For R Fohr (1999), Daumier's internalized realism was 'supported by an unstable craft, in constant evolution but characterized by unusual frankness: a thick, smooth finish, sometimes applied lightly with the brush, sometimes impetuously 'tasselled' or triturated, dense, warm colours, with earthy and ochre shades, while the light colours were enhanced with subtle, sparkling flashes, a chiaroscuro...' Daumier opposed volumes to each other, created artificial luminous contrasts and dared to present his work intentionally unfinished, which was unacceptable for painting at the time but is today considered modern: 'I begin everything 25 times; at the end, I do it all in two days.'

• The style of his paintings was similar to that of his lithographs, with a graphic quality, the modulation of the whites and blacks being turned in his oil paintings into browns and ochres, worthy of Rembrandt's chiaroscuro (*We Want Barabbas*) – sometimes enhanced by patches of colour, red, blue, green or yellow. Unusual precision in the modelling might accompany sketched, outlined forms reminiscent of Rubens (*The Fugitives*), the glimpse of a silhouette or a lost profile. He moulded his figures in clay before drawing or painting

A GREAT PAINTER

◆ Badly received by the general public and the world of art in his own time, with the exceptions of Delacroix, Corot and Millet, Daumier was not as successful as he deserved to be. He remained misunderstood and unknown.

◆ Described as a realist and visionary because of his sculptural approach, Daumier was an unusual artist who foreshadowed modern art in his rejection of the conventions of his time.

◆ He chose his subjects from real life (figures such as lawyers and art collectors and scenes from the everyday life of ordinary people) and treated them in a variety of ways. His satires sublimated grotesque and tragic themes.

◆ His pictorial approach, marked by a great plastic vigour, varied and quick, was adapted to suit each work. Looking back, his 'unfinished' touch may be described ˷s Impressionist, and his powerful treatment and use of close-up as ˷ressionist.

em. Sometimes he squared up his figures, sketched out masses, applied impasto and high-
.ghts, and drew or created at random. A master of his art, Daumier easily moved from one
technique to another.
- His orderly arrangements and his sometimes frieze-like compositions, simple and well-
structured, reveal a certain 'Classicism' (*Passers By, Third-Class Carriage*).
- Works marked by an absolute spontaneity and revealing Fragonard's influence (*Pierrot
Playing the Mandolin*) contrasted with other expressive pictures in which the faces and
deformed bodies were outlined in black, filling the foreground and addressing the viewer
directly (*Hypochondriac*).

The Laundress
1863. Oil on canvas, 49 x 33.5cm, Paris, Musée d'Orsay

*Daumier depicted the common people of Paris working along the banks of the Seine during the Second
Empire. He raised the figure of this massive, solitary, anonymous, ordinary woman, endowed with a
certain nobility, to the rank of symbol of the working class. The artist revealed the tediousness of the
woman's everyday life and noted the social injustice which forced the lower classes to live parallel lives
with the bourgeoisie, as symbolized by arrogant lawyers with their corrupt morals, and print collectors
who only cared about discovering a rare and beautiful picture. These were the themes which inspired him
throughout his career. The smooth, well-blended execution of this picture makes the volumes compact
while emphasizing the contrasts of the chiaroscuro and refining the colours.*

Don Quixote and Sancho Panza
c.1868. Oil on canvas, 52 x 32.6cm,
Munich, Neue Pinakothek

*For over 20 years Daumier
experimented with the theme of
Cervantes' heroic knight and his
faithful equerry (29 paintings, 41
drawings). In this painting, the form
of Don Quixote, riding his horse
Rosinante, fills up the main space,
while the faithful Sancho Panza
follows slowly in the distance,
grumbling. The faceless rider conveys
his haughty bearing to the viewer.
Sancho Panza merges with the rocky
landscape in the intense light and is
lost in the arid, clay-covered natural
landscape, dominated by a dazzlingly
blue sky. The spareness of the
composition is eminently modern. The
economical use of forms and colours
reinforces the contrast between the
sickly horse and his master, full of
confidence but just as scrawny,
between the curve of the horizon and
the straightness of the spear. The
broad, dry brushstrokes are in
harmony with a graphic style
reminiscent of Giacometti.*

KEY WORKS

Workmen in the Street, c.1839, Cardiff, NM of Wales
Two Lawyers, c.1848, Lyon, B-A
The Republic, 1848, Paris, Orsay
The Miller, his Son and the Donkey, 1849, Glasgow, AG
The Fugitives, c.1849, Minneapolis
The Waiting Room, c.1851, Buffalo [NY], Albright-Knox AG
The Print Collectors, 1853–5, Algiers, B-A
Three Lawyers Conversing, c.1856, Washington, Phillips coll
Passers By, c.1858, Lyon, B-A
The Thieves and the Ass, c.1858, Paris, Louvre
Man on a Rope, c.1850–60, Boston, MFA
The Drama, c.1859, Munich
Crispin and Scapin, c.1858–60, Paris
The Print Collector, c.1860, Philadelphia, MA and Paris, PP
The Laundress, 1863, Paris, Orsay
Three Collectors, c.1865, Paris, PP
Don Quixote Reading, c.1866, Melbourne, NGV
The Pardon, c.1866, Rotterdam, BVB
Don Quixote and Sanzo Panza, c.1868, Munich, NP
Lawyer Reading, c.1869, Winterthur, Bühler coll
Woman Carrying a Child, 1873, Zurich, E. G. Bührle foundation

BIBLIOGRAPHY

Ives, C, Stuffman, M and Sonnabend, M et al, *Daumier Drawings*, exhibition catalogue, Metropolitan Museum of Art, New York, 1992; Larkin, O W, *Daumier: Man of his Time*, Weidenfeld and Nicolson, London, 1967; Maison, K E, *Honoré Daumier: catalogue raisonné of the paintings*, watercolours and drawings, 2 vols, Thames and Hudson, London, 1968; Vincent, H P, *Daumier and his World*, Northwestern University Press, Evanston, IL, 1968

Courbet

Imposing and sensitive, eager for fame but generous, friendly and fun-loving, wholeheartedly devoted to his choices, a republican and socialist, Courbet was the great innovator of realism, of 'truth' in painting. The accuracy of his drawing, his command of muted colours, the confidence of his brush and his knife, the accuracy of his observation of objects and people and his almost metaphysical reflections on the mystery of life make him a great artist.

LIFE AND CAREER

• Gustave Courbet (Ornans 1819–Switzerland 1877), a French painter, was born into a prosperous farming family. After a brief training as a Neoclassical artist in Besançon, he went to Paris in 1839. He enrolled at the Steuben workshop, the Swiss Academy and worked hard at the Louvre.

• Courbet started painting in 1836. His first work accepted at the Salon (where he rarely exhibited until 1870 because of successive rejections) was a self-portrait: *Self-Portrait with a Black Dog* (1842, Paris). He was a prolific painter: *The Desperate Man* (1843, Paris, pr coll); *Lovers in the Countryside* (1844, Lyon, B-A); *The Wounded Man* (1844, Paris, Orsay); *Man with the Leather Belt* (1845, Paris, Orsay); *The Cellist* (1847, Stockholm, Nm), painted the year his illegitimate son was born; and *Portrait of the Artist* (1849?, Montpellier). He painted several portraits including one of his sister *Juliette Courbet* (1844, Paris, PP) and *Portrait of Baudelaire* (1847, Montpellier, Fabre).

• In 1846 he became interested in realism, portraying subjects of everyday life in a brisk, smooth style: *After Dinner at Ornans* (1848, Lille, B-A) and the very large *Burial at Ornans* (1850, Paris). The artist then painted *The Peasants of Flagey Returning from the Fair* (1850, Besançon); *Firemen Going to a Fire* (1850, Paris, PP), a new version of *The Night Watch* by *Rembrandt; *Girls of the Village* (1852, New York, MM); *Women Bathing* (1853, Montpellier) which all created scandal, and *The Wheat Sifters* (1854, Nantes). Courbet took part in the Revolution of 1848, producing the frontispiece for the magazine *Le Salut public* ('Public Safety'); he struck up a friendship with *Daumier, Corot and F Bonvin, the writers Baudelaire, and Champfleury and the socialist Pierre Proudhon. After the coup d'état of 2 December 1851 he opposed the rule of Napoleon.

• In 1854 Courbet was famous as far as Vienna and Berlin. In Montpellier he painted the collector Bruyas in *Bonjour Monsieur Courbet!*, also known as *The Meeting* (1854, Montpellier). In 1855 he created *The Painter's Studio*, also known as *A Real Allegory* (Paris), published his *Manifesto of Realism* and organized the 'Exhibition of 40 Paintings': this first exhibition of the work of a living artist was presented in the grounds of the Universal Exhibition of 1855.

• In the 1860s and 1870s he explored a new, more sensual artistic approach: *Young Women on the Banks of the Seine* (1856, Paris); *The Rest during the Harvest Season* (1866, Paris, Orsay) and *The Origin of the World* (1866, Paris, Orsay); and *Woman with a Parrot* (1866, New York, MM). He excelled in all genres: the portrait with *Bruyas* (1853, Montpellier, Fabre); *Woman in a Black Hat* (1863, Cleveland, MA), *Portrait of Jo* (1866, New York, MM) and the famous *Portrait of Pierre Joseph Proudhon in 1853* (1865, Paris, PP); *figures de fantaisie* such as *The Trellis* (1863, Toledo, MA); the still life *Basket of Flowers* (1863, Glasgow, AG); landscapes on their own and with animals: *The Quarry* (1857, MFA); *Stag Taking to the Water* (1861, Marseille, B-A); *The Source of the Loue* (1864, Hamburg); *Cliffs at Étretat* (1866, Ottawa, NG); *A Thicket of Deer ...* (1866, Paris); *Woman in the Waves* (1868, New York); and *Stormy Sea* (1870, Paris).

• In 1870 the Franco-Russian war broke out. Courbet, at the peak of his fame, refused the Légion d'honneur. In 1871 he joined his Paris friends involved in the Commune. Elected chairman of the Commission des Arts, he rescued works of art and reorganized museums. The Third Republic accused him of having taken part in the destruction of the column in the Place Vendôme. He was tried, condemned, imprisoned and ruined as a result. Very upset and much weakened, he painted his last paintings: *Still Life with Apples and Pomegranates in a Bowl* (1869, London); *Still Life with Three Trout from the Loue River* (1872, Bern, K);

Self-Portrait at Ste Pélagie (1874, Ornans) and *The Château de Chillon* (1874, Ornans). These pictures reflected the impact his detention had on him. His last painting, unfinished, was *Panoramic View of the Alps, la Dent du Midi* (1877, Cleveland). He died in exile in Switzerland.

Courbet discussed the subject of light with his contemporaries Corot and Whistler, the Barbizon painters, Eugène Boudin and Johan Barthold Jongkind. *Manet, *Degas and P Puvis de Chavannes were inspired by him. He also influenced artists outside France such as the Russian Repin, the Belgian J Stevens and the German Otto Müller. He also inspired artists of the 20th century such as Soutine, *Matisse, *Picasso and Balthus.

APPROACH AND STYLE

The themes developed by Courbet were varied: few historical subjects, still lifes, portraits, self-portraits, *figures de fantaisie*, genre scenes, work scenes and the landscapes of Franche-Comté. His paintings were all oil paintings, ranging from small to huge.

His customers were clerical (Saules church), town councils (Lille, Nantes and others), public figures (the Turk Khalil Bey, the Dutch collector and art dealer H J Visselingh, the Comtes de Morny and de Choiseul), patrons (Bruyas, E Baudry) and friends (such as Hetzel, Castagnary and Ordinaire).

Courbet taught himself at the Louvre by copying the Venetian painters *Veronese and *Titian. He admired the Spanish painters *Velázquez, F Zurbarán and J de Ribera and was inspired by the Dutch painters, especially *Hals and *Rembrandt. He was familiar with the art of *Ingres and further developed the art of Gros and *Géricault. He travelled throughout France (Franche-Comté, his native region, Fontainebleau and Le Havre) and also to the Low Countries and Germany.

'I studied the art of the ancient and modern artists, espousing no system and without prejudice', Courbet declared. 'I drew the analytical, independent approach of my own individuality from the global knowledge of tradition.' In 1861 he agreed to teach about 30 pupils. He advocated a simple, objective, varied vision of contemporary everyday life, accessible to all, captured and portrayed from life.

• Originally Courbet was interested in all subjects and painted many portraits of friends as well as self-portraits in which he posed in several roles, thereby revealing a certain narcissism. He expressed a poetic, sometimes premonitory, fiction of his future life (*The Desperate*

A GREAT PAINTER

◆ During his lifetime Courbet's success was linked to the violent reaction of official art which considered his art 'vulgar and scandalous'. Although his friends and critics admired his work, his artistic merits were not recognized by the public. His artistic talents were re-established in the public esteem in the 20th century. 'The excellence of his technique alone has had such great influence that it would not be an exaggeration to say that modern painting would be different if Courbet's art had not existed', wrote André Breton (1935).

◆ A socialist and a passionate defender of the Republic in the world of politics, he revealed himself as a revolutionary and pioneer of social realism in painting. Nonetheless, he was one of the last Romantics in the tradition of Gros, Géricault and *Delacroix.

◆ Opposed to any formal, imposed training, Courbet believed more in individual talent and work than in theory. Having freed himself, like Géricault, from the constraints of tradition by claiming freedom in art, he was the first artist to organize an exhibition of his own work in reaction to the institutional Salon.

◆ Courbet chose his subjects and characters from everyday reality: peasants, a burial, firemen, stone-breakers and so on. But in transgressing the hierarchy of genres, he successfully transcended his subject by transforming it into a social allegory, treated like a history painting, on a large scale.

◆ Courbet painted the 'real' without concession to the picturesque and used sombre colours without technical brilliance which led the official critics to call his paintings ugly.

◆ His rigorous brush, paintbrush and knife technique was the result of hesitations, *pentimenti*, reworking and continuous research.

COURBET

Man, The Wounded Man) with Romantic lyricism. He was influenced by the realist, sombre art of Zurbarán (*Man with a Pipe*), the crude, sensitive portraits of Velázquez and the arabesques and light colours of Ingres (*Juliette Courbet*).

- In 1846 Courbet became interested in the Dutch painters Rembrandt and Hals because of the realism of their portraits of guilds and their self-portraits using a rich technique.
- In about 1848 he became artistically mature (*After Dinner at Ornans, Burial at Ornans*), abandoning Romanticism and developing his ideal of popular realism, portraying the 'real', the prosaic and the insignificant. He displayed great plastic energy, full of sombre, austere shades, effects of contrasts, technically pleasing but not flashy, and with lively, contemporary subjects. His male and female nudes of 1853 (*Women Bathing, The Wrestlers*, Budapest, SM) were presented like a realist manifesto for the human body. He replaced the Romantic impetus of Gros and Géricault with the calm and reality of everyday life.
- After 1855, Courbet's art reached its peak. He painted what he saw freely, relying on his sensitivity. Thus modern art was born, founded on visual sensation. He abandoned country themes and his art developed: his drawing became expressive through simplification and stylization, he introduced muted colours in the Venetian manner of Titian and Veronese but retained the thick, dark shadows, created by blending earthy colours. He softened his style by using more liquid paint and introduced glaze (*Young Women on the Bank of the Seine, Portrait of Pierre Joseph Proudhon*). Throughout his career he alternated pleasing subjects (such as landscapes and women) with 'committed' themes (moralizing or political). According to Champfleury, his paintings were full of symbolism after his imprisonment (*Woman in the Waves*). During the last years of his life his paintings varied in quality.

Burial at Ornans
1850. Oil on canvas, 315 x 668cm, Paris, Musée d'Orsay

This painting caused a scandal at the 1850 Salon. The critics and even his friends thought the characters 'vulgar' and 'ugly'. In this painting Courbet declared his 'realist position, that is to say a loyal friend of true reality'. He sought to reveal the beauty and heroism which exist at the heart of everyday life. He touched the social, religious and aesthetic foundations of society.

He was bold enough to portray the middle classes and peasants in the same painting. He offended the Church by rejecting the traditional representations of the saints, heaven, paradise and hell, keeping only the cross. Courbet also snubbed the academic order of art by choosing a gigantic format, usually reserved for history painting, and applying it to this genre scene. The artist defied 'ideal beauty' and signed the 'burial of Romanticism'. 'Realism is the negation of the ideal', he declared in 1861; it is 'democratic art'. He invited the viewer to enter into the subject. The style is concrete, 'naïve' in Baudelaire's sense; it is modern in the expressive black outline of the faces, the contrasting tones, the dark, brown colour which predominates and the lively technique.

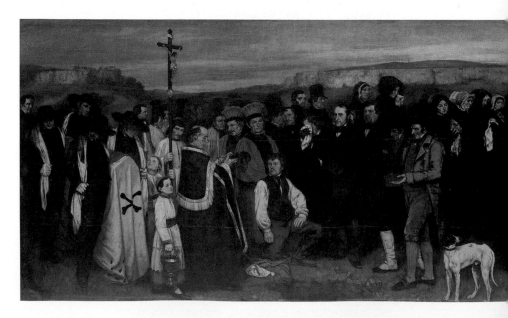

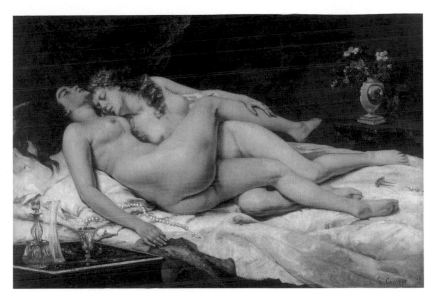

Sleep, also known as **Sleeping Women**
1866. Oil on canvas, 1.35 x 2m, Paris, Musée du Petit Palais

A rich Oriental, the Turk Khalil-Bey, commissioned two paintings from Courbet: this one and The Origin of the World (1866, Paris, Orsay). The two characters, two nudes from a seraglio, are erotic and voluptuous. rivalling the Venuses and Danaes of the Venetians. This sumptuous painting is more allegorical than prosaic, yet it is dominated by a feeling of sensuality. Courbet excelled in the refinement of the setting, the delicate tones of the still life, the symbolism of the broken pearl necklace, a sign of the sin, and the chalice, an object of repentance.

KEY WORKS

Self-Portrait with a Black Dog, 1842, Paris
Portrait of the Artist, known as *The Man with a Pipe*, 1849?, Montpellier
A Burial at Ornans, 1850, Paris
The Peasants of Flagey Returning from the Fair, 1850, Besançon
Women Bathing, 1853, Montpellier
The Wheat Sifter, 1854, Nantes
Bonjour Monsieur Courbet!, also known as *The Meeting*, 1854, Montpellier, Fabre
The Painter's Studio: A Real Allegory, Paris, Orsay
Young Women on the Banks of the Seine, 1856, Paris, PP
The Source of the Loue, 1864, Hamburg, K
Portrait of Pierre Joseph Proudhon in 1853, 1865, Paris, PP
Sleep, also called *Sleeping Women*, 1856, Paris, PP
A Thicket of Deer at the Stream of Plaisir-Fontaine, 1866, Paris, Orsay
Woman in the Waves, 1868, New York, MM
The Source, 1868, Paris, Orsay
Still Life with Apples and Pomegranates in a Bowl, 1869, London
Stormy Sea, 1870, Paris
Self-Portrait at Ste Pélagie, 1874, Ornans, Musée Courbet
Panoramic View of the Alps, la Dent du Midi,1877, Cleveland, MA

BIBLIOGRAPHY
Callen, A, *Courbet*, Jupiter Books, London, 1980; Clark, T J, *Image of the people: Gustave Courbet and the 1848 Revolution*, 2nd edn, Thames and Hudson, London, 1982; Fried, M, *Courbet's Realism*, University of Chicago Press, Chicago, IL and London, 1990; Lindsay, R, *Gustave Courbet: His Life and Art*, Jupiter Books, London, 1979; Nochlin, L, *Gustave Courbet: A Study in Style and Society*, New York University, New York, 1963; ten-Doesschate Chu, P (ed), *Courbet in Perspective*, Prentice-Hall, Englewood Cliffs, NJ, 1977

REALISM, IMPRESSIONISM, POST-IMPRESSIONISM, SYMBOLISM AND ART NOUVEAU (1849–1904)

The discoveries of the second half of the 19th century brought about the division of knowledge; philosophy became independent from physics and chemistry. These advances had applications in industry but also in art.

In France this period opened with the Revolution of 1848. *Courbet took an active part in this and created the frontispiece of the magazine *Le salut public* ('Public Safety'). The leader of realism, he upset the conventions of bourgeois society as did *Daumier. Academicism, which existed in every country, was rejected: *Manet, the mentor of modernism, encouraged the Impressionists including *Monet, Renoir and others, and the loners *Degas and *Cézanne. Japonisme influenced many artists in the 1860s and even more who opened other aesthetic directions in the 1870s and 1880s: the post-Impressionists *Van Gogh, *Toulouse-Lautrec, then the Neo-Impressionists *Seurat and the Symbolist Primitivist *Gauguin.

The French painters were no longer satisfied with Paris as a place to work but settled themselves in Barbizon (near the forest of Fontainebleau), on the Normandy coast (Honfleur, Étretat and so on), in Brittany (Pont-Aven, Le Pouldu) and in the south of France (Antibes, Cagnes-sur-Mer, Arles and St Tropez in particular).

The development of science and technology

The great discoveries. In 1859, Charles Darwin published *The Origin of Species through Natural Selection*, the first scientific theory of the evolution of species. It destroyed the idea of man created by God in his own image, on which humanism was based. Distorted and extended to the social field, Darwin's work was used to advocate racial elitism. In medicine, Pasteur invented preventive vaccination and the process of pasteurization, and he declared that spontaneous generation did not exist (1860–4), while Claude Bernard created an experimental method of investigation. The Austrian botanist Mendel threw light on the laws of heredity and founded genetics (1865). The French physiologist Marey studied the circulatory functions in the human body, then movement using chronophotography (1882). In 1890 Branly, another Frenchman, invented the 'coherer' with iron filings which made it possible to receive telegraph signals without wires, the prelude to radio broadcasting. Steam vehicles (1891) were succeeded by cars with internal combustion engines (1894). The Automobile Club of France (1895) supported the first automobile Salon (Paris, 1901). Louis Lumière invented the cinematograph (1895). The same year, the German Röntgen discovered X-rays. The Austrian Freud published *The Interpretation of Dreams* (1900).

The 'possible and desirable marriage between science and art'. In accordance with this wish expressed by Pasteur in 1860, the first attempts were made at co-operation between physical sciences and the arts since the end of the 18th century. The physicist Charles studied the effects of light on varnishes while the researches into ultraviolet and infrared light by A L Bayle were used in the study of drawings and paintings. To the question asked by Arago in 1839, 'could photography serve the arts?', the Classical painter Delaroche responded in the affirmative, as did the critic and poet Baudelaire. Niepce and Daguerre first used their inventions to reproduce works of art before they attempted landscapes and portraits. *Delacroix, Degas and Bonnard made use of photography before painting: photographs of nudes, the world of the dance or scenes from life and horses in movement by Muybridge. The photographic portrait became naturally coloured thanks to Ducos de Hauron (1869). The applications of science to art became widespread at the end of the 19th century. X-rays enabled the first X-ray photographs of paintings to be taken (1888). The analysis of movement which Marey published in *Chronophotographies d'un homme en mouvement* ('Chronophotographs of a man moving', 1894, Paris, Bibliothèque Nationale) would have found an echo with the Futurists, who were enthusiastic about the automobile and speed, and then with *Duchamp.

The artists had been accustomed to making use of empirical chemistry. Henceforth, the scientists intervened. The information contained in *La Chimie appliquée aux arts* ('Chemistry applied to the arts', 1818) by Chaptal enabled industry to produce numerous dyes and stains by the end of the century. In 1810, Goethe had put forward his *Theory of Colours*, thoughts on colour and light with which the Romantic painter *Friedrich and the Nazarene Overbeck were familiar. In 1839 Chevreul demonstrated in *De la loi du contraste simultané des couleurs ...* ('On the law of simultaneous contrast of colours ...'), that 'putting a colour on a canvas ... it is coloured by the complementary colour of surrounding space'. This perception and the *Introduction à une esthétique scientifique* ('Introduction to a scientific aesthetic') by Henry (1886) were of great interest to the colourists Van Gogh and Seurat.

A world in total reconstruction

Political, economic and social changes. The development of industrialization and commercial and financial markets affected every country: Great Britain was in first place, Germany came next, and France had been catching up since 1880. The bourgeoisie triumphed. In 1851, Great Britain, ruled by Queen Victoria (1837–1902), organized in London the first universal exhibition, the Great Exhibition in the Crystal Palace; this building designed by the architect Paxton became a symbol of the power and modernity of the country, in contrast with the solemnity of Victorian painting, which recognized neither the Pre-Raphaelites nor the Symbolists. While Great Britain had a great colonial empire and far-flung markets, the country became weaker after 1870 in the face of competition, particularly from Germany.

At the end of a long process, Bismarck achieved the political unity of the German states in the Reich (1871), after conquering France. Germany developed its merchant navy, the guarantee of its strength. This strength supported academic painting. Isolated by German unity, the decline of the Austria of Franz-Joseph I began. Hungary became an autonomous state in the heart of Austria-Hungary (1867) after the defeat of Austria by Prussia. Poland was crushed by Prussia in 1863 as it tried to revolt: the instigators took refuge in Austrian Galicia.

Spain, impoverished by wars of independence, lifted itself up with difficulty.

Italy, divided and at war, became unified in 1871. The north became industrialized and the movement of the *macchiaioli* against academic painting built up in Florence, while the south, still feudal, became bogged down. In Russia, the reforming policy of Alexander II enabled his successor Alexander III to encourage industrialization while using the manual labour of the former serfs. The nationalist realist painter Repin was already attempting to educate the people as the *proletkult* (culture of the proletariat) would seek to do 50 years later. The Russian Empire conquered almost the whole of central Asia (1864–85) and then became involved in the Balkan countries against the Ottoman Empire.

William III, King of the Netherlands, ensured peace and prosperity (1849–90) and the freedom of artists (Jozef Israëls, Jan Toorop). Norway, the country of Munch, remained attached to Sweden until 1905. Switzerland, neutral since 1815 and economically strong, inspired the dark landscapes of Böcklin. In the United States Lincoln could not escape the War of Secession, of which one of the issues was the abolition of slavery, decreed in 1871; in spite of this, the black population would remain excluded for too long from the richness of the country, which, since 1875, was the most prosperous of the industrial nations.

In London, the First International (1864–76) was created by Marx, the theorist of 'scientific' socialism, which succeeded the socialism of Fourier, Owen and Proudhon. The Second International was founded in 1889.

Cultural development. In Great Britain the novelist H G Wells became famous with *The War of the Worlds* (1898), critical of the Victorian world. Shaw, writer and theatre critic, was very active in favour of socialism and in art criticism, defending innovative artists. Conrad went on an initiatory voyage of discovery. The Irish poet Yeats, rich in symbolism, mixed Irish folklore and mysticism.

In the literary field, the hegemonic, militarist country of Prussia gave birth to the realism of Fontane and Raabe, the esoteric and religious symbolism of Stefan George, and then to the Expressionist dramas and novels of Wedekind, Heinrich and Thomas Mann. The philosopher Nietzsche took a new look at Pan-Germanism in the name of individual freedom. The 'young Hegelians', including Ludwig Feuerbach, clung to the dialectic and opted for atheistic materialist positions. Marx criticized this mechanistic materialism and declared the necessity of a radical transformation of society. In music Wagner drew the material of renewal from a Romanticism impregnated with German legends. Settled in Vienna, Brahms united Romanticism with musical purity. In Austria, the decline of the empire fed different trends: the writers Hofmannsthal and Trakl mused about life, the decline of society and death; Rilke was dominated by the emotion of a god to come who would give a meaning to life; and Kraus judged Viennese life with ferocity (*Le Flambeau* magazine, 1899). The desire for renewal was expressed in Vienna through Jugendstil architecture. Bruckner and Mahler opened the way to serialism and atonality, and psychoanalysis came on the scene. Hungarian by birth, the virtuoso pianist Liszt lived in Paris. The intellectual movement 'Young Poland', created in about 1890, sought a national identity removed from German-ness, intellectualism and materialism; it was represented by the naturalistic novels of Gabriela Zapolska and the lyric and metaphysical poetry of Kasprowicz.

Belgium was anchored in Symbolism; the painting by van Rysselberghe, *La lecture* (1903), resembled the literary personalities of the Free Aesthetic (Verhaeren and Maeterlinck in particular). César Franck composed symphonic poems.

In Spain, Blasco Ibáñez was nicknamed 'the Spanish Zola'. The literary current of *costumbrismo* by E Calderón described the 'ways and customs' of the country. The musicians Albéniz and Granados revealed a musical nationalism.

In Russia in 1855 Chernayevsky published *The Aesthetic Relationship of Art and the Reality*, in which he defended the movement of the peasant community to the socialist community. Dostoyevsky, Tolstoy and Chekhov were the great figures of literary realism and Blok was distinguished by his Symbolist

poetry. Tchaikovsky, cosmopolitan and lyrical, was influenced by French musicians, and the group of the Five introduced new musical currents.

From 1860, Italian 'realism' in literature (de Roberto), painting (Fattori), and music (Puccini) was dominant in the face of the lyricism of d'Annunzio. The opera composer Verdi was triumphant. The intellectual prestige of Norway was considerable after 1850 as a result of the Expressionist and nationalist writers Ibsen and Björnson. The musician Grieg influenced the French composers Debussy and Ravel.

American literature was distinguished by writers as varied as Hawthorne (*The Scarlet Letter*, 1850), Melville (*Moby Dick*, 1851), Mark Twain (*The Adventures of Tom Sawyer*, 1878) and the British writer of American origin, Henry James (*The Ambassadors*, 1903). Whitman remained the great name of American poetry. In the field of architecture, Sullivan 'invented' the skyscraper (1890-1). The painters Homer, Eakins, Ryder and in particular Whistler, Mary Cassatt and Sargent 'inaugurated' American painting.

The avatars of a republican France

Revoution, combat and disillusion. Since 1842, Sue described the extreme poverty of the Parisians at the bottom (*Les Mystères de Paris*). The realist painter Meissonier immortalized the birth of the Second Republic with *The Barricade, June 1848*. Victor Hugo made a speech against poverty in 1849 and, after the coup d'état of Louis-Napoleon Bonaparte on 2 December 1851, he expressed his opposition in *Napoléon le Petit* (1852). His Gavroche ('street urchin') in *Les Misérables* (1862) died on the barricades singing about the progress of socialism. Flaubert incorporated his amorous disappointments together with the failure of the Revolution of 1848 and society in *L'Éducation sentimentale* (1864-9). Proudhon, mutual socialist, was associated with Courbet, who painted his portrait. Between 1853 and 1870 the Prefect Haussmann brought about the renewal of Paris, clearing the grand boulevards, organizing the distribution of water and the sewers, and creating green spaces. Manet (the Tuileries) and Monet (the stations) painted this modern Paris while Daumier drew the people of the less salubrious parts. Lesseps opened the Suez Canal in 1869. The French defeat at the hands of Prussia led to the declaration of the Third Republic on 4 September 1870. Thiers negotiated the surrender (28 January 1871) which ended with the loss of Alsace-Lorraine, then crushed the revolt of the Commune in Paris which had broken out in March 1871. Courbet was president of the Beaux-Arts commission of the Commune; while he recorded it with his drawings, Victor Hugo wrote *L'Année terrible* (1872).

The Dreyfus affair (1894-9) tore the country apart and revealed the anti-Semitism that was latent in part of French public opinion: Zola took the side of Dreyfus and published 'J'accuse' in January 1989. Dreyfus was rehabilitated in 1906. During this time, the colonial empire continued to grow; French Polynesia welcomed Gauguin in 1891.

Cultural diversity. French literature and poetry, from Lamartine (b.1790) to Jarry (b.1873), showed evidence of great vitality. In *Les Fleurs du mal* (1857) Baudelaire celebrated, as he put it, the 'party of the brain'. His aesthetic awareness and his taste for novelty made him a great poet and a talented art critic. He joined with Banville in being opposed to realist poetry and was a precursor of Parnasse (1866). This literary circle devoted to the contemplation of beauty included Gautier, Leconte de Lisle, Heredia, and later Verlaine, author of *Fêtes galantes* (1869), painted by Carrière, and Mallarmé, painted by Manet (1876). Mallarmé became a symbolist with *Un coup de dé jamais n'abolira le hasard* (1897), and the prince of poets on the death of Verlaine. He opposed the 'deregulation of the senses' which Rimbaud – immortalized by Fantin-Latour in *The Table Corner* (1872) – defended in his *Illuminations* (1884). Isidore Ducasse, 'Comte de Lautréamont', practised the excess and the parody of the pre-surrealist style in *Les Chants de Maldoror* (1869), after which Flaubert depicted in *Madame Bovary* (1851-6) the mores and the social reality of the provinces. Jules Verne introduced science fiction with *From the Earth to the Moon* (1865), illustrated by Doré. Zola, friend of Cézanne and Manet, foreshadowed naturalism with *Les Rougon-Macquart* (1871-93). The works of many other writers such as Maupaussant, Daudet, Huysmand, France, George Sand and others revealed the diversification of naturalism. The republican historian Michelet, professor at the Collège de France, rejected the Empire, supported the revolutions and participated in the foundation of the Third Republic. The positivism of Auguste Comte was applied to history by Fustel de Coulanges. Renan's religious, rationalist history (*Vie de Jésus*, 1863) and the encyclopedic knowledge of Taine, for whom the work of art was the product of a time and a milieu (*Philosophie de l'art*, 1882), worked towards renewal. But Bergson was opposed to positivism (*Essai sur les données immédiates de la conscience*, 1889).

In music, Gustave Charpentier further advanced the realist aspirations of Gounod, Bizet (who dominated opera), Saint-Saëns and Chabrier, friend of Manet. While operetta reigned supreme under the Second Empire with Offenbach, the melodies of Fauré and the new sonorities of Debussy inaugurated modern music.

French hegemony in painting

France was the hub of the aesthetic revival, and artists from all over the world converged towards Paris. **The turning point of the 1850s: from Romanticism to Realism.** Delacroix's paintings, exhibited at the Universal Exhibition of 1855, showed that Romanticism was still very much alive and well. The painting of landscape outdoors, advocated by the Barbizon painters Théodore Rousseau, Daubigny and Millet, continued and was characteristic of the Hague School in the Netherlands, and more especially it inspired Courbet. In 1848 he initiated and led an important innovative movement: realism. This term, used by the painter in 1855 in his *Manifesto of Realism*, described a style of painting which raised the subjects of daily life to the rank of history paintings. He proposed an objective, simple vision of life. Daumier, Millet and Meissonier were all influenced by this new vision, as were the photographs of Marville. With his 'Exhibition of Forty Paintings', Courbet held the first retrospective of a living artist, held in the vicinity of the Universal Exhibition of 1855.

Realism also spread to the Tervueren School in Belgium through Dubois, a friend of Courbet. The American painter Whistler introduced the French realist landscape to Great Britain. In Frankfurt Courbet encouraged the work of Thoma and Leibl admired the 'master'. The art of the Berlin artist Menzel reflected a nationalist academic realism. In Austria Wasmann and Waldmüller concentrated on peasant themes. In the 1860s the *macchiaioli*, Florentine 'tachist' painters, including Fattori, depicted contemporary, rural life, landscapes and portraits in a range of dull colours with pronounced chiaroscuro. In about 1870, the Russian Repin, a member of the itinerant nationalist, realist group of the Peredvijniki, 'the Itinerants', founded a 'Russian art'.

Pre-Raphaelites and Japonistes. The British painters Hunt, Rossetti and Millais, hostile to Victorian Academicism, expressed their political opinions through their paintings. Nationalist and nostalgic for the past, these Pre-Raphaelites painted religious and literary subjects, allegories and medieval legends and were influenced by Gothic art and the Italian painters before *Raphael.

From 1860 onwards, after the commercial treaty between the United States and Japan, artists discovered Japanese books and engravings by Hokusai (*Hokusai Manga*, 1814–48) and by Hiroshige. The aesthetic approach of Japanese engravings introduced unusual formats in painting, unusual centering such as compositions with large diagonals, off-centre or truncated figures and motifs seen in close-up. Artists also adopted the shapes, outlined in black, bright and matt flat tints while rejecting modelling and chiaroscuro.

Official art and the buyers. In France official painting, also known as *art pompier* (pompous art) reflected the teachings of art academies, based on the nude in Graeco-Roman antiquity, the art of the masters of the Renaissance, the Classical rigour of *David and the idealism of *Ingres. Cabanel, Gérôme and Bouguereau among others followed this path. The themes depicted, emptied of their content and meaning, became like clichés. With their balanced composition, the drawing distinguished by perfect lines and details and smooth finish, their history paintings and society portraits started to seem insipid and their languid nudes idealized and conventional. Napoleon III supported this art, and the State bought *The Birth of Venus* (Cabanel, 1863). The bourgeoisie loved it and the academic painters found the numerous commissions for portraits a godsend. Although Ingres, Flandrin and Winterhalter made an excellent living from it, their ambition drove them towards history painting while Carolus-Durand and Bonnat subsequently concentrated on society paintings. The pictorial ideal of Anselm Feuerbach was influenced by the eclectic art of Couture. On the other hand, the American portrait painter Sargent, famous in Paris and later in London from 1884 onwards, remained faithful to Victorian art.

The artists confronted official art: the rebellion of the 'refused'. Courbet clashed with the rules set down by the Académie des Beaux-Arts: the artist rejected the hierarchy of genres and he refused to comply with the rules of polite society which said that a peasant and a bourgeois should not be depicted as equals. He expressed himself with sometimes brutal realism and bold brushstrokes. As for Manet, he shocked the jury and the public when he exhibited his first paintings with their thick blotchy, brushstrokes, broad, coloured or black flat tints, without modelling, as in Japanese engravings. When in 1863 the jury refused to exhibit over 3,000 out of the 5,000 paintings submitted, the artists rebelled. Napoleon gave in and set up the Salon des Refusés, separate from the official Salon but situated in the same building. Manet, Monet, Whistler, Pissarro, Jongkind, Fantin-Latour and Cézanne exhibited there. This 'secession' heralded the end of the reign of the all-powerful Académie, created two centuries earlier.

1863 was a key date, that of Delacroix's death and the presentation of Manet's *Olympia*, Ingres's *Turkish Bath* and Cabanel's *Venus*. The Pre-Raphaelite Millais was elected a member of the Royal Academy and Gustave Doré illustrated Cervantes' *Don Quixote*. The category of historical landscape in the Prix de Rome was abolished. That year the future Neo-Impressionist Signac, the future 'Nabi with the sparkling beard' Sérusier, and Munch, the future Symbolist-Expressionist were born and the architect Viollet-le-Duc began working on the restoration of the chateau de Pierrefonds.

Impressionism: an international success. The country landscape of French and English tradition, free of any historical subject, came to be seen with the works of Corot, Daubigny, Boudin and Jongkind; their sensitivity to light and atmospheric variations, like the works of Courbet, attracted the attention of the future Impressionists. The seaside photographs of Le Gray also foreshadowed the researches carried out by the Impressionists. With the exception of a few realist artists, all the defenders of pictorial renewal went through an Impressionist phase. Monet, who had led the movement since 1862, was surrounded by Renoir, Pissarro, Sisley, Berthe Morisot, Bazille and others. They tried to capture movement, nature, modernity and the fleeting moment in pictures painted in the open. They used pure, primary and complementary colours and applied the paint with quick, small brushstrokes, on a canvas prepared with white, using pencil brushes or wider brushes, creating an effect which when seen from a distance reconstituted the subject. Rejected from official circles and labelled *barbouilleurs* (daubers), they exhibited in 1874 in the studio of the photographer Nadar; Manet, who did not see himself as an Impressionist, was not there. Cézanne and Degas on the other hand remained faithful to the movement more through their presence than their aesthetic approach. Between 1874 and 1886 there were seven more Impressionist exhibitions. The Salon des Indépendants, which accepted all trends and movements, was founded in 1884.

Impressionism spread throughout Europe and the United States. The American Mary Cassat lived in France, her compatriot Whistler introduced the Impressionist landscape into Great Britain where it was greatly admired by Wilson Steer, who was strongly influenced by Renoir and Monet. The Scottish landscape painter McTaggart was also influenced by Impressionism, as were the German artist Liebermann, founder of the Berlin Secession (1890), and the landscape painter Stanislawski, a member of 'Young Poland'. The Russians Levitan and Serov distanced themselves from Russian academism, the latter moving towards Impressionism. The Italian Impressionists de Nittis and Zandomenegh (a friend of Degas and Renoir) had settled in Paris while Reycend lived in Turin.

Post-Impressionism: Neo-Impressionism, the Nabis, the Pont-Aven school and Japonisme. In 1886 the Impressionists each went their own way. Between 1886 and 1891, Seurat rationalized Impressionist aesthetics, basing his work on scientific research and developing Divisionism. The painters Pissarro, Luce and Signac adapted Neo-Impressionism to any theme. After 1887 the style spread to Belgium (Van Rysselberghe) and Italy (Pelizza da Volpedo).

In about 1888, when Sérusier presented his manifesto painting *The Talisman*, a few painters decided to call themselves the 'Nabis' ('prophets' in Hebrew). Bonnard became the 'very Japonard Nabi' while Vuillard developed a graceful intimism. Maurice Denis, the 'Nabi with the beautiful icons', reinterpreted sacred art in a Symbolist language and stated that that 'one must remember that a painting is essentially a flat surface covered with colours, assembled in a certain order'. The Flemish artist Verkade was nicknamed the 'obeliscal Nabi'. The Dane Ballin, Hungarian Rippl-Rónai and the Swiss Vallotton were also members of the group.

The school of Pont-Aven was also founded in 1888. Gauguin, Anquetin, Émile Bernard and the Dutchman Meyer De Haan settled in the village of Pont-Aven (Finistère). They produced a sacred art which was pure and poetic, inspired by the wild, 'primitive' landscape of Brittany, combining Cloisonnism and Synthetism: shapes were outlined in black as in Japanese engravings and the colour was applied in flat tints obliterating all detail.

Having aroused the interest of artists such as Manet and Degas, Japanese engravings became very fashionable between 1876 and 1895. Van Gogh is said to have borrowed the stick-like stroke, Toulouse-Lautrec borrowed their erotic subjects and Bonnard their motif with squares.

The success of naturalism and the reactions: Symbolism and Art Nouveau. Under the Third Republic Courbet's art triumphed as did naturalism, an off-shoot of realism veering towards academicism. From 1880 onwards, Bastien-Lepage and Raffaelli applied scientific observation to themes of social life and used a technique very similar to Impressionism. Their contemporary MacGregor, a member of the Scottish group the Glasgow Boys, and the young Dutchman I Israëls painted the same subjects but with an aesthetic approach which resembled that of Manet. In the years 1890-1910, Cottet, who belonged to the *bande noire*, was fascinated by Brittany; the solidity of his characters was inspired by Cézanne.

Between 1886 and 1890, an artistic movement developed which rejected bourgeois naturalism and positivism: Symbolism. According to Aurier, a critic of this movement, the Symbolist work was born from an idea; it was embodied in the idealized, allegorical women who inhabit the serene landscapes of Puvis de Chavannes or the legendary heroines present in the visions of Moreau. Redon's paintings emanate serenity and a dream-like atmosphere. The Symbolism developed by Rops represents a fantastic world tinged with eroticism. The Symbolist movement attracted other artists such as Khnopff, the leader of the Libre Esthétique, and Ensor who transformed society into a mass of skeletons and masks. The British artist Burne-Jones continued in the path of the Pre-Raphaelites. There were two important Swiss artists: Böcklin who admired Germanic art and Hodler who was more attracted to the French landscape. Munch's desperate art created distorted shapes reminiscent of Expressionism while the naive art of the *douanier* (customs officer) Rousseau borrowed from Primitivism and Symbolism.

If Symbolism recovered the dream, it became, in this decadent *fin-de-siècle* moment, a nightmare and announced the beginnings of Expressionism.

Jugendstil (Art Nouveau in France and modern style in Great Britain) integrated all the arts including architecture in a global vision. Thus it integrated the decorative arts and furniture with painting. *Klimt dominated this art after the foundation of the Viennese Secession in 1897. His anti-academic, Symbolist decoration developed towards a decorative art, rich in poetic symbols, feminine and erotic, heightened with gold and silver. The Dutch painter Toorop shared this aesthetic as did the British artist Beardsley and the German Eckmann, but Art Nouveau did not interest any French painters.

A new society of artists and new networks for art. The Beaux-Arts ceased to be the obligatory route for training as an artist. Painters were also trained in private studios such as Gleyre's atelier, the Académie Suisse and the Académie Julian. Cafés became places for meeting or discussing art. At the end of the 1840s, Courbet frequented the Brasserie Andler-Keller with his friends Baudelaire, Daumier, Corot, Duranty and Castagnary; he declared his right to paint 'the vulgar and the modern'. In his early days, Manet often visited the Café Tortoni where he would be among the writers Théophile Gautier and Musset. When the offical Salon began to turn down the avant-garde (1859) the Café Mormus became the refuge of these rejected painters. At the end of the 1860s, Manet, Monet, Renoir, Pissarro, Sisley, Degas and Cézanne, the photographer Nadar and the writer Zola met at the Café Guerbois, known as the 'café of the green eyeshades', where Impressionism was founded. After 1875, they chose the Café de la Nouvelle Athènes, which welcomed Manet and his friends, then Degas and his Italian disciples, the poets of the Parnassus group and the Symbolists. In 1889 the painters of the Pont-Aven group, Gauguin, Émile Bernard and Anquetin exhibited at the Café Volpini within the Universal Exhibition.

Excluded from official sales channels and the commissions of the bourgeoisie, the Impressionists found a welcome from art dealers such as Durand-Ruel. Vollard was interested in Cézanne, Gauguin, Bonnard and Van Gogh. However, the artists experienced a difficult time until the end of the century. Collectors multiplied: they included Caillebotte, painter and friend of the Impressionists, Bruyas the friend of Courbet, the Schneiders, industrialists and bankers, the Duc de Morny, the Rothschilds and the Rouart and the Camondo families. Publications appeared: *L'Artiste, L'Événement, La Gazette des beaux-arts, L'Art moderne* and others.

Art gave rise to aesthetic debates. The critics supported 'their' artists passionately. Champfleury, pioneer of art criticism, published *Du réalisme* (1857) and defended Courbet as did Castagnary after 1860, against the Neo-Grecian tendency of Gérôme, christened the 'tracing school', who was promoted by the critic Delécluze. The British critic and sociologist Ruskin encouraged the Pre-Raphaelites. Baudelaire admired Delacroix and encouraged Manet, 'painter of modern life'. He came out against landscape, 'an inferior genre ..., the stupid cult of nature'. In photography he saw only the servant of painting and confirmed that it was 'the refuge of all failed painters'. Burty was opposed to this concept and applauded the entry of photography into the Salon of 1859 next to the paintings. Zola sang the praises of Courbet in *Mes haines* (*My hates*, 1866) and of Manet, Monet, Sisley and Pissarro in *Mes salons* (1866–8). The Goncourt brothers rejected the Impressionists. Gautier admired the portraits of Ingres but detested the realism of Courbet, 'the Watteau of ugliness', and he preferred the academicism of Couture for his educational role. Duranty campaigned for renewal, as did Duret who, in *Critique d'avant-garde* (1885), insisted on 'the intrinsic quality of painting in itself'. Fénéon defended Seurat. Huysmans remarked his commitment to naturalism and later admired the Symbolist painter Moreau.

Between 1849 and 1904, a movement developed, initiated mainly by the French, whereby artists demanded absolute pictorial freedom. The arts had been liable to stylistic interference and brutal opposition. Artistic trends and individual talents multiplied. The tensions between the avant-garde and the academies led to the success of aesthetic novelty in all countries. 'I tried to establish the right to dare to do anything', Gauguin wrote to Maurice Denis in 1899. 'Today you – painters – can do anything, and what is more, no one is surprised by this.' This period heralded a new era, that of modern art, initiated by Munch with Expressionism, by Gauguin, Toulouse-Lautrec, Van Gogh and Seurat with Fauvism and by Cézanne with Cubism.

Manet

Manet adopted a resolutely modern attitude in the way he expressed his immediate visual experience of contemporary life. His works gave structure to space and volumes. His knowledge of Japanese prints inspired the artlessness of his perspectives and the flat colour-washes in which he used pure colours and black. The open air paintings demonstrate to his Impressionist talent. His final, naturalistic works have a very personal energetic and synthetic style.

LIFE AND CAREER

• Born into a French upper middle-class family, Édouard Manet (Paris 1832–Paris 1883) twice failed the entry exams for the École Navale (naval college) before receiving the agreement of his parents to devote himself to painting.

• From 1850 to 1855 he worked in the official art studio of Thomas Couture, and then went on to work on his own, copying paintings by the old masters in the Louvre and galleries across Europe. He admired *Velázquez, *Rembrandt, *Hals, *Titian and *Delacroix for the truth of what they painted.

• In 1859, encouraged by Delacroix, he submitted *The Absinthe Drinker* (Paris, Orsay) to the Salon, which they turned down. In 1862 Manet's favourite model, Victorine Meuret, made her first appearance in his work in *Woman Singer With Cherries* (Boston, MFA). Then came three works which caused a scandal: *Music in the Tuileries Gardens* (1862, London), a scene of contemporary life; *Le Déjeuner sur l'Herbe* (1862, Paris), shown at the Salon des Refusés; and *Olympia* (1862, Paris), first exhibited in 1865. Opposed to the French Academy school of painting, Manet made friends, and shared his ideas about art, with Charles Baudelaire and Émile Zola, both of whom supported him in his approach to his work: 'I don't like the word art, I want life to be the thing that gets painted' (Zola, 1866). Faithful to his Baudelairean way of seeing, Manet painted society as it was, as it revealed itself to him. He translated it onto canvas as he sensed it, faithful in representing every aspect of the present moment unconventionally and with a plasticity that was modern. He spurned the historical preferences and archaeological approach cherished by painters of the Academy. The rejection of *The Fifer* (1866, Paris) by members of the jury at the 1866 Salon and his exclusion from the Exposition Universelle of 1867 encouraged Manet to show 50 canvases in an independent exhibition space near to that of *Courbet and left Zola determined to defend Manet publicly in *L'Événement*. Manet became the leader of the independent artists who met at the Café Guerbois, among them *Degas, Pissarro, Renoir, Frédéric Bazille and *Monet.

• During these years from 1862 to 1870, Manet tackled some very different subjects. Spain was in vogue and inspired a number of Manet's paintings including *Lola de Valence* (1862, Paris, Orsay) and *A Matador* (1866-7, New York, MOMA). Yet Manet also painted still lifes, such as *Fishes* (1864, Chicago, AI) and *Vase of Peonies* (1864, Paris, Orsay); religious scenes such as *The Dead Christ and the Angels* (1864, New York, MOMA); moments from contemporary history including *The Execution of The Emperor Maximilian* (1867, Boston, MFA); simple subjects from everyday life such as *The Balcony* (1868-9, Paris, Orsay) and *In the Garden* (1870, Shelburne [Vermont], mus); and portraits: *Portrait of Zacharie Astruc* (1866, Bremen, Kunsthalle), the art critic, *Portrait of Émile Zola* (1868, Paris) and *Portrait of Berthe Morisot* (1870, Providence [Rhode Island], MA; 1872, pr coll).

• In 1872 at Argenteuil, Manet drew nearer in style to the work of his friends Monet and Renoir in terms of both the subjects he chose and his lightening of his palette. He painted in the open air *The Railway* (1872-3, Washington, NG), *The Bon Bock* (1873, Philadelphia), a work which was well received at the Salon, *On the Beach* (1873, Paris, Orsay), *Monet in his Studio Boat* (1874, Munich) and *Argenteuil* (1874, Tournai, B-A).

• Manet became firm friends with Stéphane Mallarmé in 1873 and painted the poet's portrait (1876, Paris), which his contemporaries thought a very good likeness, while Mallarmé himself said it 'captured my whole soul'. This painting radiated 'the friendship between two great minds' (G Bataille, 1955). In 1874, Manet decided to pursue his own artistic approach alone and refused to exhibit with his friends at the studio of the photographer Nadar. Consequently he did not feature in the first 'Impressionist' exhibition, finding the actual name of little relevance to his paintings. He felt closer to the naturalism of Zola, which he expressed in *Nana* (1877, Hamburg, K), *The Beer Waitress* (1878, Paris, Orsay) and *La Liseuse* (1889, Chicago).

- In 1881, Manet was finally awarded a medal from the Salon and the Légion d'honneur. In failing health, he increasingly worked with pastels, finding it a less tiring method than oils. His last masterpieces were *A Bar at the Folies-Bergère* (1881–2, London) and *Carnations and Clematis in a Crystal Vase* (1882, Paris). He died from gangrene in 1883.

'One day people will recognize the place he held', Zola declared in 1880. The critic J-A Castagnary insisted that 'he has left his mark in the history of contemporary art. And when people come to write about the developments and the twists and turns of 19th-century French art, they will be able to ignore Monsieur Cabanel but will have to take account of Monsieur Manet'. It was Manet's modernity that made him the precursor of, first, *Gauguin, *Van Gogh and *Toulouse-Lautrec, then *Matisse and Fauvism, and finally abstract art.

APPROACH AND STYLE

Manet was fond of the medium-sized and large formats which enabled him to paint people life-size. He presented scenes from contemporary urban life, realist everyday subjects, such as café waitresses, actors, the crowd and Spanish themes. He also painted portraits, seascapes, paintings about contemporary history, a number of religious works and still lifes, and only a few landscapes, the favourite subjects of the Impressionists. He admired Velázquez, drew inspiration from the naturalism of Zola and the 'modernity' advocated by Baudelaire, who foresaw that Manet 'will be the painter, the true painter who will be able to show us how big we are in our ties and our polished high boots'. Manet discovered Japanese prints and then found himself drawn to the Impressionism of Monet and Renoir.

- Until 1871, Manet painted the characters of his era. He expressed a visual experience that obliterated traditional representation with an almost photographic precision. Taking his cue from Baudelaire, Manet's modern way of seeing retained the elements of the present and rejected the fiction of the Academy's vision: 'There is only one true thing', he declared, 'and that is to work with what one sees at the first glance. I have a horror of all that is useless'. He painted what he saw and not what he knew (*Music in the Tuileries Gardens*).
- Zola recognized in Manet the merit of painting by means of masses or blobs, and always in a key truer than that of reality itself. As in Japanese prints, Manet applied his colours in broad flat colour-washes, without contour or gradation of colour, features of the Classical model. Black, banned by the Impressionists, had a high profile in his work. He used blacks and whites, light and shade, in direct contrast with each other, with no transition or half-tone. 'He all but did away with half-tones. The immediate transition from shade to light was his constant pursuit. Titian's luminous shadows appealed to him deeply' (A Proust, 1897).
- Manet's technique, close to that of fresco painting, was seen by his detractors as 'daubing'. The flat washes of pure colour, reinforced by the juxtaposition of flat black washes, conveyed volume and form. Manet reduced the third dimension, flattened volumes using violent contrasts of light and shade, and aroused a feeling of drama (*Olympia*, *The Fifer*). 'Conciseness in art is a necessity and an elegance', Manet declared. 'In a figure, one simply

A GREAT PAINTER

◆ Manet's worth as an artist and the fact that it caused scandal or praise was recognized in his lifetime.
◆ His aesthetic independence and the innovatory quality of his painting made him the standard-bearer of avant-garde artists, enamoured of modernism and artistic freedom and in opposition to French Academy art as exemplified by someone like Cabanel.
◆ He broke new ground by representing urban life and painting, as the Impressionists did, in the open air.
◆ Manet mastered a technique close to that of fresco painting. He positioned his human subjects and inanimate objects on an untreated canvas which had been coated with a very light sizing. He then applied oily, liquid paint with the brush. Before the painting was dry, he added the half-tones and the blacks. He did the background afterwards, hence the violent contrasts of colours. Each coat retained an outline, the whole forming a composed image.
◆ He introduced the style of Japanese prints discovered by Baudelaire: bold compositions and broad flat colour-washes. He excelled in the art of contrasting light and shade (*Olympia*). He possessed a free and rapid technique which obliterated the subject in some portraits (*La Liseuse*).

has to seek the big light and the big shade, and the rest will follow naturally'.

• The time Manet spent at Argenteuil between 1872 and 1874 lightened the palette of sombre, contrasted colours of his earlier paintings. Now he painted his most luminous and most Impressionist masterpieces: rural landscapes and scenes on the banks of the Seine painted in the open air, using patches of divided colour, a free-flowing, supple technique, and modulated light (*Argenteuil*).

• From 1875 onwards, Manet returned to the art of his early years, and yet his palette remained light. His plasticity derived from putting together forms he defined by areas of sombre colour and of light, and from compositions whose rhythm was driven by structural and 'schematic' lines. His broad, vital and synthetic brushstroke captured an immediate and fleeting visual impression which led to the obliteration of the painting's subject (*La Liseuse* or *La Lecture de l'illustré*).

KEY WORKS

Manet painted about 450 works.
Music in the Tuileries Gardens, 1862, London, NG
Le Déjeuner sur l'Herbe, 1862, Paris, Orsay
Olympia, also 1862, Paris, Orsay
Fishes, 1864, Chicago, AI
The Fifer, 1866, Paris, Orsay
Portrait of Émile Zola, 1868, Paris, Orsay
The Balcony, 1868–9, Paris, Orsay
The Bon Bock, 1873, Philadelphia, MA
Monet in his Studio Boat, 1874, Munich, NP
Portrait of Mallarmé, 1876, Paris, Orsay
La Liseuse or *La Lecture de l'illustré*, 1879, Chicago, AI
A Bar at the Folies-Bergère, 1881–2, London, CI
Carnations and Clematis in a Crystal Vase, 1882, Paris, Orsay

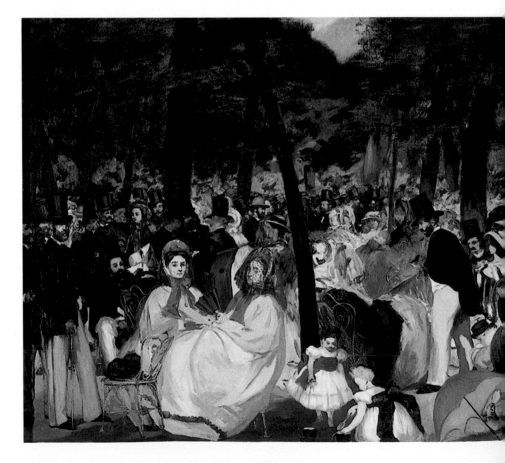

La Liseuse or **La Lecture de l'illustré**
1879. Oil on canvas, 61.7 x 50.7cm,
Chicago, Art Institute

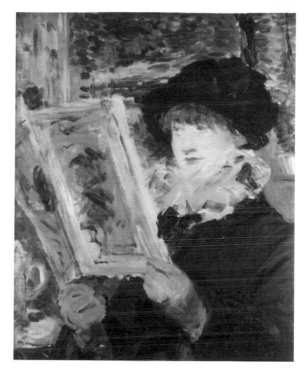

*In some parts of Manet's late works, 'the
free and rapid technique produced an
almost abstract decorative effect which was
very effective in bringing out areas of
intense black, to some extent united, and
created by the hat and the clothes ... the
objects depicted are difficult to identify ...
Manet's fashioning of the young woman's
tulle collar illustrates the exuberance of
creation he loved, here using rapid and
relatively thin strokes to suggest the fabric's
transparent folds ...' (C S Moffert, 1983).
This work combines elements of
Impressionist practice with traditional
techniques. Manet verged on abstraction by
almost obliterating the subject, so that the
model becomes unidentifiable. This painting
is in every respect the opposite of his
Olympia. Only the critics linked them: they
disliked La Liseuse for the freedom of
Manet's pictorial method, and then they
were shocked by what they judged to be a
blasphemous interpretation of the subject in
Olympia*

Music in the Tuileries Gardens
1862. Oil on canvas, 76 x 116cm, London, National Gallery

*Painted during the reign of Napoleon III, this work depicts the
'spectacle of the elegant way of life' (Baudelaire), echoing the title
of the poet's book, The Painter of Modern Life. Manet has
treated a subject from the world of fashionable society as if it
belonged to the 'noble' genre. The figures in the foreground portray
real people: Manet himself in a top hat, leaning over, Baudelaire,
and the artist's friends Offenbach, Champfleury, Fantin-Latour,
Scholl and Théophile Gautier by the trunk of a tree.
The chairs, the hats and the children's ribbons and bows provide
the curving lines, while the tree trunks, and the men's top hats
and morning coats add in the vertical ones. The bright colours in
the broad areas of flat colour-wash are enhanced by a number of
brighter strokes.
This painting scandalized Manet's contemporaries on account of
both its technique, which allegedly 'caricatured' the faces and only
sketched in the clothes, and the 'obsession [on the part of the
artist] with seeing in blotches' (Babou, 1867). Zola replied that
the viewer had to position himself 'at a respectful distance; he
[Babou] would then have seen that the blotches were alive, that
the crowd were speaking, and that this painting was one of the
artist's most key works, one in which he showed most particular
obedience to his eyes and his nature'. In this sense,* Music in the
Tuileries Gardens *would be the first work of modern painting.*

BIBLIOGRAPHY

Clark, T J, *The Painting of Modern Life: Paris in the Art of Manet and his Followers,*
Thames and Hudson, London, 1985; Reff, T, *Manet: Olympia,* Allen Lane, London,
1976

captivated by composition and played with different forms and the ways in which human beings move. His Japanese-style works were amplified by the upward or downward glances of his subjects, the clashing contrasts, and the back-lit scenes, and some of them, in the dividing-up of the space, looked like camera shots. Degas constructed his subjects with great meticulousness, placing the image subtly and often off-centre, and this increased the impression of movement or imbalance (*The Orchestra at the Opéra*).

• Degas was clearly resistant to Impressionist technique. He preferred the representation of movement using light to aid perception; the fleeting expression of a pose analysed, dissected and put together again, sometimes with the help of photography. He flooded his scenes with a cold artificial light that accentuated forms. Pastel, a dry pigment which is opaque, thick and quick to use, was a very appropriate medium for his art.

• In the 1870s Degas preferred using pastel on monotype to convey the ephemeral and the fleeting. He superimposed bold layers of pastel, in bright or finely shaded tints, and put them next to an intense black. This pigment made it easy for him to touch up what he had already done: 'No art is less spontaneous than mine', he said.

• Degas stripped his subjects of the picturesque and the anecdotal. His dancers, who, on stage, created sylph-like arabesques in the most extraordinarily balanced poses, were portrayed in the wings, exhausted, their energy used up, bodies gone limp and looking almost awkward. His paintings of women washing themselves and getting ready made no concessions to them either. The colours came alive and the monochrome canvases were animated by touches of pure colour. His pastel-hatched lines could sometimes make flesh look blue, green, violet, pink and orange, outlining a blurred body under cold light.

• His pastel landscapes (1890–3), laid out like a stage set, did away with form and conveyed a sense of the atmospheric in compositions which were both sober and feverishly hatched.

• At the turn of the century Degas, his eyesight failing, simplified the composition of his pastels, increasingly shaping his forms by employing thick, rapid hatched lines of colour and

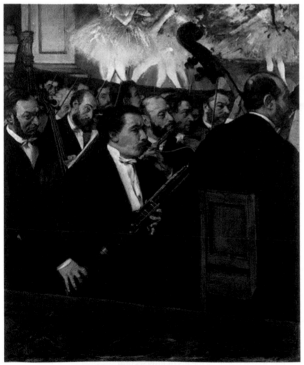

accentuating coloured shadows (*Dancers*). Degas the realist, an illusionist in his centring of the image, was not strictly academic any more than he was a naturalistic or an Impressionist painter.

The Orchestra At the Opéra
c.1868–9. Oil on canvas, 56.5 x 46cm, Paris, Musée d'Orsay

*Degas painted his friend D Dihau, a bassoonist at the Opéra, in the orchestra pit surrounded by fellow musicians. The composition and especially the wholly original centring of the image owed much to *Daumier and to Japanese prints. A handrail at the bottom of the picture marks the edge of the pit and Degas invites viewers to enter the painting by catching their eye with the scroll of the double bass in the foreground. In the upper part of the scene, Degas has boldly cut across the top of the group of moving dancers dressed in brightly coloured, feathery tutus which he has painted with a lightness of touch, and bathed in a cold, fierce light, while in the foreground the motionless musicians in uniformly black formal evening dress are engulfed in semi-darkness.*

BIBLIOGRAPHY
Dunlop, I, *Degas*, Thames and Hudson, London, 1979; McMullen, R, *Degas: His Life, Times and Work*, Secker and Warburg, London, 1984; Rich, D C, *Degas*, Harry N Abrams, New York, 1951; Sutton, D, *Edgar Degas: Life and Work*, Rizzoli, New York, 1986; Thomson, R, *Degas: The Nudes*, Thames and Hudson, London, 1988

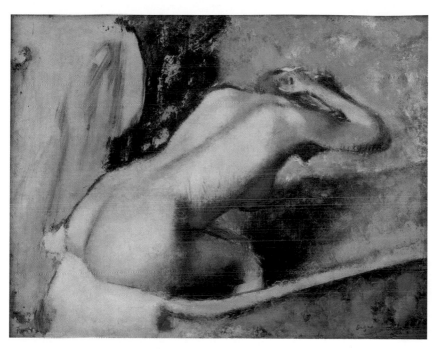

Woman Drying her Neck
1890–5. Pastel on cardboard, 62.5 x 65cm, Paris, Musée d'Orsay

'Up until now', Degas argued, 'the nude has always been represented in attitudes which presuppose an audience. But my women are simple, honest souls whose sole concern is to attend to their bodies. I show them, with no hint of flirtation, like animals cleaning themselves.'
Degas rejected the ideal beauty of the Academy's view of the female nude in favour of natural and intimate poses. Women were either doing or undoing their hair, washing or rubbing or drying themselves, as in this pastel set in a sober interior, the woman seen from behind, her face hidden. The pastellist's virtuosity shines out, and the subtle tones with their rich harmonies are at their densest under the cold light which throws coloured shadows and leaves a green reflection in the woman's hair. Degas here pushes to the extreme the technique of vertical hatching, but he was also able to create bodies in a softer way, as in The Tub.

KEY WORKS

The works of Degas amount to more than 2,000 paintings and pastels.
The Bellelli Family, 1859, Paris, Orsay
Degas and Évariste de Valernes, c.1864, Paris, Orsay
The Parade, also called *Racehorses in Front of the Stands*, c.1868, Paris, Orsay
The Orchestra at the Opéra, c.1868–9, Paris, Orsay
The Cotton Exchange in New Orleans, 1873, Musée de Pau
The Dancing Class, c.1875, Paris, Orsay
Women Combing their Hair, 1875–6, Washington, Phillips coll
Absinthe, 1876, Paris, Orsay
Café-Concert at Les Ambassadeurs, 1876–7, Lyon, BA
Laundresses Carrying the Washing, 1876–8, Stanford, Howard J Sachs coll
Café Singer, 1878, Cambridge [Mass.], FAM
At the Milliner's, 1882, New York, MM
Women Ironing, 1884, Paris, Orsay
Woman Doing her Hair, 1887–90, Paris, Orsay
Dancers in the Wings, 1890–5, Saint Louis [Missouri], City AM
Woman Drying her Neck, 1890–5, Paris, Orsay

Monet

Monet, the master of Impressionism, studied landscape in the open air so as to be able to experience the feeling of atmosphere in the moment. He tried to capture the ephemeral quality and mobility of light in nature, reflections in water, and clouds, as well as in urban surroundings. He chose primary colours and their complementary ones, pure and vivid colours which his brushstroke fragmented actually on the canvas. He coloured shadows. His touch was a slowing one, the application thick or smeared, horizontal or vertical.

LIFE AND CAREER

• Claude Monet (Paris 1840–Giverny 1926), French painter, met the open-air landscape painter Eugène Boudin in 1858 and discovered his own vocation. His parents, who were grocers in Le Havre, encouraged him and he went to Paris, in 1859 attending the Académie Suisse where he met Pissarro. Monet admired the works by landscape painters Daubigny, Corot and Rousseau in the Louvre. After a period in Le Havre with Boudin and Johan Barthold Jongkind, he entered the studio of the academic painter C Gleyre. Here he met among others Bazille, Renoir and Alfred Sisley. In 1863, Monet set out with Bazille for Chailly, near Barbizon, and there they painted landscapes in the manner of Daubigny, Narcisse Diaz and Jean-François Millet. That same year, Monet discovered the works of *Manet. In 1864, Monet was in Honfleur with Boudin and Jongkind. He spent the summer at Sainte-Adresse staying with his parents. In Chailly he set to work on Le Déjeuner sur l'Herbe (1865, Paris and Moscow) in the spirit of Manet, except that Monet painted his in the open air. *Courbet generously provided him with both advice and financial assistance.

• At the 1865 Salon, Monet showed The Mouth of the Seine, Honfleur (USA, pr coll) and Pointe de la Hève (London, pr coll); and, in 1866, views of the forest of Fontainebleau and Portrait of Camille Doncieux (Switzerland, pr coll), his future wife. These works enjoyed success, whereupon Monet discharged himself from Courbet's supervision and pursued his own experiments in plasticity in Women in the Garden (1866, Paris), The Church of Saint-Germain-L'Auxerrois (1867, Berlin museums) and Quai du Louvre (1867, The Hague, Gm). At Sainte-Adresse, Monet was inspired by seascapes, people and gardens, as in Terrace at the Seaside, Sainte-Adresse (1867, New York), but problems with his eyesight forced him to interrupt his work.

• Monet now came up against fresh financial difficulties. In 1868, at Le Havre, he showed some seascapes including The Beach at Sainte-Adresse (1867, Chicago, AI) and The Magpie (c.1868–9, Paris). While in Fécamp he painted Madame Gaudibert (1868, Paris, Orsay), some interiors, some still lifes, and Le Déjeuner (1868, Frankfurt, SK). In the autumn of 1869 he was back in Étretat and Trouville: The Beach at Trouville (1869–70, London; Paris, Marmottan) and L'Hotel des Roches Noires (1869–70, Paris, Orsay).

• At the outbreak of the Franco-Prussian War in 1870, Monet left for London, where he discovered the English landscape painters and *Turner. Here he painted London, Houses of Parliament (1871, London, Astor coll). On his return to France by way of the Netherlands, he immortalized The Windmills at Zaandam (1871, USA, pr coll).

• From 1872 to 1878, he lived in Argenteuil, where he met up again with Manet, Renoir, Sisley and Caillebotte and painted Impression, Sunrise (1872, Paris). This work was the manifesto of the Impressionist movement. Regatta at Argenteuil (1872 and 1874, Paris), Poppies, Argenteuil (1873, Paris) and Le Déjeuner (1873, Paris) reinforced this new direction in art.

• Like Daubigny, Monet installed his studio in a boat on which he then travelled up and down the Seine: The Studio Boat (1874, Otterlo, K-M), The Bridge at Argenteuil (1874, Munich, and Paris, Orsay); and Summer, Poppies (1875, Switzerland, pr coll; USA, pr coll). His Madame Monet in Japanese Costume (1876, Boston, MFA) was a particularly remarkable painting among those shown by the gallery owner P Durand-Ruel.

• Once back in Paris, Monet set up his easel at La Gare Saint-Lazare (1877, Paris; Cambridge [Mass.], FA; Chicago, AI), thus launching the principle of series of paintings. He also painted The Rue Saint-Denis (1878, Rouen, B-A) and The Rue Montmartre (1878, Paris, Orsay).

• During his stays in Vétheuil and Poissy from 1878 to 1883, Monet immortalized in paint views of the Seine, the countryside in flower, the sea, and the cliffs at Dieppe and Pourville. His wife died in 1879.

• In 1883, Monet settled in Giverny, discovered the Côte d'Azur and the light there, and went on to Étretat and Belle-île. In 1886, he took part in the last Impressionist exhibition, and returned from the Netherlands with more than one painting of Tulip Fields (Paris, Orsay). Monet stayed in Antibes – Saint-Jean-Cap-Ferrat (1888, Boston, MFA). He enjoyed great

success from his joint exhibition with Rodin in 1889 at the Petit gallery.

• In 1890 Monet bought a house in Giverny. In his garden he had a small Japanese bridge built over a large pond filled with water-lilies (*nymphéas*) which he painted tirelessly. He produced the series of *Haystacks* (1890–1, Paris, Orsay) and *Poplars* (1891, London, TG). He remarried in 1891. He worked on the *Rouen Cathedral* series (1892–3, Paris and Washington, NG) and painted scenes in Normandy. The London winters from 1900 to 1903 were his inspiration for *The Thames* (Paris, Orsay) and *London, Houses of Parliament* (1904, Paris, Orsay). While in Venice in 1908 and 1909, he painted *The Doges' Palace* (New York, Brooklyn M) and *The Grand Canal* (Boston, MFA).

• *Les Nymphéas* enjoyed great success in 1909 and Monet developed this theme in his garden studio with *Water-Lilies, Sunset* (1910, Zurich, Kunsthaus), *Nymphéas* (1914–18 and 1920–6, Paris); and *La Maison de Giverny* (1922, Paris, Marmottan). He went back to work after a cataract operation, but died in 1926.

Monet shared with Pissarro, Manet, Renoir, Sisley and Berthe Morisot his desire to be free of the rules governing plasticity in art that were current at the time. His way of painting was being emulated across Europe and in the United States, and it was in him that *Gauguin, *Van Gogh and *Seurat found the starting point for their own art. Monet remains the precursor of the art of abstract landscape and of lyrical abstraction.

APPROACH AND STYLE

Monet loved the landscapes along the banks of the Seine, the seaside, the cathedrals in Paris and Rouen, the Gare Saint-Lazare, the countryside, and his own garden in Giverny, although he also painted a number of portraits and still lifes. His chosen medium was oil paint on small and medium-sized canvases, though he used huge ones for the *Nymphéas* series. He used oils on wood only when painting stage sets. Winning the admiration of a small circle of art lovers, the works of Monet found homes in the collections of his friends, painters (Courbet, Caillebotte), patrons, art dealers and art critics. He was familiar with the aesthetic philosophy of *Delacroix, the art of Turner, Boudin and Jongkind's way of painting from nature, and Japanese prints, which he collected. Monet lived mainly in Le Havre, Paris, Argenteuil and Giverny, and travelled along the Seine, from Fontainebleau to Rouen. He also traversed the Normandy coast from Deauville to Dieppe, explored the Côte d'Azur, discovering Bordighera and Antibes, lived in Algeria and London and spent time in Holland and in Venice.

• Monet's earliest paintings derived from the sombre, melancholic landscapes of the Barbizon School. Then he was influenced by Manet and Courbet, working in broad brushstrokes and using thick, sustained, assertive colours (*Le Déjeuner sur l'Herbe*). He learned from the example of C Corot, who had himself moved away from the academic approach to art, and from Boudin and Jongkind who initiated him into the mysteries of open-air painting; his works, painted on location in front of the subject, became distinctive for their spontaneity and luminosity.

A GREAT PAINTER

◆ Admired by connoisseurs of art, Monet enjoyed fame late in life. From the 1950s onwards, abstract artists designated Monet as their master. His success and his notoriety were both unrivalled.

◆ Monet went against art's traditional precepts: the French Academy called him a 'dauber', the critic L Leroy an 'impressionist'.

◆ He devoted himself to landscapes which were peaceful and decked with flowers (water-lilies, irises, poppies and tulips) and dispensed with any historical or mythological context.

◆ He painted in the open air. He squeezed pure colour out of the tube and fragmented it straight onto the canvas, where his eye reconstituted it into images.

◆ Monet abandoned perspective and frontal viewpoints in favour of a number of superimposed levels or multiple centrings of the image, using a high-angle downward view or looking at the image from below. He replaced a clear brushmark with a blur, and exchanged greys and blacks for colours which he put alongside one another. He dispensed with chiaroscuro and bright tones, preferring coloured shadows. His complex, diversified touch developed out of 'classicism' towards the beginnings of non-figurative art and abstraction.

◆ The chromatic impact of his *Nymphéas* suggested sensation, and no longer emotion.

MONET

- In 1866 Monet painted his earliest masterpieces; he captured the changing nature of air and light. He trusted in his own eye, in his creative intuition, and, he said, in 'the impression of what I myself, being quite alone, had experienced', with no aesthetic programme or system to relate it to. The result was pure fragmented colours applied straight onto the canvas, light-filled reflections and coloured shadows which surrounded and enveloped human figures (*Women In The Garden*).

- In 1870, the art of Turner inspired him to paint his own misty landscapes. In Argenteuil, Monet used the canvas to capture an instant of atmosphere, an impression of movement, the quivering of plant life and the sparkle of water. His pictorial touch became more of a blur, more discontinuous. The unity of his works (such as *Impression, Sunrise*) was ensured by the way in which he structured his compositions around central points of light.

- Monet loved the combination of red and green, horizontal brushstrokes to suggest waves, vertical rod-like strokes for grass and foliage, and smears for shimmers. His execution was swift and fragmented, and his brushstrokes could alternate between fluid and thick in the same painting.

- He had a fondness for painting series of works: the subjects of these were portrayed at different times of the day and Monet froze them in a fleeting moment of visual perception: 'I slog away a lot, I am persistent, wanting to create a series of different effects', he declared, as he searched for 'the instantaneous, above all the outward appearance, the same light used widely throughout'. Monet reached the apogee of his art when his approach triggered the osmosis of subject, sensation and technique.

- His final works recorded his reveries about flora and water, the proliferation of wisteria, white water-lilies and reflections in water; Monet painted with total freedom. The shape of the image was distorted into live, convulsive, abstract matter.

Impression, Sunrise
1872. Oil on canvas, 48 x 63cm, Paris, Marmottan

'I had sent off to the exhibition in the Boulevard des Capucines in April 1874 a piece I'd made in Le Havre, from my window, of the sun in mist and, in the foreground, of a number of ships' masts sticking up … I was asked for a title for the catalogue, and what I'd done certainly couldn't pass for a view of Le Havre; so I replied: "Put down Impression". Out of that, Impressionism was created and the jibes came thick and fast'. 'They are Impressionists in this sense, that they convey not the landscape but the sensation produced by the landscape' (J-A Castagnary, 1874). The kind of perspective being suggested here came very close to abstraction. On the other hand, the black boat, the reddish glow of the sun and its reflection in the water ensured the appearance of landmarks just as, in a more subtle way, they did the distant port and its cranes, the boats and the smoke from the factories. The sky, mist and water have been turned pink, violet and bluish by light and colour. The freedom of Monet's method can be seen in the fluidity of the more distant stretches of water, while the thick impasto he has applied captures the sun's reflection.

Green Reflections, Room 1, Wall 3 (east), **Cycle of Nymphéas** or **Large Decorations**
1920–6. Oil on canvas, 2 panels each 2 x 4.25m, Paris, Orangerie des Tuileries

*Monet's 'water-garden' was overflowing with water-lilies (in French nymphéas, nymphea being the
botanical name for the white-flowered water-lily). The Nymphéas or Water-Lilies, terms which from
then on were automatically identified with Monet's name, described the aquatic and floral works he
painted between 1899 and 1926. In 1918 Monet offered two decorative panels to Clemenceau, then
Prime Minister of France, as a gift to the nation. This gift was formalized on 12 April 1922, by which
time it consisted of 22 paintings which Monet had completed between 1920 and 1926.*
*Monet created a world without beginning or end, without horizon or shore, a world bathed by sky and
sea, which embodied 'limpidity, iridescence and reflection all at once' (P Claudel, 1927). 'It is an uneasy
feeling as well as a pleasure to see oneself surrounded by water on all sides without being touched by it'
(R Gimpel, art dealer). Although the spectacle of colour, pure, abstract and lyrical creation, concealed the
subject, water-lilies remained the source of inspiration and the real subject.*
This enormous series became an obsession for Monet, who worked on it up until his death.

▌KEY WORKS
Monet painted hundreds of canvases of which the most important number about 400.
Le Déjeuner sur l'Herbe, 1865, Moscow, Pushkin and Paris, Orsay
Women in the Garden, 1866, Paris, Orsay
Terrace at the Seaside, Sainte-Adresse, 1867, New York, MM
The Magpie, c.1868–9, Paris, Orsay
La Grenouillère, 1869, New York, MM
The Beach at Trouville, 1869–70, London, TG and Paris, Marmottan
Impression, Sunrise, 1872, Paris, Marmottan
Regatta at Argenteuil, 1872 and 1874, Paris, Orsay
Poppies, Argenteuil, 1873, Paris, Orsay
The Bridge at Argenteuil, 1874, Munich, NP and Paris, Orsay
La Gare Saint-Lazare, 1877, Paris, Orsay
Étretat, Rough Sea, 1883, Lyon, B-A
Woman With An Umbrella, Paris, Orsay
Rouen Cathedral, 1892–3, Paris, Orsay and Washington, NG
The Water-Lily Pond: Pink Harmony, 1900, Paris, Orsay
London, Houses of Parliament, 1904, Paris, Orsay
Les Nymphéas, 1914–18 and 1920–26, Paris, Orangerie des Tuileries

BIBLIOGRAPHY
Clarke, M and Thomson, R, *Monet: The Seine and the Sea*, National Galleries of Scotland Publications,
Edinburgh, 2003; House, J, *Monet, Nature into Art*, Yale University Press, New Haven, CT and London,
1986

Cézanne

In solitude, Cézanne constructed an artistic approach from which Cubism would draw inspiration. The 'brutality' of his early works was succeeded by mastery and balance, and then by a formal colour harmony which ensured a work's unity. 'He has treated objects as he has treated man ... He takes them and hands them over to colour. He imposes on them a form which can be reduced to abstract formulae, often mathematical ones ... and which we call image' (Wassily Kandinsky, 1910).

LIFE AND CAREER

• Paul Cézanne, French painter (Aix-en-Provence 1839–Aix-en-Provence 1906), had, as early on as his college days, formed a friendship with Émile Zola, who encouraged him to paint. In 1859 he decorated Jas de Bouffan, the country house of his father, who had started out as a hatter and then became a banker, and his mother, who had been a worker in his father's factory.

• In 1861 Cézanne was in Paris where he was trained at the Académie Suisse and often visited the Louvre. In 1863 he was a witness to the quarrel between 'official' art and the new painters including *Courbet, *Manet and *Delacroix.

• His first period, labelled 'Romantic', produced some sombre works, such as *The Artist's Father* (1860–3, London, NG), *Portrait of Uncle Dominic* (1866, New York) and *Portrait of Achille Empéraire* (1866, Paris, Orsay). Cézanne was fond of scenes which were erotic or macabre but in any case fleshy and brutal, such as *The Orgy* (1867–72, pr coll) and *The Abduction* (1867, Cambridge, King's College). He painted still lifes: *Loaves and Eggs* (1865, Cincinnati, AM); *Still Life with Kettle* (1869–70, Paris). He spent the Franco-Prussian War of 1870 in L'Estaque, producing *Snow Thaw at L'Estaque*, c.1870, Zurich) and then painted *Chestnut Tree Avenue at Jas de Bouffan* (c.1871, London, NG).

• In 1873 at Auvers-sur-Oise, with Hortense Fiquet, the companion who had just given birth to their child, Cézanne initiated his 'Impressionist' period alongside Pissarro and *Van Gogh. He worked at touch and colour in *The View of Auvers* (c.1873, Chicago). He exhibited *A Modern Olympia* (1873, Paris) inspired by Manet, and *The House of the Hanged Man at Auvers* (1873, Paris) at the first Impressionist exhibition (1874), at which he was taunted, as he would be again in 1877 at the time of the Group's second show, the last where he would show his work side by side with theirs. Cézanne gave his objects and figures rhythm in space: *Still Life With Soup Tureen* (c.1873–4, Paris); *Still Life With Vase and Fruit* (c.1877, New York, MM); *Madame Cézanne in a Striped Skirt* (c.1877, Boston); *Madame Cézanne Leaning on her Elbows* (1873–7, Geneva, pr coll); *Self-Portrait* (c.1875, Paris, pr coll); and the portraits of V Chocquet. The voluptuous, brushed bodies of the *Six Women Bathing* (*Baigneuses*, 1874–5, New York) pinpointed his relationship with space and colour.

• During his mature period, Cézanne in 1884 visited his friends Zola, *Monet and Renoir at L'Estaque, after meeting Adolphe Monticelli in Marseilles. He moved away from the Impressionists in *The Bridge at Maincy* (1879–80, Paris) and *Melting Snow at Fontainebleau* (1879–82, New York, MOMA). The air shimmers around the *Three Bathers* (1879–82, Paris).

• Cézanne studied the geometry and volumes of forms and of composition, which he organized in his views of *Mont Sainte-Victoire* (1885–7, London; New York, MM; Paris, Orsay), the village of *Gardenne* (1886, Merion, BF) and *Rocks at L'Estaque* (1882–5, São Paulo).

• In 1886, his father died and left him comfortably off; he broke with Zola and withdrew from company. Only a few initiates were supporters of his work, including the art dealers J Tanguy and A Vollard and the critics J K Huysmans and Zola.

• *The Five Bathers* (1885–7, Basle) and *Le Grand Baigneur* (1885–7, Paris) provide a synthesis of Cézanne's artistic approach and the way in which his human figures merge, in form and plasticity, with the nature world surrounding them.

• Cézanne produced his major works from 1888–90 onwards. His constructions revealed how the foundation and substance of a work were expressed using forms he had made geometrical: *The Blue Vase* (1889–90, Paris), *The Kitchen Table* (1888–90, Paris), and *Apples and Oranges* (c.1899, Paris). His human figures were robustly anchored in their setting, as with *Harlequin* (1888–90, Washington, NG), *Woman with Coffee Pot* (c.1890, Paris) or the series of *Card Players* painted between 1890 and 1896 (Merion; Paris, Orsay; New York, MM; London, CI). It was the dream, however, that haunted *Boy in Red Waistcoat* (1890–5, Zurich, E G

Bührle Foundation) or the *Portrait of Ambroise Vollard* (1899, Paris), one of the most geometric portraits Cézanne ever painted.

• Delicate colours soften *Mont Sainte-Victoire* (c.1890, Paris) and *The Lake at Annecy* (1896, London, CI), whereas the landscapes of Provence show an evident rigour of construction which became increasingly marked: *La Maison Maria* (c.1895, Forth Worth, Kimbell, AM); *Quarry at Bibémus* (c.1895, Essen, FM); *The Great Pine* (c.1898, São Paulo, MA).

• Cézanne took part in the Universal Exhibition of 1889 and showed work in Brussels in 1890. The retrospective exhibition of his work, held at Vollard's in 1895, was an event; at last he achieved recognition, and praise was heaped upon him at the 1903 Autumn Salon.

• Cézanne's final works glorified geometric form and colour: *Men Bathing* (1900-5, Merion, BF; London, NG); *Les Grandes Baigneuses* (1906, Philadelphia); the views of Le Château Noir; the skulls; the last of the *Sainte-Victoire* paintings (1904-6, Philadelphia; Moscow; Zurich, E G Bührle Foundation); *Woman in Blue* (1900-4, St Petersburg) and *Portrait of Vallier* (1904-6, Washington, NG).

In 1905, Vollard put on a show of Cézanne's watercolours. The 'retrospectives' became more frequent. Cézanne's way of seeing influenced, among others, the Nabi group of painters, notably Émile Bernard, as well as the Fauves and in particular the Cubists. His art established itself as the foundation of modern and contemporary pictorial aesthetics.

APPROACH AND STYLE

Cézanne became attached to painting landscapes, portraits and still lifes. Apples and fruit bowls, men and women bathing, Mont Sainte-Victoire and L'Estaque were his favourite subjects. He painted a large number of portraits of his wife and of self-portraits. He worked in different mediums, on canvas or paper, in oils, watercolour and crayon, and used a variety of formats. The main buyers of his works were Count Doria, V Chocquet, I de Camondo, S Courtauld, A Pellerin, his painter friends, and art dealers such as A Vollard. At different moments during his career, Cézanne was influenced by Spanish painters such as Ribera, the Italians *Titian and Giorgione and the French Delacroix, Courbet, *Daumier and Manet. He borrowed from them formal elements and their rhythm, which he used in support of his style. In Auvers-sur-Oise he worked side by side with *Picasso. Cézanne rarely dated his paintings; the most recent chronology of his works, which was drawn up in 1995, divides his output by decades.

• The works Cézanne created in the 1860s were distinguished by his 'gutsy' manner, which expressed his explosive impulses and his agonies. He would compose onto a sombre back-

A GREAT PAINTER

◆ Cézanne met with scorn and incomprehension from his contemporaries until the 1890s.

◆ He copied the Impressionists. He also developed a new way of seeing forms which was geometric, coloured and pre-Cubist.

◆ Cézanne made Mont Sainte-Victoire and L'Estaque famous. He brought fresh vision to the painting of a woman bathing and made it the subject of an imposing and modern way of constructing an image.

◆ In his late work he evolved a specific art of colour: 'his method was a singular one ... he started with shadow, and applied a first blob of paint which he then covered with another more expansive one and then a third, until all these colours, by creating a screen, shape the object as they colour it ... All these modulations of his had a function he had thought out in advance. The process lasted ... until [the colours] found their contrasts in what he had set against them' (Émile Bernard, 1907).

◆ Cézanne's compositions spurned the traditional rulebook of how to organize a painting: the vanishing point could be non-existent, and the same landscape could appear as if it were being seen from several angles. Cézanne rejected trompe-l'œil, and would instead bring together volumes related to a single flat surface in an illusion of a third dimension. Skilful geometry linked objects together, even to the point of interpenetration.

◆ He modulated his colours to infinity. His white produced multiple reflections. Gradations of colour underpinned the transition from one motif to another. His paint could be thick, even crusty, or fluid and sometimes uneven. The intentional unfinished appearance of his final works was part and parcel of his desire to attain 'formal abstraction'.

ground crude still lifes which featured few of the ordinary domestic utensils of the day, always lit in exactly the same way and evocative of *bodegones*, Spanish still lifes. The coloured paste he used and his dynamic, broad and often thickened stroke built his objects up by working on small surface areas in a way that echoed the art of Ribera and Daumier. He painted portraits with a knife, as did Courbet, and carried on Manet's fragmented, angry touch and his abundance of rough patches. The landscapes and the nudes, which shared the same plasticity, had rounded contours and a suppleness of form similar to that of works by Delacroix.

• Around 1870 Cézanne's form became less uneven; there was a harmony of colour, and the brushstroke quietened down. In these 'Impressionist' years, Cézanne replaced the priority of well thought-out labour with that of the immediate impression. However, he robustly structured his landscapes, which were devoid of human presence, and whose population of trees was 'magnificent and severe, as old as the gods and as solemn as monuments' (J and E Goncourt, 1871), using sombre colours which he shaded in order to explore the interplay of light and shade.

• At Auvers-sur-Oise in the mid-1870s he followed Pissarro's advice and painted, on location in front of the subject, masses of greenery and the cubic structures of family houses. He lightened his palette, brushed his canvases with a lightness and an exhilaration very far removed from the fluidity and atmospheric colour of Monet or the 'jabbed' painting style of Pissarro: 'Monsieur Cézanne was slapping the paint on', noted the critic G Coquiot in 1919. Cézanne's portraits, which were strangers to Impressionism, already belonged to his 'constructive' period. Unlike in his sombre, sallow self-portraits, he added touches of white to his portraits of others. The coloured shadow of pure colour emanated from his new plasticity.

• In his 'constructive' period during the 1880s, his almost geometric structure brought out what was essential in his paintings. Cézanne constructed landscapes visualized from different angles. He rhythmically arranged the various synthetic, linear or undulating levels which he allocated sparingly or profusely depending on the work, and these sometimes seem disorganized or unbalanced in the still lifes. His long brushstrokes, straight or oblique, constructed the space, while his use of an interrupted, jerky line conveyed a sense of movement. The colour became autonomous and in this it was helped by the increasingly simple form. The women bathers, dumb, monumental and pyramidal figures captured in elaborate poses, progressively merged with the solid, compact landscape. The strokes became less visible, shorter and more oblique and were placed closer together. Cézanne retained the geometrical element in order to avoid abstraction. Although he declared that 'I am the first example of a new art ... diametrically opposed to contour', his art bore witness to a science of painting which was out of the ordinary.

• In the second half of the 1880s, his landscapes (including the first series of *Mont Sainte-Victoire* paintings) the bathers and a number of portraits revealed a new serenity and grandeur. Cézanne now drew closer to his intention of 'painting like *Poussin, but from nature'. The dominant forms were massive, demonstrating that the main thought-process behind them was targeting volume and space in such a way that detail was being made insignificant. Stroke and colours presented a perfect unity of form, even going so far as to cause some melancholic portraits to dissolve in colour.

• The works of Cézanne's mature years (the 1890s), referred to as the 'synthetic' period, underlined the solidity of his compositions and the imposing presence of human figures as veritable forces of nature, self-willed and silent, immovable and grave, whom Cézanne observed with sympathy, the more so given that he did not paint them outside the actual sittings. The evident, visible preparation contributed to the modulation of colours. The thick, opaque pictorial matter now became, in some cases, as light as in watercolour and as unfinished as a sketch.

• Even though Cézanne sometimes returned to the sharp traits of his earliest works, Roger Fry argued in 1926 that the crystallization of forms had

Mont Sainte-Victoire
c.1890. Oil on canvas, 62 x 92cm, Paris, Musée d'Orsay

*Mont Sainte-Victoire took its name from the victory of Caius
Marius over the Barbarians (1st century AD). Cézanne painted
this landscape some 20 times, in two periods, from 1882 to
1890 and from 1901 until his death.*
*In the foreground there is a low wall, a large pine tree and a
copse; in the mid-ground, Cézanne has placed the valley, the
ochre roof-tops, the aqueduct and the areas containing plots of
land; in the background, he has depicted the mountain and the
Plateau du Cengle. Grandeur and calm emanate from this
composition and from Cézanne's structured brushstrokes, far
removed from the Impressionist aesthetic. The volumetric forms
in the foreground and the massive mountain far away relegate
all of the other elements in the painting to the middle distance.
Cézanne strove to achieve a dense, rigorous construction of
space. His approach aimed not to 'represent' but to compose, to
build this 'lovely motif (to quote his own words) in a solid
structure, and from now on painted for himself. The 'law of
harmony' and the 'logic of organized sensations' were revealed
in the internal geometry of nature, in Cézanne's deployment of
his brushstrokes in firm brushed blobs which contributed
towards the mobility of the whole, and in the play of subtle
contrasts between warm and cold tones (greens, blues, ochres
and mauves) which merged in a soft, gilded luminosity.
This work, which was presented to the Musée d'Orsay in the
autumn of 2000, came from the private collection of the
industrialist A Pellerin.*

CÉZANNE

been completely achieved. According to Fry, the different levels, from foreground to background, of a Cézanne painting became entangled and penetrated each other's space as a means to building a construction whose plasticity was extremely complex. Each level, he said, was closely connected to all the others. Not only did Fry find that the forms were reduced to having very simple straight-line contours, but that even the colour had been, as it were, systematized.

• From here on, Cézanne modulated his chromaticism in order to paint what he experienced: an all-powerful nature which was stocked with trees, rocky, watery or mountainous. His imposing 'tree portraits', his pine trees and rich still lifes, seen from close at hand, invade the space of the canvas.

• Cézanne's objects and fruit, either placed side by side or one on top of the other, sometimes merge with each other as a result of his use of modulated and coloured lines which have been shaded and graduated to infinity, and which make visible to the viewer his evident preparatory work in applying thin layers of paint. Cézanne created a dialectic of form between the unbalanced structure of a work and other objects in it, rebalancing the composition by so doing. This constructing of space, which was strictly Cézanne's own invention, would later be developed by the Cubists.

• From 1900 Cézanne further refined his style. His backgrounds became barely distinguishable. His final portraits were indifferent, inexpressive and anonymous, and revealed a consistency of paint which was almost crusty, it had been worked on so much.

• In his landscapes, which lacked the dimension of depth, he accentuated the geometric simplification of images and the overlapping of houses, rocks and trees: 'Treat nature by using cylinders, spheres and cones, the whole thing put into perspective', he declared to Émile Bernard, one of the Nabi group. The second series of *Mont Sainte-Victoire* paintings, where the mountain was consistently being viewed from slightly different angles, transmitted the scene's changing luminosity: 'as one variation succeeded another, their execution became more impassioned ... This mountain dissolved in a torrent of vigorous brushstrokes and became integrated with the air surrounding it and which these same brushstrokes were busy creating' (T Reff, 1978). Cézanne alternates with great ease between thick coloured layers and thin liquid ones. 'The colouring effects which provide the light are, to my way of seeing things, an instrument of abstraction, and do not allow me to cover my canvas, nor to pursue the defining of objects', he said.

KEY WORKS
The catalogue of Cézanne's work includes about 900 paintings and 400 watercolours.
Portrait of Uncle Dominic, 1866, New York
Still Life with Kettle, 1869–70, Paris, Orsay
Snow Thaw at L'Estaque, c.1870, Zurich, E G Bührle Foundation
The View of Auvers, c.1873, Chicago, AI
A Modern Olympia, 1873, Paris, Orsay
The House of the Hanged Man at Auvers, 1873, Paris, Orsay
Still Life With Soup Tureen, c.1873–4, Paris, Orsay
Self-Portrait on a Rose Background, c.1875, Paris, Orsay
Six Women Bathing, Baigneuses, 1874–5, New York, MM
Madame Cézanne in a Striped Skirt, c.1877, Boston, MFA
The Bridge at Maincy, 1879–80, Paris, Orsay
Three Bathers, 1879–82, Paris, Orsay
Rocks at L'Estaque, 1882–5, São Paulo
Mont Sainte-Victoire, 1885–7, London, NG
The Five Bathers, 1885–7, Basle), KM
Le Grand Baigneur, 1885–7, Paris, Orsay
The Kitchen Table, 1888–90, Paris, Orsay
The Blue Vase, 1889–90, Paris, Orsay
Woman with Coffee Pot, c.1890, Paris, Orsay
Mont Sainte-Victoire, c.1890, Paris, Orsay
Card Players, 1890–6, Merion, BF
Apples and Oranges, c.1899, Paris, Orsay
Portrait of Ambroise Vollard, 1899, Paris, PP
Woman in Blue, 1900–4, St Petersburg, Hermitage
Sainte-Victoire, 1904–6, Moscow, Pushkin
Les Grandes Baigneuses, 1906, Philadelphia, MA

Les Grandes Baigneuses
1906. Oil on canvas, 2.08 x 2.51m, Philadelphia, Philadelphia Museum of Art

Cézanne worked relentlessly at the theme of men and women bathing, painting a great many works on the subject between the mid-1870s and his death. Three of these, which he created on very large canvases, were done at the end of his life. The version in the Philadelphia collection is probably unfinished but apparently the most accomplished of the three and no doubt the last.

*Cézanne had in his mind's eye the aesthetics of Giorgione, Titian, *Rubens, Poussin and, as to the bathers themselves, *Watteau, Boucher, *Fragonard and Courbet. A number of naked women have come together on a sandy beach by the riverside. They are talking, stroking a whitish shape which, to judge by the other versions of the painting, would appear to be a dog, and one of them is swimming. On the other bank, two figures are standing. The oblique lines of the trees make a shape like a vault whose arches touch above the top of the painting, and the basic, 'primitive' shapes of some of the bodies are aligned with the curves of the tree trunks. In the centre of the painting, Cézanne opens the space up to a background: a similar alignment, in the centre here, links the dog, the woman swimming, the figures on the opposite bank and the chateau.*

The bodies which have been made geometric, the rhythm and positioning of the brushstrokes, and the sober, harmonious colours of blue-green, ochre and mauve, cause the figures to blend into the landscape. Cézanne applies light, opaque touches which do not cover the layer of white sizing, a source of luminosity and lightness. His pursuit of the image and not the subject or the motif, using an almost abstract mathematical form, characterized Cézanne's style and heralded Cubism.

BIBLIOGRAPHY

Cézanne, exhibition catalogue, RMN, Paris, 1995; Rewald, J, *Cézanne*, Thames and Hudson, London, 1986

Gauguin

Gauguin was an independent artist who lived on the margins of the art world, a rebel imbued with mysticism. After his Impressionistic early works, he created Synthetism and Cloisonnism, prior to establishing close links with Symbolism. He advocated a return to sources, and to a Primitivism which, drawn as it was from ancestral traditions and exoticism, came through in some brilliantly coloured, incantatory paintings with 'barbaric' titles, 'roughly' made and peopled with Breton or Tahitian deities and myths.

LIFE AND CAREER

• Paul Gauguin (Paris 1848–Atuona, Marquesas Islands, 1903), French painter, seems to have been influenced by his Peruvian ancestry and the Saint-Simonism of his grandmother, both of which provided fertile ground for his imagination. In 1851, his journalist father fled from the coup d'état and died in Panama; his family returned to Peru. While at school in Orléans from 1855 onwards, Gauguin persisted in his dreams of escape. From 1865 to 1868 he was in the merchant navy and then the French Navy itself. He became a stockbroker in 1871 and then, in 1873, married a Danish woman, Mette Gad.

• He struck up a friendship with Pissarro, bought some Impressionist pictures, and painted *The Seine at the Pont d'Iéna* (1875, Paris, Orsay). He submitted a canvas to the official Salon in 1876 and then joined the Impressionists, with whom he showed work from 1879 to 1886: *Undergrowth in Normandy* (1884, Boston), *Self-Portrait for his Friend Carrière* (c.1886, Washington, NG). From 1883 onwards he devoted himself wholly to painting. In 1885 he went through marital breakdown and poverty. In the following year he submitted 19 canvases to the Eighth Impressionist Exhibition.

• Gauguin went to stay for the first time in Pont-Aven, Brittany, where he met Émile Bernard (summer 1886) and painted *Dance of the Four Breton Women* (1886, Munich). In 1887 he set out for Martinique where he was to discover the power of colour.

• In 1888 he returned to France and developed in Pont-Aven his *Vision After The Sermon* or *Jacob Wrestling with the Angel* (Edinburgh), a manifesto work which affirmed, as he put it, 'a rustic, superstitious simplicity'.

• He then spent time in Arles with *Van Gogh and painted *Les Alyscamps* (1886, Paris, Orsay), *The Beautiful Angel* (1889, Paris, Orsay), and *Old Women in Arles* (1888, Chicago, IA). Gauguin and Van Gogh had a confrontation: Van Gogh injured Gauguin, who then returned to Paris. Gauguin took part in the 'Exhibitions of the XX' in Brussels as well as in the show held at the Café des Arts by Volpini as part of the Universal Exhibition in Paris.

• His third stay in Pont-Aven and the surrounding area, in Le Pouldu, in 1889 and 1890, reinforced his aesthetic convictions. He painted the *Portrait of Marie Derrien* (1890, Chicago, AI), *The Yellow Christ* (1889, Buffalo [NY], Albright-Knox AG), *Self-Portrait with the Yellow Christ* (1889–90, Paris) and *Christ on the Mount of Olives* (1889, West Palm Beach, NG). He immortalized *The Wrack-Balers* (1889, Essen, FM), and *Young Breton Girls by the Sea* (1889, Tokyo, National Gallery of Western Art). *Still Life with Fan* (1889, Paris, Orsay) was in the style of Cézanne, whereas his *Self-Portrait* (1889, Washington, NG) was 'synthetic' and 'Expressionist'. His *Loss of Virginity* (also called *Spring Awakening*, 1890–1, Norfolk, The Chrysler Museum) confirmed the Symbolists and the Nabi group of painters in their estimation of him, although his destitution was detrimental to his work.

• In 1891 Gauguin sold his paintings by auction and took a boat to Tahiti. Polynesia dazzled Gauguin, so much so that he thought he was in the Garden of Eden: *Tahitian Women* or *On the Beach* (1891, Paris, Orsay); *The Meal* (1891, Paris, Orsay); *Te Faaturuma* (*The Sullen Woman*, 1891, Worcester, AM); *Orana Maria* (*Hail Mary*, c.1891–2, New York); and *Arearea* (1892, Paris, Orsay). The culture of Polynesia and the lushness of its tropical colours inspired him to paint *Manao Tupapau* (*The Spirit of the Dead Keeps Watch*, 1892, New York, MOMA) and *Hina y Fatou* (*The Moon and the Earth*, 1893, New York, MOMA).

• Once again without money and now also ill, Gauguin returned to France in 1893. His paintings were aggressive and nostalgic: *Otahi* (*Alone*, 1893, Paris, pr coll), *Annah the Javanese Woman* (1893, location unknown) and *Paris in the Snow* (1894, Amsterdam, national Van Gogh mus).

• Gauguin went back to Tahiti in March 1895. Isolated, in debt, ill, depressive and overcome by the deaths of his daughter Aline and the baby born from his relationship with the Tahitian woman Pahura, the man who appears in *Self-Portrait Close to Golgotha* (1896, São Paulo) is melancholically questioning life and human destiny: *Nevermore* (1897, London, CI),

236

Te Reriora (*The Dream*, 1897, London, CI), *Where Do We Come From? What Are We? Where Are We Going?* (1897, Boston). In February 1898 he survived a suicide attempt.

● From 1898 onwards Gauguin received support and financial help from art lovers, but his living situation was a precarious one. He was involved in a bureaucratic battle with the island's civil and religious authorities, who were hostile to his painting and to his nudes. He nevertheless painted *Faa Iheihe* (*Tahitian Pastoral*, 1898, London, NG), *Two Tahitian Women* (*Breasts With Red Leaves*, 1899, New York, MM) and *Three Tahitians* (*Conversation*, 1899, Edinburgh, NG).

● In 1901 Gauguin, seriously ailing, settled in Atuona on Hiva-Hoa, one of the Marquesas Islands: *... And the Gold of their Bodies* (1901, Paris), *The Call* (1902, Cleveland, MA), *Riders on the Beach* (1902, Paris, Niarchos Coll) and *Contes Barbares* (1902, Essen). During his last years, Gauguin worked on sculpture and engraving, and wrote letters and essays: *The Modern Spirit and Catholicism* and *Before and After*. On his death, 20 of his nude paintings of the people of the Marquesas Islands were destroyed by the Bishop of Hiva-Hoa.

The life's work of Gauguin, painter, sculptor and ceramicist, had an enormous impact throughout Europe: in the art of Edvard Munch, Paula Modersohn-Becker and E Hodler, and also in the early work of *Picasso, the Fauves such as André Derain and Raoul Dufy, and the Expressionists Ernst Ludwig Kirchner, Alexei von Jawlensky and Max Pechstein.

APPROACH AND STYLE

Gauguin found his inspiration in everyday life. He captured his human subjects in their landscape surroundings or in their houses. He painted portraits and self-portraits, religious scenes, and a number of landscapes and still lifes. The scale of these varied, with medium-sized canvases predominant. Gauguin enjoyed the support of several art enthusiasts, among them Shuffenecker, Fayet and the dealers Vollard and Theo Van Gogh. Gauguin admired *Delacroix's colour and the way *Raphael and *Ingres used line. To begin with, he took his bearings from F Bonvin and Stanislas Lépine, and then, on his return from Martinique, he looked to *Degas and Cézanne. He was encouraged by Pissarro; he became involved alongside Émile Bernard in the pictorial experiments of the Pont-Aven group and in the Symbolism of Pierre Puvis de Chavannes. In Arles, he worked with Van Gogh. Yet, he maintained, 'everything I've learnt from others has bothered me. I can honestly say that nobody has taught me anything ... The centre of my art is in my own mind ... I am strong because I have never been put off my stroke by others and because I do what is in me'. Brittany, Martinique and especially Polynesia were the places where he preferred to be.

● In his earliest works, Gauguin painted the banks of the Seine in bright colours after the manner of the landscape painter Lépine. His very close tones produced a muted, hazy kind of harmony. From Pissarro, Gauguin acquired the painter's skill in applying small, closely packed strokes. Degas was his mentor when it came to his realist interior scenes (*Suzanne*

A GREAT PAINTER

◆ Misunderstood in his lifetime, except by the Pont-Aven group, the Nabis and a handful of art lovers, Gauguin was rediscovered in 1949, at the time of the exhibition at the Orangerie in Paris to mark the centenary of his birth.

◆ He was 'the first to become aware of the need for a break with the past which would enable the modern world to come into existence, the first to abandon the Latin tradition ... in order to trace original vigour back to the old barbarian tales and savage gods, and the first, too, to dare (thinking it through clearly) to transgress and even reject external reality at the same time as rationalism. He taught modern art how to create in freedom' (R Huyghe, 1949).

◆ Gauguin painted wild nature, the strength, innocence and liberty of being set free from the conventions of bourgeois society, whether Breton or Polynesian. His universal, sometimes androgynous, 'chaste' nudes were innovatory. He brought together objective reality and the imaginary world in the same painting. His religious scenes were transformed to fit the Polynesian aesthetic.

◆ His compositions were unusual: he sometimes relegated the human figure to the middle ground and played with differences of scale.

◆ He applied a flat colour-wash which had been darkened with Prussian blue or black (a process which became associated with Cloisonnism), and opened the painting to a confrontation of pure colours laid side by side in flat colour-washes (*Vision After The Sermon*).

Sewing, 1880, Copenhagen, NCG). It was from his attraction to the decorative arts that he derived his sense of the ornamental.

• In Pont-Aven (1886), Gauguin abandoned Impressionism for what he called painting 'of sensation. It's all there, in that one word', he declared. It was a refined, poetic, sacred kind of painting: 'I love Brittany. There I can find what is savage and primitive. When I hear my boots echo on this granite ground, I hear the muted, thudding, powerful sound which I am aiming for in painting', he explained. He rejected the official genre of painting and the Graeco-Roman world, turning instead to popular art, the Middle Ages and the characteristic Cloisonnism of Japanese prints. For Gauguin, Puvis de Chavannes was 'the Greek to my savage, my wolf'; the former offered the viewer the idea, the decipherable symbol, whereas Gauguin cried out for 'emotion first, understanding afterwards!'

• From his Martinique experience (1887) came his fondness for ceramics, concise drawing and saturated or pure colour far removed from the reality of nature.

• In Arles (1888) his preoccupation with equilibrium and harmony contrasted with Van Gogh's torment: 'He is romantic and I am more inclined to a primitive state of being. As far as colour is concerned … I detest the jiggery-pokery of technique' (*Old Women in Arles*).

• In Pont-Aven (1889 and 1890), Gauguin demonstrated his freedom and confidence in his art, which bore the hallmarks of Cézanne's form, primitive art and the Breton tradition (*Self-Portrait with Yellow Christ*).

• In Tahiti he saturated the canvas with lush colours. The energy of Polynesian traditions and the indolent beauty of its women made him think of the broad classical rhythms of Egyptian bas-reliefs, early Italian depictions of the Virgin Mary and the flat colour-washes of Japanese prints. His Oceanian female nudes became massive, dispensing with any sexual connotation, and claimed an increasingly key place in his output. This nostalgia for a lost world nourished Gauguin's taste for symbolism; he introduced floral motifs and totemic figures which formed sexual or religious symbols. 'Line is colour', he wrote at that time, 'pure colour! Everything must be sacrificed to it. The intensity of colour will indicate the nature of the colour'. Form and shade of colour gave his paintings a vital force which was both spiritual and emotional (*Arearea*).

• In Paris (1893), his work became tinged with nostalgia. The temptation of Impressionism (*Paris in the Snow*) and the remnants of his Pont-Aven experience surfaced again.

• In Tahiti and Atuona (1895–1903), Gauguin's physical frailty was manifest in his work; his colours grew pale and only occasionally was his technique vibrant. Poverty compelled him to use paint sparingly on the canvas. His Tahitian women and his self-portraits bore the scars of his disillusionments.

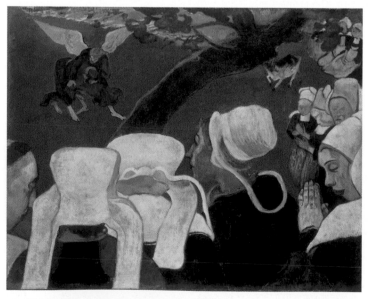

BIBLIOGRAPHY

Gauguin, exhibition catalogue, RMN, Paris, 1989; Thomson, B, *Gauguin*, Thames and Hudson, London, 1987

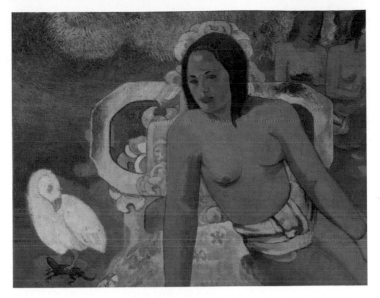

Vairumati, 1897. Oil on canvas, 73 x 94cm, Paris, Orsay.

This young Polynesian Eve takes on a mythical dimension as painted by Gauguin. He described her as follows: 'she was tall of stature, and the sun's fiery light shone in the gold of her flesh, while all the mysteries of love lay sleeping in the night of her hair'. The lavishly sculpted and gilded bed-head resembles the back of a throne and creates a halo round the young girl's head, accentuating the suggestion of her as goddess-mother, source of all life. The totemic dimension of this body, with its massive, stiff arms and legs, is allied to the sensuality of the face and breasts which are in essence Classical and western. The decoration on the woodwork of the bed and the incantatory posture and gestures of the two women in the background recall the bas-reliefs of Borobudur (Java, Indonesia). The white bird holding a lizard in its talons symbolizes the eternal cycle of desire, possession and death, an allegory of paradise lost.

KEY WORKS
Gauguin's work consists of about 460 paintings.
Undergrowth in Normandy, 1884, Boston, MFA
Dance of the Four Breton Women, 1886, Munich, NP
Vision after the Sermon or *Jacob Wrestling with the Angel,* 1888, Edinburgh, NG
Les Alyscamps, 1886, Paris, Orsay
Self-Portrait with the Yellow Christ, 1889–90, Paris, Orsay
Tahitian Women or *On the Beach,* 1891, Paris, Orsay
Orana Mari, c.1891–2, New York, MM
Mahana no Atua, 1894, Chicago, AI
Self-Portrait Close to Golgotha, 1896, São Paulo, MA
Where Do We Come From? What Are We? Where Are We Going?, 1897, Boston, MFA
... And the Gold of their Bodies, 1901, Paris, Orsay
Contes barbares, 1902, Essen, FM

Vision after the Sermon or **Jacob Wrestling with the Angel**
1888. Oil on canvas, 73 x 92cm, Edinburgh, National Gallery of Scotland

Talking about this painting, typical of the Pont-Aven school, Gauguin declared: 'I think I have created a great rustic and superstitious simplicity in these figures. The whole thing is very severe. For me, in this painting, the landscape and the struggle only exist in the imaginations of the people praying, in the aftermath of the sermon. That is why there is a contrast between the indigenous people and the struggle in their landscape, a struggle which does not belong there and is disproportionate'.
The absence of depth, the decorative lines, and the pure colours simplify the representation. Gauguin has 'compartmentalized' the Breton headdresses and the trunk of the apple tree placed diagonally across the canvas. The ground has become, synthetically, a scarlet blob applied in a flat colour-wash. The influence of Japanese prints can be seen in the apple tree, the uplifted perspective of the ground seen as though it were vertical, the figures cut off halfway down and the relegation of the main subject to the middle ground.

Van Gogh

The output of Vincent Van Gogh was painted over a period of only ten years. It was intimately linked to the events of his life and bore the distinguishing marks of his tormented and unstable personality as well as of the places where he lived. Van Gogh's canvases are inflamed by his frantic quest for an osmosis between colour, drawing and form.

LIFE AND CAREER

• Vincent Van Gogh (Groot Zundert, Brabant 1853–Auvers-sur-Oise 1890), Dutch painter, was the son of a pastor and nephew of an art dealer. From infancy he showed symptoms of psychological malaise and artistic gifts. While employed by the Galerie Goupil, from 1869 to 1876, in The Hague, Brussels, London and Paris, the young Van Gogh discovered the art of Jean-François Millet. Disappointment in love and his search for the absolute inclined him towards evangelism. His fanaticism earned him a repudiation from the Church. In August 1880, he took up his pencils and set out to dedicate himself to art.

• While living in Holland from 1880 to 1885, in The Hague and Etten, where his parents lived, Van Gogh drew assiduously, used watercolours and studied street scenes and painting with his cousin, A Mauve, a painter of some renown at that time. With sympathy and realism Van Gogh portrayed the working people of northern Holland and Nuenen in the Brabant, which he found in the literature of Émile Zola or Charles Dickens and in the paintings of Millet: *Peasant Woman Gleaning, Back and Profile* (1885, Otterlo, K-M) and *The Potato Eaters* (1885, Otterlo, K-M). He also painted a number of autumnal landscapes.

• In the town of Antwerp, where he lived from November 1885 to February 1886, Van Gogh discovered the art of *Rubens and the Japanese prints of A Hiroshige and K Utamaro. It was then too that he embarked on the series of self-portraits which included the humorous, macabre *Head of a Dead Man with Cigarette* (1886, Amsterdam, national Van Gogh mus).

• After moving to Paris in February 1886, Van Gogh discovered colour as used by the Venetians and also by *Delacroix. On a visit to the studio of the naturalistic painter Fernand Cormon, he met *Toulouse-Lautrec. Van Gogh's brother Theo introduced him first to Pissarro, who was generous with his advice, and then to *Seurat, Paul Signac and *Gauguin. He often went to see Julien Tanguy (Tanguy père), the colour-grinder and paint salesman whose portrait he painted (1887, Paris, Rodin). He also admired *Cézanne and Adolphe Monticelli.

• Van Gogh's output developed, not only in terms of portraits (*The Italian Woman*, 1887, Paris; *Portrait of the Artist*, 1887, Paris; and *Self-portrait at the Easel*, 1888, Amsterdam, national Van Gogh mus), but also as regards genre scenes such as *Restaurant Interior* (1887, Otterlo, K-M), *Small Gardens on the Hill of Montmartre* (1887, Amsterdam, SM) and *Le Moulin de la Galette* (1887, Paris) and his still lifes: *Still Life With Lemons* (1887, Amsterdam, national Van Gogh mus) and *Yellow Books* (1887, Switzerland, pr coll).

• In 1888, after his brother Theo's plans to marry had been announced, Vincent left for Arles. The Mediterranean light enthused him: *Le Pont de l'Anglois* (1888, Otterlo) and *La Plaine de la Crau* (1888, Amsterdam, national Van Gogh mus). He shared with Gauguin a desire to go beyond Impressionism and Neo-Impressionism and invited Gauguin to meet up with him in the south of France. Gauguin's influence and his conception of colour can be seen in *Promenade* (1888, St Petersburg, Hermitage) and *The Dance Hall, Arles* (1888, Paris). Yet some of Van Gogh's paintings reveal a more personal technique: *Woman From Arles* (1888, Paris, Orsay and New York, MM), *Portrait of Eugène Boch* (1888, Paris), and *The Postman Roulin* (1888, Boston, MFA). He also painted some landscapes: *La Crau with Montmajour in the Background, Arles* (1888, Amsterdam, national Van Gogh mus), *The Sower* (1888, Otterlo, K-M), *Green Ears of Wheat* (1888, Jerusalem, Israel mus), the series of *Sunflowers* (1888, Amsterdam, London and elsewhere); and *The Red Vine* (1888, Moscow), the only one of Van Gogh's works to be exhibited in his lifetime. He did a number of night scenes, including *Café, Evening* (1888, Otterlo, K-M), *Café, Night* (1888, New Haven, Yale University, AG), *Starry Night* (1888, Paris), *The Unloaders* (1888, Lugano, TB) and the well-known *Van Gogh's Bedroom, Arles* (1889, Paris). The experience of a shared artistic life ended in crisis on 24 December 1888 when Van Gogh attempted to kill Gauguin, and then cut off his own ear: *Self-Portrait with Ear Cut Off* (1889, London).

• Van Gogh lived in Saint-Rémy-de-Provence from January to May 1889. He was hospitalized and then confined at his own request and suffered from bouts of dementia.

Nevertheless, colours lit up his landscapes as they did his floral compositions and portraits: *Two Shrubs Behind a Fence* (Amsterdam, national Van Gogh mus), *Undergrowth* (Amsterdam, national Van Gogh mus), *Poplars* (Munich, NP), *Cornfields* (Otterlo, K-M), *The Olive Grove* (Otterlo, K-M), *Starry Night* (New York, MOMA), *Irises* (Malibu, J P Getty Museum), *Self-Portrait* (Paris), *Portrait of Trabuc, Chief Warder of the Saint-Paul Asylum* (Soleure [Switzerland], KM), all dating from 1889; and *The Siesta* (1890, Paris, Orsay).

• In the summer of 1890, at Auvers-sur-Oise, Van Gogh was taken in and looked after by Dr Gachet. He continued his painting experiments: *Church at Auvers* (1890, Paris), *Stubble Fields at Cordeville, Auvers-sur-Oise* (1890, Paris), *Portrait of the Artist* (1890, Paris), *Portrait of Dr Gachet* (1890, Paris) and *Stairway at Auvers* (1890, Saint-Louis, CAM). He painted some new flower bouquet pictures. His brother Theo told him he was off to Holland and Vincent once again felt abandoned. His anguish manifested itself in his last works, *Cornfield with Crows* (1890, Amsterdam) and *Trees, Roots and Branches* (1890, Amsterdam). On 27 July 1890, he shot himself in the chest and died on the morning of 29 July.

It was Van Gogh who taught Fauvism and Expressionism about the power of colour. His correspondence with his brother Theo, who was a moral and financial support to him throughout his life, offers unique documentary evidence of the course that Van Gogh's life took.

APPROACH AND STYLE

Van Gogh was a painter of portraits, especially of self-portraits, and of landscapes, but his output also included scenes from the lives of ordinary people, among them peasants and weavers, interiors (of a restaurant and café, his own bedroom and the psychiatric hospital), some floral compositions and some still lifes. His paintings in oils on canvas are small and medium-sized. Theo Van Gogh and Dr Gachet collected Van Gogh's paintings, and the Belgian painter Anna Bloch bought from him the only work sold in his lifetime: *The Red Vine*. The people he met and the places he stayed in had a direct impact on his art. In Holland Van Gogh was influenced by *Hals, *Rembrandt and the realist painter Mauve. In Antwerp he was impressed by the colour of Rubens. In Paris, his discoveries included the realistic subjects of Millet and *Daumier and then the art of the colourists *Veronese and Delacroix. He rubbed shoulders with Impressionism, Neo-Impressionism, the influence of Japanese prints, Synthetism, the painters of the Pont-Aven group and, later on, Cézanne, Gauguin, Monticelli and *Toulouse-Lautrec, their revelation to him being how the possibilities of colour could be invigorated by the light in Provence.

• In his early work, Van Gogh stood in the way of his own genius by choosing to paint people of lowly birth realistically, as Millet and Daumier did. He drew from nature, chose a sombre bistre or bitumen palette and a brush with which to apply his preparations of thickened paint with a markedly expressive effect; his chiaroscuro was an imitation of his fellow Dutch artists Hals and Rembrandt. About 200 paintings (genre scenes, landscapes and still lifes) date from this period, including *The Potato Eaters*.

• It was in Paris that the transformation of Van Gogh's art took place. His discovery of colour as used by the Venetians, Rubens, the Impressionists and the Post-Impressionists spurred him on to lighten his palette. Although his landscapes still had Corot's restraint *(Le Moulin de la Galette)*, his bouquets and human figures were imbued with a vivacity of colours. Japanese prints taught him freedom of application, simplicity of subject, and the combination of drawing and the clear-cut, bright flat colour-wash; the Neo-Impressionist Signac, on the other hand, showed him how to work with a fragmented stroke *(The Italian Woman)*. His works became more alive, the material he used grew thicker, the colours richer, and the light more subtle *(Restaurant, Interior)*.

• In the South of France, first in Arles and then at Saint-Rémy, Van Gogh set about cap-

A GREAT PAINTER

◆ Disliked and misunderstood as a painter, an 'accursed' artist, Van Gogh enjoyed no commercial success from his work in his lifetime; only his close friends and his brother encouraged him.

◆ Van Gogh's approach outstripped Impressionism and Neo-Impressionism. His aesthetic bore witness to a particular energy which integrated his life's experiences with his art.

◆ His impact on art gave colour a new intensity and invented new rhythms for the brushstroke, while his Expressionist tone was completely new.

Van Gogh

turing the coloured light which would enable him to go beyond both Impressionism, which was too allusive for his taste, and Neo-Impressionism, which was too pointillist, and so regain a formal unity and develop expression and the symbolic quality of form and colour.
• The work he shared with Gauguin and the influence of the technique of the print prompted him to saturate the backgrounds of his pictures with colours, which he applied with discontinuous brushstrokes in the Neo-Impressionist manner. He reached maturity in his art when he created harmonies of yellow, greens, blues and mauves, unprecedented in their chromatic density and luminous vibrancy, and revealed a virtuosity and an almost gestural power in his brushstroke; the materiality of his paintings gave their subjects a tactile presence (*Sunflowers*). He seldom used warm tones, seeking instead, as he wrote, 'enervated, neutral tones with which to harmonise the brutality of the extremes' in a work. This development in brushstrokes is palpable in *The Olive Grove* and *Starry Night*: 'the blaze of colours in the Arles works is succeeded, in his convulsive paintings with their narrower range of resonance, by a different blaze, the dazzling impact of graphic art and brushstroke whose discontinuous, sinuous features communicate even the dynamics of madness' (R Fohr, 1999).
• Having settled near Paris in Auvers-sur-Oise, Van Gogh painted some 90 canvases, his final masterpieces amid the anguish of new crises. His style here was a tormented, uptight, chaotic one, his colours often cold and as though deadened (*Church at Auvers* and *Stubble Fields at Cordeville*).

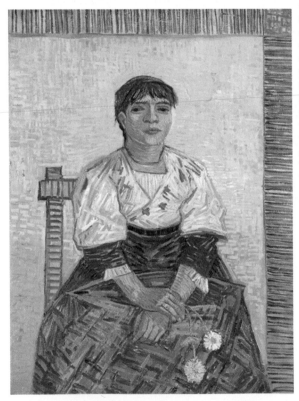

• The 40 or so portraits he completed throw light on his artistic approach, evolving from chiaroscuro to an intense and then saturated use of colour; from a sober technique to an animated one, and then one driven by anger; and from a realist style to, first, a Neo-Impressionist and then an Expressionist and Fauve one.

The Italian Girl
1887. Oil on canvas, 81 x 60cm, Paris, Musée d'Orsay

Although Van Gogh's concern throughout his career was to represent the human element and paint self-portraits, he turned in this painting to a subject then in vogue, that of the solitary woman, here sitting in a café. She has the same features as a former model of his, Agostini Segatori, who ran the Café du Tambourin on Boulevard de Clichy in Paris. Van Gogh had come across her there while attending meetings of the Impressionists and Divisionists. As in the portrait of Tanguy père, which dates from the same time, so here Van Gogh has used modernity in the service of his creative impulses. He has placed this portrait in a reduced pictorial space and given it no perspective. The yellow background, deriving from the pure, opaque flat colour-wash technique used in prints, bears witness to a vigorous, 'pre-Fauve' technique. This stylized woman seems to be constrained, like a prisoner, by the painting's frame and the chair-back, both of them asymmetrical, which balance the composition. Van Gogh used oblique hatched lines in order to build up Agostina's dress and vertical and horizontal streaks which accentuate his model's frontal, almost hieratic, pose. He kept his red and green for her face, his idea being, as he wrote, to 'convey the terrible passions of humanity'.

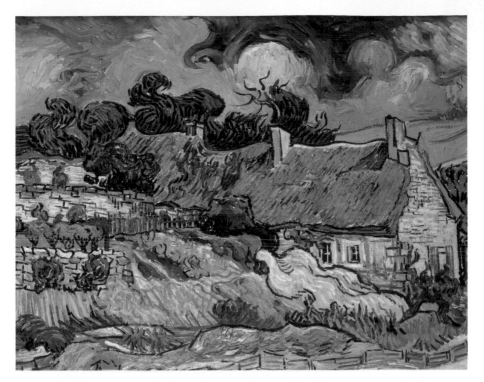

Stubble Fields at Cordeville, Auvers-sur-Oise
1890. Oil on canvas, 73 x 92cm, Paris, Musée d'Orsay

Shortly before his suicide, Van Gogh was once again marvelling at these 'seriously' beautiful houses and the spectacle of nature. He painted them using toned-down colours which he merged one with another. The purplish blues and greens dominate the work. The house seems to disappear beneath the lush greenery. Van Gogh's swirling, tormented, convulsive technique, with its abundantly thickened paint, lets the bare canvas show through. This heightened, feverish expressiveness, also detectable in the portraits dating from the same period, was accompanied by a frenzy of painting, with Van Gogh producing something like a canvas a day in these last weeks of his life.

KEY WORKS

The Potato Eaters, 1885, Otterlo, K-M
Le Moulin de la Galette, 1887, Paris, Orsay
The Italian Woman, 1887, Paris, Orsay
Portrait of the Artist, 1887, Paris, Orsay
Le Pont de l'Anglois, 1888, Otterlo, K-M
The Dance Hall, Arles, 1888, Paris, Orsay
Portrait of Eugène Boch, 1888, Paris, Orsay
The Red Vine, 1888, Moscow, Pushkin
Sunflowers, 1888, Amsterdam, national Van Gogh mus
Starry Night, 1888, Paris, Orsay
Van Gogh's Bedroom, Arles, 1889, Paris, Orsay
Self-Portrait with Ear Cut Off, 1889, London, CI
The Olive Grove, Paris, Orsay
Self-Portrait, Paris, Orsay
Church at Auvers, 1890, Paris, Orsay
Portrait of Dr Gachet, 1890, Paris, Orsay
Stubble Fields at Cordeville, Auvers-sur-Oise, 1890, Paris, Orsay
Cornfield with Crows, 1890, Amsterdam, national Van Gogh mus

BIBLIOGRAPHY
Van Gogh and Millet, exhibition catalogue, RMN, Paris, 1998

Seurat

Seurat, the founder of Neo-Impressionism, drew his inspiration from scientific theories of colour in developing the approach known as Divisionism. He worked on the linearity of composition and the expression of the individual brushstroke in order to create an 'optical painting' in which rationality would serve as a springboard for the creative imagination.

LIFE AND CAREER

● Georges Seurat, French painter and art theorist (Paris 1859–Paris 1891), studied at the École des Beaux-Arts with H Lehmann, a disciple of *Ingres. He received a classical education and read what had been written about colour by C Corot, *Delacroix and the chemist M E Chevreul (*The Law of the Simultaneous Contrast of Colours*, 1829). In 1879, the Fourth Impressionist Exhibition gave him 'an unexpected shock'. Between 1881 and 1883 he was influenced by the subjects chosen by the Barbizon School and by Impressionist technique. The academic jury of the École des Beaux-Arts accepted his *Portrait of the Painter Aman-Jean* (New York, MOMA).
● However, his first important work, *Bathing at Asnières* (1884, London), was refused. Seurat was already simplifying his use of form. In 1884, he struck up a friendship with Paul Signac, a painter who would become the brains behind Divisionism, and received support from Pissarro. In *Sunday Afternoon on the Island of La Grande Jatte* (1886, Chicago), Seurat applied the technique of the 'division' of colours in pure and complementary brushwork, the result being an 'optical painting'. The scandal which this painting caused among members of the French Academy and the public was countered by the enthusiastic response of the Symbolist poet Émile Verhaeren and by interest from the critics F Fénéon and G Kahn. Seurat's work enjoyed great success when it was exhibited in New York by Durand-Ruel and in Paris by Martinet. Seurat took part in the final Impressionist exhibition in 1886 and also showed at the Salon des Indépendants: *La Grande Jatte* and *Les Poseuses* (1888, Paris, Orsay), *The Circus Parade* (1888, New York), *The Hullabaloo* (1890, Otterlo) and *The Circus* (1891, Paris). Seurat also painted some landscapes: *Grandcamp* (1885, London, TG) and seascapes: *Honfleur* (1886, Otterlo, K-M).
● Charles Henry's *Introduction to a Scientific Aesthetic* (1886) established the relationship between the expression of line and colour. From then on, Seurat worked on the quality of individual lines, their inter-relatedness and their proportions in the composition. He died suddenly in 1891.
● The shortness of Seurat's life, his theory, his method and his relentless research help explain why he completed so few paintings. Seurat's art resonates in the work of his pointillist followers Signac, Pissarro, M Luce and C Angrand as well as influencing the Expressionists, the Fauves, the Cubists, the Futurists, and even the De Stijl movement and the Bauhaus.

APPROACH AND STYLE

Seurat painted country landscapes, seascapes, scenes at the water's edge, portraits and some nudes. He was fond of popular entertainments, parades, circuses and concerts. His research prompted him to choose increasingly large formats for his work.
He took an interest in theoretical writings on colour, steeped himself in the art of the antiquity and then in the works of the Classical masters including *Piero della Francesca, Ingres and P Puvis de Chavannes, the landscapes of the Barbizon School and the method of the Impressionists. He drew from live models.

A GREAT PAINTER

◆ Seurat's worth as an artist was recognized in his lifetime. His work aroused controversy.
◆ He broke with Impressionism and invented Divisionism, also known as Neo-Impressionism.
◆ His scientific research was in pure and complementary colours, lines in a composition, and technique. Seurat applied pure colours directly onto the canvas, working with them in divided and directed strokes. The blending was exclusively optical. He abandoned traditional perspective and depth.
◆ Seurat demonstrated that science can extol talent, and visual acuity heighten expertise.

BIBLIOGRAPHY

Seurat, exhibition catalogue, RMN, Paris 1991; Thomson, R, *Seurat*, Phaidon, Oxford, 1985

The Circus

1891. Oil on canvas, 1.85 x 1.52m, Paris, Musée d'Orsay

This unfinished masterpiece combined Seurat's theoretical approach and his supreme handling of plasticity. It demonstrated his scientific mastery of colour and the lines of the composition. It gives the viewer of the painting a sense of being projected into the centre of the circus ring alongside the clown who is launching the movement of the circling parade. Seurat conceived the composition in terms of lines with no perspective or depth to add to the effect. The juxtaposition of pure and complementary colours, in which yellow and violet are dominant, causes a vibrancy in the interplay of light and shadow. The brush has been applied in lines, curves and arabesques. This painting illustrates Seurat's skilful tactic of contrasts: vertical, horizontal and curved lines; primary colours and their complementary colours; the realism of the subject and the lack of realism in the scene; the calm of the static spectators set against the gaiety of the moving performers with their expressive, funny faces; and poor people in the upper tiers while the rich occupy the front seats. The whole composition has been cleverly orchestrated and is alive, decorative and brilliant.

KEY WORKS

Seurat painted only about 30 works.
Bathing at Asnières, 1884, London, NG
Sunday Afternoon on the Island of La Grande Jatte, 1886, Chicago, AI
The Circus Parade, 1888, New York, MOMA
The Hullabaloo, 1890, Otterlo, K-M
The Circus, 1891, Paris, Orsay

• In his earliest works Seurat was very involved with theories of colours. He drew meticulously in black Conté crayon on Ingres paper in order to achieve a chiaroscuro in a gradation or contrast of colours after the manner of the Barbizon School. Seurat simplified the forms of his human figures, drawing his inspiration from Ingres and Pierre Puvis de Chavannes, until he had achieved a solid, imposing outline reminiscent of Piero della Francesca. The influence of Impressionism was evident in Seurat's choice of subject, in the clarity of his light, and in his light but broad brushwork, which was both intersected and sweeping.

• In 1884 he applied his mathematical skill to colour and line. He used pure colours in juxtaposition as recommended by complementary colour theories, and a contrast which dispensed with depth. He went on to use colour to harmonize the lines in the structure of a work in order to construct what he called a 'logical, scientific and pictorial' system. He described himself as an 'Impressionist-Luminist' working towards a 'optical way of painting'. In *Beyond Impressionism* (1886), Fénéon defined Seurat's technique: 'Instead of grinding up his paint mixtures on the palette ... this painter puts touches of paint straight onto the canvas in order to convey local colour, by which I mean colour which will catch the surface of the canvas in white light ... This is colour which Seurat has made achromatic not on his palette but indirectly on the canvas by virtue of the laws of simultaneous contrast and via the intervention of further sequences of touches ... not plastered on with the brush but applied using tiny spots of colour'. With decoration in mind, Seurat sometimes painted the border of the canvas and the frame of the picture with a range of tones which were in contrast with that of the picture itself. The pictorial application of his theory of colour reached its height from 1888 onwards.

• It was not until 1890–1 that Seurat achieved an emotional symbolic expression of line and colour. The coloured commas, hatched lines and short-stick marks followed the outline and direction of each element in the picture; curves, arabesques and diagonals gave a sense of movement and of gaiety, whereas the horizontals and verticals suggested calmness.

Toulouse-Lautrec

Toulouse-Lautrec may have been ugly and deformed, but he was full of vitality, an eccentric, generous man who led a libertine, Epicurean existence and suffered great distress on account of his handicap. Physical setbacks aside, he painted another kind of marginal existence, that of nightlife, with lucidity and passion. His vigorously brushed approach to constructing a painting, using intermingled or juxtaposed strokes, and his sometimes hybrid technique, were remarkable. Bright bold colours were a hallmark of his work.

LIFE AND CAREER

• Henri Marie Raymond de Toulouse-Lautrec Monfa, known as Henri de Toulouse-Lautrec (Albi 1864–Malromé, Gironde, 1901), French painter, came from an aristocratic family and was the child of parents who were first cousins. He spent his childhood in Paris and in the Aube region, and a passion for horses and hunting, the admiration of courage and glory, and the pleasures of drawing were all features of his upbringing.

• In 1878, while suffering from an incurable bone disease, he worked assiduously and freely at painting and drawing. He trained with the animal painter R Princeteau and demonstrated the elation and modernity which would be the hallmarks of his work: *Artilleryman Saddling His Horse* (1879, Albi, Musée Toulouse-Lautrec), *A Dog-Cart* (1880, Albi, Musée Toulouse-Lautrec), and *Alphonse de Toulouse-Lautrec Driving his Mail Coach to Nice* (a portrait of his father, 1881, Paris).

• The influence of *Manet and the Impressionists is evident in *Young Routy in Celeyran* (1882, Albi, Musée Toulouse-Lautrec), *Madame la Comtesse Adèle de Toulouse-Lautrec Monfa* (1883, Albi, Musée Toulouse-Lautrec), a portrait of his mother, and in *Self-Portrait* (c.1883, Albi, Musée Toulouse-Lautrec).

• In 1882, he entered the École des Beaux-Arts, joining the studios of first Léon Bonnat and then Fernand Cormon. He formed a friendship with Émile Bernard, Louis Anquetin and in particular *Van Gogh: *Van Gogh* (1887, Amsterdam, national Van Gogh mus). His 'Academy' expertise, evident in *Carmen Gaudin*, in which he portrays the singer known as *Rosa la Rouge* (1884, Williamstown), evolved into a great freedom of execution in *Portrait of Madame Lily Grenier* (1888, New York, W S Paley coll). The circus world fascinated him: *Bareback Rider at the Cirque Fernando* (1888, Chicago). In 1888, his participation in the exhibition 'of the XX' in Brussels was a success. The influence of *Degas is palpable in the naturalism of *Woman Drinking* (1889, Albi, Musée Toulouse-Lautrec), *The Laundress* (1889, pr coll) or *Justine Dieuhl Seated ...* (1891, Paris).

• Around 1890, Toulouse-Lautrec's style came closer to that of Renoir and the Nabi group. Through them he met the Natanson brothers, founders of La Revue Blanche. His paintings celebrated the night-clubs of Montmartre: *Ball in the Moulin de la Galette* (1889, Chicago, AI); *Dancing at the Moulin-Rouge* (1890, Philadelphia); and *At the Moulin-Rouge* (1892, Chicago, AI). His favourite haunts were Le Chat Noir, café-concert venues such as the Alcazar and the Scala – and the brothels: *The Sofa* (1893, São Paulo), and *Salon in the Rue des Moulins* (1894, Albi). He visited these places every night, as both spectator and consumer, accompanied by his cousin, Dr Tapié de Celeyran. He admired popular songstresses including Nini Peau-de-Chien and Rosa la Rouge, and met the can-can dancers named Grille d'Égout, Rayon d'Or, Nini Patte-en-l'Air, Trompe-la-Mort, la Mélinité (Jane Avril) and, above all, la Goulue and the dancer Valentin le Désossé. His paintings idealized these women: *La Goulue Arriving at the Moulin-Rouge* (1892, New York, MOMA); *At the Moulin-Rouge: Start of the Quadrille* (1892, Washington); *Jane Avril Arriving at the Moulin-Rouge* (1892, London, CI); *Jane Avril Dancing* (c.1891–2, Paris), and *Jane Avril Leaving the Moulin-Rouge* (1892, Hartford, WA). On the other hand, he was merciless when he portrayed the spectator-as-voyeur and the procurer. With fury and precision he painted *Woman in a Black Boa* (1892, Paris), *Monsieur Boileau* (1893, Cleveland), *Monsieur Delaporte* (1893, Copenhagen, NCG), *Dr Tapié in the Wings at the Theatre* (1894, Albi, Musée Toulouse-Lautrec) and *Oscar Wilde* (1895, Beverly Hills, CHL, Lester coll). His lithographs, which he made from 1891 onwards, were enormously successful.

• The Boussod et Valadon gallery put on Toulouse-Lautrec's first exhibition in 1893. In 1895 he helped to create the models for stage sets at the Théâtre de l'Œuvre and the Théâtre-Libre, and painted la Goulue's fairground booth at the Foire du Trône (Throne Fair) on the theme explored in *Moorish Dance* (1895, Paris, Orsay).

- He took an interest in female singers and in actresses: *Yvette Guilbert Greeting the Audience* (1894, Albi) and *May Belfort* (1895, Cleveland mus). The circus world fascinated him just as much: *The Clowness Cha-U-Kao at the Moulin Rouge* (1895, Winterthur) and *The Clowness* (1895, Paris, Orsay). Under Toulouse-Lautrec's paintbrush, dancers writhe about: *Marcelle Lender Dancing in 'Chilpéric'* (1896, New York, Whitney coll) and *Melle Églantine's Company* (1896, pr coll). Like Degas, he was drawn to the intimate moments in women's lives: *Woman Combing Her Hair* (1891, Paris, Orsay), *Woman Pulling up her Stocking* (1894, Albi, Musée Toulouse-Lautrec), *La Toilette* (1896, Paris) and *À la toilette* (1898, Albi, Musée Toulouse-Lautrec). He immortalized a prostitute woman-friend lying relaxed on her bed in *Alone* (1896, Paris, Orsay).
- His travels took him to London, Belgium and Spain in 1896 and to Holland in 1897.
- His routine of living by night led him into alcoholism. In 1899, after a first attack of delirium tremens, he had to undergo a course of detoxification. He drew and painted his last masterpieces in a frenzy of activity: *Au Rat-Mort* (1899, London, CI); *L'Anglaise du Star* (the singer Miss Dolly, 1899, Albi, Musée Toulouse-Lautrec); *The Milliner* (1900, Albi) and the lyric tragedy *Messaline* (1900, Zurich, Bührle coll). Suffering from paralysis, he sold his Paris studio and went back to live with his mother in the Château de Malromé, where he died at the age of 37.

Toulouse-Lautrec and the Nabi group (Émile Bernard, Anquetin and others) shared the aesthetic which advocated using flat colour-washes. Toulouse-Lautrec influenced *Gauguin; the boldness of his colours heralded Art Nouveau and the Fauves, and the violence of expression deriving from the drama of his own life foreshadowed the Expressionists. His freedom as to subject, tone and line proclaimed the arrival of modern art. His parodies and hoaxes anticipated Dadaism. After his death, Toulouse-Lautrec's mother bequeathed many of his paintings, drawings, engravings and posters to the Musée d'Albi.

APPROACH AND STYLE

Toulouse-Lautrec was loyal to women of the night: dancers, actresses, clowns and prostitutes. He portrayed them alone or surrounded by the atmosphere of night-clubs and brothels, in full view at the front of the stage or left to themselves in the wings. He also painted the clientèle of bars, racecourses, concerts and balls, as well as friends of his, and self-portraits. He painted on various different sizes of canvas, wood or cardboard.

He worked for la Goulue and for theatres. The art-dealer Theo Van Gogh and his friend Joyant sold several of his paintings.

He had a Parisian career. Although he trained at the École des Beaux-Arts, he was drawn to the works of *Manet, Impressionism, Van Gogh, Renoir and the Nabi painters. He appreciated the art of Degas and Japanese prints by Hiroshige, Utamaro and Hokusai.

- In his earliest works he demonstrated the vivacity and freedom of his technique in 'portraits' of high-spirited horses (*The White Horse 'Gazelle'*, 1881, Albi, Musée Toulouse-Lautrec). He was readily won over by Manet's modernity, and by the use of bright colour

A GREAT PAINTER

◆ Toulouse-Lautrec became famous in 1895, mainly as an illustrator and poster-designer. His talent as a painter was recognised after his death, when a retrospective exhibition was held in 1902 at the Durand-Ruel gallery.

◆ This 'urban genius' (J Cassou, 1968) was radically different from the proponents of all the other styles and movements of his age as much in his choice of subjects as in technique and use of colour.

◆ He created scenes of night-time pleasures. He immortalized can-can dancers and prostitutes with their counterparts, the procurers and lusting clients.

◆ He could create a work of art with just a few lines or angry jabs of the brush, the effect of which could be either transparent or opaque. His daring in composing harmonies of bright tones and coloured shades made him the precursor of the Fauves and the Expressionists.

◆ Toulouse-Lautrec used all the processes: painting, pastel, drawing and engraving. He was fond of unprepared wood panels and thick, rough brown or grey cardboard which would absorb the liquid paint in places and so give the work a base layer of matter. He traced the outline of forms with oils or turpentine and painted his human figures in oils, sometimes enhancing them with light gouache. His posters were masterpieces of wit and audacity.

and the vibrant brushwork of the Impressionists. He constructed his paintings solidly by simplifying the planes of perspective. The hieratic quality in *Cézanne immobilizes Toulouse-Lautrec's portraits and self-portraits, the way his subjects are reflected in a mirror or have their backs turned, and sometimes he adopted the Spanish-Dutch style then in vogue. His pointillist or vigorously hatched paintings took their cue from Van Gogh's technique. However, more sombre tones and a more sober technique ensued from his academic training at the Beaux-Arts (*Carmen The Redhead*, 1881, Albi, Musée Toulouse-Lautrec).

• As an independent artist, Toulouse-Lautrec kept his distance from the styles of the age. He described the festive, marginal world-within-a-world of nightlife in a way that was devoid of curiosity or voyeurism and had no moralizing social or humanitarian agenda. 'Every evening, I go to the bar to work', he wrote. In that milieu he painted the wild rhythms of the can-can, the dancers' legs making arabesques as they kicked the air and offering glimpses of their swishing petticoats. He painted the *filles de joie*, shameless and faded, transfigured by the artifice of make-up. In night-club or bar, he sketched the silhouettes of men on the look-out for pleasure; his portrayals of women, although realistic, were more indulgent and idealized womanhood. Like Degas, from whom he borrowed his style in genre Parisian scenes and his taste for contemporary subjects (*The Laundress*), his hawkish instinct for observation and psychology enabled him to capture his models 'live', in the immediacy of their existence, no matter what their social milieu. 'I have tried to create what is true and not what is ideal', he said. 'Only the figure exists; the landscape is, and should be, no more than an accessory', he said.

• His Japanese-style centring of the image was original and arbitrary: major vanishing lines gave the paintings their depth and favoured dynamic empty spaces; the particular angles he used gave prominence to the foregrounds. He concentrated on the expressive strength of drawing and on sharp, rapid, expressive and suggestive lines, at the expense of contour. His resonant colour, a mixture of orange, red, pink, purple and a range of greens and mauvish blues could become 'sometimes muddy-looking, almost dirty, depending on the context' (G Geffroy, 1893). Often applied in flat colour-wash, in the traditional Japanese manner, or brushed on, his colour came alive beneath the harsh glare of electric footlights. Cold light drew out the human figures from shadow and accentuated their facial features humorously as *Daumier had (*Jane Avril*). In his self-portraits, Toulouse-Lautrec revealed irony and even a well-honed sense of caricature.

• His final works, which he constructed soberly by using large vertical or oblique lines, were coloured with strident (*Messalina*) or luminist tones which contrasted with a sombre background (*The Milliner*).

Dancing at the Moulin Rouge
1890. Oil on canvas, 115 x 150cm, Philadelphia, McIlhenny Collection

On the left of this painting, the dancer Valentin le Désossé is directing a female dancer with bright red hair and a high chignon, possibly la Goulue, during a public rehearsal. La Goulue had created a routine called a 'naturalistic quadrille' derived from the French can-can, which involved putting her leg behind her head and finishing the pose by doing a dramatic splits and letting out a shrill cry. To the right, in the background, the viewer can see Toulouse-Lautrec's friends the painters M Guibert, F Gauzi and M Desboutin and the photographer P Sescau. At the back, full-face, another famous dancer, Jane Avril, the painter's muse, is recognizable, and being compared with the elegant lady standing in the foreground.

Toulouse-Lautrec constructed a deep perspective which draws the viewer's gaze along the central horizontal and right-hand diagonal lines. The movement of the dancers is in contrast with the static pose of the audience. The bright colours and pale tones beneath the cold light stand out clearly against the hatched areas of black clothing and the sombre hats of the men.

BIBLIOGRAPHY
Toulouse-Lautrec, exhibition catalogue, RMN, Paris, 1992.

MODERN ART AND THE BEGINNINGS OF CONTEMPORARY ART (1905–65)

The art of the 20th century has reflected social upheavals, political and ideological developments, scientific and technical progress, the changing position of humanity in society (socialism, communism) and humanity's view of itself (psychoanalysis).

The movements of the 20th century were already taking shape at the end of the 19th century: *Van Gogh and *Cézanne were forerunners of Fauvism and Expressionism in the case of the former and Cubism in the case of the latter. But Cubism, like abstraction (hints of which were already present in the work of *Manet and *Monet), represented an irreversible break.

Although Gauguin (d.1903) fled from 'civilization' to return to the source of 'primitive' humanity, painters such as *Léger, the Italian Futurists (Severini) and later the Russians (Larionov) were fascinated by the industrial world, speed and movement. However, this kind of society disgusted the Dada artists. The other sign of the times, the move towards the United States, was also beginning to take shape. Besides the avant-garde American painters (Max Weber and Dove among others), the 1913 Armory Show in New York included European artists from the late 19th century to *Duchamp (*Nude Descending a Staircase*). This painting caused a scandal, as later did the Dada artists (Picabia) and the Surrealists, inspired by psychoanalysis (*Ernst, *Miró). The exile of artists to the United States, triggered by the emergence of totalitarian regimes, accelerated further with World War II, which affected most of the important painters in Europe. Their influence played a decisive part in the birth of the great American painting of the future, from *Pollock to *Warhol.

This book stops at this point. It would be difficult to go beyond the 1960s since there is insufficient distance to select enduring masters with confidence.

The scientific and technical revolution

After his initial work on the quantum theory in 1905, Einstein formulated his general theory of relativity in 1914, which led to his research into atoms and nuclear energy. At the beginning of the century, radio communication was developed. Mass-produced cars increased from a few thousand in about 1910 to 400 million in the 1950s. Aeronautics developed: Blériot crossed the English Channel by plane in 1909 and Charles Lindbergh crossed the Atlantic in 1927, the year in which talking films were invented. European and American scientists developed the technique of radar in the 1930s. The American company Du Pont de Nemours marketed nylon in 1938. Rediscovered in 1900, Mendel's laws on the principles of heredity eventually led to the identification of the double helix of DNA (1953), which opened the way to the development of molecular biology and genetics. Progress in astrophysics put the Soviet Union ahead in the conquest of space with the Sputnik satellite (1957), followed by the first man in space in 1961. Finally, computers were developed.

Europe torn apart (1905–1939)

Industrial, commercial and financial capitalism experienced a meteoric rise in the West, which led to demands of workers and revolutionary movements. The economic development in Germany and its powerful navy, together with the arms race between countries, created an explosive tension in Europe after the wars in the Balkans (1912–13). Eight million people lost their lives in World War I in which the Triple Alliance (Germany, Austria-Hungary, Italy and later Turkey) was opposed by the Triple Entente (France, Great Britain, Russia and later Japan and the United States). The Wall Street Crash of 1929 weakened the economy of all the European countries. Nevertheless, art and culture were developing independently of all political vagaries.

A secular France followed by a socialist France. The Dreyfus Affair mobilized the republicans against the ultra-Catholic, nationalist and anti-Semitic conservatives. The indirect consequence of this confrontation was the separation of Church and State in 1905: the first secular State was born. The cries for war were opposed by the pacifist socialism of Jean Jaurès who was assassinated on 31 July 1914, on the eve of mobilization. France emerged victorious from the war thanks to the intervention of the Americans. In 1924 the Cartel of the left won the elections against the Bloc national. The economic crisis unsettled the country and the far right tried to end the Republic (6 February 1934). In 1936, the Popular Front (a communist-socialist alliance) won the elections, thus enabling important social reforms to be introduced. In 1939 Hitler dragged France and Great Britain into another World War.

Great Britain in turmoil. The Labour Party was founded in 1906. Lloyd George signed the Entente Cordiale with France in 1904 and subsequently the Anglo-Franco-Russian Triple Entente in 1907. The

reduced power of the House of Lords was accompanied by important social reforms. After World War I the country enjoyed sharp economic growth. Churchill re-established the parity between the pound and the dollar in 1925. In 1931 this flourishing economy was hit very hard by the economic crisis resulting from the Wall Street Crash. This depression led to great social misery, demonstrations and the birth of a far-right pro-Hitler movement in 1933. In 1938 the Munich Pact was signed with Hitler and Mussolini by Chamberlain on behalf of Great Britain and Daladier for France. This agreement ratified the German occupation of Czechoslovakia. War was only declared after Germany invaded Poland in 1939.

The emergence of the United States. In 1890 the States of the Union extended from the Atlantic to the Pacific. After the War of Secession, the large number of immigrants contributed to the economic recovery. In April 1917 the United States went to war against Germany first and foremost to defend the freedom of the seas. The help they provided to the Allies boosted their own industrial and agricultural production. After the war President Wilson failed to persuade the Senate to ratify either the Treaty of Versailles or the entry of the United States into the League of Nations (created in 1920). In the 1920s, the US policy of protectionism continued, immigration was slowed down and Prohibition decreed. Organized crime flourished and racism worsened. Revolutionary and anarchist movements were crushed (Sacco and Vanzetti were executed in 1927). The Wall Street Crash of 24 October 1929 ('Black Thursday') resulted in bankruptcies and unemployment. Roosevelt, who had just been elected president, launched a planned economic policy: the New Deal. From 1937 onwards he supported the European democracies.

The rise of totalitarian regimes

If colonial imperialism was characteristic of the 19th century, the 20th was marked by the birth of totalitarian regimes in Europe. World War I, disastrous for Russia, crystallized the people's discontent and enabled the Bolsheviks to come to power. In Germany and Italy, losers of the war, the desire for revenge contributed to the birth of Fascism and Nazism. A little later in Spain Franco established his right-wing government with the complicity and help of the Mussolini and Hitler regimes. Under these regimes art and culture were subjected to the constraints of the government.

Russia, from revolutionary fervour to Socialist Realism. After the creation of the Soviets on the Front in 1917, Lenin, leader of the Bolsheviks, took power in October and led the Revolution, then signed the peace with Germany. He was succeeded by Stalin in 1924. Most artists (*Malevich, the inventor of Suprematism, *Kandinsky, Lissitsky, Chagall) took part in the promotion of the revolution. However, Tamara de Lempicka, a future central figure of Art Deco, and Bakst, a decorative painter, fled the revolution. From 1912 onwards, poets and writers including Mayakovsky, Bourliouk and Khlebnikov were seduced by modernity and encouraged Malevich. Lenin directed art towards the people: in 1919 the 'Tenth State Exhibition: Abstract and Suprematist Creation' was organized. But political pressure became excessive, with Stalin condemning the avant-garde in 1922. Numerous artists (Kandinsky, Chagall) left the Soviet Union and went to France and Germany. Others gave in reluctantly to the government's orders: Malevich returned to figurative painting and Lissitsky divided his time between Germany and Moscow. The *proletkult* (culture of the proletariat), launched in 1922, continued until the 1970s. Those who accepted it, such as the official academic painter Guerassimov, were rare.

Writers such as Pasternak and Solzhenitsyn took part in the revolutionary movement until the 1930s. Meanwhile the system of concentration camps expanded: Solzhenitsyn and Chalamov survived the gulag but the poet Mandelstam did not. The novelist Cholokhov defended the concept of Socialist Realism. The composer Stravinsky arrived in Paris in 1909 with Diaghilev's Ballets Russes and the dancer Nijinsky before travelling on to the United States. Meanwhile in the Soviet Union the works of Prokofiev and Shostakovich were criticized by Stalin's regime. Nevertheless, the Soviet cinema produced several masterpieces with films by Eisenstein and Pudovkin.

Fascist Italy. After the Great War, Mussolini called upon ex-servicemen and organized a new party, the Fascists (*fasci*). In October 1922 he marched on Rome with his partisans, the 'black shirts'. He became *duce* in 1925, 15 years after Marinetti, author of the *Futurist Manifesto* (1910), had declared: 'An [Italian] racing-car is more beautiful than the *Winged Victory of Samothrace*'. His nationalism led him to believe in Mussolini's Fascism (*Futurism and Fascism*, 1924). In 1922 the Novecento movement, whose Neoclassical art reflected the regime's spirit, was created: the painter de Chirico joined it. He renounced his early metaphysical works, his architectural landscapes inhabited by timeless mannequins that heralded Surrealism. The writer d'Annunzio supported Fascism in his nationalist speeches but the young Moravia began to express concern about it in 1929 and then, threatened by the regime, fled the country. The novelist Buzzati (*The Desert of the Tartars*, 1940) expressed anguish and a feeling of absurdity and unreality which led to Silent Death. The Neo-Romantic composer Castelnuovo-Tedesco fled from Italy in 1939 to escape from Mussolini's anti-Semitic policies. Toscanini refused to conduct Wagner in Bayreuth and was very critical of Austria for forbidding the retransmission in Germany of concerts directed by the Jewish conductor Bruno Walter in Salzburg. The film maker Camerini – the 'Italian René Clair' – pleased the authorities with his social conformism, as did Blasetti.

Nazi Germany. After the end of World War I, the Weimar Republic (1919–33) was founded and its parliament, elected by universal suffrage, tried to turn round the economy in spite of the draconian conditions of the Treaty of Versailles, and then the economic crisis of 1929. But political agitation weakened the young Republic. After organizing the Brownshirts and the SA (Sturmabteilung, 'Stormtroopers'), Hitler became Chancellor on 30 January 1933. He opened the first concentration camps to rid himself of those who opposed him.

Most artists left the country. Some, such as Nolde and Mies van der Rohe, tried to negotiate with the regime, but in vain. A total of 650 avant-garde works were confiscated and shown at the exhibition of 'Degenerate Art' in 1937: the Expressionists Nolde, *Kirchner and Schmidt-Rottluff, Kandinsky, Jawlensky, Marc, Macke, Kokoschka and Schiele, the Dada artists Schwitters and Grosz, those of the Bauhaus and the Neue Sachlichkeit ('New Objectivity'), Dix and Beckmann were all blacklisted. In contrast Martin-Amorbach and the sculptor Breker were glorified for their 'powerful Aryan German beauties'.

The music of the beginning of the century, represented by Mahler, Berg and Schoenberg, creator of the 'twelve-note method' known as serialism, contrasted with that of Wagner, which became the official music. Richard Strauss, who was 69 in 1933, compromised his reputation because of his involvement in Nazism, although he supported the writer Zweig who left Austria. Kafka and Rilke were criticized by the regime, as were Thomas Mann, Musil and Brecht who fled the country. Murnau's cinema, which was a blend of Expressionism, Romanticism and social realism, and the work of the experimental animated film maker Fischinger were replaced by a generally mediocre production, with the exceptions of Leni Riefenstahl, who glorified the pomp and grandeur of the Nazis, and Harlan whose *Jew Süss* (1941) expressed anti-Semitism. The great Austrian and German film makers (Murnau, Preminger, Pabst, Lang, Ophuls, followed by Sirk) left the country, as did the photographer Gisèle Freund.

Franco's Spain. In 1923, during the reign of Alfonso XIII, Primo de Rivera established a dictatorship. However, the Republic won the elections in 1931. The Frente Popular (Popular Front) won the elections in 1936 but General Franco began a civil war and el Caudillo ('the Leader', as Franco was known) held absolute power between 1939 and 1975.

*Picasso, who had been living in Paris since 1904, expressed his anti-Franco commitment with *Guernica* (1936), a painting which the painter declared could only return to Spain after the restoration of the constitutional monarchy; and *Woman Crying* (1937). The Surrealist Miró was a Republican sympathizer and went to Paris. Dalí, another Surrealist who was also familiar with Freud's work, created semi-hallucinatory images based on his method of 'critical paranoia' while using an academic technique. His eccentricities, his declarations in favour of the Franco and Hitler regimes and his mercenary mentality led to a lasting quarrel with André Breton in 1941.

Among the poets, besides Jiménez, the group Generation 98 included Unamuno, Lorca, Aleixandre and Alberti who were all Republicans. Lorca was executed in 1936 while Jiménez left Spain. Gómez de la Serna, who was to literature what Picasso was to painting, went to Argentina. The legendary guitarist Segovia emigrated in 1938. The composer Falla, at first neutral or well-disposed towards the Nationalists, left the country in 1939. Among film makers, Buñuel (*Le Chien Andalou*, 1928, produced with Dalí) moved to Mexico while Bardem tried to breach the Franco censorship which Carlos Saura also defied.

Art beyond nationalities

From the very beginning of the 20th century, painting broke free from its national identity to become international.

Artists without frontiers. The pioneers of the avant-garde symbolized this globalization. The Franco-Cuban artist Picabia worked in Germany with the Dadaist movement, in France with the Surrealists and in the United States with the Frenchman Duchamp. The Russian painter Kandinsky founded the German Expressionist group Der Blaue Reiter and discovered abstraction in Munich. He was welcomed by the Surrealists in Paris where the Dutchman *Mondrian conceived his first abstract painting and invented Neoplasticism. He founded De Stijl in the Netherlands, went to London and then to New York. Malevich worked in Russia and Berlin while the Spaniard Picasso invented Cubism in Paris with the Frenchman *Braque. World War I separated the artists: among the artists who were called up (Léger, Ernst), some were wounded (Braque) or killed (Macke, Marc), or became depressive (Kirchner); others continued their work abroad (Picasso in Rome, Duchamp in New York).

The Bauhaus in Germany. This internationalization continued after World War I. Between 1919 and 1933 the Bauhaus welcomed some of the most eminent artists of the time: the Russian lyrical abstract artist Kandinsky and constructivist Lissitsky, the Swiss *Klee, the Dutch Neoplasticist and then Elementarist Van Doesburg, the Hungarian Moholy-Nagy and, among the French artists, the purist Ozenfant, the Dadaist Duchamp and the Cubist Gleizes.

Abstract art totally abolished all national references. Figurative painting still reflected the cultural traits of the individual countries: German Expressionism, its sense of drama and its descriptive violence, which continued with the Neue Sachlichkeit, were still in the tradition of *Grünewald; French Fauvism

revealed the artists' purely chromatic concerns, inspired by the colourists *Rubens and *Delacroix; the art of Picasso, powerful and dramatic with its perceptible Spanish flavour, differed from the harmonious, balanced art of the Frenchman Braque. In the field of abstract art, on the other hand, the lyricism of Kandinsky, the 'other reality' of Kupka, the Rayonnism of Larionov , the Orphism of Robert Delaunay, the 'non-figurative' art of Bazaine, the 'abstract landscape' of Bissière, the abstract expressionism of Rothko and Joan Mitchell did not reflect any nationalism or distinctive identity. This was also true of the art of *Dubuffet, the 'spatialism' of Fontana, the kinetic art of Vasarely, the minimalism of Newman and the graffiti art of Basquiat.

Artists who were victims of totalitarian regimes were welcomed with open arms by the democracies.

Art between 1905 and 1939

The dominance of colour: Fauvism and Expressionism. 1905 marked the birth of Fauvism at the Autumn Salon in Paris. *Matisse, the movement's mentor, was surrounded by Rouault, Vlaminck, Dufy, Derain, Van Dongen and Braque. Rouault used bright colours, Vlaminck expressed himself freely and forcefully while Dufy combined the precision of drawing with colour as Braque did. Van Dongen introduced an emotional content into his portraits while Soutine tended towards Expressionism with his tortured technique and sorrowful figures.

The tormented landscapes of the Norwegian Symbolist painter Munch, inhabited by tortured characters, also formed a link with the newly emerging Expressionism. Born from the German and Austrian Secessions, the groups Die Brücke ('The Bridge') and Der Blaue Reiter ('The Blue Rider') were created respectively in Dresden in 1905 and in Munich in 1913. The former was founded by Kirchner who portrayed the bourgeoisie of Berlin. The latter was led by Jawlensky who painted hieratic (hieroglyphic) figures and Kandinsky, together with Marc, well known for his blue horses.

The German Expressionist writers such as Wedekind, Hesse, Lasker-Schüle and Werfel expressed a vital emotion in the Nietzschean sense. Freud published *Three Essays on the Theory of Sexuality* (1905).

The dominance of form: Cubism. In Paris in 1906, Cézanne heralded Cubist art. This formal revolution was led by Picasso, Braque and then Gris, who excelled in still lifes made with *papiers collés* (collage). The objective was no longer to depict reality as it appeared but simultaneously to reveal its various facets, from the front, in profile and in three-quarter view. There are no writings on this particular movement in art but the Cubist periods are well defined: Cézanne-inspired Cubism (1907–9), Analytical Cubism (1909–12) and Synthetic Cubism (1912–14).

The influence of these movements. While Cubism was approaching abstraction in its Analytical phase, but without ever venturing as far, Italian Futurism glorified mechanics and inspired painters such as Boccioni, Severini and Russolo who exalted speed and urban life. At the same time in Moscow, Russian Primitivism, led by Larionov, Goncharova and the poet-painter Bourliouk, was inspired by Russian culture and folklore. These artists founded an avant-garde association, the 'Knave of Diamonds', which in 1910 exhibited the works of the Fauves, Expressionists and Cubists together with their own work and that of artists such as Exter, Malevich, Kandinsky, Jawlensky and Lentoulov. From 1911 onwards, Russian artists such as Bourliouk and Lentoulov were influenced by the Futurist Marinetti. In 1913 Larionov founded Rayonnism (*Rayonnist Manifesto*): he created non-figurative rays of colour-light on his canvases. Léger introduced the art of form and colour expressed in large flat tints while Robert Delaunay painted *Windows* (1912), in which the decomposed forms incorporated colour and movement. This aesthetic approach inspired the American abstract painters of the 1920s. The group La Section d'Or ('The Golden Section', 1912) proposed another vision of Cubism developed by the brothers Duchamp-Villon, Villon and Duchamp, and La Fresnaye.

The birth of lyrical and geometric abstraction. While Picasso and Braque defended figurative art, Kandinsky, Mondrian and Malevich presented their first abstract works. As Worringer had anticipated in 1908 in his book *Abstraction and Empathy*, pure abstraction was the result of 'an instinctive necessity, the geometric abstraction'. In 1910, responding to an 'interior necessity', Kandinsky painted his *First Abstract Watercolour*: his abstraction was not geometric but lyrical. In 1915 Mondrian painted *Oval Composition* and Malevich created *Black Square*, thus justifying Worringer's intuition.

The 'School of Paris'. Between 1903 and 1930, over 60 Jewish painters from Central Europe arrived in Paris, the international centre of art. These included Marcoussis, Soutine, Sonia Terk Delaunay, Kisling, Chagall, Pascin, Mané-Katz, Kikoïne, Krémègne, Survage and many others. These artists congregated in Montmartre and Montparnasse where they founded the 'Jewish School of Paris', which in 1920 became the 'School of Paris'. Subsequently other artists joined, including Modigliani, the Japanese Foujita, Weissberg, Janco and Atlan, each with their own style. They also rubbed shoulders with painters such as Picasso, Braque, Utrillo, Derain, van Dongen, Gris, poets such as Apollinaire, Jacob, Cendrars, Cocteau, Reverdy and sculptors such as Orloff, Lipchitz, Zadkine, contemporaries of Brancusi. In the same period, James, then Proust and Joyce laid down the foundations for a new literature. They were the contemporaries of Gide, Valéry and Claudel. Debussy, Fauré and Ravel heralded the era of French contemporary music, followed by Satie and Les Six (which included Honegger and Milhaud).

From subversion to the power of the unconscious: Dada and Surrealism. The Dada movement, created by the anti-militarist writers, including Tzara, was founded in 1916. In the *Dada Manifesto* (1918), Tzara, disgusted by the war, attacked bourgeois values and advocated subversion and scandal. The Dadaist artists Picabia, Duchamp, Man Ray, Ernst and Schwitters met up again after the war in Berlin, Cologne, Hanover, Paris and New York and advocated pure expression without logic. Surrealism extended the Dada movement and then replaced it. In 1924, Breton published his *Surrealist Manifesto*, followed in 1928 by Surrealism and Painting. The 'Pope' was surrounded by writers such as Aragon, Soupault, Bataille, Desnos, Eluard and Artaud, Dadaist painters and new artists including Masson, Magritte, Tanguy, Miró and Dalí, and the photographer Brassaï. Inspired by *The Interpretation of Dreams* (1900) by Freud, whom Breton visited in 1921, the unconscious became the source of 'convulsive beauty' for the Surrealists.

Surrealism flirted with communism but the movement was divided by two opposing tendencies: those who favoured a politicization of the movement and those who succumbed to the temptation of form. Differences deepened and the number of exclusions increased, heightened by Trotsky's expulsion by Stalin in 1929, the war in Morocco and the economic crisis. Breton forecast a 'world catastrophe' in a vision similar to those of Huxley and Steinbeck.

The return to Realism. This movement took place in the 1930s although the pictorial avant-garde survived. Sometimes social, sometimes 'magical', this Realism brought together artists such as Pignon, Laurens, Fougeron and Gromaire on the one hand, and Balthus and Delvaux on the other. In sculpture the art of Germaine Richier, Laurens, Lipchitz and Zadkine fluctuated between abstraction and figurative art while the work of Bourdelle and Maillol remained classical. In the United States the Realist tradition was rejuvenated by painters such as Kane, Hopper and Shahn.

Art and the Second World War

Modern War. Confronted with Nazism, the Soviet regime, weakened by the purges of 1936, hesitated about which alliance to enter and signed the German-Soviet pact (August 1939). Hitler, aiming to build a 'large Germany that would last for a thousand years', occupied France and tried to crush Great Britain which offered fierce opposition. In June 1941 he turned against the Soviet Union. In December 1941 Japan sank the American Navy in Pearl Harbor: as a result the United States entered the war. The Allies (Great Britain, Soviet Union, United States) confronted the Axis powers (Germany, Italy, Japan, Hungary, Slovakia). All the modern technological developments in the field of weaponry were used in the conflict, including the nuclear bomb in Japan (August 1945). The conflict caused the death of 50 million people. Similarly, industrialization and large-scale planning were part of the Nazi 'final solution' which aimed completely to eliminate groups that were judged undesirable (Jews, gypsies, homosexuals and the insane).

Reflections of the horrors. Painters created images full of anguish and sadness (Picasso, *The Ossuary*; Braque, *Billiards*; Gruber, *Job*; Olivier Debré, *The Dead of Dachau*; Fautrier, *Hostages*; Music, *Dachau 1945*), sometimes contrasting gaiety or mysticism with despair (Miró, *Constellations*; Newman, *The Name*). In 1941, during the occupation, the Braun gallery organized an exhibition whose enigmatic title 'Twenty Young Painters in the French Tradition' was perhaps a dig at the occupying forces. Artists such as Lapicke, Bazaine, Manessier and Estève took part in the exhibition. They defended the French heritage of Cézanne, Bonnard, Matisse and Braque against American art and abstraction of all kinds. That same year Goebbels, German minister for propaganda, organized a journey to Germany for French painters and sculptors. Dunoyer de Segonzac, van Dongen, Vlaminck and Derain were among them.

On the literary scene, resistance asserted itself with writers such as Cohen, Aragon, Malraux, Sartre and Camus, while Varèse and Messiaen played their part in the field of music. Some writers, including Céline, Brasillach, Drieu and La Rochelle, collaborated with the Germans; the first went into exile, the second was executed and the third committed suicide.

New York, new art centre. A large number of European artists chose to go into exile: Ernst, Léger, Klee, Masson, Mondrian, Dalí and Matta joined Picabia, Duchamp and the Eastern European artists who were already in New York. From 1942 onwards abstract expressionism began to develop, encouraged by Peggy Guggenheim with her gallery Art of this Century. It attracted painters of European origin such as Gorky, de Kooning and Rothko, and the Americans Gottlieb, Kline and Guston.

From the post-war years to the 1960s: the pre-eminence of America

The traditional artistic categories (such as painting, sculpture, engraving and photography) gradually disappeared and were replaced by the concept of 'plastic arts' which embraced all possibilities and materials.

The political situation. After the war the map of Europe changed dramatically. The eastern part of Germany was placed under the control of the Soviet Union as was Poland and almost all the Balkan countries. The United States occupied Japan until 1952. The tension between the West and the Soviet Union led to the Cold War and the construction of the Berlin Wall (1961). The superpowers recognized the creation of the State of Israel in May 1948. Mao Zedong's communists expelled the armies of

Chang Kai-shek and founded the People's Republic of China in 1949. The movement towards decolonization turned to war in Indochina (1946–54), as it did in Algeria (1954–62). It was 'peaceful' in Morocco, Tunisia and Black Africa. The countries of the Commonwealth were also given their independence while the Portuguese colonies only acquired theirs later. The Korean War (1950–3) saw American and Chinese troops fighting each other. In 1954 the Americans took over from the French to support South Vietnam and only left the country in 1973 after a war which caused massive public protests in the United States. The Treaty of Rome led to the creation of the European Economic Community (1957).

The Triumph of abstract expressionism. This was the main art of this period. The second generation of artists (Noland and Louis) saw the emergence of women artists: Helen Frankenthaler and more especially Joan Mitchell and, in the field of sculpture, Louise Nevelson. *Pollock developed action painting ('gestural' painting). The human scale of European paintings contrasted with the gigantism which characterized American art.

Neodadaism. Still in the United States, Rauschenberg and Johns were developing a Neodada aesthetic approach; the former, inspired by Schwitters, created 'combines', combinations of painting and sculpture, while the latter attacked the American symbols such as the flag. Faithful to Dada, Twombly covered his canvases with scribbles, dirty marks and coloured drips: the 'tremor of time', according to Barthes.

Pop art targeted the consumer society and portrayed its mechanisms; mass-production, techniques using cartoons and consumerist imagery identified the art of Warhol, Lichtenstein, Wesselman, Kitaj and Rosenquist between 1955 and 1970.

European art, between figurative art and abstraction. Many trends were developing in Europe. While Picasso, Braque, Matisse, Ernst and Miró continued their work, Bonnard and Villon painted landscapes and domestic scenes. The abstract art of Maria Elena Vieira da Silva and Louise Bourgeois, one a painter, the other a sculptor, commanded attention. Giacometti, painter and sculptor, the very figure of independence, created figurative works in which space gnawed at the material and form while Buffet created 'miserabilist' paintings. In 1948 artists including Jorn, Alechinsky and Appel founded Cobra. They created fantastic, primitive, instinctive art with lively forms, between abstraction and figuration. In the course of his curtailed career, de Staël opted for 'figurative art and thick paint', reminiscent of Van Gogh's art, while Poliakoff introduced soft, geometric abstraction. Artists such as Wols and Fautrier were described as 'informal', Mathieu, Hartung, Soulages, Francis and Riopelle as abstract and Tobey, Degottex and Bissier as 'zen calligraphers'. Dubuffet experimented constantly with new materials inventing unusual configurations while Tàpies concentrated exclusively on the material. With their unique style, *Bacon and Lucian Freud, rooted in existentialism, depicted the torments and solitude of the human condition.

Diversification of trends. Kinetic and optical art, plastic and art photography, the 'de-construction' of the picture (supports-surfaces), technology (video, cybernetics, computers) and conceptual art all made their appearance. There was a return to figurative art in New Realism, narrative figurative art, Minimal Art, Super Realism, graffiti art and New Figurative Art. Installations and performance art also made their appearance.

The discarding of traditional parameters during the 20th century led to a burst of countless creative experiments. The various materials, durable or perishable, happenings, wrappings and mixed productions opened up new horizons for an art which constantly questioned itself and society. But the commercial speculation which characterizes today's art market endangers the survival of authentic creations. This situation is very noticeable in Japan and the United States and it is now also affecting Europe.

Will the art of the future produce creations founded on plastic, iconic and semantic research? Will it be produced by computer, or will it be the result of new sensibilities and techniques? Will a change of course and destruction be necessary to provoke a new renaissance? According to André Breton, what the history of art tells of is the way art 'somehow gives rebirth to the magic which fathered it', and what it feeds on is only the discarded scraps of this magic, the works themselves.

Klimt

Solitary and timid, Klimt was the founder of the Viennese Secession and the master of Jugendstil. He created a symbolic, sensual, dream-like world in which he celebrated woman. The ornamental, geometric and decorative motifs in brightly coloured flat tints, sometimes on a gold or silver background, stylized linear curves tangled in a maze of meandering lines, all characterize his work.

LIFE AND CAREER

• Gustav Klimt (Vienna 1862–Vienna 1918), an Austrian painter, was the son of an engraver-goldsmith. His family, of modest means, had suffered from the economic depression which had hit the declining Austro-Hungarian empire. From 1876 to 1881, Klimt attended the classes of F Laufberger at the School of Decorative Arts in Vienna. He joined forces with his brother Ernst and F Matsch to produce the decorative work in the Sturany palace (1880, Vienna), the Reichenberg Theatre (1882–3, Liberec) and the royal castle of Pelesch (1883, Romania).

• At first Klimt painted in the Classical tradition: *The Fable* (1883, Vienna, HM der SW) and *The Idyll* (1884, Vienna, HM der SW). The trio subsequently decorated the Karlsbad theatre (1886, Karlovy-Vary) and the Burgtheatre (1886, Vienna) where he decorated the ceiling above the two large staircases. Klimt then painted *Interior of the Old Burgtheatre in Vienna* (1888, Vienna). In 1898–9 he decorated two lintels in the music room of the arts patron N Dumba in the same vein: *Schubert at the Piano* and *Allegory of Music* in which the academic chiaroscuro was replaced by a neutral light without shadows. In 1891 he became a member of the Association of Viennese Painters.

• In 1894, two years after the death of his brother Ernst, the Ministry of Culture and Education commissioned him and Matsch to paint three allegories (1894–1907, destroyed in 1945) to decorate the main hall of the University of Vienna: first *Philosophy Study*, then *Medicine* and *Jurisprudence*. *Philosophy Study* was awarded the Gold Medal at the Universal Exhibition in 1900 but its erotic nature, the rhythm imposed by the artist to the falling bodies and the physical and mental engulfment of the characters shocked the members of the government commission; Klimt was forced to withdraw his work. A similar claim to freedom and truth was expressed in *Jurisprudence* and *Medicine*: the first was a parable of the inanity of the State and the second of the powerlessness of science. They were in the same Symbolist style as *Love* (1895, Vienna) and *Music* (1895, Vienna).

• In 1997 the artist founded the Union of Figurative Artists of Austria which aimed to reform the arts according to the principles of Art Nouveau and to raise Austrian art to an international level. This 'Viennese Secession' became reality in the construction of a building and the creation of a new magazine, *Ver sacrum*, geared to Symbolist and Pre-Raphaelite artists. Between 1897 and 1905 the Secession organised 19 exhibitions on 'Japonisme', Post-Impressionism and so on. At the same time, literature (Hofmannstahl, Musil) and music (Mahler) also experienced a revival, and Freud discovered the unconscious.

• In 1898 the artist immortalized *Sonja Knips* (1898, Vienna), painted *Moving Waters* (c.1898, pr coll), became interested in landscapes as reflected in the *Garden Path with Chickens, After the Rain* (1899, Linz, Neue Galerie der Stadt Linz), *Farmhouse with Birches* (1900, Vienna) and *Beech Forest* (c.1901–2, Dresden).

• The 'golden style' was an interpretation of these new concepts: *Judith I* (1901, Vienna) and *Gold Fish* (1901–2, Soleure, pr coll). He painted the *Beethoven* frieze (1902, Vienna), *Birch Wood* (1903, Linz) and *Pear Tree* (1903, Cambridge [Mass.], FAM). During that same year of 1903, Klimt visited Ravenna; the Byzantine mosaics inspired him to paint *Life is a Struggle* (or *The Golden Knight*, 1903, location unknown) and the frieze in the Palais Stoclet in Brussels (1905–11). This 'golden style' blossomed further in *Hope I* (1903, Ottawa, NG), *The Three Ages of Woman* (1905, Rome, GAM), *The Kiss* (1907, Vienna), *Danae* (1907–8, Graz, pr coll) and became the 'silver style' in the portraits of *Fritza Riedler* (1906, Graz, pr coll) and *Adele Bloch-Bauer* (1907, Graz, pr coll).

• In 1905 the Secession broke up. After visiting Florence and Paris (1909), Klimt painted *Life and Death* (1908–11, Vienna), exhibited *Judith II* (1909, Venice, GAM) and *Portrait of an Elderly Woman* (1909, Paris, F Landau coll). He painted *Schloss Kammer Am Attersee* (1910, Vienna, ÖG) and *Forester House in Weissenbach on the Attersee* (1912, United States).

•After 1910 his art developed towards Expressionism: *Hat with Black Feathers* (1910, Graz),

Family (1909–10, pr coll). During the last years of his life he painted *Portrait of a Young Girl* (1912–3, Prague), portraits including *Barbara Flöge* (1915, Vienna, H Donner coll), *Friederike Maria Beer* (1916, New York), *Johanna Staude* (1917–8, Vienna, ÖG) and landscapes like *Apple Tree II* (1916?, Vienna, ÖG) and *Path with Chickens* (1917, destroyed).

● In Romania, he was struck by the extraordinary polychromy of Slavonic art, its mosaics, frescoes and fabrics. On his return he painted *The Cradle* (1917, New York, pr coll) and *The Bride* (1917–8, pr coll), which he could not finish. He died of a stroke.

Klimt took part in numerous exhibitions and was awarded many prizes all over Europe. His art influenced the Expressionists in Austria such as Egon Schiele, Richard Gerstl and Oskar Kokoschka.

APPROACH AND STYLE

Klimt painted the plural woman, portrayed in her allegorical, mythological and symbolic dimension or in portraits, often fashionable. He painted landscapes in a wide range of formats, and produced very large mosaics and frescoes. His portraits were often square, full-length and frequently life-size.

Klimt's clients included A Lederer and N Dumba as well as the architect O Wagner, the Grand Duke of Hesse and the Belgian A Stoclet.

The artist had received a classical training but he was also interested in modernist artists including Fernand Khnopff and Jan Toorop. In Ravenna he discovered the Byzantine mosaics, in London the work of Whistler, in Paris Post-Impressionism and in Romania the vividness of colours in art.

● Klimt was trained in history painting, in the tradition of the Austrians Laufberger, Makart and Anton Romako. His first decorative paintings were academic and naturalist, reminiscent of the art of the *Carracci brothers, *Michelangelo and the masters of the *quattrocento* (*The Fable*). Together Klimt and Matsch developed the concept of the classical allegory. Klimt had also mastered the art of 'photographic realism' (*Interior of the Old Burgtheatre in Vienna*).
● He later evolved towards Symbolism (*Love*), representing the dream by allegorical elements: floating heads, soft colours and melancholic beauty. He expanded his range of symbols: the sphinx symbolized the artist's freedom while the achenes of the dandelions with their feathery hairs symbolized the diffusion of new ideas.
● His Classical portraits of beautiful Viennese women, languid and melancholic were reminiscent of Whistler's art and the Pre-Raphaelite compositions in which heads were crowned with flowers (*Sonja Knips*). The flowers and heads, half visible in the background, have a strong symbolic value in the tradition of the Belgian artist Fernand Khnopff.
● His landscapes, at first classical and naturalist, later sombre and sentimental, became impressionist (*Garden with Chickens*).
● His modernism did not diminish his love of the classical myth; Klimt updated it in the light of the emerging science of psychoanalysis. His paintings reflect the duality between Eros and Thanatos, life and death, reality and dream. He replaced the Symbolist representation by the 'idealized' allegory, introduced formal innovations: his stylization of forms was accompanied by a flatness of space, inspired by Japonisme, the Nabi painters and Jan Toorop. The artist excelled in what was known as the 'geometrizing', gilded period of the Jugendstil (the *Beethoven* frieze): Klimt's decorative elements developed, curled, formed spi-

A GREAT PAINTER

◆ Klimt was successful during his lifetime first as a decorator, then as a painter. He fell into oblivion for a long time before becoming internationally famous.
◆ He distinguished himself from the nationalist, academic Austrian art by his association with the Jugendstil. He tried to abolish the boundaries between painting and the applied arts and raise decoration to the rank of major art. He achieved the synthesis between Art Nouveau and Symbolism.
◆ Klimt re-interpreted the sensual and erotic representation of woman. He represented taboo themes including pregnancy, auto-eroticism and female homosexuality.
◆ This master of decoration invented a geometric style, alternating circles, rectangles and triangles, which he painted in coloured flat tints on a background of pure gold leaf and stuck-on gold paper which he then embellished with stones and enamels.

rals and curves, twisted and became tangled in an impetuous whirl which took all kinds of shapes, streaks of lightning and snakes' tongues, tracery of vines, curving chains, streaming veils and taut nets' (L Hevesi, 1909). Klimt painted delicate silhouettes with defined outlines and without shadow, shown in a neutral light and placed in asymmetric compositions. The bodies seemed to float in space and sometimes merged with the water (*Moving Waters*). The distributions of empty and full spaces added rhythm to the painting. The precious, linear ornamental decoration in which the human figures were barely visible invaded the space of the canvas. While the gold-coloured surfaces and motifs were reminiscent of Byzantine mosaics (the *Stoclet* frieze, *The Kiss*), other works were clearly inspired by the brightly coloured illuminations of late antiquity, Egyptian, Mycenaean and Celtic art, or they borrowed the curvilinear elements of Japanese engravings and the pure arabesques of Art Nouveau.

• Klimt produced sketches on card or parchment, in tempera, mixing watercolour, purpurin dye, silver, white feldspar chalk, silver and gold leaf on a paper support so that the preparatory project technically resembled the final work as closely as possible (the frieze in the Palais Stoclet). He also painted with casein on a trellis, coated with stucco (the *Beethoven* frieze). The refined mosaics were embellished with enamel, semi-precious stones and coloured glass.

• His portraits of women were surrounded by tracery, geometric motifs, gilt and silvering, applied as flat tints. Only the very delicate hands and the eroticism of the sensual faces, surrounded by a mass of hair, were still linked to reality. Their finely hatched treatment was reminiscent of Khnopff (*Fritza Riedler*).

• The landscapes painted at the beginning of the 1900s reveal a certain pointillism, inspired by *Seurat (*The Pear Tree*) or 'comma' strokes, a brightly coloured palette whose intensity matched that of *Van Gogh (*The Beech Forest I*). Later Klimt raised or lowered the line of the horizon to ensure that the landscape was revealed in all its verticality, removing all space (*The Park*). The fragmented compositions, divided in a linear manner, show his sense of dissymmetry and entanglement of shapes, materials, motifs and colours.

• After 1910, Klimt no longer painted decorative pictures and he abandoned gold backgrounds; his portraits, in neutral colours, silvery white and brown black, or bright colours were half-length while the bold brushstrokes were reminiscent of *Toulouse-Lautrec. His full-length portraits were embellished with Korean and Romanian decorative motifs, dominated by blazing colours: shades of orange, red and pink. The rising perspective with pyramid effect (*Cradle*) or plunging perspective (*Young Girl*) were accompanied by a slackening in the decorative precision; the medley of fabrics became de-structured and the paint more spread.

• Landscapes acquired depth again. He introduced rural elements: a farm, houses, water or chickens. The motifs became more abstract, pre-Expressionist.

KEY WORKS

Klimt's catalogue runs to 208 works.

The Idyll, 1884, Vienna, HM der SW

Interior of the Old Burgtheatre in Vienna, 1888, Vienna, HM der SW

Philosophy Study, Jurisprudence, Medicine, allegories of the University of Vienna, 1894–1907, destroyed

Love, 1895, Vienna, HM der SW

Music I, 1895, Munich, NP

Farmhouse with Birches, 1900, Vienna, ÖG

Beech Forest, c.1901–2, Dresden, SK, Gg Neue Meister

Portrait of Sonja Knips, 1898, Vienna, ÖG

Judith I, 1901, Vienna, ÖG

Beethoven frieze, 1902, Vienna, ÖG

Birch Wood, 1903, Linz, Neue Galerie der Stadt Linz

Frieze in the Palais Stoclet in Brussels, 1905–11, Brussels, in situ; studies on Vienna, ÖG

The Kiss, 1907, Vienna, ÖG

Portrait of Fritza Riedler, 1906, Vienna, ÖG

Life and Death, 1908–11, Vienna, pr coll

Forester House in Weissenbach on the Attersee, 1912, United States, pr coll

Hat with Black Feathers, 1910, Graz

Portrait of a Young Girl, 1912–13, Prague, Národní Galerie

Friederike Maria Beer, 1916, New York, Beer Monti coll

Apple Tree II, 1916 (?), Vienna, ÖG

The Bride, 1917–18, pr coll

The Kiss
1907. Oil on canvas, 180 x 180cm,
Vienna, Österreichische Galerie

*This work is characteristic of
Jugendstil in its matt and shiny gold
effects and the geometric décors
which surround the lovers. Their
bodies and volumes disappear in the
rich display of juxtaposed,
fragmented motifs, painted in flat
tints as in a mosaic: the coloured
circles which symbolize the 'female'
element and the 'masculine'
rectangles are surrounded by gold,
black and silver. The gold of the
sparkling background is like a halo
round the two figures and binds
them together. The cascade of
triangles which have fallen from the
woman's dress and the carpet of
flowers where the woman, her eyes
closed, is kneeling as in a sacred
moment while clinging to the man's
neck, reveal the lovers' amorous
turmoil. The dream-like, unreal
atmosphere submerges the realist
idyll suggested by the truthfulness of
the faces and hands which expresses
the tension of the bodies.*

Young Girl
1912–13. Oil on canvas, 190 x
200cm, Prague, Národní
Galerie

*This very dynamic, circular
composition seen from above,
interweaves lascivious bodies,
naked or dressed in colourful
Romanian fabric, richly
decorated with circles, spirals,
flowers and ribbons, painted in
bold brushstrokes. Klimt
borrowed *Matisse's pure colour
and modelling of the flesh. The
women are staring at the
'voyeur' viewer who is looking
at the young girl sleeping while
imagining her body. The 'idea'
seems to prevail over the
concept of Jugendstil décor
present in his earlier works.*

BIBLIOGRAPHY
Ducros, F, *Klimt*, Hazan, Paris, 1992; Dumont (ed), *Klimt's women*, exhibition catalogue, Yale University Press, New Haven, CT and London, 2000; Passeron, R and Coradeschi, S, *All the paintings of Klimt*, Flammarion, Paris, 1983

Kirchner

Tall, slim and handsome, the young, cheerful, enthusiastic Kirchner became a tormented, fragile man. This master of Expressionism created an art inspired by sincerity, emotion and anguish, reflecting his time. His work was based on the expressive value of colour alone, pure and saturated. He developed simple, angular forms with flattened volumes, inspired by wood engraving.

LIFE AND CAREER

• The German painter Ernst Ludwig Kirchner (Aschaffenburg 1880–Frauenkirch, near Davos, 1938) was born into a middle-class family. In 1901, he enrolled at the Dresden art college where he learnt wood engraving for which he showed great talent. In 1903–4 he completed his training in Munich under the guidance of Hermann Obrist. In about 1904 he became acquainted with Jugendstil. He also admired African and South Sea sculpture, Post-Impressionism and Fauvism.

• In 1905 Kirchner graduated as an architect but decided to concentrate on painting: *Lake in a Park* (1906, pr coll). He founded the movement Die Brücke ('the Bridge') in Dresden with the painters Erich Heckel, Karl Schmidt-Rottluff and Fritz Bleyl, and drew up its manifesto. He was the group's most influential member until its dissolution in 1913.

• *Road* (1907, New York, MOMA) and *Street, Dresden* (1908, New York, MOMA) were inspired by Fauvism. His output was prolific: *Young Girl under a Japanese Sunshade* (c.1909, Düsseldorf, KNW), *Young Girl with Cat: Fränzi* (1910–20, Minneapolis, IA). The painter immortalized young naked models: *Dodo, Fränzi and Marcella* (1909–20, Stockholm); sometimes he portrayed himself next to them, in an indoor setting (*Self-Portrait with Model*, c.1910, Hamburg) or in an outdoor setting on the shore of Lake Moritzburg: *Four Women Bathing* (1909, Wuppertal), *Nudes Playing under the Trees* (1910, Munich) and *Semi-naked Woman with Hat* (1911, Cologne).

• In October 1911, Kirchner discovered Cubism in Berlin. He drew his inspiration from the urban atmosphere: *Tower Room* (1913, pr coll), *Berlin Street* (1913, New York), which shows Berlin 'tarts' parading in the street, and *Five Women on the Street* (1913, Cologne). He loved circuses: *Circus Rider* (1914, Saint Louis, pr coll). The landscapes of Fehmarn Island in summer had a mellowing effect on his art: *Young Girls on a Beach* (1912, Kirchner bequest), *Moonrise in Fehmarn* (1914, Düsseldorf). He continued to portray life in Berlin as shown in *Dancing Girls* (1914, Turin), *La Toilette*, known as *A Woman before the Mirror*, 1912–13, Paris) and *Female Nude in a Tub* (1912, pr coll). He immortalized *Red Tower – Halle* (1915, Essen).

• During World War I Kirchner suffered a nervous breakdown after being called up in 1915. His self-portraits reflect the depth of his depression: *The Drinker* (1915, Nuremberg, Germanisches Nationalmuseum) and *Self-Portrait as a Soldier* (1915, Oberlin). In 1924 he produced one of his masterpieces, the woodcuts for the illustrations of *The Wonderful Story of Peter Schlemihl* (the man who lost his shadow) by Von Chamisso, a German writer and scholar of French descent.

• In 1917, Kirchner moved to Switzerland to convalesce and recover his peace of mind. His newly found serenity was clearly reflected in his Alpine landscapes and mountain villages: *Winter Night in Moonlight* (1919, Detroit), *Davos in the Snow* (1923, Basel), *Life in the Mountains* (1924–5, Kiel, Kunsthalle).

• The trend of modern art towards abstraction destabilized him while at the same time his reputation became established in Germany. His style swayed: *A Group of Artists* (1926, Cologne), *Two Nudes in the Woods* (1927–9, pr coll), *Lovers* (1930, pr coll). In 1931 he became a member of the Academy of Fine Arts in Berlin. In the meantime, in 1927, he had been commissioned to paint a mural for the Essen museum, a project on which he worked until 1934 but which was not to see the light, probably because of the rise of Nazism.

• His last works were more serene: *Shepherds in the Evening* (1937, pr coll). His expulsion from the Academy of Fine Arts and the confiscation in 1937 of 639 of his works by the Nazis, who judged his work as 'degenerate art', would explain his suicide in 1938.

A painter, sculptor, illustrator, xylographer, lithographer and engraver on copper, master of the pen, pencil, chalk, charcoal, watercolour and oil paints, Kirchner excelled in all these arts. He left many writings under the pseudonym Louis de Malle. He also influenced the abstract Expressionist movement Der Blaue Reiter ('The Blue Rider') and later the Bauhaus.

APPROACH AND STYLE

The themes of the nude, the couple and urban life always inspired the artist. He painted street, indoor, cabaret, theatre and circus scenes, portraits and self-portraits. The Swiss landscapes came later. He evolved from small to large formats.

Kirchner remembered the painter Hermann Obrist's 'sociology' lesson. He was familiar with the art of *Klimt and Jugendstil, Japonisme, the Neo-Impressionism of Paul Signac, the Post-Impressionism of *Van Gogh, the art of Munch and that of the Nabis and *Gauguin. He was inspired by the fauve colours of *Matisse and the 'geometrism' of *Cézanne. He was influenced by the German engravings and African and South Sea sculptures, and German art of the Middle Ages.

Berlin, Fehmarn Island (in the Baltic Sea), Moritzburg Lake (near Dresden) and Davos (in Switzerland) were all a source of inspiration.

● In Munich, Obrist advised him 'not to give a hasty impression but an in-depth expression of the essence' and to 'conceive art like an intensified, poetic form of life'. In contrast to his contemporaries, Kirchner wanted to 'breathe new life into German art', to express individual neuroses, his revolt in the face of the economic depression, the war and later Nazism. As a result he rejected the carefree representation of reality in favour of the 'fierce vigour' of contemporary life, moving away from the purely plastic concerns of his time. 'The renewal must not only be reflected in the forms but should also be expressed in the birth of new thought' (*Manifesto of the Blaue Reiter*). To achieve this, the painter declared in 1937, 'I first had to invent a technique to capture all that in the movement ... with rapid, bold strokes ... back home I drew large drawings from memory, thus learning to represent movement, discovering new forms in the exaltation and haste of this work which, without copying nature, nevertheless recreated ... what I wanted to recreate. Besides these forms were pure colours, as if the sun had produced them'. On the subject of the Neo-Impressionists he added: 'I found their drawing weak but I studied their use of colours, based on optics, and finally opted for the contrary, namely non-complementary colours, allowing the eye to produce the complementary colours itself, according to the theory propounded by Goethe. This makes paintings more colourful. Wood engraving ... strengthened and simplified my forms and it is with this knowledge that I arrived in Dresden.'

● In Dresden, the art of the German Middle Ages with its violence, the innovative framing of Japanese pictures and African and South Sea sculptures led him to distance himself from academic art once and for all. He increased this pure, 'primitive' impetus by painting in a way similar to how he engraved on wood, thus producing bold, archaic effects.

● In about 1905 he applied the Neo-Impressionist touch and then the fragmented, passionate technique of Van Gogh (*Lake in the Park*) to his pure, contrasting colours. He drew inspiration from Munch's anguished painting, portraying colourful, luminous surfaces, saturated and expressive. His spatial architecture was strong and the figures were portrayed as flat silhouettes in a two-dimensional approach. He applied the tempera technique when painting on canvas and diluted his oil paints with petrol in order to achieve thin layers with a matt finish. For the pure colours he dipped his brush directly in the pot.

● In 1907 his strokes broadened, their shape became more elongated and the thick coloured paint overflowed beyond the outline of the volumes, thus obliterating the drawing. Kirchner combined the expressive power of colour with the emotive intensity of eroticism (*Young Girls on a Beach*). From 1909 onwards he developed a more synthetic approach: his style became calmer and volumes were drawn with broad strokes. The paint, applied in flat tints, was contained, echoing Matisse's decorative style.

A GREAT PAINTER

◆ Although misunderstood, Kirchner enjoyed some fame during his lifetime. Like Gauguin, he was convinced of the posterity of his art.

◆ An artist of his time, Kirchner developed an emotional Expressionism, rejecting the exclusively plastic and formal concerns of Impressionism, Post-Impressionism and Fauvism.

◆ He painted his 'social' portraits in new light as illustrated in his representations of the high-class Berlin prostitutes (*demi-mondaines*, courtesans).

◆ He explored new plastic possibilities; his use of colours was supported by strong tension and eroticism. He invented an original 'hieroglyphic' calligraphy and a range of new colours in his engravings, enhanced with oils.

KIRCHNER

- His experience in wood engraving favoured this taut style with its sober, concise lines (*Seated Girl: Fränzi*, 1910–20, Minneapolis, IA). His mellow landscapes and nudes with their simple colours were inspired by the Nabis and Gauguin (*Four Women Bathing*).
- Between 1911 and 1914, in Berlin, Kirchner expressed his fascination mixed with acrimony for the capital. His portrayal of bourgeois urban life, informed by Cubist aesthetics, spoke of solitude and the psychological state of the élite in the light of a possible war, of malaise and crude eroticism (*Semi-Naked Woman in a Hat*). He used a simple frieze composition, gave depth to his forms, emphasized calligraphy and portrayed women sometimes with lyricism, sometimes with harsh colour dissonances, frozen in spectral light, seen in a deformed and sometimes deliberately grotesque perspective. He pulled the plane of the painting downward towards the viewer and enclosed the figurative elements in thick, summary, interrupted strokes. Forms became elongated and angular, the range of colours restricted.
- In 1913 he chose to paint larger pictures, rejected the bright colours typical of Die Brücke in favour of softer colours: 'Ochre, blue and green are the colours of Fehmarn, of the wonderful shores reminiscent of the lushness of the South Seas, of flowers', the artist declared in 1912.
- In 1915, in spite of ill health, Kirchner continued his pictorial research (*Self-Portrait as Soldier*), simplified forms, making them more primitive as far as the treatment of faces and the female nude were concerned. Invalided out of the army, he painted the Davos valley in pure colours. From 1921 onwards he conceived and produced patterns for petit point tapestries in which he further developed the simplification of forms and coloured flat tints.
- In 1923 his paintings became more serene, all feelings of anguish having disappeared. He established a balance between figuration, a more traditional spatial construction and clear colours, saturated with light. The angular shapes were replaced by more peaceful forms (*Mountain Life*). Between 1926 and 1929 he evolved timidly towards a lyrical abstraction: 'I see the possibility of a new type of painting. The liberation of surfaces. The goal I have always aimed for'. In his later work he strove to achieve a synthesis between decorative art and Expressionism.

KEY WORKS

Kirchner left more than 2,000 paintings and engravings, of which about 1,000 were paintings and decorations of houses and chapels.

Lake in a Park, 1906, pr coll
Street, Dresden, 1908, New York, MOMA
Four Women Bathing, 1909, Wuppertal, Von der Hetdt Museum
Marcella, 1909–20, Stockholm, Moderna Museet
Nudes Playing under the Trees, 1910, Munich, SMK
Self-Portrait with Model, c.1910, Hamburg, K
Semi-naked Woman with Hat, 1911, Cologne, Ludwig mus
Young Girls on a Beach, 1912, Kirchner bequest
A Woman before the Mirror, 1912–13, Paris, MNAM
Berlin Street, 1913, New York, MOMA
Five Women on the Street, 1913, Cologne, Wallraf-Richartz Museum
Moonrise in Fehmarn, 1914, Düsseldorf, Km
Dancing Girls, 1914, Turin, pr coll
Red Tower – Halle, 1915, Essen, FM
Self-Portrait as a Soldier, 1915, Oberlin, Allen Memorial Art Museum
Winter Night in Moonlight, 1919, Detroit, IA
Davos in the Snow, 1923, Basel, Km
A Group of Artists, 1926, Cologne, Ludwig mus
Lovers, 1930, pr coll
Shepherds in the Evening, 1937, pr coll

BIBLIOGRAPHY

German Expressionism, exhibition catalogue, Paris Museums, Paris, 1992

Self-Portrait with Model
c.1910. Oil on canvas, 1.50 x 1m, Hamburg, Kunsthalle

*This scene, set in a studio, shows the painter's desire for tranquillity,
far from the perverted civilization. Yet, the expression on the faces
remains morose as if still aware of the aggression of the outside
world. The closed, clear-cut shapes, typical of wood engraving, recall
the painter's experience of that technique. The plastic expression of
the red and the grating juxtaposition of the orange and mauve liven
up the painting and arouse the spectator's emotion: 'We accept all
colours which, directly or indirectly, express pure creative impetus',
the painter declared.*

Matisse

An unobtrusive man and a consummate artist, Matisse, the creator of Fauvism, stands out as a master of line and pure colour. He also expressed happiness and bliss through his use of pleasing colours, pure or subtly harmonious, applied in bold strokes, as flat tints or intertwined in rich arabesques, revealing a strong sense of décor and monumentality. Matisse ended his career producing pictures made with paper painted with gouache in pure colours, cut and glued.

LIFE AND CAREER

• The French painter Henri Matisse (Le Cateau-Cambrésis 1869–Nice 1954) was to have followed in his father's footsteps, having studied law in Paris from 1887 to 1888. He started work as solicitor's clerk in 1889 and began painting in about 1890. In 1892 he enrolled at the Académie Julian and at the School of Decorative Arts where he met Albert Marquet. In 1895, he was noticed by Gustave Moreau who accepted him immediately into his studio without having to pass the competitive examination of the School of Fine Arts. There he met Georges Rouault and Charles Camoin.

• His first canvases, painted between 1890 and 1904, reflected the influence of Émile Bernard, *Van Gogh, Camille Pissarro and others. In Belle-Île he painted *Breton Weaver* (1896, Paris, MNAM), *Still Life with Two Bottles* (1896, Paris, MNAM) and *Tray* (1897, Niarchos coll). In 1898 Matisse married. He discovered the works of *Turner in London and Mediterranean light in Corsica: *Corsican Landscape* (1898, Paris, C Grammont). In Toulouse he painted *Still Life with Pewter Pot* (1898, location unknown) and *First Orange Still Life* (1899, Paris, MNAM).

• He discovered the innovations introduced by *Gauguin, *Cézanne and Japanese art. In order to earn a living he competed together with his friend Marquet for the decoration of the Grand Palais on the occasion of the 1900 Universal Exhibition. The following year he exhibited at the Salon des Indépendants. André Derain introduced him to Maurice de Vlaminck during the Van Gogh retrospective. *A Glimpse of Notre-Dame in the Late Afternoon* (1902, Buffalo) showed his admiration for Cézanne.

• His 'Fauve' period which lasted until 1907 began in the summer of 1904 when he went to Saint-Tropez as a guest of Signac, the master of Divisionism: *Signac's Terrace in Saint-Tropez* (1904, Boston, Gardner mus), then *Luxury, Calm and Voluptuousness* (1905, Paris). In the summer of 1905 he joined Derain in Collioure and turned away from pointillism. *Marine* (1905, San Francisco, MOMA) and *Pastorale* (1905, Paris, MNAM), exhibited in the same room with his friends' paintings, were described as 'Fauves' at the 1905 Autumn Salon. Pure colours dominated in *Window* (1905, New York), *Woman with a Hat* (1905, San Francisco, Walter A Mass coll) and *Portrait of Madame Matisse* (The Green Stripe, 1905, Copenhagen). Matisse was also influenced by artistic trends as diverse as the art of Gauguin, African art and German Expressionism (*Gypsy*, 1906, Saint-Tropez, Annonciade). The woman, shown in *Joie de vivre* (1905–6, Merion [Penn.], BF) became a recurrent theme; Matisse portrayed her half-dressed or naked, sometimes lascivious as in *Blue Nude* (1906, Baltimore), painted after his return from Algeria. A pioneer of Fauvism, he became the mentor of French painting abroad and opened an academy of international painting. He published *Notes d'un Peintre* (*A Painter's Notes*) (1908) and painted *The Red Room* (*Harmony in Red*) (1908, St Petersburg), *Music* (1909, St Petersburg) and *Dance* (1909, St Petersburg).

• He spent time in Moscow in 1911 in order to supervise the installation of *Dance and Music* (St Petersburg, Hermitage), commissioned in 1909 by the Russian collector Shchukin. He was in Spain in 1911 and 1912, then in Morocco in 1912 and 1913. His very varied work was Expressionist in *The Algerian Woman* (1909, Paris, MNAM) and *Pink Nude* (1909, Grenoble, B-A), in the style of Cézanne in *Still Life with Oranges* (1912, Paris, Musée Picasso) and *Portrait of Madame Matisse* (1912, St Petersburg, Hermitage), heralding the coloured flat tints which characterized *The Painter's Family* (1911, St Petersburg, Hermitage) and *Conversation* (1911, St Petersburg, Hermitage), *Red Fish* (1911, Moscow). His constant pictorial research was reflected in *The Red Studio* (1911, New York), *Interior with Eggplants* (1911, Grenoble), *Blue Window* (1912, New York, MOMA). It is also expressed in the serenity and simplicity which marked his portraits (*Zora the Moroccan*, 1912, St Petersburg, Hermitage; Moscow, Pushkin).

• Between 1913 and 1917, Matisse drew inspiration from various sources: the east with its Andalusian arabesques and Moroccan light in the *Moroccan of the Rif* (1913, St Petersburg);

Cubism, which led to *French Windows in Collioure* (1914, Paris), *Goldfish and Palette* (1914–15, New York, pr coll) and *Coloquintes* (1916, New York, MOMA); and abstract art in *The Piano Lesson* (1917, New York). But he also remained faithful to Post-Impressionist realism in *The Music Lesson* (1917, *Merion* [Penn.] BF).

● From 1918 onwards, he was much inspired by the Mediterranean light of Cagnes and Nice where he moved in 1921: *Interior Nice* (1917–18, Copenhagen, SMFK and 1921, Paris) and *Young Girl in a Green Dress* (1921, New York). Matisse combined a decorative style with monumental classicism: *Decorative Figure on an Ornamental Background* (1925, Paris).

● Between 1930 and 1938 he diversified and became involved in sculpture, engraving, tapestry cartoons and drawings for décor and costumes. He travelled to Tahiti (1930), San Francisco, New York and Merion where for Dr Barnes he painted *Dance* (1931–2, Merion, and 1931–3, Paris, MNAM). He painted numerous variations of the *Pink Nude* (1935, Baltimore).

● In 1938 Matisse lived in Cimiez before moving to Vence in 1943. During the war he only painted small canvases such as *Romanian Blouse* (1940, Paris, MNAM). He drew, illustrating some of Montherlant's books, but he now preferred scissors to brushes: *Jazz* (collection of 20 gouaches, cut out, 1943–4, pr coll); *Polynesia, the Sky* (1946, Paris, MNAM). Between 1947 and 1951 the artist concentrated on the building and decoration of the *Chapelle de Rosaire in Vence* (stained glass and ceramic panels).

● Matisse's last paintings included *Young Woman in White*, also known as *Young English Woman* (1947, pr coll) and *Large Red Interior* (1948, pr coll); these reflected his aesthetic development, as did his cut-out gouaches such as *Hair* (1952, pr coll), produced between 1950 and 1954.

Matisse had numerous foreign pupils. His artistic output was extremely diverse during the first half of the 20th century. The many exhibitions which succeeded each other from 1948 onwards, the creation of the museums at Le Cateau-Cambrésis and the villa in Avenue des Arènes-de-Cimiez in Nice reflect the importance of his art. He played an important part in the Fauve movement with Raoul Dufy, Derain and Vlaminck, and in the Expressionist movement with *Kirchner and Alexei von Jawlensky. *Picasso, *Léger and Robert and Sonia Terk Delaunay were all inspired by his use of colour and his linear, monumental style at some point during their careers.

A GREAT PAINTER

◆ The leader of the Fauves since 1905, Matisse was famous during his lifetime but more with artists and collectors than with the general public. The Autumn Salon organized a retrospective of his work during his lifetime (in 1945). His fame continues, as is reflected in the many exhibitions of his work, for instance in New York (1951 and 1992–3) and Paris (1970, 1993, 1999 and 2001).

◆ Matisse was considered a major protagonist among the avant-garde artists of the 20th century. His art broke with the pictorial tension of the beginning of the century, offering instead beauty, tranquillity and joie de vivre.

◆ He was interested in the female figure, portrayed as a voluptuous creature in a subtle, cheerful interior, filled with luxurious objects, surrounded by lush vegetation. The windows opening onto the luminous world outside counterbalance the intimate atmosphere of the interior, dominated by the decorative exuberance of the rugs and tapestries embellished with arabesques while the silent movement of the goldfish introduces a feeling of tranquillity.

◆ Matisse reinterpreted the great linear, monumental style while introducing the bold layouts of Japanese prints.

◆ He rehabilitated pure colours as opposed to the muted colours and bituminous shades of the academic painters of his time. He conveyed movement and expression through the use of bright or muted colours, applied sometimes with a large brush, sometimes with flat tints, on canvas or paper. Reds and blues played a particularly important part in his work.

◆ Matisse mastered and mixed all the techniques to produce his own personal synthesis: he juxtaposed small pointillist touches with broad flat tints, mixed together oils and distemper on the same support, and so on; and he invented a collage made up of papers previously painted with gouache.

MATISSE

APPROACH AND STYLE

Matisse abandoned portrait and self-portrait painting in favour of a more general representation of the human figure, mainly female. He portrayed her indoors, clothed or nude. He opened windows onto the landscapes of Paris, Vence, Morocco and Tahiti. He painted scenes of interiors, his own studio and a few still lifes.

His oil paintings and gouaches ranged from very small to very large.

The gallery owner Ambroise Vollard organized the first personal exhibition of the painter in 1904. The buyers were mainly foreign: the Russians S Shchukin and I A Morozov; the Americans G and L Stein, C and E Cone and Dr Barnes; and the Dane J Rump, as well as some Germans and Swiss. Sembat was one of the rare French collectors.

Several places were a direct source of inspiration in Matisse's art: Corsica, Collioure, Morocco and Algeria, Tahiti and Nice. He was also influenced by the art of Pissarro, the pointillism of Signac and *Seurat and the Post-Impressionist experiments of the Nabi Émile Bernard, Cézanne, Van Gogh and Gauguin among others. He was inspired by Japonisme and the Classicism of *Ingres.

- The paintings produced between 1890 and 1904, mainly still lifes, reflected the influence of Neo-Impressionism and Émile Bernard. Matisse's landscapes were reminiscent of Van Gogh's style. Whether a portrait or narrative scene, the light colours were linked more to the objects than the subject. Yet, Matisse recalled Chardin's themes (*Tray*, 1897) and used thick impasto (*Still Life with Pewter Pot*)
- The light of Corsica and Toulouse illuminated his colours. The pure, saturated colours of the forms, at first massive and sober, mellowed. In 1904 he became interested in the rigorous technique of Divisionism, 'logic in purity' (Signac), to create an Arcadian vision of happiness (*Luxury, Calm and Voluptuousness*). This brief involvement with Divisionism, in which pure and complementary colours were applied in dots, led to the birth of Fauvism.
- Between 1905 and 1907, Matisse retained only the purity of colours from his pointillist period. He distanced himself from it by applying small strokes next to wide impasto. His creative enthusiasm was accompanied by a bold arrangement, sometimes Japanese in style, with a vigorously expressive line consisting of decorative arabesques and by an explosion of pure colours without gradations which excluded shadows and modelling. The cycle of the great still lifes started with *Red Carpets* (1906, Grenoble). The brushstrokes became bold (*Portrait of Madame Matisse*). Matisse's Fauvism was moving closer to Expressionism (*Gipsy*).
- The pictorial period which followed Fauvism was harmonious, serene and happy; Matisse re-invented the Golden Age (*Joie de vivre*). 'I want', he said in 1908, 'a balanced, pure art which does not worry or perturb, I want the man who is tired, overworked and exhausted to savour tranquillity and peace in front of my painting.' His bucolic themes, the pastoral, bacchanal and mythological scene with their sacred figures, expressed as he said, his 'almost religious feeling of life'. Subjectivity prevailed over reality, the part over the whole: 'I show a fragment and I whisk the spectator along with the rhythm, I encourage him to follow the movement of the fragment that he sees so that he feels that he has seen the whole.' Matisse favoured the motif, the decorative object (mural tapestry, rug, vegetation, aquarium, etc) and colours at the expense of expression but not emotion. The large format, the undulating line of the bodies and objects, the garlands of coloured arabesques and splashes of bright colours created a subtle balance between rigour and sensitivity (*Red Studio*). Some of his still lifes retained touches of Cézanne. Matisse concentrated on inhabited interiors and open windows (*Conversation*).
- World War I shattered his dream. The painter returned to sombre shades and simplified masses. He embraced Cubism (*The Piano Lesson*) and translated realist elements into abstract motifs through a complex play of coloured combinations and pure geometric forms. He introduced the colour black and coloured surfaces that heralded the American abstract Expressionism of the 1950s (*French Windows in Collioure*). At the same time he returned to realism (*Laurette in a White Turban*, 1916, Baltimore, MA).
- In 1917 the Mediterranean light of Nice enlivened his subjects and created a certain exoticism; his paintings were filled with palm trees and nude or half-clothed odalisques. The décor inspired by oriental ceramics played a major part, as did the figure, treated classically (*Decorative Figure on an Ornamental Background*). In his mature period, Matisse combined the formal, coloured monumental with the decorative.
- After 1928 Matisse showed complete mastery of the dynamic arabesque, painted or cut out of paper, painted with gouache. He combined concision of line and decorative talent (*Dance, Pink Nude*), 'a form of expression of space and movement through well-defined

Portrait of Madame Matisse, also called **The Green Stripe**
1905. Oil on canvas, 40.5 × 32.5cm, Copenhagen, Statens
Museum for Kunst

*This work dates from the artist's Fauve period, which exalts all the
colours, admired individually or as a whole. The juxtaposed colours
create a luminous depth, outside all reference to reality and perspective.
They impose a new plastic construction, a new aesthetic musicality.
Matisse emphasized the 'arbitrary impression aroused at first sight by
the green stripe which divides the face of Madame Matisse, an
impression which is not impossible to analyse. The green stripe clearly
marks the boundary separating the area of shadow from the area of
light on Madame Matisse's face. The green ridge which represents the
ridge of the nose [creates] a succession of coloured planes … the green
line between the ochre side and pink side of the face, the blue hair
between the green background and the violet background, the emerald-
coloured collar between the orange shoulder and the violet shoulder …
The fighting, the final hand-to-hand skirmishes are over. Now colours,
like allies after the victory, share the conquered land' (P Schneider,
1982).*

impasto' (Michel Hoog, 1968), close to 'abstract formalism' (P Schneider, 1993). He represented South Sea motifs of pure decorative fantasy. The chapel at Vence reveals a great sobriety of forms, human (St Dominic), animal (fish) and vegetable (geometric motif), and colours, and of yellow, blue and green. The painting is luminous, decorative and conveys an impression of the sacred: 'There is no break between my earlier paintings and my cut-outs, only more absoluteness, more abstraction', the artist declared in 1952. His glued-on paper respected the integrity of the surface which implied the purity of the colours, the sincerity of the drawing and the integration of the figure into the background.

• Matisse's last paintings reveal his continued research in line and colour. He paid a last homage to woman, now portrayed in her fullness.

Decorative Figure on an Ornamental Background
1925. Oil on canvas, 131 x 98cm, Paris, Musée National d'Art Moderne

The redundancy of the qualifying adjectives 'decorative' and 'ornamental' clearly shows Matisse's intention. The sculptural, three-dimensional realist figure, which also exudes a certain exoticism, is set in a two-dimensional, unreal environment created by the decorative background. The floral and geometric motifs which decorate the rugs and wallpaper are heavy, insistent and heterogeneous: Persian rug, Venetian mirror, baroque paper, Oriental cache-pot ... As in Klimt's later work, the decorative plane merges with the pictorial plane and each object looks as if about to be flattened and merged into the décor. For instance, the blue surface of the mirror does not reflect anything but merges into the blue wall. The seated female figure contrasts with the background surrounding her through her treatment: only the excessive stylization of her body is in harmony with the excess of the décor. All of Matisse's work excelled in the confrontation of figure and background, objective and subjective in which the stylized figure and background sometimes clash violently in their colours (Young Woman in White, 1946).

Hair
1952. Gouache-painted paper, cut out and glued on white paper mounted canvas, 110 x 80cm, private collection

From the 1950s onwards, Matisse created a series of blue nudes made without a model. The Hair is part of this new plastic approach. The painter covered large sheets of paper with gouache before cutting them out (without resorting to a preliminary drawing) and then sticking them onto a support. He reworked his cut-outs by removing some and adding others. The artist 'draws, paints and sculpts' with his scissors, he 'cuts the colour to the quick', to use the expression. He added volume to the body without resorting to trompe-l'œil; it is the gaps, the whites that articulate the body and place it in space. The luminous colour conveys depth and poetry to these almost abstract works, reflecting an absolute which comes to life in the artist's hands.

KEY WORKS
In a career stretching over 60 years, Matisse created more than 1,000 painted works, not counting cut-paper and stencilled works, drawings, illustrations, engravings, sculptures, stained-glass windows, costumes, tapestry cartoons and ceramics.
Still Life with Two Bottles, 1896, pr coll
Still life with Pewter Pot, 1898, location unknown
A Glimpse of Notre-Dame in the Late Afternoon, 1902, Buffalo [NY], Albright-Knox AG
Luxury, Calm and Voluptuousness, 1905, Paris, pr coll
Window, 1905, New York, J H Whitney coll
Portrait of Madame Matisse, Green Stripe, 1905, Copenhagen, SMFK
Joie de vivre, 1905-6, Merion [Penn.], BF
Blue Nude, 1906, Baltimore, MA
The Red Room, Harmony in Red, 1908, St Petersburg, Hermitage
Dance, 1909-10, St Petersburg, Hermitage
Red Fish, 1911, Moscow, Pushkin
The Red Studio, 1911, New York, MOMA
Interior with Eggplants, 1911, Grenoble, BA
Conversation, 1911, St Petersburg, Hermitage
Moroccan of the Rif, 1913, St Petersburg, Hermitage
French Windows in Collioure, 1914, Paris, MNAM
The Piano Lesson, 1917, New York, MOMA
Interior Nice, 1917-18, Copenhagen, SMFK and 1921, Paris, MNAM
Young Girl in a Green Dress, 1921, New York, Colin coll
Decorative Figure on an Ornamental Background, 1925, Paris, MNAM
Dance, 1931-2, Merion [Penn.], BF
Pink Nude, 1935, Baltimore, MA
Polynesia, the Sky, 1946, Paris, MNAM
Chapelle de Rosaire, 1947-51, Vence
Large Red Interior, 1948, pr coll

BIBLIOGRAPHY
Barr, A H, *Matisse: His Art and His Public*, Museum of Modern Art, New York, 1951; Cowling, E, *Matisse Picasso*, exhibition catalogue, Tate Publishing, London, 2002; *Henri Matisse*, exhibition catalogue, RMN, Paris, 1970; *Matisse in Morocco*, exhibition catalogue, Thames and Hudson, London, 1990

Braque

Braque was a hard-working, thoughtful, unassuming artist with great pictorial sensitivity. With Picasso he was the founder of Cubism. He methodically and slowly developed his profound, concentrated art. He excelled in collages and large-scale still lifes and, later, in series on a theme (such as billiards, studios or birds).

LIFE AND CAREER

• The French painter Georges Braque (Argenteuil-sur-Seine 1882–Paris 1963) was born into a family of craftsmen in Le Havre. At the same time that he started his career as a house painter, which increased his awareness of the materials, he also met Othon Friesz and Raoul Dufy at fine arts evening classes.

• He arrived in Paris in 1900 and enrolled at the Académie Humbert (1903) and in Léon Bonnat's workshop at the Beaux-Arts. Enthralled by the paintings of the Fauvists exhibited at the 1905 Autumn Salon, he joined their group. He painted *The Port of L'Estaque* (1906 and 1907, Paris, MNAM) and *The Little Bay at La Ciotat* (1907, Paris, MNAM).

• In 1907, having seen *Cézanne's retrospective, Braque became interested in the geometric forms created by the master. He met *Picasso through Apollinaire and admired *Les Demoiselles d'Avignon*. He returned to his brushes: *Viaduct at L'Estaque* (1907, Minneapolis, IA; 1908, Paris, MNAM); *Large Nude* (1907–8, Paris). The geometric masses are multiplied in *Musical Instruments* (1908, Laurens coll) and in *Harbour in Normandy* (1909, Chicago).

• Towards the end of 1909, Braque and Picasso started working closely together to develop Cubism. They stayed with the Spanish artist Juan Gris in Ceret in 1911 and the summer of 1912 in Sorgues. They were then separated by the war.

• Analytical Cubism (1909–12) began to take shape in Braque's still lifes: *Woman with a Mandolin* (1910, Munich, NP), *Le Guéridon* (1911, Paris) and *The Portuguese* (1911, Basel, Km). The new technique of *papier collé* (collage) which had made its appearance in Synthetic Cubism (1912–4) was present in *Guitar*, collage (1912, pr coll), *La Statue d'épouvante* (*Rule of Terror*, 1913, pr coll) in a which a cursive drawing was added to the collage and in *Man with Guitar* (1914, pr coll). *Woman Musician* (1917–18, Basel) marked the end of Synthetic Cubism and the collaboration between Braque and Picasso.

• Wounded during the war, Braque began painting again in 1917, encouraged by Gris and the sculptor Henri Laurens. His still lifes revealed the poetic development of his Cubist inventions: *Guitar and Clarinet* (1918, Philadelphia), *Guitar and Fruit Bowl* (1919, Paris, MNAM), *Sideboard* (1920, Basel) and *Guitar and Glass* (1921, Paris, MNAM). He also produced a few human figures including the *Canéphores* series (1922, Paris, MNAM) and still lifes such as *Marble Table* (1925, Paris, MNAM), *Still Life with Clarinet* (1927, Washington) and *Le Guéridon* (1929, Washington). In the *Guéridon* series, he produced *Still Life with Apples on a Pink Table-Cloth* (1933, Princetown, Chrysler AM). His work confirmed the maturity of his classical, measured talent, in the French tradition. The first large-scale exhibitions, organized in the 1930s in Berlin, New York, Basel, London and Brussels, paid tribute to the artist. In 1937, he was awarded the Carnegie Prize after *Matisse and Picasso.

• On the eve of World War II, Braque reintroduced the human figure in *Woman with a Mandolin* (1937, New York, MOMA), *Le Duo* (1937, Paris, MNAM), *The Painter and his Model* (1939, New York, pr coll) and *Model* (1939, New York, pr coll).

• During the war, the artist portrayed food shortages in *Carafe and Fish* (1941, Paris), *Bread* (1941, Paris) and *Black Fish* (1942, Paris); he showed death in *Vanitas* (1939, Paris) and *Still Life with Skull* (1941–5, pr coll). The *Billiards* series (1944–9) showed broken tables. In 1943, the artist began working on a series of sculptures.

• After the Liberation, suffering ill-health, Braque painted irregularly. In 1948 he was awarded the International Grand Prix of the Venice Biennale. He began working on the *Studio* series: *Studio II* (1949, Düsseldorf, KNW), *Studio III* (1949–51, Vaduz), *Studio IX* (1952–6, Paris, MNAM). The bird which crosses these pictures is present again in his last paintings; *L'Oiseau quadrillé* (*Squared Bird*, 1952–3, pr coll), *Black Birds* (1956–7, Paris), *Nest in the Foliage* (1958, Paris) and *À tire d'aile* (1956–61, Paris). Braque decorated the ceiling of the Salle des Étrusques at the Louvre (1952–3, Paris) and produced cartoons for the stained glass windows of the Chapelle Saint-Bernard (Saint-Paul-de-Vence, Fondation Maeght).

An all-round artist, Braque was a painter, decorator, painter-illustrator, sculptor and lithographer. Like that of Picasso, whose fame somewhat pushed him into the background, his work had a powerful impact on modern and contemporary aesthetics.

APPROACH AND STYLE

During his Fauve period Braque painted landscapes and a few nudes. Cézanne's treatment of volumes influenced his representations of landscapes, nudes and still lifes. During his Analytical Cubist period, he favoured still lifes with a musical theme and characters who were often musicians; he abandoned landscapes. When he moved to Synthetic Cubism he introduced fruit bowls and fruit to his still lifes, which featured musical instruments.

After World War 1 and until his death, he remained faithful to these themes but introduced female figures. He painted still lifes with fish, series centred round the theme of billiards, the studio and birds. Braque's work ranged from small formats to more ambitious compositions.

The art dealer D H Kahnweiler exhibited the artist's work in France, while the New York art dealer L Rosenberg preferred his large still lifes. J Paulhan and the Russians Metchianinoff and J Zoubaloff all bought his work.

Braque was influenced by the Fauve aesthetics of Matisse and Derain and followed Othon Friesz to Antwerp. In Paris, L'Estaque and La Ciotat, he produced work in the Fauvist tradition, then in the style of Cézanne. In Paris, Ceret and Sorgues, with Picasso, he developed Cubism. Braque was also close to his friends Gris and Laurens.

● In Le Havre, he turned away from the 'Impressionist atmosphere' and became involved in Fauvism. He was the last one to join the Paris group, in 1906. His work revealed his interest in the organization of forms, combined with sumptuous colours (*L'Estaque*). He loved this 'pure', enthusiastic, direct painting which he described as 'physical' and 'devoid of romanticism'.

● During the winter of 1907–8, he became involved in Cubism. Cézanne's influence was visible in his geometric shapes, consisting of broad, juxtaposed strokes. But the colours remained Fauve, with broken, luminous tones (*Viaduct in L'Estaque*). Then Braque softened his palette, chose Provençal colours in the style of Cézanne such as ochre, yellow, green and grey. After creating the *Large Nude*, which revealed the combined influences of Cézanne (*Bathers*), Matisse (*Blue Nude*) and Picasso (*Les Demoiselles d'Avignon*), he conceived 'shapes reduced to geometric patterns, in other cubes' (L Vauxcelles, 1908).

● In his numerous landscapes, he opposed coloured masses which were linked by the modulations of the coloured spaces between the masses: 'What attracted me most – and it was the guiding force behind Cubism', he wrote, 'was the materialisation of this new space which I felt.' Braque decomposed the elements and rearranged them vertically making them appear closer to the spectator. He thus reduced what he called 'visual space', favouring 'tactile space' instead (*Harbour in Normandy*). In the next phase he abandoned the landscape in

A GREAT PAINTER

◆ Rejected at the 1908 Autumn Salon, Braque was crowned with success at exhibitions during the 1930s and awarded several painting prizes. Nevertheless he remains less well known to the public than Picasso.

◆ Like Picasso, Braque revolutionized western painting during the 20th century by developing with him the Cubist language, rejecting the illusionistic representation of the object and introducing innovative plastic procedures.

◆ In 1908 the artist developed an analytical vision of objects (*Musical Instruments*). He was the first, before Picasso, to use the technique of collage. Together with Picasso, he created the picture-object, using mixed techniques and materials such as oil, sand, sawdust and metal filings.

◆ He painted prosaic subjects such as pedestal tables, billiard tables, fireplaces and he also created personal thematic associations: a Studio crossed by a bird ...

◆ A real genius of composition, he invented complex, monumental, refined constructions as illustrated in his large still lifes of the 1920s with their dark colours, sustained by a matt, black or grey preparation, in the series of duos or women on their own, produced between 1939–45 and in the *Studio* series, painted between 1949 and 1956.

BRAQUE

favour of the human figure and especially still life, 'because in still life there is tactile ... almost manual space'.

• From 1909 onwards, Braque and Picasso shared their stylistic experiments in Analytical Cubism (1909–12). This involved the search for the tangible reality of things whereby the structure of the object prevailed over colour. In order to achieve this Braque flattened the volumes in monochrome shades of beige and reduced sharp angles. He kept a few curves in order to preserve the legibility of the subject. The divided strokes, both vibrant and unitary, resulted in the creation of flat planes (Le Guéridon).

• But soon, at the risk of losing the meaning of the picture, he introduced real elements, evolving towards what is known as 'Synthetic' Cubism (1912–14). He added concrete elements, which were painted in trompe-l'œil (imitation wood, letters, numbers, nails) and intended to emphasize the material nature and flatness of the work to the analytical shapes (Le Guéridon or Still Life with Violin). These elements reintroduced colour to the pictures. Braque was also the first artist to imitate the grain of the wood using a painting comb and to master the technique of imitation marble. He then produced printed letters using a stencil. He sometimes added sand, sawdust or iron filings to his pictorial material, subverting traditional painting techniques. Braque put a definitive end to illusionistic painting.

• Braque's pictorial development then diverged from that of Picasso. Braque was more interested in colours while Picasso was more interested in space and form. In 1914, to avoid the risk of sliding into abstraction, the artist restructured the constituent elements of the work into a concentrated, almost volumetric composition (Man with a Guitar).

• The still lifes with collage produced after the war were airier, less innovative. The paintings favoured a pictorial language and superimposed colours that were meticulous and refined, dense, rhythmic, coloured and decorative (Sideboard). The painter reintroduced the figure, abandoning the line in favour of wide, voluptuous arabesques in the classic French tradition of *Ingres, *Courbet and Renoir (Les Canéphores). Les Guéridons, Chimneys and still lifes in which a bunch of grapes might be placed next to a musical instrument were strongly constructed and dynamic in their vertical format. The rich impasto and dark colours further increased their severity and monumentality (Marble Table): the 'pictorial fact' and plastic autonomy prevailed over the object.

• From 1928 onwards, the colours lightened. Braque used a floating, continuous line, reminiscent of Picasso's undulating line (Still Life with Red Tablecloth, 1934, pr coll). He displayed his sense of the ornamental which was colourful, lively and imaginative. He gave attention to the human figure, seen simultaneously half-face and in colour, and in profile as a silhouette (Model).

• The paintings painted during the war reflect the austerity of the times which the artist expressed through simple subjects (Two Black Fish, 1942, Paris, MNAM), sometimes morbid (Vanitas) in sober compositions and dark colours, and sometimes with a granular texture. Life was in suspense (Patience) and Braque turned his back on the period (Man with Easel, 1942, Paris, Louise Leiris gallery).

• From the end of the war until his death, Braque's work displayed a homogeneous stylistic development while also revealing a 'pictorial poetry'. For instance, he developed the theme of the Studio, crossed by birds living and in flight, which he later portrayed on their own in a stylized manner.

BIBLIOGRAPHY

Barr, A H, Cubism and Abstract Art, facsimile of 1936 edn, Secker and Warburg, London, 1975; Georges Braque rétrospective, exhibition catalogue, Maeght Foundation, Saint-Paul, 1994; Golding, J, Cubism, A History and an Analysis 1907-1914, 3rd revised edn, Faber, London, 1988; Hope, H R, Georges Braque, Museum of Modern Art, New York, 1949; Rosenblum, R, Cubism and Twentieth Century Art, new edn, Harry N Abrams, New York, 1976

Le Guéridon or **Still Life with Violin**
1911. Oil on canvas, 116 x 81cm, Paris, Musée National d'Art Moderne, Centre Georges-Pompidou

This painting dates from the Analytical Cubist period when Braque and Picasso worked together, comparing their development on a daily basis: 'In spite of our very different temperaments we were both guided by a common thought', that of creating a 'new space' and plane.
In this painting, the highly structured, sophisticated visual language does not allow the direct reading of the subject. The viewer must concentrate in order to try and reconstruct the subject, seen from the bottom upwards. The lower part of the violin and the stick are placed on a table which slides towards the viewer's plane. The painter suggests the progressive movement of the objects through interrupted oblique planes and small horizontal and fragmented geometric strokes. The monochrome colouring, a grey-ochre, reinforces the destructuring of the shape into different planes.

273

BRAQUE

Model, 1939. Oil on canvas, 1 x 1m, New York, private collection

During the years 1936–44, Braque painted figures in front of an easel. For this painting the artist chose a square format to portray a woman drawing. Sitting up and silent, she has the same presence value as what surrounds her in this interior full of ornamental motifs and objects. The objects flattened on the plane of the painting remove all impression of relief. The light and shadow divide the body of the Model vertically. This chiaroscuro shows her face both full-face (seen in the light) and in profile (drawn by the shadow). Braque's contribution lay in the extension of Cubist aesthetics. The painter exploited the antithesis of negative–positive, obscurity–light and profile–full-face. This duality was particularly significant in these times of conflict, dominated by adversity and hope, war and peace, light and shadow. 'It seems just as difficult', the painter wrote, 'to paint the in-between as the objects. I believe that this "in-between" is as important an element as what they (people) call "the object". It is the relationship of these objects between themselves and of the object with the "in-between" which constitutes the subject.'

Marble table or Fruit on a Tablecloth with a Fruit Dish
1925. Oil on canvas, 130.5 x 75cm, Paris, Musée National d'Art Moderne, Centre Georges-Pompidou

This monumental still life, vertical and complex, is one of the masterpieces produced during the 1920s. The composition, trompe-l'œil marble and dark colours are striking. The construction in juxtaposed planes shows a large void on the right side of the picture while the large slab of green marble, which echoes that of the wall, is arranged along an oblique axis which extends beyond the canvas and makes up the left part of the composition. The still life straddles both parts, spreading out towards the foreground in order to increase the tactile effect of the apples and pears.
The restricted and austere colours (brown, green, grey and black) are emphasized by skilful plastic associations and a perfect equilibrium in the harmonious rapport between the fruit bowl and glass, the marble and fruit. The still life is enclosed inside a broad white strip, painted boldly, to mark the distance between the objects and light up the painting. The composition and geometric patches of colour are in the tradition of the collage technique. Braque combined volume and colour very closely.

Picasso

An artist who symbolizes 20th-century art, Picasso distinguished himself through his revolutionary art, combining Cubism with a very personal vision. His work was divided into phases of different styles: the 'blue' and 'pink' academic periods, Cubism, Classicism, Surrealism, avant-garde and others. He freed imagination and technique to the edge of abstraction but intentionally remained within figurative art. He alternated violence and poetry. An indefatigable artist, he experimented throughout life trying out new approaches, thematic as well as plastic and technical.

LIFE AND CAREER

• Pablo Picasso, properly Pablo Ruiz Blasco (Málaga, Andalusia, 1881–Mougins 1973), Spanish artist, was exceptionally long-lived, his life spanning almost the whole of the 20th century. His father was a painter and professor of art in Málaga. Pablo lived in Barcelona and enrolled at the school of Fine Arts and Architecture in 1895. During that period he painted large academic paintings. He was attracted by the avant-garde and Expressionism. He was much moved by the poverty around him, the misery of prostitutes and alcoholics, as well as the suicide of his friend Casagemas.

• In 1900 he became friends with *Matisse, Apollinaire and Max Jacob in Paris. It was in 1901 that he began using his mother's name Picasso to sign his paintings. Haunted by the lively memory of the dramas he had seen around him, Picasso used bluish shades in his paintings; this was the blue period (1901–4) with *Absinthe Drinker* (1901, Glarus) and *Old Jew with a Boy* (1903, Moscow, Pushkin). These two paintings are pervaded with deep sadness, the same sadness that emanates from the portraits of *Célestine* (1903) and *Mother and Child in a Scarf* (1903, Barcelona, Picasso mus).

• The 'blue' period was followed by the 'pink' period (1904–6): *Les Bateleurs* (1905, Washington); *Enfant et Saltimbanque Assis* (1906, Zurich, Kunsthaus) and *Two Brothers* (1906, Basel).

• On his return from Andorra in the summer of 1906 Picasso, influenced by *Cézanne's art, changed the direction of his style: *The Harem* (1906, Cleveland, MA), *Portrait of Gertrude Stein* (1906, New York) and especially *Les Demoiselles d'Avignon* (1907, New York) which marked the beginning of modern art.

• His Cubist adventure in which he joined forces with *Braque lasted from 1907 to 1914. The Cézanne-influenced period (1907–9) ended with *Portrait of Clovis Sagot* (1909, Hamburg). The Analytical Cubism (1907–12) which succeeded it 'decomposed' the *Portrait of D H Kahnweiler* (1910, Chicago) and that of the *Mandolin Player* (1911, Basel, pr coll). Synthetic Cubism renewed links with reality: *Nature morte à la chaise cannée* (1912, Paris), *Bottle of Vieux Marc, Glass and Newspaper* (1913, Paris); *Violin and Guitar* (1913, Philadelphia, AM) and *Portrait of a Young Girl* (1914, Paris).

• After World War 1 Picasso returned to a more immediately readable art. He designed décors and costumes for: *Parade* (1917) and *Pulcinella* (1920) etc. His 'Ingresque' paintings (*Three Women at the Fountain*, 1921, New York), his 'Pompeian' paintings (*Women in White*, 1923, New York) and his 'classical' paintings – *Portrait of Olga Kokhlova* (1923, Grenoble), his wife, and his son *Paul as a Pierrot* (1925, Paris, Musée Picasso) – were a deliberate hiatus in relation to the experiments carried out by the avant-garde except for his Cubist painting *Three Musicians* (1921, New York, MOMA).

• In 1925 Picasso became interested in Surrealism: *The Dance* (1925, London), *Seated Bather* (1929, New York), *Figure on the Seashore* (1931, Paris, Musée Picasso).

• In 1932 he met Marie-Thérèse Walter whose beauty inspired him to paint *The Dream* (1932, New York) and *The Muse* (1935, Paris). Between 1930 and 1934, Picasso carved busts and nudes and worked with metal, encouraged by his friend, the Spanish sculptor Julio Gonzalez.

• Living in Spain in 1933 and 1934, he immersed himself in bull-related themes, particularly the Minotaur, of which he produced engravings. *Guernica* (1936, Madrid), his most famous painting, shows his commitment against war and fascism. He expressed his suffering in *Woman Crying* (1937, London), a portrait of his companion Dora Maar.

• During World War II his work was haunted by the spectre of death: *Night Fishing at Antibes* (1939, New York), *Still Life with Steer's Skull* (1942, Düsseldorf), *Le Charnier* (1944–5, New York, MOMA).

- A the end of the war, Picasso met Françoise Gilot. He became a communist and painted *Massacre in Korea* (1951, Paris, Musée Picasso). In 1949 *Peace Dove*, symbol of the Peace Movement, made the artist and his commitment legendary. His family paintings expressed his happiness: *La Joie de Vivre* (1946, Antibes). In 1948, the Picasso family settled in Vallauris. His interest in bull-related subjects developed further.
- In 1953, the couple separated and Picasso moved to Cannes in 1955, where he painted *Studio in Cannes* (1956, Paris). In 1958 he married Jacqueline Roque who inspired many of his paintings. He boldly reinterpreted the most famous works of artists such as *Courbet, *Delacroix, *Velázquez and *Manet. He painted *Landscape* (1972, Paris) in Mougins where he lived until his death.

An artist who was constantly researching in all fields of art, whether it be painting, sculpture, engraving, ceramics and even do-it-yourself, Picasso remains one of the great creators of the 20th century and the least theoretical of painters. He paved the way for modern, contemporary art, from Dada collage to *Mondrian, from Cubist sculpture to new figurations. Three museums have been devoted to him in France: in Antibes (1947), Vallauris (1959) and Paris (1985).

APPROACH AND STYLE

In his paintings from the 'blue' and 'pink' periods, Picasso painted mainly people: children, mother and child, portraits of women and then of street acrobats and circus scenes. When he became involved in Cubism, he mainly painted portraits of friends, his wives or companions and his children but he also painted nudes and landscapes. Still lifes with musical instruments were the favourite subject of his glued paper collages. The bull-related themes made their appearance in 1933. The Classical and Surrealist periods and those that followed show his love of the human figure and the animal as a symbol.

The artist increased the variety of sizes, techniques and supports he used; he worked mainly with oils on canvas and on wood but also introduced new textures. He used not only crayon, charcoal and watercolours but also gouache and Indian ink on paper and card. D H Kahnwiler and Ambroise Vollard were his first art dealers; they were followed by European and American collectors and gallery owners: Durand-Ruel, Metchianinoff, Bernheim Jeune, I. Rosenberg and then P Rosenberg.

Picasso questioned all the forms of expressions inherited from western art and other civilizations. He remembered the ancient masters and medieval sculpture from Catalonia and Spain. He was interested in Nordic Expressionism, French Post-Impressionism and Italian art and he was passionate about 'primitive' art.

Although he travelled to Andorra, Rome and Spain, his favourite places were Paris and the South of France.

- When still young he became interested in E Munch and *Toulouse-Lautrec, *Gauguin, Puvis de Chavannes, the Nabis and the passionate, monochrome art of his Catalan friend I Noñell. He absorbed the style of all these painters with great ease.

A GREAT PAINTER

◆ Universally known from 1949 onwards because of his painting *Peace Dove*, Picasso was one of the most famous and prolific artists. Like *Michelangelo and *Leonardo da Vinci, he changed the course of art.

◆ Picasso invented a new plastic approach, Cubism, which revolutionized 20th-century art.

◆ His constantly renewed the range of themes treated: his still lifes were inspired by the world of café life and music; the urchin and cat referred to death, the bull symbolized male potency and the wounded horse, femininity (*Guernica*). The compositions and deformations of his figures created the desired emotion.

◆ In his pictures, Picasso used collage (eg newspaper or bottle labels glued onto the support), and everyday materials such as sand and plaster, or a piece of oilcloth to represent the cane seat of a chair. He thus created the ancestor of the 'ready-made'. He created the painting-object by associating the false and the real. In his sculptures he assembled objects or their imprint in plaster and various materials.

◆ His new aesthetic approach represented a subject from different angles at the same time by reducing the volumes to an ensemble of flat surfaces presenting multiple, decomposed facets. The face, often portrayed like a primitive mask, was not spared. The nudes, monumental and rustic, with their curves or angles, exude gentleness or violence.

PICASSO

- In his 'blue' period (1901–4), Picasso portrayed pathetic, immobile, Hispanic figures in icy blue colours (*Célestine*). The 'pink' period was less dark and more lively (*Les Bateleurs*). The artist then became interested in antiquity: the bodies of his characters become more thickset and monumental (*Two Brothers*).
- His first important stylistic change of direction came in 1906; he displayed a certain formal 'primitivism' and rusticity which remained the trademarks of his art (*Portrait of Gertrude Stein*). His forms were influenced by Iberian and African sculpture but also by Cézanne, the sources of the Cubist revolution heralded by *Les Demoiselles d'Avignon*.
- Picasso's Cubism (1907–14) was a product of a personal intellect that excluded any aesthetic manifesto: 'Cubism has its own plastic objectives. We only consider it a means of expressing what our eyes and mind perceive with all the possibilities which drawing and colour have in their own right', the artist stated in 1925. He showed what he knew about objects and not what he saw. He reproduced reality while suppressing the illusionistic perspective, modelling, chiaroscuro and colour inherited from the Renaissance. He deconstructed the volume by presenting it simultaneously from different angles (full-face, three-quarters and in profile).
- This aesthetic development which took place in parallel with that of Braque went through three successive phases: the Cubism which is known as 'Cézanne-inspired' (1907–9), Analytical or Hermetic Cubism (1909–12), and finally Synthetic Cubism (1912–14).
- The Cézanne-inspired conception of the shape of objects had simplified them and reduced them to geometric masses which lay flush with the surface of the canvas, removing all perspective. In his Cézanne-inspired period Picasso used coloured masses in neutral shades to unify the voids and the 'filled' areas (*Still Life with Vases*, 1906, St Petersburg, Hermitage).
- Analytical Cubism extended this approach further, pumping up and breaking the volumes, shattering them into planes and facets (and broken angles) which continue into a space, itself analyzed like a solid mass while gradually being reduced to the plane of the picture (*Portrait of D H Kahnweiler*). Perspective disappeared and the colours became monochrome, 'the form tending to dissolve in its opposite and become crystallized in a few increasingly hermetic signs … pictures were reduced to indecipherable rebuses' (A Fermigier, 1968). Paintings and sculptures were a tangled mass of open facets, in a continuous and new treatment of space, volume and light.
- But faced with the danger of the dissolution of reality, the pictorial research carried out by Braque and Picasso changed direction and was deflected towards a Synthetic Cubism which recomposed the object into wide planes and no longer into volumes. Reality was reintroduced through the addition of printed letters painted or glued on, scraps of newspaper (*Bottle of Vieux Marc, Glass and Newspaper*) and raw materials (*Nature Morte à la Chaise Cannée*). The war which separated Picasso and Braque put an end to this period (*Portrait of a Young Girl*).
- In 1917, Picasso's love of ancient sculpture and the classicism of the Roman Renaissance led him to return to a more traditional representation. He went through a serene, Epicurean period (1917–24), with an antiquarian, Pompeian slant, marked by elegant drawing and monumental shapes, in the epic tradition (*Three Women at the Fountain*). He conceived *Ingres-like portraits characterized by a sinuous drawing and sumptuous rendering (*Portrait of Olga Kokhlova*) and still lifes with classical busts.
- During his 'Surrealist' years (1924–9) Picasso's work expressed aggression, reflecting the disruptions caused by his stormy relationship with Olga. Picasso allowed his unconscious to express itself in a convulsive, dream-like atmosphere (*Dance*). The female figure was subjected to violent deformations and fierce colours. Complex shapes and metaphors of sexuality were mixed together.
- At the beginning of the 1930s his encounter with Marie-Thérèse Walter and Matisse's odalisques inspired his poetic, sensual, calm paintings (*The Dream*). He produced sculptures using junk material and engravings with mysterious, cruel themes.
- Picasso made passionate pleas against the monstrosities of the war in Spain and World War II in *Guernica* and *Le Charnier*. The portraits of Dora Maar, deformed, haggard and dislocated with swollen, monstrous extremities (*Woman Crying*), expressed his horror of war and fascism.
- Between 1946 and 1953 he immortalized the newly-found peace and happiness of family life with Françoise Gilot. His work, created under the Mediterranean sun, expressed robustness and serenity and revealed the renewed links with an idyllic antiquity (*La Joie de Vivre*). He abandoned the decorative approach.

Les Demoiselles d'Avignon
1907. Oil on canvas, 2.45 x 2.35m, New York, Museum of Modern Art

This painting is one of the foundation stones of the 20th century: it paved the way for modern art. The preparatory work for this painting was considerable: it included some 20 paintings, about 40 drawings and 700 preparatory sketches. This long genesis clarifies the subject· prostitutes from an Avignon brothel are receiving clients (who are not shown). This painting in which five women call out to the voyeur-viewer is the first Cubist work.

The picture is in the style of Cézanne in its structure, which arranges the figures against a structured background. The two faces on the right reveal an Iberian and African influence in the simplifications of the forms and the stylization of the eyes. The areas of shadow in this representation without depth are created by hatching. The extreme stylization of the women on the right of the picture has deformed the faces and bodies.

Picasso developed these plastic innovations in order to solve a pictorial problem: portraying the figures in space without resorting to traditional methods. Matisse achieved this through the opposition of Fauvist colours, while Picasso accomplished it through the decomposition of forms. The latter conceived his figures by dislocating and fragmenting them: he placed a nose in profile in a face seen full-face, he suppressed or displaced parts of the human body; the mouth might be placed in the area of the chin or the eyes high up in the face. Each one of the Demoiselles is isolated in her space, her frontality and the stylization of her body. It is the viewer who restores unity in the painting.

PICASSO

- The last 20 years, the 'Jacqueline years' (1954–73), inspired a prolific production, dominated by beautiful portraits. Picasso returned to his favourite themes: the painter opposite his model, the female nude, the couple, sex and bullfighting. At the end of his career, rather than at the beginning as most artists tend to do, Picasso reinterpreted masterpieces by *Raphael, Ingres, Velázquez, Delacroix, Manet, *Poussin and *David, posing the question of his place vis-à-vis the great masters.

Bottle of Vieux Marc, Glass and Newspaper
1913. Charcoal, pieces of paper glued and pinned on white paper, 63 x 49cm, Paris, Musée National d'Art Moderne, Centre Georges-Pompidou

After the Analytical period, Picasso introduced new, incongruous materials in his work, such as pieces of paper, glued on and pinned on, which eliminated the subjective writing of the brush and at the same time ensured the identification of the subject: the newspaper, or the tablecloth made from a piece of wallpaper, its border decorated with moulding and printing. The use of the brush confirmed the representation of rediscovered reality: the handwritten words are informative, the neck of the bottle is seen from above while the bottle itself is seen from the front. The geometric drawing and composition express the flatness of the support.

KEY WORKS
Picasso's œuvre consists of more than 16,000 paintings and drawings
Absinthe Drinker, 1901, Glarus [Switzerland], Huber coll
Célestine, 1903, pr coll
Les Bateleurs, 1905, Washington, NG
Two Brothers, 1906, Basel, Km
Portrait of Gertrude Stein, 1906, New York, MOMA
Les Demoiselles d'Avignon, 1907, New York, MOMA
Portrait of Clovis Sagot, 1909, Hamburg, Kunsthalle
Portrait of D H Kahnweiler, 1910, Chicago, AI
Man with a Pipe, 1911, Fort Worth [Texas], Kimbell AM
Nature Morte à la Chaise Cannée, 1912, Paris, Musée Picasso
Bottle of Vieux Marc, Glass and Newspaper, 1913, Paris, MNAM
Portrait of a Young Girl, 1914, Paris, MNAM
Three Women at the Fountain, 1921, New York, MOMA
Portrait of Olga Kokhlova, 1923, Grenoble, B-A
The Dance, 1925, London, TG
Seated Bather, 1929, New York, MOMA
The Dream, 1932, New York, pr coll
The Muse, 1935, Paris, MNAM
Guernica, 1936, Madrid, Museo Nacional, Centro de Arte Reina Sofia
Woman Crying, 1937, London, TG
Portrait of Dora Maar, 1937, Paris, Musée Picasso
Night Fishing at Antibes, 1939, New York, MOMA
Still Life with Steer's Skull, 1942, Düsseldorf, KNW
La Joie de Vivre, 1946, Antibes, Musée Picasso
Portrait of Jacqueline Roque, 1854, pr coll
Studio in Cannes, 1956, Paris, Musée Picasso
Landscape, 1972, Paris, Musée Picasso

Portrait of Dora Maar
1937. Oil on canvas, 92 x 65cm, Paris, Musée Picasso

Picasso represented his companion with the body seen from the front and the face simultaneously in three-quarter view and in profile. This portrait portrays a physical and psychological reality, translated into the Cubist language with its stylization. He has immortalized the model's inner violence through the dynamic pose, the sharp or broken lines which sculpt the expressive hands with bright red nails and shape the clothes in very strong colours. This portrait is in strong contrast with the contemporary portrait of his former companion, Marie-Thérèse, which expresses gentleness and voluptuousness through her closed curves and blondness. Although a certain serenity seemed to emanate from this portrait of Dora Maar, this was no longer the case with Woman Crying, *painted the same year, in which she symbolizes the drama of war, as a pendant to* Guernica.

BIBLIOGRAPHY

Barr, A H Jnr, *Picasso: Fifty Years of His Art*, Museum of Modern Art, New York, 1946; Cowling, E, *Matisse Picasso*, exhibition catalogue, Tate Publishing, London, 2002; Cowling, E, *On classic ground: Picasso, Léger, de Chirico and the new classicism 1910-1930*, exhibition catalogue, Tate Gallery, London, 1990; Gilot, F and Lake, C, *Life with Picasso*, with a new introduction by Tim Hilton, new edn, Virago, London, 1990; Penrose, R, *Portrait of Picasso*, 3rd revised edn, Thames and Hudson, London, 1981; *Picasso Museum*, catalogue of the collection, RMN, Paris 1985-96

Léger

Léger's peasant appearance reflected his reputation as a hard-working artist, persevering and trusting, and a meticulous observer. From his first experiments with Cézanne-inspired Cubism, he found himself fascinated by the modern world through the intermediary of industrial objects and a perception of urban and social reality, which he portrayed as monumental.

LIFE AND CAREER

• Fernand Léger (Argentan 1881–Gif-sur-Yvette 1955), French painter, was the son of a Normandy cattle breeder. He studied architecture in Caen from 1897 to 1899 and went to Paris in 1900. He enrolled at the École des Arts Décoratifs (1903) and followed the classes of L Gérôme, then of G Ferrier. Few Impressionist or Fauve paintings of that period have survived; the painter destroyed what he described as the 'Léger before Léger' pictures. *Cézanne's paintings exhibited at the 1904 Autumn Salon and the 1907 retrospective showed him the importance of volumes.

• *Fruit Bowl on a Table* (1909, Minneapolis, IA) marked the beginning of his Cubist period. Having moved to the building La Ruche in the 15th arrondissement of Paris, he struck up a friendship with the Delaunays, the poets Max Jacob, Apollinaire and Blaise Cendrars.

• In 1910 he began to develop his own style: *Nudes in the Forest* (1909–10, Otterlo) in which volumes collide and interlock, *The Wedding* (1911, Paris, MNAM) and *The Roofs of Paris* (1912, Biot, Musée Fernand Léger) which shows Delaunay's influence. *Woman in Blue* (1912, Basel) showed a tendency towards abstraction. In that same year, the artist exhibited at Kahnweiler's and took part in the exhibition of the 'Knave of Diamonds', organized by *Malevich in Moscow. In 1913 at the Wassilief Academy, he defined his aesthetic approach through 'the intensity of contrasts'. Paintings such as *Contrast of Forms* (1913, Paris and New York) again showed a tendency towards abstraction. The following year he returned to figurative painting: *House in the Forest* (1914, Basel, Km), *Still Life with Books* (1914, pr coll) and *Woman in Red and Green* (1914, Paris, MNAM).

• He was called up during World War I, his painter's eye then attracted to military hardware. He portrayed his regimental companions like articulated mechanical robots: *Soldier with a Pipe* (1916, Düsseldorf, KNW) and *A Game of Cards* (1917, Otterlo). Gassed at Verdun, he was invalided out.

• Between 1918 and 1923, during what became known as his 'mechanical' period, he was as much fascinated by the industrial world as by breechblocks, shells and guns: *Les Disques* (1918, Paris), *In the Factory* (1918, New York , Sidney Janis gal) and *City* (*La Ville*) (1919–20, Philadelphia, MA). In 1919, Léger married J Lohy. He reintroduced the human figure in *Le Remorqueur* (1920, Grenoble, B-A), *Man with a Dog* (1920, pr coll) and *The Mechanic* (1920, Ottawa). He also painted scenes of interiors: *The Circus* (1918, Paris, MNAM), *Le Grand Déjeuner* (1921, New York) and *La Lecture* (1924, Paris).

• In 1921 the artist met *Mondrian and Theo van Doesburg; their aesthetic conception had a major influence on his *Mural Composition* (1924, Biot, Musée Fernand Léger). In 1925 he worked with Delaunay at the Arts décoratifs exhibition and painted a mural for Le Corbusier's L'Esprit Nouveau pavilion. In 1923 he created the scenery and costumes for several ballets including *La Création du monde*, based on a libretto by Blaise Cendrars.

• In 1924, the artist entered his 'purist' period which ended in 1927. He opened a studio with Amédée Ozenfant which had international influence. Purism, associated with the magazine L'Esprit nouveau of which Le Corbusier was a major driving force, advocated lyricism of the object and great restraint of form. He expressed this new approach in *Mechanical Ballet* (1924), the first film without a plot to show objects in close-up; the artist continued in the same vein in *Siphon* (1924, Buffalo), *Nature morte au bras* (*Still life with Arm*, 1927, Essen, FM) and *Composition with Hands and Hats* (1927, Paris, Galerie Maeght).

• From 1928 onwards, movement and nature, animal, vegetable and mineral, were introduced in *Dance* (1929, Grenoble, B-A), *Gioconda with Keys* (1930, Biot), *Bather* (1931, pr coll) and *Composition with Three Figures* (1932, pr coll)

• In 1931 and in 1935 Léger travelled to the United States; New York and Chicago hosted his first American exhibition.

• In 1936 he was deeply marked by the Popular Front which also inspired his large realist compositions produced for the celebrations organized by the trade unions and later for the

1937 International Exhibition in Paris; his optimism shines through in *Composition with Two Parrots* (1935–9, Paris) and *Adam and Eve* (1935–9, Düsseldorf, KNW).

● During World War II, Léger went into exile in the United States. There he recalled the dockers swimming in Marseilles harbour: *Divers on a Yellow Background* (1941–2, New York), *Polychrome Divers* (1942–6, Biot). He was fascinated by New York nightlife: *Dance* (1942, pr coll) and *Acrobats and Musicians* (1945, Saint-Paul-de-Vence, Fondation Maeght). He produced landscapes such as *The Forest* (1942, Paris, MNAM) and began working on the cyclists series including *Big Julie* (1945, New York) before saying goodbye in *Adieu New York* (1946, pr coll).

● He spent the last decade of his life (1945–55) in Paris. His commitment to the reality of everyday life led him to join the Communist Party. He celebrated the life of working people in *The Constructors* (1950, Biot) and that of leisure and sport in *Acrobats in the Circus* (1948, pr coll), *Leisure* (1948–9), *La Partie de campagne* (1954, Saint-Paul-de-Vence, Fondation Maeght) and *The Great Parade*, 1954, New York). In 1965, his writings on art were published under the title *Fonctions de la peinture*.

Léger's art heralded the arrival of the new realism. His art influenced European and American artists and even Pop Art. In 1960 the Musée Fernand Léger was opened in Biot.

APPROACH AND STYLE

Léger favoured themes associated with the city, work and leisure (parties and sport) and he celebrated industrial objects. His work glorified or suppressed individuals and also revealed his involvement in social and political life (Popular Front, Communist Party). He was fascinated by monumentality and urbanization. He preferred large compositions and painted on canvas and walls.

After D H Kahnweiler, L Rosenberg and L Carré (1945) also opened their doors to him. His clients included the French families Gourgaud and de Noailles and the Americans A E Gallatin and N Rockefeller, as well as Scandinavians.

In Paris Léger discovered Cézanne and, in the battlefield of Verdun, the aesthetic impact of the industrial object. The artistic experiments of *Mondrian and Theo van Doesburg (De Stijl) and Le Corbusier influenced his conception of monumental décor. He also took part in Purist experiments.

● From 1907 onwards Léger showed what he had learned from Cézanne; he interlocked the various planes with a great concern for the structure, following the master's lesson to the letter: 'Treat nature in terms of spheres, cylinders and cones'. He developed what became known as the 'tubist' style, geometric and cold, which organized shapes as volumes or flat tints. These shapes, interlocked, purely plastic and unified by the cold light, fought a 'battle of volumes', as the artist explained. At the same time he was much interested in Delaunay's Orphism (*The Wedding*).

● From 1913 onwards Léger developed a dynamic Cubism, close to Futurism, a homage to the modern, industrial world. He used geometric, flat tints, outlined in black, painted boldly in a few shades (*Contrast of Forms*). Called up for military service, he portrayed the soldiers as steely grey automata, in an icy light (*Soldier with a Pipe*), then underlined the contrasts of the shapes: the limbs become naked, cold machines (*A Game of Cards*). War revealed the sculptural quality of military equipment: 'I was dazzled', the artist wrote, 'by

A GREAT PAINTER

◆ Léger was famous and saw his work exhibited in museums during his lifetime, both in Europe and the United States.

◆ He rediscovered 'the aesthetic aspect of the war' (breechblocks, shells) and of industrial objects (bearings, gears).

◆ His characters and mechanical objects ended up resembling each other. He concentrated on the 'intensity of contrasts' of shapes and colours.

◆ His monumental vision of the modern everyday world and the world of working people revealed a new classicism.

◆ The differences in scale which he created between objects (*Gioconda with Keys*) and close-ups heralded the non-hierarchy of the images of pop art.

◆ His talent for mural painting, stained glass and ceramics enabled him to collaborate on a number of architectural projects.

the breechblock of a 75 open in strong sunlight.' This fascination inspired his mechanical period (1918–23). From then on, he expressed his passion for the beauty of machines and objects in bright colours (*Les Disques*). When he associated the human figure and machine, he only portrayed the plastic dimension (*The Mechanic*) which he considered 'a battle for classcism' which opposed 'curves and straight lines, flat surfaces and modelled surfaces, pure local colours to blended greys'.

• The monumentality of his 'illuminations of walls' (Léger) of the next period was inspired by Mondrian's Neoplasticism which led him to the creation of abstract compositions.

• His Purist period cannot be separated from his experiments in the world of cinema; *Mechanical Ballet* (1924) eliminated all characters, showing bare objects in close-up so that they became almost abstract. This fragmented, amplified aesthetic approach was also present in his paintings: mechanized shapes were interlocked in a stable, frontal composition, the coloured contrasts being treated as perfect flat tints (*Nature Morte au Bras/Still Life with Arm*). He also mixed flat tints and volume in his objects, which were always shown in close-up (*Siphon*). He combined Neoplasticism, Bauhaus rigour and Russian constructivism. The supremacy of drawing, monumentality and Purism all became part of his classicism.

• From 1928 onwards, Léger concentrated on the 'intensity of contrasts' which found a new expression in *Gioconda with Keys*: the disproportion between the bunch of keys and the character symbolized the pervasive modernity as opposed to the outdated past. Later, movement and nature replaced the object. Flexible shapes floating in space replaced frontality and immobility. Léger created circular compositions filled by characters which he linked to each other by means of a cord or ribbon (*Dance*). The concept of association of opposites led him to oppose abstract elements to human figures.

• At the end of the 1930s, bodies floating freely in space reflected Léger's happiness (*Composition with Two Parrots*). In 1939, on the eve of his departure for the United States, his perception of the dockers swimming and having fun in Marseilles harbour was of athletes swirling in space, removing the final frontal resistance and all spatial points of reference (*Divers...*, *Acrobats and Musicians*). This new dimension in his work was associated with a dissociation of colour and drawing, resulting from the impression produced by the night lighting of the town (*The Great Parade*).

• From 1945 onwards Léger developed an art accessible to all in which the human figure was omnipresent, in particular on the themes of leisure and work (*La Partie de campagne*, *The Constructors*).

Les Disques
1920. Oil on canvas, 2.40 x 1.80m, Paris, Musée National d'Art Moderne, Centre Georges-Pompidou

Léger revealed a world of 'implacable, beautiful machines'. During this 'mechanical' period he celebrated the dynamism and rhythm of reality. These discs, inspired by the aesthetic approach of Robert and Sonia Delaunay, symbolized wheels, gears, the mechanism of a connecting rod or road signs and advertising hoarding. According to the painter, the strident colours reflected the way in which 'manufacturers and shopkeepers confront one another by brandishing colour as an advertising weapon'.

Leisure (Homage to Louis David)
1948–9. Oil on canvas, 1.54 x 1.85m, Paris, Musée National d'Art Moderne, Centre Georges-Pompidou

*The concept of paid holidays inspired Léger to paint this structured scene, solid and complex, in which the characters are linked by the play of arms. The painter transformed the bodies of the workers into a dilated, monumental, imposing, square 'architecture of shapes'. He gave them the same, dignified, sculptural, powerful treatment as he would a machine or an object, symbolizing industrial society. Léger here paid tribute to *David as Picasso did to *Courbet and *Velázquez. In this context, Léger can be said to be in the Classical tradition of David and *Ingres.*

KEY WORKS

Fernand Léger painted 1,320 pictures.
Nudes in the Forest, 1909–10, Otterlo, KM
Woman in Blue, 1912, Basel, Km
Contrast of Forms, 1913, Paris, MNAM; NewYork, MOMA
A Game of Cards, 1917, Otterlo, KM
Les Disques, 1918, Paris, MAM de la Ville, palais de Tokyo; 1920, Paris, MNAM
The Mechanic, 1920, Ottawa, NG
Le Grand Déjeuner, 1921, New York, MOMA
La Lecture, 1924, Paris, MNAM
Siphon, 1924, Buffalo [NY], Albright-Knox AG
Gioconda with Keys, 1930, Biot, Musée F Léger
Composition with Two Parrots, 1935–9, Paris, MNAM
Divers on a Yellow Background, 1941–2, New York, MOMA
Polychrome Divers, 1942–6, Biot, Musée F Léger
Big Julie, 1945, New York, MOMA
The Constructors, 1950, Biot, Musée F Léger
Leisure, Homage to Louis David, 1948–9, Paris, MNAM
The Great Parade, 1954, New York, Guggenheim

BIBLIOGRAPHY

Bauquier, G, *Fernand Léger, catalogue raisonné*, 7 vols, Maeght, Paris, 1990-2001; Cowling, E, *On classic ground: Picasso, Léger, de Chirico and the new classicism 1910-1930*, exhibition catalogue, Tate Gallery, London, 1990; Descargues, P, *Léger*, Maeght, Paris, 1995; *Léger*, exhibition catalogue, Georges Pompidou Centre, Paris, 1997

Kandinsky

A humane, simple, intuitive artist, Kandinsky was a great exponent of abstract and lyrical art. He drew his inspiration from his 'inner need' and removed all figurative objects from his work. He promoted his theory by founding Der Blaue Reiter (the 'Blue Rider' group). He developed it further and taught it at the Bauhaus. His work exudes a spirituality enriched with Slavonic and Oriental references. His free use of colour and shape expressed the intensity of his emotions.

LIFE AND CAREER

• Wassily Kandinsky (Moscow 1866–Neuilly-sur-Seine 1944), a French painter of Russian origin, had a middle-class upbringing. Although he felt attracted to drawing, painting and music, he studied law and economics and pursued a university career in Moscow.

• In 1889, during a trip to the Vologda region, a distant district in the north-east of the country, he discovered rural architecture and Russian folk art. In 1895, at an exhibition of the French Impressionists in Moscow, he was fascinated by *Monet's *Haystack*. He admired Rembrandt's paintings in the Hermitage. In 1896 Kandinsky enrolled at the school of A Azbé in Munich. Later he attended the classes of Franz von Stück at the Academy (1900): *Kochel. Cascade I* (1900, Munich). Unsatisfied, he founded the Phalanx group in 1901 (dissolved in 1904); there he met his companion, the painter G Münter. *Old Town II* (1902, Paris, MNAM), *Russian Scenes* (1904, N Kandinsky coll) and *Couple on Horseback* (1906–7, Munich, SG) were painted during this period. He also produced coloured wood engravings.

• Escaping the conservatism which dominated the Munich art world, the artist and his companion travelled throughout Europe (1903–9), from Odessa to Paris and returned to Germany via Venice and Italy.

• Kandinsky returned to Munich in 1909 and later settled in Murnau. He started experimenting with colour and form: *Landscape with Tower* (1908, Paris, MNAM), *Blue Mountain* (1908–9, New York, Guggenheim) and *Oriental* (1909, Munich). In Munich the artist founded the New Society of Munich Artists with his friend Alexei von Jawlensky; other painters joined. His first abstract work was a watercolour (1910, Paris). In reaction to the New Society's refusal to present one of his abstract works at the exhibitions, he created Der Blaue Reiter (named after one of his paintings made in 1903), which attracted Franz Marc and the avant-garde artists. *Concerning the Spiritual in Art* (1911), a theoretical exposition of his non-figurative pictorial experiments with the series *Improvisation, Impression* and the ten *Compositions* (1909–13), was attacked by the critics.

• His oil paintings revealed the development of his research into the abstract: *Romantic Landscape* (1911, Munich, SG) and *With Black Arch* (1912, Paris). In Berlin he exhibited his paintings in the Der Sturm gallery (1912) and took part in the first Autumn Salon (1913). He also published his autobiography in German, *Looking back on the Past* (1913).

• In 1914 the war broke out. In 1917 Kandinsky returned to Moscow and revealed his sympathy for the Russian Revolution. He married Nina Andreievskaia. Having become a member of the artistic section of the Commission for Artistic Progress, he taught at the Academy of Fine Arts, created museums all over the country and in 1921 founded the Academy of Artistic Sciences. He painted little: *Moscow II* (1916, Murnau, pr coll), *In Grey* (1919, Paris), *White Line* (1920, Cologne, Ludwig mus) and *Black Weft* (1922, Paris, MNAM). The disintegration of the political situation caused him to leave for Germany.

• In 1922 he was invited to Weimar by Walter Gropius, director of the Bauhaus, who appointed him Professor. He developed his pictorial theory in *Point and Line to Plane* (1926) and described his prolific work as 'lyrical geometricism': *Composition VIII* (1923, New York), *Transversal Line* (1923, Düsseldorf, Km), *On the White II* (1923, Paris, MNAM), *Calm Tension* (1924, Paris), *Yellow-Red-Blue* (1925, Paris, MNAM) and *Several Circles* (1926, New York). With his pupils he produced sketches for the murals in the music room of the Jurifreie Kunstausstellung ('Exhibition Without Jury') in Berlin (1922, reconstituted in Paris at MNAM in 1977).

• In 1925, the Bauhaus moved to Dessau. Kandinsky painted and exhibited widely: *Quadrat* (1927, Paris, Maeght coll), *Thirteen Rectangles* (1930, Paris), *Unstable Composition* (1930, Paris). He created scenery and costumes for the staging of the piano suite *Pictures at an Exhibition* by Mussorgsky (1928), wall ceramics for the music room of Mies van der Rohe

(1931, Berlin) and took part in the exhibition of the Circle and Square Group (1930).
- In 1933 the Bauhaus was closed by the Nazis who confiscated 'degenerate art' and put up for auction 57 of Kandinsky's paintings. The artist fled to France after painting *Development in Brown* (1933, Paris, MNAM).
- The Surrealists welcomed him warmly in Paris. He painted his last works: *Montée Gracieuse* (1934, New York), *Entre Deux* (1934, Paris, pr coll) and *Accompanied Centre* (1937, Paris). During the war, he created *Composition X* (1939), *Horizontal* (1939, Basel, Beyeler gall) and *Watercolour* (1940, Paris), *Delicate Tensions* (1942, Galerie Maeght), *Reciprocal Agreement* (1942, Paris) and *Five Parts* (1944, pr coll). His last painting was entitled *L'Élan Tempéré* (1944, pr coll).

The art of Kandinsky, painter, decorator, graphic artist, wood engraver and poet, is inseparable from his theory. This creator of lyrical abstraction paved the way for the artistic experimentation of 20th-century art, which was followed by American and French abstraction. The developments (Action painting, tachism, calligraphy, nuagism, etc) are grouped under the term 'informal art'.

APPROACH AND STYLE

At first Kandinsky painted popular scenes and landscapes, crossed by blue riders. He then created geometric shapes with their infinite variations. Later he invented stellar and amoebic motifs and imaginary animalcules.

He produced small watercolours, sketches and drawings, large oil paintings and murals.

He was sought after by collectors from the very beginning and when he became famous at the Bauhaus. Kandinsky worked mainly in Russia (Moscow), Germany (Munich, Murnau, Weimar, Dessau, Berlin) and Paris. He travelled to Venice, Odessa, Tunis and Paris where he discovered *Cézanne, *Matisse and *Picasso and then Surrealism. He worked with Franz Marc and *Klee, then at the Bauhaus.

The artist was fascinated by Russian popular art (he painted naive imagery and votive offerings reminiscent of icons) and Bavarian popular art.

- In rural Russia of 1889, the bright, 'primitive' colours of popular and folk images which decorated the *isbus* (Russian log cabins) gave him the impression of 'entering into the painting'. In 1895, looking at one of Monet's *Haystack* series, he understood that the subject was no longer the 'indispensable element' of the painting: 'Suddenly I found myself for the first time in front of a painting which represented a haystack, as the catalogue said, but I did not recognize it'. Although his early works revealed the influence of Impressionism, the paint was laid on more thickly (*Kochel. Cascade I*); pure colours also gave him a point of artistic reference. His innovative perception clashed with the Classical conceptions of the Munich schools.
- His travels through Europe contributed to his artistic blossoming. He created dazzling paintings inspired by Russian imagery, based on sketches drawn from life or from memory. The colour, applied as splashes (*Landscape with Tower*), played a part in its own right and was sometimes reminiscent of Art Nouveau or Jugendstil (*Couple on Horseback*).
- In 1909 Kandinsky, when contemplating one of the paintings hanging upside down in his studio, fortuitously discovered that colour reflects 'an inner blaze' and that the presence of 'objects', of 'objective' forms, and their filling with colour, was detrimental to the truth

A GREAT PAINTER

◆ Although Kandinsky was famous during his lifetime, the innovative nature of his work was only recognized after 1945, as a result of the contributions of G Münter and N Kandinsky and the retrospectives.
◆ Kandinsky was the forerunner of abstract art. He broke with figurative art and became 'one of the greatest revolutionaries of vision' (André Breton).
◆ His work, depending on the period, tackled figuration, geometrism and abstraction.
◆ He used the fluidity of watercolour and the geometric rigour of the ruling pen and compass. Oil on card, canvas and glass, watercolour, gouache, Indian Ink, wood engraving, illustration, tempera wall painting, etc were all techniques used by Kandinsky.
◆ Kandinsky was among the first to use white as a colour in his abstract work. He allowed shapes to burst open and colour to overflow freely.
◆ The artist endowed colour with a symbolic and musical value.

of the work. From then on he preferred pure, violent colour, which became an autonomous expressive element and fulfilled his 'inner need' as a painter and musician, a friend of Schoenberg, a man interested in metaphysics, in the anthroposophy of Rudolf Steiner and Bergson's philosophy.

• In 1910, his first 'leap into abstraction' was a watercolour. It took him one more year before he transposed it into oils. During his Blaue Reiter period (1911–14), his work was animated by religious feelings (*St George*). At the same time, the figure of the Blue Rider, symbol of his non-objective, revolutionary art, was still present in his canvases. In 1914 Kandinsky had reached a peak in his art.

• His return to Russia, during the revolution, was accompanied by 'peaceful' paintings with 'much brighter, pleasanter' colours (*Moscow II*); during this period he painted few paintings and this gave him time to develop the theory of a 'science of art' which he developed further at the Bauhaus.

• At the Bauhaus (1922–33) he created a lyrical 'geometrism': 'The new aesthetics can only become reality when signs become symbols' he said; 'for me the shape is only a means to reach my goal ... I want to enter into the shape'. In order to achieve this he had to represent 'not the external appearances of an object but its constructive elements, its laws governing tension', that is, pure colour, the composition of geometric shapes and dynamism of the line (*On White II*). His very free lyricism (*In Grey*) developed into a geometry of abstract motifs (*Black Weft*). The circle, triangle and square were bearers of spirituality (*Composition VIII*). Horizontal lines struck 'cold and low', vertical ones 'warm and high'; angular lines were 'young' while curved ones were 'mature'. Shapes were associated with a colour code: 'Passivity is the dominant character of pure green' which 'corresponds to the sound of the violin being played softly'; red is 'violent' and corresponds to the beating of the drum, yellow is 'provocative' and black 'alarming', while blue is 'soothing' and 'has the depth of the organ'. The line expressed tension, colour a musical state, an emotion (such as warmth, joy or fear). He favoured the circle, 'dispenser of joy'.

• In his paintings of the last decade, produced in Paris, bright colour prevailed over shape which dwindled and sometimes became transformed into an ideogram (*Montée gracieuse*). Under the influence of Surrealism, geometry gave way to free, flexible shapes (*Sky Blue*).

Sky Blue
1940. Oil on canvas, 100 x 73cm, Paris, Musée National d'Art Moderne, Centre Georges-Pompidou

Kandinsky reveals his amazing inventive ability in this painting. He has imagined multiform, amoebic, larval and tentacled creatures drawn from the depth of his unconscious, from his 'inner need'. Their rounded outlines, supple and floating, are filled with fresh, delicate colours. Suspended in the air, they move gracefully against the celestial, luminous blue of the sky. The meticulous treatment of the various elements contrasts with the boldly painted background, vibrating in the light, reminiscent of the artist's first abstract paintings.

With Black Arch
1912. Oil on canvas, 1.89 x 1.98m, Paris, Musée National d'Art Moderne, Centre Georges-Pompidou

In 1912 Kandinsky had already abandoned figurative painting two years earlier. He based his construction on the 'principle of dissonance', which offered more possibilities than the 'insistent geometry' that had predominated until then (Kandinsky's words to Schoenberg in 1912). The music of abstract forms was in osmosis with the research carried out by Schoenberg who was to abolish tonal material. He perceived his work as a 'contest of sounds, lost equilibrium, reversed "principle", sudden rolling of drums, important questions, aspirations without obvious aims, seemingly incoherent impulses, ruptured chains, broken links joined together again, contrasts and contradictions, this is our harmony'. Objective forms, black graphic elements and colours liberate each other mutually, each preserving its own trajectory.

KEY WORKS

Kandinsky created over 1,100 paintings and 1,300 watercolours. The MNAM in Paris owns more than 1,300 works covering all techniques.

Kochel. Cascade I, 1900, Munich, SG
Landscape with Tower, 1908, Paris, MNAM
Oriental, 1909, Munich, SG
Improvisation VII, 1910, Moscow, Tretiakov gall
First abstract work (watercolour), 1910, Paris, MNAM
With Black Arch, 1912, Paris, MNAM
Composition VII, 1913, St Petersburg, Hermitage
In Grey, 1919, Paris, MNAM
Composition VIII, 1923, New York, Guggenheim
Calm Tension, 1924, Paris, pr coll
Several Circles, 1926, New York, MNAM
Thirteen Rectangles, 1930, Paris, MNAM
I Instable Composition, 1930, Paris, Galerie Maeght
Montée gracieuse, 1934, New York, Guggenheim
Accompanied Centre, 1937, Paris, pr coll
Composition X, 1939, pr coll
Sky Blue, 1940, Paris, MNAM
Reciprocal Agreement, 1942, Paris, MNAM

BIBLIOGRAPHY

Dabrowski, M, *Kandinsky, Compositions*, exhibition catalogue, Museum of Modern Art (MOMA), New York, 1995; Grohmann, W, *Wassily Kandinsky: Life and Work*, Thames and Hudson, London, 1954; Roethel, H K, *Kandinsky, Catalogue raisonné of the oil-paintings*, 2 vols, Sotheby's, London, 1982-1984

Malevich

A lonely figure, Malevich played a major part in Russian avant-garde art. Educated in Western pictorial art (Impressionism, Cubism, Futurism and so on), he developed geometric abstraction or 'Suprematism'. The sober, geometric shapes, at first abstract and later figurative, in black, white or bright colours, were characteristic of his art.

LIFE AND CAREER

• Kasimir Severinovich Malevich (Kiev 1878–Leningrad 1935), Russian painter, was born into a poor family of Polish origin. His father worked in a sugar refinery. Malevich studied for five years at an agricultural college. In 1900 he enrolled at the Kiev Academy; he admired the icons, rural wall decorations and the 'naturalist' motifs of Russian 'travellers' or gypsies. He worked as an industrial designer for the railways in order to earn enough money to go to Moscow.

• He arrived in Moscow in 1904 where he attended the School of Painting, Sculpture and Architecture and discovered French contemporary and anti-academic painting in private Russian collections. He took part in the failed revolution of 1905. His first Impressionist paintings such as *Woman Flower* (1903, St Petersburg, Russian mus) or *Portrait of a Member of the Artist's Family* (c.1906, Amsterdam, SM) were followed by large colourful gouaches: *High Society in Top Hat, Relaxing* (1908, St Petersburg, Russian mus). The Fauve and Primitive influence was noticeable in *Bather* (1911, Amsterdam, SM), *Brawl on the Boulevard* (1911, Amsterdam, SM) and the earthy-coloured *Peasant Woman with Buckets and Child* (1911, Amsterdam, SM). *Bathers* (1908, St Petersburg, Russian mus), *The Woodcutter* (1912, Amsterdam, SM), *Woman with Buckets* (1912, New York, MOMA), *Reaper on Red Background* (1912–13, Moscow, Tretiakov gall) are examples of *Cézanne-inspired Cubism. *The Portrait of Ivan Klyun* (1913, St Petersburg, Russian mus) shows the deconstruction of the figure according to Analytical Cubism. Malevich was also influenced by the Futurism of F T Marinetti: *The Grinder* (1912–13, New Haven, Yale University, AG).

• From 1910 onwards he exhibited with the Russian avant-garde artists at the exhibitions of the 'Knave of Diamonds' (1910), the 'Donkey's Tail' (1912) and 'The Target' (1913). In 1912, Kandinsky presented his paintings at the Blaue Reiter Exhibition. *Transit Station: Kunsevo* (1913, Moscow, Tretiakov gall) was inspired by the work of the poet V Khlebnikov. *An Englishman in Moscow* (1914, Amsterdam), *Partial Eclipse with Mona Lisa* (1914, St Petersburg) and the scenery and costumes for the opera *Victory over the Sun* (1913, pr coll) were examples of Cubo-Futurism.

• In 1915 Malevich became the leader of the Russian avant-garde. In St Petersburg he took part in the Tramway V Exhibition and later he also participated in the last Futurist exhibition '0.10' in which he presented *Black Square* (St Petersburg). He published the *Manifesto of Suprematism*. The following year Malevich developed his theory in *From Cubism and Futurism to Suprematism*. He took abstraction to its extreme in order to achieve the perfect, 'supreme' expression: *Suprematism and Supremus No. 50* (1915, Amsterdam) and *Self-Portrait in Two Dimensions* (1915, Amsterdam). After painting *Supremus No. 58* and *Suprematism* (both 1916, St Petersburg, Russian mus) and *Suprematist Painting* (1916, St Petersburg, Russian mus), he produced the radical *White Square on White Background* (1918, New York) which expressed the nihilistic philosophy to which he adhered.

• During the Revolution, Malevich, an anarchist sympathizer, taught at the Moscow Academy, then at that of Vitebsk. He rejected Marc Chagall's figurative art. In 1922 he took part in the first exhibition of Russian art in Berlin. In 1927 a retrospective of his work was organized in Warsaw and Berlin. The publishing section of the Bauhaus published his Suprematist theories under the title *The Non-Objective World*.

• Between 1923 and 1929, he painted *Black Square, Black Circle* and *Black Cross* (St Petersburg). Recalled in the Soviet Union in 1927, he fell from grace: his work did not correspond to the aesthetic canons of official art. In 1930 he was arrested and many of his writings were destroyed. In the last eight years of his life he painted over 200 paintings which synthesized his Neoprimitive-Cubo-Futurist period and Suprematism. He reintroduced the figure in *The Carpenter* (1927, St Petersburg, Russian mus), *Spring* (after 1927, St Petersburg, Russian mus), and painted *At the Dacha* (after 1928, St Petersburg, Russian mus), *Complex Premonition* (also known as *Bust in a Yellow Shirt*, c.1928–32, St Petersburg, Russian

mus), *Landscape with Five Houses* (c.1928–32, St Petersburg, Russian mus) and *Man Running* (1932–4, Paris, MNAM). *Worker* (1933, St Petersburg, Russian mus) and his *Self-Portrait* (1933, St Petersburg, Russian mus) displayed a laboured realism.

Malevich died of cancer in 1935. He left paintings, writings, samples of Suprematist ceramics, Planeites and Architectonicas, Suprematist plaster 'sculptures of architecture'. He became the symbol of the free spirit persecuted by the Stalinist regime. His coffin was Suprematist and his grave was marked by his signature: a black square. He heralded the contemporary art of the 1960s, particularly the American.

APPROACH AND STYLE

At first Malevich took his subjects from Western painting (bathers, Impressionist and Symbolist portraits). Later he was inspired by rural life, Cubist compositions and portraits. His Suprematist paintings consisted of geometric shapes: squares, rectangles, circles and crosses. At the end of his life he returned to the landscape and figurative portrait, realist or Suprematist.
Malevich painted with oils, mostly on medium-sized canvases.
Rural life strongly marked Malevich's art. In Kiev he admired the popular art of the icon painters and the 'primitive' decorations of the peasants' houses. In Kursk, he admired the Russian 'naturalists' Repin and Chichkine. In Moscow he discovered contemporary European art: Impressionism, Art Nouveau, Neo-Impressionism, Symbolism, the Nabis, *Cézanne, Fauvism, Cubism, Futurism, Expressionism and the Russian avant-garde art of Larionov and Goncharova. The avant-garde, hermetic writings of the poet V Khlebnikov encouraged him towards abstraction in art. From 1927 he was subjected to the constraints of the *proletkult* (culture of the proletariat).
• Malevich's first paintings reveal a virtually self-taught development which reflected the evolution of Western painting of the previous 30 years, from Impressionism to Futurism. Malevich added a local touch, inspired by Russian icons, 'crude' peasant art with its pure colours and simple forms, and also by the Primitives.
• From 1910 onwards his art developed in line with the Russian avant-garde. Cézanne-inspired and Analytical Cubism and Italian Futurism all had an impact on his art. He continued to explore the distance that separated sign and reality, introduced by the Cubists, by trying to abolish the opposition between form and content, the foundation of figurative aesthetics, in order to isolate the 'pure' signs. He thus created *zaum*, the a-logical, 'ultra-rational', 'transmental, transrational' canvas, under the influence of the Russian poet Khlebnikov and his meta-language (*zaum*), composed of new, sober words and sounds. Malevich favoured the simplest form, the square or rectangle, next to figurative motifs and simple abstracts (*Partial Eclipse with Mona Lisa*). He elaborated formal non-logical associations, painted or with collage, on different scales (*An Englishman in Moscow*). He became briefly interested in Dadaism, writing a word or sentence in a frame drawn on a piece of paper (*Brawl on the Boulevard*). The last stage curtain of the spectacle *Victory over the Sun*, a square divided diagonally into two equal parts, one black, one white, led him to Suprematism.
• When tackling abstraction, Malevich continued the work undertaken on the relationship between form, colour and space. 'Painters must reject subject and objects if they want to be pure painters', he declared; he put this precept into practice in *Black Square*, a Suprematist painting and a key to modern art.

A GREAT PAINTER

◆ Malevich was recognized as the master of the Russian avant-garde as early as 1915. The exhibition of 1927 in Berlin confirmed his artistic importance.
◆ A pioneer of geometric abstraction like *Kandinsky and *Mondrian, he was the inventor of Suprematism which heralded the end of painting: he painted the first painting of modern art (*White Square on White Background*).
◆ His abstract paintings of the 'world without object' were first named after what they showed (*Black Square, Red Square* etc) before being given an actual title (*Suprematism*) and a number.
◆ Malevich invented the notion of *zaum* in painting.
◆ His figurative paintings produced after 1927 maintained the same geometric and coloured foundation as his previous abstract paintings.

MALEVICH

- He then complicated the order of the coloured rectangles (*Supremus No. 58*), in the hope of discovering the degree zero of art. He arranged simple geometric shapes (squares, triangles, circles), black, white or brightly coloured or pastel, before achieving the 'supreme' harmony of *White Square on White Background* which merged form and space. Only a subtle nuance in the brushstrokes and finish separate the white square from the white background of the painting. The light reacts differently on the two white textures, thus slightly changing the tonality. 'Sail away! The free white abyss and infinity are in front of us!', cried out the artist who was passionately interested in aviation and space (1919). 'I have been transfigured into the zero of forms and been beyond the zero into creation, that is towards Suprematism, towards the new pictorial realism, towards non-figurative creation.' For D Vallier (1969), 'Form has ceased to be a sign of space and become an allusion to space, and the picture itself, through its material presence, is now only an allusion to painting.' In retrospect, the painter was to associate this 'white abyss' with the social renewal of the Russian Revolution. He continued to experiment with minimal colour and geometry on a white background until 1929.
- Forced to return to the Soviet Union (1927), he took (of his own free will or under duress?) a new stylistic direction. He returned to his Impressionist (*Spring*) and Primitivist (*At the Dacha*) beginnings. He then associated Suprematism with the theme of the working people, advocated by socialism. He simplified forms and painted them in bight colours, without any concern for reality: a face clearly divided in two parts, one red, one white with red and orange hair (*Peasant in a Field*, c.1930, St Petersburg, Russian mus), a person reduced to pure geometry (*Bust in a Yellow Shirt*), colossi in identical positions, with two-coloured faces and soberly multicoloured clothes (*Sportsmen*, c.1928–32, St Petersburg, Russian mus). These figures sometimes appear without detail: an oval shape evoking a face, a mitten-like hand with no fingers.
- His last paintings, very figurative (*Worker*), were inspired by the Renaissance (*Self-Portrait*); they remained Suprematist in the application of colours. His signature, a black square, is a reminder that he was 'the man of Suprematism'.

Complex Premonition, also known as **Bust in a Yellow Shirt**
c.1928–32. Oil on canvas, 99 x 79cm, St Petersburg, Russian Museum

At the end of his life, Malevich returned to figurative painting, also called 'figurative Suprematism' by some. His character, an automaton without articulated joints and moulded in one piece, was made up of volumes which have been simplified to the extreme: an oval for the head, a cylinder for the neck, a geometric shape for the chest and two long tubes for the arms. Only the thin string tied round the waist adds a touch of reality and indicates that the subject is facing the viewer. The colossus is frozen in front of a landscape conveyed by coloured flat tints. The yellow, the colour of light and life, does not reduce the silence which emanates from the picture: perhaps it reflects the solitude of the artist or the freedom that was muzzled by the Stalinist regime, possibly symbolized by the black shadow gradually invading the empty face whose thoughts have already vanished.

KEY WORKS

BIBLIOGRAPHY

Kasimir Malevich, 1878-1935, exhibition catalogue, National Gallery of Art, Washington, 1990; *Malevitch*, exhibition catalogue, Georges Pompidou Centre, Paris, 1978; Nakov, A, *Malevich*, Catalogue raisonné, Biro, Paris, 2002

Suprematism
1915. Oil on canvas, 101.5 x 62cm, Amsterdam, Stedelijk Museum

Malevich painted this painting the same year as Black Square. *Here, geometric shapes vary from a stroke to a flat surface. They are intertwined, superimposed or moving away from each other. A thin black line divides the painting into two parts: the large black quadrilateral, slightly tapered towards the top, is moving away from its support in the right top corner and appears irresistibly to follow the little black dashes which are sliding away, sucked out of the canvas into space, emptiness, 'nothing'; the shapes with their pure colours in the bottom part of the painting appear more stable. Here he has begun to draw the 'world without object'.*
What is striking in this painting 'is the relationship between the shapes and the space which surrounds them, the space which although separating them also makes them gravitate towards each other. If one had to prove the existence of this active presence in space, it would be enough to isolate a shape, look at it on its own for it to become just any inert plane. Then as soon as it placed back in its environment, it comes to life again, filled with a tension which attracts the eye, driving it faster, less fast' (Dora Vallier, 1980).

Mondrian

Entirely concentrated on his art, which he constructed step by step, Mondrian lived modestly and on his own. This pioneer of abstraction was searching for a universal plastic language: in 1920 he invented Neoplasticism, a geometric abstraction. He elaborated a system of planes, crossed by verticals and horizontals, orthogonal shapes with plenty of variations: brightly coloured shapes, greyish and bluish or white background: greyish or black lines, more or less wide, long and numerous, then coloured.

LIFE AND CAREER

• Piet Mondrian, properly Pieter Cornelis Mondrian (Amersfoort 1872–New York 1944), Dutch painter, was brought up by strict Calvinist parents. He father designed posters. His uncle, a painter, belonged to the Hague School, close to that of Barbizon. Mondrian became an art teacher in 1892, then enrolled at the Amsterdam Academy in A Allebé's workshop and attended evening classes from 1895 to 1897. He was interested in theosophy, a philosophy which aimed at achieving a knowledge of God through the knowledge of the inner self. He painted landscapes such as *Mill by the Water* (c.1900, New York, MOMA). He spent time in Brabant: *Farm at Nistelrode* (1904, The Hague, Gm).
• He spent the summer of 1908 in Domburg in Zeeland and was influenced by Fauvism (*Mill in the Sun*, 1908, The Hague; *Red Tree*, 1908, The Hague) and by Edvard Munch (*Wood near Oele*, 1908, The Hague). Mondrian experimented with different Neo-Impressionist trends in his series on churches, dunes, sea and trees: *Dune* (1910, The Hague), *Silvery Tree* (1912, The Hague).
• With other painters, including J Toorop, he founded the Circle of Modern Art and exhibited at the Amsterdam Museum where he discovered Cubism which took him to Paris: *Still Life with Ginger Pot I* (1911–12, The Hague).
• In 1912 he settled in Paris. He exhibited at the Salon des Indépendants and continued with his variations on still lifes, including the tree, and became involved in Cubist geometry: *Flowering Apple Tree* (1912, The Hague) and *Still Life II* (1912, The Hague). He removed the third dimension in *Composition No 7* (1913, New York, Guggenheim) and *Oval Composition* (1913, Amsterdam), then reintroduced colour in *Oval Composition with Light Colours* (1913, New York, MOMA), *Composition No 9, Blue Façade* (1913, New York, MOMA) and *Composition in Blue, Grey and Pink* (1913, Otterlo, K-M).
• Back in Domburg in the Netherlands in 1914, trapped by the war, he returned to his old serial themes but this time he expressed them with the signs + and – (plus and minus): *Composition No 5* (1914, New York), *Pier and Ocean* (1915, Otterlo) and *Composition* (1916, New York, Guggenheim). He met Theo van Doesburg who was working with the painters Bart van der Leck and Georges Vantongerloo on the avant-garde journal *De Stijl* (October 1917). Mondrian took an active part in the magazine between 1917 and 1922; his articles came to represent the doctrine held by the group.
• The discovery in 1916 of the plain flat rectangles and pure colours of Van der Leck played a decisive part in the development of Mondrian's art. He conceived *Composition in Blue B* (1917, Otterlo), *Composition No 3 with Coloured Planes* (1917, The Hague, Gm), tightened the structure in *Composition. Lozenge with Grey Lines* (1918, The Hague) and painted *Composition. Planes of Light Colour with Grey Lines* (1919, Otterlo).
• The 1920s marked a turning point in his art. Mondrian returned to Paris; he exposed his theory of Neoplasticism in *Natural Reality and Abstract Reality* and illustrated it in *Composition with Red, Yellow and Blue* (1921–5, The Hague, Gm; 1927, Houston), *Lozenge Composition with Red, Yellow and Blue* (1921–5, Washington) and *Composition No 2 with Black Lines* (1930, Eindhoven, Stedelijk van Abbemuseum). He took part in group exhibitions in Paris, London, Amsterdam and The Hague. In 1922 an exhibition entirely devoted to his work was organized in the Amsterdam museum. The following year the De Stijl group exhibited in the L Rosenberg gallery where Mondrian met his future biographer, Michel Seuphor.
• After a disagreement with Van Doesburg, Mondrian left De Stijl in 1924. He became a member of the Circle and Square in 1929 which was renamed Abstraction-Creation in 1932. He created *Composition with Yellow Lines* (1933, The Hague, Gm), which heralded his last

stylistic period. He painted *Composition* (1933, New York), *Composition with Blue and Yellow* (1936, Düsseldorf, KNW) and *Composition in Red, Blue and White II* (1937, Paris).
- In the autumn of 1938, on the eve of the war, he fled to England, then to New York in 1940: *Place de la Concorde* (1938–43, Dallas), *Trafalgar Square* (1940–3, New York, MOMA) and *London Composition* (1940–2, New York, Buffalo, Albright-Knox AG). The American gallery Dudensing exhibited his work including *New York City I* (1941–2, Paris).
- In his last paintings colour played again a major part: *Broadway Boogie Woogie* (1942–3, New York) and *Victory Boogie Woogie* (1943–4, The Hague, Gm), which remained unfinished. Mondrian died of pneumonia on 1 February 1944.

Mondrian had many pupils during his lifetime: Theo van Doesburg (until 1926), Georges Vantongerloo, then the Frenchman J Gorin. He also influenced some Bauhaus artists. He left many writings outlining his theories.

APPROACH AND STYLE

Churches, trees, the sea, dunes, windmills, rivers were all sources of inspiration for Mondrian's early paintings before being transformed into *Composition*. New York gave him architecture and music. The artist painted with oil on medium-sized canvases. The art dealer L Rosenberg introduced him but collectors, such as Katherine Dreier, were few and far between.
After the Netherlands (Amsterdam, the province of Brabant, Domburg in Zeeland), Mondrian painted mainly in Paris and New York.
Theosophy, Jan de Sluyters' Fauvism, the art of Munch, of *Van Gogh and *Seurat all played a part in Mondrian's development. He borrowed plastic elements from Jan Toorop. Paris introduced him to Cubism and Bart van der Leck his coloured planes.

- At the beginning of his career, until 1907, Mondrian painted landscapes in the tradition of the Hague School and the Impressionists (George Henrik Breitner). He was influenced by the Fauves and admired Van Gogh and Seurat's Divisionism. In 1942 he wrote: 'The first thing to change in my painting was the colour. I replaced natural colour by pure colour. I had come to the conclusion that it was impossible to represent nature's colours on canvas.' In about 1910, his palette became lighter and the brushstrokes became divided, reminiscent of the art of Toorop (*Dune*).
- In 1912 the reality of the motif began to fade in favour of a subjective representation of form and colour. His adherence to theosophy led him to search for a materialization of the ideal form of the absolute and universal truth. He understood the importance of Cézanne-inspired Cubism (*Still Life with Ginger Pot I*). The ochre and grey monochrome palette, oval framing and shaded-off contours revealed the influence of Analytical Cubism. He stacked a multitude of verticals and horizontals in pink, light blue and brown-yellow shades which

A GREAT PAINTER

◆ Mondrian was famous during his lifetime from 1937 onwards among a select circle of enthusiasts in both Europe and the United States. Although he enjoyed immediate posthumous fame with retrospectives in New York (1945), Amsterdam (1946) and Basel (1947), the radicalism of his art remained misunderstood for a long time. The Denise René gallery only exhibited him in Paris in 1957 and his first French retrospective was at the Orangerie in 1969.
◆ A painter who broke with tradition, in 1913 Mondrian developed an exemplary construction of geometric abstraction as a 'destructive element', according to the artist himself, of the pictorial tradition of the Renaissance. He proposed a redefinition of painting based on a universal reading.
◆ Mondrian wanted 'each of his paintings to be a step forward', to achieve 'a new expression of the form' beyond the simple representation of nature.
◆ He freed himself from the restrictions of subjects in favour of serial *Compositions*. His subjects, first drawn from nature, became orthogonal geometric constructions which he refined to reach the absolute; curves and sharp angles were banned. He favoured pure colours and exploited the relationship between colour and non-colour; he also made a few paintings in black and white only. He invented Neoplasticism.
◆ Theosophy was one of the foundations of his aesthetic development: materializing the absolute.

MONDRIAN

replaced objects (*The Blooming Apple Tree* and *Still Life II*). He abandoned all realist reference as he evolved towards an almost total abstraction (*Oval Composition*).

• In 1914 the painter reflected on the division of the canvas and distribution of coloured planes in order to achieve the 'universal pictorial language', the absolute. He excluded all 'particular' perception, all identity of form. He built his language by means of 'plus' and 'minus' signs (+ and –), structured in a horizontal-vertical sequence; as he explained later these represented the universal principle of the erect male and prone female, the spiritual and material (*Pier and Ocean*).

• After meeting Van der Leck in 1916, Mondrian adopted his 'exact' technique as opposed to the random technique of the Cubists (*Composition in Blue B*). The following year, the artist conceived rectangular flat tints in pure colours (*Composition No 3 with Coloured Planes*). In 1918 his planes joined up with each side being shared by at least two flat tints; the line thus created was thick and coloured black by the artist. The space created was less segmented and took on a calm, noble and 'open' dimension (*Composition in Coloured Planes with Grey Contours*).

• During that same year Mondrian conceived rhomboid compositions in which he introduced a double system of perpendiculars which defined modules. The rectangles floated and there was no longer any background. The painter eliminated the opposition between figure and background but the rhythm and repetition were still 'particularities' that impeded his desire for absoluteness (*Composition with Areas of Light Colour and Grey Lines*). He never eliminated the concept of opposition because each element was, according to him, 'defined by its opposite' which was the very foundation of Neoplasticism (1920). The sea could not be conveyed by an abstract horizontal and the tree by a vertical; a dialectic had to be developed to ensure the reciprocal neutrality of the verticality and the horizontality and annihilate all 'particularity' (Y-A Bois, 1982).

• The literal translation of 'Nieuwe Beelding' (Neoplasticism) was the 'new image' which Mondrian gave the world. His plastic correspondence was conveyed through the opposition between primary colours in flat tints (red, blue, yellow) and non-colours (black, grey, white), between the vertical and horizontal, between large and small sizes, between the line and the coloured surface (*Composition with Red, Yellow and Blue*).

• In 1932 Mondrian cross-ruled his canvas with close, parallel double black lines crossing from side to side. Then he coloured them. They did not overlap.

• In 1937 the square and lozenge were replaced by a grid with a tightly constructed framework. Colour was reduced and rejected towards the edge of the canvas (*Composition in Red, Blue and White II*).

• On his arrival in New York in 1940, he was fascinated by the city with its rectilinear grid, resounding with the sound of jazz. His grid motif took on the colour of this musical rhythm while the background remained white, and black disappeared completely (*New York City*). Then small coloured and light grey squares multiplied along the lines on or under which coloured rectangles slid or were superimposed (*Broadway Boogie-Woogie*).

KEY WORKS

Mondrian painted 1,123 canvases.
Wood near Oele, 1908, The Hague, Gm
Silvery Tree, 1912, The Hague, Gm
Still Life with Ginger Pot I, 1911–12, The Hague, Gm
Flowering Apple Tree, 1912, The Hague, Gm
Oval Composition, 1913, Amsterdam, SM
Composition No 5, 1914, New York, MOMA
Pier and Ocean, 1915, Otterlo, K-M
Composition in Blue B, 1917, Otterlo, K-M
Composition. Lozenge with Grey Lines, 1918, The Hague, Gm
Composition. Planes of Light Colour with Grey Lines, 1919, Otterlo, K-M
Lozenge Composition with Red, Yellow and Blue, 1921–5, Washington, NG
Composition with Red, Yellow and Blue, 1921–5, The Hague, Gm; 1927, Houston, Menil coll
Composition, 1933, New York, MOMA
Composition in Red, Blue and White II, 1937, Paris, MNAM
Place de la Concorde, 1938–43, Dallas, MA
New York City I, 1941–2, Paris, MNAM
Broadway Boogie Woogie, 1942–3, New York, MOMA

The Blooming Apple Tree
c.1912. Oil on canvas, 18 x 106cm, The Hague, Gemeentemuseum

*This tree, dating from Mondrian's Cubist period, has lost its value as a real object. The artist has abandoned the descriptive form of pictorial language in favour of an elliptical, centripetal composition, carved up into purely graphic curves and lines, planes and dynamics which replace the traditional branches and ramifications, not in the semiological perspective of *Picasso or *Braque, but to unify the pictorial field of the painting.*

Composition with Red, Yellow and Blue
1927. Oil on canvas, 29.5 x 35cm, Houston, Menil collection

This painting, typical of Neoplasticism, is rigorously structured and reveals the particular dialectic developed by Mondrian. The black vertical and horizontal lines cross each other at right angles while the squares of primary colours – yellow, blue and red – echo the non-colour tinged with greyish-blue. The central square, perfectly defined, contrasts with the coloured rectangles, which are pushed to the extremities of the canvas.

Green is excluded from this painting as it was from all of Mondrian's work: this colour represented the very essence of nature, which the artist rejected in his plastic approach in order to achieve absolute form. Theosophy placed the representation of nature at the lowest level in the scale of values.

BIBLIOGRAPHY
Bois, Y-A et al, *Mondrian*, exhibition catalogue, Museum of Modern Art, New York, Bulfinch, London, 1994; Joosten, J M, *Piet Mondrian: Catalogue Raisonné of the Works of 1911-1944 (Vol 2)*, V and K Publishing/Inmerc, Blaricum, Cercle d'Art, Paris, 1998; *Piet Mondrian, 1872-1944*, Catalogue, Solomon R. Guggenheim Foundation, New York, 1971; Welsh, R P, *Catalogue Raisonné of the Naturalistic Works (Vol 1)*, V and K Publishing/Inmerc, Blaricum, Cercle d'Art, Paris, 1998

Klee

Klee was a 'painter-poet', watercolourist and an unclassifiable, authentic theoretician; his work is inseparable from music. His composition, line, colour, measure, rhythm and relationships created a pictorial approach which mixed geometric motifs, often in the shape of a chequerboard, a reference to the themes of nature and the cosmos.

LIFE AND CAREER

● Paul Klee (Münchenbuchsee 1879–Muralto-Locarno 1940), Swiss painter, spent his childhood in Bern. He hesitated between a career as a violinist (his parents were musicians) or as a painter. In 1900 he enrolled at the Munich Academy where he studied briefly under Stück. He spent the following two years travelling through Italy. Back in Bern he played in the municipal orchestra to make a living. At the same time he painted watercolours and made drawings and engravings.

● In 1905–6 he travelled to Berlin and visited the exhibitions there. In Paris he explored the Louvre, then settled in Munich, an active centre of the Jugendstil, with his wife, the pianist L Stumpf, and exhibited with the Munich Secession. He studied the engravings of William Blake, *Goya and James Ensor and became interested in *Van Gogh and *Cézanne. In 1910 he painted *Girl with Jugs* (Bern); his first exhibition at the Bern museum was a success.

● In 1911, Klee met the members of the Blaue Reiter including *Kandinsky and Franz Marc, and discovered Cubism. He illustrated Essay on the Light by Robert Delaunay and painted watercolours: *In the Quarry* (1913, Bern) and *Battlefield* (1913, Basel, Beyeler gall).

● His journey to Tunisia with August Macke and Franz Marc in April 1914, to Hammamet and Kairouan, where he discovered colour: *Motif from Hammamet* (1914, Basel), *Saint-Germain Tunis* (1914, Paris, MNAM).

● The war broke out, he was called up and became separated from his friends. Demobilized in 1918, he wrote an essay on the elements of graphic art, painted watercolours and produced drawings. In 1920 he published his theories on art. Monographs were devoted to him and the Goltz gallery in Munich exhibited his work including *Cacademoniac* (1916, Bern), *Coloured Angles* (1917, Switzerland, pr coll), *Under the Black Star* (1918, Basel, Km) and *Villa R* (1919, Basel, Km). In November 1920 Gropius invited him to teach at the Bauhaus and Klee went to Weimar. He worked from linear motifs, drawn with a ruler – *Enchainment* (1920, Bern, Km, Paul Klee Foundation), *Crystal Gradation* (1921, Basel), *Castle in Spain* (1922, Bern, Km, Paul Klee Foundation), *Eros* (1923, Lucerne, Rosengart gall) or with irregular lines drawn freehand – *Analysis of Various Perversities* (1922, Paris, MNAM), *Landscape with Child* (1923, Grenoble, MAM) – or associating the two: *Affected Place* (1922, Bern) and *Ventriloquist and Crier in the Moor* (1923, New York). Colours were applied in relation to this geometry and their respective 'sonorities' created a play of correspondences with such simplified motifs as trees, birds, moons and bodies.

● After a trip to Sicily in 1924 he followed the Bauhaus to Dessau (*Ancient Sonority*, 1925, Basel), teaching skills and creative activities. Between 1926 and 1931 he travelled in Europe and Egypt: *Florentine Villa District* (1926, Paris), *Portrait of an Acrobat* (1927, New York, MOMA), *Cat and Bird* (1928, New York, MOMA), *Main Road and Secondary Road* (1929, Cologne, Km). To celebrate its jubilee, MOMA organized a retrospective of his work.

● In 1931, tired of the Bauhaus, Klee accepted a professorship teaching pictorial technique at the Düsseldorf Academy. In 1933 he was expelled by the Nazis, who classed 17 of his works as 'degenerate art'. He returned to Bern where, increasingly successful, he organized the large exhibition of 1935 which showed his *Magical Squares* and his 'Divisionist' paintings: *In Rhythm* (1930, Paris), *Pyramid* (1930, Bern, Km, Paul Klee Foundation), *Individualized Measurement of Strata* (1930, Bern, Km, Paul Klee Foundation), *Ad Parnassum* (1932, New York), *Coming to Bloom* (1934, Winterthur, Km) and *Light and Bones/Ridges* (1935, Bern, Km, H and M Rupf foundation).

● Klee was suffering from the skin disease scleroderma and his attacks were becoming more frequent. He expressed his anguish in his paintings: *Fear* (1934, New York, Rockefeller coll). His 'primitivist' vocabulary was borrowed from children's drawings and dreams. Between 1937 and 1939 his paintings were invaded by labyrinths and hieroglyphs: *Legend of the Nile* (1937, Bern), *Harmonized Combat* (1937, Berne, Km, Paul Klee Foundation), *Harbour and Sailing Boats* (1937, Paris).

• World War II and approaching death inspired him to paint *Explosion of Fear III* (1939, Bern), *Angel still Female* (1939, Berne) and *Death and Fire* (1940, Bern). Besides these sombre pictures he also painted more serene representations, with cheerful, light motifs such as *La Belle Jardinière* (1939, Berne) and *Rock Flora* (1940, Bern).

While Klee drew some of his inspiration from the history of his time, the peculiarity of his own universe played an even more important part in his work. His theoretical teaching and pedagogy were closely linked to his activities as a graphic artist, engraver and painter. His *Journal* was published by his son Felix. The Paul Klee Foundation was created in 1946. It placed the works of the artist in the Bern museum in 1952.

APPROACH AND STYLE

The range of Klee's subjects was infinitely wide, from figurative motifs (characters, terrestrial, aquatic and celestial landscapes) to sober or polymorphous geometric shapes (arrows, crosses, dots, lines, chequerboards, grid, parallel, oblique, labyrinths) and writing (pictograms, ideograms and hieroglyphs).

His works, watercolours or gouache, were often the same size as writing paper. His oil paintings and pastel paintings, on canvas or newspaper, were usually medium- to large-size.

Klee was encouraged by the German galleries Thannhauser and Goltz in Munich, Flechtheim in Berlin and the Paris galleries D H Kahnweiler, Vavin-Raspail and Louis Simon. Numerous collectors and museums bought his work.

Bern, Berlin, Munich, Weimar and then Dessau were his main residences. He travelled in Italy, in Paris he discovered *Rembrandt, *Leonardo da Vinci and Goya and misunderstood the avant-garde; in Berlin he became involved in the Blaue Reiter group and was interested in Cubism. In Tunisia he discovered the power of light.

• From the very beginning, Klee distanced himself from Classical tradition and the art of his time, preferring instead the equilibrium of line and colour which he used in gradations of dark pinks and greens that projected beyond the line. He was particularly fond of monochrome effects and used a form of Symbolism. His drawings and delicately coloured watercolours were in the tradition of the Blaue Reiter group. His oil paintings, few in numbers before 1914, revealed a freedom of expression, a balance of the composition and harmony of colours which he had borrowed from Van Gogh and Delaunay, Cézanne and Cubism (*In the Quarry*).

• Tunisia was a shock: 'Colour has got hold of me, I do not need to pursue it any longer', the artist wrote. He saw colour as an equivalent of space, movement, time and music. He abandoned the traditional rules of landscape painting and added plastic vibrations to his warm colours (*Motif from Hammamet*). The war slowed him down but the memory of Tunisia's colours continued to be a source of inspiration, guiding him towards a formal freedom, full of fantasy (*Cacademoniac*).

• From 1920 onwards Klee gradually conceived geometric constructions in which he tended towards a pure, subjective and intuitive expression, animated by the crystalline, vibrant, transparent finesse of watercolour (*Gradation of Crystal*). He drew geometric motifs with a ruler, parallel (*Enchainment*), with sharp angles (*Eros*) or seen in perspective. He created an aerial, unusual style of freehand drawing, full of intensity, while maintaining the poetic, vibrant irregularity of the strokes (*Analyses of Various Perversities*). Sometimes he mixed the aesthetics: against a geometric background on which he carried out his colour experiments, he drew motifs in the shape of curves (*Affected Place*).

A GREAT PAINTER

◆ Klee very quickly became famous. His art was officially recognized in 1935 and in 1960 he was discovered by the public. His most recent retrospectives were those organized at the MNAM in Paris in 1985 and by MOMA in New York in 1987.

◆ Although Klee's art was avant-garde, this master of the watercolour remained on the fringes: 'Down here, I cannot be caught ...' (epitaph taken from his *Journal*).

◆ The originality and extreme diversity of his themes, the variety of his sources of inspiration, the richness of the drawing and forms, the uniqueness of his chromatic expression, his concern with format, the countless techniques, mixed and related to the materials, were a reflection of his amazing inventiveness.

• 'Art does not reproduce the visible, it makes it visible', Klee wrote. He neither represented nature slavishly nor did he reject it entirely. His images created forms born from associations and 'other latent extra truths'. Musicality was expressed through the style of drawing and rhythm of the lines, punctuated by harmonious and harmonic-coloured chords, measured and in time. Although the drawing remained the major object of his concern and never lost its autonomy, colour also played a central part, based on 'terrestrial, intermediary and cosmic' colours. The first ones were naturalist and intuitive, the second ones were the seven colours of the rainbow and the last ones were part of the circle of the six fundamental colours, completed by black and white.

• His introduction to tapestry inspired his fragmentation and repetition of the motif which led to a 'Divisionism' consisting of a mosaic of colours in which each piece would be a brushstroke, irregular and close in colour to the next one (*Ad Parnassum*); the texture of the tapestry suggested to him pictorial impastos in the shape of a checkerboard (*In Rhythm*).

• Klee sometimes also broke the geometric structure to return to a figurative style (*Cat and Bird*), or lightened the geometry by destroying the symmetry (*Main Road ...*) or by blurring the geometric contours of the shapes by a 'manual' finish (*Florentine Villa District*). When the work became more abstract, the title still remained concrete (*Ancient Sonority*), his geometric layouts providing a thematic support (*Castle Garden*, 1931, New York, MOMA).

• After 1935, although sick and weak, Klee resumed the formal and rhythmic research he had started at the Bauhaus. He opposed colours and motifs by conceiving coloured geometric planes of different sizes and dark lines and curves which approximately underlined them (*Harbour and Sailing Boats*), sometimes changing into hieroglyphs (*Legend of the Nile*) or reminiscent of the poetic alphabet of his youth. This was his way of declaring that 'writing and drawing are identical in essence'.

• His late work expressed his anguish, his sadness and death through his tragic characters, conveyed with 'primitive' figurative drawings, like a child's. This highly economical style of drawing also applied to the plastic treatment of his last themes which expressed a vigorous, symbolic opposition to Hitlerism (*Explosion of Fear III*) or a serene, happy vision of approaching death.

Florentine Villa District
1926. Oil on canvas, 49.5 x 36.5cm, Paris, Musée National d'Art Moderne, Centre Georges-Pompidou

Klee prepared a chequerboard motif over a thick coating and filled the squares with incised and drawn motifs. His geometric backgrounds, here irregular, are reminiscent of his Tunisian watercolours. The range of faded pinks and ochre yellow, mellow and poetic, conveys the colour harmonies of Florentine villas. The interpenetration between coloured rectangles and incised lines and curves prevents all symmetry. His drawing alternates elements close to pictograms or ideograms with 'figurative' representations: Klee has projected the facades of villas onto the surface of the canvas but still preserved a few points of perspective in the stairs.

Harbour and Sailing Boats
1937. Oil on canvas, 80 x 60.5cm,
Paris, Musée National d'Art
Moderne, Centre Georges-
Pompidou

*In this painting produced a few years
before his death, the arbitrary and
diffuse coloured planes, blurred and
mellow, animate the background in a
pastel effect. The delicacy of the drawn
shapes is a metaphor for the lightness
of the sailing boats floating in this
space, which appears more cosmic
than aquatic. However, the coloured
triangles of the sails are clearly
outlined. Slightly differently
orientated, they suggest the movement
of the light breeze blowing into this
harbour labyrinth.*

KEY WORKS
The catalogue of Paul Klee's works includes over 9,000 titles, 5,000 of
which are drawings.
Girl with Jugs, 1910, Bern, Felix Klee coll
In the Quarry, 1913, Bern, Felix Klee coll
Motif from Hammamet, 1914, Basel, Km
Cacademoniac, 1916, Bern, Km, Paul Klee Foundation
Crystal Gradation, 1921, Basel, Km
Affected Place, 1922, Bern, Km, Paul Klee Foundation
Eros, 1923, Lucerne, Rosengart gall
Ventriloquist and Crier in the Moor, 1923, New York, MM
Ancient Sonority, 1925, Basel, Km
Florentine Villa District, 1926, Paris, MNAM
Cat and Bird, 1928, New York, MOMA
In Rhythm, 1930, Paris, MNAM
Ad Parnassum, 1932, New York, MOMA
Legend of the Nile, 1937, Bern, Km, H and M Rupf Foundation
Harbour and Sailing Boats, 1937, Paris, MNAM
Explosion of Fear III, 1939, Bern, Km, Paul Klee Foundation
Rock Flora, 1940, Bern, Km, Paul Klee Foundation

BIBLIOGRAPHY
Grohmann, W, *Paul Klee*, 2nd edn, Lund Humphries, London, 1958; Klee, P, *The Diaries of Paul Klee, 1898-1918*, University of California Press, Berkeley, CA, 1968; *Paul Klee*, exhibition catalogue, Georges Pompidou Centre, Paris, 1985

Duchamp

After paying a brief homage to the spirit of the time, Duchamp, an outsider and free spirit, cultivated, pessimistic and ironic, proceeded to explode the artistic values of his time by integrating everyday objects into his art. His Dada inventions, disconcerting, enigmatic, absurd and poetic, revolutionized the very concept of art.

LIFE AND CAREER

• Marcel Duchamp (Blainville, Seine-Maritime, 1887–Neuilly-sur-Seine 1968), French artist, belonged to a middle-class family which boasted two other great artists: his brothers Jacques Villon and Raymond Duchamp-Villon.
• Duchamp started painting in 1902 and studied in Paris from 1904 to 1905 at the Académie Julian. At the time his art could be described as being somewhere between Neo-Impressionism (*Landscape at Blainville*, 1902, Milan, A Schwartz coll), Fauvism and Cubism (*Woman Naked in a Tub*, 1910, pr coll) and Symbolism (*Portrait of Doctor R Dumouchel*, 1910, Philadelphia; *Paradise*, 1910–11, Philadelphia). *Cézanne's influence is present in *The Game of Chess* (1911, Philadelphia) and that of *Matisse in *Young Man and Girl in Spring* (1911, Milan, A Schwartz coll).
• In 1911, in Puteaux, at his brothers' house, he met those whom *Braque called the 'Cubisteurs': Albert Gleizes, Roger de La Fresnaye and Jean Metzinger. Duchamp conceived the *Sonata* (1911, Philadelphia, MA), *Yvonne and Magdeleine Torn in Tatters* (1911, Philadelphia, MA) and *Portrait* (also known as *Dulcinea*, 1911, Philadelphia, MA).
• Inspired by the Futurist Cubism of Frank (Frantisek) Kupka and the chronophotography of É J Marey, he composed *Portrait of Chess Players* (1911, Philadelphia, MA), the *Coffee Mill* (1911, London), *Sad Young Man in a Train* (1911, Venice), *Nude Descending a Staircase No 1* (1911, Philadelphia, MA), and especially *Nude Descending a Staircase No 2* (1912, Philadelphia, MA), rejected by the Salon des Indépendants, then exhibited in 1913 at the Armory Show in New York where it caused a scandal. *The Bride* (1912, Philadelphia, MA) and *The King and Queen Surrounded by Swift Nudes* (1912, Philadelphia, MA) display the same Cubo-Futurist vein. A theatrical adaptation of the caustic and surrealist before its time, *Impressions of Africa* (1911–12) by R Roussel fascinated him. A librarian in Sainte-Geneviève (1912–14), he reflected on the fourth dimension and its implication in art.
• The artistic turning point happened when Duchamp was aged 25: he painted on glass *Glider Containing a Water Mill in Neighbouring Metals* (1913–15, Philadelphia), and mounted the box with the *3 Standard Stoppages* (1913, New York, MOMA), heralding the ready-made which he invented in 1916. His paintings were provocative: *The Chocolate Grinder* (1914, New York, MOMA), *Network of Stoppages* (1914, New York), *9 Malic Moulds* (1914–15, Paris).
• Demobilized in August 1915, he joined Francis Picabia in New York where he introduced Dada. He worked on *The Large Glass*, also called *The Bride Stripped Bare by her Bachelors, Even* (1915–23, Philadelphia). The aggression of *Fountain*, a urinal exhibited as a work of art in 1917, marked the revolution of the ready-made. In 1918 Duchamp signed his last painting on canvas, *Tu m'* (New Haven).
• The painted ready-mades such as *LHOOQ* (1919, Philadelphia), a moustachioed version of the *Mona Lisa*, the experiments on the perception of relief, *Rotary Glass Plates* (Precision Optics) (1920, New Haven), then his passion for chess with which he made a living, took up all his energy between 1923 and 1934.
• In 1942, Duchamp frequented the other exiled Surrealists in New York, André Breton, *Ernst, A Masson and Yves Tanguy. From 1946 to 1966 he worked on the assembly of *Étant donnés 1. La chute d'eau; 2. Le gaz d'éclairage*) (Philadelphia, MA). In 1955, he acquired American nationality.

Duchamp died in France on 2 October 1968. The symbol of absolute freedom, he also left writings. His ready-made art inspired the Neodadaist artists, new realism and Pop Art. His Rotoreliefs herald optical and kinetic art.

APPROACH AND STYLE

At first Duchamp was interested in landscapes, portraits, nudes and genre scenes. Between 1912 and 1918, he painted erotic, enigmatic works and coloured optical discs. He worked in all formats, on canvas, card and glass.

From 1915 onwards his patrons, W and L Arensberg, bought almost all his creations, now on display at the Philadelphia Museum.

Duchamp's first paintings were influenced by Neo-Impressionism, Symbolism, the Nabis, Fauvism, Cubism and Futurism. The artist lived in Paris but mainly in New York.

• Between 1902 and 1911, Duchamp's work revealed the influence of Cézanne and Matisse. He was close to the silent symbolism of O Redon. His originality was already becoming apparent in the haloed hand of *Doctor Dumouchel* and the 'distortions' of the body, in the 'torn to tatters' portraits of *Yvonne and Magdeleine* which 'de-theorized' the concept of Cubism.

• In the tradition of Giacomo Balla, Frank Kupka and the photographer É J Marey, his Cubo-Futurist works tended towards the movement, abstraction and mechanization of forms. With *Nude Descending a Staircase*, he created 'a static image of movement'. He distanced himself from the Cubist and Futurist aesthetics which banned the nude by decomposing the 'object' and the movement into superimposed thin sheets and tubes.

• In 1911–12, Duchamp had become interested in *Impressions of Africa* by R Roussel which fascinated him with its 'passion for the unusual'. The crazy machines and the play upon words were an integral part of the humour expressed in his creations (*The King and Queen surrounded by Swift Nudes*). Painting 'must not be excessively visual or retinal. It must also be of interest to the grey matter'. *Glider Containing a Water Mill*, *The Chocolate Grinder* and *9 Malic Moulds* were confusing both because of their enigmatic character and their quirky titles.

• In 1918 Duchamp rejected 'intoxication through turpentine', declaring *Tu m'* (sometimes translated as 'You F*** Me Off'), the enlightening title of his last painting. As a medium he now chose glass (*The Large Glass*) and the ready-made in two or three dimensions: pencil on a postcard reproduction of the *Mona Lisa* (*LHOOQ*, 1919), an iconoclastic Dada game confirmed by *LHOOQ Shaved* which attacked Western painting. He became interested in optical effects (*Rotary Glass Plates*). Nevertheless, painting remained a sporadic source of inspiration: in 1967–8, he created erotic-humorous drawings and engravings, inspired by *Ingres's Turkish Bath* and the *Woman with White Stockings* by *Courbet. His work, which confirmed that 'it is the spectator who makes the painting', revealed the boundaries of art.

A GREAT PAINTER

◆ From 1913 onwards, *Nude Descending a Staircase* made Duchamp the most famous Frenchman in New York. After his death his fame among the public decreased.

◆ The artist broke radically with the traditional rules of art. His intellectual and Dadaist approach advocated 'anti-art'. He revolutionized the art of the second part of the 20th century.

◆ The artist created in the context of total freedom. He denounced the narrowness of the 'retinal' dimension of the work, at the expense of the intellect and eroticism. He invented the ready-made in painting and especially in sculpture.

◆ Duchamp was innovative in the use of unusual materials such as glass panels, lead, red lead paint and dust.

DUCHAMP

The Large Glass
Also known as **The Bride Stripped Bare by her Bachelors, Even**
1915–23. Oil, varnish, lead sheet, red lead paint, silver plating and dust in two glass panels, mounted in an aluminium, wood and steel frame, 2.725 x 1. 758m, Philadelphia, Museum of Art

This unfinished 'machinery', consisting of two glass panels erected vertically against each other (broken in transit), was inspired by Impressions of Africa *by Roussel, full of mechanical and Dadaist gadgets. Steeped in lust and eroticism, this 'intellectual expression' represented the culmination of numerous years of research.*
In the bottom part of the glass panel Duchamp reproduced in perspective his early isolated works, The Chocolate Grinder, 9 Malic Moulds *and* Glider Containing a Water Mill *and in the top part he included the bride 'as being a projection of a 4-dimensional object'. The bachelors of the 9* Malic Moulds *are condemned to masturbate, as symbolized by* The Chocolate Grinder, *an allegory of the solitary pleasure of the bachelor who 'crushes his chocolate on his own' while the bride with her fluttering veil punctured by squares, is thought to be waiting for love.*
The work remains enigmatic. The bride can communicate with the bachelors by means of the 'letter-box', the 'hinge' between the two glass panels. What is the meaning of the openings, the 'impacts' on the right side of the panel? Why so many bachelors and no husband? If the composition remains one of the most impenetrable of the century, the title (in French La Mariée Mise à Nu par ses Célibataires, Même) *is just as disconcerting with the addition of the word* même *(even) which may be a play of words:* m'aime *(loves me) or* eux-mêmes *(themselves).*
Duchamp remarked that the Bride, in her conceptual richness, is beyond painting and art, and that it 'provokes' thought. In this work on glass he also synthesized his research into movement, space and its projection on the surface, a different form of art from retinal art.

KEY WORKS
Duchamp created few paintings.
Portrait of Doctor R Dumouchel, 1910, Philadelphia, MA
Yvonne and Magdeleine Torn in Tatters, 1911, Philadelphia, MA
Coffee Mill, 1911, London, TG
Nude Descending a Staircase No 2, 1912, Philadelphia, MA
Glider Containing a Water Mill in Neighbouring Metals, 1913–15, Philadelphia, MA
The Chocolate Grinder, 1914, Philadelphia, MA
Network of Stoppages, 1914, New York, MOMA
9 Malic Moulds, 1914–15, Paris, MNAM
The Large Glass, also called *The Bride Stripped Bare by her Bachelors, Even*, 1915–23, Philadelphia, MA
Tu m', 1918, New Haven, Yale University, AG
LHOOQ, 1919, Philadelphia, AM
Rotary Glass Plates (Precision Optics), 1920, New Haven, Yale University, AG

BIBLIOGRAPHY

Golding, J, *Marcel Duchamp: The Bride Stripped Bare by Her Bachelors, Even*, Allen Lane, London, 1973; Lebel, R, *Marcel Duchamp*, translated by George H. Hamilton, Trianon, London, 1959; *Marcel Duchamp*, exhibition catalogue, Georges Pompidou Centre, Paris, 1977

Ernst

An innovative and subversive artist, Ernst, the 'Leonardo of Surrealism', dominated the Dada movement and especially Surrealism. His exuberant imagination, his sense of the absurdity of the world, his dream-like, poetic universe, inspired by Germanic Romanticism and fantasy, are breathtaking. Ernst, a tireless inventor, was constantly changing his means of expression; collage, frottage (rubbing), transfer and grattage (scratching) all contributed to the creation of a varied, colourful, fantastical world.

LIFE AND CAREER

• Max Ernst (Brühl, Rhineland, 1891–Paris 1976), French painter and sculptor of German origin, was taught the basics of painting by his father, a primary school teacher and amateur painter. In Bonn, between 1909 and 1912, he studied Nietzsche and Freud, the history of art and German literature. He admired *Bosch, *Picasso and *Friedrich. The influence of *Van Gogh is noticeable in his *Landscape with Sun* (1909, Ernst coll) and his encounter with Hans Arp was decisive.

• In 1913 he frequented the Young Rhineland circle, became friends with the Expressionist artist August Macke (*Crucifixion*, 1913, Cologne, Wallraf-Richartz mus), and discovered Fauvism and Cubism. The synthesis of these influences can be seen in *The Immortality* (1913–14, Tokyo, Miami gall). His first engravings and canvases, connected with Die Brücke ('The Bridge'), were exhibited in Berlin in 1913 at the first German Autumn Salon, then in Bonn and Cologne. Called up by the army, he expressed his malaise in a watercolour *Fish Combat* (1917, pr coll). He married and his son Jimmy also became a painter.

• His meeting with the Dadaist Hans Arp in 1919 in Cologne was a turning point in his career. With the anarchist Baargeld he founded the provocative *Zentrale W/3*. Ernst developed into a more artistic direction: he created lithographs (*Fiat Modes, Pereat Ars,* 1919, pr coll) and produced large paintings such as *Madam the Boss at the River's Edge* (1919, Stuttgart, Staatsgalerie), *The Great Orthochromatic Wheel which Makes Love to Measure* (1919–20, Paris) and *Dada Degas* (1919–20, L Aragon coll). Arp and Ernst created 'fatagagas' (*Fabrication de tableaux garantis gazométriques*: manufacture of pictures guaranteed to be gasometric), and also Dada photo-collages: *The Chinese Nightingale* (1920, pr coll), *The Punching Ball* and *The Immortality of Buonarotti* (1920, Chicago). Dada disappeared that same year.

• In 1921, André Breton invited Ernst to exhibit his collages and Paul Éluard asked him to illustrate his works. Ernst moved to Paris and created *The Elephant Celebes* (1921, London), *Approaching Puberty* or *The Pleiads* (1921, Paris, pr coll), *Oedipus Rex* (1922, Paris), *Ubu Imperator* (1923, Paris, MNAM), the *Pieta* or *Revolution by Night* (1923, Turin). He exhibited at the Salon des Indépendants in 1923 and became the principal figure of Surrealism in painting. He painted the famous *The Blessed Virgin Mary Chastising the Child Jesus before Three Witnesses* (1926) and constructed picture-objects. He explored the unconscious more methodically: *The Hundred Thousand Doves* (1925, pr coll), *Monument to the Birds* (1927, Marseille), *Joie de Vivre* (1927, London, R Penrose coll), *The Great Forest* (1927, Basel, Km).

• In 1925, Ernst introduced frottage: *The River Love* (1925, Houston, Menil coll) and *Natural History* (1926). In 1927–8 he applied the process to painting, enhancing it by the addition of grattage (scratching): *Shells* (1927, pr coll) and *The Horde* (1927, Amsterdam, SM). Imprints and photomontages completed the panoply of techniques used by Ernst.

• In 1929 he created the collage-novels including *La Femme 100 Têtes* – 'The Girl with 100 Heads' but phonetically 'The Girl without a Head' (1929, Éditions de l'Œil, Paris) – and *Une semaine de Bonté*, 'A Week of Goodness' (1934, Éditions Jeanne Bucher, Paris). He was deemed a 'degenerate artist' by the Nazis.

• In the 1930s he became involved in sculpture and spent the summer of 1934 in Switzerland at the house of Alberto Giacometti. In 1936 he showed his work at the New York exhibition 'Fantastic Art, Dada, Surrealism'.

• The painter developed a visionary, disturbing, dream world, often inhabited by vegetable and mineral elements: *The Entire City* (1935-6, Zurich), *Barbarians Marching West* (1935, New York, pr coll), *Landscape with Wheat Germs* (1936, Düsseldorf, KNW), *The Spanish Physician* (1938, Chicago, pr coll). A visionary, he also painted war: *The Plane-Sucking Garden* (1935, Houston) and *The Angel of Hearth* (1937, Geneva, J Krugier gall).

• On the eve of World War II he broke with the Surrealists. A German citizen, during the war he was arrested by the Vichy police and interned at the Camp des Milles near Marseilles

before being handed over to the German authorities. But he succeeded in emigrating to New York. He evoked the war in *The Anti-Pope* (1941–2, Venice, Peggy Guggenheim coll), *Europe after the Rain* (1940–2, Hartford) and *The Witch* (1941, New York, pr coll).

● Ernst married Peggy Guggenheim in New York in 1941. Young American artists were taken by *Painting for Young People* (1943, Geneva, Krugier gall), *Young Man Intrigued by the Flight of a Non-Euclidian Fly* (1942–7, Zurich, Loeffler coll) and the new technique of drip painting which the artist used in *Panic-Stricken Planet* (1942, Tel-Aviv, mus).

● In 1943 the artist met Dorothea Tanning. This heralded a productive, peaceful period for him. The two of them moved to Sedona in the Arizona mountains. Ernst created *Euclid* (1945, Houston), *The Blue Hour* (1946–7, pr coll) and *Feast of the Gods* (1948, Vienna).

● Back in France in 1953, he first settled in Paris, then in Touraine (Huismes) and then in the Var (Seillans). He conceived *The Great Albert* (1957, Houston, Menil coll), *Little Girls Catching Butterflies* (1958), *The Marriage of Heaven and Earth* (1962, Houston, Menil coll), *The Fête in Seillans* (1962, Marseilles, Cantini), *The Last Forest* (1960–9), pr coll), etc. *Sleepwalking Fish* (1972, Paris, pr coll) was one of his last canvases.

Ernst left theoretical writings. His prolific and varied career as painter, engraver, sculptor, poet and essayist make him one of the most important artists of the 20th century. His technique inspired American Action painting (*Pollock), the *matiéristes* (*Dubuffet, Antonio Tàpies, etc) and the Tachists (Sam Francis, Jean-Paul Riopelle etc).

APPROACH AND STYLE

Ernst painted all kinds of subjects, rational and irrational, allegorical and metaphysical and gave them coherent or incoherent titles: animal and fantastical forms, human and humanoid shapes, panoramic views of shapes, terrestrial and celestial *Configurations*.

He used mainly medium- to large-sized canvases for his oil paintings but preferred small formats for the collage-novel and photomontage.

A few friends such as Éluard commissioned work from him. The major European and American museums and large private collections bought his work.

Ernst studied art in Bonn, became involved with Dadaism in Cologne and then with Surrealism in Paris. Early on in his career he was inspired by Giorgio de Chirico, *Duchamp and Francis Picabia. His art was admired in New York. He spent the last years of his life in France.

● Ernst was interested in the ancient masters and in contemporary artists in order to do better. He also found inspiration in German Romantic and fantastical literature, avant-garde poetry and the unconscious.

● A master of Dadaism in 1919, he defined collage 'as an alchemical composition of two or more heterogeneous elements, resulting from their unexpected rapprochement'. He proceeded in the same manner for photo-collage: the 'fatagagas' (*The Immortality of Buonarotti*). He had the idea while browsing through sale catalogues of books and objects; the pictures were cut out, stuck down and reworked. His humorous, dream-like and absurd collages were sometimes reminiscent of de Chirico's metaphysical painting: the harsh light, long shadows and torso doll of *The Elephant Celebes*. The 'machinistic' collages are reminiscent of Duchamp and Picabia (*The Great Orthochromatic Wheel*). He put together photo-

A GREAT PAINTER

◆ Ernst quickly became famous and his art was admired early on in his career. His first prize for painting at the Venice Biennale in 1954 gave him international recognition. He had numerous retrospectives after 1951: Berne, Paris, New York, Stockholm, Cologne, Zurich, Venice, Amsterdam, Stuttgart and London.

◆ A leading light of Dadaism in Cologne and of Surrealism in Paris, Ernst was a pioneer of the new reality.

◆ He created a strange, barbaric bestiary, enigmatic forests, sometimes vegetable and alive, sometimes mineral and petrified, and devastated cities, frozen in time. He painted the 'iconography of the unconscious'. The titles, often out-of-step with the picture, further increased the strangeness of his work.

◆ He constantly invented new techniques: collage, photographic collage, 'fatagaga', frottage, the collage-novel and drip painting. In Ernst's work themes are expressed through technique and the technique, having become the content, creates the theme (W Spies, 1991).

graphs and pictures which he then re-photographed to eliminate all traces of the collage.

• In 1921, Ernst was already interested in the 'means of achieving total liberation of the spirit'; he explored his dreams and his unconscious in dream-like, enigmatic works, with a dry, neutral texture (*Approaching Puberty, The Staggering Woman*). He painted as André Breton later suggested to artists 'outside all control of reason, outside all aesthetic and moral preoccupation' (*A Surrealist Manifesto*, 1924).

• In 1925 he enriched his collages with 'frottages' (*River Love and Natural History*): he placed a piece of paper on a strip of wood and rubbed it with graphite. 'At first', he explained, 'I automatically obtain a chaotic background through the rubbing process and other techniques; I then try to interpret this chaos by using my mind and giving it ambiguous, paranoiac, mythical, contradictory shapes and meanings according to an inverted logic.' Rubbing created imprints which were full of metaphors: an underlying landscape. He then extended the technique to other supports. In the case of oil paintings he used the technique of grattage (scratching the paint). Birds, imaginary creatures, monsters and strange vegetable and mineral landscapes (*Joie de Vivre*), reminiscent of Friedrich's, were born of his elaborate, scratched, rubbed-down painting (*The Horde*).

• In 1929, he developed the collage-novel: inspired by 19th-century engravings, fabulous fairy tales and crime novels, he illustrated disturbing stories with imaginary characters.

• The anxiety caused by the war increased his creation of fantastical, cruel and barbaric motifs (*The Plane-Sucking Garden, Europe after the Rain*). In New York, he used the transfer technique invented by the Surrealist O Dominguez. In this way he lightened the pictorial material. In 1941 he invented drip painting: 'Attach a string to an empty tin,' he explained, 'make a hole in the bottom, fill the tin with very liquid paint and swing the tin at the end of the string above the canvas, placed flat on a surface. Guide the tin by moving your hand and arm' (*Panic-Stricken Planet*). He added: 'The drops create surprising lines on the canvas. And that is when the game of mental associations can start.'

• He then entered a more serene period; the luxuriant, spongy, tragic landscape was replaced by a more structured one, often animated by simple geometric shapes, set in a colourful, joyous, light-hearted atmosphere (*Feast of the Gods*). He increased his cosmic visions; the lunar disc (*The Marriage of Heaven and Earth, The Last Forest*) became a leitmotiv. From 1965 onwards, he returned to the technique of assembling materials.

BIBLIOGRAPHY

Ernst, M, *Writings*, Gallimard, Paris, 1970; Max Ernst, *Catalogue of works*, 5 vols., Houston-Cologne, 1975-1987; *Max Ernst*, exhibition catalogue, Georges Pompidou Centre, Paris, 1991 and 1998

The Plane-Sucking Garden
1935. Oil on canvas, 54 x 74cm, Houston, Menil collection

An intuitive and visionary artist, Ernst anticipated the declaration of war in this painting. He shows a broken-up plane, overrun by a fantastical, dream-like, mineral vegetation, which became increasingly important in the following years through the use of transfers as an artistic technique. The pastel colours appear to be out of step with the subject: they conjure up calm rather than drama; visual pleasure prevails here over the importance of the event.

KEY WORKS

Fish Combat, 1917, pr coll
The Great Orthochromatic Wheel which Makes Love to Measure, 1919–20, Paris, MNAM
The Elephant Celebes, 1921, London, TG
Approaching Puberty or *The Pleiads*, 1921, Paris, pr coll
Oedipus Rex, 1922, Paris, pr coll
Pieta or *Revolution by Night*, 1923, Turin, pr coll
The Blessed Virgin Mary Chastising the Child Jesus before Three Witnesses, 1926, J Krebs coll
Monument to the Birds, 1927, Marseille, Cantini
The Great Forest, 1927, Basel, Km
Shells, 1927, pr coll
The Entire City, 1935-6, Zurich, Kunsthaus
The Plane-Sucking Garden, 1935, Houston, Menil coll
Europe after the Ruin, 1940–2, Hartford, Wadsworth Atheneum
Euclid, 1945, Houston, Menil coll
Feast of the Gods, 1948, Vienna, 20th Century mus
Little Girls Catching Butterflies, 1958, pr coll
The Marriage of Heaven and Earth, 1962, pr coll
The Last Forest, 1960–9, pr coll

The Last Forest
1960–1969. Oil on canvas, 1.14 x 1.46m, Paris, Musée National d'Art Moderne, Centre Georges-Pompidou

The theme of the forest was a constant in the work of Max Ernst, vegetable or mineral forest, rectilinear or intertwined, shown in daytime or night time, always fantastical and dream-like, inhabited by strange creatures, vegetable and animal and in particular birds. This painting is characteristic of the style of this artist, a mixer of many techniques. A Surrealist representation, it is creation of the unconscious, introducing unpredictability through using frottage and transfer. But it was also the result of a conscious, lucid process on the part of the artist in his use of grattage (scratching) and griffure (erosion).

Miró

Plump, cheerful and unassuming, Miró conceived a dream-like, poetic universe, inhabited by biomorphic creatures, women and birds, set in a starry, ethereal space, emanating happiness. This Surrealist artist par excellence created imaginary, personal shapes which combined arabesques, circles and lines to bright colours as well as black, applied in flat tints or as vibrant paint.

LIFE AND CAREER

• Joan Miró (Barcelona 1893–Palma de Majorca 1983), Spanish painter, was the son of a jeweller and watchmaker. In 1907, he trained in business while at the same time attending classes at the School of Fine Arts of La Lonja in Barcelona. At the age of 17, working as a clerk in a large department store, he became ill because he could not devote himself to his art. He was sent to his parents' farm in Montroig (Catalonia) to convalesce. In 1912, Miró attended the free Academy of Gali and became acquainted with the ceramicist L Artigas.

• The artist was influenced by the Impressionists, Fauves and Cubists who exhibited in Barcelona in 1916: *Standing Nude* (1918, Saint Louis) and *The Farm* (1921–2, Washington, NG). The artist met the critic M Raynal and the painter Francis Picabia and exhibited at the Dalmau gallery (1918).

• From 1920 onwards, Miró divided his time between Montroig and Paris. Living close to the studio of André Masson, being acquainted with the poets P Reverdy, Tristan Tzara and M Jacob and attending Dada events, he remained on the fringes but moved away from reality: *Nude with Mirror* (1919, Düsseldorf, KNW) and *The Farmer's Wife* (1922–3, New York). His first Paris exhibition took place in 1921 at the La Licorne gallery.

• His meeting with André Breton and the Surrealist group in 1923 reinforced his development towards a poetic, dream-like art: *Ploughed Earth* (1923–4, New York), *Harlequinade* (1924–5, Buffalo), the highly symbolic *Maternity* (1924, London, R Penrose coll), *The Siesta* (1925, Paris, MNAM) and *Dog Barking at the Moon* (1926, Philadelphia, MA), and poetic, humorous paintings such as *Person Throwing a Stone at a Bird* (1926, New York).

• Automatism and an inventive imagination inspired the three *Dutch Interiors* (1928, New York; Venice, Peggy Guggenheim coll; Chicago, Marx coll), influenced by the Dutch painting of *Vermeer, Jan Steen and others, and the *Portrait of Mrs Mills in 1750* (1929, New York, MOMA) after *Constable. He composed several collages with different textures: *Collage* (1929, pr coll).

• From 1929, the year he married, until 1936, the artist lived mainly in Montroig. He exhibited in New York and started to produce lithographs and etchings. He gave free rein to his power and lyricism in *Seated Woman* (1932, New York, pr coll), *Young Girl Practising Physical Education* (1932, Küsnacht, E C Burgauer coll), '*Snail Woman Flower Star*' (1934, Madrid, Prado) and *Portrait of a Young Girl* (1935, New York, Kiam coll). The series of *Painting* (1933, Berne, K; 1933, Prague, Národní Galerie; 1933, Barcelona) and *The Circus* (1934, pr coll) also expressed the artist's imagination and verve.

• The Spanish Civil War was traumatic for Miró. He had anticipated it in the series *Characters*, entitled 'wild period', in which he portrayed monstrous creatures, gesticulating with mouth open and teeth showing: *Characters before Nature* (1935, Philadelphia). At the height of the Spanish Civil War, they proclaimed the artist's anguish (*Triptych*, 1937, Zurich, pr coll) and heckled the viewer in the poster *Help Spain* (1937, pr coll) which expressed Miró's support for the Republicans. *The Reaper* (1937, lost), a mural painting produced for the Spanish Pavilion at the 1937 Universal Exhibition in Paris, and the terrible *Woman's Head* (1938, Los Angeles) also illustrated the drama of the Civil War. Miró sought refuge in ethereal poetry, detached from reality: *The Escape Ladder* (1939, Chicago).

• In 1940 Miró went to Paris. His work now illustrated his exploration of the world of dreams; the series of *22 Constellations* (1941, Chicago), a major project, was started in Varengeville, centre of the Surrealist movement, and completed in Palma de Majorca and Montroig in 1941.

• He went back to Barcelona in 1942, working on paper and producing lithographs and ceramics with Artigas. He returned to his favourite themes (*Woman and Birds at Sunrise*, 1946, Barcelona; *People in the Night*, 1950, New York), and started working on a series on

canvases around the subject of the *Red Sun* (1948, pr coll), and then completed the series of the *Painting* (1949, Basel; 1953, New York).
● From 1954 onwards Miró produced rough or brightly coloured sculptures, ceramic mural panels such as *Wall of the Sun* (1955–6, Paris, Unesco) and after a stay in the United States in 1957, the one at Harvard (1960).
● In the 1960s the artist continued to develop his themes and his artistic exploration. At the same time, he started work in Majorca on three enormous canvases, *Blue I*, then *Blue II* and *Blue III* (1961, Paris) in which the artist still mixed dream and cosmic space. Miró constantly innovated plastically and technically: *Painting III* (1965, Barcelona, Joan Miró Foundation), *Woman and Bird* (1967, Paris), *Woman and Birds in the Night* (1968, Barcelona, Joan Miró Foundation), *May 1968* (1973, Barcelona, Joan Miró Foundation) and *Burnt Canvas* (1973, Barcelona, Joan Miró Foundation).

Miró cultivated all the arts: painting, lithography, etching, sculpture, ceramics, tapestry and more. The Fondation Maeght in Saint-Paul-de-Vence has a large collection of his art, as does the Miró Foundation, created in 1975 in Montjuic near Barcelona. Given the very personal nature of his plastic art, Miró did not have followers but attracted the interest of contemporary artists.

APPROACH AND STYLE

A painter of women, birds and the celestial universe, Miró worked with oils on canvas, paper, cardboard, wood, copper, wood fibre and plaster supports and other materials in all kinds of sizes.
The Dalmau gallery in Barcelona, the Licorne gallery in Paris, and P Matisse, an art dealer in New York, supported his art.
In Barcelona, Miró discovered French Impressionist, naive, Fauve and Cubist art. In Paris he became closely involved in the Surrealist movement. In Amsterdam he was inspired by the interior scenes of the minor Dutch masters and Vermeer. Montroig (Catalonia), Cuirana, Prades, Varengeville (Seine-Maritime) and Palma de Majorca remained his main sources of inspiration.

● Between 1916 and 1919, Miró painted in the style of *Van Gogh, Fauvism, the ornamental style of *Matisse (*Standing Nude*) and Synthetic Cubism. He mixed the formal approach of Cubism and the colours of the Fauves. From 1918 onwards his *détailliste* technique introduced an astonishing precision in the representation of the landscape and 'surreal' details and a variety of equally surprising shapes. This period reached its peak and end in 1921–2 (*The Farm*). But from 1920 onwards the artist began to introduce pure plastic signs, sometimes gentle, sometimes cruel, which heralded Surrealism (*The Farmer's Wife*).
● In 1923 he became fascinated with automatism and created a dream-like, lyrical, poetic universe, part fantasy, part animal, graphically dense and colourful, exuding happiness and lightness. Miró was inspired by a 'purely interior model' (Breton, 1925), dense (*Harlequinade*) or sober (*Maternity*). In *Ploughed Earth*, a Surrealist version of *The Farm*, the *détailliste* precision of the early days gave way to 'abstract' signs, based on the metamorphosis of the elements of reality.
● In his mature period, in 1924–5, Miró at first used a very personal figurative language (*Harlequinade*); then he chose an automatic pictorial language, characterized by an unpre-

A GREAT PAINTER
◆ Miró's talent was recognised early on by the Surrealists: Breton described him as 'the finest feather in the Surrealist cap'.
◆ Miró broke away from the European figurative and abstract styles and adopted a weightless, dreamlike style, combining geometric shapes, arabesques, enigmatic signs and human or animal hybridizations. He gave free rein to his imagination. His canvasses are unusual, gentle, poetic and sometimes even violent.
◆ Throughout his lifetime, he developed certain themes including women, birds and stars. Like Ernst, he placed the sun at the centre of his work.
◆ Miró experimented with techniques and supports, including crumpled paper, burnt canvas and melted supports.
◆ His often brightly-coloured pictorial universe demonstrates his constant inventiveness and the coherence of his work, along with a high degree of aesthetic freedom.

dictable and cheerful line and unfinished appearance (*Siesta*), the only Surrealist element being the form's dream-like quality (*Person Throwing a Stone at a Bird*). He reinterpreted forms and colours of Dutch interior scenes and known portraits of past centuries with inventive fantasy. His imaginary portraits, consisting of undulating, highly shimmering flat colours, stood out against a background divided into geometric flat tints, also coloured, in which black still had its place (*Seated Woman*). These 'characters' who are rooted to the ground move around as independent biomorph motifs in a vibrant ethereal space (*Painting*).

• The Spanish Civil War and World War II influenced Miró's art in a very different way. The Civil War prompted him to create moving female monsters, screaming as they express their suffering (*Woman's Head*). Black now invaded his pictures; expressions were lyrical and violent, and the mood ferocious. The conflict of 1939–45, further increasing the horrors of war, prompted him mentally to escape reality and take refuge in dreams that were reflected more in the titles than in the motifs and execution of the pictures: the figures were sad and dazed, while roughly worked areas and perfect flat colours were used together on the same canvas, whose texture the artist allowed to show through (*The Escape Ladder*); or he worked on paper 'dirtied' with black marks or rings. At the same time, Miró's *Constellations* with their ethereal, coloured, poetic motifs celebrated women, birds and the starry night, the promise of life and renewal.

• The artist then concentrated on his favourite subjects, women, birds and the sky, which he treated with lightness and joy (*People in the Night*). The glowing solar disc was nearly always present in the paintings of this period. In about 1953, his compositions became more sober, the figures simpler and more archaic, the brushwork more rustic (*Painting*); this development led the artist in 1961 to enrich his art with the plastic contributions of American art, using large monochrome formats (*Blue* series).

• In his last works, he went so far as 'assassinate painting' to use his own words. He used oils in the same way as watercolours (*Painting III*), cracked a white wall, conceived material for its own sake (*Woman and Bird* then *May 1968*), painted on crumpled paper (*Woman and Bird*), also worked on fabric (*Woman and Birds in the Night*). He even burnt his canvas (*Burnt Canvas*).

The artist constantly renewed his art in order to prevent visual familiarization and the declining power of the signs while preserving the dream-like, poetic dimension.

Dutch Interior I
1928. Oil on canvas, 92 x 73cm, New York, Museum of Modern Art

Miró was inspired by H M Sorgh's Lute Player. *He discovered this minor 17th-century Dutch master during a trip to Holland in 1928. He did not interpret or imitate the intimate musical moment in the original painting, but translated each detail into his own fantastic, surrealist vocabulary. The lute is clearly identifiable as are the dog and the cat. In contrast, the landscape seen through the opening in Sorgh's painting, on the left, has become a coloured ensemble in which can be seen a black branch and a white oval shape, symbolizing the light, perforated by a red circle which is a transposition of the thick curtain. The white tablecloth has become a white shape on the ground while the listeners have turned into the black 'foot' on the right.*
The undulating, slender elements of the composition dance to the sound of the 'smiling' lute and the jingling colours.

Blue III

1961. Oil on canvas, 2.70 x 3.55m, Paris, Musée National d'Art Moderne, Centre Georges-
Pompidou

The last panel of a large-scale triptych, this painting inaugurated Miró's move into his new studio in Majorca. The luminous azure, crossed by a comet's tail and a black star, is the result of his thorough research during the 1950s and his knowledge of abstract Expressionism which he discovered during his trip to the United States in 1957. This painting synthesizes Miró's development with remarkably few means. The artist's favourite themes, the star, the comet and the infinity of the sky are all there. The pictorial treatment (the black flat tint symbolizing the star, the deliberate blur of the reddening comet and the long, supple rope of the tail) illustrate the variety of the painter's technique. The unfathomable universe, imbued with spirituality, is conveyed by these inimitable blues, applied with light, vibrant rubbing.

KEY WORKS

In the course of his long career of 65 years, Miró created thousands of canvases, gouaches, drawings and ceramic pieces.

Standing Nude, 1918, Saint Louis, AM
The Farmer's Wife, 1922–3, New York, Mme Marcel Duchamp coll
Ploughed Earth, 1923–4, New York, Guggenheim
Harlequinade, 1924–5, Buffalo, Albright-Knox AG
Person Throwing a Stone at a Bird, 1926, New York, MOMA
Dutch Interior I, 1928, New York, MOMA
Seated Woman, 1932, New York, pr coll
Paintings, 1933, Barcelona, Joan Miró Foundation
Characters before Nature, 1935, Philadelphia, MA
Woman's Head, 1938, Los Angeles, Winston coll
The Escape Ladder, 1939, Chicago, pr coll
22 Constellations, 1941, Chicago, AI
Woman and Birds at Sunrise, 1946, Barcelona, Joan Miró Foundation
People in the Night, 1950, New York, pr coll
Painting, 1949, Basel; 1953, New York, Guggenheim
Blue III, 1961, Paris, MNAM
Woman and Bird, 1967, Paris, Lelong gall
Woman, Bird and Star, 1978, Barcelona, Joan Miró Foundation

BIBLIOGRAPHY

Erban, W, *Joan Miró, L'Homme et son Oeuvre*, Taschen, Paris, 1998; *Miró*, exhibition catalogue, Georges Pompidou Centre, Paris, 1992

Dubuffet

Dubuffet was a solitary, innovative artist who carried on his research in the tradition of the 20th century. He created a polymorphic range of work, organized in cycles which developed from research into 'brute' texture to the multicoloured patterns of the *Hourloupe* and painted collages, eventually achieving an almost abstract art in spite of his constant recourse to figurative representation.

LIFE AND CAREER

• Jean Dubuffet (Le Havre 1901–Paris 1985), French painter and sculptor, was born into a family of wine merchants. In 1916 he enrolled for evening classes at the School of Fine Arts in Le Havre. In 1918 he went to Paris where he attended the Académie Julian for six months, after which he worked on his own. He struck up a friendship with André Masson, Fernand *Léger and Juan Gris, then painted *Botany Lesson* (1924, Paris, Jean Dubuffet Foundation, Périgny-sur-Yerres). He hesitated between painting, music and literature. He travelled to Lausanne and to Italy, he worked in Argentina, then took over the family business in Le Havre. There he married and then moved to Bercy in Paris in 1930. In 1933 he returned to painting and in 1935 he became involved in sculpture. In 1937 he abandoned painting again. He remarried and 1942 he decided in favour of an artistic career. His childhood friend G Limbour introduced him to the writers J Paulhan, Paul Éluard, P Seghers, F Ponge and the painter Jean Fautrier.

• After a first turbulent exhibition in Paris in 1944, he began work on a large cycle of paintings including *Countryside with Cyclists* (1943, Paris, MAD) which he described as 'Art Brut' in 1945 because of its intentionally primitive appearance. The series of the *Hautes Pâtes*, exhibited under the title *Mirobolus, Macadam and Co.*, included among others *Venus of the Pavement* (1946, Marseilles). His portraits included *Pierre Matisse, Obscure Portrait* (1947, Paris) but 'however beautiful they were' they caused a scandal.

• During his stays at El-Golea in the Sahara, between 1947 and 1949, he produced colourful paintings such as *Arab with Palm Tree* (1948) and a series of *Grotesque Landscapes*.

• Back in Paris, he met André Breton and created the Compagnie de l'Art Brut, whose first exhibition was held in 1949. Dubuffet created the series *Ladies' Bodies: Miss Spider* (1950), *Gymnosophy* (1950, Paris, MNAM), then the character of *Metafizyx* (1950, Paris, MNAM) and *Music in a Muddy Country* (1950); he used 'vulgar', unusual materials and aroused indignation. Between 1951 and 1955 Dubuffet produced *Landscaped Tables*, *Landscapes of the Mind* and *Stones of Philosophy*, followed by *Momentary Places*, the *Pâtes Battues* and *Assembly of Imprints*. He stayed in New York where he met *Pollock, *Duchamp and Yves Tanguy.

• Between 1953 and 1955 he livened up about 20 paintings by adding butterfly wings: *Small Characters and Dog* (1953, Paris, MAD) and *Pearly Garden* (1955, Paris, MAD). In the summer of 1954 in Auvergne he chose the cow as a model. He also produced lithographs.

• He started work on the series of the *Texturologies*, including *Physics of the Soil* (*Texturology XXIII*, 1958), and became interested in the theme of the beard with *Beard of Light of the Blind* (1959, pr coll) and *Have you Picked the Beard Flower?* (1959, pr coll), a poem illustrated with drawings.

• In the tradition of Art Brut he produced the boldly painted *Mass of Soil/Soil Mass* (1960, Paris), full of spirituality, and *Rue Pifre* (1961, pr coll).

• Between 1962 and 1974, the artist created with the Hourloupe, the second large cycle of his career: *Trotte the Houle* (1964), *Bank of Ambiguity* (1963, Paris, MAD). Applying the same aesthetic approach he developed architecture projects and sculptures made with modern materials (such as polyester, epoxy, painted sheet metal). From 1969 onwards, he began building his studios in Périgny-sur-Yerres, and installed there a painted environment, La *Closerie Falbala*.

• The series of *Parachiffres*, animated by impulsive, frenetic stripes, was followed by that of the *Society Events, Abridged Places*. Dubuffet then became interested in assemblage with the series of *Theatres of Memory* (1975–9): *Easter Holidays* (Paris, 1976, Dubuffet Foundation), *The Weaving Vision* 1976, pr coll).

• The sites of these assemblages became increasingly ambiguous and indeterminate. In 1981–2, the artist produced 500 small paintings on paper, grouped under the title *Psychsites*, followed by *Unpredictable Sites: Site with 5 Characters* (1981, pr coll) and *Arms Dangling* (1982, pr coll).

• In 1983 he developed a form of abstraction with the *Sighting Points* series in which the

figure disappeared in favour of blue and white lines: *Mire G 131* (1983, Paris), *The Competition of Things* (*Mire G 174, Boléro*, 1983, Paris), the Non-Lieux series, produced on a black background continued in a similar vein and marked the end of his career: *Non-Lieux H 51* (1984, pr coll), *Idéoplasme XVI* (1984, pr coll), *Parcours* (1985, pr coll).

Having decided on an artistic career late in life, this 'deconstructivist', writer and poet developed into a virulent detractor of culture in *Prospectus for Amateurs of all Kinds* (1946), *Dissertation on the Development of my Work from 1952* and *Asphyxiating Culture* (1968-9). In 1967 the Musée des Arts Décoratifs benefited from a substantial donation from the artist. Shunning groups and schools, Dubuffet had no followers but his innovative art influenced many artists such as Antonio Tàpies, Willem de Kooning and Asger Jorn.

APPROACH AND STYLE

Dubuffet first painted heads and portraits, country landscapes, views of the Sahara and Paris, then indistinct, conceptual human figures. He glued on butterfly wings and made positive use of soil and matter, and even beard hair. His work took the form of cycles of variable length.

His work ranged from medium to large formats. The artist painted with oils on canvas, sometimes enhanced with materials added and incised; he used paint made with glue, applied oils to panels of staff (plaster and hair) and to Isorel softboard, or vinyl on canvas, or acrylic on paper mounted on canvas. He also used commonplace materials, even some 'discredited' substances such as tar and gravel.

Dubuffet rejected all reference to the art of the past and his contemporaries.

The Drouin gallery in Paris and the P Matisse gallery in New York recognized his originality early on.

• Dubuffet started his artistic career after 1924 with a painting which could be defined as being somewhere between Classicism and the avant-garde. He attacked Western art as elitist. He wanted to paint for everyone and this led him to rethink art, its practice and the customs associated with it. He was searching for a completely new means of expression.

• From 1944 onwards, he revised the 'figurative' vocabulary by conceiving Art Brut (1945-62), free of all pictorial conventions. He depicted subjects from everyday life in a spontaneous, unexpected form, sometimes ferocious and destructive, with barbaric candour, reminiscent of a child's drawing, the expressions of the insane and the brutality of graffiti and scribbling.

• After his small Sahara paintings with their violent colours, Dubuffet emphasized the archaic, frightening expression of the 'anti-psychological, anti-individualist' portraits and the bodies of the naked characters whose flesh he modelled with thick paint, broken up by quick strokes. With these 'insults to the face', this deliberate clumsiness and coarse, earthy colours, Dubuffet celebrated neither beauty nor ugliness but the treated matter which created the body from the inside. He claimed that an amateur painter could be more gifted than a professional and that the aesthetic criteria imposed by galleries, museums and critics were outdated. He defended a coherent deconstruction of art.

• The use of butterfly wings reassembled into beautiful images was merely a poetic, thematic and pictorial pause.

A GREAT PAINTER

◆ Dubuffet's early work shocked the critics and the public. Only a few initiates appreciated its innovative nature: the painters Fautrier and Jorn, the writers Breton and Paulhan. Later his work was better received, especially in the United States. Retrospectives were organized in major museums during the artist's lifetime: in Paris, (1960, 1972-3, 1981, 1991) and in New York (1962, 1972-3).

◆ Dubuffet made a clean slate of Western art, rejecting subject, material and aesthetics. He created a 'mental' art. For him, 'art must be born of the material': he thus inverted established artistic reasoning.

◆ He completely changed the 'figurative' vocabulary and plastic approach, imposing Art Brut which preceded culture, working in cycles and series including the *Hourloupe*.

◆ He used poetic and prosaic materials: butterfly wings, dirty grease, asphalt, rust and used materials, etc; and he mixed media, such as lacquer and oil paint

DUBUFFET

• He then returned to Art Brut; this, he said, must 'be born of the material ... and be fed by instinctive lines and inscriptions. The main gesture of the painter is to coat. Spirituality must use the language of the material'. At the time the artist favoured 'discredited' materials, unusual and unworthy of art, such as dirty grease, gravel, sand, coal, splinters of glass and rust. He scratched, scraped and incised the material. He produced strange landscapes and 'texturologies' of floors and walls made from unstable materials. He used tar and asphalt, both monochrome and dense, very close to the raw material.
In 1959 he was completely absorbed by 'beards', both living and ancestral, and they too were made from assembled materials; he even dedicated a poem to them.
• The diversity of his Art Brut work led to different interpretations: was it the representation of an archaic memory and the unconscious, an impression taken at the 'wild state' as André Breton claimed, or the new, thought-out expression of an artist who liked, according to G Picon, to be 'insurrectionary, illegal, scandalous'? It was a reappraisal of culture, of the *Asphyxiating Culture* (Dubuffet's writings). The artist showed an objective reality, devoid of cultural customs, like that of the non-knowledge of the Brut 'artists', those inspired and instinctive innocents.
• With *Paris Circus* and the imposing cycle of the *Hourloupe* which occupied him from 1962 to 1974, Dubuffet abandoned Art Brut and its materials in favour of a form closer to painting. Although figuration was now more direct, making room for objects of everyday life such as a coffee pot, tap or bicycle, it took the form of sinuous lines, mostly black, like pieces of a puzzle with multicoloured stripes, then three-coloured, on a white or sometimes black background. He developed this proliferation of irregular shapes on the canvas, placed in imaginary architecture, sculptures and surroundings. He even applied it to a spectacle *Coucou Bazaar* (1971–3) which should be looked at like an 'animated picture'. Sometimes an 'anti-naturalist', cellular character is included.
• In contrast to the *Hourloupe* 'system' were the *Theatres of Memory* (1975–9), places which were more mental and visual than physical and tactile, reconstituted from fragments cut out of old canvases, like 'our memories which appear suddenly higgledy-piggledy in the theatre of our thought'. These parts were interlocked or juxtaposed to form large compositions, including 'landscapes', characters and shapes.
• The *Psycho-Sites* and *Unpredictable Sites* (1981–2), ideograms of archaic characters, seen full-length, wandered suspended in an indeterminate place, brightly coloured: 'My aim is not to portray an object or a place but to represent thought, to convey it so that it can be felt', the artist explained.
• As for the *Sighting Points* (1983), the 'sighting point' of the eye and element reflected by a mirror, these excluded characters and all figurative motifs in favour of a labyrinth of abstract lines with violent graphics in blue and red on a background of flat tints in yellow or white. 'Free of any representative articulation and obligation, the lines became frantic, colours were exaggerated and the informal forces broke loose', Michel Thévoz wrote. *The Dismissals* (1984) represented yet another step forward towards this blueprint of the painter's language: the interwoven lines and curves, with a predominance of white, on a black background, were brightened up by red and blue strokes, painted boldly and vividly. Dubuffet's work and philosophy illustrated this path towards 'point zero' of art, the thought-out 'nothing', a unique development in western thought.

KEY WORKS

Dubuffet created thousands of works divided into series and cycles.
Venus of the Pavement, 1946, Marseilles, Cantini
Pierre Matisse, Obscure Portrait, 1947, Paris, MNAM
Arab with Palm Tree, 1948, pr coll
Miss Spider, 1950, pr coll
Metafizyx, 1950, Paris, MNAM
Music in a Muddy Country, 1950, pr coll
Pearly Garden, 1955, Paris, MAD
Physics of the Soil, Texturology XXIII, 1958, pr coll
Mass of Soil/Soil Mass, 1960, Paris, MNAM
Trotte the Houle, 1964, pr coll
Easter Holidays, 1976, Paris, Dubuffet Foundation
Unpredictable Sites: Site with 5 Characters, 1981, pr coll
Mire G 131, 1983, Paris, MNAM
Non-Lieux H 51, 1984, pr coll

The Metafizyx
1950. Oil on canvas, 116 x 89cm, Paris,
Musée National d'Art Moderne, Centre
Georges-Pompidou

*Neither alive nor dead, neither bony nor
fleshy, this archaic creature, half-man,
half-monster, is 'slightly funny and
slightly laughable'; according to Dubuffet
this was how all creations must function.
Grimacing, imposing and weather-beaten,
this 'brute' character is knotty, complex
and inhabited inside by the earthy
material with which the painter has
replaced the flesh, bones, muscles and so
on. The scratched and incised body, which
also displays suffering, conjures up
'human savagery'. It also inspires a
feeling of unease, 'but it is an unease
which I endure willingly', the artist said.
Dubuffet rejected all concept of beauty;
instead he faced reality in its brutal truth.*

Trot the Ball
1964. Oil on canvas, 89 x 116cm, private collection

*This painting is part of the Hourloupe cycle (1962–74) which signified a return to oil painting, a seemingly
more rational construction, organized like a puzzle. In this painting the assemblage consists of painted shapes,
irregular areas of solid blue, white and red and others striped in different directions; of similar colours, they are
outlined in black and white and interlocked against a black background. In this labyrinth where the eye gets lost,
the painter aimed to create 'an unreal and insane mental map and, and as far as references and suggestions are
concerned, completely indeterminate locations'.*

BIBLIOGRAPHY
Jean Dubuffet, catalogue of works, ed, J-J Pauvert, Paris, Weber, Geneva, 1964-0; Thevoz, M, *Dubuffet*, Skira,
Geneva, 1986; *Dubuffet*, exhibition catalogue, Georges Pompidou Centre, Paris, 1981

Bacon

Bacon's chubby, tormented face, the body and face of his real and imaginary models were the subject of his tortured, gnarled art in pursuit of the 'traces left behind by human existence'. The indifference and solitude of everyday life, banal and intimate, stimulated his vision of humanity which he captured immobile or moving in the most trivial situations, and subjected to severe plastic distortion.

LIFE AND CAREER

• Francis Bacon (Dublin 1909–Madrid 1992), a self-taught British painter, was the asthmatic son of a horse-breeder and was educated by a private tutor. Thrown out by his father, he moved London in 1925, then to Berlin. From 1926 to 1927, he lived in Paris, where he discovered the art of *Picasso and the films of Buñuel. He painted a few watercolours. An interior decorator and furniture designer, he also painted sporadically from 1929 onwards, then abandoned painting for ten years.

• In 1944 he destroyed many of the paintings of this period, keeping only ten of them, including a *Crucifixion*. This was also when he decided to devote himself entirely to painting: *Three Studies for Figures at the Base of a Crucifixion* (1944, London) which portrayed monstrous creatures, the *Flayed Ox* after *Rembrandt, and *Figure in a Landscape* (1945, London). His penchant for series, on the 'scream' among others, became evident from 1944 onwards. In *Painting* (1946, New York, MOMA) he referred to the war and Mussolini, whom he portrayed as a dictator with a disturbing fixed grin. He painted numerous heads including *Head VI* (1949, London) and carried out preliminary work for his *Study after Velázquez's Portrait of Pope Innocent X* (1953, Des Moines). His liking for series was also reflected in his many nudes such as *Study for a Crouching Nude* (1952, Detroit, IA) and in *Study for a Portrait of Van Gogh III* (1957, Washington, Smithsonian Institution).

• Bacon also captured attitudes of everyday life (*Two Figures in the Grass*, 1954, pr coll) and seated figures in his numerous portraits as well as heads such as *Study for a Portrait* (1953, Hamburg, K). He had several exhibitions: at the Hanover Gallery in London in 1949, in New York in 1953, the Venice Biennale in 1954, the Rive Droite gallery in Paris in 1957, Documenta in Kassel in 1959, etc.

• In the 1960s he returned to his recurrent themes and developed them: *Study after Innocent X* (1962, Humlebaek [Denmark], Louisiana M), *Crucifixion* (1965, Munich), *Second Version of 'Study for a Corrida No 1'* (1969, Basel, Beyeler gall) and *Second Version of 'Painting 1946'* (1971, Cologne, Ludwig coll).

• From 1965 onwards he became interested in people in the process of moving: *After Muybridge – Study of the Human Body in Movement – Woman Emptying a Bowl of Water* and *Paralytic Child Walking on all Fours* (1965, Amsterdam, SM).

• The portrait remained an integral part of his work throughout his career; he painted his friend George Dyer whom he met in 1964 and with whom he lived until the latter's suicide in 1971: *Portrait of George Dyer Talking* (1966), *G Dyer Bicycling* (1966, Basel, Beyeler coll) and *Portrait of George Dyer in a Mirror* (1968, Madrid, Thyssen-Bornemisza). He painted *Three Studies for a Portrait of Isabel Rawsthorne* in the form of a triptych (1968, Madrid, Thyssen-Bornemisza) and *Three Studies of Lucian Freud* (1969, pr coll).

• Continuing with the theme of the nude and clothed characters, he modified their framing in space: *Lying Figure with a Hypodermic Syringe* (1963, Switzerland, pr coll), *Three Figures in a Room* (1964, Paris MNAM), *Lying Figure* (1969, Basel, Beyeler gall), *Three Studies of a Man's Back* (1970, Zurich) and *Three Studies of Figures on Beds* (1972).

• He remained fascinated by the impulses which generated movement: *Body Moving* (1976, pr coll), *Character Moving* (1978, Los Angeles, pr coll), *Jet of Water* (1979, pr coll; 1988, London, Marlborough, IFA), *Figure Moving* (1985, pr coll).

• From 1969 until his death in 1992 he painted self-portraits. His work included those of 1969 (pr coll), 1970 (pr coll), 1971 (Paris), *Self-Portrait with Injured Eye* (1972, pr coll), the paintings and small triptychs of 1973, 1974 (pr coll), 1976 (Geneva, pr coll) and the triptych of 1985–6 (London, Marlborough, IFA).

Bacon influenced Italian painting between 1950 and 1960 as well as the new figurative movement.

APPROACH AND STYLE

Bacon reinterpreted pre-existing iconographic themes: the Crucifixion, the portrait of Innocent X and Battleship Potemkin. He painted numerous nudes set in an enclosed interior and portraits of his friends and himself. The characters were often depicted on their own or in twos, rarely in threes. He made a few paintings of chimpanzees, a dog (1952–3), bullfights (1969) and a small number of rare landscapes.

He painted individual paintings, series of paintings or secular triptychs, in small format for close-up portraits as well as large formats.

The painter was encouraged by the gallery owner F Mayor and his paintings were bought by wealthy collectors including M Sadler and, from 1946 onwards, by A Barr for MOMA in New York. The Marlborough Gallery in London exhibited his work from 1957 until his death.

Bacon was a contemporary of Expressionism and minimal art. His sources of inspiration included *Picasso's Cubism, the Postcubism of the sculptor Henry Moore, photography and in particular the decomposition of movement by Muybridge, X-rays, Buñuel's Surrealist films and the reading of medical textbooks.

• The complete absence of anecdotal and emotional elements in his early paintings reflect Cubist and Postcubist influence (*Crucifixion*): 'I want my picture to be very orderly', he said. Surrealism and the dimension of the automatic gesture met his second requirement.
• Between 1945 and 1950, Bacon reinterpreted famous paintings by, for instance, *Grünewald, Rembrandt, *Velázquez, *Van Gogh and Picasso. He first looked for traces of human existence in painted, photographed or filmed representations made by others before taking the risk of capturing it on his own face and that of his friends.
• He developed his unusual style and his obsession with the human figure in the early 1950s . His characters, physically tortured by his painting, were prisoners of their hatred and mental suffering which they sometimes expressed by screaming (*Head VI*, *Three Studies for Figures at the Base of a Crucifixion*). He emphasized this impression of being walled in by the addition of 'cages' 'which enclosed the model so as to capture him better', he explained (*Study for a Crouching Nude*, the *Popes* series).
• In the 1960s, his role of neutral and objective observer became even stronger. His ability to 'eliminate all sentimental context' was facilitated by a framing of the subject which placed the painter and the viewer no longer in the direct field of the painting but elsewhere, either higher or lower.
• His development, which focused on the human figure, was shared with a whole generation of artists searching for a violent, pitiless form of expression. Bacon preferred the everyday poses of ordinary or marginal people (drug addicts, homosexuals, etc). 'For me it is really like setting a trap which enables me to capture a fact at its most lively moment', the artist explained. He perceived reality in its moments of crisis and tended towards the drama-

A GREAT PAINTER

◆ Bacon's success has not ceased to grow since 1950 and has given rise to many questions regarding the meaning of his work.
◆ Rejecting abstraction, which he defined as decorative, he said that he captured life and reality in a representation detached from tradition.
◆ He concentrated on the representation of postures, realistic or imaginary; he painted intimate, crude subjects, sometimes shocking, twisted, vomiting or defecating. The gaping mouth, shouting out the truth to a disguised social image, was characteristic of Bacon (*Pope Innocent X*).
◆ The artist used unusual centring, photographic or cinematographic, raised or seen from above. He also drew lines of perspective on the canvas which then became the cage enclosing the painted character. He invented the triptych portrait.
◆ His paintings, painted directly on the canvas without preparatory drawing, could not be modified or the object of second thoughts. If there were any, they formed an integral part of the painting.
◆ The painter presented a completely new plastic interpretation of human figures; the bodies were truncated, amputated, assaulted and subjected to unbearable torsion; the faces were disfigured, tortured and erased in places. His style was brutal and disturbing and his colours bright and acid; he had a preference for light colours ranging from light pink to violet, from orange to red. The brushstrokes were supple and cursive, the paint matt with a granular impasto.
◆ Bacon's paintings are disturbing: they scare or challenge the viewer.

tization of everyday life. Bacon displayed the bodies of his subjects, inflicting on them all sorts of contortions, sometimes to the point of dismemberment and disintegration, depending on the tortuous rambling of his imagination; he depicted these bodies in ordinary, intimate postures: sitting, lying, defecating or making love (*Two Figures in the Grass*). The gaping mouth played a fundamental part. It was cruel in Mussolini's face; screaming in that of the mother; inspired by *Poussin's *Massacre of the Holy Innocents*; and agonizing in the screaming nurse from Eisenstein's *Battleship Potemkin*. These 'primal' attitudes inspired him to make a physical connection between humans and animals, the dog and the chimpanzee.

• The space in which Bacon situated his characters was also ordinary (a bedroom, a bed, a bathroom) or indeterminate and empty. This association between face and surroundings increased the impression of ambiguity and unease. The silence echoed everywhere, in the expression on the faces and in the abyss separating the characters in the triptychs: they do not communicate.

• With his brush he belaboured the portraits of his friends and his self-portraits, painted from memory or from a photograph. The pictorial material 'devoured' the face or erased it in part as if to destroy the face in order to get behind it and penetrate inside the thinking being, while retaining the physical reality. He created a striking harmony between the colour and the expression on the faces of George Dyer, Isabel Rawsthorne, Lucian Freud, Henrietta Moraes, Michel Leiris and in his self-portraits.

• He used Expressionism for his personal purpose: an oppressive, aggressive deformity of the face, frozen in the moment, from love to death; a character invading the foreground; a brutal brushstroke leaving behind powerful traces of rough impasto. The influence of minimal art was reflected from 1962 onwards in the large colourful flat areas of colour, in harmony with his subjects.

• In about 1965 he became interested in the movement of bodies, deformed and jagged, more than in moving bodies (*After Muybridge – Study of the Human Body in Movement*).

• From 1970 onwards he created space around his figures by producing vast triptychs consisting of paintings designed to be seen simultaneously rather than separately. This made it possible to perceive, between the panels, the differences making tangible the truth of the characters, shown full-length, head-and-shoulders or in close-up, sometimes with the edge of the picture sometimes cutting into the face. In his individual paintings he divided the background into three parts and separated the image by means of a mirror. The contrast between the colour of the floor and that of the wall, straight or curved, increased. The colour, now very confidently controlled, ranged from shades of pink to orange but also included cold hues such as blue, grey and beige.

KEY WORKS
Bacon created about 600 paintings.
Three Studies for Figures at the Base of a Crucifixion, 1944, London, TG
Head VI, 1949, London, The Arts Council of Great Britain
Study after Velázquez's Portrait of Pope Innocent X, 1953, Des Moines Art Center [Iowa]
Two Figures in the Grass, 1954, pr coll
Three Figures in a Room, 1964, Paris, MNAM
Crucifixion, 1965, Munich, SMK
Portrait of George Dyer Talking, 1966, pr coll
Three Studies for a Portrait of Isabel Rawsthorne, 1968, Madrid, Thyssen-Bornemisza Foundation
Three Studies of Lucian Freud, 1969, pr coll
Self-Portrait, 1969, pr coll
Second Version of 'Painting 1946', 1971, Cologne, Ludwig coll
Self-Portrait, 1971, Paris, MNAM
Three Studies of Figures on Beds, 1972, pr coll
Body Moving, 1976, pr coll
Three Studies for a Self-Portrait, 1972, 1973 and 1979, pr coll
Figure Moving, 1985, pr coll

BIBLIOGRAPHY
Sylvester, D, *Interviews with Francis Bacon*, Thames and Hudson, London, 1995; *Bacon*, exhibition catalogue, Georges Pompidou Centre, Paris, 1996

Three Figures in a Room (central panel)
1964. Triptych, oil on canvas, each panel: 1.98 x 1.47m, Musée National d'Art Moderne, Centre Georges Pompidou

Using a 'panoramic' shot, Bacon has depicted three naked characters in a same room; they are each engaged in an ordinary, everyday occupation, displaying complete indifference to their neighbour. The figures are situated in a space below the eye line of the painter, and of the viewer, as if to reinforce this isolation.
The affective and physical neutrality is emphasized by the bare, beige room. The deformed nudes who have become 'bodies without organs' (G Deleuze, 1981) reveal a lively, bubbly plasticity in which Bacon has developed his own figurative techniques. They contrast with the soberness of their environment, both formally and chromatically.

Self-Portrait
1971. Oil on canvas, 35.5 x 30.5cm, Paris, Musée National d'Art Moderne, Centre Georges-Pompidou

The violence of the gesture which guided the brush has dissolved the bone of the jaw, deformed the mouth and swollen the face. 'Bacon's head comes to us from afar, erased, washed, masked, cleansed, covered with circles, ellipses, pastilles, scarred by pustules and commas. Every brushstroke is an additional illusion which is piling up on the previous ones. An illusion, an accident or even a tiny catastrophe ... it is here no more than a ghost, freed from its own reflection. Bacon yearned to capture the mystery of appearance in the mystery of the treatment' (P Muray, 1982, The Corpses in the Triptych).

Pollock

Promoter of abstract Expressionism and more especially of Action painting, Pollock painted what he was: an artist in touch with his unconscious and wasted by alcohol. He developed a revolutionary technique, drip painting, filling his canvases with splashes of colour and tangled, rambling drips, dark or brightly coloured.

LIFE AND CAREER

• The American painter Jackson Pollock (Cody, Wyoming, 1912–Springs, Long Island, 1956) was the fifth son of a poor family which moved around in California and Arizona because of his father's numerous professional failures. After some difficult years in Riverside, near Los Angeles (1924–8), he studied art at the Manual Arts School (1928–30) in Los Angeles. This is where he met the future abstract Expressionist painter Philip Guston.

• In 1930 Pollock moved to New York to join his brother Charles who was studying painting and to whom he owed his initiation to art. He enrolled at the Art Students' League where he attended the classes of Thomas Hart Benton, leader of the regionalist school. There he met the Mexican mural painters José Orozco, Diego Rivera and David Siqueiros, and travelled throughout the United States. At the same time he was beginning to be interested in European painting. In 1935 the Federal Art Project commissioned large mural paintings from him as part of the Roosevelt programme to provide financial assistance for artists. In 1936 Siqueiros invited him to take part in his experimental workshop: spray painting and airbrushing, and using industrial synthetic paints and pigments. During these years of economic depression he lived in poverty, became an alcoholic, spent time in detoxification centres and underwent Jungian psychoanalysis.

• His early work, produced in the 1930s, revealed his artistic culture: *Woman* (1930–3, New York, L Krasner Pollock coll), *Going West* (1934–8, Washington), *The Flame* (1937, New York, MOMA), *Circle* (1938–41, New York, MOMA) and *Birth* (1938–41, London, TG). The influence of Mexican mural painting is clearly visible in *Naked Man with Knife* (1938–41, London, TG).

• In 1941, through the painter Lee Krasner whom he had known since 1936 and would marry in 1945, Pollock met Hans Hofman and the future pioneers of abstract Expressionism: Robert Motherwell, Arshile Gorky and Roberto Matta. He also met the European artists who had fled from the war including *Miró, the Surrealists *Ernst, André Masson, the poet André Breton, and the Neoplasticist *Mondrian. In order to help them, Peggy Guggenheim founded Art of This Century in 1942 which functioned both as museum and gallery. She invited Pollock to exhibit there, entered into a contract with him and commissioned a mural from him, *Mural*, for her residence in New York (1943, New York, Iowa University). This artistic turmoil inspired Pollock to paint *Stenographic Figure* (1942, New York), *The She-Wolf* (1943, New York), *The Moon Woman Cuts the Circle* (1943, Paris, MNAM), *Guardians of the Secret* (1943, San Francisco), *Gothic* (1944, New York) and *The Blue Unconscious* (1946). The artist's last 'classic' work before he moved on to abstract Expressionism was *Eyes in the Heat* (1946, Venice).

• In 1947, Pollock produced his first drip paintings and took part in the last exhibition of Art of This Century; he signed a contract with the B Parsons gallery. His painting, now gestural, was described as Action painting by the American critic H Rosenberg. Pollock painted *Alchemy* (1947, Venice, P Guggenheim coll), *Cathedral* (1947, Dallas), *Summertime: Number 9 A* (1948, London, TG), *Arabesque: Number 13 A* (1948, New Haven), *Black and White* (1948, Paris) and *Tiger: Number 3* (1949, Washington). He took part in the 1948 Venice Biennale.

• In 1950 his art was at its peak: *Lavender Mist: Number 1* (Washington), *Autumn Rhythm: Number 30* (New York), *Composition* (Lugano) and *One: Number 31* (New York) which is considered his greatest masterpiece. Some of his paintings are exhibited at the Museo Correr in Venice. He joined the group of the 'irascible' abstract Expressionists: Adolphe Gottlieb, Hoffmann, Willem de Kooning, Ad Reinhardt, Mark Rothko and others.

• From 1951 onwards he returned to the use of black and white, showing *Picasso's influence: *Echo: Number 25* (1951, New York, MOMA), *Number 7* (1952, New York); *Portrait and a Dream* (1953, Dallas, MFA). *Convergence* (1953, Buffalo, Albright, Canberra) is less immediately readable. But Pollock did not abandon drip painting, as illustrated by *Blue Poles: Number 2* (1952, Canberra). His work was exhibited by the gallery owner S Janis, the last

gallery in which he exhibited. He painted his last masterpiece, *The Deep* (1953, Paris), and some less innovative paintings such as *White Light* (1954, New York, MOMA).

A serious alcoholic, Pollock died in a car crash at the age of 44. He was the initiator of the postwar artistic turmoil in the United States, which then spread to a second generation of abstract Expressionist artists (J Mitchell, Helen Frankenthaler) and Abstract painters (Sam Francis, Jean-Paul Riopelle). Abstract European artists such as Pierre Soulages, Olivier Debré and Antonio Saura were also influenced by him.

APPROACH AND STYLE

Pollock painted a representation of himself, based on the unconscious. He worked with oils on supports such as canvas, hardboard and plywood which varied in size, ranging from small to medium, large and sometimes very large.

Peggy Guggenheim was his first client and patron while MOMA was the first museum to buy one of his paintings (*The She-Wolf*) in 1944.

As a child he was familiar with Indian art and sand painting and in New York he became interested in Mexican mural painting. He discovered the art of Picasso and Miró through *Cahiers d'art* before meeting the artists themselves. He was also interested in Surrealism and took part in the abstract Expressionist movement.

• His first paintings, under the guidance of Thomas Hart Benton who refused to imitate the European avant-garde but had great respect for Italian Renaissance, show his knowledge of Indian, Mexican and European art and especially his ability to assimilate them (*Going West*).

• In the early 1940s his expression became personal and was based on an aesthetic synthesis. From Picasso he borrowed the invention of the curvilinear style of drawing (*Stenographic Figure*). He admired Miró's free 'biomorph' motifs. From the Surrealists he took up automatic writing and the role of the unconscious associated with his own analytical development (*The Moon Woman Cuts the Circle*, *Guardians of the Secret*). His interest in mural painting and his reflections encouraged him to abandon easel painting. He mixed together his own artistic references, Amerindian influences, mythical Symbolism and Jungian totemism. His graphic conception and use of figurative Symbolism displayed his pictorial sensibility, eloquence, strength and the density of the materials he used.

• In 1944 he resolved the question of the figure-content relationship and strove towards what he called 'non-objectivity' in order to 'veil the image' which he had deconstructed (*Gothic*). He abandoned the surrealist use of images and moved towards Masson who translated the impulses of the unconscious without imagery.

• Resolutely opposed to the decorative, he created more angular paintings in 1945–6, still semi-figurative (*The Blue Unconscious*).

A GREAT PAINTER

◆ Encouraged very early on by Peggy Guggenheim, Pollock became famous in the 1950s as a result of the photographs and film by H Namuth showing him at work in his studio, and the writings of the critics H Rosenberg and C Greenberg. He was acknowledged in the retrospectives organized by MOMA in 1956 and 1957, which have been followed by others from the end of the 1970s until today: New York, Paris, Houston and London.

◆ Pollock created gestural painting, also known as Action painting, which rejected the traditional relationship between painter and painting.

◆ In his work abstraction was devoid of subject and object: his drip paintings were usually given the title *Number*, sometimes preceded by the name of the colours projected onto the canvas or by a qualifying title.

◆ Pollock used new materials: metallic paint or car lacquer and sometimes a support made of fibreboard.

◆ He developed drip painting, invented by Ernst, to a high level of sophistication; he projected droplets of thin paint onto a canvas laid on the floor which then ran away through the pierced background, and he enhanced the work with fine streaks of paint applied with a stick dipped in a little pot of paint.

◆ He invented all-over painting, placing all the points of the canvas on the same level. The pictorial result was a tangle of directed drip painting, straight and flowing, and little splashes of various size.

POLLOCK

- In about 1947, after some to-ing and fro-ing between figurative painting and abstraction, Pollock evolved towards a style which was described by the critic C Greenberg as 'all over' (filling in the entire surface of the canvas). This radicalization of abstraction highlighted the impossibility of decomposing the work according to the criteria of form and content, the disappearance of the motif, the levelling of all elements and the cancellation of every touch of colour by the one that followed (*Eyes in the Heat*). Pollock became the master of abstract Expressionism, of Action painting (*Cathedral*). He abandoned easel painting in favour of vast canvases and gave up traditional techniques in favour of drip painting. He placed his canvas flat on the ground and walked round it; he walked over it and entered into it. 'He therefore looked at his work from above; the role of the artist is that of creator, he unleashes the action while controlling it' (G C Argan, 1950). He moved 'sideways in the painting' and claimed that 'what had to take place on the canvas was not an image but a fact, an action'. The rapidity of the execution dominated the material, the subject of the painting followed from the body, the gestural trail replaced colour, 'the line was entirely transparent ... it does not structure' but creates 'optical space' (M Fried, 1965). Black, white and grey-blue, the colours of the lacquer and aluminium paint which Pollock used, were predominant. The artist tried to achieve a balance between controlled and spontaneous creation; the former was used in the shape of black tracery which he called the 'initial image'; the latter, free and emerging from the unconscious, produced a complex labyrinth of dribbles, more or less coloured, in several stages, until visual saturation was reached (*Arabesque: Number 13 A*). Pollock was a jazz musician of painting in the style of Charlie Parker and John Coltrane who 'played several times "over" their own recordings' (J-L Chalumeau, 1997).
- In 1950 he had completely mastered his art: the space of the canvas appeared vast, the gradations gentle and the delicacy of the drawing extreme. Canvases sometimes entirely covered with paint, at times in exaggerated superimposed layers (*Tiger: Number 3*), were superseded by an ethereal style of drawing, using a fluid, light pictorial material which allowed the neutral coloured canvas to show through. To use C Greenberg's words in 1950 describing *One* and *Autumn Rhythm*, this created an astonishing 'flat depth ... a strictly pictorial third dimension, strictly optical'. Driven by passion, Pollock succeeded in concealing the image, the figure, in a fragile, knotty weave whose maze the eye tried to follow.
- In 1951, having reached this peak in his art which showed how far he had pushed the boundaries, but also exhausted and weakened by alcohol and mental problems, Pollock returned to the representation of readable figures, to *Black Paintings* (black tracery on white background, done with a brush (*Number 7*), sometimes reminiscent of Picasso. The unprepared canvases absorbed the pigments like blotting paper, creating a subtle palette ranging from jet black to pale grey. He also painted in colour (*Portrait and a Dream*), returning now and again to drip painting (*Blue Poles*).
- In all his later paintings, visually abstract but with evocative titles, Pollock used a pastry piping bag which spouted thick jets of paints. His plasticity ranged from fluffy (*The Deep*) to tangled strokes and splashes (*White Light*).

Composition
1950. Oil and lacquer on canvas, 55.8 x 56.5cm, Lugano, Switzerland,
Thyssen-Bornemisza Collection

The size of this drip painting, one of the smallest produced by the artist, does not take away from its plastic monumentality. In 1947 Pollock summed up his technique in the following words: 'My painting does not come from an easel. I hardly stretch my canvas before I start painting. I prefer to put the canvas straight on the wall or on the floor. I need to feel the resistance of a hard surface underneath. On the floor I feel more at ease. I feel closer to the painting because I can take part in it, insofar as I can walk all around it, work from all four sides, and literally be in the painting [...] I steer clear of the traditional tools of painting such as easel, palette, brushes, etc. I prefer sticks, trowels, knives and thin paint which drips or a thick impasto of sand, broken glass and other incorporated materials.'

KEY WORKS

Pollock painted 320 canvases of which 32 date from 1950, the peak of his art.
Going West, 1934–8, Washington, Smithsonian Institution
Stenographic Figure, 1942, New York, MOMA
Guardians of the Secret, 1943, San Francisco, MOMA
Gothic, 1944, New York, MOMA
The Blue Unconscious, 1946, pr coll
Eyes in the Heat, 1946, Venice, Peggy Guggenheim coll
Cathedral, 1947, Dallas, MFA
Arabesque: Number 13 A, 1948, New Haven, Yale University, AG
Black and White, 1948, Paris, MNAM
Tiger: Number 3, 1949, Washington, Smithsonian Institution
Composition, 1950, Lugano [Switzerland], Thyssen-Bornemisza coll
Lavender Mist: Number 1, 1950, Washington, NG
Autumn Rhythm: Number 30, 1950, New York, MOMA
One: Number 31, 1950, New York, MOMA
Number 7, 1952, New York, L Krasner Pollock coll
Blue Poles: Number 2, 1952, Canberra, Australian NG
Portrait and a Dream, 1953, Dallas, MFA
The Deep, 1953, Paris, MNAM

BIBLIOGRAPHY

O'Connor, F V, *Jackson Pollock*, Museum of Modern Art, New York, 1967; O'Connor, F V and Thaw, E V, *Jackson Pollock, A Catalogue Raisonné of Paintings*, Yale University Press, New Haven, CT, 1978; *Jackson Pollock*, exhibition catalogue, Georges Pompidou Centre, Paris 1982; *Pollock*, exhibition catalogue, Houston, 1996

Warhol

A provocative dandy and the ambitious king of American pop art, Warhol took emblematic objects and celebrities from the consumer society and made a soup can into a star. The technique of using flat acrylic paint or silk-screen printing, and the sometimes great multiplication of images, were part of the technical and plastic innovations of his art.

LIFE AND CAREER

• Andy Warhol, properly Andrew Warhola (Pittsburgh 1928–New York 1987), American painter, was born to parents of Slovakian origin. He studied graphic design at the Carnegie Institute of Technology in Pittsburgh. After graduating, he left for New York in 1949 where he became a well-known advertising designer, and was known particularly for the 'Zsa Zsa Gabor Shoe' (1956, New York, S Frankfort coll) .Nevertheless, he dreamt of becoming a 'great' artist.

• In 1959, the 'Sixteen Americans' exhibition held at MOMA grouped Robert Rauschenberg and Jasper Johns under the title 'pop art'. Warhol soon followed: *Dr Scholl* (1960, New York, MOMA), *Large Coca-Cola* (1960, New York, pr coll), *Bottle of Perfume* (1961, New York, R Miller Gallery), *Superman* (1961, Paris, G Sachs coll). He discovered the comic strip as used by Roy Lichtenstein and adapted it: *Superman* (c.1961, Paris).

• 1962 marked a turning point for Warhol with the introduction of silk-screen printing: *Campbell's Soup Cans* (1961–2, Washington, NG) and *Big Campbell's Soup Can, 19 Cents* (1962, Houston, Menil coll) were both immediately successful. He created his first series: *200 Dollar Bills* (1962), *200 Campbell's Soup Cans* (1962), *Green Coca-Cola Bottles* (1962, New York, Whitney Museum) and made *129 Die in Jet (Plane Crash)* (1963, Cologne). He immortalized the stars: *Marilyn Diptych* (1962, London), *Liz Taylor* (1963, pr coll), *Triple Elvis* (1964, Richmond [Virginia], MFA) and produced *Mona Lisa* (1963, New York, Blum Helman Gallery). In 1963 he made his first film in his Factory, a centre of New York culture where he introduced the rock group, the Velvet Underground.

• In about 1964, Warhol systematized the technique of mass-produced silk-screen printing on canvas and applied it to images of the stars: *Marilyn* (1964, New York, MOMA), *Jackie and Jackie II* (1964, New York), Jackie Kennedy as the smiling bride and then as a widow, *Elvis* (1965, Toronto, Art Gallery of Toronto). He worked on *Flowers* (1965, New York, pr coll), *Cow Wallpaper* (1966, New York, L Castelli coll) as well as household and food products: *Brillo Box* (1964, New York, Andy Warhol Foundation for Visual Arts) and *Colored Campbell's Soup Cans* (1965, Waltham [Mass.]). He took on the crudest subjects: the *Electric Chair* series (1964–8).

• Without giving up his work on still images, the subject of *Self-Portrait* (1967, pr coll) was passionate about film (*Kiss*); his ground-breaking techniques became part of the cinematographic avant-garde.

• In 1968, the murder attempt of which he was the victim inspired him to produce *Skull* (1976, New York, Andy Warhol Foundation). He devoted himself to commissions for the jet set: *Ladies and Gentlemen* (1975, New York, Andy Warhol Foundation). He introduced brushstrokes into his portraits: *Mao* (1972, London, Saatchi coll) and *Julia Warhol* – his mother (1974, New York, Andy Warhol Foundation). He carried out technical experiments (*Oxidation Painting*, 1982, Zurich; *Joseph Beuys*, 1980, Berlin, E Marx coll) and he painted further series, including *Dollar Sign* (1982, New York, L Castelli gall). In 1984, he produced *Rorschach* (New

York, L Castelli gall), in 1986 *Campbell's Noodles Soup* (Salzburg), *60 Last Suppers* (1986, New York) and *Camouflage Self-Portrait* (1986, New York).

Painter, illustrator, film maker, writer, Warhol was a media star. He was the symbol of the period 1960–80. He left numerous writings including *The Philosophy of Andy Warhol: From A to B and Back Again*, *The Andy Warhol Diaries* and *POPism: the Warhol Sixties*.

APPROACH AND STYLE

Warhol used everyday imagery such as shoes and cartoon strips. He also depicted American society in all its aspects: consumer goods (soup cans), finance (the dollar), the star system (Elvis Presley, Marilyn Monroe, Liz Taylor), politics (J F Kennedy, Mao, Nixon), sport and various events (air crash, car crash, race riots, suicide, fugitives) taken from news photographs. Subjects such as food poisoning or the atomic bomb contrasted with the rural, carefree attitude of his flowers and cows. Warhol's preferred mediums were silk-screen printing and acrylic on canvas.

Before Warhol, Roy Lichtenstein, Jasper Johns, Robert Rauschenberg, James Rosenquist, Tom Wesselmann and Claes Oldenburg were drawing their subjects from advertising and cartoon strips. The American artists W M Harnett and J Baberle had already painted paper money in the 19th century; the repeated cartoon strips hark back to Ad Reinhardt, the vibrant backgrounds to Mark Rothko, and his skulls to the 'vanity' paintings of the 17th century. Warhol parodied abstract impressionism. He was inspired by the psychological tests carried out by the Swiss psychiatrist and neurologist Hermann Rorschach.

• During the 1950s Warhol became aware of the return to representation although abstract Expressionism predominated. In his publicity creations, he used a technique of transfer on blotting paper. He parodied consumer goods with humour, covering them with gold and silver ('Zsa Zsa Gabor Shoe'), and sometimes treating them in an Expressionist manner (*Bottle of Perfume*).

• Then Warhol took on the values of pop art and introduced the comic strip (*Superman*). However 'to become a famous painter', he declared, 'I have decided to go into various areas in which I can lead'. In 1962 he took everyday consumer goods, which he enlarged to unusual sizes using a projector and then projected onto a canvas: the dollar, Coca-Cola or a tin of Campbell's soup. His screen prints were mechanical and impersonal, without depth, with flat, vivid, unreal acrylic colours.

• Following the uniqueness of the motif came serial compositions. The duplication of the same coloured or black and white motif, seen in its entirety or represented in a fragmented way and repeated, saturated the eye and neutralized or augmented the emotions. The rendering alternated the perfection of the flat tint and the variety of chance (*Marilyn Diptych*). Perception swung between representation and abstraction (*100 Cans*). By the use of different stencils, Warhol introduced diversity into the repeated motifs (*Green Coca-Cola Bottles*).

A GREAT PAINTER

◆ Warhol is equally famous for his work and for his membership of the jet set. A retrospective of his work was mounted in 1990, in New York and Paris.
◆ The artist moved away from abstract Expressionism and minimalism towards pop art.
◆ He raised 'objects' of mass consumption to the level of works of art.
◆ He used innovative techniques: transfers and 'dabbing', the projector, stencil and above all silk-screen printing on canvas. He experimented with original plastic effects caused by urine on copper, and by modified negatives.
◆ Warhol pushed the figurative object into the abstract world.

Warhol

- He worked out a picture 'strategy' with an eye to power and to his publicity role. He was no longer interested in 'objective reality' as executed by *Pollock or *Bacon but he focused on the 'dynamic condition'. His images were factual, in other words rapid, multiple, strong, and then 'gone'.
- In about 1964, he systematically applied the screen-printing technique to his series: stars, political figures and various events.
- In the mid-1970s, he enriched his portraits with brushstrokes in acrylic paint in rapid wide zigzags, or worked with his finger (*Mao, Julia Warhol*): the champion of screen-printing became transformed into a 'traditional' artist (*Mona Lisa*).
- From the end of the 1970s Warhol reverted to 'pure' screen-printing on canvas. He experimented with uric acid (urine) on a copper panel (*Oxidation Painting*) and the rendering on paper of a negative sprinkled with diamond dust (*Joseph Beuys*). He returned to 'dabbing' (*Rorschach*). Finally, he became interested in the printed motifs of military clothing (*Self-Portrait with Camouflage*).

KEY WORKS

Warhol produced a huge number of screen prints on canvas, with a varying amount of multiples.

Superman, c.1961, Paris, G Sachs coll
200 Dollar Bills, 1962, pr coll
200 Campbell's Soup Cans, 1962, pr coll
Green Coca-Cola Bottles, 1962, New York, Whitney Museum
129 Die in Jet (Plane Crash), 1963, Cologne, Ludwig Museum
Marilyn Diptych, 1962, London, TG
9 Jackie, 1964, New York, pr coll
Colored Campbell's Soup Cans, 1965, Waltham [Mass.], Rose Art Museum, Brandeis University
Self-Portrait, 1967, pr coll
Mao, 1972, London, Saatchi coll
Oxidation Painting, 1982, Zurich, T Ammann FA
Campbell's Noodles Soup, 1986, Salzburg, pr coll
60 Last Suppers, 1986, New York, Castelli gall
Camouflage Self-Portrait, 1986, New York, MOMA

BIBLIOGRAPHY

Warhol, exhibition catalogue, Tate Gallery, London, 1971; Crone, R, *Andy Warhol*, Thames and Hudson, London, 1970; *Andy Warhol*, exhibition catalogue, Georges Pompidou Centre, Paris, 1982

Colored Campbell's Soup Can
1965. Acrylic and screen-print on canvas, 1.93 x 1.22m, Waltham
[Mass.], Rose Art Museum, Brandeis University

*In 1962 Warhol explained his first 'Campbell's': 'I simply paint the
things that have always seemed beautiful to me, the things that we use
every day without thinking about it.' The banality of the subject
propelled his art and his personality to the forefront of the art scene.
The choice of colours (pink, blue, orange and green) echoed those used
in advertising. Building on the multiplication of an identical image, in
this serial representation Warhol has enriched the colour from one can
to the next.*

GLOSSARY

Acrylic: a man-made polymer; a synthetic and organic paint medium that came onto the market in America in the 1930s. It was originally intended for use in industry, and is soluble both in water and special thinner. Richly coloured, opaque and resistant, acrylic paint gives a unique neutral finish of flat, solid colour and enables the artist to work quickly (Warhol, Bacon). Its strong adhesive quality means that other materials like sand, marble dust or glass fibre can be easily incorporated into the artwork (Duchamp, Miró, Pollock, Dubuffet). A convenient, flexible medium, it is easy to rework, dries quickly and keeps its colour intensity well. It forms the basis of most modern synthetic paints.

Aerial perspective: the gradual alteration and blurring of shapes, colours and contrasts caused by the empirical effects of distance and light (see Leonardo).

Artistic style: the qualities of manner, mode, treatment or technique that distinguish the work of one artist or school from another (for example, elongated figures, smooth brush strokes or impasto).

Axonometric perspective: projecting orthogonal or oblique lines onto a flat surface in order to represent a figure in three dimensions. This means that all lines running parallel to the picture plane remain parallel to it, with vertical lines running perpendicular to them into infinity. This technique is often used in architectural drawings.

Baroque perspective: an extreme form of illusionist perspective using all the typical illusionist techniques: foreshortening, *da sotto in sù*, grisaille (see Correggio and Pietro da Cortona).

Bifocal perspective: this technique uses two lateral vanishing points. Piero della Francesca used a very low horizon line, in comparison to, say, Uccello who also used a version of this system.

Binder or medium: the substance or vehicle that holds the pigment particles in a paint or varnish. It can be based on oil (natural or artificial oils), glue or resin (natural or synthetic varnish). The binder determines the optical and technical qualities of the paint: its ease of use, consistency, opacity or transparency, resistance and drying time. It is not the same as a dilute solution (eg turpentine in oil, where oil is the binder).

Bistre: a brown colour made from a mixture of soot, water and gum (a sticky plant secretion) used in drawings and as a wash in water-colours. It was in use very early, and was certainly employed in manuscripts in Italy in the 14th century: outlines were drawn with a quill and shadows created using a paintbrush. In the 20th century it began to be replaced by sepia.

Bitumen: asphaltum, a natural material, often occurring near oil deposits: a mixture of a carbon-rich element with linseed oil and wax. The shiny brown colour allowed painters to create a transparent effect in shadowed areas. It was particularly popular in the 19th century, in oil paintings where a Rembrandtesque chiaroscuro effect was sought, or for retouching repairs. Over time, it becomes opaque, moves and causes irreparable damage such as cracks and dark stains, making a bitumen base a nightmare for restorers (Reynolds, Ingres, Wilkie).

Bodegón: a 16th-century Spanish term describing paintings of a humble kitchen interior (furniture, crockery), or a display of food (game, fish, eggs etc). The genre reached its peak in the 17th century (Cotán, Zurbarán, Velázquez), when the term was practically synonymous with "still life".

Broken tints: an area containing a mixture of colours, usually in small adjacent dabs (see Van Gogh).

Cangianti: iridescent colours or a transition from one shade to another, spread seamlessly over the same surface to give a shot silk effect. Used in the 14th century to model drapery as if it was woven with a warp of one colour and the weft of another, its use became fashionable in the 16th century and was developed by the Mannerists, in particular Pontormo.

Central, classical or Albertian perspective: a strictly geometric form of perspective invented by the 15th-century architect Alberti. A central vanishing point is fixed at the point where the main or central line of the visual pyramid intersects with the horizon line. The shape and height of the object are projected onto the surface. All lines running parallel to the picture plane remain parallel to it, and all other lines converge at the central starting point. This technique was pioneered by Piero della Francesca.

Chiaroscuro: using the contrasts of light and shadow to model the volume and shape of an object or to unify space and depth of a composition. Caravaggio and Rembrandt both used sharp contrasts in their theatrical night scenes, to achieve dramatic effects of small areas of focussed light within mysterious pools of darkness.

Conversation piece: a small painting of at least two people in conversation, or often a large family group engaged in communal activity, usually in a domestic setting or garden. Developed in 18th-century England and popularized by Hogarth.

Cool colours/tints: colours close to blue and green.

Da sotto in sù: this means "from the bottom up", referring to foreshortened figures or objects seen from below. The use of extremely sharp perspective creates the illusion of a figure rising upwards into extended space (used to great effect by baroque painters like Lanfranco, Corregio and Pietro da Cortona).

Distemper: paint that has been ground in water and then thinned (distempered) with glue (gum) just before it is applied. It is used mainly for scene painting or on walls and ceilings, which must be perfectly smooth and meticulously prepared. Very occasionally used for easel painting. The technique requires the artist to work very quickly as the colours dry fast, making it impossible to rework areas or build up layers.

Figura serpentina: a serpentine line (Vasari), often expressed in the human figure. This sophisticated idea originated from the *contrapposto* technique (figures are asymmetrically poised, with one part of the body turned in a different direction to another), and was developed in the 16th century by Michelangelo and the Mannerists, who developed twisting, corkscrew movements and increasingly elegant figure proportions refined beyond naturalism.

Flat tint: an outline filled with perfect solid colour, with no volume and no trace of brushwork.

Foreshortening: the use of perspective to create a strikingly distorted view of the human body, in an effort to represent depth on a two-dimensional surface. This technique was used slightly by Giotto and to more dramatic effect by Mantegna, Uccello and Michelangelo, as well as by the Baroque masters.

Fresco: a wall painting using inert, earth pigments such as ochre, umber or terre vert, which do not react adversely or change colour when in contact with lime (*buon fresco*). The paint is mixed with water and applied with a brush to a final surface layer of still-wet fine, lime plaster (*intonaco*) or smooth or grainy mortar (a mixture of sand and lime). During the drying process, chemical reactions cause a strong bonding of colours and *intonaco*. It is possible to paint on a dry surface (*fresco secco*) using a wider range of brighter colours bound with gum or egg, but the colours are not so durable. Blues, for example, must be applied *a secco*.

Frottage: rubbing the paper over a rough, dry surface with graphite to pick up marks, as in brass rubbing. This technique was used in combination with oil paint in the 20th century (see Ernst).

Glaze: transparent or semi-transparent colour heavily diluted in oil, applied over an area of dry under-paint to modify the optical effect, like a tinted camera filter. Simple, single-tint glazing was particularly popular during the Renaissance. Titian developed subtle multi-layered glazes in his later works. The term is imprecisely applied to the final touches made to an oil painting, sometimes over the varnish layer.

Grisaille: a monochrome painting or sketch in shades of grey, to create the effect of relief sculpture. This technique was used for illuminations, drawings, sculptors' preparatory sketches, frescoes, canvasses and stained glass. It became very popular in France in the 14th century, then later in Italy and with northern painters (Uccello, van Eyck, Mantegna, Giovanni Bellini, Brueghel, Bosch and Corregio, then Rubens, Ingres, Boucher and Manet).

Grotesque: used to describe ornamental decorations, usually on walls or ceilings, which combine fantastic architecture, strap-work, plants, mythical animals and monsters (gryphons). The style was very fashionable in the 15th century (Ghirlandaio, Pinturicchio). In the late 15th century the term was used to describe the painted interiors of Ancient Rome (the Golden House of Nero). Such embellishments became popular with the Mannerists in the 16th century (Giovanni da Udine in Raphael's studio, Rosso, Primaticcio), then came back into fashion in the 19th century (Audran, Boucher) when the city of Pompeii was uncovered.

Guelphs and Ghibellines: warring factions from two German families. The Guelphs (Italian

form of the German Welf) were Bavarian dukes whose feudal power was opposed to the imperial Hohenstaufen family, who were known as the Ghibellines (Italian form of the German Waibling) after their castle. The conflict spread to northern Italy in the 13th and 14th centuries, with rival city-states siding either with the Guelphs, who were loyal to the Pope and rejected imperialism (Arezzo, Assisi, Florence), or with the Ghibellines, who supported the German Empire under Frederick Barbarossa.

Impasto: the laying on of colour thickly, usually characterised by bold and free handling and irregular thickness of layers of paint created by a paintbrush or palette knife. This produces bumps, dips and ridges of different sizes, creating a three-dimensional effect of light and shadow (see Hals, Rubens, Delacroix, Fragonard, Monet, Van Gogh, Pollock).

Linear perspective: a technique based on a fixed vanishing point, in which shapes appear smaller as they get further away. It is possible, however, to create a distorted effect by using even slightly curved lines. Light also plays a role, as Leonardo discovered.

Maestà: the Virgin in Majesty.

Monotype: a direct printing technique involving transferring an original design or painting in ink or paint from a metal (or other) surface to paper while wet, in order to create a unique work of art (used notably by Degas and Gauguin). Weaker second impressions can be taken from the residual ink.

Pala: a large altarpiece for a church, often on multiple wood panels.

Palette knife painting: a technique anticipated in the 17th century and popularized in the 19th century, in which paint is applied to the canvas using a trowel-shaped steel knife of variable width (see Turner, Goya, Courbet, the Impressionists).

Perspective: the geometric science of depicting real or imaginary objects in three-dimensional space, starting from an arbitrary fixed point. This technique of portraying three-dimensional visual reality on a flat surface is based on both empirical and rational principles.

Pigment: a mineral, organic or synthetic substance, ground up to produce colour.

Primary and complementary colours: the primary colours of paint pigments are red, blue and yellow. Secondary colours are achieved by mixing two of the primaries to get green, orange or purple. Complementary colours are those that enhance each other and give the most intense effect when placed in close proximity. The complementary of the primary colour red is green (the mixture of the other two primaries, blue and yellow). Complementary colours have been used with increasingly deliberate effect since 19th-century optical theories (Chevreul) were studied by painters (Delacroix, Monet, Seurat).

Primitive, parallel or intuitive perspective: a construction based on a single vanishing point, using empirical methods. This rather clumsy technique, used notably by Cimabue and Giotto, was improved upon by Brunelleschi and Alberti.

Rational or Brunelleschian perspective: rational perspective was invented in the 15th century by the architect Brunelleschi, with the aim of creating a visual and empirical method for the realistic portrayal of distances and dimensions. This method, pioneered by Masaccio but no longer used today, was based on the principle of a central vanishing point.

Reworking or retouching: the marks left when a correction is made to a drawing or painting in progress.

Saturated colour: pure colour, completely unadulterated with white.

Sfumato: blurred outlines and softly fading colours. No crisp definition of the edges of forms. In perspective space, the air is smoky and the scene is shrouded in bluish mist (see Leonardo).

Silk-screen printing: a sophisticated stencil process where a fine mesh of silk is tacked to a wooden frame as support for a cut paper stencil or other method for blocking out the design, such as glue. A separate screen is required for each colour. Warhol used a developed process of printing a photosensitive or photochemical transfer onto a screen or canvas coated with emulsion.

Tempera painting: a technique used mainly for manuscripts and panel painting, based on pigments and egg binder. The elaborate processes involved are described in detail by Cennino Cennini in his 14th-century text, *Il Libro dell'Arte*.

Warm colours/tints: colours close to red and orange.

Index

This index lists the 73 Great Painters, and others who participated in or influenced the art discussed in this book.
The page numbers in bold refer to sections which focus on one of the 73 selected artists.
An asterisk preceding an artist's name in the main text (or in a legend) means that he is one of the selected painters.

Photo credits